THE ART OF PLACEMAKING

The Art
Placem

RONALD LEE FLEMING

of
aking

*Interpreting Community
through Public Art
and Urban Design*

MERRELL
LONDON · NEW YORK

Contents

6 Acknowledgments
8 The Townscape Institute

11 The art of placemaking: an introduction

30 I. Case studies

33 Gateways: creating a sense of arrival

73 Transit facilities: providing orientation for travelers

95 Murals: part of a town-enhancement strategy

129 Integrating placemaking into architecture

165 Placemaker as turf definer

187 Sculpture as place setting

208 II. Interpreting place:
 from marker to memory trail

210 Placemaking interpreted:
 revisiting the past, revealing future choice

242 III. The character of street furniture

244 An armature for placemaking

252 Street furniture: a compendium of projects
 252 Benches
 257 Streetlights
 260 Hatch covers and pavements
 264 Gates and fences
 267 Wall decoration
 270 Sculptural elements

286 IV. Public-art planning:
 what we have learned from the past

288 Planning for placemaking

322 Annotated guide to public-art plans

328 Failure and the potential for redemption

342 Curatorial truth and contextual consequences: the evolution
 of federally funded public art at the GSA and NEA

358 The artist's perspective: working in the field of public art
 Dimitri Gerakaris, artist-metalsmith, New Canaan, New Hampshire
 Gregg LeFevre, bronze sculptor, New York
 Andrew Leicester, environmental art, Minneapolis
 William P. Reimann, stone etchings and sculpture, Cambridge, Massachusetts
 T. Ellen Sollod, environmental art, Seattle

374 Select bibliography
379 Index

Acknowledgments

This book is dedicated to my children, Severine, Siena, and Reynolds, whose eyes keep the world fresh and whose spirits keep their father whole. They are the ultimate Placemakers.

THE PRODUCTION OF THIS BOOK has been a saga evolving over a decade. Although we had discussed some of the ideas in previous books, we began afresh with new analysis and case studies and, as the work progressed, we found more and more convincing material. There is no formal body of material on this subject; after all, "placemaking" as we defined it was a word that we popularized in 1981 with our first book on public art.

Finding the material was mainly via word of mouth through a network of colleagues and friends around the country. Consequently, there are many to whom we owe thanks for their participation in the information gathering, or for their general support. Like many of the works themselves, this collaborative effort has involved the assistance of artists, artisans, architects, arts administrators, historians, planners, and reporters of the urban scene. They have helped us to find the projects, and then to research them, in many cases from initial concept through to implementation. They have also helped us to evaluate projects and public spaces; indeed, we learned a lot by watching certain pieces of public art and particular public spaces over time. Public-art failure is among the more poignant stories that we tell, and an argument for the placemaking approach.

We have to acknowledge at the outset that ten years is a long period, so we are also grateful for the patience of our friends and colleagues. Of course, we must take complete responsibility for our own assessment, but there is much we would not have known without the candor of so many sophisticated observers of the built environment. We have decided to acknowledge our professional colleagues in the footnotes, and the photographers are credited in the captions next to their work. If you do not see a photo credit, it is because we took the picture ourselves. We want to offer our sincere thanks to those who took the time to call back to answer questions, or who had the patience to review our drafts.

We are particularly grateful to the artists who answered a set of questions that we prepared about the process of commissioning public art and urban-design work. All of them have projects featured in this book, and so they have had to cope with the tedium of our queries before. We think that their answers add a constructive complexity to the discussions, and a candor that cuts to the core. We already knew four of the five artists before we started the book, and have worked with three of them on public-art commissions over the course of the years. So thank you, old friends Dimitri Gerakaris, Gregg LeFevre, Andrew Leicester, and Will Reimann. And thank you, too, Ellen Sollod—we look forward to getting to know you in the coming years.

We are also grateful to our board, which has encouraged us to persevere on this project over the decade. Dr. John Constable has always taken the long view with a generosity of spirit and an analytical frame of mind that has been an inspiration. Philip Behr has come up faithfully to our board meetings from his base in Philadelphia, and put us in touch with William H. McCoy, then chairman of the Radnor Township Planning Commission, who became the major catalyst behind the award-winning Radnor

Gateways Design Strategy. William Sutherland Strong, Boston, our intellectual property expert, guided us through our change to private foundation status and has long been our legal advisor.

Over the years, there have been other advisers and friends. Professor Nathan Glazer encouraged us to publish in the very last issue of *Public Interest*. The resultant article, co-written with Townscape staffer Melissa Tapper Goldman, helped us to press our argument about federal policy and public art in this book. Other advisers include David Bird, Cambridge, Massachusetts; E. Pope Coleman, Cincinnati; Lester Glenn Fant III, Washington, D.C.; James Greene, architect and planner, Columbus, Ohio; Grant R. Jones FASLA, Seattle; Frank Keefe, Boston; the late Edmond H. Kellogg, Pomfret, Vermont; the late James Lawrence FAIA, Brookline, Massachusetts; Robert McNulty of Partners for Livable Communities in Washington, D.C.; Professor Charles G.K. Warner, Lincoln, Massachusetts; Roger S. Webb, Boston; and the late William H. Whyte, Jr., who gave us our first professional audience in 1971.

Because this has been such a long-term project, there are many staff, interns, and volunteers to thank. Some worked on case studies sporadically for a period of years; some were with us for only a few months. Some were focused on this project, and others helped only incidentally while on other assignments. We hope that we have remembered everyone and ask forgiveness if we have unintentionally left someone off the list. Thanks go first and foremost to Melissa Tapper Goldman, a recent graduate of the University of Chicago, who worked on and off at The Townscape Institute for three years. She did a major part of the research and writing for the mural chapter, as well as the aforementioned work on federal policy and public art. She contributed to case studies and recruited other staff. She came back from California for the final effort, and we are grateful for her goodwill, intellectual curiosity, and tenacity of purpose. One of her recruits was her long-time friend Jennie Miller, a young Harvard graduate, who worked on case studies and street furniture. Melissa also brought in Claire Gunter, who provided in-house editorial assistance in the weeks before the book went to the publisher. Those who have worked on *The Art of Placemaking* include Adam Varat; Sarah Murray; Sarah Bromberg; Jill Trendler; Moriah Evans; Alana Murphy; Heather Rubenstein; Heather Williams; my former assistants Dr. Ruth Shackelford and Jennifer Allen; Aparna Majmudar; Thomas McClain; Ryan Smith; Sylvia Kindermann; Gabrielle Clark; Kerry Schneider; Rachael Johnson; Chloe Taylor Evans; my former assistant and all-round Girl Friday, the estimable Dorothy Healy, whose good humor has kept the office tranquil; and Maura Scanlan, who has stepped into her shoes.

This book represents a culmination of efforts over many years, and so I also wish to thank those individuals and families who have nourished body and soul during the past decade, and those who were the initial mentors and muses in my youth. For that first grounding, I would like to thank Rufus and Leslie Stillman of Litchfield, Connecticut, collectors and patrons who sheltered me and stimulated my interest in modern and contemporary art. I enjoyed staying in their Marcel Breuer-designed houses, after my fellowship in the decorated arts and history at Historic Deerfield, Massachusetts, in 1963, where I spent a blissful summer after college. Noré V. Winter, former director of Townscape services, now of Boulder, Colorado, and Brent C. Brolin of New York, architect and author of *Architecture in Context*, provided professional support and inspiration during the early decades of main street projects.

For their support during the past decade, a time of stress, I should like to thank the late Lady Fiona Baker of Cambridge, England; Minette Basel and her parents, the late William K. and Minette Bickel of Pittsburgh; William P. Carey, New York; Ljiljana Cook, Cambridge, Massachusetts; Nicholas Danforth, Weston, Massachusetts; my sister, Susan Fay Fleming, Salt Lake City; Ainslie Gardner, her son Stewart, and her family, Newport, Rhode Island; Rosemary and Torrance Harder, then of Concord, Massachusetts; Dr. Michael Johnson, Cambridge, Massachusetts; Joanne Lawson-Derby, Washington, D.C., and Houston, Texas; Gregg LeFevre, New York; Sandra Ourusoff, New York; William Page Reimann, Cambridge, Massachusetts; Earl St. Germans, Cornwall, England; Jill Spaulding, New York; Elisabeth Vines FRAIA, Adelaide, Australia; Rob Walker, Newport, Rhode Island; Raynor and Ranne Warner, then of Lexington, Massachusetts; and Kimball Wheeler, Los Angeles.

Finally, I would like to thank my parents, the late Mr. and Mrs. Ree Overton Fleming of Laguna Hills, California. To them my sister and I owe much gratitude for the happy and loving environment they provided for their children. This was the ultimate blessing, as it secured in us the confidence to define our own challenges and to seek the civic good on our own terms.

The Townscape Institute

The award-winning Chelsea, Massachusetts, revitalization project used a $3.1 million federal grant to transform the streetscape of this gritty low-income city just north of Boston. Ronald Lee Fleming was the principal design advocate for changing the building façades to respect community character and recruited Carol Johnson and Associates to do the landscape design for brick sidewalks and generous street planting. Two percent of the budget went for public art that provided a placemaking orientation—thus setting a precedent of quality for low-income cities across the nation.

Townscape design is the art of giving visual coherence and organization to the collage of buildings, streets, and spaces that make up the urban environment. Since its incorporation in 1979, The Townscape Institute, a nonprofit, public-interest planning organization in Cambridge, Massachusetts, has used this concept to improve the legibility and livability of cities, towns, and neighborhoods. The Institute's range of endeavors supports the notion that the whole can become more than simply the sum of its parts. By advocating visual enhancement of the built environment and projects combining public art and urban design, The Townscape Institute affirms, enhances, and reveals a sense of place. For more than thirty years, the Institute's president and staff have worked in over one hundred communities and ten countries with a practice that includes consulting, advocacy, education, and the execution of design work. The Institute's projects seek to reveal "place meaning" and thus to encourage a sense of proprietorship toward locale that can nourish a positive ethic for the built environment. To achieve this goal, The Townscape Institute develops strategies that strengthen people's claim to their own environs by fostering mental associations to them. Such projects include pioneering Main Street revitalization efforts; cultural identity programs, including interpretive markers and computer software; and the commissioning of public art and artisanry.

Ronald Lee Fleming served as the Executive Producer of an award-winning 28-minute film on Newburyport, Massachusetts, entitled *A Measure of Change* (1975), which documents the evolution of preservation planning as well as "Main Street" and waterfront design issues. The Townscape Institute also produced an exhibition and video, *What So Proudly We Hailed* (1989–90), which traveled for two years around the country and was co-sponsored by local preservation groups. It has been hosted at sixteen locations.

One of the Institute's most ambitious projects, the Radnor Gateways Enhancement Strategy, a 5-mile trail of megalithic monuments and milestones, won the Environmental Design Research Association and *Places* magazine of environmental design award for design in 1998.

Publications have always been integral to The Townscape Institute's advocacy rôle. The Institute has authored a trilogy entitled *The Power of Place: Towards an Ethic for the Built Environment*, which comprises *Façade Stories: Changing Faces of Main Street Storefronts and How to Care for Them* (1982), *On Common Ground: Caring for the Shared Land* (1982) and *Place Makers: Public Art That Tells You Where You Are* (1981). The influential series was nominated for a Pulitzer Prize by the Massachusetts Historical Society in 1982. One of the books became a traveling exhibition that toured the country. Also, Harcourt Brace published a book and poster series entitled *New Providence: A Changing Cityscape* in May 1987. The text and illustrations trace the evolution of an imaginary but typical American city from the nineteenth century to 1990 with issues documented in fifty-five American cities and towns.

The Institute's most recent publication, a technical handbook entitled *Saving Face: How Corporate Franchise Design Can Respect Community Identity*, was published by the American Planning Association with a revised and expanded edition in 2002. This work illustrates case studies of communities that have successfully persuaded fast-food and gasoline franchises to modify their designs in ways that respect local contexts.

RONALD LEE FLEMING has authored books on historic preservation, visual quality, and environmental education. His lifelong concern for the character and memory of places was expressed through his pioneering "Main Street" planning projects in the 1970s. His rôle as founding chairman of the Cambridge Arts Council—integrating the work of artists into the cityscape—gave resonance to his definition of "placemaking" in the early 1980s. With degrees from Pomona College and Harvard's Graduate School of Design, he lives in Cambridge and at Bellevue House, Newport, Rhode Island.

The Art of Placemaking
An Introduction

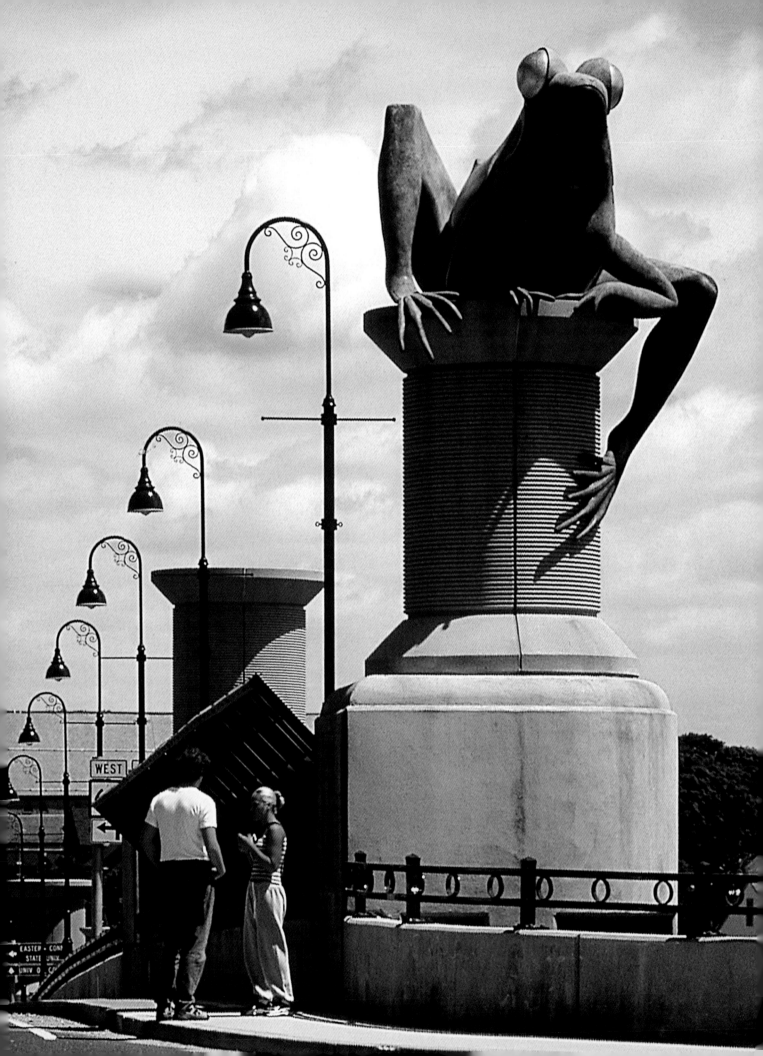

Thread City Crossing,
Windham, Connecticut;
see p. 24. Photo: Jeff
Goldberg, ESTO.

M OST READERS WILL ASSUME THAT the title of this book is a
play on words about the content of the book. There is a description of art, and there is discussion
about place, and then there is the mix of art and culture, which is the art of placemaking. But the
major conversation in the book is about particular projects of art and craft. These are the collection
of public-art case studies, accrued and analyzed over a ten-year period from 1995 to 2005. The reader
attracted to pictures could move immediately to the portals of this collection. There, one can view a
shifting scale of projects ranging from cast highway abutments in Phoenix and Scottsdale to hand-
crafted tree guards and grates in Louisville and Mercer Island. These projects, which have engaged
the energies and ingenuity of artists and artisans across the country, enrich the narrative of place
meaning. Consequently, they collectively tell a larger story about the need for such work. They are,
in fact, the evidence of a changing attitude, and the argument for increased policy attention to the
problem of how to create and sustain "place" in America.

But it is well to linger first over the *double entendre* of the title, and to tease out some notions
about the state of the art that we have uncovered in the process of assembling this collection of case
studies. For there is an art to placemaking that needs to be understood in a time when that proverbial
"sense of place" is disappearing all around us. The questions that first need to be asked are: What makes
this art of placemaking both possible and necessary in our time? Why are the conditions ripe for
it? How have they changed since we last wrote about the subject in 1987 when there were fewer and
often more simplistic projects to examine?[1]

Certainly, we hear the word "placemaking" more often these days. "Place" words are now
attached as a requirement to many planning and urban-design proposals in this country, and that
is a significant change. There is now increasing lip service paid to the importance of place. But the

larger condition of place, encapsulated in the well-worn term "a sense of place," appears ponderously in the fulsome language of architectspeak. It is probably used as often as "paradigm shift." We would argue that this profligate use of the phrase attests to its now being included in the consciousness of the age, but, because it is such a heavily freighted phrase, it is often at risk of losing its integrity. The words get stretched to accommodate a variety of conditions until they are overused and exploited. Of course, there are those people to whom these words are still tender for the promised seduction of their aspirations and for the very poignancy of the desires they evoke: who, after all, does not want "a sense of place"? But more often, the words are discovered to hide the harlotry of a smarmy marketing slogan—abused, hackneyed, and spiritually hollow.

"Sense of place" is easily touted to flaunt the cosmetic charms of a new development slapped up with an instant picturesqueness of pasteled and plastered sheet rock. With names like "Cedars' Rest," these projects eviscerated the native vegetation when they were built. Or "sense of place" can be employed to describe some slick architectural megamonument, flaunting glittering spangled glass, polished metals, and crisp stone façades. Such monuments are often seen in the magazines of the architectural press. Here the image can be tarted up with clever photography, displaying shiny surfaces and/or the chiaroscuro of voluptuous modulated volumes.

OFTEN THERE is a sterility of humanistic vision. Sometimes the shimmer of image disguises the degradation of the collective meanings of setting and public space. The phrase "sense of place" can also conjure up the specter of blasted hopes; just add the words "loss of" to "sense of place" and there is a ravished matriarch. For "loss of place" implies the bittersweetness of memory. That special locale that caressed the senses and left a resonance in the mind's eye may now be a detritus of gas stations and fast food or spec-built office towers!

Place is not merely what was there, but also the interaction of what is there and what happened there. For the lovers of place in the design professions—the topophiliacs, as we are called—it may be a recollection of a distinctive physical setting that is the strongest sensation, such as the memorable double green of Chelsea, in the back hills of Vermont, or the juxtaposed squares of medieval stonework in Todi, Italy. Certainly, those who have a design sensibility instantly grasp the tactile components that create the physical image of a place. Those very special places of distinctive material culture are being documented now at a spectacular rate, and coffee-table books about them have become a small industry. However, saving such extraordinary places is not what this book is about.

For most people, it is probably not the architecture that turns a physical locale into a well-loved place; it is more often the remembrance of human interaction that helps us to claim it. Of course, a good physical design should aid that interaction, but, ultimately, it is the recollection of patterns of life lived in a particular building or space that creates the "cornerstones" of mental association[2] and gives such places the patina of affection. This is the vesting process. Traditionally, the modesty of some of the places or structures has not made them the obvious candidates for architectural surveys and historical registers. However, those surveys and registers are increasingly acknowledging this overlay as being of cultural significance:[3] the International Committee for Monuments and Sites has, in some of its recent conferences, identified this "intangible landscape" as an important preservation value.[4]

The German poet Rainer Maria Rilke understood this more encompassing view of place, and the need to know real things. Writing in 1925, he said, "even for our grandparents, a house, a well, a familiar tower, were infinitely more intimate." They were the things in which "the hope and meditation of our forefathers once entered. The animated things with which we share our lives are coming to

Hostile takeover

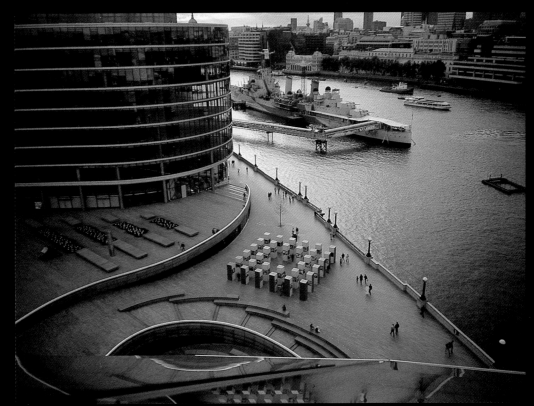

RIGHT Sir Norman Foster designed London's new City Hall, constructed between 1998 and 2003 on the River Thames opposite the Tower of London. It is sleek and elegantly formed but for the deadly amphitheater and the actively hostile public space surrounding it. The little interpretive monuments, a stone forest on a sterile plain, cannot compensate for an antiseptic encounter. A people-supportive, shaded place, full of redolent meanings, might have been fashioned here. Instead there is a crisp form, perhaps seductively photogenic in model layout, all edge and no comfort. The interpretative stele were connected to the adjacent building, and have now been removed.

RIGHT Clement Meadmore's *Open End*, originally situated in downtown Cincinnati, now sits in the grounds of a Catholic high school on the outskirts of town. This photograph from the 1980s shows it downtown, covered in protective plastic. Photo: Paul J. Zook.

FAR RIGHT The nonfunctioning concrete fountain known locally as the "Tank Trap" sat from 1971 to 1995 in the main intersection in Eugene, Oregon, now open to auto traffic and enlivened by placemaking columns commissioned by the county's Lane Arts Council.

RIGHT Isaac Witkin's *Everglades* was installed as part of an urban park downtown revitalization project, and has sat inert in the fenced-off central downtown.

Story of three benches

The Franklin Street bench of 2002, in Chapel Hill, North Carolina (right), animates the space and provides some interpretive content. The unique design from artist Arlene Slavin differentiates it from a generic bench; the seat back interprets local trees. Chapel Hill Public Arts Commission, North Carolina. Photo: Karen Slotta. Contrast this with the Boston City Hall Plaza bench (center right). Simple and generic, the seats are formally aligned without regard to the animation of the plaza they blankly overlook, and devoid of the personality a craftsman's hand could provide, with no interpretive content. But perhaps the massive concrete hulk carries a hidden meaning—recalling the Cold War age, as it seems designed to survive nuclear assault.

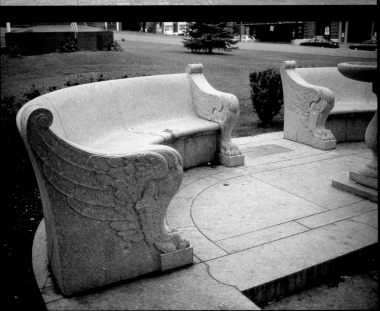

Both types differ from this graceful Classical bench (bottom left). Dating from the City Beautiful movement, at the turn of the twentieth century, with voluptuous carving, it graces the sidewalk edge of the park where oldtimers watch the action on Main Street in Great Barrington, Massachusetts. These Classical forms are coming back, thanks in part to the efforts of the Institute of Classical Architecture and Classical America, but today there may be a need to combine the form with more specific information about the place. The City Beautiful initiative was largely the effort of the upper middle class, who were familiar with the language of classicism, and sought to adorn major civic spaces. The forms would be more relevant today if combined with some of the imagery of the neighborhood's "classicism with a human face." This is something of a pun on the slogan used in Czechoslovakia during the time of Soviet influence, when the Communist government spoke about "Socialism with a human face."[12]

It is a challenge to find urban spaces designed between the 1960s and 1980s that have the kind of embedded meanings suggested by this literary analysis. Indeed, it is a challenge to find public spaces designed during that period that have become significant places. The Proustian capacity to recover past time and the Stendhalian notion of clustering associations that can enable the individual to reimagine his or her own connection to place were certainly not a part of Modern Movement design education. The *tabula rasa* approach, which spawned what has been called tabletop architecture, was the norm in most cities. The result was dead spaces that tell no tales. Indeed people usually did not stop to talk, but scuttled across these spaces.

Adding some place meaning is not the complete solution to the problems of failed major public spaces: the Federal Reserve Plaza in New York, the plaza in front of Boston City Hall, or the plaza in downtown Albuquerque are three sites that have been agonized over in redesign efforts during the past two decades. The original designers of these spaces often combined arrogance about asserting an untraceable design image with a profound naïveté about how people actually use public space, and no recognized memory of what happened there before. To cure the condition of "dead space that tells no tales," some designers and urbanists have put an emphasis on the configuration of uses. This is one good idea, but standing alone it is not placemaking as we have defined it. Places resonate because they have meaning, and certainly the layering of activity can generate more meaning over time. While use configuration is critically important to the vitality of a locale, placemaking requires deeper research into the meanings of the space, and then more interaction between several design principles.

Placemaking should be the handmaiden of urban design. It should enable an urban-design strategy to vest itself through the creation of publicly accessible meanings. Consequently, the *elements* of placemaking serve broad urban-design objectives that go beyond their intrinsic values as works of art, or their function as amenities, street furniture, and interpretation. Four urban-design objectives need to be respected if we are to reclaim the dead spaces of the Modernist era. They are, briefly:

1. Orientation: this covers the research that reveals the layers of meaning, and only then affirms the metaphors through interaction with community.
2. Connection: this refers to the design of that meaning in a holistic and integrated way throughout the site.
3. Direction: this provides the visual clarity that links the placemaking elements so that the visitor can clearly navigate the space.
4. Animation: this tests how the varied uses and activities that can build complexity in and around the space will be deployed.

Individual placemakers often integrate these different design elements. Indeed the meaning of these elements, and hence their memorability, is strengthened by the fact that they can often perform several rôles. Let us examine how the placemakers relate to those urban-design principles:

1. Orientation
All self-respecting placemakers provide some information, some publicly accessible clue to meaning. It can be as subtle and modest as a 10-in. cast-bronze puppet that recalls the life of a street performer, set on the edge of a bollard (see p. 21).

2. Connection

Individual placemakers can bind a site together with a matrix of related messages and engage each other in a visual relationship that helps define spatial ties.

3. Direction

Placemakers are well equipped to guide people through a space. Small inserts in the pavement and plaques on walls can catch the eye and move pedestrians on a trail through a housing development while alluding to the flora and fauna of an old stream bed, now the adjacent railroad tracks. Markers describe the architecture of the building and the industry, in this instance the compass-making that happened here (see p. 21).

4. Animation

Inserts in bronze of the detritus left after an open-air market are constantly polished by pedestrian feet in a downtown cross-walk, and recall the activity long established in this place. Dancing steps along a sidewalk can show where the bus stops, but the designers of a megalithic monument intended as a town gateway in Radnor, Pennsylvania, did not anticipate that it would be used as a pagan summer solstice site.

Using these placemaking tools, and relating them to urban-design principles, it is possible to reformulate some of the banal spaces that pockmarked cities in the 1970s and 1980s. Part of the answer to the questions we asked on p. 13 lies in seeing how citizens have cast out the old design and embraced the placemaking approach. In the *Place Makers* book of 1987, we included a photograph of the thuggish concrete abstraction of a fountain that was planted in the 1970s in the middle of a downtown pedestrian mall in Eugene, Oregon. We viewed this as the ultimate dead space with its pitiful concrete monolith, which, like the one on Boston's City Hall Plaza, soon stopped working.

The reason that placemaking is necessary is epitomized in this one banal space, which obviously did not tell one very much about Eugene. People called the fountain that blocked the crossroads at the city center the "Tank Trap," and at least one candidate ran for mayor with the pledge to remove it. The answer then was that placemaking was possible *because it was necessary*. Lo and behold, the "Tank Trap" is gone. What is more, it has been replaced by delicate sculpted signposts made by artists, informing you where you are, and where you can go in the surrounding area.

Signs combine the design principles articulated above. They provide orientation, physical connection over space and time, and links to other sign elements on the adjacent corners. They literally "stake out" an area that can be animated with pedestrian uses, including moveable concession stands. Eugene is examined in more depth as a case study in the section "Failure and the potential for redemption" (pp. 328–41), because revitalizing a downtown space does not necessarily save a downtown. There is, after all, the larger American tragedy of land use, which placemaking cannot redeem. By this we mean failure of political will to restrict sprawl at the edges of even the more politically enlightened cities.

Viewing what has been "coming down" in the old malls of American downtowns, and even in some of the public plazas, is heartening. The shift away from concrete abstractions and grotesquely contorted structures that sheltered only modest amenities, and the growth of this more humanistic concern for the *spiritus loci*, are gratifying. In retrospect, they give our previous *Place Makers* book a prophetic ring.

The heaviness and exaggerated self-importance of many features that landscape architects regularly implanted in the older downtowns were criticized in the 1987 book: such features as the mushroom-like shelters that, on closer inspection, were found only to disguise telephone booths; massive bulwarked drinking fountains; outsized information kiosks and sunken pits in plazas that

Four tools of placemaking

ORIENTATION (RIGHT)
The replica of Igor Fokin's puppet "Doo-Doo" recalls the puppet shows that drew crowds to this spot in Harvard Square, Cambridge, Massachusetts, where he performed for years up to his death. The Russian artist Konstantin Simun commemorated his fellow immigrant. The accompanying plaque of bronze bricks that fits into the traditional paving pattern pays tribute to Fokin and to all street performers, and is installed in the sidewalk immediately adjacent to the bollard monument. Photo: Melissa Tapper Goldman.

CONNECTION (FAR RIGHT)
The highway abutment in Scottsdale, Arizona, creates a place-specific relationship along a 5-mile corridor. Photo: Laurie Campbell/Scottsdale Cultural Council.

ANIMATION (RIGHT)
William P. Reimann's entryway circles at the Radnor–Lower Marion border on Philadelphia's main line recall megalithic monuments in Radnorshire, Wales, and inspired local, self-appointed druids to perform their rites here. The resulting entry in a police notebook supported the award that this project received from *Places* magazine.

DIRECTION (FAR RIGHT)
Gregg LeFevre's plaques move pedestrians through the building corridor from the street. Cypress Street Lofts, Condominium Development, Brookline, Massachusetts, Resource Capital Group and The Townscape Institute. Photo: Melissa Tapper

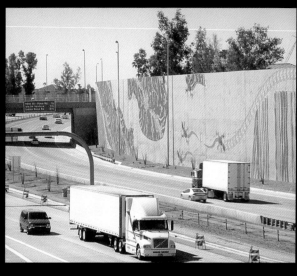

COM•PASS, *n. A device used to determine geographic direction.*

110 – 112 CYPRESS STREET
THE RITCHIE BUILDING

The Ritchie Building, a three-story, flat-roofed panel brick structure, is restored and integrated into this condominium development of 46 units. Edward S. Ritchie, a physicist, constructed it in 1883 to accommodate his growing navigational instrument production business, first known as E. S. Ritchie & Co. and later as E. S. Ritchie & Sons. Because of the significance of the building's history, it was listed on the National Register of Historic Places in 1985 as part of the Brookline Multiple Resource Area, paying tribute to Brookline's industrial era of the late nineteenth century.

At the time Ritchie constructed this manufactory, he had already gained renown for his compasses: the first patented and produced in the United States, the first liquid-filled in the world, and the first supplied to the U. S. Navy from within the country. Ritchie's compasses quickly became the standard for the Navy and merchants alike; he had sold over 30,000 by 1900, only fifty years after developing them. Ritchie Navigation of Pembroke, Massachusetts continues to manufacture the instruments today, though Ritchie's descendants have not owned the business since 1936.

An early Ritchie compass, courtesy of Ritchie Navigation of Pembroke.

In 1888, just five years after the construction of the Ritchie Building, the Town of Brookline raised Cypress Street to cross over the railroad tracks that now serve the MBTA Green Line - Riverside Branch. This changed the building's setting against Cypress Street and impacted a series of renovations – an attached garage in 1918, a loading elevator in 1953, and new entrances on several occasions. As new businesses took over the building, it continued to evolve to accommodate the changing character of the Town's commercial base, including offices for a medical group from 1973 to 2000.

The Ritchie Building underwent its most dramatic upheaval in 2003, when area developer RCG LLC, led by a team of Alex and David Steinbergh and Thomas Costagliola, partnered with neighboring landowners Richard and Bonnie Pearson to restore the building's original façade as part of a condominium development. To accomplish this, the development team commissioned a carefully engineered hydraulic lifting system to raise the 720-ton building up two full stories. The process took about three months and successfully re-set the structure 18 feet above its original foundation.

The building lifted to its present height.

The renovation of the Ritchie Building is noteworthy, reflecting a change in sensibility toward historic preservation. The Ritchie Building is neither an architectural monument nor an outstanding illustration of a style, but it is significant because it contributes to our collective memory in a transformed landscape. The Ritchie Building signifies the importance of preserving Brookline's historical context as well as its historical styles. It is likely that this sensibility, in addition to shaping our experience of this particular site, represents a change in preservation philosophy where context is given increased significance over content.

may have been the subconscious retreat to the barbecue for city boosters who returned to suburbia each night and did not initially understand their capacity for hiding street crimes. The major contribution to the redesign of Boston's Copley Square was simply to flatten out the space and get rid of the huge concrete conversation pit, which had been the site of muggings and public urination. Many of the out-of-scale, so-called improvements that studded or pitted those dreary downtown spaces are either gone or on their way out without much fanfare.

What we are seeing now is more confidence at the local level, more place-based work, as well as a greater number of experienced and sophisticated commissioning agencies, with more complex and holistic agendas and resulting design efforts. These are presented in the following pages as case studies, using a standard format of analysis. The effort in the writing was to create a user-friendly guide to these projects with clear information about the breakdown of costs and the complications of construction methods. We want to make it possible to empower local planning agencies, arts commissions, historic preservation organizations, downtown commissions, and developers to emulate this work and to use multidisciplinary teams that employ folklorists and historians as well as artists, designers, artisans, and engineers.

Particularly exciting among these new case studies are the infrastructure projects—highway and mass transit systems, water treatment plants, and parks—where large-scale and integrated works are being created with powerful images of place. The walls of highway underpasses in Phoenix and Scottsdale have become the concrete canvas for depicting the flora and fauna of the region and the patterns of the craft of the original Hohokam peoples. They are produced at a scale that sets a precedent for projects that will continue to have a much greater impact on the population at large. Similarly, projects that affect systems, and thus have the potential to affect the lives of more people, are extremely important even when the intervention is modest in comparison to the infrastructure of a highway underpass or abutment. The transit projects, such as the bus-shelter systems in Tempe, Salt Lake City, and Seattle, or the streetcar line in New Orleans, evoke locale even in humble ways. Community characteristics can be identified with a sign that celebrates a place name on the station, or a transit shelter that includes a panel of photographs and poetry celebrating a neighborhood and an adjacent ball park. They add incrementally to this realized power of place. Placemaking opportunities at this *systems* scale come at least partially out of an increased emphasis on citywide arts planning that allows for opportunities to be defined earlier in the capital expenditure process. This issue is discussed at some length in the last chapter.

In this book placemaking art has also been linked to the more modest and didactic acts of place interpretation. We have located interpretation on the continuum with narrative art, and have sought to demonstrate how the artist, writer, and craftsman can make these interpretive elements more evocative. Witness, for example, the markers along the Hackensack River in New Jersey, which are infused with a particular charm by the touch of the poet. The power of complex graphic-design overlays and juxtapositions, and the use of more exotic crafted materials all add to the memorability of these devices. Markers can provoke and engage. They can ask questions rather than merely provide well-digested truisms. By building up the informational access in a particular locale, they may, in the long run, seed it for placemaking art.

We are also encouraged by street furniture that breaks away from that advertised in the catalogues that fall out of architectural magazines. Set down carelessly on American streetscapes, such generic models often condemn a site to an instant and dating banality. All of those Main Street projects begin to look the same because most civic programs did not deploy street furniture as a way of defining place. Exceptions include tree guards in Louisville that are shaped like the architectural order of

adjacent buildings or the personalities of local characters; benches in Seattle that articulate elements of local history in boat landing sites around Lake Union; and benches outside the restored Santa Fe railroad terminal in San Diego that echo, in decorative tiles, the motif of the station. But there are still not enough options here, and the problem seems to be related to the retreat of the artisan to the fine arts gallery and the failure of the critics to notice the work that has been done.

Since the publication of *Place Makers*, the New Urbanist movement has grown in importance, but the concept of crafting special place-related street furniture in these new projects appears to have been neglected; at least, the author did not see any such furniture in Kentlands, Maryland, or in Celebration, Mizner Park, or Windsor, Florida. With the increased emphasis on community form, and the dynamic of configuring patterns of use that strengthen community function, employing place-makers would be an obvious method of creating orientation and meaning. As architect and critic Christopher Alexander noted at the Congress of New Urbanism held in Providence, Rhode Island, on June 2, 2006, "New Urbanism hasn't succeeded in putting soul back into buildings."

However, even in such a sympathetic setting, educational barriers remain formidable between the architects and landscape designers responsible for these projects, and the artisans and fine artists who are best able to provide this level of richness and complexity. For a new town, it takes a special client already committed to the concept of integration, or some community-imposed requirement like a percentage for public art with a specific emphasis on craft and street furniture, to make this happen. As the communities are new, there is not yet an apparent popular mandate that might encourage the definition of a process for the community builder to follow in order to create buildings that, as Alexander puts it, "nourish the soul."

The problem of process

As we gathered together these disparate projects, with their common denominator of community content, we asked ourselves if there was a model for eliciting that content. Was there a relationship between the amount of community involvement and the quality of the artistic products? Was there a formalized process, or was it just luck that the communities achieved place-related art? Of course, in all these projects we sought a certain level of artistic quality, and we did not analyze the projects that we did not select. We were mindful of the old adage that a camel was a horse designed by a committee. Some of the projects came through arts organizations in which there were professional staff and an existing track record of experience in implementing public art.

What we did discover, in a survey of arts organizations and artists, was that people who returned the survey wanted a process for eliciting community meanings. We saw little evidence of a formal process in the projects that we had identified. One distinguished arts administrator who came up with the idea of the Artist-Made Building Parts (AMBP) program in King County (Seattle area) actually called us to find out about the Environmental Profiling concept that we outline on pp. 316–20. That profiling idea involves an organized collection of information about a site, a neighborhood, or an entire community. The idea is to profile the history and character, the design constraints and opportunities, behavioral data about how people use the site, and the artistic traditions in the area. This information is drawn into a brief, which is then used to elicit metaphors that are relevant to the place. This process empowers the community and requires that its members do some homework before the artists are solicited.

In fact, in some of the projects that we analyzed, somebody was doing all or part of this work. Usually it was the independent artist, sometimes responding to information in a call for proposals. Sometimes

the call for proposals defined the problem and gave some of this information. This encouraged the artist to do the background research. Certainly, in many locales it is a commonsense solution to seek consensus because, without some agreement, it would be impossible to commission art.

We interviewed the operatives in what we call the "mural towns." These are communities where comprehensive collections of murals have been commissioned and promoted as part of an economic development and/or tourism strategy. The very capacity to put up such highly visible and concentrated art in old blue-collar cities required a consensus as well as an arts operative with business skills.

One axiom that could come out of this still-loose analysis is that if the process really involves the community, it will focus on the place. Another axiom, which probably needs to be more broadly tested, is that listening to the place can offer at least the potential of defining the most unique public-art solution. The very fact of listening closely to the *spiritus loci* means that the artist usually has to move away from the body of work that he or she has already created. The challenge is to be a problem solver for the community. The proposition here is that the very constraints of working within the context of community information and the resulting community-inspired metaphors actually encourage greater creativity. After all, the great European masters who worked for a bishop, a cardinal, a prince, or a pope were invariably given the subject matter for their commissions, yet somehow it did not appear to cramp their individuality as artists!

To anchor this argument about thematic constraints of place acting as a stimulant to creativity, we can briefly examine two recent projects: the frogs on the bridge over the Willimantic River in Windham County, Connecticut, *Thread City Crossing*; and the immigrant gateway sculptures in Boston's Mattapan Square. The Willimantic Bridge supported the identity of this old industrial city, once the headquarters of the American Thread Company, which operated the largest mill in the world. Gigantic precast concrete spools stand on the abutments of the recently revamped bridge, overlooking the thread factory, Windham Mills. Twelve-foot bronze frogs sit on the spools at each end of the bridge, some with legs charmingly extended. The frogs recall an incident that took place during the French and Indian War, when frogs fighting for water in a dying pool created such a din that the townspeople fled the town, fearing an attack. Descendants of the embarrassed residents made the frog a city logo. City leaders fought through the legislature for the frog sculptures to be paid for out of the construction budget for the bridge.

BELOW, RIGHT *Thread City Crossing* in Willimantic, completed 2001, frog sculptures by Leo Jensen, Ivorytown, Connecticut. Local protest about the construction encouraged Maguire Group, the bridge engineer, to hire Centerbrook Architects to design the bridge, setting a precedent. Photo: Jeff Goldberg, ESTO.

BELOW, FAR RIGHT *Rise*. Two bronze sculptures spanning Blue Hill Avenue in Mattapan, Boston, operate as a gateway. Former residents Fern Cunningham-Terry (shown) and Karen Eutemey crafted the pieces in 2000. They were installed in May 2005.

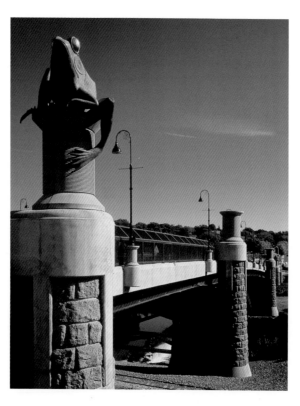
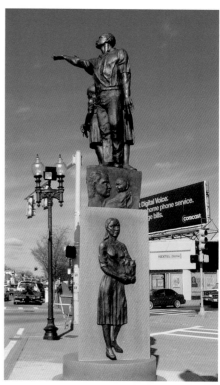

In Mattapan, two 19-ft bronze sculptures on granite bases, entitled *Rise*, frame the entrance to Mattapan Square and the South Shore. Figures with outstretched hands innovatively suggest an arch across Blue Hill Avenue. The granite bases are mounted with bronze reliefs depicting past inhabitants of the neighborhood. They include a Native American carrying a fish, a reference to a tribe that settled the area four hundred years ago, and a soldier from the famous black 54th Regiment that once camped on the square during the Civil War. A third relief shows a Jewish woman carrying groceries, representing the Eastern Europeans who settled Mattapan in the early twentieth century. Crowning the work is a black family, reaching skyward, representing the wave of African American and Caribbean immigrants who have settled in the last three decades. A more abstract sculpture on the opposite side of the square also represents a family, similarly reaching skyward and forming an "implied" arch over the street.

In both the bridge and the gateway sculptures, the driving force for the place-related public art was community leadership. In both cases, the "environmental brief," as we have termed it above, came from this community. Both projects support the axiom that a strong community mandate will nurture place-specific art that is original in its scope. In these two cases, community input into the design did not result in a camel rather than a horse. The quality was high because the leadership chose competent artists to execute the projects, although Mattapan might appear to some the epitome of political correctness in terms of subject matter. But if this had been a state-mandated percentage for public art with a state jury selection, it would probably have been even more politically correct to commission abstract art without particular reference to community.[13] In fact, Massachusetts no longer has an operating 1 percent requirement for state capital expenditures: during the governorship of Michael Dukakis, as part of the renovation of the legislative annex building, the imposition of a clock that the legislators thought was both too abstract and too ugly caused them to shut down the program.

The lead architect on Windham's Bridge, William Grover FAIA of Centerbrook Architects and Planners, said of the 1 percent program in Connecticut:

> When there's a Percent for Art, some committee in the state gets to pick the artist and you never know what you're going to get. The artist does what the artist thinks is a good thing to do. Our point was that this is not just a piece of art stuck on to a lawn or an airport, or a bridge. This is a specific form that has to go on this bridge I think it's more likely that interesting bridges will be built because of this.[14]

The frogs have generated a modest tourist industry in Willimantic, and one can now buy T-shirts with frogs on them. The Connecticut roads website reports that "the 'frogs' have catapulted the bridge to the forefront of American roadside kitsch." Certainly, this is a serious issue for place-making. There are some writers concerned with the American landscape, such as Deborah Karasov, writing for the *Public Art Review*, who believe that "the idea of people becoming responsible for their places is an anachronism Even the most brilliant artist will never be able to endow modern spaces with a convincing and enduring sense of place using facile tactics that rely on an appeal to nostalgia, parochialism or even bitter memories."[15] We have attempted to exclude from our survey works that try too hard to be charming; whether the frogs make the test is still up for debate. Although the origins of the project may be forgotten, like the frog myth in the minds of the townspeople, the very perception of the frogs as town icons may be enough to insure their preservation and anchor them as placemakers and protectors of the bridge.

Some objects can be taken for caricature at first glance. Placemakers, when deliberately created as artwork, should still retain a certain privacy, even if one finds them lovable.[16] A sense of privacy can enable the viewer to explore them—not once, at a single glance, but over time. In our survey we tried to avoid objects that appear self-conscious, but there will probably be honest disagreements about some of our choices and whether they stray over the line. We are seeking to make a larger point about the authenticity of community empowerment in the placemaking process.

Certainly, the larger fight over the bridge at Windham seems an authentic act to protect the integrity of place, and the subsequent enthusiasm for the frogs is anchored deeply in the town's history. However, it may have been obscure until the architect's team carried out its placemaking brief in a process that appears close to the environmental profile we describe on pp. 316–20 below.

William Grover said in response to a question about the frogs:

> I don't think that the myth of the frogs was widespread before, although some time in the distant past the frogs had become a symbol of Windham. We were digging around the archives of the old town hall, and we found an old letterhead with a frog on it. We did a lot of research on the past history of the town and tried to incorporate things into the bridge that would make it feel like the history of the town. We do a lot of work with community participation in the design process. That's what's most interesting to us, rather than making an architectural statement of our own, making a statement of the community. This bridge is really a statement of the community and not of the architect.[17]

The change in a $13-million bridge and the populist politics involved in getting the increased allocation ($90,000 for all four frogs) appear to offer fresh proof that systems can be changed, and that there is a false defeatism in the academic apologia that nothing can be done because of "the economics of scale, the co-modification of land and labor, the conquest of nature, and the quantification of virtually everything" in Karasov's lament.[18]

These two projects, the bridge and the "implied" arch, were the products of community struggle and introspection. The final chapter of this book demonstrates how the planning process can strengthen the capacity of communities to achieve placemaking results. As we note, there are dramatic changes in the experience level in this arena of planning. Communities and artists are doing more research, even if it is not formalized in the actual brief, and even if combining this with a set of metaphors and concepts attached to it is not called the "environmental profile."

There are more multidisciplinary teams now, and more master-planner artists working in collaboration around the country, providing an umbrella of protection and support for less experienced artists. And there are a lot more plans, some for individual facilities, such as airports or water-treatment systems, and others covering entire counties. In many cases, they are serious and create an impetus for thoughtful action.

So we approach the future with a guarded optimism. We believe that some of the failures of public art, which we also document in the final chapter, may have taught some lessons. But as we note in our analysis of the federal agencies supporting public art, there is still a great capacity for self-deception and failure to evaluate. We hope that the increasing number of collaborating multidisciplinary teams will provide the antennae for increased place-sensitivity and responsiveness. We also hope that this energy will affirm the identity of more real places. We trust that the increased realization of place will strengthen the very constituencies that bear witness to the value of place as part of American culture.

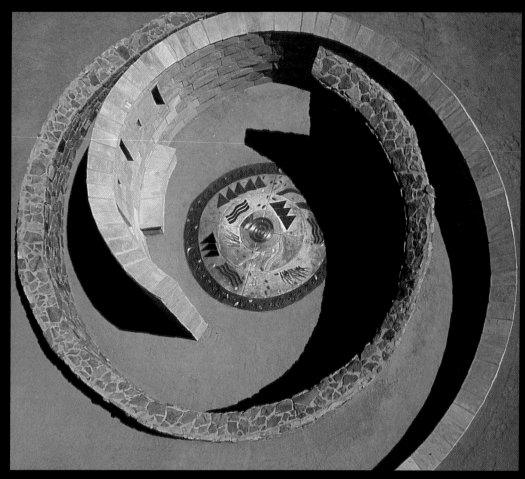

An upward arc: adding public value

ABOVE The GSA commissioned Richard Serra's *Tilted Arc* for the Federal Plaza in New York in 1981. It removed the piece in 1989.

RIGHT Like *Tilted Arc*, Catherine Widgery's *Trail of Dreams, Trail of Ghosts* in Frenchy Park, Santa Fe, guides and diverts the walking path of its audience. But by engaging and contextualizing this experience, Widgery's sculpture enriches the park rather than hijacking a functional path as *Tilted Arc* did. Serra's artistic intervention caused a firestorm of divisive controversy. In the central open area of Widgery's work, 5 ft below grade (above right), a mosaic of stone, glass, metal, and concrete depicts the journey using Native American symbols in a pattern language. The spiral wall is carved with images of goods brought into the Indian world by the Spanish (far right). Photos: courtesy of the artist.

RIGHT Another part of the work is at De Vargas Park, Santa Fe. Here, a dome of steel cutouts casts the imagery of the belief systems of the two cultures, merging in light and shadow. Photo: courtesy of the artist.

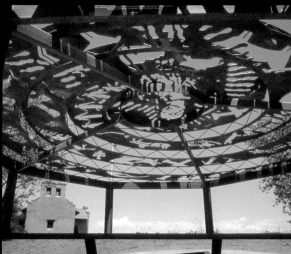

Placemaking, then, seeks to create conditions in which culture and art are not separated. The objective is to construct procedures that can nourish and sustain place. In the process of doing that, we need to restore some sense of authenticity to that phrase "sense of place" that we worried was being abused at the beginning of this chapter. To achieve and sustain an imagery of place we shall need to affirm an increased sense of identity in both old and new American environments. We need to locate images in those environments that stimulate our curiosity about where we are, inspire some reverie about how we can claim a future there, and, on occasion, encourage a whimsical smile about choices already taken.

The merging of art and culture should make the stored humanity of places accessible to the whole community, not just to the design professions. We all live in our consciousness even if we have little understanding of the architecture and urban design around us. Indeed most people are going to see their own meanings in place and not necessarily know or care about what architects or designers mean to impose on them. But it should be the responsibility of the designers to mitigate the conditions of amnesia foisted on us by so many of our environments.

The positive force of making those meanings in the environment more accessible should restore a vision of place as a declaration of public value. It is this mental linkage to a sense of value, to a connection with community, that becomes the foundation for an ethic of care. This should be the unifying reason for treating the environment with a greater sense of responsibility.

The forester, teacher, and writer Aldo Leopold, working in the early part of the twentieth century, recognized this connection between ethic and image when he wrote: "An ethic presupposes the existence of some mental image of land as a biotic mechanism. We can be ethical only in relation to something we can see, feel, understand, love, or otherwise have faith in."[19]

Catherine Widgery's artwork *Trail of Dreams, Trail of Ghosts* addresses this merging of art and culture, and extends this ethic to the built environment. In 2002, Widgery won a New Mexico design competition celebrating the El Camino Real de Tierra Aldentro (the trail the Spanish followed from Mexico to what is now the southwestern United States). Her design created structures on two park sites in Santa Fe, New Mexico, using the motif of intertwined spirals on a Native American bowl found nearby, repeated in different structural materials. These structures, crafted in smooth and rough stones expressing the masonry of Spanish and Native American cultures, " become intertwined as a result of the people, the goods, and the ideas that traveled along the trail's vast and treacherous lengths."[20]

Slightly reminiscent of Richard Serra's sculptures when seen from above, Widgery's work poses a challenge and demonstrates a dramatic policy shift toward respect for place nearly thirty years later. In the early 1980s, Serra's Cor-ten steel arc, known as *Tilted Arc*, deliberately confronted the users of the Federal Plaza in New York. It was designed to block their visual access, and this rather minor point became an outsized political controversy as artists lined up in a politically correct display of solidarity behind the work on the grounds of free speech. Although the sculpture was done by a strong artist, three days of public hearings revealed that it was not designed to be public art that would enhance the experience of the space. After the hearings the General Services Administration (GSA) granted the petition, signed by nine hundred occupants, judges, and office workers from the adjacent federal building. The petition asked the GSA to remove this object, and only a rusty brown stain remained in the space for some years, before landscape architect Martha Schwartz redesigned it.

Perhaps that stain will be judged the high-water mark of a certain arrogant attitude toward the public realm, a kind of antediluvian desire to assert the individual vision of the artist without regard for the public well-being. The Widgery sculpture shows another way. Unlike *Titled Arc*, it welcomes pedestrians and embraces them within its space. It offers the intimacy of historical depiction when viewed close up. There is the sophisticated craft of narrative mosaic at the pedestrian's feet in one location and the play of light and shadow in merging religious imagery on the ground at the other. No stain of arrogance here, but a complexity that encourages repeated visits. Indeed, Mexican day laborers waiting in the park here for work have served as unofficial guides, explaining the imagery to Anglo visitors.[21]

This example demonstrates how we can extend Aldo Leopold's concept of an ethic beyond the natural world, which he describes so movingly in *Sand County Almanac*, published after his death. There is a growing recognition of the need to conserve and enhance the built environment. A keener sense of what we have already lost reinforces the extension of this ethic. Placemakers are a kind of armature that can support this; they can, as Leopold puts it, "enable us to feel, understand, love, or otherwise have faith in" a particular place.[22]

The task at hand is to use this ethical sense to guarantee a future environment worth caring for. We must ensure that what we build in the next few decades, which will probably be as much as we have built in the last century, will be worth remembering. This poses an entirely new vision for preservationists. It is to secure a past for the future by building a future that will be worth remembering. To do this we shall have to broaden the constituency for care. As the profiles in this book reveal, there is a great diversity of people and organizations interested in the creation, maintenance, and enhancement of place. It is only with the recognition of this broader constituency that conservationists and planners can successfully confront the haunting specter of placelessness and the attendant siren-call of a phony "sense of place." It is only with a much deeper awareness of how to create and sustain this emotive value in the built environment that we can assert alternatives to the banality that too often surrounds us.

We can challenge that banality by transforming the concrete walls of freeway abutments with the imagery of Native American patterns, by turning water-treatment systems into pathways etched with lessons in conservation, by enlivening a transit ride with poetic references to an adjacent neighborhood, and even by softening the edges of a bollard with a lovable object. The bronze puppet "Doo-Doo" both recalls and foretells the animation of street theater in Harvard Square, Cambridge. Bollards have hard surfaces that resist change. But the problem as we see it is not the dilemma of being caught between a rock and a hard place. Rather, the problems that this book seeks modestly to address are how to change the surface of the rock, as Catherine Widgery has done in this last Serra-deflating vignette, and how to reveal that evidence of public value, which will insure an ethic of care, protection, and enhancement for our built environment. Forward.

1 Ronald Lee Fleming and Renata von Tscharner, *Place Makers: Creating Public Art That Tells You Where You Are*, San Diego: Harcourt, Brace, Jovanovich, 1987.

2 The New Hampshire Bicentennial program used the term "cornerstones" to identify, through a statewide nomination process, the places in each town that people cherished. They were the places to which local people, not trained historians, attached exceptional meaning, a kind of cultural landmark status for very common features.

3 See Jim O'Grady, "Landmarks for Common Folk," *New York Times*, November 5, 2000.

4 This was a weighty topic at the 16th assembly of the International Committee for Monuments and Sites, in Xi'an, China, in the autumn of 2005, which the author attended and where there were complaints that the Chinese were sweeping away, in their cities and towns, all the modest remnants of the past and leaving only a few simulacrums for the tourists.

5 Letter of 1925, which otherwise discusses the themes of the *Elegies*. Reprinted in R.M. Rilke, *Duino Elegies and the Sonnets to Orpheus*, trans. A. Poulin, Jr., Boston: Houghton Mifflin Company, 1975.

6 See James R. Watson, Supervisor Comprehensive Planning, Old Colony Planning Council, Brockton, Massachusetts, undated letter to the *Hingham Herald*, September 2004, on the reason why the steps of Derby Academy, Hingham, were significant and should be preserved.

7 See Howard Mansfield, *The Bones of the Earth*, Emeryville, Calif.: Shoemaker & Hoard, 2004.

8 See Ronald Lee Fleming, "Public Also Has a Rôle to Play in City Projects," *Boston Globe*, October 4, 1993.

9 Abraham Lincoln, from his inaugural address, March 4, 1861.

10 Marcel Proust, *Swann's Way*, New York: Vintage Books, 1970.

11 Stendhal (Marie-Henri Beyle), *On Love*, trans. Philip Sidney Woolf and Cecil N. Sidney, New York: Peter Pauper Press, n.d.

12 See Ronald Lee Fleming, *Censored Laughter: Czech Political Cartoons from the Dubcek Period* (privately published), 1971.

13 Based on a conversation with the artist Fern Cunningham-Terry, February 15, 2006.

14 William Grover FAIA, architect, Centerbrook Architects and Planners, interview, August 6, 2004.

15 Deborah Karasov, "Is Place-making an Art?," *Public Art Review*, Autumn/Winter 1996.

16 See Ronald Lee Fleming, "Lovable Objects Challenge the Modern Movement," *Landscape Architecture*, January 1981.

17 Grover interview, August 6, 2004.

18 Karasov 1996

19 Aldo Leopold, *Sand County Almanac and Sketches Here and There*, New York: Oxford University Press, 1987.

20 Catherine Widgery, 'A Red Ringer', *Landscape Architecture*, May 2002, p. 20.

21 Catherine Widgery, artist, Cambridge, Massachusetts, interview, February 13, 2006.

22 Leopold 1987.

I

Case Studies

33 Gateways
Creating a sense of arrival

73 Transit facilities
Providing orientation for travelers

95 Murals
Part of a town-enhancement strategy

129 Integrating placemaking
into architecture

165 Placemaker as turf definer

187 Sculpture as place setting

Gateways: Creating a sense of arrival

34 *Our Shared Environment*
Thomas Road Overpass, Phoenix, Arizona

42 *The Path Most Traveled*
Pima Freeway Enhancement, Scottsdale, Arizona

48 Radnor Gateway Enhancement
Radnor, Pennsylvania

54 *Cincinnati Gateway*
Cincinnati, Ohio

58 *Over-the-Rhine Gateway*
Cincinnati, Ohio

62 *Fenceline Artifact*
Denver International Airport, Denver, Colorado

66 Buffalo Bayou Sesquicentennial Park
Houston, Texas

Our Shared Environment

THOMAS ROAD OVERPASS • PHOENIX, ARIZONA

Project description

The mile-long overpass zone features thirty-four adobe murals, in both motorist and pedestrian scale, built into the highway's sound walls. Stanchions in the form of Hohokam reptiles support the overpass

Artist

Marilyn Zwak

Agency

Street Transportation Department, Phoenix Arts Commission Percent for Art

Date

1990

Dimensions

Murals range from 3¹/₂ × 5¹/₂ ft to 13 × 133 ft; columns are 24 ft high

Materials

Bas-reliefs made of metal lath and cement plaster, set within beds of hand-etched stabilized adobe 3 in. deep

Cost

Design phase $25,000 Materials $23,000 Fabrication/installation $67,000 Artist's fee (including labor and travel) $110,000 TOTAL $225,000

Photography

Courtesy of the artist and Phoenix Office of Arts and Culture

 EARLY IN THE UNIQUE collaboration that would result in Marilyn Zwak's popular installation *Our Shared Environment*, James Matteson, director of the Street Transportation Department for the City of Phoenix, knew that "we are plowing new ground. We are in an area that has never been tested before."[1] The groundbreaking establishment of this design team, including both an artist and the more traditional engineers, was part of what would become the momentum for Phoenix's continued linking of public art and infrastructure.

The City's noteworthy dedication to the support of public art began with a Percent for Art ordinance in 1985, but truly proved itself during the recession of the early 1990s, when public art survived threatened budget cuts. The City established the Phoenix Arts Commission in an effort to "protect, enhance, serve, and advocate excellence in the arts in Phoenix and to raise the level of awareness and involvement of all city residents in the preservation, expansion, and enjoyment of the arts."[2] The 1985 Percent for Art ordinance earmarked 1 percent of all municipal construction budgets for public art. According to program manager Greg Esser,

> the primary focus of the Percent for Art program is design-team projects where artists are able to influence the design of urban space in a way that directly reflects local history, geography, and communities to create a sense of place. These public-art projects also often create new opportunities for community participation in the design of our shared urban spaces that would not otherwise exist.[3]

However optimistic this sounds, the nascent Phoenix Arts Commission still faced the problem of supporting public art in a city known not for its monumental landmarks but for its growing suburban sprawl. So, with arts-commission funding, outside consultants William Morrish, Catherine Brown, and Grover Mouton outlined the direction of the city's public art in 1988, with the milestone Phoenix Public Art Master Plan. They focused on small-scale projects to complement the city's collection of scattered neighborhoods, instead of a city-defining work by a marquee name.

In Ed Lebow's words:

> The thrust of the plan was to make something memorable out of daily arrivals and departures—to create orienting, you-are-here experiences for the average walker (who usually drives) in the city. The plan's prescription was a slew of artist-designed gateways, streetscapes, and public markers. These were intended to give Phoenix's increasingly aimless expanse a more coherent and comprehensible pattern.[4]

The Phoenix Public Art Master Plan continues to shape public art today, despite the controversy with which the commission would later be associated.

One major element of Phoenix's master plan addressed another widespread but controversial trend of the 1980s—the construction of miles of new highways. Residents of northeastern Phoenix bitterly complained about the plans of Arizona Department of Transportation (ADOT) to build a six-lane highway (originally called the Squaw Peak Parkway but now known as State Route 51) that would divide their neighborhood, destroy historic houses, and uncover archaeological remains. The damage to the neighborhoods proved inevitable, but public-art projects along the highway had the possibility of creating a visual imprint of community identity, as well as giving something back to the cleaved neighborhoods in the wake of such a damaging force as the highway construction.

Although there had been an earlier overpass project (two untitled murals by Robert Delgado, finished in 1988), the overpass at the junction of State Route 51 and Thomas Road would be the first real test of Phoenix's radical vision of a full collaborative design process between artists and engineers. The Phoenix Street Transportation Department assembled a team of engineers and contractors familiar with the plans for the overall layout of the highway system. A public panel organized by the Phoenix Arts Commission selected Zwak, an Arizona artist

PAGE 32 View from the Cincinnati Gateway; see pp. 54–57. Photo: courtesy of the artist.

BELOW Marilyn Zwak's *Our Shared Environment* incorporates the motifs and materials of the indigenous Hohokam population into a highway overpass in Phoenix.

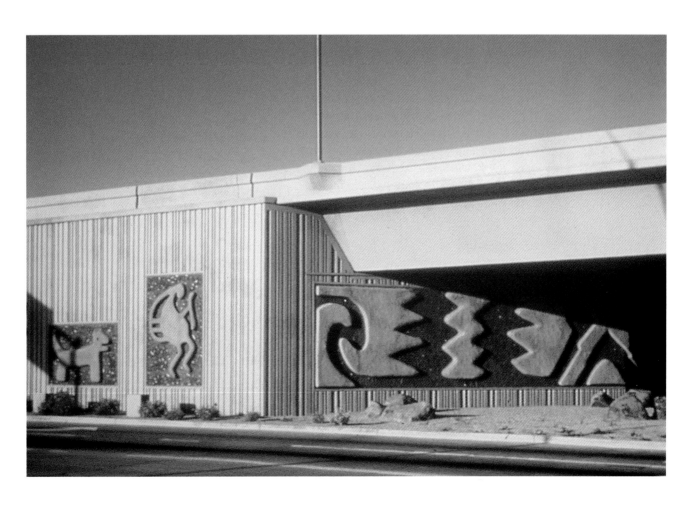

specializing in sculptural adobe, who proposed to investigate

> how art could serve as a healing factor for the wounds inflicted on the neighborhoods that were bisected by the Squaw Peak Parkway, and how the historical significance of the Parkway/Thomas Road site (remains of over forty Hohokam Indians were discovered at the site) could be acknowledged and preserved.[5]

These two parties began a completely collaborative design process, the result of which was a unique addition to the Phoenix landscape. As the first project to take this leap of faith at the beginning of the planning process, the Thomas Road Overpass is truly "a model project in that it represents the public-art program's emphasis on involving artists in the design of Phoenix's urban landscape in the hope of improving the city's overall aesthetic appearance."[6]

Description State Route 51 at Thomas Road is an intersection between a dense urban environment, a major surface arterial route, and the ever-expanding Phoenix highway system. As the highway gradually rises to the 30-ft height of the overpass, it leaves a mile's worth of wall between it and the ground. This complex location produced problems for the design team, who wanted to create a comfortable environment for pedestrians to cross the highway, while providing the drivers on Thomas Road with relief from the monotony of the typical soundwalls along the route. However, Zwak was motivated by the potential of such a dynamic location:

> I like the fact that it's going to be able to help a lot of people, I think, because of its city setting and the effects of the environment on us. By incorporating art into a project like this, where people are passing by on an everyday basis, I think I can soften their life a little bit, add a sense of humor, open up their imaginations and give them a sense of play—becoming a child again.[7]

However, Zwak knew that even a strong design would be challenged because of the controversy of the new highway. So she climbed Squaw Peak in search of a vision, and there she "received an inspiration that said,

'All used up.' Then I went to the Pueblo Grande Museum and opened a brochure. It said that the direct translation of 'Hohokam' is 'all used up.'"[8] Zwak had her inspiration: she would create a memorial to the native culture based on artifacts unearthed by the construction project. Working with the engineers to customize the planned installation, Zwak created thirty-four adobe murals, ranging from $3^1/_2 \times 5^1/_2$ ft to 13 × 133 ft and all 3 in. thick, based on authentic Hohokam designs. Installed in shallow cavities in the wall fashioned to house the artwork, Zwak's murals wrap the walls alongside the highway, as well as beneath the overpass, to envelop the viewer completely:

> I want the walls to be so full of design that people feel as though they're passing through a tunnel of earth. I want them to have a sense of the Hohokam, of the wonder of their work, how beautifully refined it was. I want to honor them. By taking their work to this monumental size, I think you'll see it in a way you never have before.[9]

Designed to engage both the pedestrians and the drivers who use the overpass, Zwak's artwork encompasses two levels of detail. The murals on the exterior soundwalls along Thomas Road, and the 11 × 170-ft continuous adobe band stretching along the interior wall of the overpass, are designed at a vehicular scale. Each mural has a simple design—Zwak's interpretation of numerous abstract, human, and reptile patterns based on the Hohokam pottery shards found at the site—executed in sculptural relief to match the bridge and set within a natural etched field of adobe. The size, simplicity, and color contrast of these murals make them intelligible from a passing car. But, carved into the darker adobe of the background, Zwak included a level of detail usually overlooked by rushing drivers. Intending to design continuous visual complexity for pedestrians passing under the bridge, she solicited the help of the very people who would frequent the walkways, to create this small-scale art for their own appreciation. Zwak hoped that allowing local residents to take ownership of a personalized project would begin a process of healing:

> On the Squaw Peak project, I planned the expansive adobe murals so that the public

(over three hundred) could have a personal experience with the adobe. The individual works were then integrated into the whole with an abstract series of etchings. I feel the public enriched the work with their individual efforts; they personalized it. It gave them a sense of ownership of the work and assisted in a healing process for some. This freeway was very disruptive to the historic neighborhoods it bisected. I wanted the art to serve these people in a special way.[10]

For the more than eight months that Zwak and her assistants applied 150 tons of adobe on site, curious onlookers were allowed to watch the installation and later to contribute their own artwork under the overpass. People carved their names, thoughts, and designs, or left mementos, such as keys, tools, or bottlecaps, in the drying adobe. One woman, particularly bitter about the intrusion of the highway, satirized the politics behind the construction and left a little comforted. Although some of the details have worn away with time or been removed by vandals, their

The murals beneath the overpass are illuminated at night.

impressions remain in tribute to the unique community involved in the slow process of healing instigated by the installation of *Our Shared Environment*.

Zwak's relationship with the engineers on the design team was just as innovative as her collaboration with the community. Entering the design process, the master plan called for a single bridge to span the entire length of the overpass. As conversations continued, the design team began to consider three shortened spans supported by columns to be a safer, more efficient, and cheaper (by about $500,000) alternative. The engineers envisioned the standard "golf tee" columns of the highway system; however, Zwak designed a series of columns, based on a Hohokam reptile figure that appears to be holding up the bridge. Project design engineer Jerry Cannon led the efforts to find a balance between technical process and artistic vision that would make Zwak's design feasible from an engineering perspective without sacrificing safety or the budget:

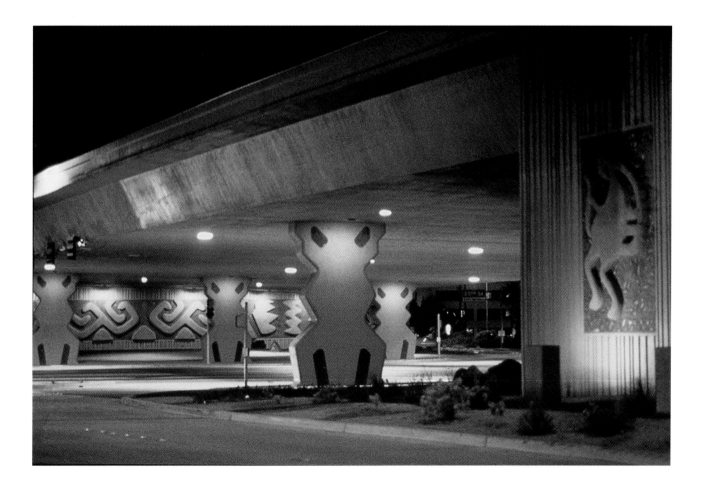

I took a drawing of her column design to contractors and asked them what they thought. If they had told me, "This is the most stupid thing in the world," I would have backed off. But their attitude was that it wouldn't cost much more than the "golf tee" column. Actually, since the artist's design is just a rectangular column with a couple of bumps on it, it is easier to build than the "golf tees," which require more analysis.[11]

Working closely with Cannon, Zwak adapted her design and materials, mainly by adding a reinforcing rebar core to the poured concrete column and filling decorative voids with adobe, to adhere to engineering standards. As is most evident with the compromise and collaboration behind the memorable Hohokam reptiles supporting the overpass, "together they designed and engineered a bridge that neither could have developed on his or her own."[12]

Design impact In 1990, the Phoenix Public Art Master Plan was a growing success that garnered press from the art world and the mass media alike. With optimistic ambition and revolutionary ideas about the relationship between artists and engineers, it "established the now-acclaimed link between public art and infrastructure, and showed Phoenix how to transform itself from a sprawling act of real estate into a thoughtful expression of urban design."[13] Cities across the nation formulated their own public-art plans, such as Houston's

Green Ribbon Project, following Phoenix's successful example. The Phoenix Public Art Master Plan's proposed integration of art and infrastructure was most completely embraced by the Street Transportation Department, especially in its popular Thomas Road Overpass. Completed eight months ahead of schedule and $1 million under budget, the overpass was an award-winning model of the master plan, winning the Arizona Society of Professional Engineers' Outstanding Engineering Project of the Year in 1990, the 1991 Environmental Excellence Crescordia Award, and the Award for Best Public Art from the *Arizona Republic* in 1992.

Although the Squaw Peak Parkway brought Phoenix Arts Commission's vision "closest to fruition,"[14] another highway project would threaten the future of public art in Phoenix the very next year. In *Wall Cycle to Ocotillo* of 1992, the artists Mags Harries and Lajos Héder of Cambridge, Massachusetts, installed thirty-five sculptural containers—ranging from teapots to painted vases—along a stretch of the highway. Since twenty-nine of the pieces are placed on the residential side of the soundwall, the work is barely visible to passing drivers. Despite several attempts to solicit public opinion through town meetings and surveys, the artists received little local response to help tailor the pieces to their final locations. Reaction, both local and national, was certainly heard when these two shortcomings were compounded by an economic downturn that made the $474,000

BELOW In this picture, both the large-scale reptile patterns and the pedestrian-scale pieces of artwork in the background are visible.

BELOW, RIGHT One passerby personalizes *Our Shared Environment* with a small-scale carving.

commission seem frivolous. An initial letter from an angry resident quickly grew into outrage with the help of the local media. According to *Newsweek*, "this decorative flourish was meant to make people feel better about the ten-lane highway that had been put through their backyard. The pots bombed. The residents seethed."[15]

Unfortunately, the Phoenix Arts Commission was dragged into the spotlight even though *Wall Cycle* was not one of its Percent for Art projects. The project was in fact commissioned by the City of Phoenix Planning Department as a Freeway Mitigation project, and the arts commission was involved in providing assistance to the planning department. The money for highway construction was raised by a sales tax that had been voted into effect by the public in 1985. The enhancement budget came out of another bond, for highway mitigation, voted into effect in 1988.[16] Still, most of the money from this funding effort went to major construction, and no money for highway enhancement came from the Percent for Art budget. Although it did not manage the project, the arts commission was blamed, and became the object of bad publicity relating to the failed attempt at highway mitigation. Because of this misconception, the public became critical toward the arts commission, and the relationship between the two became strained. At a time when political shift in the city government turned it against public art, in part because of economic troubles in the early 1990s and increased fiscal conservatism, the Percent for Art program struggled to maintain its funding.[17] In 1996, the state cut funding for aesthetic enhancement on highways.

According to Ed Lebow, "if the bureaucratic and fiscal moods are right—as they were when the brawl erupted over *Wall Cycle to Ocotillo* in 1992—controversy can even be used to suggest that the program that caused it has 'insufficient oversight,' that it is using the talents of too many outsiders, that its administrators are not properly reporting to the powers that be, or that the program is squandering public funds."[18] Beyond favorable politics and economics, the controversial installation lacked the main strengths of the Thomas Road Overpass. First was the experimental but ultimately rewarding group

dynamics between Zwak and the engineers during the design process. Zwak claimed: "I could see from the start that all of the potential lay in the relationships on the team. It depended on what happened between us as people. And it worked. I don't think I've seen anyone support an artist's work the way this team has supported mine."[19] This collaboration is fundamental to the possible integration of infrastructure and public art at the core of the Phoenix Public Art Master Plan, but projects at this time lacked this cooperative spark, and resulted in public works ornamented by art, instead of designed art:

> Few artists and city departments are really up to that task. Most of the artists who have worked here have wielded the cookie-cutter as deftly as the dullest engineers and bureaucrats. Too many have promoted tedious formulas that they defend with trumped-up pleas for artistic freedom and autonomy. Too few understand the give and take of urban design and how to address the compelling limits of a project's purpose and setting.[20]

However, the public embrace of the Thomas Road Overpass is a result as much of Zwak's cooperation with the surrounding communities as of her relationship with the design team: "Zwak responded in an almost clichéd way: involve people in a project and they will take ownership of it and be its stewards. The theory works: a truth too often overlooked in public projects."[21] This engagement of the local neighborhoods in projects as expensive and potentially controversial as the Squaw Peak Parkway enhancement project was always acknowledged, but not specifically addressed, by the Phoenix Arts Commission. William Morrish, one of the authors of the original master plan, cited this open-ended quality as room for evolution in the program in a retrospective article in 1997: "Citizens are thinking about things they can do to enhance their neighborhood—revitalizing neighborhood parks, fixing streets and improving transit nodes. We always sensed that after the first wave of infrastructure, the program would have to shift to neighborhood-based projects."[22] *Wall Cycle to Ocotillo* marks a pivotal point in the history of Phoenix's

public art, between the impressive growth culminating in the Thomas Road Overpass and the necessary changes in attitude for Morrish's "second wave."

Despite the negative publicity and time diverted from *making* art to defending its right to funding, public art has continued to flourish in Phoenix. The Phoenix Arts Commission has sustained no funding changes and has not yet finished revising the master plan, but relies on annually written plans that specify each year's expenditures. It has installed more than eighty public-art projects with its annual budget of over $8 million.[23] Even when the arts commission was weakened, and during the Squaw Peak pot controversy when it was almost eliminated, this public support kept public art alive in Phoenix: "People had come to realize that infrastructure can and should be more than only purpose-driven."[24] This enduring connection between public works and public art is the legacy of such seminal projects as the Thomas Road Overpass. Through her revolutionary collaboration with the design team, and her ability to include the community, Zwak proved the viability of Phoenix's optimistic vision during the early years of its arts commission, and changed local opinions of art. Even though Phoenix's specific programs and plans would be further tried and revised, Zwak's *Our Shared Environment* at the Thomas Road Overpass set the public expectations that would motivate future public art in the city.

In recent years, Phoenix has been involved in a number of successful infrastructure projects. The City has taken to heart the need for neighborhood involvement that, while present in the commission's earlier stages, had not been so finely tuned in its implementation. A pedestrian bridge by artist Ed Carpenter, designed in the form of a grasshopper, allows children to walk to their junior high school when a local wash is flooded. This project had

South Mountain Community College

College administrators sought to create a coherent visual identity at the Phoenix school, with the help of artist Marilyn Zwak, based on the culturally diverse population that the school serves.

South Mountain decided to use part of its share of new funds to repair the exfoliating 1979 structures through a $2 million exterior renovation.

Zwak transformed the cement campus amphitheater with a pavement inlay of a mandala, 50 ft in diameter. Symbols from each of the campus's buildings nestle between the star's points. The amphitheater is the gathering point for the campus community and the site of graduation ceremonies.

As a testament to the success of the redesign, South Mountain enrolment doubled to four thousand students in 1997, the year after completion. Since then, several new housing developments visible from the campus have echoed the campus buildings' earth tones and the soft lines of the adobe.

The design won Phoenix's Crescordia Award for projects that blend architecture with the surrounding environment.

BELOW, RIGHT The campus architecture is embedded with Hohokam symbolism. Photo: Ron Christensen.

BELOW, FAR RIGHT Pavement inlay of a mandala. Photo: Ron Christensen.

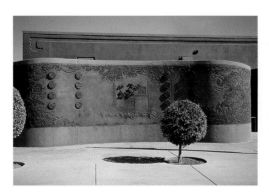

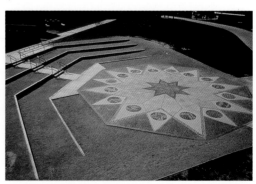

a $35,000 budget for design and was funded by pooled Percent for Art money through the City of Phoenix Street Transportation Department.[25] The wings of the grasshopper reflect the mountain profile, and the structure whimsically mimics the children as they "hop" to school.

Another pedestrian/bicycle bridge over the Squaw Peak Parkway is by Laurie Lundquist at Nisbet Road. It uses the standard safety cage as sculptural material to create a mountainscape playing off the mountain profile visible to the south. The ADOT and City of Phoenix Street Transportation Department's Capital Improvement Program paid for this effort from the Percent for Art budget.[26]

The Sunnyslope Canal Demonstration Project, completed in 2000, provided trail and landscape improvements to the Sunnyslope Canal. It was conceived by a team consisting of landscape architects, artists, and an environmental consultant. Along the pedestrian/equestrian path and bike trail, the team created small plazas, each demonstrating a different local feature, including a view of

Squaw Peak and a "water table" with a map of the ancient Hohokam canal system. This project had a budget of just under $1.5 million from several sources, including Percent for Art, municipal funds, and federal funds.[27]

Patrick Park Plaza, a smaller neighborhood project by the artist Jody Pinto, was completed in 1992. In response to a street being widened, the artist filled some of the space using a park in the form of a double spiral (a symbol used in Hohokam culture), with one spiral on each side of the street. The two spiral parks connect the sides of the street as well as add cohesiveness to the streetscape. As a response to community concerns, the project addressed neighborhood needs, taking advantage of the changing street's construction opportunity to provide a sense of place. This project was funded by Street Transportation Percent for Art funds.[28]

One of Phoenix's greatest successes in working with infrastructure projects is its policy to accumulate Percent for Art money within each city department. This means that when smaller projects arise, where a minimal art budget would not provide the opportunity for an effective work of art, the arts commission is able to save this budget within a city department and use it for larger and more significant projects, making many of the recent projects possible. For this reason, and because of the strong relationship built between the public in the Phoenix area and the arts commission over many years of dedicated work, infrastructure in the City of Phoenix is linked to art by an effective arts commission and a public who have learned to expect no less.

A version of this case study appeared in Scenic America's Scenic Solutions *CD-ROM resource, September 2003.*

1 Edward Lebow and Betsy Stodola, "The Thomas Road Overpass at the Squaw Peak Parkway," in *Public Art Works: The Arizona Models*, ed. Betsy Stodola, Denver: Western States Arts Foundation, 1992, p. 48.

2 Gia Cobb, "By the People, for the People: Public Artworks Program Aims to Enhance Sense of Community," *Arizona Republic*, September 14, 1997, p. G1.

3 Greg Esser, public-art program manager, Phoenix Arts Commission, Phoenix, correspondence, July 30, 1998.

4 Edward Lebow, "Plans and Possibilities," *Places*, vol. 10, no. 3 (Spring 1997), p. 54.

5 Project description, courtesy of the Phoenix Arts Commission.

6 *ibid.*

7 Quoted in Lynn Pyne, "City Stops for Roadside Art," *Phoenix Gazette*, June 14, 1990, p. D1.

8 Quoted in Lebow and Stodola 1992, p. 43.

9 Quoted in Anne Stephenson, "Freeway Bridge is Built of Mud, Steel and Frogs; Overpass Design Honors Hohokam," *Arizona Republic*, March 11, 1990, p. F1.

10 Marilyn Zwak, artist, Cochise, Arizona, correspondence, August 23, 1997.

11 Quoted in Lebow and Stodola 1992, p. 45.

12 "Phoenix Overpass Mixes Engineering, Art, Ancient History," *American City and County*, August 1992, p. 81.

13 Lebow 1997.

14 Reed Kroloff, "From Infrastructure to Identity," *Places*, vol. 10, no. 3 (Spring 1997), pp. 56–57.

15 Stryker McGuire, "Phoenix on the Rise," *Newsweek*, July 12, 1993, pp. 58–60.

16 See Nina Dunbar and Deborah Whitehurst, "An Elephant in Your Living Room, or the Squaw Peak Pot Controversy," *Monographs*, vol. 1, no. 1 (October 1992), p. 2.

17 *ibid.*, p. 7.

18 Lebow 1997, p. 55.

19 Quoted in Stephenson 1990, p. F1.

20 Lebow 1997, p. 55.

21 Frederick Steiner, "Connecting Infrastructure to Deep Structure," *Places*, vol. 10, no. 3 (Spring 1997), p. 61.

22 William Morrish, "Raising Expectations," *Places*, vol. 10, no. 3 (Spring 1997), p. 63.

23 Phoenix Arts Commission, correspondence, September 7, 2001.

24 Kroloff 1997, pp. 56–57.

25 See 7th Avenue Bridge Project fact sheet, Phoenix Arts Commission.

26 See Nisbet Road Bridge Project fact sheet, Phoenix Arts Commission.

27 See Sunnyslope Canal Demonstration Project fact sheet, Phoenix Arts Commission.

28 See Patrick Park Plaza fact sheet, Phoenix Arts Commission.

The Path Most Traveled

PIMA FREEWAY ENHANCEMENT · SCOTTSDALE, ARIZONA

Project description

Southwestern-themed foam cutouts, paintings, and concrete reliefs enhance 6¼ miles of the Pima Freeway's sound-barrier/retention walls

Artist

Carolyn Braaksma

Architect

Andrea Forman

Landscape architect

Jeff Engelmann

Agencies

City of Scottsdale and Scottsdale Public Art Program

Date

Construction 1998–2001

Dimensions

6¼ miles long, 3–55 ft high

Materials

Concrete form liners, paint, foam build-outs

Cost

$54.8 million for highway construction
$2.15 million capital improvement budget from City of Scottsdale, including $40,000 artist's fee and $250,000 in construction contract from ADOT

Photography

Tarah Rider Berry, Heidi Bishop, Carolyn Braaksma, Laurie Campbell, Dan Coogan, Public Art Program, City of Scottsdale, courtesy of Carolyn Braaksma and Scottsdale Public Art

THE EXPONENTIAL GROWTH of Phoenix's urban sprawl has long been creating a logistical nightmare. The city has expanded enormously in the last fifty years, and is continuously spilling its population into over-burdened commuter suburbs. As the web of major highways connecting these communities expands quickly, so does the mission of designers to ensure that these highways do not create an alienating commuting environment. However, to facilitate the rapid expansion of highway construction, Arizona eliminated funding for highway enhancement in 1996. While the highways provide a much-needed physical connection between communities, they homogenize the relatively young suburban towns. Residents on whom the highways had an impact focused their attention on the need for increased corridor identity as a means to bring back some sense of community to their rapidly evolving neighborhoods.

Although the Arizona Department of Transportation (ADOT) maintained standard enhancements called "rustication" (wooden paneling along highway sound-barrier/ retention walls), individual communities were left with the possibility of leaving the highways barren or paying the bill for additional enhancement themselves. Scottsdale, an affluent Phoenix suburb renowned for its arts scene, saw this as an opportunity to distinguish itself from neighboring communities and to reflect its emphasis on the arts. When Scottsdale's Pima Road was recommended as the site for a new freeway, Scottsdale City Council member and soon-to-be-elected mayor Sam Campana suggested the implementation of the city's Percent for Art policy as a means to enhance the highway and add distinction to a city already known for its artists, galleries, and public-art projects.[1]

Enhancement of the Pima Freeway was a challenging idea, as the Percent for Art ordinance that had been in place since 1985 was intended for more modest projects. "You can't just come in and say, 'OK, now we do a freeway project.' It takes a lot of relationship building, trust building," says Margaret Bruning, associate director of public art at the Scottsdale Public Art Program.[2] A precedent

had been set by the controversial Squaw Peak Parkway project in Phoenix just a few years earlier (see pp. 34–41), when the efforts of public designers to enhance the sound-barrier/retention walls on the residential side of the parkway met resistance from some drivers, who could see little from the road; and the buzz and controversy over this allocation incurred community criticism of the design by Mags Harries and Lajos Héder of Cambridge, Massachusetts. Essentially, highway art was already viewed as a tricky business. "It was a scary time for everyone,"[3] says Bruning. In spite of this, with support from the mayor and the public, Scottsdale was ready to start the process of building what would become the largest and most expensive highway-enhancement project in Arizona.

Description The ADOT created sound-barrier/retention walls reaching up to 50 ft tall in some areas to relieve the noise and the cleaving of neighborhoods that often accompany highway construction. The enhancement comprises $6^{1}/_{2}$ miles of decorated highway walls, but the most extensive work was done on the first $1^{1}/_{2}$ miles, where the walls are highest and therefore provide the largest canvas. The artists painted the walls in colors indigenous to the desert landscape—gray, tan, sage green, pink, and lavender[4]—and filled them with huge images of regional flora, desert-dwelling reptiles, and abstract Native American motifs. The forms, which include repeated themes in some forty different combinations, are marked in tile and

textured concrete panels, with foam build-outs attached for additional relief texture. The large-scale desert motifs are proportioned to account for the speed and perspective of highway driving, while the opposite sides of the walls contain similar, though more detailed, images for pedestrians to examine from the abutting sidewalks.

The team also designed decorative handrails, overpass fencing, texturing on walls, and underpass support enhancement. In Bruning's words, "it has literally reinvented the freeway environment."[5]

Design process After ensuring a budget from Scottsdale's 1996 Capital Improvement Fund, the City created a review committee composed of Scottsdale Transportation and Planning and ADOT staff. The City of Scottsdale sent out its requests for proposals, and compiled a highway-design team composed of Jeff Engelmann, a landscape architect from nearby Tempe, and the architect Andrea Forman of Scottsdale. The design team joined the Public Art and Collections Committee[6]—comprising fifteen community residents, including artists, architects, educators, and collectors—in choosing the Denver artist and concrete specialist Carolyn Braaksma from forty respondents to a public call to artists.[7] Two committees, the Public Art and Collections Committee, and the Scottsdale Cultural Council Board (Scottsdale residents) approved the selection and an artist design fee of $40,000.[8]

In order to familiarize Braaksma with the local needs and landscape, Jeff Engelmann

BELOW The completed Pima Freeway enhancement project runs along $6^{1}/_{4}$ miles of highway in Scottsdale, Arizona. Photo: Dan Coogan.

BELOW, RIGHT The lizard motif also appears on columns supporting this overpass. Photo: Public Art Program, City of Scottsdale.

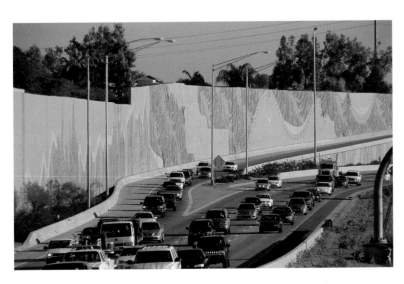

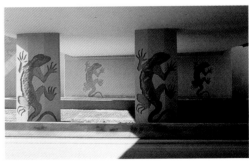

took her to local botanical gardens and other highway art projects. Because of the significant impact that the highway would have on the towns it threaded through, the design team made coping with community and environmental issues a key part of its artistic scheme. Although the need for the road was undeniable, the increased traffic and commuting would, according to Forman, "also bring, to a certain extent, the destruction of a mountain habitat It will drive development faster than people can enlarge the mountain preserve."[9]

The team wrote up a mission statement to guide the design process. They discussed the highway as a means for a journey and for choice, and conceptualized it as a path taken by Native Americans before the arrival of European colonizers, and by wildlife before human settlement. This mission statement focused the group and kept the ideas centered on one goal. Forman considered it to be a useful tool for such a large project.[10]

By the time Forman, Engelmann, and Braaksma had developed the aesthetic package, the highway engineering on parts of the Scottsdale roadway was approaching 90 percent completion. Consequently, the time frame for completion of the preliminary plans was extremely narrow. The team had a window of four months to work on the designs for the first $1^1/_4$ miles of highway, the largest design space. They worked nights and weekends in order to meet the deadlines and strict engineering guidelines defined by the ADOT. With the City of Scottsdale prepared to pay the

project costs, the design team's first objective was to prove to the ADOT that their ideas were feasible and practical.

It was the combination of a landscape architect experienced in freeway work, an artist experienced with concrete as a medium, and a manufacturer with a product that could survive the process, that persuaded the ADOT to approve the plans. Bill Evans, ADOT project manager for the $1^1/_4$ miles of initial construction, commented that the artist and supplier were, between them, "able to convince us [that] 'we've done this before, we can do it again...' The ADOT will agree to this, but you've got to meet the schedule."[11] Enhancement of various kinds is an option given to any community through which the DOT builds a highway. Scottsdale's enhancement plans just happened to be the largest and most expensive that the department had seen, costing the City of Scottsdale an estimated $4.5 million at the conclusion of the project.[12]

According to Evans, "We supported them, it was going to be their bill If they could get the designs done we were more than willing to put it into the project."[13] Still, not all members of the highway review board were as enthusiastic. As an artist working in concrete, Braaksma had past experience of working with DOTs that had left her somewhat frustrated. She commented: "For any project, the biggest obstacle any time is the DOT."[14] The creative goals of planning an art project and the engineering constraints of freeway construction require a great deal of problem-

BELOW Detail of concrete texture and tile. Photo: Tarah Rider Berry.

BELOW, RIGHT This panel represents local lizards at a scale that can be viewed by passing cars. Photo: Carolyn Braaksma.

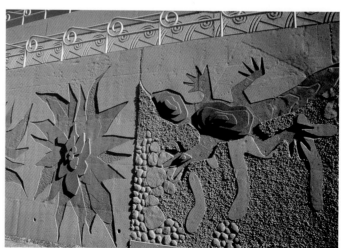

solving. Engelmann urges: "Find someone to put on your team who's dealt with [a DOT] before, who understands their language and can talk their language."[15]

Part of the reason that the ADOT opposed the Scottsdale project in the first instance was the precedent that it would set. According to Bruning, "Everyone's got their own goals and perspective when it comes to building a freeway."[16] The organic, representative forms are contrary to the usual patterned decoration already in many other Phoenix highway projects. "We didn't get very many comments from ADOT [about the design]," says Engelmann, "because I'm not sure they firmly grasped exactly what was being planned."[17]

The team transformed their desert motif concepts into reusable elastomeric formliners for the surfaces of the concrete sound walls, retaining walls, and bridge supports. After the forms were stripped from the concrete, the artwork was cast into the concrete with a maximum of $1^1/_2$ in. of relief on the finished surface. Before the process could be used at a large scale, the ADOT required the contractor to cast large test panels at the construction yard, with the same concrete, formliners, and techniques to assure the ability to provide a satisfactory product.[18] The pre-test was successful, and when actual construction began, the walls were additionally furnished with foam build-outs and red decorative tiling of cactus images. Once the walls were poured, residents were pleased with the textural relief that was visible in the gray cement color,

and contacted the Scottsdale Cultural Council and the office of Scottsdale's transportation planning director, Alex McClaren, to request that the walls not be painted!

The design team had wanted to leave the walls unpainted, celebrating the natural colour of the concrete, but the ADOT insisted that the walls be painted to facilitate maintenance and cleanup in the case of any vandalism. The team chose paint colors from the ADOT's list of standard options, so that the ADOT could maintain the walls. Finally, the design team and the highway department compromised on a set of colors, including a gray mixed to match the cement's natural tone. This color is used on most of the highway wall space, while brighter colors fill in the detailing of the shapes. The full, original color palette covers the pedestrian side of the walls.[19] ADOT contractors installed the walls, tiles, fencing, and foam, and painted all of the surfaces. The main $1^1/_2$-mile stretch was opened to the public in December 1999.

Design impact The visual effectiveness of the art in changing the highway experience is beyond doubt, but the members of the design team did not expect the public to glean much meaning from the content itself. "There was a much bigger picture to this thing in our minds," says Engelmann. "I'm not sure the general public ever gets it … . I think it's absorbed as … a pleasing graphic movement. And that's OK in my opinion, as long as public art creates some communication among the people who see it."[20]

BELOW The scale and visible progression of the panels along the highway are impressive. The purple cacti in the center are a local species. Photo: Laurie Campbell.

BELOW, RIGHT Pedestrian-scale enhancements run alongside the jogging trail. Photo: Dan Coogan.

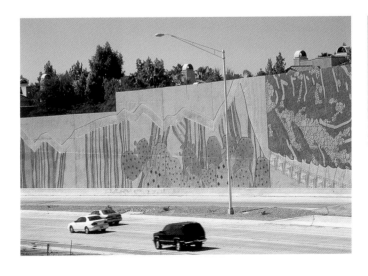

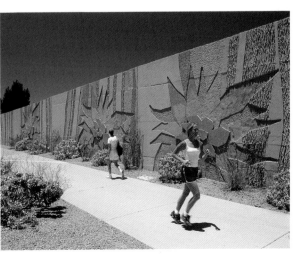

During the design phase, community meetings held at various libraries in the city spread public awareness of the project. The public input from the community meetings did not affect the project's course or implementation. Engelmann attended all these meetings and felt that they were part of public art's obligation to its audience, while Braaksma, who flew into Scottsdale to work with the team, commented: "You dream about [community involvement] in the beginning, but in the end you have deadlines to meet."[21] While the response was overwhelmingly positive, "their [the community's] concern was not so much about what we were doing as how the highway itself was going to impact them,"[22] says Forman. The public insisted, like the ADOT, that keeping to the original schedule was an important issue; they did not want to wait any longer than necessary for construction to begin.

Still, some people remained opposed to the project on the basis of cost. Misleading figures printed as part of project publicity further exacerbated this. As with so many public-art projects, the exact cost of the artwork is difficult to isolate; the walls would have been made of concrete anyway, thus requiring contractor's work, and would have been visually enhanced in some other way. The town spent approximately $2.15 million on capital improvement during the course of this project, in contrast to the $97.5 million spent on the total construction for the segment of the highway around the enhancement.

Many residents thought the price was well worth the results, while some felt that the project was too showy or too expensive. One Scottsdale resident called into the *North Scottsdale Times*, saying: "The work is very good on the railings, but it's very fancy. Most of us wouldn't put something that fancy in our homes." Another commented: "We spent lots of money for a lot of things that will never last like this."[23] Overall, the impetus of the public-art program, combined with the support for the arts built up in Scottsdale over the years, produced results that please community residents.

While lingering problems with the project are minimal, the troubles with logistics and the timeline caused a few setbacks. Since the design team spent most of its effort on the highway-scale images, the pedestrian-scale art did not receive as much attention. The resulting walls contain images awkwardly proportioned for pedestrian visibility, and with less narrative movement than those on the highway side. Budget limitations were one reason for this problem; the team simply could not afford to create separate formliners for what was deemed a less significant part of the project.[24] Another technical setback is the possible deterioration over time of the foam build-outs, which were initially added to give more depth of shadow to the figures. Engelmann believes that with more time, the team could have researched the materials further to alleviate these maintenance issues.

Although the project has been greatly admired, it is not an easy model to follow. Recently, another Phoenix suburb attempted to hire the same artist to do a scaled-down highway project for a smaller budget. Kate O'Mara, who now runs the public-art program for Mesa, Arizona, worked as public-art project manager for the Pima Freeway project. She hired Braaksma to produce design concepts for Mesa, but ultimately the contract to build the sound-barrier/retention walls in Mesa was underbid by a contractor who had no plans to incorporate wall enhancement at all. Although the ADOT and the City of Mesa still intend to incorporate placemaking enhancement on the highway, such enhancements will take other forms than those of the Scottsdale project.

The pitfalls are obvious, but it is possible to re-create Scottsdale's mixture of money and support. Unlike Mesa, Scottsdale had a firm advocate in municipal politics, Mayor Sam Campana. "One of the first things you need to have," says Engelmann, "is a champion for the project The mayor was strongly behind making this a reality."[25] Meanwhile, certain ADOT staff members are beginning to encourage City involvement. Braaksma comments: "It's starting to change a little bit. But just because it's changing in Arizona or California doesn't mean it is changing where you live or where I live It helps when there's already something done in a region, but at some point it takes a visionary."[26]

The cohesion of the team was the other successful element in the design process. The three members worked together in

Engelmann's office during the round-the-clock design sessions. According to architect Andrea Forman:

> You can get such a flash of ideas between three minds that are approaching a project really differently. When you've got your discipline behind you, you think about things in a certain way We were able to communicate with each other on an artistic level where we weren't in competition [because none of us could] take complete credit for the project.[27]

As team leader, Engelmann was committed to creating an atmosphere in which the three team members could interact and be productive at their own tasks. The collaboration brought with it fresh ideas and encouragement, which were essential to overcoming the enormous challenges at hand.

The advice given by the ADOT and the design team alike was clear: start early. "These things are always in crisis management," says Braaksma.[28] There are bureaucratic and political reasons why the decision-making process takes time, but at all ends, it runs more smoothly without tight deadlines. Bill Evans recommends "early involvement with the ADOT, making [your] wishes known ... early in the process so that you can have a more harmonious relationship between the two consultants, the community, and the state."[29] Time probably would not have made a significant difference to the overall images; the design team agrees that extra time would have strengthened the research but not changed the overall image and significance. However, the four-month design period required a design team willing to work long hours until the planning was complete. For an artist having his or her work reviewed and changed in the revision process, Braaksma advises: "Get broad shoulders."[30]

The project will affect commuters, visitors, and locals alike. *The Path Most Traveled* was given a Valley Forward Environmental Award in 2001. Scottsdale's continued commitment to infrastructure projects, including enhancements of public buildings, parks, walls, and tree grates, establishes the built environment within the city as a purposeful visual space, where the quality of the aesthetic surroundings is a priority and considered a quality-of-life issue. The Pima Freeway project is just one aspect of this overall approach to infrastructure as conceived through the city's public-art program. Scottsdale's portion of the Pima Freeway is a landmark for out-of-town visitors and locals, creating a sense of place out of a constructed environment. In addition to her work on the Pima Freeway project, architect Andrea Forman sits on the development review board in Scottsdale. "If a community doesn't take care of itself," she says, "then who is it going to turn to? It's nobody's fault but its own if it becomes just another bedroom community that doesn't reflect any personality or character As a citizen you've got to demand it."[31]

1 See Joan C. Fudala, "Highway to Heaven," *Scottsdale Airpark News*, March 2001.

2 Margaret Bruning, assistant director of public art, Scottsdale Public Art Program, correspondence, August 15, 2001.

3 *ibid.*

4 *ibid.*

5 *ibid.*

6 Andrea Forman, architect, Scottsdale, correspondence, September 14, 2001.

7 Scottsdale Museum of Contemporary Art project information packet.

8 *ibid.*

9 Forman correspondence, August 23, 2001.

10 *ibid.*

11 Bill Evans, ADOT project manager, correspondence, August 28, 2001.

12 Jeff Engelmann, landscape architect, Tempe, correspondence, August 28, 2001.

13 Evans correspondence, August 28, 2001.

14 Carolyn Braaksma, artist, Denver, correspondence, August 17, 2001.

15 Engelmann correspondence, August 28, 2001.

16 Margaret Bruning, correspondence, August 15, 2001.

17 Engelmann correspondence, August 28, 2001.

18 Braaksma correspondence, September 14, 2001.

19 Engelmann correspondence, September 6, 2001.

20 *ibid.*, August 28, 2001.

21 Braaksma correspondence, August 17, 2001.

22 Forman correspondence, August 23, 2001.

23 "Sound Off," editorial phone calls, *North Scottsdale Times*, October 2000, pp. 6–9.

24 Forman correspondence, August 23, 2001.

25 Engelmann correspondence, August 28, 2001.

26 Braaksma correspondence, August 17, 2001.

27 Forman correspondence, August 23, 2001.

28 Braaksma correspondence, August 17, 2001.

29 Evans correspondence, August 28, 2001.

30 Braaksma correspondence, August 17, 2001.

31 Forman correspondence, August 23, 2001.

A version of this case study appeared in Scenic America's Scenic Solutions *CD-ROM resource, September 2003.*

Radnor Gateway Enhancement

RADNOR, PENNSYLVANIA

Project description

Thematic design elements recalling megalithic monuments from Radnorshire (now central Powys), Wales, line the eighteenth-century turnpike. Marked iconography of the town-ship seal along a 5-mile corridor with the work of a multifaceted team of artists, planners, landscape architects, and craftspeople

Artist

William P. Reimann

Planning

The Townscape Institute

Landscape architects

Coe, Lee, Robinson & Roesch

Agency

Radnor Township Design Review Commission

Date

1988–99

Dimensions

Thirty objects along 5 miles of highway

Materials

Stone

Cost

TOTAL $400,000 estimated, including: The Townscape Institute planning $75,000; Landscape architects $75,000; Artist (megalithic monuments) $27,000; Artist and craftsman (clock) $65,000; Wayne Plaza implementation $100,000; Radnor beautification: $48,000

Photography

Courtesy of The Townscape Institute

AN ATTRACTIVE SUBURB approximately 15 miles west of Philadelphia, Radnor has accommodated throughout its history a number of transit routes to channel travelers to and from Philadelphia, the hub of the region. Radnor is a suburb of private affluence, if not civic presence, and its residents have long resented the fact that the town is seen more as a transitory blip on a traveler's radar screen than as a unique destination in its own right. Radnor's planning board and The Townscape Institute of Cambridge, Massachusetts, collaborated to address this problem. The result was a combination of landscape architecture and highway design that gives Radnor an identity of its own amid the web of road and rail that envelops the region, creating a sense of place with which residents and transients alike have come to identify.

Beginning with the Lancaster Turnpike, the oldest turnpike in the country (completed in 1794), Radnor has long known the presence of highways. The township has seen the old Conestoga wagon and Indian trail give way to the Old Lancaster and Conestoga roads, which connected the farmlands of the West to Philadelphia. It witnessed the coming of the Columbia (later Pennsylvania) Railroad in 1846 and experienced the increased development that followed the rail line. And, because of a population explosion following World War II that more than doubled the number of inhabitants from 13,000 in 1950 to 29,000 in 1990, the transit systems have kept coming. Radnor Township is now criss-crossed by some of the busiest transportation routes surrounding Philadelphia, most significantly Route 30.

As an attractive and easily accessible location close to Philadelphia, Radnor Township has prospered. Many wealthy citizens of Philadelphia settled in Radnor, building estates and mansions, and bringing the sophistication of Philadelphia to the countryside. As the population of the region has continued to grow steadily, these estates have been subdivided and the mansions often turned into institutional buildings that hold the schools and government offices of a young, dynamic community. In its latest incarnation, the town that has gone from Welsh Quaker village to ritzy playground of Philadelphia's powerful élite is a wealthy suburb, the median

family income of which hovers just short of $72,000. Radnor houses the headquarters of international corporations and educational institutions that continue to bring work and prosperity to the region, including Sun Company, Wyeth–Ayerst, Fidelity Mutual, Unisys, Chilton, and T.V. Guide, as well as American College, Cabrini College, Eastern College, branches of Penn State and Valley Forge Military Academy, and Villanova.

Radnor residents were justifiably concerned when construction began on Interstate 476, the "Blue Route," which threatened to invade the township with the increased noise, traffic, and homogenization that a large circumferential highway around Philadelphia can bring. Because of litigation brought about by nearby Swarthmore, the highway took more than thirty-five years to build, and set a Pennsylvania highway cost record of $600 million. In its completed state it runs 21¹⁄₂ miles from the Pennsylvania Turnpike to Interstate 95. Fearful that the highway would diminish their sense of

community, as well as bring down property values in the town, Radnor residents realized that they would have to take steps to minimize the intrusion of the new pathway and enhance the existing positive features of their township.

William H. McCoy II, long an active member of the planning board, sought out the author, Ronald Lee Fleming, who heads the nonprofit Townscape Institute in Cambridge, Massachusetts. The Radnor Township Design Review Commission subsequently hired The Townscape Institute, which then recruited the Philadelphia landscape architecture firm of Coe, Lee, Robinson & Roesch, and artist William P. Reimann, to enhance a 5-mile stretch of the Blue Route with stone markers and objects that hark back to the town's seal and its Welsh forefathers.

Description The prevalence of quarries made stone the most popular early building material in Radnor, and it has been used for walls and buildings throughout the township. With this in mind, the design team conceived a project

A stone circle is set by the side of the road.

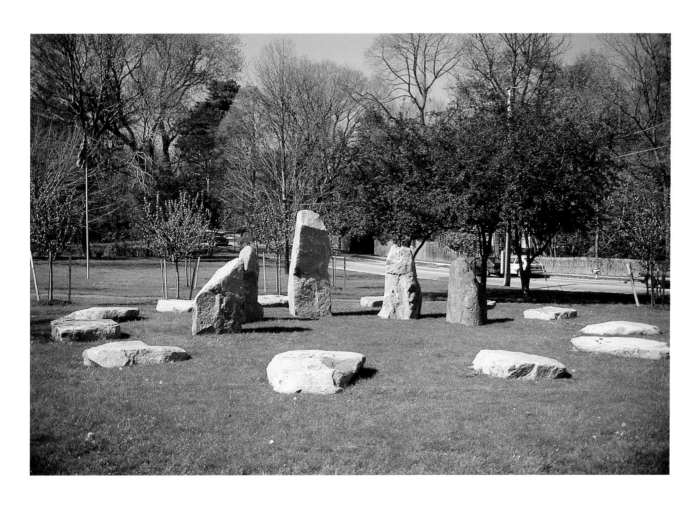

that was based on four elements: stone, the medium intrinsic to the area; the Welsh landscape of the town's forefathers; iconography of the township's seal; and the directional markers of the early turnpike. As the township retains many eighteenth-century stone structures, the use of similar materials would reinforce the town's design vocabulary. Similarly, using a material inherently linked to the landscape would make the enhancements less intrusive to the town's fabric, while also adding a sense of permanence and presence to the structures created by the design team.

With the material of the enhancements localized, the designers focused on evoking the history of the town and its original settlers with elements they were positioning along the road. The project itself consists of some thirty objects along the 5-mile stretch of highway, a "series of punctuation marks in that long strip of suburban development," according to Fleming. The monuments serve to create ties of memory to the original settlers' homeland of Radnorshire, Wales; to this end, the designers created a circle of stones reminiscent of Britain's ancient stone rings, an entry sculpture in a series that stretches across the township from this eastern border to the west.

The original turnpike milestones were 13 in. high, easily visible to passing carriages. Today's project features 8-ft-high milestones that are scaled for the speed of modern-day driving. These markers are emblazoned with the town's seal and, with stone benches, occur throughout the 5-mile corridor, serving as signposts to indicate that travelers are entering the town. Stenciled forms on the 14-ft-high sound-barrier walls encasing two Blue Route bridges recall elements of the town's seal, including a dragon, lion, tree, and wheatsheaf. Traversing the Blue Route, drivers also pass groups of stones in the form of cairns, plinths, arches, and other Neolithic compositions that recall the Celtic heritage of the town's original settlers. As the center of town nears, the objects become larger, culminating in a stone obelisk and, at the top of the exit ramp of the Blue Route at the intersection with Route 30, a 120-ft-tall stone cairn and a giant dragon 90 ft high that sprawls by the angled roadside cut of the new Interstate 476.

The most recent addition to the project is the electrically animated Wayne Clock, which has a green tree from the town seal that drops open on the hour to reveal a mechanically operated dragon and lion who stick their tongue out and claw at each other respectively. Under the rim, the Conestoga wagon, liberty bell, steam locomotive, and limited electric trolley —all of historical import in the town's development—perform quarter rotations at fifteen-minute intervals past four milestone markers.

Design process There was no formal process used to select Ronald Lee Fleming and The Townscape Institute to spearhead the enhancement project. McCoy had heard Fleming give a speech in Philadelphia years before, and, on his recommendation, the township selectmen chose Fleming as the township consultant and asked him to select a design team that would provide a multidisciplinary approach. Fleming did some research, and chose Coe, Lee, Robinson & Roesch, and Reimann. Although on the Harvard faculty, Reimann had the added advantage of being from a nearby town and was experienced in stone-cutting and shaping.

Radnor has no Percent for Art ordinance, so a township-enhancement committee of selectmen and corporate leaders collected the funds for the project. The Radnor Gateway Enhancement Strategy committee included representatives of the township government, the planning commission, and the town manager. The township contributed a percentage of the funding, and the committee also met with corporations and individual executives to collect the remainder of the funds for the enhancement.

As it happened, the construction of the highway itself unearthed large rocks that Fleming realized could be used for the project: "They were breaking up the stone, so we said, 'Hey, hold on ... leave us about fifty of those rocks.' And we started from there." The project had no official timeline; rather, the design team constructed the objects one by one, with the circle of stones constructed at the eastern entry by Lower Marion almost immediately.

Initially, the township was worried that the stone structures planned by the design team might provoke a negative reaction among the townspeople. As a result, some of the larger envisaged projects were not carried through.

Fleming recalls a scheme that involved using a mound that had once been the site of a gas station. The design team intended to surround the mound with stones and put a large, upright boulder on the top. Because of hesitancy on the part of the township, the design team scaled the concept down, and the rocks ended up being used as a border to the site. Fleming notes: "That was always the problem and sometimes we would get ahead of this conservative community's cautiousness of what we were about." Proceeding with no official timeline, however, enabled the design team to gauge residents' feelings about a number of the intended enhancements. Fleming recalls: "We were able to test with incrementals. We did a few things. They liked the things, we did some more. So you could say the best proof of the fact that they approved what we were doing was that they saw a few things and kept employing us to do more."

According to Fleming, the project could not have been completed without the commitment of McCoy, who was politically attuned and experienced in working with town boards. A Republican, McCoy was tied to the majority of the town selectmen. Fleming feels that going directly to the conservative

BELOW, RIGHT The stone markers are decorated with the city's seal.

BELOW, FAR RIGHT The seal also appears on the overpass, along with other emblems important to the town's history.

BOTTOM A giant griffin is set beside the new Interstate 476.

members of the township to have a big discussion about public art would probably have killed the project before it even began. The support of McCoy was the key that unlocked doors for the design team and enabled them to negotiate with Pennsylvania's Department of Transportation (PennDOT) and the township government without the distractions that dealing more directly with the townspeople would incur. PennDOT allowed the design team to use its construction equipment to build a large cairn marking the entryway to Route 30 from the Blue Route. Fleming remembers: "We ended up using their bulldozers to build the cairn ... that was

remarkable in itself." McCoy was also instrumental in persuading the township to pick up the cost of insurance and PennDOT to cover the charge of covering the sound-barrier walls, part of the enhancement budget, thus removing some of the financial load from the design team's shoulders.

Design impact Not only did Fleming, Reimann, and Coe, Lee, Robinson & Roesch's designs soften the impact of the transit route on the physical layout of the town, but they also helped to strengthen the sense of community within Radnor, making the township a more desirable place in which to live. McCoy says:

BELOW, RIGHT The Radnor cairn marks the entrance to Route 30 from the Blue Route.

BOTTOM Drawing of Radnor by William P. Reimann.

"As a stockbroker, I don't know a better invest-ment that we could have made as a community. When the Blue Route went in, everyone thought property values would go down, but with the Radnor Enhancement Community Strategy in place, property values are rising."

Fleming notes that while people seem to appreciate the unique landscape that the design team created, they are not necessarily clear about why the project was planned in Radnor, nor do they understand the connection to Wales. He feels that the creation of an interpretive panel located in the "Four Corners of Wayne" (Radnor's town center) would be helpful in explaining the references and goals of the project; indeed he proposed a "memory wall" that would perform this function. Fleming notes, however, that "even if people don't get the connection, they get the continuity and the physical impact of having thirty design elements stretching across the 5-mile corridor."

Physical impact aside, some people are going out of their way to engage fully in the physical landscape that the design team created. Much to their consternation, local police have noticed cloaked and hooded figures conducting nocturnal solstice ceremonies in the stone circle. Bones have been found buried within the giant stone cairn. The landscape that has been created apparently has some spiritual significance for residents above and beyond the original intentions of its designers, and is serving as a powerful landmark in the community.

Noting the positive results of the Radnor Gateway Enhancement Strategy, Radnor Township officials are beginning to propose other public-art projects to embellish the community further. Radnor's effort to enhance its gateways and principal transportation corridor served as the starting point for the community's broader design review effort. A new design code seeks to maintain William Penn's original image of Radnor as a "Green Countrie Towne," and is implementing a number of township rehabilitation projects. Although the city still has no Percent for Art ordinance, there is a fund for enhancements supported by corporations. The township has shown ingenuity in borrowing extra parking space from a public utility. In exchange for extensively landscaping the lot as it fronts on the Lancaster Pike (just one block north of Wayne Center), it is able to rent the lot to shopkeepers and their staff, thus freeing up parking in the center. The parking income, about $20,000 a year, is now allocated to expanding the enhancement program. In recent years, this has included installing lighting fixtures and more attractive parking meters, as well as more street trees.

Radnor residents are not the only people noticing the success of the Radnor Gateway Enhancement Strategy. The Radnor expenditures are relatively modest, and the project now demonstrates how enhancement funds can be used under the Intermodal Surface Transportation Efficiency Act of 1991. The project received the first award given by Environmental Design Research Associates/*Places* magazine in 1998, a sequel to the now-defunct *Progress Architecture* magazine awards. The Radnor Gateway Enhancement Strategy has been the subject of articles in the *Washington Post* and *Planning* magazine and an exhibit on *Planning Futures* at the National Building Museum, Washington, D.C. More recently, in 1999, the project received an urban-design award from the Boston Society of Architects. Other townships have since contacted The Townscape Institute, seeking ideas on how best to enhance highway corridors within their own communities.

The success of the project hinged not only on the strong design vocabulary that threaded through the enhancement objects, but also on the consistency of the vision behind the project. "I think that's the point," Fleming notes. "I had a defined agenda … . It's different from a lot of public-art projects around the country where each person comes up with their own impression as they see it. We had come up with a metaphor and set of urban-design concepts and then the artists *contributed their ideas within the framework of that metaphor*. The strength of this project … is that it created this sense of continuity over time and space."

A version of this case study appeared in Scenic America's Scenic Solutions *CD-ROM resource, September 2003.*

Cincinnati Gateway

CINCINNATI, OHIO

Project description

A 2½-acre artist-
designed park brings
the varied history of
Cincinnati to life

Artist

Andrew Leicester

Agency

City of Cincinnati

Date

1988

Materials

Various

Cost

$914,000

I N PREPARATION FOR Cincinnati's 200th aniversary the City planned and designed the 2½-acre Bicentennial Park at Sawyer Point, part of a larger revitalization project along the riverfront that had been going on for more than a decade. The City wanted to commemorate the bicentennial and to beautify the park with a major artwork, so it held an international competition for the commission and, out of the six finalists, chose Andrew Leicester, who had teamed up with MSR Architects in Minneapolis to do the project.[1] Leicester's winning idea was to create an entrance that consciously worked with elements of the larger project, and which was "essentially an urban levée with references to prehistory, Indian culture of the Ohio River, and the famous serpent mound ..., which is why we made the entrance into an abstraction of a lock."[2]

The commission had requested that the piece "highlight Cincinnati's past and impress tourists,"[3] but Leicester's choice of focus— Cincinnati's past as a center for the swine trade—was unpopular with those residents eager to put behind them the city's nickname of "Porkopolis." The artist proposed placing winged pigs at the top of the columns of the pedestrian bridge and, though heated debate ensued, the city council approved the concept in early January, just in time for the pigs to be prepared for the June inauguration.

Description Although the gateway pigs caused the most public controversy, the principal feature of Leicester's project is a 750-ft-long earthen mound topped with the Ohio River Walk, which follows a 450-ft water-course mapping the actual river's configuration. This element was very expensive to build as securing its structure required intensive study, analysis, and labor. The walkway above it crosses a suspension bridge that pays tribute to the many bridges along the Ohio.[4] The bridge cables are attached to four 20-ft pillars through the gaping mouths of sculpted fish, and those pillars are topped by the celebrated winged pigs. At the point where Cincinnati appears on the map, the mound is cut by both of the lock abstractions described above, which serve as the symbolic entrance to the city and the real gateway to the adjacent park.

The brick walls forming the sides of the lock feature artifacts, emblems, and images from Cincinnati's rich past. For instance, several bronze heads crafted by local artists were inspired by Native American pipe bowls, and there are quite a few reproductions of artifacts and fossils unearthed in the Ohio Valley. On one of the entrance walls there is a brick mosaic depicting a cross section of the Ohio–Erie canal, featuring each community along its length, ending with Cincinnati. Here, the seven hills upon which the city was founded are emblazoned with the names of those who made substantial donations to the project.

Through this eclectic mix of culturally significant memorabilia protrudes the prodigious, commemorative *Flood Column*, 85 ft tall. This grand gesture, topped by a bronze arc, is visible directly through the canal

lock and suspension-bridge stacks. This is a time capsule based on biblical precedent, and contains various items commemorating the city's bicentennial. The column itself, Leicester comments, is "a map of the Ohio River system's history." Three major floods occurred in Cincinnati's first two hundred years, one of which apocalyptically rose to 100 ft above flood level. At this point there is a cleft in the column containing a large carved and bleached piece of driftwood, which,

according to Leicester, is, "if you will, a taunt to the Ohio River to dare to come and get it."[5]

Design process Preparation for implementing the design went through several stages. The soil was unstable because of its proximity to the Ohio River and the neighboring swamplands. Old riverboat skeletons and rusted metal formed surprising additions to the already viscous soil, which required Leicester to order core samples. To support the

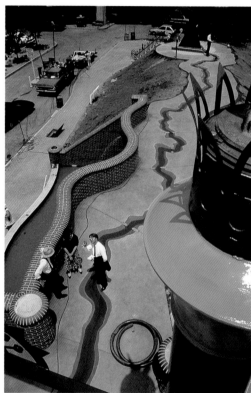

ambitious project, architects determined that they would need to fix eighty 5-ft concrete pilings into the bedrock to avoid settling. As Leicester was concerned with finding the exact location of the long-buried watercourse, he worked with contractors to survey the site, using geomancy to pinpoint the exact location of the historic canal bed.[6] The unanticipated costs of these footings caused the project to go over-budget, much to the annoyance of city officials, who treated Leicester like a pariah at the opening ceremony.

Although only a small part of the overall design of the gateway project, Leicester's winged pigs sparked a significant amount of controversy and debate during the initial stages of the design's implementation. Despite the verve with which Leicester presented his celebratory swine to Cincinnati, he was also serious about their cultural significance, and when asked if he would have included them without public support, he asserted that he would have exercised artistic license, pointing out that the purpose of the gateway project was to showcase Cincinnati's prosperity, in which pigs had played an important rôle.[7] Eventually, the heightened controversy reached as far as New York, with the *Wall Street Journal* carrying the wry headline, "Perhaps New York Would Accept the Pigs in Trade for *Tilted Arc*."[8] Finally, a member of the city council called a public hearing to review the issue, and the public showed overwhelming support for the pigs, wearing pig snouts and waving pig banners.[9] On June 1, 1988, the project, swine and all, was endorsed and dedicated.

Design impact Since the dedication of the *Cincinnati Gateway* and Sawyer Point Park on June 1, 1988, both have been used frequently, and the benefits of the project are evident. Culturally, Cincinnati has been enriched by this historically informative work. However, the winged swine have truly stolen the limelight.

Initially, T-shirts and mugs were the extent of Cincinnati's publicity for the flying pigs. Then, in 1995, Erika Doss published *Spirit Poles and Flying Pigs: Public Art and Cultural Democracy in American Communities*. In her book, Doss cited the gateway as "an amusing, interactive, historically informed model of contemporary art."[10] Aside from heightened cultural awareness and intellectual bantering,

the work has had social and economic ramifications. Cincinnati is now unafraid of being associated with pigs. The city produced a cookbook entitled *I'll Cook When Pigs Fly*,[11] and, since 1997, has held the Flying Pig Marathon, annually proclaimed the most creatively named marathon by *Runner's World* magazine. According to the *Cincinnati Enquirer*, "the organizers saw it as a name that would not only promote a fun event but also tie in nicely with Cincinnati's history."[12] The organizers are proud to announce that since the title has changed, participation has doubled and revenue increased accordingly.[13]

Within the scope of public-art projects nationwide, the *Cincinnati Gateway* in Sawyer Point Park has played an important rôle in showing how an artistic vision can be achieved. In this particular case, Leicester had considerable artistic license by contract, and was free to determine how influential the public could be in the commissioning. As he explains,

> I have spent my career protecting the integrity of my works against the corrosive forces of other people's opinions. The great criticism of public art is that it is a milksoppy pabulum for the masses and that it doesn't have any kind of cutting edge or it doesn't address contemporary issues. So one develops strategies as one shepherds or guides an idea through various forces, pushing and pulling it. You really have to be quite diplomatic, yet stick to your guns; you have to be prepared to make concessions and you have to throw in lots of red herrings or sacrificial lambs. I am always prepared to concede pieces to the group, but I have already loaded the work up with superficial elements to begin with so that I can lop them off as it goes through, but the core idea, the golden center or nucleus of it, remains inviolate, so when it finally emerges and gets built, it's substantially the way I originally wanted it to be.[14]

Few artists have been able to develop such a refined means for dealing with public impact interfering with artistic vision. And although Leicester does keep his vision central, he is careful to take responsibility for ensuring place and community significance in his work, which is why this project, like others he has done, is still enjoying public success years after completion.

1 Robert H. Richardson, city architect, Cincinnati, correspondence, January 2, 1998, and Andrew Leicester, artist, Minneapolis, interview, January 4, 1998.

2 Leicester interview, March 25, 1998.

3 Claire Ansberry, "Perhaps New York Would Accept the Pigs in Trade for *Tilted Arc*," *Wall Street Journal*, January 19, 1998, p. 1.

4 From the summary of Leicester's winning entry description.

5 Leicester interview, February 4, 1998.

6 See John Johnston, "This Little Piggie Flew into History," *Cincinnati Enquirer*, May 7, 2004, p. E1.

7 Leicester interview, February 4, 1998.

8 Ansberry 1998. See pp. 28 above and 345–46 below for an explanation of the *Tilted Arc* controversy.

9 See Johnston 2004.

10 Erika Doss, *Spirit Poles and Flying Pigs: Public Art and Cultural Democracy in American Communities*, Washington, D.C., and London: Smithsonian Institution Press, 1995.

11 See Johnston 2004.

12 *ibid*.

13 *ibid*.

14 Leicester interview, February 4, 1998.

Over-the-Rhine Gateway

CINCINNATI, OHIO

Project description

A three-sided clock and bell tower stands on a triangular traffic island at the intersection of a major state highway. It features illuminated clocks and nineteen cast-bronze bells that ring hourly

Artist

David Day

Agency

City of Cincinnati
City Gateway Program

Date

Dedicated November 1, 1996

Dimensions

55 ft tall

Materials

Brick and cast stone masonry

Cost

$100,000 donated by the Verdin Bell Company
$135,000 donated by the Corbett Foundation
$133,000 donated by the City of Cincinnati
TOTAL $368,000

T HE *OVER-THE-RHINE GATEWAY*, a 55-ft bell tower, or campanile, at the northeast corridor entrance into downtown Cincinnati, welcomes visitors to the area. The tower stands on a traffic island at the intersection of Liberty Street, Reading Road, and I-471, the entry point to a historically significant neighborhood. The name recalls the Germanic ancestry of the area's original population, while simultaneously celebrating the diversity of the current community with various icons adorning the tower. The construction of the tower in 1996 marked the first project of nearly a dozen gateways planned by the Department of Public Works' City Gateway Program. Robert H. Richardson, city architect, and Paul Knue, editor of the *Cincinnati Post*, first conceived this urban initiative in 1993:

> We looked at the most highly traveled city entrances that needed some enhancement. Major city streetscapes had been completed in the center of Cincinnati, but some of the edges needed a lot of work. The idea of the program was to form a public–private funding and

design partnership and to embellish the major city entrances in ways that not only improved the area, but also established a strong historical tie to the origin of place, its current identity, and the story or identity of the corporation or corporations that, along with the City, were co-sponsors.[1]

Artist David Day's *Over-the-Rhine Gateway* involved precisely this collaborative funding process. The City, the nearby Verdin Bell Company (a clock-and-bell manufacturer), and the Corbett Foundation (renowned for supporting the arts in Cincinnati) formally underwrote the tower. The Office of Architecture and Urban Design (OAUD) initiated the enhancement project, lobbied for City Capital Improvement Funding, and used the City money as leverage for matching private funding. The OAUD then solicited artists' work, hired historians to write accounts of different sites, and used graphic designers to make storyboard presentations to corporations. The graphic designers visually combined place history with corporate icons to generate interest and encourage sponsorship.

The Verdin Bell Company initially approached the City about constructing a bell tower near its headquarters. The president of the company, Jim Verdin, saw drawings of other proposed gateways in the newspapers and wanted to create a similar structure. The Verdin family had started the company after emigrating from Alsace, France, in around 1835, using old-world iron-forging skills as they embarked on clock manufacturing in Cincinnati.[2] Their business has been a staple in the city and key to the economic health of the Over-the-Rhine community to the present day. The proposed bell tower enhanced the gateway to the city while referring to a significant business that shapes the character of the neighborhood. Jim Verdin officially contracted David Day to draft initial design concepts, and the City later worked with Day on the detailed design.[3]

Verdin and Richardson then approached the Corbett Foundation about co-sponsorship. The foundation, a long-standing arts supporter, was "particularly enthralled with

This red-brick bell tower is built on a triangular base and features arched openings throughout, as well as three steeply pitched gables with permanent decorative banners. Photo: David Day.

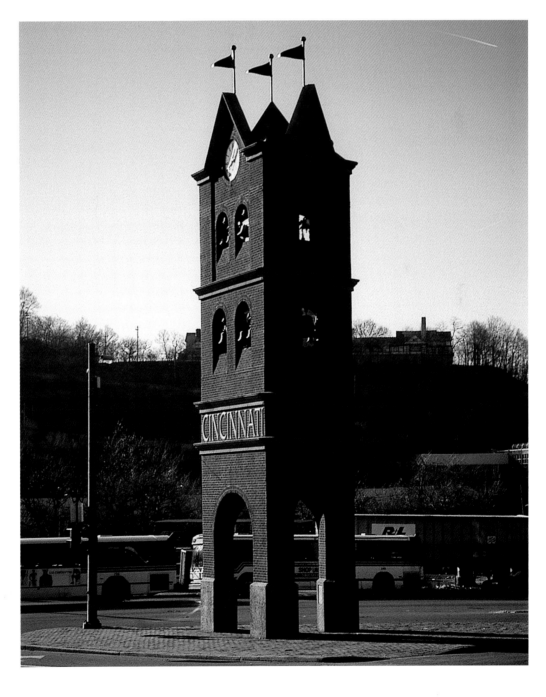

the aspect that the campanile could literally be 'played' for concerts, as well as the potential for involving the neighborhood kids,"[4] and agreed to co-sponsor. From dusk to dawn, a welcoming lighting system inside the tower automatically illuminates the bells and brick plaza from above.

Three large cast-bronze plaques on the Frank Street façade commemorate the three major donors. Three brass plates located on the inside of the tower's legs announce these donors, the firms that contributed to the design and construction of the tower, and recount a brief history of Over-the-Rhine. Brick pavers surrounding the tower are engraved with the names of donors who funded perpetual maintenance. The campanile is now privately owned.

Design concept David Day wanted to capture the historic flavor of the Over-the-Rhine community and sought to create a place-appropriate metaphor. The Over-the-Rhine name pays homage rather blatantly to the cultural character of this neighborhood, at a time when it is imperiled:

In 1830s Cincinnati, many citizens thought that crossing the Old Miami and Erie Canal downtown was like crossing the Rhine River into Germany because its predominant spoken language was German—hence the name "Over-the-Rhine."[5]

Originally something of a derogatory comment, by the mid-nineteenth century the term "OTR" was widely used, especially among German Americans, who took particular pride in calling attention to the special character of the neighborhood. Wave after wave of immigrants—Saxons, Bavarians, Prussians, Alsatians and later European Jews, Irish, Scots, English, Italians, and Africans—created a neighborhood of coexisting ethnic diversity that inspired the design of the tower.[6]

The architectural motifs refer to the anonymous nineteenth-century contractors who built a wonderful array of Italianate, Federal, Greek Revival, Second Empire, Queen Anne, and Renaissance Revival buildings that still stand in the neighborhood. Day designed and constructed a brick masonry tower roughly the same height and appearance as the neighboring 1850s buildings, and incorporated the time-worn look of distressed brick and limestone masonry.[7]

The tower directly recalls these waves of immigrants. The 55-ft-tall, three-sided, roofless brick masonry clock-and-bell tower houses nineteen cast-bronze bells with bronze finials. The bronze icons on the bells

Lansing Steam Clock Tower

David Day also designed the Lansing Steam Clock Tower in Michigan, another clock that refers to a unique city history. The 28-ft-tall, stream-driven clock tower is programmed to produce factory-like whistle blasts marking the hours between 8 am and 5 pm. The blasts are a reference to Lansing's early days as a factory town, when the sound of steam whistles structured the lives of many of the city's inhabitants. The tower is located on a prominent downtown corner, and its cast-limestone, Art Deco style is in full view of its inspiration, the early 1940s streamlined modern steam-and-power plant on the Grand River. The structure was a gift from the Lansing Rotarians to commemorate the 150th birthday of Michigan's capital city. The history of the Rotarians, as well as the city's own chronicle, is inscribed on the tower. The eight-sided structure contains four panels that describe the site, the tower's design and implementation process, the Rotary Club's sponsorship, and the history of Lansing and its connection to steam power. Between the plaques are four tall, narrow windows that allow passersby to observe the internal antique clock works and brass steam fittings. In addition, four self-illuminated modern clock faces maintain the tower's Art Deco appearance. The tower was dedicated in September 1997, and cost $140,000.
Photo: W. Spencer Parshall.

represent the most significant ethnic groups that have settled in Over-the-Rhine since the 1830s. The icons include a bear holding a shield for Bavaria, a flower for France, the eagle of Saxony, a lion representing England, the shamrock of Ireland, a thistle for Scotland, a falcon for Africa, a Star of David representing European Jews, and a wreath surrounding a she-wolf for Italy.[8]

Sound is produced by an elaborate system of electronic controls that allows a phalanx of fourteen bells to play the Westminster Chime or simple passages from songs. There is also a parallel digital bell system amplified in the tower with a manual override so that songs can be played on a portable keyboard by a carillonneur. In addition, three bells—a cast-bronze miniature Liberty Bell replica, an American Heritage bell, and a cast-brass railroad locomotive bell—can be rung by a rope at the beginning of on-site community ceremonies. The bells sound a singular tone that symbolically draws on a myriad of cultures and histories; they further serve to link the fluctuating ethnicity of the neighborhood with the consistency of the Verdin bell product, a steady influence on this particular community.

Day consulted the archives of the Cincinnati Public Library and the Cincinnati Historical Society to develop his historical metaphors. Avoiding the pitfalls of contemporary stereotypes for the icons, he searched for symbols with origins dating from the medieval period or older. In the case of the African icon, he consulted a childhood friend, a local authority on matters of black visual history. Day, a native of Cincinnati's Over-the-Rhine, and of Scots/Irish origin, drew much inspiration from his personal experience with his German neighbors.

The handcarved limestone roundel on the tower was created by local sculptor Karen Heyl and depicts the official seal of the City of Cincinnati. Large bronze letters along the top of the tower announce the passage into Over-the-Rhine from downtown Cincinnati. The tower affirms Cincinnati's pride with the city seal, while paying equal homage to the many transient cultures in the neighborhood.

Design impact The Gateway Program "fixes up the front doors of the city, the places that people see most, especially tourists and visitors."[9] Still, the gateway has arguably had the most positive response from Over-the-Rhine natives. One local, Lisa Spanos, owner of Art Design Consultants, says, "I think that it instilled a sense of pride in our location in Over-the-Rhine. There are not many new things being built to aesthetically add to the surroundings. For people [who] actually live here, they feel like somebody's paying attention and doing something nice to add to the community."[10] City architect Richardson confirms this, adding, "We have had many neighborhoods approach us [about ideas to] enhance the beginnings and ends of communities."[11] Richardson was referring to the physical dimensions of neighborhoods, but the tower also demarcates the "end" of a traditionally German neighborhood and its transformation into a more culturally diverse place. Some newer residents have commented on the relevance of the *Over-the-Rhine Gateway* today. E. Pope Coleman, a resident who is on the board of the Over-the-Rhine Foundation, injects a critical note about the tower. Although he likes the concept of neighborhood markers, of which the tower is the largest, he says, "any time you have to ask what the metaphor is, it fails." He is disgruntled because the bells have not worked since lightning struck the tower some years ago, and the foundation has been burdened with paying for the maintenance and the annual insurance totaling $4000. According to Day, the bells have been in working order since 2001 thanks to the Verdin Bell Company's maintenance.

The bell tower inspired local artist Fabienne Christenson's work *Heard in Plain Sight*, a series of panoramic paintings. "Bells call us to do things that lift our spirits up," Christenson says. "They mark time. They record joyous and sorrowful events. They are harmonious."[12] Christenson climbed the tower and noticed: "While I was up in the tower, I could hear a great many sounds that you would not think could carry that far: children calling to each other, shouts for help, lovers laughing, the click of stoplights. I was entranced. It was a very interesting viewpoint." The tower both sounds its own ritualistic, placemaking chime and passively encapsulates a spontaneous nexus of city sounds: a continually fresh and fleeting sense of the city.

1 Robert H. Richardson, city architect, Cincinnati, correspondence.

2 See verdin.com.

3 Richardson correspondence addressing the *Cincinnati Gateway* Funding Program Summary, January 2, 1998.

4 *ibid.*

5 David Day, artist's statement, December 8, 1997.

6 *ibid.*

7 *ibid.*

8 See Derek Krewdel, "Christenson Sees Hope Through Bell Tower," *The Downtowner*, April 23, 2002, p. 13.

9 Cliff Peal, "Gateways Open Up Downtown," *Cincinnati Post*, May 27, 1999, p. 1A.

10 Quoted in Mike Pulfer, "Gateways Say Welcome: Donations Helped Build 10 Architectural Projects," *Cincinnati Enquirer*, July 2, 2001, p. A1.

11 *ibid.*, p. A6.

12 Krewdel 2002.

Fenceline Artifact

DENVER INTERNATIONAL AIRPORT · DENVER, COLORADO

Project description

A 1000-ft fencelike installation, including fossil rocks from the site's excavation, native cottonwood trees, and historic artifacts to commemorate the site's former use as farmland

Artists

Buster Simpson and Sherry Wiggins

Agency

Denver International Airport Public Art Program

Date

1988

Cost

$914,000

Photography

Courtesy of Buster Simpson

At the time of its construction, Denver's international airport (DIA) was the largest construction project in the world, costing $4.2 billion and covering 53 square miles. The 1.2-million-sq.-ft area of the main terminal's soaring white canopy mimics the Rocky Mountains' front range, and provides a landmark that has come to represent Denver itself. The airport's aesthetic does not end with the architecture. An ambitious $9.5 million art program, funded by the City and County of Denver's Percent for Art ordinance, commissioned twenty-seven works by forty artists throughout the terminal, three concourses, subway system, and entrance roads, garnering much press coverage and mixed reviews. Some projects have been very well received, while others have been fraught with controversy and delays.

A blue-ribbon Art Steering Committee composed of artists and arts professionals was formed during construction in 1989, to write and implement a master plan for artwork at DIA and to oversee the selection panels. Sites were identified for commissioned works, and, in 1990, the committee held national competitions to select artists for each location. Because the site and artist selection occurred before the airport was built, many pieces benefit from close relation to the architecture. Antonette Rosato and William J. Maxwell's *Kinetic Light Air Curtain*, for instance, features 5280 small propellers fastened into the subway wall, which turn when a train passes, while Michael Singer's popular untitled garden has a built-in irrigation system.

To emphasize the airport's rôle as a transportation hub, committee members gave the theme of "Art Journey" to the artists. Interpretations varied from the literal to the metaphorical. For example, David Griggs's *Dual Meridian*, which includes bright red, undulating tracks, recalls train travel and roller-coasters. Filmmaker Dick Alweis made a short documentary about DIA's art entitled *A Different Sense of Time*, which runs repeatedly in the terminal. Other works focus on Native American, African American, and Hispanic contributions to Denver culture. In all, airport art planners focused on site-specific, culturally relevant art that records the site's history, purpose, and evolution.

Artists Buster Simpson and Sherry Wiggins created *Fenceline Artifact*, a 1000-ft-long fence composed of used and abandoned farm implements, sited between incoming and outgoing airport roads a mile south of the terminal. Wiggins, a Boulder-based artist, often involves ecological themes in her artworks, which include the landscape redesign of a major Denver thoroughfare. Simpson, a nationally known, Seattle-based artist, also focuses on ecological change, often juxtaposing environmental and human timescales. *Host Analog*, a permanent installation at the Oregon State Convention Center, features a decaying Douglas fir log, expected over time to sprout saplings that will develop into fully grown trees. For DIA, Simpson designed both *Fenceline Artifact*, which explores the landscape's recent history, and *Prairie Wedge*, which displays rotating exhibits of native plantings as a "homage to high plains agriculture."[1] *Prairie Wedge* is visible on the ground outside the terminal through a full-height window.

Description For *Fenceline Artifact*, Wiggins and Simpson collected rusting and abandoned farm implements from nearby ranches, many of which had been sold and demolished during construction of the airport. DIA occupies a previously agricultural region beyond Denver's outskirts, and displaced dozens of farmers. Many farming families had occupied the same plots for more than a century. However, as most of them did not hold legal title, having lost ownership during the Depression, they were not compensated when the airport acquired their sites through eminent domain. *Fenceline Artifact* records their history and "attempts to heal the wounds created by the obliteration of a place by a massive public-works project."[2] The artists interviewed eight of the local ranching families and directly compensated them by paying for old farm equipment to use in the work. Wiggins explains:

> In working on [DIA], Buster and I spent a lot of time on the site, looking at what had been taking place there as the land kept changing use. The dislocation of the farmers and the agricultural life of the place seems like such a big issue in our whole culture. We couldn't just let it go without leaving a memory We tried to do the farmers some goodwill by placing their implements in the position of memorializing.[3]

Fenceline Artifact stretches between roads leading toward and away from DIA. Antiquated tractors, plows, rolls of wire, a grain drill, and a

Fossils and historical artifacts create the fencelike boundary that joins the airport's two access roads.

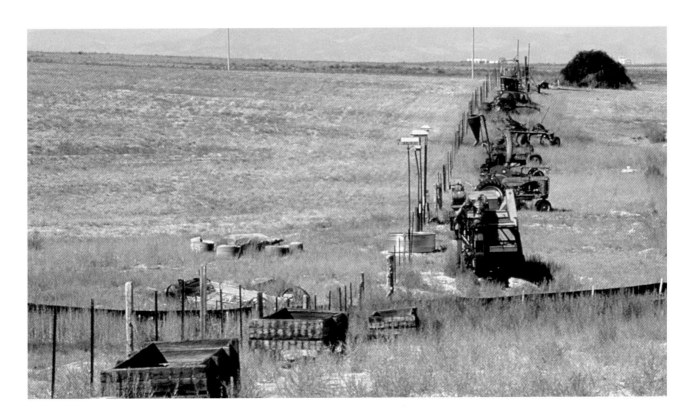

hay conveyor constitute some of the many tools lined up along a 4-ft-high fence of wooden poles and wire. Four evenly spaced birdhouses on 12-ft poles punctuate the row of farm equipment. Architects conducted local cultural surveys as part of their airport background research, making several plans and drawings of characteristic homes. Simpson and Wiggins based the birdhouse replicas on four typical plans. Porcelain enamel signs at eye-level on the poles describe each house, and show a typical plan.

The vintage machinery stands out against the barrenness of the high plains. However, it is interspersed with local rocks and landscaped with native cottonwood and huckleberry trees. As the trees grow, they will dispel some of the site's starkness. Simpson and Wiggins also envisioned a multiuse trail-and-picnic area stretching from terminal parking areas to the fenceline. This area has not been installed yet, and a lack of airport funding makes its fruition unlikely. As the site includes neither parking nor pedestrian access, only motorists see the work, through the windows of moving cars. On the ingoing road, DIA's modern terminal frames the ageing farm implements, providing a commentary on modern life's rapid pace and evolving culture, which often treats its roots as detritus. The road out provides a longer impression. For safety reasons, the airport built a snow fence behind *Fenceline Artifact*; the artists view this as one more layer on the changing landscape.

Old farming machinery and indigenous trees recall the layers of history contained in the airport grounds.

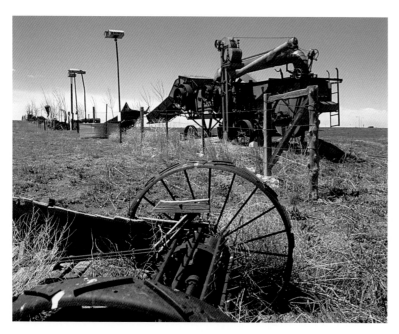

Design impact The artists sought to question the current landscape by putting it in the context of its previous use. The first reaction of many viewers is to wonder at the assortment of farm junk in the middle of a field. On learning more, however, people often realize that the beauty of it lies in its relation to the landscape's history and the new airport. Columnist Baxter Black:

> My reaction, which apparently was a common one, was ... "What!" ... Since then I have driven by the fence countless times. One day I began to sense that the fence was more than just a boondoggle boneyard The creators of *Fenceline Artifact* have turned our boneyard into a monument. It is a tribute to the people and machinery who have made it possible for civilization to cling, albeit tenuously, to the windy, unpredictable, unforgiving plain.[4]

Local farmers, many of whom have memories of the artifacts, have been similarly moved. Sherry Wiggins says:

> When we were building *Fenceline Artifact*, during the construction of the airport, a lot of the people who worked on the airport would stop by and talk to us. A lot of these people had grown up on the plains and farmed and ranched. They appreciated the piece. Other people have commented that at first they thought that somebody just forgot to take this stuff away when they built the airport, but then realized that it was put there on purpose and liked the idea of the reminder of the agricultural life of the area.[5]

While many react favorably to the work, it has also spawned controversy because of its inaccessible location and unfinished appearance. The Mayor's Office of Art, Culture and Film, which backs the airport art program, has received many complaints that the fence's worn appearance detracts from the airport's sleek, modern character. More commonly, people react to the high budget for a work that is hardly visible. Mary Voelz Chandler of the *Denver Rocky Mountain News* criticizes *Fenceline Artifact* as "art that you *could* see but probably don't; it is a fleeting glimpse, at best, and it is neither in nor out of context if you don't know it's there or what it is."[6] Other local newspaper art writers have also criticized *Fenceline Artifact* for its context-poor isolation. The *Denver Post*'s Steve Rosen writes that it "looks like a junkyard

in a desert."[7] He notes, however, that the growth of the trees will make the barren site into a more inviting, attractive location.

Nonetheless, access to the fenceline remains nearly impossible. Traffic-safety concerns prevent the airport from installing parking, or even an informational sign, nearby. Funding scarcities prevent the creation of the hiking trail. Drivers are often too busy following the maze of signs directing them to the terminal to notice the fenceline. Reacting to these concerns in an attempt to improve accessibility to the piece, airport art officials suggested moving *Fenceline Artifact* to a nearby location that houses a historic barn and a buffalo pen. Simpson and Wiggins balked at the idea, not wanting to see their concept, which depends on the juxtaposition of the weathered fenceline and the modern airport, turned into a "cutesy historical vignette" reminiscent of a theme park. Arguing that if it were moved, the fenceline would be nothing more than a museum piece, not a contemporary part of the landscape, the artists successfully convinced the airport to retain it in its present location.

Steve Rosen commented, "The problem with DIA's public art is that much of the collection is hard to notice."[8] Several other airport artworks also lack impact, diminished by being the wrong size, easily overlooked, or in inaccessible locations. Successes stand out by virtue of being accessible and engaging the viewer. Critics and passengers universally delight in Gary Sweeney's *America ... Why I Love Her*. Two wall-size plywood maps of the United States face each other in the baggage-claim area, illustrated with offbeat sites and quirky museums throughout the country, such as The World's Largest Peanut, in Ashburn, Georgia, and the Psychiatric Museum in St. Joseph, Missouri. Sweeney also included giant photos of family road trips and a joke aimed at people waiting in the baggage area. An arrow points to Denver, captioned, "You are here ... but your baggage is in Pittsburgh." One Denver critic wrote: "*America ... Why I Love Her* ... reminds its viewers of the sense of discovery inherent in travel, [and] does so in a place where nervous people are most likely to be feeling negative about traveling, at a baggage-claim area." Another commented: "The unabashedly nostalgic installation has a way of setting childhood memories in motion, taking people back to a time when road trips across America in the family station wagon were a necessary rite of passage."[9] A third said: "*America ... Why I Love Her*, which refers to both Denver and travel, is funny, smart, and appropriate."[10]

America benefits from accessibility and familiar subject matter. The various weird museums are depicted in bright, solid colors, and people have time to scrutinize them at leisure as they await their luggage. By referring to themes that are nostalgic and familiar to many Americans, *America* captivates its viewers. By contrast, *Fenceline Artifact* is a somber and thought-provoking work that can only be appreciated if viewers question modern influences on an older landscape. Also, in stark contrast to the viewing conditions at the baggage-claim area, *Fenceline Artifact* affords only a passing glimpse on a speedy highway. The irony of driving at speed by the past-recalling *Fenceline Artifact* in one's haste to get to the airport was intended by the artists, but the result is rather self-defeating: as one reviewer points out, "What can art say if you can't see it?"[11]

Barring trail access, *Fenceline Artifact* would benefit most from better documentation. Each artwork inside the terminal has a small plaque nearby explaining the piece. At first, plaques contained only the artist's name and the work's title and materials. Because the public was frequently confused, airport art officials realized that the art's often abstract or enigmatic forms necessitated short explanations as well. *Fenceline Artifact*'s plaque abuts a terminal window through which the fence is partly visible. Simpson and Wiggins are also creating explanatory postcards to distribute in the terminals. Wiggins says,

> Respecting the history, geography, cultural experiences, and spirit of a particular place seems the ultimate challenge to me. It makes each art-creating experience different and special. It might be difficult for people to understand as art, because people are so used to art being a commodity with a specific monetary value, but in the end I think people do appreciate placemaking as a relief from the monotony of rampant development.[12]

Fenceline Artifact, which successfully relates to Denver's history and culture, also needs to relate to the viewer.

1 Denver International Airport brochure.

2 Broward Urban Design Context, Broward County, Florida.

3 Sherry Wiggins, artist, Longmont, Colorado, interview, August 18, 1999.

4 Baxter Black, "Farm Art," *Albuquerque Livestock Market Digest*, October 15, 1996.

5 Wiggins interview, August 18, 1999.

6 Mary Voelz Chandler, "Access to the Arts Can be Tough at DIA," *Denver Rocky Mountain News*, May 16, 1999.

7 Steve Rosen, "A Critical Look at DIA Art: Mostly It's Hard to Find and Hard to See," *Denver Post*, March 19, 1995, p. E1.

8 *ibid.*

9 Susan Froyd, "Travels With Sweeney," *Denver Westword*, June 4, 1998.

10 Michael Paglia, "A Site for Sore Eyes," *Denver Westword*, March 8, 1995, p. 57.

11 Chandler 1999.

12 Wiggins correspondence, February 16, 1998.

Buffalo Bayou Sesquicentennial Park

HOUSTON, TEXAS

Project description

Public-arts projects in Buffalo Bayou Sesquicentennial Park, on Houston's historic waterfront, celebrating the city's 150th anniversary

Artists

Team HOU, Mel Chin, and Dean Ruck

Agencies

Buffalo Bayou Partnership, Central Houston Civic Improvement Inc., and the Cultural Arts Council of Houston and Harris County

Date

Phase I completed August 1989; Phase II completed May 1998

Dimensions

10 acres of park

Materials

Seven 70-ft-tall steel towers, 1050 drawings laser-cut from stainless-steel plates, porcelain enamel panels, sound equipment, compressor equipment

Cost

$250,000 for public art along the Promenade; $35,000 for public art on the Common. Includes artists' fees, materials, and other project costs

I N THE 1980s, the 10 acres of lush greenery and manicured parks that stretch along the Buffalo Bayou were nothing but a parking lot and a popular dumping ground alongside a polluted stream. Today, Buffalo Bayou Sesquicentennial Park, in the heart of downtown Houston, Texas, transforms the area. The park is part of a $22.5 million[1] urban waterfront reclamation project that aims to stimulate an overall regeneration of the downtown core, while introducing place-defining public art and involving the community.[2]

Since the turn of the last century, Houston has faced many of the environmental challenges that plague other American cities. By the late 1800s, a growing network of railroads and roadways was degrading the significance of the bayou, once the city's main transportation artery. The opening of the Port of Houston and the Ship Channel in 1914 eroded the bayou's economic value upstream of the Turning Basin, the navigational hub of the Ship Channel.[3] In addition to these setbacks, devastating floods in 1929 and again in 1935 forced the city to channel the river. As a result, it was no longer seen as an asset to the local economy or even, for that matter, as a place of natural beauty. Until the creation of Sesquicentennial Park, Houstonians considered the Buffalo Bayou to be nothing more than a mosquito-ridden nuisance.[4]

Despite conservation efforts resulting from the Clean Water Act of 1972, lack of funding diminished the hope of restoring the area. The turning point in the bayou's troubled history came in 1985, when then mayor, Kathy Whitmore, appointed a task force to devise redevelopment plans for the bayou area. From this initiative, plans developed for a park to reclaim the historic waterfront, and to celebrate the 150th anniversary of Texas's independence, as well as Houston's history.[5] While the task force came up with the initial idea, Team HOU (an architecture team consisting of Guy Hagstette, Robert Liner, and John Lemr) won the 1986 national competition to design the specific park plans.[6] Hagstette, an architect, headed the design team that was created solely for the purpose of completing this project.

The park's construction was divided into two phases. Phase I, completed in August 1989,

covers 2¼ acres of waterfront, and consists of a central fountain, boat launch, gatehouse, pavilion, and a grand staircase that leads to the park's Promenade. This phase alone cost over $6 million. Phase II, the more expensive and complicated part, was completed in 1998. It covers 8¼ acres and cost over $13.4 million. The rest of the $22.5 million budget was used for other park and plaza improvements to connect the Sesquicentennial Park to other outdoor recreation areas via bicycle and hiking trails.[7] The second phase brought such additions to the park as the Promenade (a walkway along the waterfront), the Common (a sloping circular lawn for outdoor theater events), the upper and lower gardens, and the Preston Avenue Pedestrian Bridge.[8] In addition, it called for the inclusion of two permanent public-arts projects that became *Seven Wonders* (also referred to as the *Seven*

Community Pillars) by Mel Chin and *Big Bubble*, *Sounds from the Past*, and *Site Seeing*, all by Dean Ruck.

When Phase I failed to bring substantial numbers of Houstonians to the park, the planners recognized the necessity of Phase II for community interaction. Design and bureaucratic delays slowed the inception of the second phase.[9] In 1994, five years after the completion of Phase I, the Harris County Commissioner's Court authorized the Harris County Flood Control District to give $5.6 million to fund the preparatory construction necessary for Phase II to begin.[10] Once flood-control mechanisms were in place, other funding possibilities began to surface. While the original program for the park, as developed by Team HOU, called for public art to be incorporated in the design, it also added $285,000 to the park's total cost.

The Grand Opening of Phase II, Buffalo Bayou Sesquicentennial Park. Photo: George Hixson.

To make financial matters even more challenging, at the time of the park's construction, Texas ranked next to last among the states in per-capita support for the arts. Houston did not have an ordinance dictating how much of the public construction budget should be used for public works of art. Using public dollars to pay for the public art in Phase II was optional. This support had to come either from funds allocated out of the general pool of public money to support public art, or from additional grants, corporate sponsorship or fund-raising.[11] In December 1999, a law was passed that required 1.75 percent of eligible capital project funds to be allocated to public art. However, the law only applies to design plans put in place after the 1999 fiscal year.[12]

In May 1997, a groundbreaking ceremony was held to honor major donors as well as to announce details of the public-arts projects for the park. A panel, including a curator, an artist, and the chief park architect, selected Mel Chin and Dean Ruck through a national invitational competition. The panel made its decision, based on the quality and strength of the two artists' proposals, to work with Team HOU to integrate their concepts into the park. By 1998, Phase II of the Buffalo Bayou Sesquicentennial Park, including the works by Chin and Ruck, was complete.

Description Team HOU envisioned Chin and Ruck's public-arts projects as key points of interest for Houston's Sesquicentennial Park. Each artist was given a site, as well as the context in which to design. Mel Chin was asked to commemorate the themes of Houston's founding, working with the design for the park, which included seven 70-ft-tall columns representing the foundations of Houston's development: energy, agriculture, transportation, exploration, building, enterprise, and knowledge. Dean Ruck was asked to pay tribute to "the common man."[13] With two different areas to house their creations and two very different objectives, Chin and Ruck set to work. *Seven Wonders*, *Big Bubble*, *Sounds from the Past*, and *Site Seeing* came to life, each adding something distinctly its own to the park.

Seven Wonders is located on the Promenade, a 250-ft walkway along the west façade of the Wortham Theater Center. Mel Chin, a Houston native, worked with the architectural team to develop a design for the pillars that would incorporate art from the community.

Chin felt that the park should focus on the youth of the community. He enlisted the help of children from forty-two of the area's elementary schools (all of whom were born in the sesquicentennial year of 1986) to contribute to the design. With the support of two additional artists, the children's drawings were transferred on to a computer and the patterns then laser-cut into stainless-steel

BELOW *Seven Wonders* at night. Photo: George Hixson.

BELOW, RIGHT Detail of *Seven Wonders*. Photo: courtesy of the Cultural Arts Council of Houston and Harris County.

plates. These stencil forms were bolted to the steel frame of the columns, which rest upon 35-ft masonry bases. Altogether, 1050 plates, each $3^1/_2 \times 2^1/_2$ ft, adorn the seven massive pylons—150 on each.

The design commission for the Promenade, the space where Chin's pillars are located, was $250,000. Out of this budget came Chin's remuneration, the cost of the materials, construction costs, and fees for assistants and others. The general park budget allocated some funds to supplement construction costs, but the bulk of the financial burden remained. It was then decided to ask local businesses associated with the themes of the seven pillars to help fund them: each column now has a related sponsor.

The pillars not only dominate the space taken up by the Promenade, attracting the attention of park-goers, but they also enhance the downtown skyline. This effect is most visible at dusk, when the *Seven Wonders*, illuminated by the setting sun, transform into giant lanterns. Reflected in the water of the bayou, the children's steel designs are described as looking "almost like gigantic hieroglyphics."[14]

The Buffalo Bayou and its place in Houston's history have always been an inspiration for artist Dean Ruck:

I was a child of nature. Streams, fields, woods and hills were my domain and playground. That influence remains in my work. My primary refuge in Houston has been the Buffalo Bayou. I am drawn to its force during flood season and often perplexed by its paradoxical attributes: we must acknowledge its polluted past, as well as its natural beauty and historical significance.[15]

Ruck's connection to the bayou is evident in his three interactive works, *Big Bubble*, *Sounds from the Past*, and *Site Seeing*. Together these pieces tell park visitors some of the history of the Buffalo Bayou.

Ruck's work is located along the Common, a circular tree-lined space of about 1 acre. The project's budget was $35,000, including the artist's fee, materials, design, installation, and additional labor costs. *Site Seeing* allows

RIGHT Dean Ruck's *Big Bubble*. Photo: George Hixson.

BELOW Detail of *Site Seeing*. Photo: Andrew Nelson.

BELOW, RIGHT Dean Ruck's *Site Seeing*. Photo: Andrew Nelson.

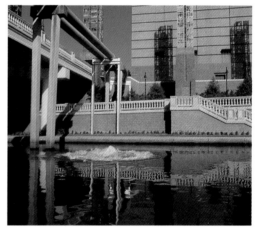

visitors to trace Houston's past through historic photographs mounted along the north edge of the Common. These fifteen porcelain enamel photographs help to tell Houston's history and celebrate the city's fifteen decades. The audio element of Ruck's *Sounds from the Past* accompanies that of *Site Seeing*, which re-creates the shriek of a steamship on the Buffalo Bayou.[16] Ruck explained the use of sound in his project, stating, "While sound may be a secondary sensation, it can also sit deeper in our memory."[17] His design concept is experiential rather than simply visual: "My approach is not in creating objects, but rather situations that get a response from viewers. I want them to have a full sensory experience in this park."[18]

Ruck's third and final element is *Big Bubble*, a large air bubble that appears in the water of the bayou and then slowly rises to the surface. The project is specially engineered through an intricate aeration system installed in the floor of the bayou. As a result, the bubble may be controlled, activated periodically throughout the day, and triggered manually by pushing a button on shore. The playful, interactive nature of the work underscores Ruck's vision as well as the continuing history that informs the present experience of Houstonians.

Design impact *Seven Wonders*, *Big Bubble*, *Sounds from the Past*, and *Site Seeing* all manage to turn the task of creating a milestone for the City of Houston into an interactive event for the whole community. By involving children in the design of the pillars, Chin sees his project solely as their work of art. Youthful imagination celebrates the importance of Houston's history, strength, and diversity by creating a stronger connection between the city's past and its future. The art component of the seven pillars adds a spectacular sophistication to the blank west façade of the Wortham Theater Center. The pillars attract attention to the Promenade, inviting people to experience, rather than just visit, the park.

The Buffalo Bayou Sesquicentennial Park opened its grounds on May 9, 1998, to eager

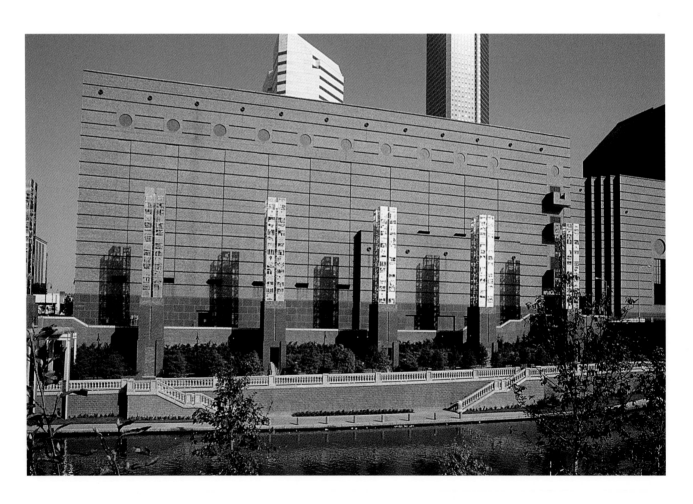

1 Anne Olson, executive director, Sesquicentennial Park, Houston, Texas, correspondence, October 16, 1998.

2 Olson correspondence, August 18, 1998.

3 See Port of Houston website, portofhouston.com/overview/tb.htm, accessed July 23, 2001.

4 See C. Pugh and P. Johnson, "Bayou Park Supporters Celebrate Downtown Destination," *Houston Chronicle*, May 3, 1998, p. 8.

5 See Jim Zook, "Public Art Is Structuring the City's Landscape," *Metropolis*, October 1998, metropolismag.com/html/content_1098/oc98hous.htm.

6 See Pugh and Johnson 1998.

7 Olson correspondence, October 16, 2000.

8 See A. Adams, "Whatever Floats is Welcome at Bayou Parade," *Houston Chronicle*, April 29, 1998.

9 Olson correspondence, October 16, 2000.

10 See Pugh and Johnson 1998.

11 See Zook 1998.

12 Debbie McNulty, Cultural Arts Council of Houston, correspondence, August 29, 2000.

13 "Sesquicentennial Park Opens!," *Civic Art and Design Newsletter*, Summer 1998, p. 5.

14 Nancy Dean, "*Putt* Artist no Stranger to Houston," *Houston Chronicle*, May 27, 1998.

15 "Sesquicentennial Park Opens!," *Civic Art and Design Newsletter*, Summer 1998, p. 5.

16 Dean Ruck, artist, Houston, Texas, correspondence, September 14, 2001.

17 "Sesquicentennial Park," *Civic Art and Design Newsletter*, Fall 1997, p. 5.

18 Quoted in Bob Tutt, "Bayou Park to Offer a Feast for the Senses," *Houston Chronicle*, May 31, 1997, p. 33A.

19 Thehobbycenter.org/news/art_fence.html, accessed July 20, 2001.

20 See Pugh and Johnson 1998.

21 "Overlooked: Make Buffalo Bayou Access, Beautification a Top Priority," *Houston Chronicle*, January 18, 2000, p. 16A.

crowds ready to celebrate the revival of the Buffalo Bayou. After extensive revitalization of a district that had contributed to the decline of the downtown area, local investors hope that the newly renovated waterfront will help to stimulate further regeneration efforts within the city. This important step in Houston's renaissance has already made an impact on future development. The Hobby Center for the Performing Arts, also located along the bayou, opened in May 2002. The "Art Fence" program, a public-art initiative started in 1999, allowed Houston school students to work with artists, creating panels for the Hobby Center that were on display for the period of construction along the fence surrounding the site.[19] As a direct result of the park, there are also proposals for restaurants and entertainment facilities that will compete for prime park-side real estate. Once complete, the Buffalo Bayou Greenbelt will link Sesquicentennial Park to Allen's Landing, a park of similar size that is soon to be constructed just east of Phase II.

Allen's Landing will provide another much-needed link between the park and the city's downtown. It will also include public art that helps to tell Houston's history. The entire greenbelt will act as a flood plain for the area. There are predictions that the city could again face floods, so the plans for the Buffalo Bayou waterfront limit the amount of development by the water's edge, to allow for flood absorption.

Like many American cities, Houston faces the challenge of attracting local investment back into run-down sections of its downtown.[20] With the help of hiking and biking trails,

good restaurants, shopping opportunities, entertainment venues, and parks, the City of Houston can once again provide reasons for people to remain downtown. The *Houston Chronicle* highlighted Sesquicentennial Park's potential to contribute to the city's revitalization by redefining how people remember the Buffalo Bayou:

> In order for the bayou to reach its full potential as a scenic focal point for Houston, the city, county, Port of Houston and business establishments must commit themselves decisively to that goal. Buffalo Bayou is a natural stream that is at least as majestic as the Seine as it flows through Paris. Given the necessary public and private investment (about $200 million, modest for large public-works projects), Houston can regain an invaluable waterfront, burnish the city's image, and significantly expand the city's short supply of usable green space.[21]

Houston has made a commendable effort to provide an oasis for its tourists, commuters, and downtown residents. While the park as a whole continues to be underused, park planners have taken steps, including the completion of Allen's Landing, to address this problem. In addition, there are plans to increase the number of programmed events in the park to give Houstonians more reasons to visit it. While there are still improvements to be made, Sesquicentennial Park's public art, with its participatory strategy of community involvement and sensory effects, demonstrates the potential for placemaking.

Transit facilities: Providing orientation for travelers

74 *Ghost Series*
 Long Island Railroad Terminal Concourse, Penn Station, New York

80 New York MTA Stations
 Greenwich Village Murals
 Bay Shore Icons
 Wings for the IRT: The Irresistible Romance of Travel
 Woodside Continuum

90 *Memory: Arizona*
 Sky Harbor Airport Mosaic, Phoenix, Arizona

Ghost Series

Project description

Five ceramic murals
based on elements from
drawings of the original
Penn Station

Artist

Andrew Leicester

Agency

New York Metropolitan
Transportation
Authority, Arts for
Transit

Date

1994

Dimensions

Murals range from
6 × 9 ft to 8 × 50 ft

Materials

Handmade glazed
ceramic tiles

Cost

Artist's fee $40,000
Fabrication $160,000
Installation unknown
(budget tied in with
station construction
costs and masonry)

Photography

Courtesy of the artist

ANY TRAVELER passing through the modern tunnels of Penn Station would have a difficult time imagining the Neo-classical "temple to transportation"[1] that once graced these same city blocks. The present underground corridors and low-ceilinged lobbies hardly resemble the original 9-acre monument to "the great age of steam locomotion, coinciding with the golden age of industrial prosperity and optimism for the future of America."[2] Designed by McKim, Mead & White between 1906 and 1910, the original ground-level Penn Station imitated the Baths of Caracalla and the Basilica of Constantine with a Classical palette of Roman travertine and New England rose granite. Penn Station welcomed visitors with a grandeur befitting the great city of New York: "When you got off the train after traveling all the way across the continent, and you entered that huge hall, the main waiting room with its gigantic Corinthian columns, you knew you had arrived in a real metropolis."[3]

Unfortunately, public opinion of Penn Station followed the pattern familiar to historic landmarks:

It is very much appreciated when it is put up, then it sort of disappears into the city when other buildings become more noticeable or celebrated. And just a little while before it is rediscovered, it is thought to be absolutely worthless. That's the dangerous moment for a building.[4]

The soaring walls of light marble were expensive to keep clean, the grand lobbies had been filled with the homeless during the Depression, and the structure did not gracefully adapt to the requirements of modern transportation. It was at a vulnerable moment in 1963 that the president of the Pennsylvania Railroad asked, "Does it make any sense to preserve a building merely as a monument?"[5] While it was a building that embodied the grandeur of a lost time, McKim, Mead & White's Penn Station was no longer efficient as an up-to-date transportation hub or as a profitable establishment. Plans for the renovation of the site called for a modern underground station, while a corporate high-rise and Madison Square Garden rented the ground-level lot. So the original Penn Station

was demolished to make way for modernity, efficiency, and profitability on October 28, 1963, an event that provoked dramatically different reactions, including disbelief, acceptance, and protest. According to an editorial:

> Until the first blows fell, no one was convinced that Penn Station really would be demolished or that New York would permit this monumental act of vandalism We will probably be judged not by the monuments we build but by those we have destroyed.[6]

The Lipsett Wrecking Company dumped the remains of McKim, Mead & White's temple—now just tons of broken glass and iron, and fragments of marble and granite— into a landfill site in the New Jersey Meadowlands. When, in 1999, a *New York Times* photographer documented Penn Station's resting place, New York senator Daniel Patrick Moynihan recalled his dismay at the careless destruction of these Neo-classical monuments: "You thought: What have we done? Has the city been sacked?"[7]

The outrage came too late to save the original Penn Station. However, the strong emotions excited by the demolition of such a landmark will guarantee that its memory outlasts the building itself. On a personal level, lovers of the original building ventured deep into the Meadowlands, searching for architectural fragments that could be loaded into their cars and scattered across the nation. One of the four *Day and Night* sculptural pairs is now part of the Eagle Scout Tribute Fountain in Kansas City, while four decorative eagles guard the Market Street Bridge in Philadelphia. It seems that everyone took a piece of history through which to remember the wronged building. More publicly, the plight of the original Penn Station exposed a wider audience to the mounting threats against endangered landmarks across America. According to the artist Andrew Leicester, McKim, Mead & White's Penn Station is "the sacrificial lamb that finally initiated the historic preservation movement in the United States."[8] The demolition gave a

PAGE 72 Detail of *Day and Night.*

BELOW Andrew Leicester's *Corinthian Column* is installed on the Long Island Railroad terminal concourse.

jolt to the tradition of public apathy: the New York City Landmarks Preservation Commission was founded in 1965 and the National Register of Historic Places established in 1966. Although the mistakes of the past could not be undone, their repetition could be avoided in the future.

Public dismay at the demolition of the original building was only exacerbated by disappointment at the Penn Station that replaced it. According to the art historian Vincent Scully, "once one entered the city like a god, now one scuttles in like a rat."[9] The underground corridors and low ceilings of the lobbies were anticlimactic compared to the soaring space of McKim, Mead & White's design, travelers were often annoyed by delays, and the modern station did not age well. By the autumn of 1991, commuters rated the station's physical condition at 3.8 out of 10.[10]

Renovations, costing $190 million and lasting through 1994, included the construction of a 90-ft glass-and-brick tower over the south entrance; air-conditioning; new walls of marble and granite; raising the ceilings over the concourse; new restrooms and waiting room; an expanded police station; and a schedule board. The MTA's Arts for Transit program included a Percent for Art ordinance for the new station. From a pool of artist proposals, Arts for Transit

commissioned Maya Lin's *Eclipsed Time*— an overhead sculpture that projects a clock of sorts on to the floor of the corridor—and Andrew Leicester's *Ghost Series*.

Description Leicester's inspiration for *Ghost Series* came from Penn Station itself:

> I think one of the things ... was the fact that Penn Station, just like Grand Central Station, just like most railway stations at the turn of the century, celebrated this wonderful mode of transportation. When you walked into the entrance to Penn Station there was this huge 65-ft cavernous vaulted space, larger than Grand Central. Now contrast this with the grand entrance to the modern Penn Station, with its dropped ceilings and generic spaces.[11]

Leicester wanted his installation to comment on the sacrifice behind the new Penn Station, while exposing the lost architecture to a new audience of commuters by continuing the trend of appropriating elements from the original building. This fascination with the juxtaposition of old and new continued to motivate the artist, even as his design evolved from a series of floor etchings to wall murals in order to achieve the durability necessary in a major transportation hub. Leicester's five mural reliefs are

The capital of *Corinthian Column* lies on its side in the corridor.

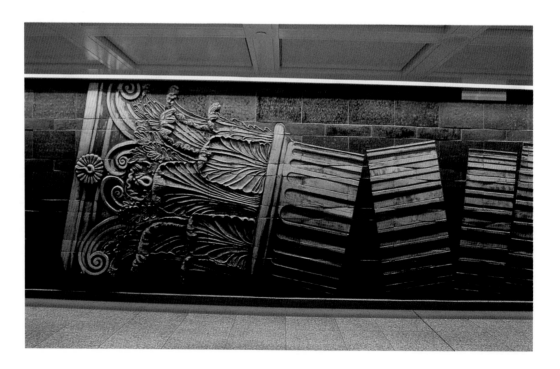

scattered throughout the renovated station, "to reveal the old station behind these walls."[12] Handcrafted and carefully installed to follow the irregular course lines of the marble wall, the elements of *Ghost Series* seem original to the building, but are marked by an underlying irony.

Corinthian Column is actually created by the interplay between two 65-ft-long murals that face each other along the walls of the corridor to the 34th Street entrance. Broken into a series of fragments, like those dotting the Meadowlands, Leicester's columns are an obvious allusion to the destruction of the original station. But *Corinthian Column* is part of a deeper commentary. Leicester says: "In order for me to put this full-scale replica of this column in the entrance to the new station, I had literally to lay it on its side, and even there it would hardly fit. So it's a kind of ironic statement, that we squeeze one of the celebratory elements in the new entrance."[13] What was once part of the celebrated façade

does not even fit under the low ceilings of the new station.

Day and Night, a 500-sq.-ft mural at the 7th Avenue end of the east concourse, is an even more pointed reference to the controversial events of 1963. Adolph Wineman had created four sculptural pairs for the main entrances of the original McKim, Mead & White building. The woman to the right of the clock was "Day," with open eyes and a garland of flowers. To the left of the clock was "Night," with closed eyes and a lunar halo. Leicester adopted these figures, but omitted the numbers and hands of the clock face. Instead, he embossed it with "10/28/63." Much like the melted watches of Hiroshima, Leicester's *Day and Night* is a memorial to a frozen point in time, for conservationists and architecture-lovers alike.

The final two murals complete Leicester's examination of the past and present. One, installed above a staircase leading to the Long Island Railroad Concourse, is a cross section blueprint of McKim, Mead & White's design.

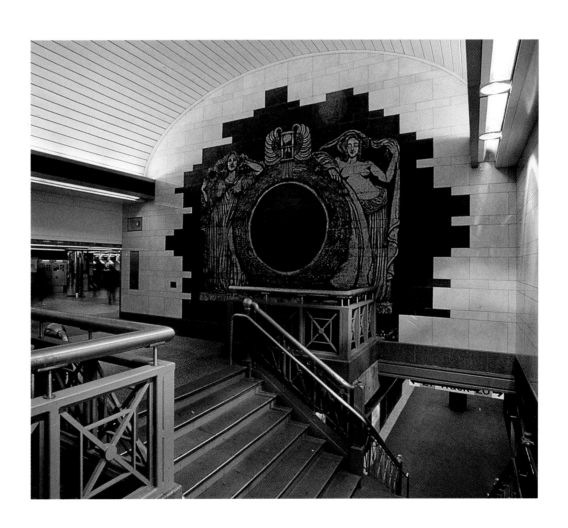

The other is a reproduction of a sculpture of Mercury, the Roman god of trade and travel. Holding a purse and a staff of two intertwining snakes, *Mercury Man* glorifies commerce and watches over the travelers who pass him on their way from the Long Island Railroad Concourse to the lower platform level. But these images are dangerously tilted, and set amid broken stones and other evidence of the fate of the original station. By grounding his murals in this destruction, Leicester underscores the history that was sacrificed for modernity. He has resurrected Neo-classical beauty, but only precariously, in the new station.

The 1994 renovations finally brought to an end the station's decreasing efficiency and the public's growing dissatisfaction. According to Mary Green, a resident of Queens, "It's wonderful, it's going to be gorgeous. We have a lot of out-of-town visitors, and we used to be ashamed to bring them here."[14] A major element of the project that really connected with the commuters and tourists who use the station was the public art. Purposely interactive, both commissions demand that

people pause to notice the work and consider their relationship to it. For Lin's *Eclipsed Time*, this is a physical interaction as the viewer's body passing through the corridor interrupts the projection from the ceiling to the floor below. For Leicester's *Ghost Series*, this interplay is more contemplative. According to Linda Dixon, a partner at LDDK Studios, the manufacturer and installer of the tiles:

> Coming up from North Carolina for a week, to touch up the murals, we got to listen to pedestrians going through and talking about them. They immediately assumed the murals were old material found in the walls. We had to tell them it was brand new, rather than an artifact that had been dug up.[15]

Ghost Series is powerful since it engenders this incredulity with its ability to "create the feeling that work crews 'uncovered these ghosts of the past' while knocking down other walls or during the renovation."[16] Each viewer who encounters one of the elements in the halls of such a modern station must ultimately consider the past and its relationship to the

Detail of *Mercury Man*.

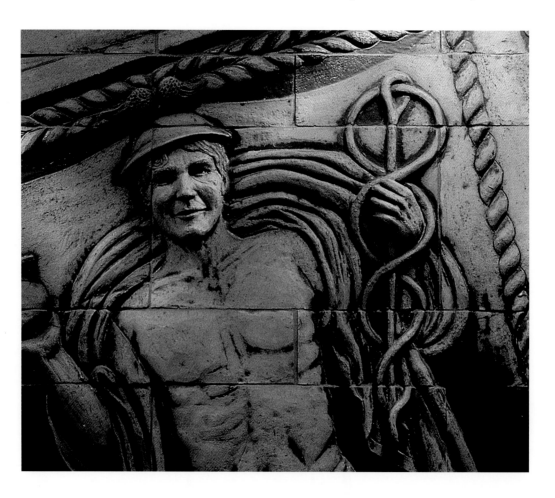

1 Andrew Leicester, artist, Minneapolis, interview, January 8, 2000.

2 MTA pamphlet, courtesy of Andrew Leicester.

3 *ibid.*

4 Anne Matthews, "End of an Error," *Preservation*, March/April 1999, p. 46.

5 *ibid.*

6 *ibid.*

7 *ibid.*

8 MTA pamphlet.

9 Quoted in Matthews 1999.

10 See Stewart Ain, "High Marks for New Penn Station," *New York Times*, October 9, 1994, p. 13LI-1.

11 Leicester interview, February 4, 1998.

12 MTA pamphlet.

13 Leicester interview, February 4, 1998.

14 Bruce Lambert, "At Penn Station, the Future Pulls in, Recalling the Past," *New York Times*, May 1, 1994, pp. 13–16.

15 MTA pamphlet.

16 Ain 1994.

17 Liz Leyden and Michael Grunwald, "New Penn Station has $484 Million Ticket," *Washington Post*, May 20, 1999, p. A16.

surrounding present. The Neo-classical style, a celebration of the glory of past civilization and the unique splendor of ruins, seeps into the planar station, undermining its visual denial of a relationship to the past. The sacrifice behind the modern corridors, so rarely considered during the rush of commuting, is revealed through a deliberate contrast between Neo-classical beauty and the remnants of destruction.

Leicester readily admits, in reference to *Corinthian Column*, that the power of his work lies in exposing the irony in the fact that what was celebrated in the original Penn Station is omitted in later incarnations of the building.

With this journey to rediscover the original Penn Station for a mass audience, Leicester continues a national fascination that began with nostalgic protesters searching the Meadowlands for mementos, and that is still alive today. In 1999, President Clinton signed a $484 million financing plan to convert the Farley Post Office Building into a new Penn Station, with implications for preservationists and lovers of architecture alike: "We can honor one of the first great public buildings of the twentieth century and create the first great public building of the twenty-first century."[17]

A companion to the original station, the Farley Post Office Building on 8th Avenue is a working post office, also designed by McKim, Mead & White. But it will soon have a new life, thanks to the success of Senator Moynihan's efforts since 1993 to recapture the grandeur of the original Penn Station. Since the underground tracks from the existing station continue under the Farley building, the post office will make a contemporary train station reminiscent of the original Penn Station with relatively straightforward renovations, including a glass semi-dome bisecting the building over the ticketing hall, designed by Skidmore, Owings & Merrill.

Although the building already has McKim, Mead & White's characteristic treatment of space, which will be emphasized by the planned design, the redevelopment project includes a search for the discarded remains of the original Penn Station. Members of the Penn Station Redevelopment Corporation, with the help of countless volunteers and the support of crusading Senator Moynihan, have combed the New Jersey Meadowlands for fragments of the station: brass and leather stools, lampposts, balusters, and clocks. Dozens of these surviving architectural fragments—either discovered in the Meadowlands or returned from temporary homes across the nation—will be incorporated as decorative elements and exhibits in the newest version of Penn Station. This literalization of the fragmental appropriation in Andrew Leicester's *Ghost Series* shows its importance as the midpoint of the grassroots preservation movement: Leicester's mural series is the pinnacle of the widespread practice of collecting fragments from an original building, and it is the beginning of the integration of these elements into construction that culminates in the ambitious planned renovations of the Farley Post Office Building.

New York MTA Stations

NEW YORK

R OMARE BEARDEN'S STAINED-GLASS WINDOW illuminates the Westchester Square station with a full moon revealing shadowy trains creeping between the vividly colored skyscrapers of New York's disjointed skyline. At the 50th Street station along the A line, Matt Mullican's black-and-white granite etchings illustrate the local architectural history through site plans, varied perspectives, and aerial views. José Ortega's festive *Una Raza, Un Mundo, Universo* recalls the Caribbean-tinged street-scene directly above the 149th Street station. And in the Metro-North Cortlandt station, Robert Taplin's three bronze statues—an Iroquois man, an industrial worker, and a land surveyor—depict the main eras of the history of the Lower Hudson Valley.

The artworks break the monotony of commuting, just as they attract tourists' cameras to the work of the Arts for Transit program. Established by the New York Metropolitan Transportation Authority (MTA) in 1985, Arts for Transit "encourages the use of public transport by presenting visual and performing arts in subway and commuter rail stations."[1] This integration of art and travel can take several forms through Arts for Transit. Under the Percent for Art scheme, 1 percent of the construction budget for all new or renovated stations throughout the entire MTA system funds the installation of permanent art for specific stations. By sponsoring museum and gallery exhibits based on this art, and by distributing an informational pamphlet on each work as well as a more comprehensive catalogue of the entire permanent collection, Arts for Transit brings artworks out of the tunnels. The program also sponsors live music in the subway stations through its Music Under New York program.

Some artists are commissioned early in the design process for a station, while others are not chosen until the construction is nearing completion, but the selection process is the same. Arts for Transit reviews New York's Department of Cultural Affairs slide library and other slide banks to generate a preliminary list of artists appropriate for the planned project. Often working with community members and local professionals, these artists are asked to submit proposals for the installation. The main restrictions placed on the artists include insuring a level of durability that can be easily maintained in a subway environment and, when applicable, harmonization with

Project description

New York's Metropolitan Transportation Authority has a Percent for Art ordinance. The resulting artworks are often reminiscent of the subway system's historic artworks

Agency

New York Metropolitan Transportation Authority, Arts for Transit

Date

1985–present

existing historic ornamentation (since Arts for Transit is concerned with preserving and enhancing the elements of original art that remain, as well as continuing to create new artworks for New York's growing transit system). The rest is left to the artist. A panel of arts professionals, with input from community members, then selects an artist from these finalists for each commission.

All the permanent installations in New York's MTA system are the products of two intertwined histories—that of the immediate locale and the subway system's artistic past. Art has been included in the design of New York subway stations since the earliest Interborough Rapid Transit stations were built, between 1904 and 1920. Founding subway designers George Heins and Christopher LaFarge followed the ideals of the "City Beautiful" movement by extensively ornamenting stations with ceramic panels, mosaic station signs, and bronze medallions. Grand Central Terminal's constellation-filled ceiling, recently restored by the MTA, also dates from this early period. However, by the 1970s, "subway art" had come to refer to the monumental graffiti that covered the sides of subway cars. As public transit's share of available transportation investment decreased through the 1950s, 1960s, and 1970s, ridership declined and original art decayed in the poorly maintained stations.

Beginning in 1982, the MTA poured billions of dollars into capital improvements in an effort to rehabilitate the ageing transit system and address facilities that had fallen into disrepair, including the creation of Arts for Transit in 1985, and an anti-graffiti program. With the successful installation of over 150 commissions, the Arts for Transit program has transformed the stations along New York's tracks into individual tributes to local conditions and community character that are well-kept and animated. Combined with the MTA's more specific measures directed at the once-ubiquitous graffiti, these revitalized stations are, in themselves, a deterrent to vandalism. Vigilante artists usually no longer feel the need to personalize a desolate station or, more importantly, think that they could get away with it unnoticed. Through the successful efforts of the Arts for Transit program, the MTA has repossessed the term "subway art" and returned it to the original intentions of Heins and LaFarge almost a century ago.

Design impact Since its formation, Arts for Transit has commissioned over 150 site-specific permanent installations, and 40 more are in progress. While the efforts of Arts for Transit have certainly caught the attention of weary commuters and overwhelmed tourists alike, the impact of the program has extended beyond the subway tunnels to the established art world of New York. As David Dunlap of the *New York Times* writes, "The New York subway system has quietly become a significant storehouse of contemporary art."[2] Successful gallery exhibits of Arts for Transit works and commissions by well-known artists have only strengthened the influence of this public-art program in New York's cultural world.

With the threads of site-specificity and historical continuity that run through the varied designs, the permanent installations infuse routine morning commutes with meaning and interest by respecting local conditions. The works seek to embody the local character that distinguishes one neighborhood from the next, and to continue a long history of ornamentation that sets the historic New York transit system apart from other pioneering systems. In this way, the success of the artworks cannot only be credited to individuals. Certain stations are more recognizable than others. Some receive greater press, while others encounter difficulties in installation or maintenance, but the final influence of Arts for Transit is primarily felt in the aggregation of the scores of new projects that mark the wide scope of this ambitious program. The following examples are but a glimpse into Arts for Transit's wide support of new place-specific art and design.

Greenwich Village Murals

CHRISTOPHER STREET STATION, GREENWICH VILLAGE, NEW YORK

Project description

Four mosaic triptychs of figures from Greenwich Village history

Artists

Lee Brozgold and students from P.S. 41

Agency

New York Metropolitan Transportation Authority, Arts for Transit

Date

1994

Dimensions

Twelve panels, each roughly 3 × 3 ft

Materials

Glazed ceramic panels with inlaid glass and ceramic mosaic tiles

Cost

Fabrication $24,100
Installation $9,400
Artist's fee $11,500
TOTAL $45,000

Photography

Lisa Kahane, courtesy of the artist

IN 1992, as the renovation of the Christopher Street station in Greenwich Village neared completion, the president of the Christopher Street Neighborhood Association realized that there were no plans to include public art in the remodeled station. Concerned that an area with such a rich artistic past was ignoring art in its present, he contacted Arts for Transit with ideas for an installation suitable for the unique identity of the village. Focusing on his suggestion that local schoolchildren could help tell the history of Greenwich Village, Arts for Transit selected Lee Brozgold—a New York artist whose work includes a student-assisted ceramic mural of the immigrant experience at Manhattan's Liberty High School—for the commission.

Working with local teachers, Brozgold identified nine dedicated and artistic students to participate in the design process from research to installation. Under Brozgold's tutelage, they began by re-examining their own environment, studying the history of Greenwich Village with a "neighborhood study guide," modeled by Brozgold on one issued by the Museum of the City of New York, and sketching and photographing the details of their countless walks through the village. The goal of these numerous sessions was to determine what was worthy of representation and to allow each student to discover his or her own style for capturing the character of home. From here, Brozgold acted as artist, historian, and teacher, integrating the students' wide range of drawings and concepts into a stylistically coherent finished product:

> Throughout our work together I gave the students as much ownership of this project as I could, but I never sacrificed my own aesthetic standards. I listened to the students' ideas, learned to accept their points of view, and used my own skills as a draughtsman to help them refine their drawings.[3]

The MTA specified four sites, each divided into three panels, for the installation of the mural along the remodeled platform. While Brozgold first considered painting only one figure per panel, his research, and the students' boundless creativity, convinced him that Greenwich Village's provocative history warranted more than a mere twelve representations. Attempting to capture the extent of local character more effectively, Brozgold decided on four triptychs that would include more than forty historic characters organized by their rôle in village history. Within each panel, characters move across an invented landscape that loosely portrays the range of Greenwich Village's architecture, street life, and natural geography. With such a fluid organization, Brozgold could work within the physical limitations of the installation without compromising the history of Greenwich Village:

> It seemed to me that the choices were dictated by the limitations. There were four areas, each with three sections. The first question I asked myself was whether I wanted to do a comic-book-style linear narrative. I decided against this because the areas are on opposite sides of the tracks, and commuters might see only one side. The next choice was whether to treat each panel separately or to group them. I decided to use one continuous image for each grouping. At this point, I knew I had four triptychs to work with, and started looking for themes in the history of the village.[4]

Since the modest budget ($45,000) limited the range of colors and materials, each triptych is a monochromatic painted mural framed by a multicolor border. The scenic background and minor characters are executed in a color significant to the connecting theme of the panel, and the ceramic mosaic tiles of the central figure create a colorful, contrasting focal point. While all the individuals memorialized in the mural

are significant in village history, some are not familiar either to tourists or to locals. Strengthening the educational value of this entire process, the MTA installed explanatory guides, briefly identifying the figures and their significance, to make the historical content more easily accessible to those who pass through the Christopher Street station.

Founders depicts individuals from Greenwich Village's early days—representatives from the indigenous Canarsee through early colonial settlements, as well as individuals who contributed to the formation of the village's cultural aura. A swampy natural landscape forms a backdrop for a Canarsee Indian and a Dutch land developer, while the Washington Square Arch frames Ira Aldridge, a prominent black actor at the end of the nineteenth century. *Providers* emerged from Brozgold's recognition of the village's extraordinary number of social catalysts, including Charles Loring Brace, founder of the Children's Aid Society; educational reformer Lucy Sprague Mitchell; and reform-minded mayor Fiorello La Guardia. Behind them, a dense cityscape evokes the prevailing social conditions they fought to change.

Bohemians commemorates a variety of artists, writers, and patrons of the arts who represent the socially and artistically avant-garde atmosphere of the village in the early part of the twentieth century. In the interior of Mabel Dodge Luhan's salon, a Cubist figure

of Luhan is surrounded by the writers Edna St. Vincent Millay and Eugene O'Neill, and the actress Ada Clare. Colonial pamphleteer Thomas Paine punctuates the center of *Rebels* with a burning torch held high. Splashes of bright red and yellow continue through this chaotic scene, which includes suffragist Henrietta Rodman, journalist John Reed, and participants in the village's annual Gay Pride parade.

At the MTA's suggestion, the design integrates elements of mosaic to accentuate the historic mosaic band running through the station. Brozgold included numerous details highlighting the close connections between Greenwich Village and subway history. For example, the muralist John LaFarge, who created notable stained-glass windows across the village, is one of the figures in the *Founders* panel. He was also the father of Christopher LaFarge, one of the designers of the original New York subway system. Although not as obvious an allusion as the repetition of mosaic throughout the station, such details are accessible to those with a keener knowledge of local history. By functioning on these two levels, Lee Brozgold's *Greenwich Village Murals* is an effective educational tool, commemorating famous village landmarks, discernible to the casual visitor but also offering a deeper analysis for natives more familiar with the unique character of the place.

One of Lee Brozgold's *Greenwich Village Murals*, commissioned for the Christopher Street station.

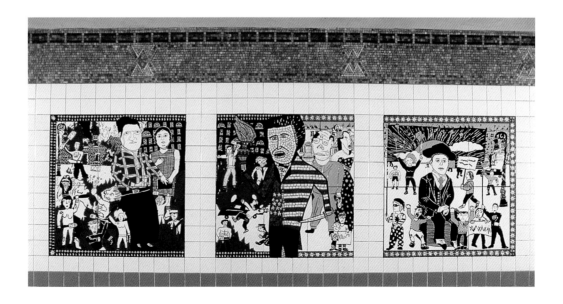

Bay Shore Icons

BAY SHORE STATION, LONG ISLAND, NEW YORK

Project description

Icons of local culture
and gridlocked cars
embedded into the
lintel and portico of the
nineteenth-century
platform shelter

Artist

Brit Bunkley

Agency

New York Metropolitan
Transportation
Authority, Arts for
Transit

Date

1992

Dimensions

Icons: 23 × 21 × 4 in. each
Clock medallion: 34 in.
diameter
Traffic jam frieze:
8 in. × 2 in. × 200 ft

Materials

GFRC castings
(fiberglass-reinforced
cement)

Cost

$15,000

Photography

Courtesy of the artist

THE SUBURBAN TRAIN STATIONS of the Long Island Railroad and the Metro-North Railroad, both under control of the MTA, receive as much attention from Arts for Transit as the subway stations in the heart of the city. The installation of Brit Bunkley's *Bay Shore Icons* during the 1992 renovation of a Victorian platform shelter is evidence of how public art can ease appropriate modernization projects within a context even more historic than the New York subway system—the Long Island Railroad. St. James's station, the oldest on Long Island, was constructed in 1873 in a style that would come to characterize the Long Island stations that followed in the late nineteenth century. While some later stations would mirror the wealthy estates in the area, St. James's station was a relatively unadorned triangular canopy supported by Doric columns along the platform. Many such original wooden structures were little more than protection from the weather. Bunkley's simple geometric icons depicting symbols of local culture through time accentuate the restrained historic nature of this building, preserved despite its transformation into the updated Bay Shore station.

The long career of the New York-born, New Zealand-based Bunkley is marked by numerous examinations of the possible meanings of icons, archetypal images symbolizing aspects of local culture. Through commissions for the Minnesota History Center, as well as museum exhibitions, Bunkley has created a personal approach exploring the relationship between iconography and social reality. His icons often accentuate existing architecture while characterizing the past of a culture through contemporary images. For him, the creation of such icons is a highly site-specific process, possible only after extensive research, that results in an understanding of local character deep enough to extend beyond the stereotypes that too often inspire icons:

In the initial designs of my iconic public work, I investigate the local history, culture, and geography of the project in regional libraries, as well as interviewing the local residents.[5]

In researching Bay Shore Icons, Bunkley was as much motivated by Bay Shore's prominent place in railroad history as by its status as the first station on Long Island. By basing his cultural icons on the bronze medallions that ornamented the New York transit system in its early years, Bunkley ultimately used this local history of transportation as a way of approaching the larger cultural history of the region. But he also updated the allusion, abandoning the traditional bronze for more durable new materials with which to simulate the original medallions. Working with New York foundry Essex Works, Bunkley used a fiberglass-reinforced cement called GFRC as the base for the casts. A plastic additive lent durability, and created a muted gray shine, mimicking the original metal. For a lintel frieze of gridlocked cars, Bunkley used the white cement without the plastic additive to feign the appearance of painted wood. Just as with the renovated Bay Shore station, Bunkley's icons are historic in appearance, but completely contemporary in convenience and durability.

Dispersed along the roof of the entire platform, Bay Shore Icons includes eight individual elements, with a row of four along the lintel of both shorter sides of the station, a portico clock, and a lintel frieze of gridlocked cars. Relying on nothing but a few lines and simple geometric shapes, the images successfully capture the culture of Bay Shore and Fire Island, a short ferry ride away.

Many images recall the ocean's influence on Bay Shore culture: a lighthouse, a sailboat, a beach umbrella, and a fish-and-wave design. A clam with a hand shows the importance of the clam industry to this area in earlier years.

Several images also recall the rôle of transport in the growth of Long Island; they include a sailboat, a motorboat, a biplane, and a car beside a barrel of gas. The plane illustrates Bay Shore's importance as a seaplane base during World War II. The frieze of gridlocked cars is a playful commentary on the current relationship between Long Island and transportation, a reminder of traffic jams connecting with commuters who can too easily recall Long Island's notoriously congested highways. While these icons are rooted in a long history, they are made appealing by their playful simplicity. Even a busy commuter has time to pause and smile at an egg-shaped sun crowning a beach umbrella, or a lighthouse that resembles a chess piece.

With his *Bay Shore Icons*, combining the integration of architectural elements with the commemorative focus of sculpture, Bunkley attempts to "explore the gray areas between architectural monuments and monumental sculpture."[6] Using a system of lintel friezes and relief panels popular since Classical times, Bunkley's icons are a sculptural addition that complements the historic character of the platform canopy while also presenting a symbolic portrait of Bay Shore, past and present. By providing this contemporary commentary on local culture without disrupting the traditional station, *Bay Shore Icons* proves that it is possible to update the look of a century-old transit system without destroying its history. The New York transit system demonstrates that it can move into the future without having to abandon the past.

Brit Bunkley's fiberglass icons make this refurbished Victorian-era platform shelter in Long Island subtly contemporary (bottom). A panel of icons decorates the short end of the lintel (below, left) and a frieze of gridlocked cars runs down the long sides of the lintel (below, right).

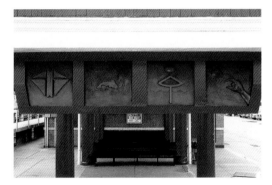

Wings for the IRT:
The Irresistible Romance of Travel

GRAND ARMY PLAZA STATION • BROOKLYN, NEW YORK

Project description

Four terracotta bas-relief
mosaics and a series of
bronze panels of winged
victory goddesses,
evoking both the historic
Soldiers and Sailors
Memorial Arch, located
above the subway
station, and "Flying
Wheels," an early logo for
the subway system

Artist

Jane Greengold

Agency

New York Metropolitan
Transportation
Authority, Arts for
Transit

Date

1995

Dimensions

55 × 110 in.

Materials

Terracotta mosaic
and bronze plaques

Cost

Materials $35,500
Installation $15,000
Artist's fee $4,500
TOTAL $55,000

Photography

Courtesy of the artist

ABOVE THE GRAND ARMY PLAZA subway station, there is a noticeable transition between the bustle of workday Brooklyn and the lush tranquillity of Prospect Park. The Soldiers and Sailors Memorial Arch, located where the concrete plaza gives way to green vegetation, marks the separation between these two worlds. Designed by John Duncan in 1895, this stone arch commemorates the North's victory in the Civil War. The monument is crowned by a quadriga—a bronze sculpture of the Greek goddess Nike heralding the arrival of Victory in a horse-drawn chariot—while a smaller figure of Victory, looking down from the stonework above the arch, greets those who pass through it. Rising above the entrance to Prospect Park, this grand arch has become a symbol of the adjacent Grand Army Plaza.

Jane Greengold approached her commission for the Grand Army Plaza subway station as a practicing artist (and lawyer) with thirty years of experience, but also, more importantly, as a resident of Brooklyn. She wanted to create a work that could address the unique context of a subway station while fashioning an identifiable emblem for Brooklyn:

> I wanted to create a site-specific work that would tie the underground station to the landscape above the ground, but that would also acknowledge the subway station itself, and be uplifting. Subway travel can sometimes be a trying experience; I wanted the work to enliven the station, with perhaps a humorous touch.[7]

Although the seminal image of the arch is a natural symbol for Brooklyn, it soon gained broader significance for the artist. While carefully researching the original symbolism of each element in the quadriga, Greengold discovered that similar representations of winged Nike, goddess of victory, have long been used to herald a triumph. This Classical and Neo-classical tradition was easily adapted from traditional conceptions of battle to modern city life:

> In the quadriga, the winged victories herald the arrival of the chariot of victory. When you enter a subway station, what do you want most to arrive?—The train. So in this work, victories herald the arrival of the train.[8]

Greengold's *Wings for the IRT: The Irresistible Romance of Travel* integrates this symbol of Brooklyn with the broader history of transportation that shaped the area. Perhaps inspired by the same Neo-classical traditions as Greengold's later meditation on the victories of transportation, early symbols for the Interborough Rapid Transit (IRT) used a similar motif: a winged train car celebrated the freedom of movement that this pioneering transportation system provided. Greengold combines these two traditions to create a work that is specific to Brooklyn, while drawing in elements of a subway history greater than any one of its stations. *Wings for the IRT* incorporates the victory goddesses of the arch with the winged car logo of the IRT to create a composite emblem unique to the Grand Army Plaza station.

Greengold's design is especially powerful since only one staircase connects the mezzanine and the platform: everyone who enters the station must encounter at least one element of *Wings for the IRT*. The center of the entire installation is the terracotta relief of a winged IRT train car flanked by two winged victory goddesses with horns. The glazed aqua-blue image, similar in color to the weathered patina of the quadriga with its gold highlights, is in visible contrast to the white tiles of the station walls. From its prominent position over the central staircase, the relief mimics the exterior arch, greeting visitors who crane their necks to examine the work as they pass below it on the way to the platform. Individual victory

goddesses welcome riders with outstretched arms and golden horns at the bottom of each of the three staircases leading to the mezzanine from the street. Small bronze plaques of the diminutive victory goddesses in the stonework of the arch, located opposite the large welcoming figures, direct riders to the exits. In confronting riders from every direction with a series of coordinating elements, *Wings for the IRT* demands acknowledgment from the constant stream of busy commuters.

Taking on the challenge of a subway station—viewed by some as another in a monotonous series, and by others as a symbol of commuting headaches—Greengold uses whimsy and humor to demand the reinterpretation of the familiar. The Neoclassical images add romance to a banal commute, and Greengold's consciously optimistic title reinforces this deliberate reference to the awe that originally

surrounded the subway system. What was once the Interborough Rapid Transit becomes the Irresistible Romance of Travel under the wings of victory in the Grand Army Plaza station. With her *Wings for the IRT: The Irresistible Romance of Travel*, Jane Greengold has created a station specific to her neighborhood while resurrecting the romance of the freedom of travel that once extended down the tracks.

Jane Greengold's victory goddesses greet travelers entering the Grand Army Plaza station.

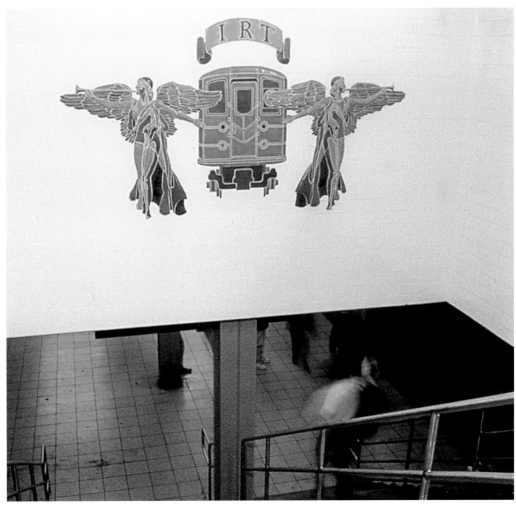

Woodside Continuum

WOODSIDE STATION, QUEENS

DURING ANY WEEKDAY RUSH HOUR, thousands of commuters pass through Queen's Woodside station, transferring between the New York subway system and the Long Island Railroad. Arts for Transit selected Dimitri Gerakaris, a New England artist, for the Woodside commission when the station (originally built in 1914) was renovated in 1998–99. According to Gerakaris, this unique station is the site of an even more significant junction: "The challenge and opportunity of the Woodside station is in its relationship to the past and to the future."[9] In his *Woodside Continuum*—a series of seven handforged steel panels that are the division between the ticketed and non-ticketed areas of the mezzanine and the adjacent ticket counter—Gerakaris attempts to teach commuters about the history of a

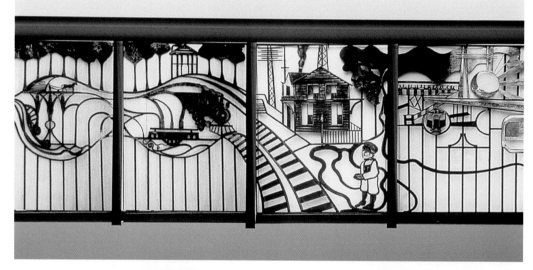

Project description

Seven steel panels trace the history of Woodside along with the evolution of the railroad

Artist

Dimitri Gerakaris

Agency

New York Metropolitan Transportation Authority, Arts for Transit

Date

1999

Dimensions

Panels 7 × 4½ ft

Materials

Steel and stainless steel

Cost

Artwork (design and fabrication) and supervision of installation totaled under $150,000

Photography

Courtesy of the artist

station they rush through daily, from the perspective of the railroads that shaped it.

The four 7 × 4$^1/_2$-ft panels installed in 1999 trace the evolving character of Queens, from a small farming village to a growing commercial district. Although in this case it is specific to Woodside, this common pattern of urbanization is obviously recognizable in towns across America:

> These images are very much Woodside-related, but certainly refer to the whole human condition ... —the flow of the stream becomes wider and wider as it is more and more packed with images from an ever more complicated way of life and what we may call "cultural acceleration."[10]

At the far left of Gerakaris's relief, the birch-bark canoe of New York's native population is replaced by a farmer plowing his field, and an early mill. In the 1860s, however, the landscape of Woodside was changed forever with the construction of the original Woodside train station. After this transitional point in Woodside history—marked by Gerakaris with the wooden frame station and an early locomotive at the midpoint of the frieze—the rural past of Queens was soon abandoned. More conveniently reached from the city by this new transit system, it was the perfect suburban area in which Manhattan workers could raise children, such as the boy with his baseball glove in the third panel of *Woodside Continuum*. But the city soon grew along these railroad tracks, as the trees of Woodside were replaced by the high-tension lines and pollution of the city. Gerakaris's final panel encompasses this acceleration toward the future, incorporating the new steel station, modern trains, and an Art Deco montage commemorating Woodside's position as the gateway to the World's Fair in 1939.

Gerakaris offers a parallel evolution in a series of three panels installed across the mezzanine adjacent to the Long Island Railroad ticket counter. In a much more linear progression than the depiction of local history—one that reflects the constant forward acceleration of technology as well as the very

tracks that directed it—the evolution of the railroad races across the three panels. An early Baldwin Ariel locomotive from 1835 is followed by an 1870s black metal-and-brass locomotive that is finally surpassed by a modern stainless-steel commuter car at the far right of the relief. The pieces are installed in two distinct locations across the mezzanine and rendered with two chronological (but somewhat differing) methods of organization, and Gerakaris intended their juxtaposition to create interplay among Woodside, the railroad, and the commuter: "My aim was to encourage people to think about continuity and to see the ways Woodside and society as a whole have changed and are changing—and the powerful rôle transportation has played in that process."[11]

Motivated by his focus on the power of transportation to change Woodside and society as a whole throughout time, Gerakaris created *Woodside Continuum* as a literal representation of the historical continuity promoted by the Arts for Transit program. His depiction of evolving Woodside, with its pulsating flowing of time through pockets of emblems, is geometrically based on the common medallion motif in early Interborough Rapid Transit stations. Here, however, Gerakaris abandons the strict organization as time accelerates, allowing his icons to tumble out of their circular frames across the panel. His history of transportation is represented by the distinctive images of the trains that have graced these stations through the years. For many, the changing appearances of trains were another ornamental element of the new culture of transit. Gerakaris's *Woodside Continuum* integrates these historic threads into one grand account of the past that challenges the commuter to consider the implications of stories usually ignored during rush hour. The artist explains: "I wanted to create a continuum, to link generations living centuries ago surrounded by wilderness, farms, country lanes, and abundant woods, with today. People rushing by may become aware of this now-vanished town and, upon reflection, realize that they are the link to the future."[12]

1 Mission statement from Arts for Transit website (mta.info/mta/aft), accessed August 30, 2000.

2 David W. Dunlap, "Next Stop, Murals; Change Here for Uptown Sculpture," *New York Times*, May 1, 1998, pp. E37 ff..

3 Lee Brozgold, "The Greenwich Village Murals," *SchoolArts*, December 1995, pp. 34–35.

4 Lee Brozgold, artist, New York, interview, August 5, 1999.

5 Brit Bunkley, artist, Jamestown, Rhode Island, correspondence, January 15, 1998.

6 ibid.

7 Jane Greengold, artist, Brooklyn, correspondence, May 19, 1997.

8 ibid.

9 MTA pamphlet, courtesy of Dimitri Gerakaris.

10 Dimitri Gerakaris, artist, North Canaan, New Hampshire, correspondence, March 29, 2000.

11 MTA pamphlet.

12 ibid.

Memory: Arizona

Project description

Glass mosaic panels modeled from postcard collage

Location

Sky Harbor Airport Terminal 4, ticketing level, southwest entry wall

Artist

Howardena Pindell

Agencies

Phoenix Public Art, Phoenix Sky Harbor Airport, Terminal 4, Phoenix Airports Museum Program Collection, purchased with Aviation Percent for Art funds through the Phoenix Office of the Arts and Culture Public Art Program

Date

Completed July 1991

Dimensions

10 × 14 ft

Material

Smalti glass

Cost

$85,159

MEMORY: ARIZONA is a tribute to the experience of the City of Phoenix. The images represented are from the artist Howardena Pindell's photographs of the city, designed into a mural, and then fabricated by glass-mosaic craftsman Constante Crovatto, in Venice. The mosaic is made from smalti glass, a traditional type of glass chip used for hundreds of years in some of the world's most notable mosaics. The piece was shipped to Phoenix from Venice for installation.

Pindell's piece is one of ten airport artworks commissioned by the Phoenix Arts Commission. Phoenix Sky Harbor International Airport was identified as one of the fourteen public-art "working zones" in the Phoenix Arts Commission's master plan. According to the Phoenix Public Art Program, "As the title suggests, the artwork is aimed at those leaving the state. It gives them the last impression of Arizona before they depart."[1]

In 1979, Pindell was in an automobile accident that resulted in partial memory loss. To regain her memory, she collected postcards depicting familiar places, and used these to create compositions on irregularly shaped boards and canvases. She used this method to create the piece at the Phoenix airport, pushing her process further by designing a mural made of glass mosaic.[2]

The visual information of *Memory: Arizona* integrates images of ethnic diversity, popular culture, business, education, and spiritual life in Arizona. The mosaic replicates an angel-like figure from a church near Tucson, a large shoe that is part of the façade of an African American school in Phoenix, fruit trees in front of Phoenix's Central Library, a Saguaro cactus (an image from Taliesin West), Navajo blankets, and seals for the Pima-Maricopa reservation, as well as urban and landscape images of Phoenix and Tucson.[3]

Design concept Pindell's first proposal for the Phoenix airport project was rejected. Originally, the artist wanted to create a smalti-glass mosaic depicting the night sky, as Arizona has one of the clearest skies for viewing the cosmos. The commission committee thought the proposal was too esoteric, and wanted something more literal that people could recognize as part of their

experience of visiting Arizona. Pindell designed a more literal proposal, including diversity as an additional component.

Pindell describes her research for the proposal as somewhat collaborative:

> Alison Kukla, of the Phoenix Arts Commission, was my mentor. She offered to drive me around the Tucson/Phoenix area for a week visiting various sites including Casa Grande, the Pima Maricopa reservation, and Frank Lloyd Wright's [house] Taliesin West. She introduced me to a local geologist who had grown up on a reservation as well as educators at the University of Arizona, Tucson and Arizona State who discussed the history of Arizona.[4]

Pindell created a photo essay based on the experience of looking at the flora and fauna and architecture, and the sense of wide open space. A New York native, Pindell took the train across the country to Phoenix, and saw the gradual change in landscape. She also visited and took photographs of Latino and African American neighborhoods and a collection in the Heard Museum. She combined all these site-specific images in a large, 10 × 14-ft collage.

Design impact "The most interesting feedback," Pindell says, "has been during the installation process, as people are acutely interested in this fascinating process. At this stage of the project they seem to feel intimately involved with its evolution, as they do at its final unveiling." During the installation of *Memory: Arizona*, Pindell says, she met with "puzzling hostility" from European American males to the Native American images. She explained that the land was originally Native American, and expands, "I feel very strongly about this since I have Native American relatives in my own melting pot of African, European, and Latino ancestors."[5]

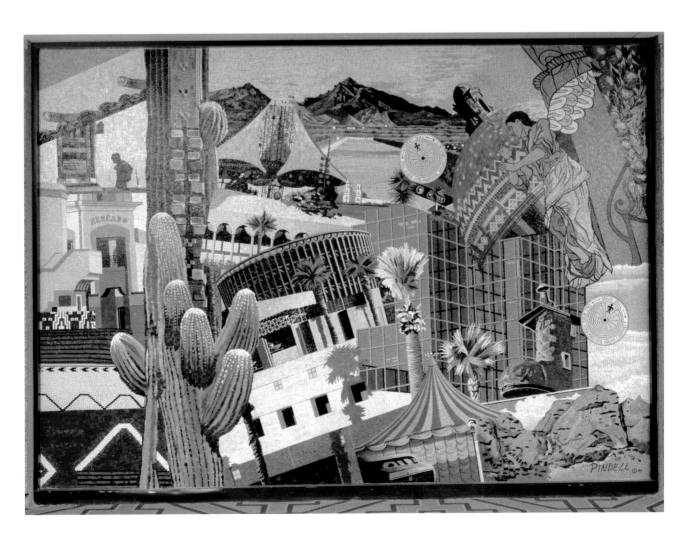

Howardena Pindell's mosaic made of smalti glass depicts the local fauna and cultures, a Navajo rug, and architecture, in a collage format. Photo: Craig Smith.

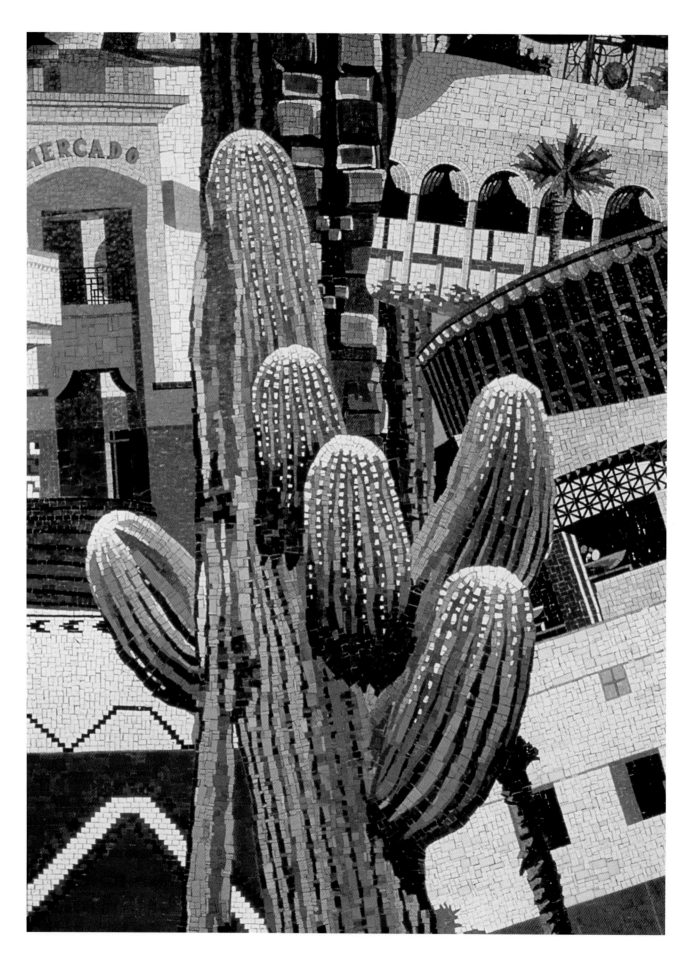

1 City of Phoenix Arts
Commission, responses to
questions from The Townscape
Institute regarding
Howardena Pindell's *Memory:
Arizona* at Sky Harbor.

2 See City of Phoenix,
description of *Memory:
Arizona*, phoenix.gov/
ARTS/cp_19.html.

3 Howardena Pindell, artist,
correspondence,
December 29, 1997.

4 *ibid.*

5 *ibid.*

6 *ibid.*

7 See Howardena Pindell,
*Statistics, Testimony and
Supporting Documentation*
(privately published), 1987.

8 Pindell correspondence,
December 29, 1997.

9 Lennée Eller, director of the
Phoenix Airports Museum
Program, interview,
22 September, 2006.

10 *ibid.*

Pindell also noted that, oddly, there was, to her knowledge, no reporting of the news of the mosaic's unveiling in the art press. The Phoenix Arts Commission mentioned it in its newsletter, and the Italian artist Constante Crovatto mentioned it in an article about his work in Italy. Pindell states, "the art world is relatively segregated, with token exceptions,"[6] and in her 1987 book, *Statistics, Testimony and Supporting Documentation*, she discusses the racial bias that exists in the art world, using statistics to prove her point.[7] Since the 1980s she has published groundbreaking studies that document the lack of representation of artists of color in the major museums and galleries. Pindell says that "she prefers the mosaic commissions because of their large scale, accessibility to the public, longevity, and the brilliance and permanence of color that is a feature of the medium."[8] *Memory: Arizona* reflects the permanent presence of many cultures to the public in a fixed mosaic form, notably in a space of travel that embodies the routine flux of new ideas and people in Arizona.

After the terrorist attacks of September 11, 2001, the security environment of the airport changed abruptly. According to Lennée Eller, director of the Phoenix Airports Museum Program, the Terminal 4 building needed to accommodate huge baggage-scanning devices that did not fit in the terminal space.[9] By the end of 2002, the Museum Program had installed a temporary wall in front of *Memory* to protect it from the machines that had been placed in front of the mural for the time being. Since then, the airport has slowly begun to create a permanent place for the machines in a separate structure, and the Museum Program will restore the mural in 2007.

Like other transit art programs around the US, the art program in the Sky Harbor Airport has had to withstand a stream of changes and to maintain its flexibility. For this reason, the airport art administrators have adopted a curatorial approach, collecting smaller moveable pieces. But for larger, architecturally integrated works in Phoenix as well as all around the country, the longevity of the art relies on the advocacy of the art commissioners within the agency. Eller has shaped her program around the idiosyncratic needs of an airport, understanding that, unlike public artworks within the cityscape, airport art is subject to constantly changing circumstances. This strains the airport's ability to provide federal VARA protections to artists (for an explanation of VARA, the Visual Artists Rights Act, see p. 309) and requires Eller to battle vocally and continually for the public art.[10] But this constant dialogue also creates a strong working relationship between the Museum Program and the other departments of airport administration, allowing Eller to work from early planning stages to orchestrate complicated tasks, such as reinstalling and restoring *Memory*.

Nonetheless, the covering of the mosaic for five years is a huge loss to the program. Public art is particularly vulnerable to such policy changes implemented hastily in a climate of fear.

Murals:
Part of a town-enhancement strategy

96 Murals: Another model for public art

114 The Mural Towns
Steubenville: City of Murals
Oregon History Murals

124 *Poet's Table*
Huntington Beach, California

Murals:
Another model for public art

E VEN WITHOUT THE BUREAUCRATIC SOPHISTICATION of a public art program, many communities across the continent have created public art through murals, some of which dominate the streetscape. In Mexico, the tradition began with painters working for political activism. The "mural town" phenomenon was born in Canada and has spread quickly across the United States. Some muralists paint the old-fashioned way, with acrylic on brick or concrete; others work on removeable sign board, or with digital media. From neighborhood groups to formalized institutions, contemporary muralism has evolved in parallel with, but often separately from, public arts agencies, each development having its own supporters and detractors. The two camps have much to learn from each other. New murals can blur the edges of media and of approaches to public art, using the professional wisdom of arts agencies. Arts agencies ought also to be able to learn from the enthusiasm, momentum, and grassroots support that mural programs receive. Murals may add vibrancy to a district, but they do not comprise a full-scale streetscape design strategy, since other factors, such as architecture and automobiles, can still dominate the visual field. Nonetheless, the mural-making process can create interest in place and a sense of community proprietorship by turning the actual walls of the community into valued works of art.

The city of Chicago, with its rich traditional mural history, now has one example of a blend between a mural and contemporary multimedia public art. Downtown's 2004 Millennium Park features a pavilion designed by Frank Gehry in addition to well-loved works of public art. Abutting Michigan Avenue, a sloshy water-covered granite fountain plaza invites children and tourists to play and explore. Catalan artist Jaume Plensa's $17 million *Crown Fountain* is a mix between a fountain, a gargoyle, and a digital display mural.[1] Two 50-ft towers double as massive LED screens covered with a wall of glass bricks. The screens cycle through photos of the faces of one thousand diverse Chicagoans. Water cascades down the sides of the towers and spurts from the mouths of the oversized visages in a play on the fountains typically found in European plazas, with a local and contemporary twist.

Muralism in society

The practice of drawing on walls goes back past the beginning of written history to some of our earliest evidence of the human spirit, inside the Lascaux caves in France. Throughout recorded history, the language of wall imagery has represented the dictates of the powerful, from the fashionable decorative paintings in the homes of élite Pompeiians, to Flemish altarpieces, to the silent autocracy of the blank concrete walls of Corbusian Modernism. But walls have also communicated deep cultural values from the bottom up, exemplified best by the Mexican struggle murals of David Alfaro Siqueiros, Diego Rivera, and José Clemente Orozco, which drew unique and moving programs from the artists' revolutionary politics. Today, muralism has emerged in America in two realms: social protest in the cities, and civic boosterism in the towns and smaller cities. Murals within the urban environment often draw from the progressive politics that the Mexican muralists advocated, using art as a vehicle for social programs and community empowerment, while employing the visual impact as a grassroots attempt to reclaim their blighted landscape. Outside the big city, mural programs have emerged nationwide in small communities, from villages to minor cities. The impetus for these murals often lies in a desire to bolster a sagging postindustrial economy with tourism dollars, while renewing a sense of civic pride among residents. The result ranges from stale retellings of esoteric or even callous histories at worst, to stunning works of art that incorporate an empowering community collaboration.

To understand the activity of American mural-making, we must look at the cultural and artistic locus of this now-widespread phenomenon. From a planner's perspective, we can see a cultural struggle for the urban field of vision: corporate advertisers impose their presence with billboards and advertising signage plastered over the windows of liquor stores and in the façades of national chains;[2] architects and developers impose a vision of the cityscape that can be sterile or even hostile to a sense of organic vibrancy; business and road signage demands blunt boldness even at the expense of pedestrian-scale experience; and graffiti writers clamor to reply to the surrounding detritus, often creating a miasma of visual noise that obscures the content of the protest. The writing on the walls makes visible the power struggles between dominating institutions and communities. Some institutions seek to protect neighborhoods and serve their apparent best interests, such as the public works departments that whitewash graffiti to restore a sense of lawfulness amid "broken windows."[3] Others, such as billboard advertisers, colonize the public field of vision for exploitative sales strategies.

PAGE 94 The Central American Resource and Education Center (CARECEN) mural *in situ* in the CARECEN community center, Los Angeles, 2002. Photo: courtesy of Social and Public Art Resource Center, Los Angeles.

BELOW, RIGHT Judith F. Baca/SPARC students and staff/Local 11, *In our Victories Lies our Future*, digital mural on vinyl, 1997. Photo: courtesy of Social and Public Art Resource Center, Los Angeles.

Graffiti is the illegal predecessor to the now-celebrated aerosol art, part of the hip-hop canon that holds great sway in American popular culture and urban subculture. Some acts of graffiti truly are works of art, using dazzling colors and technical prowess to explore the writer's individualism in the urban context. Like other art forms, the long-term practitioners develop an obsession with style and execution. But quite often, graffiti is esoteric—its obscure lettering and "tagging" of territory only transparent to a small group of initiates.[4] The canonization of aerosol art within the prominent hip-hop movement has brought recognition to the writers' protests, beginning in New York in the 1970s, against some cities' gross neglect of impoverished areas and their citizens.[5] The "urban revitalization" movement robbed many urban areas of their built heritage by bringing in bulldozers to wipe them "clean" and replace what was there with a mass of dull concrete. The canonization of any guerrilla art form co-opts and compromises the original potency of its struggle, but brings its widespread relevance to the fore. The African American mural tradition, developed from roots in the nineteenth century, has sought, through a living and powerful medium, to represent the idealized values of an under-represented segment of the American population: fine artists and community participants alike have painted within the communities that the art is to serve.[6] Philadelphia's Mural Arts Program emerged from an anti-graffiti initiative in the city, an attempt to divert the efforts of graffiti writers from protest to civic contribution.

The Mexican mural tradition falls much more squarely within the schema of "art history," enmeshed in the broader artistic trajectory of the twentieth century, while promoting the artists' political agendas, based on the populist premise that a vibrant and elevated culture must exist in the hands of the many. In Los Angeles, the Social and Public Art Resource Center (SPARC) creates explicitly political murals in a Mexican American milieu, going even beyond the founder's Chicana heritage to represent the city in its entirety. In the smaller city of Joliet, Illinois, lead muralists have studied with descendants of the Mexican tradition, following its aesthetic and political heritage and applying it to a contemporary and multicultural American political venue.

Market value: blessing and challenge

Jaume Plensa, *Crown Fountain*, 2004, Millennium Park, Chicago. Photo: Howard Ash.

Muralism is unique in public art in the United States for a number of reasons. The first is primarily economic, and sets the mural movement clearly apart from public art as a whole. Many mural programs are mainly supported privately or by foundation grants, rather than using the Percent for Art model

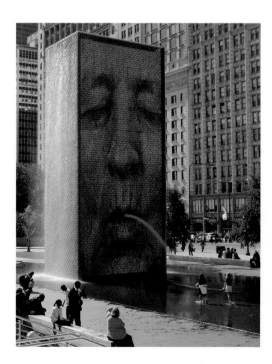

adopted by public art programs. Some programs, such as Joliet's, receive extensive funding from the city government among other sources, while smaller programs often operate entirely with private donations. The lack of mandated funding means that a program must continually justify its own existence to the community that it serves in order to receive grants and donations to cover overhead costs as well as mural-making. Also unlike some of today's public art, there is a significant market for murals, and savvy artists have been successful in expressing the (dollar) value of their contribution to communities.

Karl Schutz, pioneer of the first mural town, Chemainus, British Columbia, advocates the mural-town business model for other communities seeking an answer to their economic hardships, as Chemainus did in the early 1980s. The village draws 400,000 tourists a year (and their dollars) to the small community of four thousand. Chemainus is far off the beaten path—50 miles down the road from the ferry port, after a two-hour boat journey.[7] Schutz says that communities of any size, in any location, can benefit from the tourist income and the civic pride that a mural program generates. Now Schutz has the experience to back up his claims that murals can create a service economy through tourism. He won this victory the old-fashioned way, disproving the skeptics in Chemainus who had blocked the development of the mural program for ten years. Many communities now in the midst of economic turmoil are ready to sell their authenticity and their history to tourists, or they risk turning into ghost towns in the rapidly changing global economy. Financial forces provide their own layer of self-censorship, but some communities and mural artists have been able to focus the community storytelling process and take advantage of the constructive reconciliation of a town's history.

The effectiveness of murals in a tourism scheme confirms that there is a market for them. Unlike typical public art, which comes in a variety of media and can often be integrated into other capital improvements, the scale and quality of murals, and thus their value, are apparent at first glance. While not every business wants a mural on the side of its building, the visual language of mega-scale pictures produces a big impact. Billboards still pervade many American highways and neighborhoods. Outside official programs and public art agencies, some mural artists still make a living on individual commissions. Since murals are relatively inexpensive to produce, their value also expresses itself in their quality. Elementary school classes painting bright but juvenile murals on their schools' walls have become a phenomenon nationwide. According to Kathleen Farrell, artist and co-founder of Friends of Community Public Art in Joliet, murals can also suffer from a stigma because of their association with poverty or children's projects. Farrell had wanted to bring a world-class arts community

John Cerney, *Sam's Friendly Produce Stand*, 1997–2005, Salinas, California. Photo: courtesy of the artist.

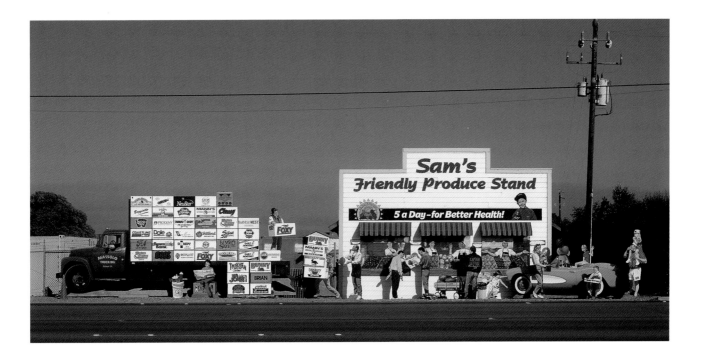

and artist movement to Joliet, starting this advocacy campaign on the walls of the working-class city. When she first proposed bringing in professional artists to create murals in Joliet, one selectman scoffed at the idea, retorting, "Oh, the ladies will do that for free."[8] For Farrell, the battle was to convince the City that the professionalism was an essential component of a high-quality product. But businesses and cities commission murals because of their effectiveness in communication. Like the silver screen in movie theaters, people understand large-format pictures, even outside art circles.

Because of their cachet, businesses also seek to sponsor murals. According to seasoned muralist Robert Dafford, corporations sometimes try to influence the content of the art.[9] The challenges of expressing patronage on walls are as old as Giotto's famous chapel in Padua, expressing his piety of course, but dedicated to the Scrovegni family. When muralists write history on the wall, this pull can be dicey. It is naïve to imagine a history written in a vacuum, or a mural painted without a patron, even if that support comes in the form of spray-paint cans in the backpack of a guerrilla artist. California artist John Cerney creates murals in rural locations, painting huge and arresting freestanding figures in cornfields, as well as entire scenes on the sides of barns. He began his career by asking a barn-owner for permission to create a mural in Salinas, California. That mural has sustained a handful of incarnations and served as a living advertisement for the artist's career and services. From 1997 to 2005, it was *Sam's Friendly Produce Stand*, a *trompe l'œil* homage to the now seemingly antiquated tradition of local businesses of the 1950s. Cerney supported the mural by charging fees for townspeople to find their likenesses included on the wall, and for fruit and vegetable companies to see their boxes sitting outside the make-believe store. This large-scale vignette has brought tourists and press to Salinas, sometimes in the form of confused out-of-towners looking to buy vegetables.[10]

For Cerney, selling space on his murals (from fruit boxes to the faces of locals) is a way to make a living, although sometimes the authorities ask for a permit to use the space for advertising when he refers to products or companies. Cerney has thoroughly blurred the line between ad and mural, using realistic but fake advertising on inset billboards for the backdrop of a baseball-park outfield, or on the side of a barn. For the fruit and vegetable companies pictured in *Sam's*, the artist's talent is a spectacle in itself, above and beyond any advertising that they could purchase through billboard signage. The lure of dazzling artistry and manual skill still creates an effect that billboard graphics cannot match. Part of this is the magic of the medium, and part is the fact that, unlike with billboards, people still trust the non-commercial sincerity of murals and are more open to their messages. Increasingly, businesses sponsor historical community murals, such as Trader Joe's in Cambridge, Massachusetts, and Staples in Brookline, Massachusetts, both created in 2005 (although in Cambridge, residents continue to have trouble with Staples as a perpetrator of commercial blight in Harvard Square). With vast blank walls on the sides of boxy buildings, such companies can do a good deed by lending their visual real estate to community arts. Conversely, they can use their sway to guide or even mislead area history in a forum that generally holds the public's faith. All skepticism aside, for conscientious businesses that move into preexisting "boxes," sponsoring murals can ameliorate some of the damage that the construction wrought in the first place.

Some communities have enshrined the distinction between advertisement and mural in law, for example St. Petersburg, Florida, which has banned the use of words or numbers in murals.[11] Murals balance on this tightrope precisely because they have a market value, something with which traditional or even new forms of public art struggle. While government-supported public art programs sometimes run on significant budgets and consider themselves as adding value to their communities, they remain more shielded from economic tides.

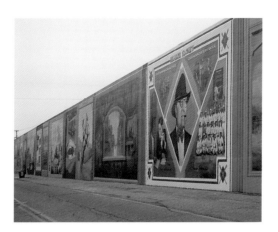

RIGHT Robert Dafford, *Portsmouth Floodwall*, 2002, Portsmouth, Ohio. Photo: Lisa Carver, courtesy of Portsmouth Murals Inc.

CENTER RIGHT *The Flood of 1937*, 2001, Portsmouth, Ohio. Photo: Lisa Carver.

BELOW RIGHT *Shawnee Village*, 1995, Portsmouth, Ohio. Photo: Lisa Carver.

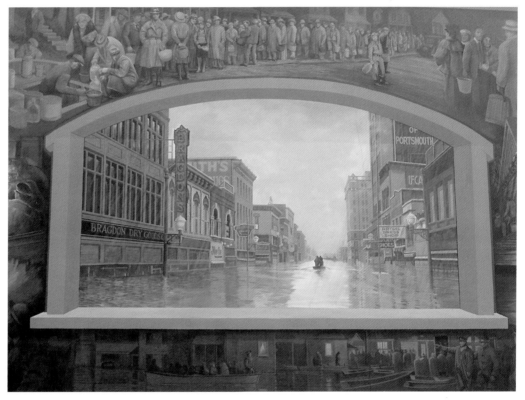

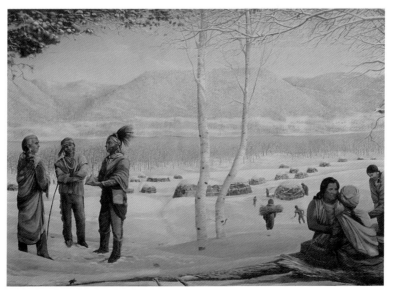

Mural programs: community ventures and public art organizations

In general, mural programs are structured quite differently from typical government-run public-art programs. Many government-sponsored public-art commissions shy away from creating murals, perhaps because of their association with anti-poverty programs, or because murals often require intelligibility and a clear "message," be it of values or history. Public-art commissions are often hesitant to put their names to "message" art for fear of controversy associated with the literal content or criticism that they are not living up to curatorial standards that may discourage figurative works. The structure of mural art programs is different. They often begin with a strong voice of local leadership, such as Kathleen Farrell in Joliet, Judy Baca in Los Angeles, or Jane Golden in Philadelphia.

Karl Schutz of Chemainus now consults for communities around the world on how to start their own programs.[12] The single key ingredient that makes a mural program viable, according to Schutz, is the presence of local leadership,[13] either an artist, as in the cases of Philadelphia, Los Angeles, and Joliet, or simply a vocal advocate, as Schutz became for his adoptive home (for an entire decade) even in the face of virulent opposition before the idea began to blossom. Local advocacy can bolster any public-art program, but the entrepreneurial nature of mural programs shows that these independent entities can run as well as their bureaucratically funded counterparts given the right synergy of talents.

Because mural programs have sprouted nationwide for a variety of reasons, each takes on its own form within a community. Portsmouth, Ohio, hired a single artist, Robert Dafford, to tell its history over the course of ten years along a blank and imposing floodwall running 20 ft high along 2000 ft of riverbank. Members of the Portsmouth community first conceived the idea for the program by visiting Steubenville, another city along the Ohio River with Dafford murals. With the help of Schutz, the citizens of Steubenville had created a mural program to stimulate a service economy through tourism in the postindustrial decline of this old steel community (see pp. 115–18). Many of the urban mural programs also emerged as social stimulators, bringing skills, education, and empowerment to young people and art students.

Freedom from government also means that the content of these murals is purely self-censoring. A mural group can embody any value system it likes, as long as it can get the community on board, although this is not always a simple task. Some allege that the mural movement always fulfills a liberal agenda. This may have more to do with the type of communities that develop grassroots mural movements, often economically struggling towns or gritty urban neighborhoods, but this is not always so. In the mural town of Palatka, Florida, one of the murals commemorates the homegrown hero Reverend Billy Graham, an evangelical Christian. Schutz strongly discourages communities from involving politics or religion in their murals, and many of the communities that he has advised have stayed away from difficult subject matter in order to avoid controversy. The thought of a well-represented history without controversy is, in many communities, incomprehensible. It is not that Schutz has a commercial or tame view of history; in fact, he routinely suggests to communities that they base the entire content of their mural programs on the histories of the native people who inhabited the land before them. So far, nobody has taken him up on this idea. For communities that wish to create a mural program out of thin air, avoiding deeply sensitive subjects may be an effective way to get more people on board. It may also help to dispel "can't do" attitudes among constituencies unable to foresee agreement about conflicts that may have divided the community for hundreds of years.

Freedom from authority-dictated content means that a community has to define the "official story" for itself. Schutz tells communities to remind themselves that the history is for the visitors, not for themselves. This attitude is in sharp contrast to the social justice murals of the 1960s and 1970s that appeared nationwide and in Mexico, or to San Francisco's famous Balmy Alley murals of the 1980s, which promoted Latino solidarity in the face of US interference in Central and South America. This approach may serve to diffuse some of the personal turf issues of constituencies within the town, and work toward the greater goal of creating a story that makes sense in some objective terms. But this attitude also runs the risk of discouraging a sense of ownership of the narrative. If the town cannot reach *some* consensus about how to depict itself for its own sake, citizens can come to neglect or even resent the murals.

No mural can represent everyone in the community, and perhaps it should not. Instead, it is useful to think of a mural as a visual record of a collaboration between a group in the community and an artist. The mural is, indeed, evidence of consensus among a group of people who bring their efforts together to make the art a reality, through social activism, finding funding support, or merely seeking permission to impose an image on a wall. Without consensus, there is no mural. And without support, a wall with a mural can quickly be vandalized or become neglected. According to muralists Jane Weissman and Janet Braun-Reinitz, the main missing ingredient that holds back today's mural movement is consensus.[14] Kathleen Farrell contended with the polarization of the community of Joliet in the mural program's younger days. At first, she intended to avoid "ethnic group" murals, but over time she was persuaded as she tried to represent the history of the town and its many immigrant populations fairly. Today, each subpopulation celebrates its history in a Joliet mural, although it took the less open-minded residents some time to become accustomed to this idea. In that sense, the murals have served a didactic function. Most of them celebrate common ideals shared across the community, and are not group-specific. Of course, there is a risk. Finding a lowest common denominator in any community is an easy way to sanitize the content of a mural and greatly devalue its contribution to community dialogue.

Even with a rock-solid community process, controversy can arise if the context changes. In Los Angeles, artist and SPARC founder Judith F. Baca created a monument to the struggle that has come with the area's changing population and to the struggles of the natives who preceded the contemporary population. The work, entitled *Danzas Indigenas*, is a set of concrete arches with textual inscriptions at a Metrolink station in Baldwin Park, a small city east of Los Angeles, the predominantly Latino population of which supports the project. The work sat peacefully for a decade before dissent arose about the place of immigration in US culture at a time of aggravated hysteria. Opposition to the notion of celebrating immigrant populations rose, and a group from outside the city, protesting against illegal immigration, began demonstrating regularly in the park in the summer of 2005, in order to pressurize the City to remove the inscriptions.[15] According to Baca, the group misrepresented such inscriptions as "It was better before they came" as an "unpatriotic" affront to whites. In fact, the monument remembers the jeers that Mexican immigrants heard upon their arrival at Baldwin Park after World War II. SPARC organized an "art day," with music, painting, and installations, to counter the protesters with positivity, although there was some tense back-and-forth. The SPARC festival overshadowed the protest, but the point was not to silence opposition. The controversy provided an opportunity for real disagreement—and communication—between the groups. Controversy is not the end of the world, and many urban mural groups face it every day. Conflict within a community can provide the basis for a constructive dialogue, injecting meaning into the entire endeavor.

The urban mural movements

I. The big city: the Social and Public Art Resource Center, Los Angeles

Each of the biggest metropolitan areas in the country (New York, Chicago, and Los Angeles) has nurtured a thriving community of muralists over the course of the past forty years. Los Angeles, the nation's second-largest metropolis, has seen its fair share of political turmoil and has found creative ways to cope with continuing conflict, as demonstrated in the Bishop's Park monument protests. Tension between black, white, and Spanish-speaking populations has at times spiraled out of control. The artistic heritage of Mexican muralists has trickled down through this city infused with Chicano culture. One local artist and community leader, Judith Baca, has fused her own artwork with youth outreach in the city. In 1974, at the suggestion of the Army Corps of Engineers, Baca began a twelve-year process of depicting the city and state from prehistory to the 1950s with the famous *Great Wall of Los Angeles*, along a flood-control channel in the San Fernando Valley. She founded the Social and Public Art Resource Center (SPARC) in 1976 with social action in mind as much as art. With government sponsorship as well as grants from individuals, businesses, and foundations, she employed over four hundred ethnically diverse young people and their families (as well as scholars) to assist with painting the half-mile mural, with the motive partly of art education and partly of mentorship of the urban youth.

For the first three years of the project, funding sources stipulated that Baca could only employ children who had previously been arrested. Many of the same youngsters returned year after year to work on the wall and enjoy Baca's mentorship. The largest mural in the world, the *Great Wall* tackled even controversial moments in history with thorough research, including waves of immigration, wars, McCarthyism, and Native American assimilation. The resulting mural shows a distinctive style that is clearly narrative while using comic-like changes in scale and vivid color schemes to draw the viewer in. Recently, SPARC has begun an ongoing and costly effort to preserve the ageing landmark and expand it to a full mile in length to include history up to the 1990s, pending a massive funding campaign. SPARC also hopes to create interpretive stations along the channel, and an interpretive center on a bridge, which will provide views across the span of the wall. Using podcasts of archival interviews with Baca and testimonials from individuals who worked on the wall, SPARC aims to make the wall's history (and the history on the wall) easily accessible to the public. This effort has already begun in cyberspace with the center's extensive website, sparcmurals.org, including news, archives, and an interactive tour of the wall. SPARC has produced a DVD of archival material entitled *Animating Democracy*, chronicling the history of the wall for the Americans for the Arts series.

Baca's program has grown over the past thirty years to engage the community at UCLA (where she is a professor in the Department of Chicana and Chicano Studies) as well as urban youth. SPARC serves the wider community through public art projects and youth education. It has facilitated local artists to create murals of artistic merit while still engaging youth outreach in many of the center's programs. In East Los Angeles in 1990, Paul Botello, a local artist, created *Combined Forces*, a traditional acrylic wall mural depicting struggles between humankind, technology, and nature in a time of rapid change. Unique styles found in these "Neighborhood Pride" murals keep the aesthetics of the walls varied and dynamic, and always alive with local artists' contributions.

Neighborhoods still approach SPARC to request murals, but the city-wide initiative has currently

RIGHT Judith F. Baca, *Great Wall of Los Angeles*, acrylic on cast concrete, 1976–83, Los Angeles. Photo: courtesy of SPARC.

CENTER, RIGHT SPARC and CARECEN staff, and students in the Digital Mural Laboratory, *CARECEN Mural*, digital mural on vinyl, 2002, Los Angeles. Photo: courtesy of SPARC.

BELOW, RIGHT Paul Botello, *Combined Forces*, acrylic, 1990, East Los Angeles. Photo: courtesy of SPARC.

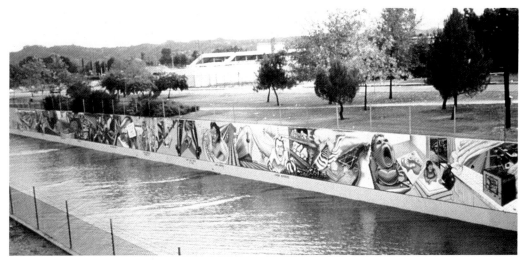

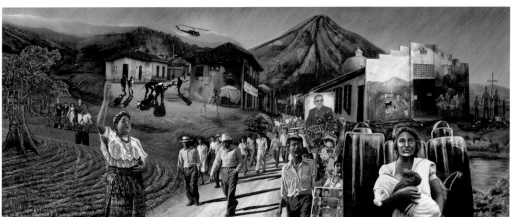

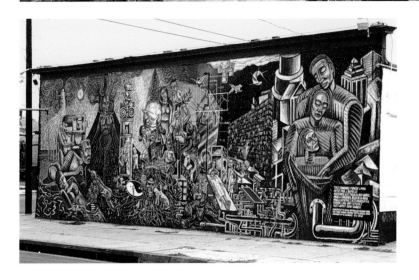

been terminated because of a crisis in funding. The City of Los Angeles Cultural Affairs Department sponsored the Neighborhood Pride initiative, which brought murals to the neighborhoods of Los Angeles from 1988 to 2002 through funding from the City, which has since dissolved, pending further negotiations with the mayor to re-envision a new future for muralism in the city. Over the course of the program, the City cut the funding in half while still requiring SPARC to complete work every year in each of the city's fifteen council districts. This situation forced SPARC to spread its resources thinly and to choose finally to stop the program rather than to compromise the output. With City sponsorship, Baca encountered issues of censorship and influence again and again, while still striving to paint the stories of the communities as accurately as possible. The only issue that she could not ultimately put on the walls—police brutality—was one that is deeply controversial but close to the hearts of many Los Angeles residents.[16] Working in a city where gangs and neighborhood groups colonize "public spaces," Baca faces the challenge of defining where civic life can take place in her community. Neighborhood overseeing of murals and public art places a burden on artists and private citizens to handle the thicket of legal challenges that comes with painting murals even on a private building. Ironically, in the poorest neighborhood there is often the *least* oversight of corporate blight, including billboards, posters, and ad-cluttered storefronts.

Since 1996, Baca has explored the rôle of new technology in mural-making. While the use of such alternative materials as parachute cloth and signboard has grown across the country, Baca has taken her studio to the computer lab, creating a new digital process. In the UCLA/SPARC César Chávez Digital/Mural Lab, Baca's students at UCLA perform community outreach, teaching artistic as well as computer skills to Los Angeles youth, crossing the class divide that has kept underprivileged children from exposure to technology. With Baca's tutelage, students paint, scan, alter, print, repaint, and rescan images, creating murals without scaffolding. This process takes the production away from the street level, which can add safety and feasibility, but subtracts an element of communication with the public and neighborhood-wide anticipation of the results. The artistic process has remained steadfast whether the work is digital or on the wall. The "digital" murals can take on photographic realism as well as all the dramatic effects of painting and computer graphics. The lab prints the resulting murals on different substrates, such as vinyl, and installs them to look much like their wall-painted counterparts.

The digital mural entitled *In our Victories Lies our Future* chronicles the history of the Local 11 Hotel and Restaurant Workers' Union. In 1998, union members worked with SPARC to depict their working environments and their contribution to the tourist-crowded city, portraying the ethic and dignity of the union workers' jobs. The mural researchers drew on oral histories as well as archival photographs.[17] The 15 × 39-ft mural, printed on vinyl, appears on the wall of the Local 11 headquarters.

The success of the Neighborhood Pride initiative during its lifetime was marked by 105 public artworks. Combining the neighborhood program with the digital lab, professional artists at SPARC worked with staff members at the Central American Resource and Education Center (CARECEN) to help youths conduct research into Central American history alongside their families and independent scholars. Participants have had the opportunity to explore their heritage while playing an active rôle in the design process. SPARC installed the digital mural in the community center in 2002.

SPARC currently supports its activities through independent commissions and grants for the expansion and restoration of the *Great Wall*, but its position within the politics of City funding is still precarious. Even without City money, SPARC receives commissions across the country as well as major foundation grants, and runs on an annual operating budget averaging between $750,000

and $920,000 (a much smaller sum than Philadelphia's program, serving a much larger population). According to executive director Debra J.T. Padilla, it is important for the program to stand up unapologetically for its right to compensation. SPARC has provided services to care for the cultural needs of an underserved community, negotiate gang truces, and encourage desperate young people to put their lives together, while simply telling the history of the city for all to see.[18] The whole population benefits from these public services, but many still hold the view that artists should produce a three-story mural for $500 and a few buckets of paint.

Although the Neighborhood Pride program is currently on hold, SPARC has created a new and unique opportunity to teach muralism in Los Angeles outside of the traditional apprenticeship method. In addition to SPARC's collaboration with UCLA, the center is initiating an MFA in community cultural development at Antioch University, with the first classes starting in the autumn of 2006. The only terminal degree that teaches mural arts, the program provides a chance for experienced muralists to teach at college level, and for young people to learn the ins and outs of mural production. As with many nonprofit, community-based arts organizations in the country, SPARC's challenge is sustaining itself, although this depends on the disposition of funders and the City. But with thirty years of survival and community support, the organization is prepared to change formats with the changing needs of the times, from acrylic to digital vinyl, from neighborhoods to the web. While the artistic and outreach processes have remained the same, SPARC's adaptability will continue to ensure its longevity.

II. Medium-sized metropolis: Mural Arts, Philadelphia

The sixth-largest metropolitan area in the country, Philadelphia experiences an ongoing struggle with urban blight. The City took a tough stand against rampant graffiti in the 1970s and 1980s with a powerful Anti-Graffiti Network, staffed by trained artists under the direction of muralist Jane Golden. Golden began in Philadelphia with the anti-graffiti group, working on the street in conditions optimistically considered "adventurous." Her grassroots fearlessness brought her in touch with troubled youth and passionate graffiti writers, many of whom eventually came to work with her on murals for the city.[19] Rather than simply whitewashing the tags, Philadelphia created a program for the youth—an alternative means of communication on city walls. While the early program was sometimes successful in its aims of education, outreach, and graffiti patrol, the organization evolved into the Mural Arts Program in 1984 and grew with the experience of working throughout the city. By 1996, the City recognized Mural Arts as a separate entity from the Anti-Graffiti Network, and Golden ran the nonprofit organization as an affiliate department to the City. Now the program runs on an annual budget of over $5 million.

In its early days, the Anti-Graffiti Network sought the help of young graffiti writers and school-children, offering pay to youth as part of an employment program. The resulting murals were generally homespun, involving many participants but without a clear aesthetic standard. Golden, a college-trained artist inspired by Mexican mural art as well as the Works Progress Administration muralists, was interested in bringing the citywide mural program to the next level. She brought in Los Angeles-based muralist Kent Twitchell in 1990 to produce the stunning *Julius Erving (Dr. J)* mural. Twitchell's technique included adhering parachute-cloth panels to a three-story building. He portrayed the basketball star in a suit, emphasizing the local hero's contributions as a community leader and icon beyond his performance on the court. The visual impact of the mega-scaled portrait raised the standard for murals throughout the city.[20]

Mural Arts still employs professional muralists. It also engages community members in the design process, even though the muralists and their assistants execute the final artworks themselves. The program garners support at a local level, petitioning for murals door-to-door. Mural Arts is also not afraid to take on difficult history, for example a mural commemorating the civil rights struggle of the gay, lesbian, and transgender community. Numerous murals illustrate such local heroes as community activist Herman Wrice and, more controversially, Frank Sinatra. The murals also celebrate local and African American histories through such depictions as a former mural portraying Harriet Tubman and scenes from the Underground Railroad. Some murals simply celebrate local traditions, such as Robert Bullock's *Welcome to Mummerland*, commemorating South Philadelphia's annual Mummers Parade. Other murals show anonymous children bearing their dreams and aspirations. Golden has worked to define her identity as a positive community rôle-model and a white woman working in many predominantly black neighborhoods without alienating the local populace.[21] Mural-making has sometimes proved to be a healing and cathartic experience for the communities involved in the design process, and has restored a semblance of pride and ownership to citizens in crumbling neighborhoods.

Mural Arts holds free art classes, serving 1000 Philadelphia students each year. In the arts community, the program employs more than 300 muralists. On the walls, 2400 murals attest to the program's success. Today, over 5000 people attend mural tours annually.

III: Urban arts in the small city: Friends of Community Public Art, Joliet, Illinois

The small working-class city of Joliet—population 136,000—sits 35 miles southwest of Chicago. As in Philadelphia and Los Angeles, muralism in Joliet began with the leadership of an artist inspired by the global mural heritage. Lead artist and co-founder Kathleen Farrell studied at the Public Art Workshop in Chicago (parallel to but separate from the Chicago Mural Group). She takes her inspiration not only from descendants of the Mexican tradition, but also from the span of art history all the way back to cave paintings. When Farrell returned to school to obtain a Master's degree in community public art, she selected an ambitious thesis: to create a mural program in Joliet in 1975. With partner Val Richards (and in 1977 artist Kathleen Scarboro), Farrell found donated materials and used money from President Carter's Comprehensive Employment and Training Act (CETA) to pay the assistants who helped produce the murals while learning the skills involved in mural painting. Around the country, the late 1970s provided an opportunity for the birth of mural programs that has never been duplicated since CETA created the chance for unemployed workers to be paid to learn a variety of skills (much like the famed Works Progress Administration of the 1940s).

With a handful of successful projects under its belt, the program was hit hard by the 1980s budget crunch, and funding was cut to all the organizations that supported Joliet's murals. After this forced hiatus, Farrell emerged again and quickly got back to work. She and her colleagues built support for their work one mural at a time, slowly convincing the community that murals were not simply feel-good Saturday-afternoon projects in poor neighborhoods. Farrell also received help from Jim Haller, an arts-friendly head of Community and Economic Development within the City. Joliet was fortunate: neighboring city Aurora banned murals, treating them in much the same way as graffiti troubles. After eight years of fruitful projects, the Friends of Community Public Art (FCPA) incorporated in 1998.[22] The group employs fifteen artists, and is hired by the City on a per-commission basis to work throughout the community, usually with particular ideas in mind for each project (supplied

RIGHT Ann Northup and
Larissa Danowitz, *Pride
and Progress*, 2002,
Philadelphia. Photo: Jack
Ramsdale.

BELOW Robert Bullock,
Welcome to Mummerland,
1999, South Philadelphia.
Photo: Jack Ramsdale.

BELOW, RIGHT Kent
Twitchell, *Julius Erving
(Dr J)*, parachute cloth,
1990, Philadelphia. Photo:
Don Springer.

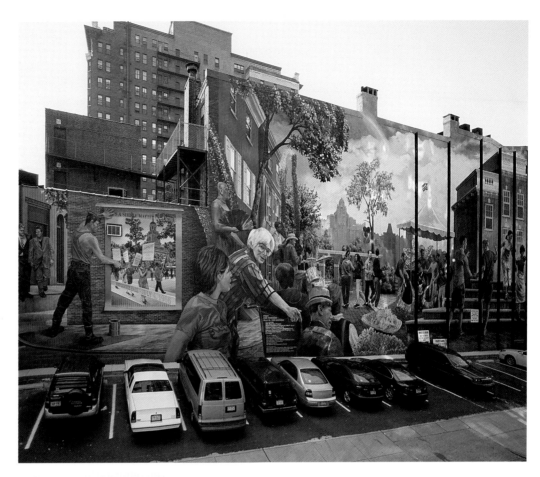

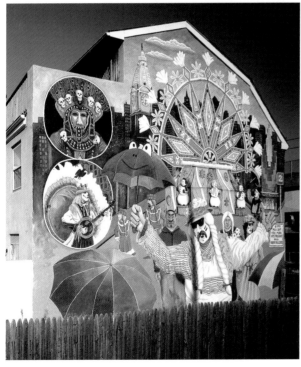

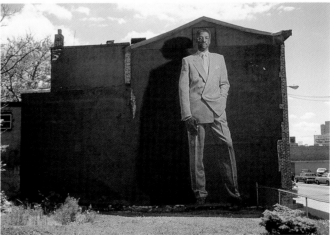

by FCPA), which the group explores in community meetings. Other towns in the region hire FCPA to create public art in nearby communities.

The artistic goals of the program were to bring first-rate art to the city's decaying downtown and to tell the community's working-class history. The struggles that FCPA tackled derived from the history of workers' rights, civil rights, and immigration. Content-building comes through meetings between community members and artists, as well as city councilmen. According to Farrell, an artist "might go in with one concept and the community has another. Then you thrash it out until you find a common design. I find that this does not compromise the design."[23] FCPA goes through an annual planning process to cover missing links and new opportunities across the city, addressing a variety of themes, from changes in the built environment to histories of local immigrant groups. They speak to community leaders, city councilmen, officials in schools and parks, heads of community centers, and people off the street in neighborhoods across town to scout out new opportunities.

The first mural that Farrell's group sponsored was a story of the city, meant to address racial tensions. Farrell brought in famous Chicago muralist Alejandro Romero in 1991 to create a first-rate mural with a big impact. Since then FCPA has created over eighty murals, as well as mosaics and sculptures. FCPA's advisory board includes as many local historians as it can find, as well as citizens from the entire spectrum of Joliet's population. According to Farrell, one major difference between the tourist-oriented mural towns and Joliet is FCPA's willingness to tackle the gritty realities of history, such as portraying dead strikers and commissioning civil rights murals. But Farrell is not above what she considers minor rewrites of history, such as painting clothing on to historically situated Native Americans who would more accurately have appeared naked.

Farrell has also found that respecting the taste of the community does not dictate the style of murals, although with FCPA's sculpture program, community members resist abstraction to a greater degree. She says,

> There's no reason you can't have abstraction. We have abstraction in all of our murals. But you can't come in as a know-it-all administrator We find that as long as you have beautiful colors and some figurative elements, people will go along with a lot of things.[24]

For Farrell, respecting community desires and finding common ground has never forced her to compromise the quality of the artwork. On a technical level, professional, trained artists create all of FCPA's outdoor murals. This has assured consistency in the program's output.

Community members can begin learning the art form as assistants to lead artists, in a traditional apprenticeship context. FCPA does not train students from scratch: they must seek out classes to attain basic drawing skills. But the organization encourages locals to learn the trade once they have demonstrated some commitment. The diversity of the program relies on recruiting local artists from all parts of Joliet society. Two lead artists eventually emerged from the group's first mural class in 1991.

Farrell has moved from creating traditional acrylic murals on stone and concrete to using new technology. FCPA still creates some traditional murals, the ones that draw crowds and rally a community behind a project, generating anticipation. But working in the studio on MDO (medium density overlay) signboard allows artists to work through the brutal Illinois winter, avoiding such inconveniences as pigeons, scaffolding, and exfoliation. It also allows for more convenient repair and maintenance of the murals, although graffiti has not been a problem, excepting the occasional handlebar moustache added to an old lady.[25] Furthermore, building owners who wouldn't have

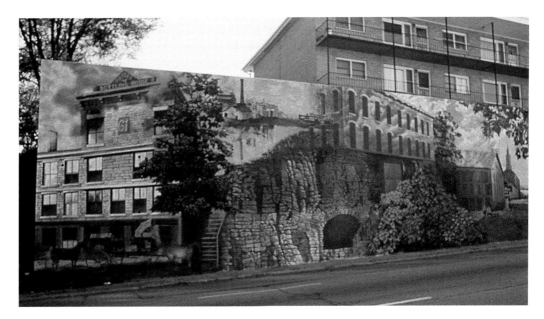

RIGHT Kathleen Farrell and Kathleen Scarboro, *Bluff Street Architecture in 1840*, acrylic on concrete, 1995, Joliet. Photo: courtesy of Friends of Community Public Art, Joliet.

CENTER, RIGHT Kathleen Farrell and Kathleen Scarboro, *Bustling Bluff Street in the 1800s*, acrylic on concrete, 1995, Joliet. Photo: courtesy of Friends of Community Public Art, Joliet.

BELOW, RIGHT Alejandro Romero, *Visions of Joliet*, acrylic on plywood, 1991, Joliet. Photo: courtesy of Friends of Community Public Art, Joliet.

BELOW, FAR RIGHT Carla Carr, *Visions from a Dream*, acrylic on MDO signboard, 1998, Joliet. Photo: courtesy of Friends of Community Public Art, Joliet.

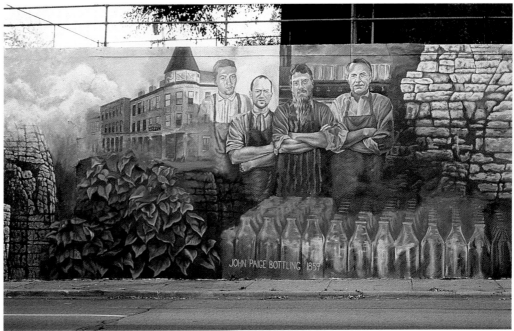

The Mural Towns

Karl Schutz's mural-town phenomenon has emerged in all corners of the country, from such gritty industrial cities as Steubenville, Ohio, to such tiny gold-rush villages as Twenty-nine Palms, California, as well as in a handful of international examples. The formula is basic: a down-on-its-luck community plus citizen advocate brings in historical murals to encourage tourism and increase the motivation to enhance the downtown area. Schutz believes that towns across the world can participate in the movement because each has a unique history.

In truth, the histories of so many communities look similar, and sometimes the same circuit of artists will create murals across the nation in uniform styles. The lack of inventiveness may be irrelevant if the town achieves first-rate work and is not competing with a neighboring community for the same "mural town" status. Schutz tells towns that the "wow" factor is of prime importance in selling tourists and locals alike on the idea of the mural town. Mural towns are often citizen-led, unlike the artist-led urban mural programs, so they address more directly the desires of neighborhood revitalization activists rather than the needs of an arts community.

In Canada, one central database depicts murals along a map of "Mural Routes" across the country from Pacific to Atlantic. The website shows the first inkling of an awareness of the mural-town phenomenon and how to harness it for tourism, organizing the movement as a coherent whole. The Mural Routes group has existed since 1994 to promote the creation of murals that commemorate the character of communities.[33] It has also sponsored seventeen murals so far in its *own* community, alongside the Scarborough Arts Council, near Toronto. The website is also a central resource, advertising calls to artists and conferences; it is also a mural-production resource guide. In the United States, mural towns appear to bubble up out of the ether, run by community leaders who want to insert some vim into the life of the town or to pick up a sagging economy.

Mural towns have the chance to bring community members together to create a narrative of their histories, while exploring the past lives of the cities or towns. Reproducing archive photos of downtown or neighborhood centers may help artists to bolster both the myths and the realities of place. In locales of urban decay, a depiction of earlier vitality may incite a community to set the bar higher than the run-of-the-mill highway exit "main street," dominated by signage from gas stations or fast-food chains. Making visible the changes in cityscape that a community has experienced is a method of interpretation, even in its simplest form. The following case studies look at a few examples of mural towns and the effects that this transformation has created in Steubenville, Ohio, as well as the Historical Society Murals in Portland, Oregon. Other prominent mural communities studied for the preparation of this research include Paducah, Kentucky; Toppenish, Washington; York, Pennsylvania; West Seattle; and Exeter, California.

Steubenville: City of Murals

STEUBENVILLE, OHIO

Robert Dever, *Dean Martin.*

In 1986, the Downtown Business Association searched for a way to revitalize the center of this gritty steel-and-coal town on the banks of the Ohio River. Louise Snider, the district's executive director, had heard about Chemainus, British Columbia, the famous first "mural town." While such has-been towns as Steubenville are strewn across the North American landscape, few have introduced such innovative programs to combat decay. The murals had turned the heart of Chemainus into an outdoor gallery, drawing nearly half a million visitors annually. Within a year of meeting Karl Schutz, the architect of Chemainus's successful program, Snider and Steubenville were well on their way to replicating the revitalization scheme. Two decades later, Steubenville business leaders attribute a flurry of restoration activity and the arrival of more than three hundred

tour buses a year, to a project that has grown well beyond its planners' grandest expectations.

The project's success was not always so certain. Snider and her associates managed to raise enough money to begin the first mural, largely drawing on the support of local banks interested in the prospect of downtown revitalization. The mural backers recognized that the support of the townspeople would be crucial to secure enough funding to progress beyond the initial mural, so they meticulously planned each step of the process. After combing through hundreds of old pictures and documents, scouring the downtown for the perfect strategic site, and searching far and wide for an artist, a committee picked Michael Wojczuk of Colorado to create a historical mural depicting the first retail area of old Steubenville.

Project description

Twenty-five murals depicting local history grace the sides of buildings in downtown Steubenville

Artists

Various (locally, nationally, and internationally known muralists)

Agency

Downtown Business Association

Date

March 1986–present

Dimensions

Various

Cost

$15,000–$30,000 each mural, from private sources (local banks, etc.), fund drives, fees from tour groups, Ohio state funds for economic development, and arts grants

Photography

Courtesy of Steubenville: City of Murals

The goals of the mural project were threefold. First, the City wanted to create such an ensemble that the downtown's "gallery" could become a tourist destination. It hoped to use tourism to launch itself into a service-oriented economy, replacing the fading industrial sector. Secondly, the murals were to act as an impetus for capital improvements in the downtown. Planners hoped that the sprucing-up of unsightly blank walls would encourage district-wide beautification. Finally, the murals were intended to teach local history and unify the community around this narrative.

Description While there was initial apathy, and even some opposition to the mural project, enthusiasm and support grew in all sectors as the first mural, *Market Street*, took shape above a parking lot on the side of the World Radio Telecommunications Building downtown. The production itself became a small tourist attraction, as townspeople gathered around Wojczuk daily to see him progress on his life-size snapshot of turn-of-the-century Steubenville. The 60 × 30-ft mural depicted a bustling Market Street awash with the colors of passersby, trolleys, and horse-drawn carriages. Wojczuk, who had created more than thirty-five murals around Denver and his adopted hometown of Boulder, returned to the state of his alma mater, Ohio University, and in his own homecoming helped re-create a place

unknown to all but the oldest Steubenvillians. *Market Street* was a smashing success, and hundreds turned out for the official dedication.

With increased public support and funding from many private sources, and some Ohio state economic development and arts initiatives, more images began to adorn the forgotten walls of Steubenville. Diverse subjects and styles were chosen by a team of local, national, and internationally known artists, all centering on a theme of historical interpretation.

Local, self-taught artist Donald Toth brought a slice-of-life nostalgia to his *White Star Market*, a 35 × 34-ft depiction of the interior of a 1920s grocery store. The inclusion in the mural of famed sports commentator Jimmy "The Greek" Snyder, whose father owned and operated the old White Star Market, not only honored Steubenville's native son, but also reminded townspeople of the melting-pot nature of the town that has welcomed immigrants throughout its history. Jimmy the Greek joins artist Robert Dever's Dean Martin in peering out from murals on to the town they once called home. Bordering on kitsch, the famous crooner's mural depicts Martin strolling down a lavish red carpet. In contrast, Dever's *Rotary Club* shows a freeze-frame of normal life. Rotary Club board members sit in a meeting, while text explains the organization's contribution to the community; there is also a portrait of a nurse tending to a young girl.

Eric Grohe, *Steel*.

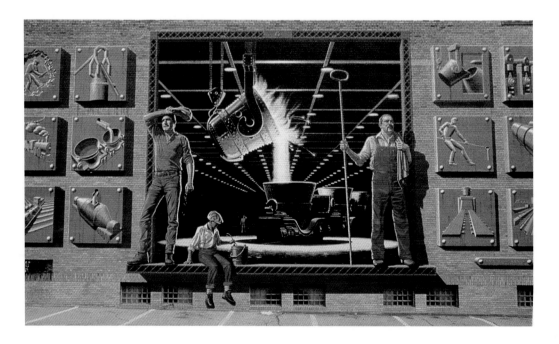

RIGHT Robert Dever, *Rotary Club.*

CENTER, RIGHT Michael Wojczuk, *Seminary Ladies.*

BELOW, RIGHT Eric Grohe, *Centennial Arch.*

While some murals depict generic Americana, and others show specific institutions or events of Steubenville's past, still others focus on the religious heritage of the city. *Religious Beginnings*, a 32 × 42-ft collage by artist Robert Dafford, includes various clergy, the Dominican Sisters of St. Peter's School, and John Neumann, a priest who lived at St. Peter's in 1841 before becoming Bishop of Philadelphia, and who was later canonized by Pope Paul VI. Among other murals depicting religious topics is Wojczuk's *Seminary Ladies*. The 42 × 13-ft celebration of the seminary's reading club is set in the garden of the 1829 school that faltered and closed because of declining enrollment during the Civil War. The crown jewel of the "collection," however, is Eric Grohe's massive *Centennial Arch*, which, at 30 ft tall and 100 ft long, is known as the "Super Mural." The viewer looks through "arches" back to a vignette of the city a century ago. Grohe also commemorated the city's backbone industry with his 45 × 90-ft *Steel*, which shows workers taking a break from a day's labor at the plant, with twelve *trompe l'œil* steel plaques depicting phases of production.

Design impact While Steubenville's outlook for the future is one of guarded optimism, the success thus far has been significant. Tourism, an industry previously unknown to this self-proclaimed "hard-core steel and coal town" has provided a steady stream of revenue. Shops, restaurants, and motels welcome the three hundred buses of senior citizens, tour groups, and schoolchildren that take in the outdoor gallery each year. City officials estimate that ten thousand people also make the trip to downtown Steubenville to see the project first-hand. In addition, the city's first-ever tourist information booth has opened to service the new hordes.

Following the tourists downtown is a steady stream of capital improvements, as shopkeepers old and new refurbish their storefronts and pay closer attention to the significance of downtown's aesthetic elements. Since the project started, eight new businesses have opened in this small town of twenty-five thousand inhabitants, and Community Development Block Grant funds of $437,000 have helped restore nine façades, while another fifteen façades await restoration. Most

dramatically, local entrepreneurs William and Juanita Welsh have cashed in on the increased tourist traffic downtown to open a $1 million Jaguar Classic Car Museum, complete with an arcade of shops and a Jaguar-themed restaurant, all centering on the "Super Mural." Old Fort Steuben, depicted in a 41 × 26-ft mural by Jack Isaac, is being reconstructed as a museum on the site where it was built as protection for early survey teams in 1787, when Ohio was part of the Northwest Territory.

While the murals have achieved the goals of bringing in tourism and stimulating capital investment, it seems as though the final goal of community education has been reached as well. The murals are incorporated into art and history curricula at local schools, and students from the entire region take lessons from the gallery on many excursions each year.

Despite these glowing endorsements for the *Steubenville: City of Murals* project, Steubenville could ultimately be a victim of its own success, as deteriorating cities in the Rust Belt and beyond seek to copy the model. Cities around the United States and Canada have adopted the town-revival formula. While faraway locales and isolated programs pose little threat to Steubenville's tourist trade, Ohio cities, such as Portsmouth, Canton, and Massillon, have already established similar projects that threaten to drain the present stream of people touring Steubenville. (For illustrations of Portsmouth's murals, see p. 101.)

Most local merchants report an upswing in business due directly to the murals. As the project matures, the early consensus about the murals has eroded somewhat, while townspeople debate what is a proper and decent representation of Steubenville history and what is frivolous or shameful. One group of citizens wanted a mural to depict the many brothels that once lined the Ohio River, which, despite their shady character, were an important part of the city fabric. The supporters were soundly defeated.

While there is indeed a level of skepticism about the future, most people in Steubenville consider the mural project a success: it is an inexpensive way to invigorate the economy, educate the townspeople about the historical importance of their city, and revive a town rich in history through the dramatic changes that industrial shifts have forced upon it.

Oregon History Murals

SOVEREIGN HOTEL • PORTLAND, OREGON

Richard Haas,
Second Perspective.

In 1989, the Oregon Historical Society commissioned artist Richard Haas to install two murals on two walls of the Sovereign Hotel in downtown Portland, where the society maintained its offices. Haas designed these two perspectival *trompe l'œil* murals commemorating Oregon's history in anticipation of the 1993 anniversary of the Oregon Trail.

When Thomas Vaughan first came to the Oregon Historical Society in 1954 as director and general editor, the organization held no property. He wanted the society to own a strategically located site, so that its large research library would be easily accessible to researchers and the public. Unfortunately, the property donations from both the City and the private sector were inconveniently located away from the city's vital core. The society programmed a building scheme for a full block of downtown Portland property. Over a thirty-year period the society acquired twenty-one separate parcels of property along a strategic block, located close to the library, the art museum, the university, and along public transportation routes, all obtained entirely through private funding.

The final building that the society acquired was the Sovereign Hotel, a nine-story Georgian building and national landmark designed by Portland architect Carl L. Linde and completed in 1923. The concrete-brick structure boasts some of the finest terracotta trim in the state. Since 1989, the lower floor of the hotel has housed the Oregon Historical Society's administration, press office, and

Project description

Oregon Historical Society renovation of the Sovereign Hotel

Artist

Richard Haas

Agency

Oregon Historical Society

Date

1990

Dimensions

Two murals, one on the west wall (46 × 81 ft) and the other on the south wall (38 × 83 ft)

Materials

Keim Silicate (special silica-based paint formulated to withstand weathering on concrete surfaces) on brick

Cost

$225,000

Photography

Courtesy of the artist, Peter Mauss/ESTO, and Douglas Kahn

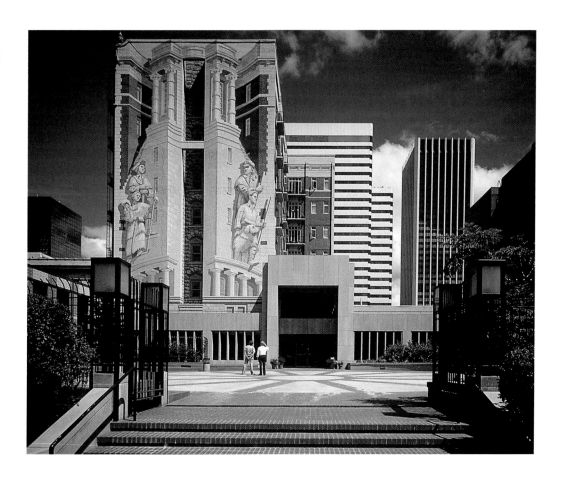

North American Pacific Studies Center as well as public reception and gallery spaces.[34] Today, a division of the society still operates a hotel out of the other floors of the building.

The Sovereign Hotel perpetually posed a problem for the society. Among all the buildings on the block, the hotel stood tallest, and two walls were "a heavily fenestrated scabrous mass of faded pink reinforced concrete slowly powdering in the famous sun and rain of Portland."[35] Thomas Vaughan discussed this visible problem with numerous colleagues and architects. Eventually, recollections of illusionist murals in Boston by artist Richard Haas provided the answer. Haas and his *trompe l'œil* murals could correct the aesthetic disaster and provide a continuation of Oregon's historic traditions. It was also directed that the mural should be grand because of its architectural scale: the artist needed to paint an entire visual field in the cityscape, creating a handsome and commanding presence that would transcend blank walls. There had to be architectural substance, not simply an eye-catching spectacle. Haas had to respect the Historical Society's preservation values while, ironically, creating something entirely new and innovative that appeared to synchronize with the past.

Description The two murals, designed to honor the state's past, depict scenes from Oregon's pioneer history. One faces a busy street and the other a serene park. The west mural (facing the street) features key members of the "Corps of Discovery" led by Captains Meriwether Lewis and William Clark across the continent from Missouri to the Oregon coast in 1804–05, including their Shoshone guide, Sacagawea; her infant child, Baptiste; and Clark's slave, York. The architectural details in the mural repeat the details on the building's façade.

The south mural (facing the park) represents Oregon's early development. The right-hand side includes tributes to the Pacific Northwest's Native American tribes and to the fur trade that first brought Europeans in contact with these tribes. On the left-hand side, covered wagons and oxen represent the overland migration to the Oregon Country in the mid-nineteenth century. The Oregon Historical Society wanted an inclusive mural that portrayed Lewis and Clark, as well as the other individuals who journeyed with them, including the slave York. Furthermore, the primary benefactor wished for the fur trade and the Oregon Trail to be displayed.

Haas did his research at the Oregon Historical Society and in New York. Portland artists Cynthia Martin, Pattison Skoshe, and Steve Baratta, along with Larry Zink of New Orleans and Harley Barlett of Rhode Island, executed the murals. They transferred a $1/24$-scale drawing by Haas on to the hotel walls with a special silica-based paint formulated to withstand weathering on concrete surfaces. This was part of an ancient German technique rediscovered by Haas that guaranteed several generations of colorful life.

Haas's prolific career as a historical muralist has generated examples of work infused with figural vitality, architectural detail, and place orientation. In 2001, he painted historical maps from different periods of Nashville's history in the city's main public library. In Kansas City, Kansas, in 1994, the artist created a mural entitled *Justice and the Prairie* for the Courthouse and Federal Building, when the General Services Administration hired him to interpret elements of the conception of justice from the history of the site. The mural depicts Native Americans and whites in a historical setting; a figure embodying justice presides over the scene.

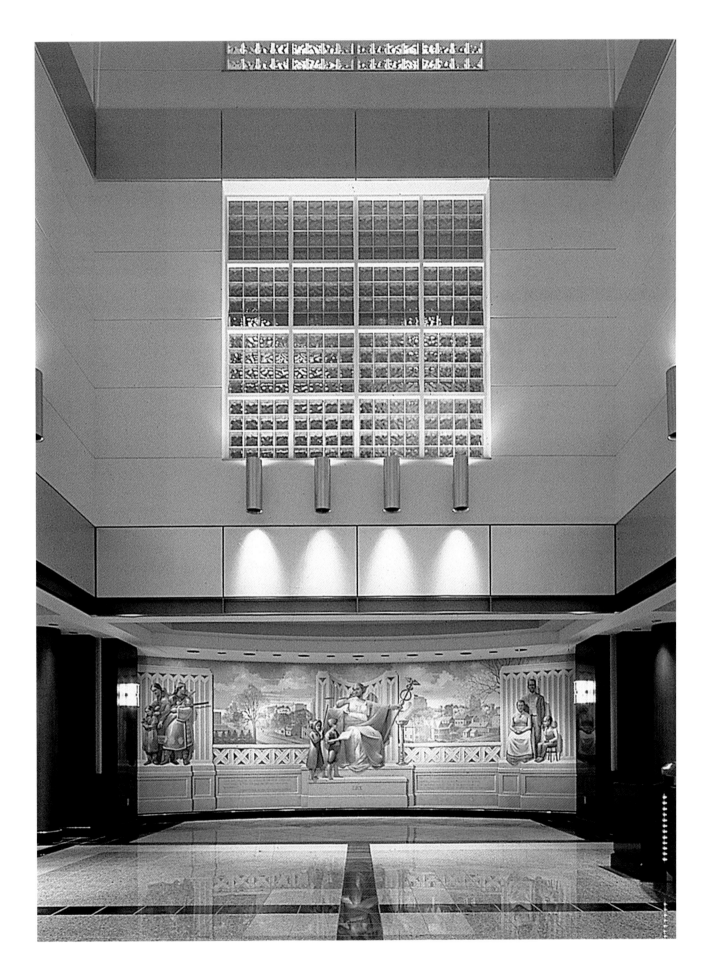

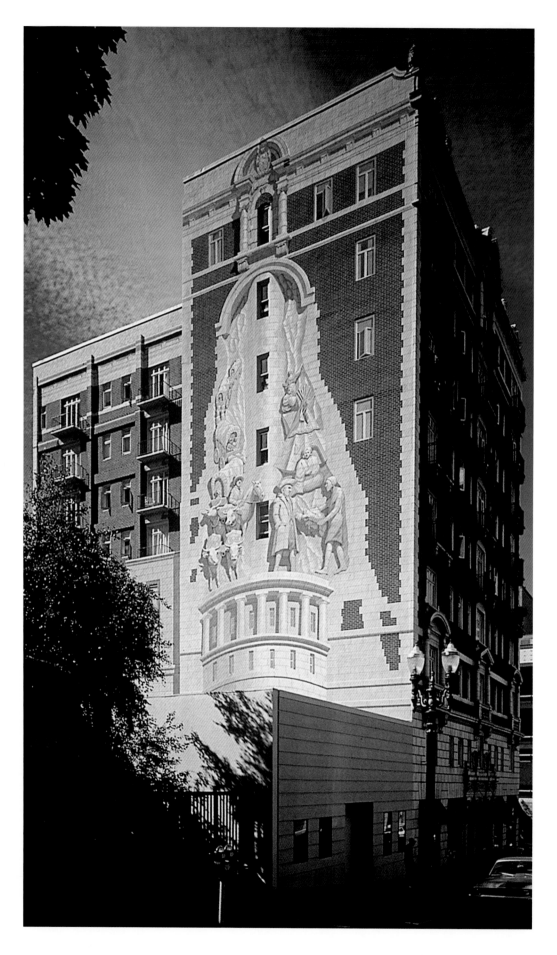

Richard Haas, Oregon
Historical Society mural,
1993.

Design impact The Oregon murals project was accomplished entirely by the private sector, without public funding. The Collins Foundation of Portland covered the cost as part of a $4.5 million expansion and remodeling project, also privately funded. The Building Committee of the Oregon Historical Society was the only organization involved in the process.

Important to this case was a single advocate, Thomas Vaughan, who left the Historical Society before the project's completion. Haas stated that the murals would never have been realized without Vaughan's influence in the city. The entire community supported Vaughan, as he had diligently served the society for nearly forty years and helped make Portland a national leader in the preservation movement. The committee trusted Vaughan's suggestions and therefore trusted Haas. Vaughan wanted the murals to engage the common passerby, thus causing reflection on their significance and inviting

the public to visit the Historical Society. The murals relate to and harmonize with the adjacent buildings; they are sensitive to architectural detail and give the illusion of claiming three-dimensional space in the cityscape.

High in the skyline, the Haas murals exert a uniquely personal and symbolic energy in Portland. They enhance the city's urban scene as points of visual and architectural interest. Vaughan believes that "the murals have created a whole new interest in downtown Portland." Although the initial purchase of the city block and the decision to paint the murals met with protest, now "crowds crane to see the pleasurable and instructive work that Haas gave to Portland."[36] Just as Boston's Haas mural inspired the murals in Portland, these have in turn encouraged the creation of other *trompe l'œil* murals and wall paintings throughout the Pacific Northwest, from the sides of superstores to the walls of apartment complexes.

1 See "Millennium Park," Wikipedia, en.wikipedia.org/wiki/Millennium_Park, accessed February 15, 2006.

2 In Cambridge, Massachusetts, The Townscape Institute has proposed an amendment to the city's signage ordinance to prevent businesses from using large-scale window space to place permanent signage and corporate branding, which would be code violations if they were situated on walls. A Staples chain store near Harvard Square has changed the character of a historic park-side street by using a swath of red along its storefront. Such brand coloring is difficult to legislate against, but can be as insidiously destructive of locale as a massive billboard.

3 This prominent theory makes the simple but controversial claim that a compounding sense of physical disorder in run-down neighborhoods promotes a sense of lawlessness and indirectly encourages criminality. It was first raised by James Q. Wilson and George L. Kelling in "Broken Windows," an article published in *Atlantic Monthly* in March 1982.

4 See Jon Spayde, "Six Loaded Questions for Contemporary Muralists," *Public Art Review*,

Autumn/Winter 2005, pp. 28–29.

5 See Melisa Rivière, "Graffiti and Aerosol Art," *Public Art Review*, Autumn/Winter 2005, pp. 25–27.

6 See Robin J. Dunitz and James Prigoff, *Walls of Heritage, Walls of Pride: African American Murals*, San Francisco: Pomegranate Communications, 2000.

7 See Chemainus homepage, britishcolumbia.com/regions/towns/?townID=31, accessed February 5, 2006.

8 Kathleen Farrell, lead artist and co-founder of Friends of Community Public Art, Joliet, Illinois, interview, December 21, 2005.

9 Robert Dafford, mural artist, Lafayette, Louisiana, interview, May 7, 2003.

10 See Carol Pogash, "Bumper Crops For the Eye," *New York Times*, February 2, 2005.

11 See Jack Becker, foreword, *Public Art Review*, Autumn/Winter 2005, p. 9.

12 Case studies of Chemainus can be found in Ronald Lee Fleming and Renata von Tscharner, *Place Makers: Public Art that Tells You Where You Are* (New York: Hastings House, 1981, and San Diego: Harcourt, Brace, Jovanovich,

1987), identifying this groundbreaking initiative before the phenomenon became an international trend.

13 Karl Schutz, mural program consultant and pioneer of the murals in Chemainus, British Columbia, interview, July 18, 2003.

14 See Jane Weissman and Janet Braun-Reinitz, "Community, Consensus, and the Protest Mural," *Public Art Review*, Autumn/Winter 2005, pp. 20–23.

15 See Wendy Thermos, "Immigration Protest in Baldwin Park is Peaceful," *Los Angeles Times*, June 26, 2005.

16 See Judith F. Baca, "Birth of a Movement: 30 Years in the Making of Sites of Public Memory," November 9, 2001, accessed online.

17 See UCLA/SPARC César Chávez Digital/Mural Lab, at the SPARC website, sparcmurals.org.

18 Debra J.T. Padilla, executive director, SPARC, interview, February 14, 2006.

19 See Jane Golden, Robin Rice, and Monica Yant Kinney, *Philadelphia Murals and the Stories They Tell*, Temple University Press, 2002.

20 *ibid.*

21 *ibid.*

22 See Jeff Huebner, *Murals: The Great Walls of Joliet*, Chicago: University of Illinois Press, 2001.

23 Farrell interview, December 21, 2005.

24 *ibid.*

25 Terry Plesnick, artist, Friends of Community Public Art, Joliet, Illinois, interview, December 21, 2005.

26 Farrell interview, December 21, 2005.

27 *ibid.*

28 *ibid.*

29 *ibid.*

30 *ibid.*

31 *ibid.*

32 *ibid.*

33 See Mural Routes website, muralroutes.com.

34 Oregon Historical Society brochure.

35 Thomas Vaughan, former director, Oregon Historical Society, correspondence.

36 *ibid.*

Poet's Table

HUNTINGTON BEACH, CALIFORNIA

Project description

A glazed ceramic tile mural on the pier, depicting elements from Huntington Beach history

Artist

Terry Schoonhoven

Agency

Huntington Beach Cultural Services Agency

Date

1998

Dimensions

38 × 9 ft

Material

Ceramic porcelain tile

Cost

Materials $7,500
Installation $4,500
Artist fee $24,500
Miscellaneous $3,500
TOTAL $40,000

Photography

Courtesy of the artist

HUNTINGTON BEACH, once a thriving beachfront suburb of Los Angeles and a favorite play spot for movie stars, tourists, surfers, and other beach-goers, had by the 1980s deteriorated into a poorly maintained string of vacant storefronts. In the hope of revitalizing the area, the city's pier was rebuilt in the early 1990s, and in 1998 citizens accepted the proposal of a Mediterranean-style entry complete with plaza to enhance the area. Ann Thorne, a public-arts consultant based in Orange County, suggested that the City include art in the project. This was met with enthusiasm from city administrators and council members and led to the commissions that decorate what is now known as the Huntington Beach Pier Plaza.

Public art was, at the time, a novel concept for Huntington Beach, and the two Pier Plaza commissions—the late Terry Schoonhoven's *Poet's Table* mural and Lloyd Hamrol's sculptural amphitheater—marked the first integration of art into the city's public space. There were no established guidelines to direct the public art process, nor was there a budget for it, so administrators and consultants had to find innovative ways to fund projects and select artists. The City joined together with local restaurant developers to fund the Pier Plaza commissions, coming up with $40,000 for *Poet's Table*, which planners decided to incorporate into preexisting design elements to reduce the cost.

City officials chose a limited number of artists, based on their past public work, to submit designs for the mural. Ann Thorne then provided those artists with research on the history of Huntington Beach to be integrated into their proposals, and acted as a liaison between the artists and the community, conveying citizens' concerns to be considered in the design proposals. Eventually, the planning team selected Schoonhoven to carry out his mural, and the result was *Poet's Table*, which draws attention to the area's history, including its discovery, industrial period, and surf culture, using unusual perspectives and chronologically disjointed juxtapositions.

Schoonhoven's past work in public art was well known throughout the region. In the late 1960s, that era of protests, riots, and colorful street life, he and three other Los Angeles

artists formed the Los Angeles Fine Arts Squad, a group dedicated to bringing art out of the studios and on to the streets. Fascinated by Los Angeles's landscape of billboards and giant neon signs, they painted large, vivid murals around the city. The best known is *Isle of California*, a fantastical portrait of an earthquake-ravaged Los Angeles. Although the Fine Arts Squad split up in 1973, Schoonhoven continued to paint murals, taking his work to subway stations, Las Vegas Airport, commercial centers, hospitals, and office buildings. Although *Poet's Table* was not as radical as his Fine Arts Squad murals, he did employ a decidedly atypical treatment of local history.

Description *Poet's Table* decorates a cement wall separating the parking lots from the amphitheater and plaza. As the wall is in a high-traffic public place right on the beach, Schoonhoven needed to use a durable material that would withstand the rigors of salt air and possible vandalism. He chose a

porcelain tile impervious to water absorption, as the more common low-fired clay would not have held up. The mural's pastel colors, though somewhat muted because of the ceramic firing process, offer a bright contrast to the gray-hued cement and flagstone that make up the plaza in front of it. All these decisions were made on the basis of Schoonhoven's rigorous pre-study of the commission:

> I have a certain process I go through for this type of project. I usually start by visiting the site to get the ball rolling. I went down to the pier that first day but nothing excited me. I had only these vague ideas about representing the poet at his table. But then I walked under the pier, and looked out at the interesting perspective of columns advancing to the sea like an old loggia. It is a dynamic perspective, which carries the mural, the columns, and the difficult shadows of the columns. The architectural perspective is the centerpiece; the figures interact around it.[1]

View of *Poet's Table* from the Pier Plaza.

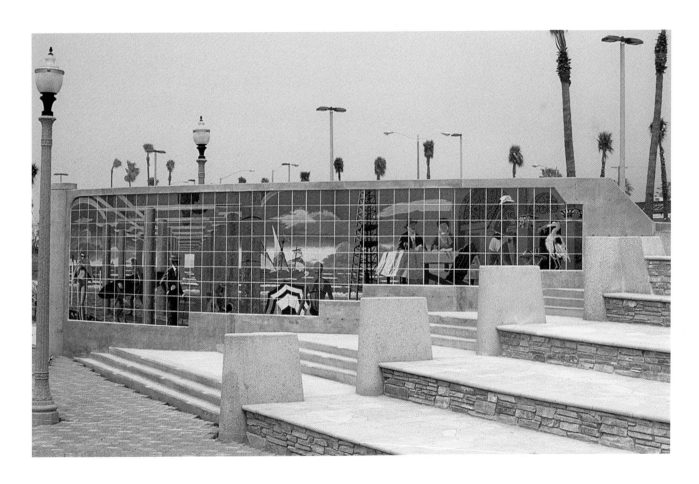

Details of *Poet's Table*.

On the left third of the mural, characters walk between the pier's repeating columns, which extend infinitely into the ocean. One man carries a surfboard through the pilings. Other people, dressed in the styles of different Huntington Beach eras, also stroll along the sand, woven among the columns. Schoonhoven explains his inspiration for this unusual perspective: "The focal point of this mural is the eye-catching table that is situated so that the poets occupying it are at eye-level with the viewer, who sees a landscape of anachronistic elements in which different eras of Huntington Beach's history interact in novel ways." Bathers in 1950s-style costume face a sixteenth-century ship, which heads toward a café built in 1930, famous for its patrons of the 1960s and 1970s. He adds: "I tried to treat the timeline more poetically. It does have historical elements, but they are arranged in a dreamlike manner."[2]

Schoonhoven deliberately chose figures to represent the city's past. A surfer, a nod to Huntington Beach's nickname, "Surf City," walks toward the real ocean. A Portuguese caravel, presumably Juan Cabrillo's *Sao Salvador*, in which he first discovered the locale in 1542, heads into the harbor. Near the poet's table on the horizontal plane is an industrial steel-ribbed tower representing the oil industry's rôle in community growth. To the far right we see the Golden Bear café, a swanky jazz club popular in the 1960s and 1970s with the Hollywood set and the art set. The building was demolished in 1995, and, as Schoonhoven states, "it is a typical American irony to tear down a landmark building and then make a nostalgic eulogy to it."[3]

Commentary on this contradiction between new construction and preservation continues within the café itself. For example, a great heron steals a fish from the café's serving tray. The heron is both a subtle protest against a controversial proposal for a housing development on the nearby Bolsa Chica wetlands, 2 miles north of the pier, and a nod to Huntington Beach's unique ecology. Above this interplay between past and present, two people share an outdoor table.

Design impact The Pier Plaza project was well publicized in frequent articles in the *Los Angeles Times*. It now hosts the United States Open of Surfing, a multicultural festival, a pier-side jazz festival, and numerous free-entry, open-air concerts. A constant stream of people relaxing, drumming, sunbathing, and just hanging out ensures a continually lively space. Of course, it has to compete with dozens of other Southern California beachside communities, many of which have followed aggressive redevelopment plans centered on their piers. That is why the agency wanted Pier Plaza to be different from the usual formula of pastel-colored paving and palm trees. As Michael Mudd of the Huntington Beach Community Services Agency says, "we wanted it to be a space with a strong identity for Huntington Beach. We wanted the city to get lots of publicity and visibility about the project, which it has."[4]

The Architecture Foundation of Orange County, which supports its burgeoning public art scene by educating citizens on the subject, gave *Poet's Table* its Art in Public Places Award in 1998. As a judge observed, "the juxtaposition of images from different time periods and the unusual relationship of elements create an underlying dynamic This interesting treatment of locally relevant subject matter gives the installation strength."[5]

The award proves that the impact of *Poet's Table* has spread beyond Pier Plaza. As the city's first artist-designed public space, Pier Plaza serves as an example of the way in which art can be integrated into urban design. According to Ann Thorne,

> There is a growing awareness that art brings enhancement to the cultural identity of a place, that it makes people aware of where they are. There is a need to integrate art projects, especially as regards the funding, into these greater revitalization projects, so that it is not just the icing on the cake. People should realize that it is part of the whole, so that when funding is scarce, it is not just the arts budget that is first to go.[6]

Thanks to Schoonhoven's *Poet's Table* and the Pier Plaza project, art has found its way into the public realm of Orange County, and its success has enthused the community, motivating it to initiate more projects. The mural is still in excellent condition and is now, after Schoonhoven's death in 2001, cared for by the City and beloved by the community.

1 Terry Schoonhoven, artist, Huntington Beach, California, interview, August 6, 1999.

2 *ibid.*

3 *ibid.*

4 Michael Mudd, Huntington Beach, Cultural Services Division, interview, August 17, 1999.

5 The Architectural Foundation of Orange County, press release, courtesy of Chip Clitheroe, June 23, 1999.

6 Ann Thorne, public-art manager, Huntington Beach, California, interview, July 30, 1999.

Integrating placemaking into architecture

130 *The Road to Hollywood*
Hollywood, Los Angeles, California

136 *Mnemonics*
Stuyvesant High School, New York

142 *New Orleans Streets*
City Hall, New Orleans, Louisiana

146 *Gutman Library*
Philadelphia University, Philadelphia, Pennsylvania

150 *A Walk on the Beach*
Miami International Airport, Miami, Florida

154 *Drawn Water*
Walter J. Sullivan Water Treatment Facility, Cambridge, Massachusetts

160 *The New Ring Shout*
Ted Weiss Federal Building, New York

The Road to Hollywood

Project description

A pavement inlay that features quotations from show-business personalities winds through the development, ending at an oversized chaise longue

Artist

Erika Rothenberg

Agency

TrizecHahn Corporation

Date

2001

Dimensions

Winds for hundreds of feet through the 1.2 million sq. ft development

Materials

Marble mosaic, concrete, fiberglass, and steel

Photography

Erika Rothenberg, Ronald Lee Fleming

ERIKA ROTHENBERG's installation continues the tradition of Grauman's Chinese Theater nearby on Hollywood Boulevard of marking the ground with the names and imprints of the stars. Rothenberg's concrete and marble mosaic floor inlay features the anonymous rags-to-riches stories of forty-nine personalities from the world of show business. The mosaic ribbon of stories winds for several hundred feet through the main floor of this recent mixed-use development, up two flights of stairs, through a courtyard, and culminates at an oversized fiberglass chaise longue on a porch overlooking the famous Hollywood sign in the nearby hills. Here is a symbol of success—reaching the casting couch—with the famous signboard as a perfect photographic backdrop for anyone's aspirations to stardom.

Hollywood & Highland is a recently constructed conglomerate of cinemas, restaurants, shops, studio broadcast facilities, and a live broadcast performing-arts theater that serves as the new home of the Academy Awards. Beth Harris, Hollywood & Highland's senior director of marketing, comments:

"TrizecHahn [the developer] has always had the vision that Hollywood could once again become a great center of commerce and entertainment."[1] Hollywood & Highland is situated at the very heart of Hollywood Boulevard, directly across the street from the El Capital Theater, a lavish rococo theater built in 1926, recently restored by the Disney Corporation. It is also adjacent to Grauman's Chinese Theater, built in 1927 and restored in 2001, long a Mecca for Hollywood stargazers who come to place their own hands and feet in their favorite actors' foot- and handprints, cast in concrete in the courtyard.

TrizecHahn wants to make Hollywood & Highland an even bigger tourist draw than Hollywood Boulevard's old theaters and the sidewalks studded with stories representing the careers of Hollywood actors and directors. Preparing for the crowds that the developers anticipate, the Renaissance Hollywood Hotel is 550,000 sq. ft, and contains 640 rooms and thirty-three suites. Hollywood & Highland's retail square footage is 640,000 sq. ft; the Kodak Theatre alone comprises 179,493 sq. ft. In all, the development covers $8^3/_4$ acres with a

PAGE 128 *The New Ring Shout*; see pp. 160–63. Photo: Bernstein Associates.

RIGHT Erika Rothenberg's entrance to Hollywood & Highland invites visitors to walk *The Road to Hollywood*.

combined total of 1.2 million sq. ft., an enormous asset and tourist attraction.

TrizecHahn used Los Angeles County's Percent for Art ordinance to make the space accessible to the public, while introducing public-art installations that animate the building site and encourage visitors to interact with their surroundings as they move through.

Description Erika Rothenberg's installation begins at the Hollywood Boulevard edge of the development, where a marble mosaic is laid into the sidewalk concrete. The mosaic proclaims *The Road to Hollywood*, and announces that it begins up the red-flagged staircase immediately beyond. Once across the metaphorical red carpet, visitors enter the centerpiece of Hollywood & Highland: the enormous open-air Babylonian Court.

Inside the Babylonian Court is a "retail facsimile of the legendary film set built

The Road to Hollywood **winds for hundreds of feet through three floors of Hollywood & Highland.**

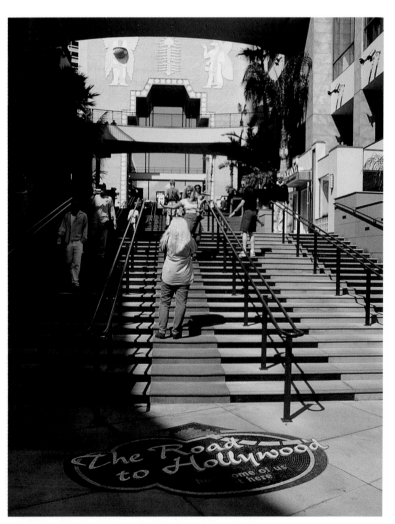

not far away by D.W. Griffith for his silent masterpiece, *Intolerance*."[2] Rothenberg's installation takes the form of a ribbon that twists, turns, and doubles back on itself across the floor. On *The Road* are mosaics containing stories of how people—both famous and not quite so well known—first came to Hollywood to try their luck. The stories, gathered by reading histories, interviewing people, and posting open calls for information, bear the owner's occupation rather than their name.

An art director's story, for example, reads: "I don't know what brought me here or how I got into the movies. All I know is that every time I start a new film, I'm as excited as that twenty-year-old kid who drove to California not knowing a soul." Similarly, an anonymous actress recalls: "I was working in an office in New York, and my boss said to me, 'You're not so good as a secretary; is there anything else you'd like to do?' So I moved to LA and began taking acting lessons."

The piece is full of tongue-in-cheek humor. Many of the stories seem to be made up; most are clichés that could, technically, happen to anyone. But that is the point, according to Rothenberg:

> The idea is to make visitors really feel the ubiquitous American dream of coming to Hollywood, and relate that dream to their own hopes and goals. We all know the story about Lana Turner being discovered in a Hollywood drugstore. But there are lots of other fascinating stories ... from teenage midgets recruited to be in *The Wizard of Oz* while walking down a street in Chicago, to future sound engineers taking off in their pickups from Abelene. Some people got there through sheer chance, others through unbelievable tenacity.[3]

The stories did happen to regular people, just like the shoppers and visitors Hollywood & Highland seeks to attract. Rothenberg stresses that fact, as well as humorously underlining it at the end of *The Road*. Visitors are welcomed to have their photographs taken on the chair, and pretend that they too will one day become stars.

Design process Because Los Angeles has a Percent for Art ordinance, administered by the Community Redevelopment Agency (CRA), the City requires the developer to define a public-art program before it will issue a building

permit. TrizecHahn retained Tamara Thomas of Fine Arts Services, Inc. (FAS) in May 1998 to design and implement the public-art projects for Hollywood & Highland. The architects, Ehrenkrantz, Eckstut & Kuhn (EEK), designed the building to fit in with the existing streetscape. EEK crafted a series of individual storefronts that made the massive project more pedestrian-friendly by reducing the scale on the boulevard.

The project was in the early stages of construction documentation when EEK commissioned Tamara Thomas to develop a

set of criteria and identify potential areas within the project for the inclusion of public art. TrizecHahn reviewed the work of approximately fifty artists from examples provided by FAS, and selected six as finalists. In June 1998, Thomas asked the finalists to study the project and prepare conceptual proposals for their own installations.

TrizecHahn interviewed the artists in September 1998. With help from the art consultant and the design team, they selected three artists to work on the project: Erika Rothenberg, a sculptor known for her

A marble mosaic tells the rags-to-riches story of an anonymous Hollywood actress.

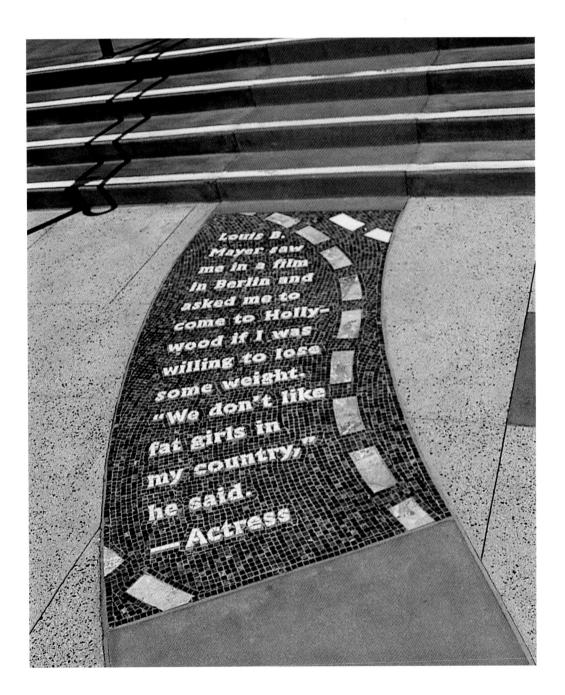

provocative and often humorous pieces; Pat Ward Williams, a painter whose large-scale "dot-screen pattern" style was judged to be a good fit for the five-story rotunda; and Michael Davis, a sculptor whose *Chandelier Fall* enlivens Hollywood & Highland's escalators. The CRA then endorsed these artists and their plans.

Once approved, the three artists fully developed their proposals. *The Road to Hollywood* is the result of a year-long design and development stage. Rothenberg worked with the architect, art consultant, designers, and project-management team to integrate her ideas seamlessly into the already designed Hollywood & Highland complex. This interaction with other members of Hollywood

& Highland's development team resulted in some alterations to Rothenberg's project:

One major change was the reconfiguration of *The Road* to end with an oversized "chaise longue" sculpture sitting upon a mosaic floor in an area of the space that overlooks the famous "Hollywood sign." TrizecHahn had originally wanted to reserve this area for other uses, but decided to relinquish it to me after the architects asked me to take a look at what I might do there, and I came up with the chaise longue idea. This, to my mind, made my project better than originally envisioned.[4]

At the end of the design development stage Rothenberg re-presented her project to TrizecHahn and to the CRA, and both

BELOW *The Road* ends at a fiberglass casting couch where visitors are encouraged to have their picture taken.

OPPOSITE The casting couch overlooks the Hollywood sign in the nearby hills.

approved it. Aside from the cooperative changes necessary for fitting the art into the project site, the artist's original concept survived intact. Hollywood & Highland broke ground in October 1998, and opened to the public on November 9, 2001.

Design impact Rothenberg received so many inquiries about *The Road to Hollywood* that she created a website to provide more information about the installation. She comments, "I am very happy with the way [the piece] turned out and with the positive public and critical response."[5] Christopher Knight, art critic for the *Los Angeles Times*, concurs, commenting that the installation "ranks among the best public projects in LA."[6]

The artist believes the design review process helped the evolution of *The Road to Hollywood*:

> There are positive and negative aspects [to design review]. The negative is that sometimes a great idea can get watered down by too many voices. The positive is that it's good to get feedback on execution, production, and installation issues.[7]

Rothenberg reports no friction in the case of *The Road to Hollywood*, and ultimately the interaction of architects and developers only helped make the piece stronger. The chaise longue at the end of *The Road* lends cohesiveness to the installation, as it connects it with visitors on another level. Christopher Knight claims that the chaise "is destined to become one of the most photographed places in town—which means, one of the most photographed places in the world. A cultural tourist, you star in your own picture."[8] The artist notes:

> The challenge of public art is for an artist to create a piece that fits comfortably into her body of work *and* provides a meaningful experience for people who use the space. In other words, you have to be true to your own art, but still try to create something that will (dare I say?) entertain a diverse group of people. Sometimes artists underestimate the public, resulting in bland public art. I try to avoid that.[9]

In *The Road to Hollywood*, Rothenberg enlivens a space that is itself intended to continue the revitalization of Hollywood Boulevard. The self-consciousness of the inlaid work encourages a wry reflection on place and the meaning of self in Hollywood, and is emphasized by the Hollywood sign in the hills beyond the development, where a dejected starlet once plunged to her death.

1 Rick Lyman, "Hollywood Boulevard Hopes for Second Act," *New York Times*, January 20, 2002.

2 *ibid.*

3 Erika Rothenberg, artist, interview, March 3, 2002.

4 *ibid.*

5 *ibid.*

6 Christopher Knight, "The 'Road' Daringly Traveled," *Los Angeles Times*, November 30, 2001.

7 Rothenberg interview, March 3, 2002.

8 Knight 2001.

9 Rothenberg interview, March 3, 2002.

Mnemonics

Project description

Four hundred artifacts
are sealed in individual
glass blocks embedded
in the walls of the new
Stuyvesant High School

Artists

Kristin Jones and
Andrew Ginzel

Agency

Battery Park City
Authority, New York
City Board of Education
and the Percent for
Art program of the
Department of Cultural
Affairs for the City of
New York

Dimensions

Each glass block 8 × 8 ×
4 in.

Date

1989–92

Cost

Artists' fee $30,000
Studio fees $45,000
Research $25,000
Materials $60,000
Installation $25,000
TOTAL $185,000

Materials

Hermetically sealed
glass blocks, stainless-
steel fasteners and
inserts, various
preserved artifacts

Photography

Courtesy of the artists

THE CONTRADICTION BETWEEN a site with no history and a school with a rich past is the inspiration for Kristin Jones and Andrew Ginzel's *Mnemonics*. Having spent a considerable time in Europe, first on a Fulbright Fellowship, then as fellows at the American Academy in Rome, the artists were sensitive to how history can infuse the present. But Jones and Ginzel found that America suffers from historical "amnesia." Their work seeks to redress this absence through meditations on the possible interpenetrations of history, knowledge, and time:

> The impossibility of knowing either time or truth, present or past is at the core of our fascination with the world and the genesis of our work for more than sixteen years … . Our thinking begins with the context and situation and weaves into question basics that may be right in front of us yet cannot quite be seen. Ultimately, we are interested in the intangibility of the present, in the resonance of moment.[1]

With their commission during the construction of Stuyvesant High School's new facility in 1989, Jones and Ginzel revisited this universal theme. With *Mnemonics*, they have created a literal mnemonic for improving memory of a history, both personal and global, for the members of the Stuyvesant community.

Founded as a manual training school in 1904, Stuyvesant High School remains the gem of the New York Unified School District. Only 5 percent of those who take the annual entrance exam are accepted; graduates of this highly selective public school include Nobel Laureates and New York State Congressmen along with other innovators in technology, science, and the arts. Throughout this long history of excellence, Stuyvesant has prided itself on fostering diversity and providing high-quality education to generations of recent immigrants, many of whom come from economically disadvantaged homes. Despite the tradition and success born in its halls, Stuyvesant's former home—a Beaux-Arts building on Manhattan's East Side that was recently named a city landmark (under pressure from Stuyvesant students)—could not keep pace with the technical requirements and growth of this highly respected school.

Battery Park City, Stuyvesant's new location at the tip of Manhattan, has a long history of its own. Originally a working part of the New York waterfront, Battery Park was dotted with piers, docks, and cranes until it fell into disuse in the 1960s. Its rebirth came in the 1970s, when a state-sponsored landfill project created Battery Park City on the southern tip of Manhattan with dirt excavated for the construction of the World Trade Center. Since then, this master-planned community has grown around Cesar Pelli's obelisk to include skyscrapers in a commercial district, an upscale residential neighborhood, and a harbor promenade. As new ground in a built-out city, Battery Park City offered rare opportunities for development in New York.

In 1987, the "Stuyvesant Coalition," composed of parents, teachers, and administrators, brought the poor condition of their existing building to the attention of the Board of Education. The ensuing negotiations behind the construction of the first new public high-school facility in New York since the completion of Fiorello La Guardia High in 1983 are more complicated than most. The Battery Park City Authority offered to lease a parcel of its land to New York in a show of goodwill toward its more established neighbor. According to their agreement, the Board of Education would fund the $150 million construction budget for this showcase of the public school system—despite widespread complaints of wasting this high sum on such a selective school—but the Battery Park Authority would remain involved, even selecting the architectural team for the project. As part of New York's Percent for Art program,

Stuyvesant students examine an element of the installation.

a portion of this record-breaking construction budget would finance public-art projects in the new facility. From its slide archives of past projects and interviews with potential artists, the New York City Department of Cultural Affairs selected two artists for the $200,000 commissions: Michelle Stuart, whose nine sand-blasted granite murals in the lobby depict such *Systems of Discovery* as Arabic numerals and early maps; and the team of Kristin Jones and Andrew Ginzel.

Description Commissioned early in the relatively short four-year construction process, Jones and Ginzel seized the opportunity to work closely with the architects and to familiarize themselves with the Stuyvesant community in an effort to overcome the indifference of "a sterile new building on a piece of land with no history—a fictitious site."[2] Jones and Ginzel sat in on classes, attended school plays, ate in the cafeteria and even hired students as aides while trying to "divine something that could belong to the place."[3] However, Jones and Ginzel's ultimate inspiration for *Mnemonics* came from global events far beyond the walls of Stuyvesant:

> At the time we were planning this, the Berlin Wall was being torn down. Pieces of it were ending up all over the world. We were also looking at the Chicago *Tribune* building, which has relics set into its exterior walls, and at a museum in Istanbul that houses a whisker from the beard of the Prophet Mohammed. People just walk around and around this thing, they are so fascinated. Relics take on religious significance for most people.[4]

Mnemonics translates this ancient tradition of religious reliquaries into a specific educational setting. Training themselves in the necessary glass-working techniques and working closely with the architects to integrate the work into the structure of the building itself, Jones and Ginzel embedded four hundred hermetically sealed glass blocks in the walls of the new facility. Eighty-eight of these include artifacts representing each year of Stuyvesant history, another eighty-eight are reserved for Stuyvesant's future, and the balance of the blocks contain artifacts representative of civilizations throughout the world. As a whole, *Mnemonics* creates a tangible treasury of the past and the present, the familiar and the distant:

> Each small vitrine is different from the next, and serves to adorn the repetitive surfaces, creating an intimate treasury that can identify both a kernel of knowledge—of memory—and the specific place. They are meant to "accumulate" in time, like the syntax of a language, to become part of the essential foundation of tangible knowledge for an audience who will experience the work over an extended time period.[5]

For the eighty-eight blocks commemorating Stuyvesant history, Jones and Ginzel worked with the alumni association and the Stuyvesant Coalition to solicit memorabilia from alumni. Metal bowls from Stuyvesant's early metal shop illustrate the school's roots as a manual training institution. A "Beat Clinton" button represents Stuyvesant's long-standing rivalry with DeWitt Clinton High. The former Stuyvesant building on the East Side is preserved through photographs in the new facility. For some students, these artifacts are physical evidence of familiar lore, while for others, often immigrant students unfamiliar with local history, they are an introduction to the Stuyvesant experience. In either case, personal encounters with these relics guarantee the survival of Stuyvesant's history.

But Jones and Ginzel equally emphasize the future of this ever-growing historic institution by including empty blocks reserved for the next eighty-eight graduating classes. Beginning in 1992 and continuing through 2080, the senior class officers will informally poll their classmates to determine what object best represents their class. This process of creating a legacy becomes a collective effort that extends throughout the four years of high school: "Students that go to the school spend four years watching the box with the year of their graduation sand-blasted inside, knowing that one day they will have to select a relic or relics from their Stuyvesant experience."[6] Some choose items of local significance, such as a memorial to a beloved administrator, or a pack of condoms to commemorate the decision to distribute contraceptives in

the school. Members of the class of 1993 memorialized a more far-reaching event, the bombing of the nearby World Trade Center, after requesting a piece of the building from the FBI. With this integration of historical lore and potential, Jones and Ginzel have challenged the students of Stuyvesant not only to question their understanding of history but also to come to terms with their place in it: "It was our hope to invent a tradition for future Stuyvesant generations, so that they might reflect on the significance of their own time and have the opportunity to make their own contribution to the visual history of their generation."[7]

Even while exalting Stuyvesant's unique history, Jones and Ginzel were also acutely aware of the egotistical tendencies of modern society:

New Yorkers, and especially teenagers, are accustomed to thinking of themselves as the center of the universe, the ultimate culture. We wanted to create some doubt ... [with] relics from civilizations that thrived for five thousand years and no student had even heard of, so as to put things in perspective.[8]

More than half of the four hundred glass blocks contain artifacts from cultures around the world intended to challenge the importance of Stuyvesant and weaken conventional ideas of civilization, knowledge, and time. Solicited from American ambassadors through the New York Department of Cultural Affairs, *Mnemonics* includes water from the Nile and Ganges Rivers, frankincense from Oman, coat buttons from an antique British army uniform, snow

The glass blocks of Mnemonics contain objects chosen by each class, as well as commemorating the school's history.

from Mt. Fuji, Thar Desert sand from India, and a piece of the Great Wall of China. By transporting students through space and time to a world beyond Stuyvesant, "the collective components or reliquaries from a visual library ... [and] together become clues to the vast collective knowledge of humankind."[9] The significance of this treasury is heightened by its placement among the robotic laboratories, networked computer systems, and classroom video monitors of the technologically advanced facility. The relics are actually present as evidence of a more global perspective and in memory of an earlier emphasis on educational empiricism; they are not mediated by the ubiquitous computer monitor of modern society. Evidence of local history and proof of other physical and cultural geographies are there for the students to witness personally.

Design impact Although a New York City Percent for Art project, *Mnemonics* blurs the distinction between public and private art. Since it is an educational facility, the security measures in place at Stuyvesant prohibit members of the general public from

exploring the work. This restriction is exacerbated by the artists' belief that *Mnemonics* should be discovered incrementally over a long period of time. Visitors to the building do not have the time to wander through the halls and stumble upon *Mnemonics* as the students do over their four-year high-school career. In this way, *Mnemonics* is a public work of art intended for a specific audience:

> The ultimate goal was to endow the new Stuyvesant High School first of all with the essence of its own history, secondly with a distinct sense of the extraordinary riches, raw materials, and curiosities that establish the basis of knowledge, and finally to give to successive generations the chance to leave their mark on the school.[10]

Jones and Ginzel's intensive research, openness to student participation in the artistic process, and close cooperation with the alumni association, make *Mnemonics* specific to Stuyvesant while demanding that students consider lands and times beyond their own immediate community.

Elements of *Mnemonics* confront students in every corner of the new facility.

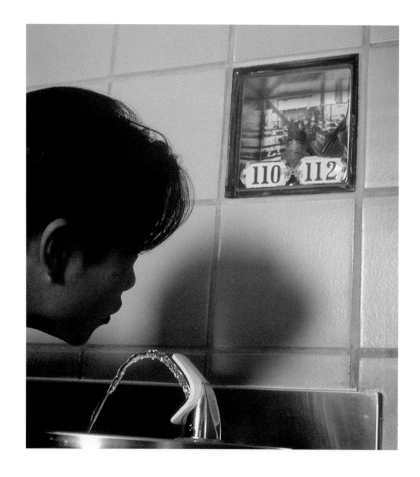

The reaction from Jones and Ginzel's intended audience has been phenomenal. According to Renée Levine, president of the Stuyvesant Coalition, "The kids love it. It is a constant surprise. You come across one every once in a while that you hadn't seen before. Kids stop and ask questions about pieces."[11] It is this constant interaction between the students and the installation that demands the re-evaluation of truth instigated, but not resolved, by Jones and Ginzel. Beyond the label sandblasted on to each block, there are no explanatory plaques or catalogue of relics. Students are required to discover each element on their own before considering the connections between artifacts that ultimately lead to a greater meaning. In this way, *Mnemonics* is a didactic exercise created by Jones and Ginzel to mirror the formal process of learning that takes place within the walls of educational facilities: "The inspiration for the work is the spirit of curiosity that ultimately seeks to unravel the mystery of the unknown. It is the dynamic dialogue between fact and mystery, between past and future that fascinates us, and has inspired the evolution of thought for this work."[12] With *Mnemonics*, Jones and Ginzel have replicated the process of education in a form custom-made for the students at Stuyvesant.

The power of the work is in the fact that the glass reliquaries are "dispersed at random to give the impression that they are everywhere."[13] Students are faced with new elements of the work at every turn, in a process of perpetual discovery. For members of the art community, the small and dispersed nature of the installation makes it a curiosity in a public-art world so often dominated by monumental sculpture: "The modest, almost hidden Percent for Art installation is out of scale both with most public art and with the ten-story, 350,000-sq.-ft school."[14] Michelle Stuart, with her *Systems of Discovery* in the school lobby, certainly took this more traditional approach. But for Jones and Ginzel, this repetition and re-evaluation of their installation is a necessary component of their work: "We wanted to build a piece that could be discovered over time, that could provide a parallel experience to learning and also allow for the generations of students to leave their own mark."[15] Their early commission allowed them to work with the architectural team in carefully planning the seemingly random scattering of glass reliquaries through the ten floors and basement, so that they would be seamlessly mortared into the walls during construction. Often, students are surprised to learn that there is an artist behind *Mnemonics*; the work is assumed to be just part of the building itself. In this way, it represents the extreme of possible cooperation between artist and architect to create a work of art that fits with the building, and complements the learning within its walls. Within the massive facility of Stuyvesant High School, Jones and Ginzel have created a literal mnemonic device for the ultimate goal of education and the ongoing process of learning to which the new Stuyvesant facility is a monument. From its walls, *Mnemonics* continually reminds members of the Stuyvesant community where they have come from and why they are there.

1 Artists' statement, jonesginzel.com/Artist's%20 Statement, accessed July 27, 2000.

2 Peter Slatin, "High School Memories," *ARTNews*, vol. 92, no. 2 (February 1993), p. 26.

3 Kristin Jones, artist, New York, interview, July 26, 1999.

4 *ibid.*

5 Project description, courtesy of the artists.

6 Jones interview, July 11, 2000.

7 Project description.

8 Jones interview, July 26, 1999.

9 Project description.

10 *ibid.*

11 Renée Levine, president of the Stuyvesant Coalition, New York, interview, July 23, 1999.

12 Project description.

13 Slatin 1993.

14 *ibid.*

15 *ibid.*

New Orleans Streets

CITY HALL · NEW ORLEANS, LOUISIANA

Project description

A painted frieze in the ground-floor corridor of New Orleans City Hall, incorporating fifty-nine New Orleans street names

Artist

Evelyn Menge

Agencies

Arts Council of New Orleans and New Orleans's Percent for Art program

Date

1993

Dimensions

346 ft × 18 in.

Materials

Pencil, pen, watercolor, polyester resin, and acrylic and enamel paint on Masonite.

Cost

$38,000

Photography

George H. Long

Ew Orleans's remarkable street names reflect its diverse and eccentric history, an eclectic mix of Caribbean, French, and American culture. Some names honor Native American tribes, such as Chippewa, Seminole, and Cherokee; others are references to Louisiana's Franco–Spanish Catholic settlers, including Ursulines, Assumption, and St. Peter; others are in tribute to the Classical Greek influences of Thalia, Socrates, and Homer.[1] In the mid-nineteenth century, a law was passed requiring that this eclectic collection of street names be displayed with ceramic tiles embedded in the street corners. This practice continued through the 1900s, although many tiles were lost during necessary modernization projects throughout the city, including the installation of phone lines or the widening of sidewalks to make them accessible to wheelchairs. A local pottery company is currently under contract with New Orleans to fabricate new tiles.

Evelyn Menge, an exhibiting artist and full-time art teacher, has long been curious about New Orleans's unusual street names and the way in which they are displayed. These weathered blue tiles inspired Menge's 346-ft-long *trompe l'œil* frieze, *New Orleans Streets*. Wrapping itself along the walls of City Hall's ground-floor corridor, Menge's painted frieze, depicting fifty-nine city street names in the style of the porcelain cornerstone tiles and a host of objects representative of New Orleans culture, provides a welcome addition to this bland government building. Fortunately, the frieze was spared from damage during Hurricane Katrina because of the location of City Hall.

After seven finalists submitted models and budget proposals for a jury's consideration, the Arts Council of New Orleans commissioned the winner—Menge's proposed *New Orleans Streets*—in September 1990, as part of its Percent for Art program. However, delays postponed work on the frieze until September 1991. The initial wait resulted from Menge's desire to involve the community in the artistic process: each member of the city council was asked to submit street names from his or her district. But, as Menge completed her research and preparation for the friezes, the then mayor of New Orleans, Sidney Barthelemy, raised concerns about the appropriateness of Menge's

design for its intended location in City Hall, the heavily trafficked area surrounding a receptionist desk and a nearby bank of elevators in the front lobby. While the deliberations continued for a year, Menge did not know if she would be able to install *New Orleans Streets*: "My most frustrating problem … during the entire process was this initial, lengthy period of waiting."[2] Eventually, city officials agreed to accept an 8-ft trial panel while they considered alternative locations for the work in City Hall. After yet more discussion, the ground-floor corridor, including the originally proposed bank of elevators, was chosen as a fitting location for Menge's frieze, now an 18-in.-high running border instead of the intended stack of five or six rows of street names. Menge finally began work on the reconceptualized artwork in September 1991, and completed the installation in time for a gala dedication ceremony with the mayor in February 1993, fifteen months after she actually began work, and more than two years after her commission. Although a frustrating postponement for all, the mutual resolution was also educational: "By going through this process, both artists and politicians have learned not to view each other as aliens."[3]

Despite her initial frustrations, Menge continued this spirit of cooperation through the fabrication of the friezes themselves: "When my work did finally begin, I welcomed community involvement. Many brought forth their ideas and street names to be included. I worked as carefully as I could to include as many of those ideas and names within the space limitations."[4] This outpouring of suggestions from the public supplemented the input solicited from city council members and Menge's own investigation including eleven years of photography and rubbings in her own neighborhood, to create a mutual dialogue. As the liaison medium between the public and the artwork, Menge felt like "a detective in my own city. Local people directed me to things I had never noticed before."[5] Menge believes that it was this combination of public collaboration and personal investigation that uncovered rewards throughout the artistic process:

> That summer I worked every day for eight to ten hours, sometimes taking breaks to search neighborhoods. There I would gather motifs for the tile bands that accompanied the street names. I also started including New Orleans symbols, such as Mardi Gras and Voodoo paraphernalia … . My readings increasingly targeted books about New Orleans; its history and many colorful characters of the past and present … . I honed and embellished my skills as an artist while I relished … the study of my city's lush mysteries and eccentricities of place.[6]

Description Resembling a continuous band of city sidewalk, *New Orleans Streets* integrates two complementary elements to evoke the indivisible relationship between the city's culture and its streets. Copies of blue porcelain tiles display the street names while an elaborate upper border highlights New Orleans's

Evelyn Menge's frieze incorporates traditional New Orleans emblems and street names.

cultural ingredients, with scale renderings of such traditional elements as Mardi Gras ornaments and voodoo dolls.

Menge, a self-described "*trompe l'œil* artist," painted the street names so that they fool the eye into appearing three-dimensional. Working from rubbings, photographs, and fragments of cornerstone tiles, Menge reproduced the various cracks, signs of weathering and fading, scars and discolorations that characterized the actual street markers with a combination of pencil, pen, watercolor, polyester resin, acrylic, and enamels on Masonite painted to resemble a sidewalk. With such a variety of materials and techniques available to her, as well as the luck to have a leaky roof in her studio that unexpectedly weathered some of the panels very realistically, Menge's street-name panels were individualized, but coordinated enough to create a cohesive 346-ft run. For example, the detail "ANIT" from the street name "HUMANITY" has cracks running through the letters, chips from crumbling tiles, and water stains. Above the street name, Menge replicated a detail from an Italian tesserae mosaic, fabricated in New Orleans in the early twentieth century, which she found underfoot at the entrance to an antique store in the French Quarter. This intense level of detail, carried through every cracked tile and decorative flourish added by the artist, allows the creation of an individual identity for each street name in the frieze.

For Menge, the border above the tiles was "an area for play," and for the discovery of local color:

Originally I had decided simply to do a series of 1-in. squares to add color and orderly pattern above the street names. I soon realized that I possessed the freedom as a public artist to explore all the indigenous symbols and artifacts of my city. I used examples of architectural low-relief elements on building façades and iron balconies. As I moved further into the year-and-a-half project, I introduced symbols that are rich to our culture.[7]

Just as with her selection of street names, Menge's list of native New Orleans emblems was slowly culled from research into the neighborhoods and everyday lives of the people of New Orleans. Among many other typical New Orleans emblems, she included Mardi Gras beads, bus transfers, oyster shells, fleurs de lis, voodoo dolls, and Louis Armstrong's signature. Although she estimates that about 20 percent of the panels contained elements that would only be fully understood by natives of New Orleans,[8] Menge also included more universal symbols, such as the cockroaches above a lawyer's door. By making particular fragments of everyday life in New Orleans visible to natives and visitors, Menge renders residents and city visitors conscious of the rich architectural, cultural, and political heritage that makes New Orleans unique.

Design impact Menge's *New Orleans Streets* has been extremely well received by both the public and the arts community. According to VIGOR, the volunteer program that gives tours

BELOW *New Orleans Streets* in its final location—the ground-floor corridor of City Hall.

BELOW, RIGHT Close-up of street sign.

OPPOSITE Musician Louis Armstrong's signature.

of Percent for Art projects in government buildings, the realism of the *trompe l'œil* effect certainly makes it a crowd favorite. The sight of incredulous visitors wondering aloud if the tiles are authentic is one that government employees have grown accustomed to—such as former chief administrative officer of New Orleans Leonard Simmons, who commented, "I see visitors reach up and touch the panels to check if her tiles are real."[9]

Once viewers overcome their initial disbelief, their attention is captured by Menge's ability to condense the essence of New Orleans into a small collection of symbols, words and artifacts that others might consider worthless. Every item can evoke a memory or a legend from native and visitor alike, drawing the viewer along the entire length of the frieze. From her own experiences discovering New Orleans, Menge realized the power of words and emblems to create a sense of culture: "These [street] names become icons that can evoke all kinds of thoughts and feelings from the viewer. There is a quirky pride of place in this city and an emotional attachment to neighborhood."[10] By combining the well-known street markers with artifacts of the lesser-known New Orleans, Menge creates a cultural treasury that makes the essence of New Orleans culture accessible to everyone.

The widespread popularity of Menge's frieze proves that public art can succeed even when delayed and debated as much as *New Orleans Streets*. In fact, the work's impact was strengthened by the very debate that plagued its beginnings, according to public-art director Mary Len Costa:

> This took many months of meetings to educate the audience about the strength of Menge's work as a whole and the strength of this piece in particular. Should this be considered a "controversy"? I think not. It is the public-art process at its best: listening to the community, educating them to a new visual vocabulary and responding to their concerns.[11]

The longest Percent for Art project ever installed in New Orleans, *New Orleans Streets* was a test case for local public-art policy. As the result of negotiations including city officials, public-arts consultants, and the arts community, its eventual installation reinforced the city's dedication to public art, and established the methods of productive interaction necessary for the continued success of public art in New Orleans. Mayor Barthelemy found a more complementary location for the work in City Hall, and artist Menge revised her design to capitalize on its surroundings. Born of mutual compromise, *New Orleans Streets* is a success for both. While New Orleans's Percent for Art program has been a visible force behind public art since its inception in 1987—commissioning more than two hundred and fifty varied works for government buildings and public spaces— it has grown steadily through the years. Featuring the work on the cover of one of its brochures, the Arts Council of New Orleans was acknowledging the impact of Evelyn Menge's *New Orleans Streets* on public art in New Orleans, as well as its beauty.

1 See Lester Bridaham, ed., *New Orleans and Bayou Country: Photographs (1889–1910)*, Barre, Mass.: Barre Publishers, 1972.

2 Evelyn Menge, artist, New Orleans, correspondence, February 28, 1998.

3 Chris Waddington, "Frieze Frames," *Times-Picayune Lagniappe*, January 12, 1998, p. 14.

4 Menge correspondence, February 28, 1998.

5 Waddington 1998.

6 Menge correspondence, February 28, 1998.

7 *ibid.*

8 Menge correspondence, March 6, 1998.

9 Waddington 1998.

10 Menge correspondence, February 28, 1998.

11 Mary Len Costa, public-art director, New Orleans, correspondence, February 15, 2000.

Gutman Library

Project description

Windows of the Gutman Library are not graced with gargoyles, but are instead braced with the handcast brick faces of prominent campus personalities, including students, administrators, and trustees

Artist

Syma

Architects

Shepley Bulfinch Richardson and Abbott (Tom Kearns, Malcomb Kent, Albert Huang)

Agency

Philadelphia College of Textiles and Science (now Philadelphia University)

Date

September 1992

Dimensions

54,000 sq. ft

Material

Handcast sculpted brick

Cost

$7.8 million

Photography

Courtesy of the artist

W HEN THE PHILADELPHIA College of Textiles and Science (Philadelphia University since 1999) was in the planning stages of its new library in the early 1990s, it put an unusual amount of responsibility for the design into the hands of the community. Its trustees and leaders understood the importance of architecture's rôle in making a statement about their school, and they wanted it to speak with a voice unique to the school. In the autumn of 1992, the Paul J. Gutman Library opened as a monument to community collaboration, the foresight of school leaders, and the spirit of the growing institution.

It was a 1989 reaccreditation committee that first suggested a new library for the school. Like the name change that came a decade later, the decision to build the library represented the school's reinvention, as well as its redefinition within the changing economy. In May of 1991 the committee commissioned Boston architecture firm Shepley Bulfinch Richardson and Abbott; the architects then selected Syma, an artist based in Hingham, Massachusetts, to design the details and ornament. The architects had been

impressed by a presentation of Syma's work in handcast sculpted bricks, a rare and difficult craft, that she had given two years before.

From the outset, the Gutman Library was a collaborative effort, in which the community contributed much of the vision, and architect Albert Huang and Syma used their considerable talents to make it a reality. A committee of students, faculty members, trustees, and administrators reached a consensus about what was needed for the new library, and from there drafted a document that guided the architect throughout the project, even determining the building site. Drawing on the architects' research, the college president's vision, and aspects of the school's curriculum, the committee agreed on a guiding theme for the project: "the harmony between man, woman, nature, and technology." The committee wanted to reflect the original character of the campus, while expressing the school's new and changing identity.[1] Throughout the process, students were invited to charrettes (collaborative sessions) with the architects to offer their opinions on design issues.[2]

RIGHT Window corners were embellished with portraits and decorative elements.

BELOW, RIGHT Clay molds were used to produce likenesses of members of the campus community.

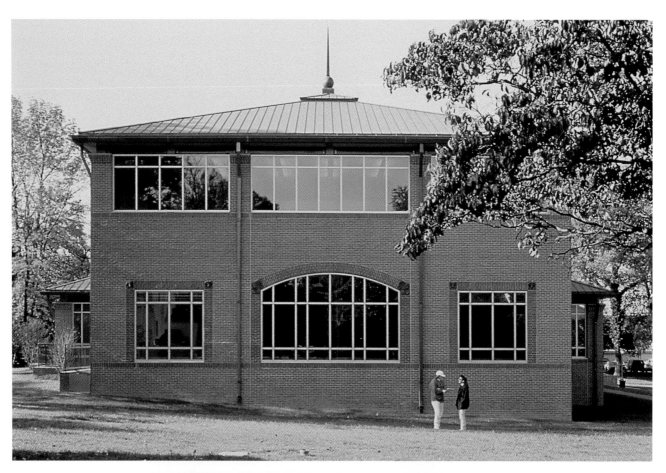

ABOVE Outside view of the library. The portraits are at the corners of the windows.

RIGHT The lamps are made from ceramic casting with brass fixtures.

The building ultimately cost $7.8 million; donors gave $6 million, and the rest was paid for by the school itself. $1 million was donated by Philadelphia benefactors, and Philadelphia University trustee Alvin Gutman made a donation to honor his son Paul J. Gutman, who died tragically in a plane crash in 1991.

Description Although the building itself went on to win the Louis Kahn Award for architecture, it is ultimately Syma's decorative work that receives the most credit for fulfilling the desires of the community. She believes that integrating her art with the architectural team's work contributed to the built environment in a meaningful way.[3] To achieve that goal she worked closely with students, librarians, professors, and administrators to understand the community better. She read basic textile textbooks, and was encouraged by a trustee to study the terracotta details on buildings designed by nineteenth-century Philadelphia architect Frank Furness. What she conceived was a modern twist on a classic theme: windows not graced with gargoyles, but braced with the handcast brick faces of prominent campus personalities, including students, administrators, and trustees. Syma's designs reflect the school's concern for the quality of the art that it displays, as well as the ways in which that art relates to the immediate community.

The artist made molds out of gauze masks of twenty-eight campus representatives, which she then filled with clay, and used the forms as the corners of windows, set in "surrounds" representing different themes and symbols of the school. These backgrounds incorporate, among other things, quilt patterns (a nod to the school's textile origins); machine gears and computer chips (representing the school's future in technology); and the horns of a ram

(the college mascot). All of these images were cast into more than five hundred bricks in Syma's studio and then incorporated into the building's design. Additionally, two 3 × 5-ft quilt-like panels flanked the front doors, and fabric is incorporated into the ceiling tiles of the building's 54,000 sq. ft of study space.

Design impact By most accounts, the design of the Gutman Library is a success, whimsy and all. For one thing, the building has become the school's centerpiece, and library usage has doubled.[4] It adequately represents a confident statement of identity in a growing school and reflects the community's diversity, boldly embracing a new, more technology-oriented identity, yet respecting the institution's history. It is unabashedly new in content and style, yet incorporates the old, most notably in the superior craftsmanship and thoroughly conceived detail of Syma's brick castings, accents that are notoriously absent from most modern-day buildings.

The creation of an intriguing, aesthetically pleasing building at Philadelphia College of Textiles and Science was initiated out of the need to construct a user-friendly library that evoked the school's contemporary nature, and embodied the president's hope that it would grow to become an international school of design where art, music, and nature would be as important as the traditional disciplines.[5] That has recently become a reality. Once a small and specialized college, the school was granted university status in 1999. Since the completion of the library, the student body has grown by 35 percent. In 2006, the school announced a plan to expand the campus, including two more new buildings, one of which will be the Kanbar Campus Center by Shepley Bulfinch Richardson and Abbott.[6]

1 Syma, artist, Hingham, Massachusetts, correspondence, November 19, 1997.

2 Jean McAuley, director of public relations, Philadelphia University, Philadelphia, correspondence, July 15, 1997.

3 Syma correspondence, November 19, 1997.

4 See philau.edu.

5 James B. Gallagher, president, Philadelphia University, Philadelphia, correspondence, October 31, 1997.

6 Philadelphia University website: building.philau.edu, accessed February 10, 2006.

A Walk on the Beach

MIAMI INTERNATIONAL AIRPORT · MIAMI, FLORIDA

Project description

An inlaid terrazzo floor brings life to Miami International Airport

Artist

Michele Oka Doner

Agency

Miami-Dade Art in Public Places

Date

1992–95 (Phase I), 1997–99 (Phase II)

Dimensions

½ mile long; 35,000 sq. ft

Materials

Terrazzo, mother of pearl, bronze

Cost

$360,000 for Phase I, $250,000 for Phase II

Photography

Courtesy of the artist, Nick Merrick, Hedrich Blessing

Michele Oka Doner's *A Walk on the Beach* brings the coastline of Florida directly into Miami International Airport. This integrated floor piece is a firm departure from the county's previous public-art endeavors. In 1981, Miami-Dade's Art in Public Places program selected Frederick Eversley's *Parabolic Flight* to enhance a patch of grass outside the entrance to the airport. A decade later, times had changed. No longer was the Art in Public Places program buying pieces of "plop" art to ornament Miami's open spaces. When the airport decided to renovate its concourses in 1991, Miami-Dade's public-art program immediately commissioned three artists whose designs would be integrated into the finished buildings from the outset of the planning process.

Oka Doner cast approximately two thousand flat bronze glyphs with forms derived from plants and sea creatures found on South Florida's beaches and in its tidal waters, and set them into the half-mile stretch of charcoal terrazzo floor along Concourse A.

The artist's intention was to greet passengers arriving at the airport with the essence of Miami. "People say Miami has changed so much, but the fundamentals are timeless: the light, water, sea life, the color. All are still here."[1] Oka Doner, a native of Miami, wanted to embody the busy terminal with exuberance and life: "They burst, they dance, they move, it's like choreography," she says of her bronze inlays.[2] The terrazzo flooring brings the magic of Florida's shoreline into a place of transit, greeting new arrivals and leaving departing passengers with a lingering image of the state's beauty.

Description The charcoal-gray terrazzo floor of the terminal sparkles with crushed mother of pearl that Oka Doner recycled from pearl buttons made in the Philippines. Terrazzo itself is a material long associated with the tropical locales of South Florida, Southern California, and Cuba; local builders often embellish the polished concrete with pieces of shell and glass. Vivian Donnell Rodriguez, executive director of Miami's Art in Public Places, notes: "For Florida, terrazzo is an old material. It looks wonderful, very elegant, but in truth is very inexpensive. It is cool, tropical,

easy to maintain, easy to clean, much easier to take care of than a patchwork of carpeting."[3]

Oka Doner's inlaid pieces of mother-of-pearl resemble the sea foam of tidal lines along the edges of the walkway, and serve as a transition between the carpeting of the individual gates and the terrazzo flooring, which is itself aglow in the reflected illumination of overhead skylights.

The two thousand highly polished glyphs that Oka Doner handcrafted are based on her philosophical interpretations of the origins of life. Images of sea coral, shells, and miniature organisms are scattered across the floor, and share space with DNA helixes, sodium molecules, and even the structure of foam as seen under a microscope. Oka Doner laid the glyphs by hand in organic clusters recalling the sea and evoking a palpable living presence

in a routine floor covering. Oka Doner created a sense of depth in the terrazzo by ranging the scale of the glyphs from two inches to two feet at random.

The walkway leads to a 51-ft-tall rotunda, the centerpiece of the concourse, where the terrazzo floor flows into an area resembling a tidal pool. Seen from the balcony overhead, the clustered forms gleaming in their dark background suggest the mystery of the sea.

Design process When Miami-Dade Art in Public Places inaugurated its master plan in 1984, it outlined, in general terms, the process of planning and selection that the agency would undertake. Community committees oversee each project that the agency sponsors. Staff often begin working with the committee before an artist is selected. Miami-Dade then

BELOW Over two thousand handsculpted bronze glyphs are embedded in the terrazzo floor of Concourse A of Miami International Airport.

BELOW, RIGHT Artistic renderings of jellyfish are juxtaposed with more realistic images of sea life (top); "Electricity" is one of two thousand unique organic images in *A Walk on the Beach* (center); detail of star coral (bottom).

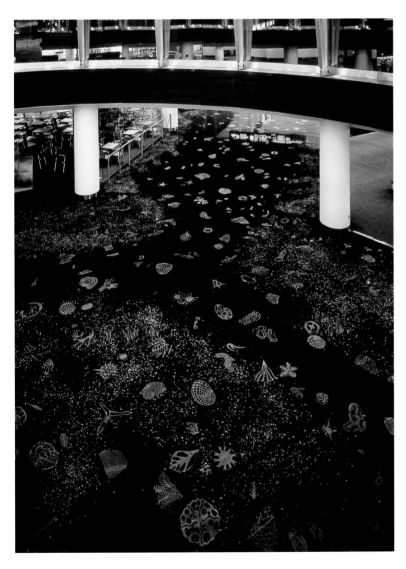

RIGHT Michele Oka Doner laid the glyphs by hand while the concourse was still at the construction stage.

BELOW, RIGHT The centerpiece of *A Walk on the Beach* is a tidal pool of glyphs massed under the arching roof of the rotunda.

involves the artist in the entire process of dialogue and design. Executive director Vivian Rodriguez notes: "The process is long but informative, and the results are much more genuine and the acceptance of the project real and committed."[4]

Miami is a "community with a very aggressive capital improvements program."[5] The Public Art Department can thus aggregate funds from a number of agencies for general public-art projects, but does most of its work with Miami-Dade Transit and the airport. In these areas, funds for those agencies must be spent on their own turf, though not necessarily on the building projects that are generating the funds.

Once the committee had selected Oka Doner for this project, Miami-Dade immediately began to integrate her ideas into the developing plan of the building: "We are clear and realistic about the goals of a project, laying out a set of expectations for the artists at the outset so that design time is well utilized," notes Rodriguez.[6]

For inspiration, Oka Doner inspected sea life through a microscope, read books on ocean life, and individually sculpted each unique bronze glyph. The forms were shaped in wax in her New York studio, then cast at a foundry, and placed in the concourse floor.

Design impact This art project is not only popular with those who visit the airport, but also with the design team behind the airport. As Rodriguez pointed out, "One key factor has been involving all the players from the very beginning I have found that most architects and engineers that we have worked with have been eager to work together if they have been a part of the planning process and the selection process from the inception of the project."[7]

Oka Doner feels that though Miami-Dade was instrumental in guiding the interface of her project with the development of the airport, the project was a success because of the freedom she had in design. She feels that "when public art is commissioned under an architect, in my experience it is very important for the artist to maintain control over the fabrication of their work."[8] She mentions her terrazzo floor installation at the US Airways terminal in Washington, D.C.'s National Airport as a case in point:

> In the National Airport project, all of the artists except for me were simply asked by the architects, Cesar Pelli & Associates [now Pelli Clarke Pelli Architects], to submit their proposals into a graphic rendering that was then executed by fabrication contracted by the architectural firm. I retained control of the images and did my own fabrication and installation, and believe they have more energy and life because they were not reduced to a simple flat graphic design. This is a control distinction in the process of community public work.[9]

Vivian Donnell Rodriguez notes:

> Over the years we have had increasing acceptance and understanding from the design professionals with whom we work. Previous successes, education, and a willingness on our part to work closely with them and communicate often have contributed to this positive working relationship. Many of the projects we do are "critical path" projects, such as floors and lighting. Projects at the airport, for example, are part of the building, integral to it. The building would not be the same building without them.[10]

In the wake of the highly successful piece, Oka Doner will complete an expansion work in the airport by 2008. Entitled *From Seashore to Tropical Garden*, this similar scheme of terrazzo and bronze will celebrate southern Florida's botanical diversity. The work will extend for 1 mile in the airport's new North Terminal development.

1 Geoffrey Tomb, "The Sea Floor: Airport's Terrazzo *A Walk on the Beach*," *Miami Herald*, April 22, 1995, p. 1B.

2 Anne Barclay Morgan, "Michele Doner, *A Walk on the Beach*," *Sculpture*, vol. 16, no. 9 (November 1997), p. 12.

3 Tomb 1995.

4 Vivian Donnell Rodriguez, executive director, Art in Public Places, Miami, interview, September 29, 1997.

5 *ibid.*

6 *ibid.*

7 *ibid.*

8 Michele Oka Doner, artist, New York, interview, October 2, 1999.

9 *ibid.*

10 Rodriguez interview, September 29, 1997.

Drawn Water

WALTER J. SULLIVAN WATER TREATMENT FACILITY · CAMBRIDGE, MASSACHUSETTS

Project description

This installation incorporates a diverse group of water-focused elements into the newly built structure of the Walter J. Sullivan Water Treatment Facility

Artists

Mags Harries and Lajos Héder Collaborative

Agency

Cambridge Arts Council

Date

1997–2001

Materials

Water, bronze, brass, terrazzo, acrylic, light

Cost

$259,000 ($85,000 for the terrazzo floor)

Photography

Courtesy of the artists, Kathy Chapman, Kerry Schneider, Christopher Barnes, and The Townscape Institute.

I N 1997, the Cambridge Arts Council conceived a permanent sculptural installation encompassing the lobby of Cambridge's new Water Department building and its environs. Mags Harries and Lajos Héder's multifaceted piece focuses on water and the idea of transparency, deftly combining such elements as a terrazzo floor map of Cambridge's water system with exposed pipes and interactive drinking fountains, connecting the building visually to the very water it treats.

In 1979, Cambridge City Council passed a Percent for Art ordinance. The goal for commissioning the art was well stated in an early program publication written by the Cambridge Arts Council's first chairman, Ronald Lee Fleming, calling for art that "engages itself directly with the surrounding environment to create, enrich, or reveal a sense of place." Such guidelines clearly influenced the design of *Drawn Water*.

The Walter J. Sullivan Water Treatment Facility sits at the edge of the Fresh Pond Reservoir, an area actively used by walkers, joggers, and outdoor enthusiasts. The Cambridge Arts Council, Mags Harries and

Lajos Héder sought to deepen the connection between people and their relationship with water, and thus *Drawn Water* is an interactive piece that connects the reservoir itself to the people who use the area for recreation, as well as demonstrating the means of transport for the eventual destination of the water.

Description Transparency is the theme of *Drawn Water*, stressing the clarity of the substance itself and a clear depiction of Cambridge and the water treatment facility's relation to that substance. The installation reaches within and without the walls of the plant; the windowed rear wall is itself open to the reservoir beyond.

To the right of the entrance is a fountain, providing the presence of water and its constant sound in the room. The fountain springs from the wall, and is framed by a portico, the remnant of the older facility. *Drawn Water* went through a series of incarnations, during which an idea book circulated including the idea of reusing the aerator. The architect of the final design, Camp, Dresser & McKee (CDM), picked this

idea and designed the fountain shown below.

A terrazzo map covers the base of the water treatment plant lobby and illustrates the elements in Cambridge's water system with brass inlays. The Charles River stretches in blue across the floor, defining one edge of the map. Fifteen different manhole cover plaques (fourteen at different Cambridge schools, one planned for Harvard Square) give a unique face to each of Cambridge's neighborhoods, and encourage a treasure hunt through the large map of the city. The city's pipes are delineated with brass strips of different widths, corresponding to the varying sizes of actual pipes, and Cambridge's fountains and swimming pools have individually designed brass symbols that mark their location on the map, as well as illustrating where the underground water reaches the surface.

Harries and Héder gauge the differing pipe sizes in Cambridge's water system more dramatically by providing seats with diameters equal to that of the subterranean carriers. These stools are lined up against a back wall of the lobby and are staggered, growing in width to the largest, 42-in., model. Bronze floor inlays point to the stools and record their width.

The rear wall of the water treatment facility is glass, allowing for an unobstructed view to the reservoir beyond. Outside the plant,

an elaborate drinking fountain again recalls man's manipulation of water force. An exposed 42-in. pipeline shows how water is carried from the facility through the ground. Where the footpath above crosses the pipe, Harries and Héder crafted a bronze water fountain in the form of a gush of water from its carrier pipe. Painted blue, the bronze surges up from the pipe yet follows its ultimate destination: the reservoir just beyond. Inside the plant is a 14-ft transparent Plexiglas water column on an axis with the pipe, that reacts with lighting and bubbles and changes in level when one drinks from the fountain.

The facility echoes the monumental brick waterworks of nineteenth-century design. The large, arching windows that face the street show color-coded machinery within the building, clearly demonstrating which areas of the plant provide particular functions for water processing. CDM also designed the tile mosaics, which depict varying scenes of water, including orange fish and a boy scuba-diving; the artists were involved in the discussion of the design process. Words written in tile add another dimension to the uses of treated water.

Design process Two years before *Drawn Water*, Harries and Héder worked on *Acoustic Weir*, another Cambridge public-art program

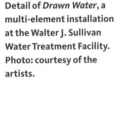

Detail of *Drawn Water*, a multi-element installation at the Walter J. Sullivan Water Treatment Facility. Photo: courtesy of the artists.

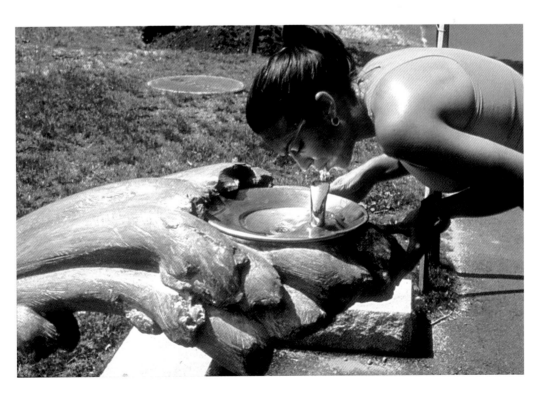

project for the enhancement of the Fresh Pond Reservoir. The piece proposed a visible water pipe from Fresh Pond to the facility but fell victim to virulent opposition by neighbors who wouldn't tolerate any art in that part of the reservation. *Acoustic Weir* was "designed in part to draw attention to a pipe that led into the treatment center, but some people felt it marred the site's natural beauty." The main purpose of the artwork was to show the water itself coming into the facility—with an underground conduit—and to make visible the waterflow to the storage facility. It was a "single hit kind of piece," according to Héder, "more in form than in effect."[1] Over a still pond, the shape of a prow was elevated—quiet and contemplative—and yet the visible water going into the facility combined turbulent water with the calming pond and grassy space.

The book of ideas for the "Fresh Pond Art

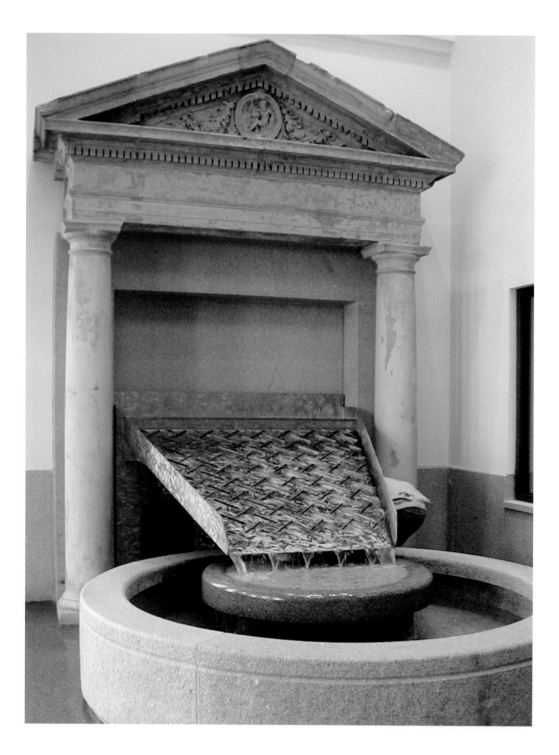

The fountain in the lobby is made from a salvaged portico of the old facility.

Piece" was presented to the project committee and the Arts Council, who selected *Acoustic Weir*. The plan went through a number of alterations and redesigns in response to public sentiment. Opposition "became fierce, and public pressure prevailed," and "although already selected, approved, and commissioned by the Cambridge Water Works, the artists scrapped the piece and began work on another idea."[2] The project committee said it didn't think *Acoustic Weir* would ever get built because no city council member would be prepared to lose voters to put one artwork in place. The committee advised Harries and Héder to design a piece closer to the plant.

Acoustic Weir grew out of yet another dropped Cambridge project:

> In 1998, Tufts University commissioned Harries to design a sculptural installation for its new Aidekman Arts Center; she came up with a prow-shaped balcony over a prow-shaped pool. The project fizzled along with the university's commitment to it. Harries recycled the prow idea in the Fresh Pond project, where it was going to be a lookout over a waterfall the artists wanted to create by cutting a pipe that feeds the pond, thus creating a consciousness that the water comes from somewhere. The idea was scratched after acrimonious debate and the

opposition from some community members to anything man-made on Fresh Pond's patch of nature. "The attacks were amazing," says Héder. "The irony is, the environment they're protecting was woods that were chopped down twenty years ago."[3]

Unveiled on October 26, the new piece—*Drawn Water*—consisted of the aforementioned terrazzo floor embedded with a map of the Cambridge water system, along with various sculptural elements that reinforce the didactic nature of the piece. Four years in the planning, *Drawn Water* went through four redesigns, "which is par for public art"; a "hysterical" public debate over it depicted the work as the "thin edge of the wedge." If this one sculptural element were permitted to despoil the landscape, who knows what would happen next—more art?"[4]

The design process for *Drawn Water* was guided by the Cambridge Arts Council protocol of combining jury review with active community participation. A community art committee and a jury are established specifically for each project. New projects are approved annually by the Cambridge City Council as part of its budget process. Cambridge's Percent for Art ordinance facilitated the evolution of the more than one hundred public-art pieces that now dot the

The lobby floor shows a map of the Cambridge water system and several manhole plaques located throughout the city. Photo: Kathy Chapman.

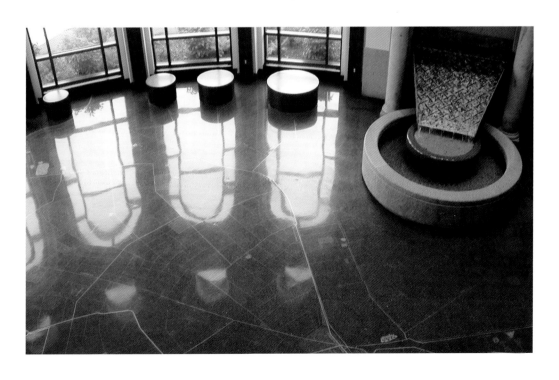

physical landscape of the city. When the City began building a new water treatment plant in 1996, the Committee on Public Art immediately began considering how to enhance the site. Harries and Héder, a married couple, both long-time Cambridge residents and artists known for their innovative installation pieces and, particularly, their work with water, were a prime choice.

In the case of *Drawn Water*, the active community participation and resistance to the original plan may be viewed as indicative of limitations placed on a public artist to complete her vision. Alternatively, the process for *Drawn Water* might instead reveal a successful interaction between artist and community so that the end result is, in actuality, a public product reflecting effective community discourse and involvement.

Drawn Water buttressed a parallel City-run project to renovate the Fresh Pond Parkway area. The Community Development Office received two separate ISTEA (Intermodal Surface Transportations Efficiency Act) enhancement grants to create a graceful link between the businesses on one side of the Fresh Pond Parkway and the dense neighborhood on the other. These grants,

amounting to $1,570,000 in 1998, partially funded new pathways, landscaping, road and pathway lighting, four new traffic lights, crosswalks, pavement markers, signs, and decorative amenities. The City provided the remaining cost of $2,430,000.

In the same year, Environmental Protection Agency legislation ordered a systematic clean-up of the nearby Charles and Mystic Rivers. Cambridge was required to address water capacity issues and impending rules about water filtration. The tightened requirements to manage combined sewer overflow during storms, which at the time caused raw sewage spill-off, needed to be addressed by newer technologies. As a result, the planning and construction of a new water treatment facility commenced in 1999 and finished in 2001. The public-art program fund-ed the total construction costs of *Drawn Water*.

Mags Harries grew up in the town of Barry, 8 miles from Cardiff, Wales, in a house with a view of the water. Her father was a sea captain on merchant ships, and later became a dock master after seventeen years at sea. "Because of Dad's job," Harries recalls, "we were always aware of the tides and the sea and the moon." Héder, who fled to America as a sixteen-year-old after the Hungarian revolution of 1956, is as

BELOW A water-themed manhole cover plaque is inlaid in city street. Photo: Kerry Schneider.

BELOW, RIGHT Replicas of subterranean pipes skirt the windows of the facility.

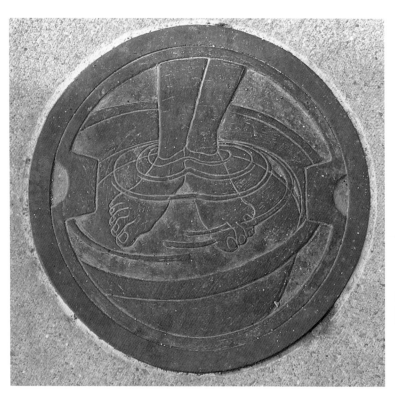

fascinated by water as his wife. "I grew up swimming in the Danube," he says. "You couldn't leave the country then, and the river seemed like a lifeline. We lived in a low-lying area, and there was always the possibility of floods. During World War II, the Russians blew up the dams, and six feet of water turned up in our house."[5] Together, the artists have accumulated an impressive roster of international public-art pieces inspired by their shared fascination with water.

Design impact The piece encourages the public to consider a taken-for-granted subject—water—and remember what a precious commodity it is. *Drawn Water* conceptualizes the city with a transport diagram, not of a subway system but rather of constantly moving underground water. The floor exposes the hidden aquatic pathways, bringing to the surface a vital source of life in Cambridge. The public is asked to consider the unseen movement of this resource when it drinks from a faucet at home, after seeing the encapsulated water in the facility dance when a passerby sips outside.

In a sense, the mapping of water reveals the progression of travel conceptually, by pointing out humankind's ability to transport a natural resource, whereas water was originally used to transport humans. The progression of human ability in controlling water is revealed first by the presence of a reservoir, next by the uncovering of idiosyncratic pathways of pipes—sometimes double, sometimes triple—and then in its use as an interactive, playful material.

The use of *sculptural* elements in the lobby also serves to reveal an *actual* process within the Cambridge water system. The large glass tower, topped with a cloud that represents the Payson Park Reservoir, is filled with water and a buoyant gold ball, linking the outdoor bronze drinking fountain and standing circular element, which acts as a viewing device. This tower is decorative in its use of the mobile ball and lights, and at the same time continues the theme of transparency, by truthfully connecting the reservoir to a simple action at the fountain.

Within the map, an average footstep equals the size of a football field. The artists chose a scale that is accessible to its expected viewer. The floor, in addition to mapping the pipes and water sources, is embedded with engraved copper medallions of various water symbols (a tear, a water bucket, a cloud, a person showering, another swimming), which indicate the locations of Cambridge's schools. The work acts as a treasure map on which children can find themselves within the larger scheme of things. And, just as the places in the real world are represented in this miniaturization, large corresponding medallions are placed at the schools. This element of the piece connects the outside world to the facility and does the reverse inside the lobby. The medallions reinforce the idea of mapping the city by water—giving the schools' pipes a type of visual subway name recognizable by water-based icons understandable to children.

In the winter of 2005, Harries and Héder installed a sister piece, *Reaching Water*, in the Cambridge Arts Council Gallery. The couple's exhibit is "by necessity more modest, but no less magical."[6] Water circulates overhead, from a bucket through a pipe and down a transparent trough, burbling all the way. In Harries's words,

> Lights pour through the water and trace glints and shadows over a white path on the floor, surrounding visitors with sights and sounds of rushing water. It's marvelous to have it coursing wildly inside the staid brick walls of City Hall annex, which houses the gallery. Video monitors and text surrounding the installation document other Harries/ Héder water projects, such as *Water Works* at Arizona Falls in Phoenix.[7]

While *Drawn Water* illustrates the existing infrastructure of water in this city, *Reaching Water* creates a feeling of water being everywhere. According to Pallas Lombardi, executive director of the Cambridge Arts Council at the time, who had worked with Harries for seventeen years, "Some public artists ignore the public, but Mags engages them from the start. She has an innate ability to create something that's accessible in every sense."[8]

1 Lajos Héder, artist, Cambridge, Massachusetts, correspondence.

2 Mary Sherman, "Cambridge's 'Water' works as accessible, playful piece," *Boston Herald*, November 4, 2001, p. 69.

3 Christine Temin, "Making art for everyone from Phoenix to Wales to their own hometown, Cambridge-based public artists Mags Harries and Lajos Héder are changing the landscape one project at a time," *Boston Globe*, May 7, 2000, p. 16.

4 Christine Temin, "Perspectives: TV Arts coverage unImpressive," *Boston Globe*, May 30, 2001, p. D1.

5 Temin 2000.

6 Cate McQuaid, "For these resourceful artists, it's water, water everywhere," *Boston Globe*, December 31, 2004, p. C15.

7 *ibid.*

8 *ibid.*

The New Ring Shout

I

Project description

A cosmogram is embedded into the floor of the Ted Weiss Federal Building, New York, which was built over an eighteenth-century African burial ground

Artist

Houston Conwill

Architect and graphic artist

Joseph DePace

Poet:

Estella Conwill Majozo

Agency

United States General Services Administration, New York

Date

April 1, 1995

Dimensions

40 ft diameter

Materials

Illuminated polished brass and terrazzo floor

Cost

$450,000

N MAY 1991, while digging the foundation for a new federal office building in lower Manhattan, construction crews unearthed the remnants of an African burial ground more than two hundred years old. Located just outside colonial New York's northern boundary, two blocks north of City Hall, the 5-acre cemetery was created in the early eighteenth century to provide a resting place for African slaves denied burial in the city's churchyards. Estimates suggest that anywhere from ten thousand to more than twenty thousand people had been interred here by 1793, when the expanding city covered the area with landfill and developed it for housing.[1] As a consequence of the city's rapid growth, many remains are still entombed under nearby buildings. At the time of the burial ground's rediscovery, historians recognized it as the largest urban pre-Revolutionary African cemetery in America.[2]

The rediscovery of the African burial ground afforded the city of New York and the African American community a rare opportunity to reclaim a neglected part of its collective history.[3] New York is often thought of as a "free" state, but slavery was a force in the

city until the 1827 emancipation of enslaved Africans. In fact, New York's history as a thriving harbor and port of entry made the city one of the major centers of the British slave trade in America.[4] Thus "the excavation turned up ... a living metaphor of racial oppression—a meaning compounded by the Government's plan to build over the site once again."[5]

An elaborate compromise between the construction of the building and the interests of this significant site followed the discovery of the burial ground. In August 1992, after a series of demonstrations on the site, letter-writing campaigns, and newspaper editorials, Congress halted the construction of the General Services Administration (GSA) building and declared the site a National Historic Landmark, thus formally recognizing the significance of the discovery. Subsequently, the city's Landmarks Preservation Commission designated the site and its surrounding area a New York historic district. In October 1992, the GSA chartered a steering committee to represent the interests of the community and to make recommendations regarding the treatment of the burial ground. In addition to mandating the analysis, curation,

and reinterment of remains removed from the site, the Federal Steering Committee also ordered the construction of a memorial.[6] Shortly afterward, President George Bush approved up to $3 million for the modification of the site plans and the "appropriate" memorialization of the burial ground.[7] As archaeologists carefully uncovered, identified, and moved the remains of some 390 skeletons, the GSA reserved part of the site as hallowed ground. The Ted Weiss Federal Building was finally constructed and completed in 1995—though not as originally intended. The building was truncated to leave a remnant of burial ground free of construction. "The preserved plot is only a fraction of the original 5-acre burial ground. Even so, it is a potent piece of urban turf."[8]

Houston Conwill, Joseph DePace, and Estella Conwill Majozo's work *The New Ring*

BELOW, RIGHT *The New Ring Shout*, detail, song line final destination. Photo: Bernstein Associates.

BOTTOM RIGHT View of *The New Ring Shout*. Photo: Bernstein Associates.

Shout, completed in April 1995, serves as one of the many memorials on the site that pay homage to Africans brought to the Americas. But this was not the artists' initial, specific intention. The GSA's Art-in-Architecture program had already commissioned a public-art installation from Conwill, DePace, and Majozo, as well as from artists Clyde Lynds and Roger Brown, before the discovery of the burial ground. Consequently, the GSA presented each artist with the option to pay tribute to the burial ground (all chose to do so), and then commissioned three more installations required to memorialize the site under the aforementioned federal mandates.

Today the collection of installations at the federal office building includes: Conwill, DePace, and Majozo's cosmogram, *The New Ring Shout*; Clyde Lynds's cast stone sculpture, *American Song*; an untitled mosaic by Roger Brown; *Renewal*, a silk-screened mural by artist Tomei Arai; and *Africa Rising*, a sculpture by Barbara Chase-Riboud.[9] The GSA also anticipates a future installation by Melvin Edwards in the form of artistic gates that will reference the African burial ground while allowing the other memorials and the site's Interpretive Center to be accessible to the public when the federal building is closed.

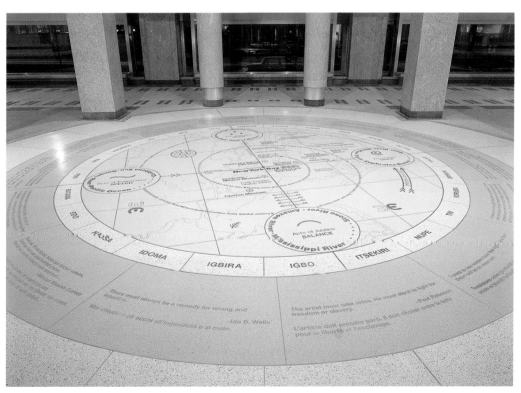

Together, these works serve not only to reflect the history and rediscovery of the burial ground site, but also to highlight the endurance and achievements of African Americans over the past two centuries. The African burial ground was designated a National Monument in 2006.

Description Marking the northernmost boundary of the 5-acre burial ground, *The New Ring Shout* is embedded in the floor of the central rotunda of the Foley Square Federal Building constructed over the historic site. Consistent with much of their previous work, and faced with the astonishing discovery of the African burial ground, the multidisciplinary team, consisting of artist Houston Conwill, architect Joseph DePace, and poet Estella Conwill Majozo, very deliberately conceived and designed the cosmogram to serve as a historical reference, a monument, and a dancing ground for tracing the tragic and triumphant journeys taken by African Americans. The work is named after the ring shout dance that is traditionally performed as part of African American burial ceremonies.[10]

Conwill, DePace, and Majozo's circular representation of the ring shout ritual in this work is composed of a terrazzo cosmogram divided into three rings and transposed on to a map of New York centered on New York Bay. The Kongo/Yoruba African American cosmogram, or crossroads symbol, is a dominant image found in folk art of the African diaspora and associated with transformation, creative survival, and empowerment.

The earth-colored, innermost ring contains inlaid, illuminated brass symbols and a multilingual spiral song line of lyrics from "twelve songs directing a transformative journey along twelve global water sites marking the migration of diverse peoples to New York."[11] This song line maps the water route of the Middle Passage and continues along the underground railroad trail to New York Bay and on to fourteen significant signposts in New York—including the Statue of Liberty, abolitionist Rufus King's house, Central Harlem, Louis Armstrong's Jazz Museum, and the United Nations.[12] The counterclockwise movement of the spiral within the inner ring corresponds with the sun's movement from east to west and parallels both the cycle of human life and the movement of the ring shout dance. Moreover, this spiral motif is an Ashante-rooted Sankofa symbol, also found in the New World, meaning "return for wisdom," thus echoing the meaning and impetus of *The New Ring Shout* in conjunction with the African burial ground.[13]

The cosmogram's middle ring is marked with the names of twenty-four African nations subjected to the slave trade, and thus reflects the practice of shouting out names of severed African nations as a rite of remembrance.[14] The outermost blue ring signifies the ocean voyage and is inscribed with critical quotations from fourteen great African American men and women, translated into fourteen languages. These quotations belong to abolitionists Frederick Douglas, Harriet Tubman, and Sojourner Truth, educator Mary McLeod Bethune, writer Zora Neale Hurston, actor Paul Robeson, humanitarian Mother Clare Hale, civil rights activists Marcus Garvey, Ida B. Wells, Malcolm X, Martin Luther King Jr., and Rosa Parks, and historians Yosef ben-Jochannan and John Henrik Clarck. The artists explain, "Their timeless words continue to challenge us to break down barriers that separate people of diverse backgrounds and to build bridges of compassion, clarifying common ground for all humanity."[15] According to DePace, the multilingual artwork is essentially multicultural, drawing on universal values, not limited to African American history.

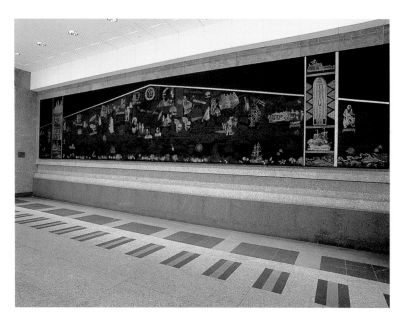

Tomie Arai's 1998 *Renewal* mural explores the lives of African slaves in New York through archaeological and historical images. Photo: Stan Ries.

Design impact Conwill, DePace, and Majozo see themselves as an interdisciplinary team of collaborating artists who create place-specific public-art installations that are designed to be catalysts for social change: "Our works are monuments intended to engage a cultural pilgrimage experience highlighting local African American history within a global context from its own cultural perspective."[16]

Through *The New Ring Shout*, the artists have provided a space where the people of New York can literally "move through their histories, connecting with the languages of both body and mind."[17] The incorporation of a culturally interpretive and interactive work with the federal building and the African burial ground contributes to celebrating the "philosophy of joyous triumph over adversity"[18] and protecting a tradition of cultural diversity and consciousness for future generations.

As an element of design, *The New Ring Shout* is slick and therefore potentially inconspicuous. Its smooth surface and the building's somehow overbearing rotunda result in the work having less impact than if the rotunda had been treated with a discrete textural material. The public and the building's users may choose whether or not to interact with the treated ground below their feet. This effect is in direct contrast to Richard Serra's controversial piece *Tilted Arc* that once stood a block away from the site of *The New Ring Shout*. *Tilted Arc*, an inward-leaning slab of Cor-ten steel 12 ft high and 120 ft long, forced people to confront it as it bisected, and blocked, the Federal Plaza space in front of another GSA building in lower Manhattan. It was removed after years of controversy (see pp. 25 and 345–47).

While *Tilted Arc* expressed hostility to its site, *The New Ring Shout* seamlessly integrates into its site. The wake of the public relations fiasco associated with *Tilted Arc* polarized the government arts commissioners and artists, whose works can be provocative or even critical of this, their hiring agency. The design team of *The New Ring Shout* had no intention of bandaging over the sores that the GSA had caused by proceeding with the building's construction.

Some people still refuse to set foot in the federal building, horrified that the government would put construction and progress ahead of respect for the dead and America's former enslaved. For the design team, this opportunity provided a way to address this conflict. According to DePace, "the first step was to acknowledge that there would be a building there. Given the responsibility of the commission, do you walk away from it out of protest? Or do you go to the belly of the beast and, in a sense, reclaim the building for this community?"[19] The design team came together to give a voice to the silent deceased, as well as the living history of their legacy.

The GSA's incorporation of public art in federal buildings has been voluntary since the establishment of the Art-in-Architecture program in 1963. However, as a result of the GSA's experience with *Tilted Arc*, all the public artworks associated with the African burial ground and incorporated into the GSA building have been chosen and accomplished within a broader dialogue with community groups. Consequently, the installations reflect the historical eras and watersheds of African American heritage, "as well as the enduring transcendent attributes and values: hope, wisdom, temperance, justice, and love."[20] Fundamentally, these works are about language, about discovering the visual vocabulary to express the meaning of a deeply significant place.[21]

> Walking through the lobby [of the GSA building], it is impossible not to think of the dead beneath one's feet and—by extension —of the nameless and unremembered dead all over Manhattan. It is as if these African dead have claimed an otherwise anonymous government building as their own.[22]

As a unique reminder of New York's early African inhabitants, the burial ground physically expresses the historical connection between Africa and America, and is thus an essential aspect of the African American experience. Within the site itself, connections to Africa are expressed physically in such artifacts as a coffin inscribed with what researchers suspect is an African ritual symbol—from a family of symbols still used in Ghana and Ivory Coast.[23] Within the federal office building, memorialization through public art visually bridges African origins and the site with diverse accounts of African American history.

1 See Herbert Muschamp, "Claiming a Potent Piece of Urban Turf," *New York Times*, March 13, 1994.

2 GSA Public Buildings Service brochure, 1999.

3 *ibid.*

4 *ibid.*

5 Muschamp 1994

6 GSA Public Buildings Service brochure, 1999.

7 *ibid.*

8 Muschamp 1994.

9 See Anon., "New Art Installation Graces Downtown Federal Building," *New York Voice of Harlem Inc./Harlem USA*, April 28, 1998.

10 See Houston Conwill, Joseph DePace, and Estella Conwill Majozo, "Statement of Approach to Public Art: *The New Ring Shout*," March 9, 1998.

11 Lucy R. Lippard, *The Lure of the Local: Senses of Place in a Multicentered Society*, New York: The New Press, 1997.

12 See Conwill, DePace, and Majozo 1998.

13 *ibid.*

14 *ibid.*

15 *ibid.*

16 *ibid.*

17 Lippard 1997.

18 Conwill, DePace, and Majozo 1998.

19 Joseph DePace, interview, April 23, 2006.

20 Conwill, DePace, and Majozo 1998.

21 See Muschamp 1994.

22 Brent Staples, "Manhattan's African Dead," *New York Times*, May 22, 1995.

23 *ibid.*

will water

al to the e

ter to Sa

water t

gling w

Placemaker as turf definer

166 **Bronzeville**
Chicago, Illinois

170 **Alvarado Water Treatment Plant**
San Diego, California

176 *Cultural Landscape*
Smith Campus Center, Pomona College, Claremont, California

182 *Black Swamp*
Bowling Green State University Campus, Bowling Green, Ohio

Bronzeville

CHICAGO, ILLINOIS

Project description

Bronze map of the community and its landmarks embedded in the sidewalk; a 15-ft-tall bronze statue of an African American migrant; a walk of fame listing notable former residents; twenty-one sculptural benches; recognition panels

Artists

Gregg LeFevre, Allison Saar, Geraldine McCullough, Mary Brogger, and others

Agencies

Funded by Metropolitan Piers Exposition Authority, administered by Chicago Department of Cultural Affairs

Date

1994–96

Dimensions

Map: 7 × 14 ft; sculpture: 15 ft high; benches: various sizes

Material

Bronze

Cost

$500,000

Photography

Todd Buchanan

A CAST BRONZE MAP in the center of Martin Luther King Drive marks the symbolic entrance to Bronzeville, a historic African American neighborhood on Chicago's South Side. New York artist Gregg LeFevre designed the map. His work includes other bronze reliefs embedded into sidewalks, plazas, and other public places in New York, Boston, Las Vegas, and Miami. Chicago's Department of Cultural Affairs commissioned LeFevre and several other artists to celebrate Bronzeville's cultural past and rejuvenate the run-down community with new public-art pieces.

Beginning after World War I, over six million disenfranchised blacks in the southern United States migrated to the industrial cities of the north, only to be segregated out of many parts of these cities because of race-based housing laws. In Chicago, Bronzeville became the center of African American life. In terms of the African American cultural luminaries, business owners, and political figures who made it their home, Bronzeville's cultural and commercial legacy rivals New York's Harlem. Among those who left their mark on Bronzeville in its heyday were Louis Armstrong, Joe Louis, Mahalia Jackson, Muddy Waters, Nat King Cole, Langston Hughes, Richard Wright, Ida B. Wells, and Malcolm X. The neighborhood was home to Chess Records, the blues record label, the *Chicago Defender*, a prominent black newspaper, and Liberty Life Insurance, the first black-owned insurance company in the northern United States.

The Depression hit Bronzeville hard: many of the black-owned financial institutions and other businesses folded, yet the cultural life of the community flowered at this time. Some of Bronzeville's greatest musicians and writers produced their finest work during the 1930s and 1940s. However, the years of disinvestment and neglect continued from the 1950s through the 1980s, as Bronzeville took on the run-down character of many other American inner-city neighborhoods. Large-scale urban renewal projects destroyed many of the neighborhood's architectural landmarks, and fragmented the community. Martin Luther King Drive, originally South Parkway, part of Chicago's "Emerald

Necklace" of grand boulevards, became a drab and anonymous thoroughfare. Massive public housing blocks stood forlornly off King Drive, and its grand median had fallen into disrepair. No marker recognized the area's vibrant cultural history along King Drive, once the focal point of the community.

In an effort to restore this cultural legacy, the City of Chicago initiated a wide-ranging system of improvements along King Drive. The public art includes a series of projects tying Bronzeville to its artistic past. There is a monumental statue, a walk of fame illustrating Bronzeville's notable residents, and twenty-one sculptural benches designed by different artists, each reminiscent of a specific aspect of Bronzeville culture. The art cost $500,000, about one-twentieth of the total project budget of nearly $10 million. King Drive was repaved, lighting was added, and landscaping amenities were provided to enhance the median divider. New signs also welcome tourists, commuters, and residents to one of "Chicago's Historic Boulevards." A quasi-

public agency, the Metropolitan Piers Exposition Authority (MPEA), which had been expanding a convention center just north of Bronzeville, funded the improvements. For years, community members had solicited MPEA investment. This time, the MPEA agreed to fund the King Drive improvements in an effort to mitigate several of the traffic disruptions that had been created as a result: for in addition to the convention center renovation, other nearby MPEA building work was forcing cars and construction vehicles to detour on to King Drive. The result is tangible; the restoration and new artworks recall King Drive's former glory, and a much anticipated revitalization is sweeping through Bronzeville.

Description Bronzeville's most visible new piece is *Monument to the Great Northern Migration*, a 15-ft tall statue of an African American migrant just arrived from the south, designed by Los Angeles-based artist Allison Saar. The man stands atop a heap of worn-out shoe soles, and carries an old, empty suitcase,

PAGE 164 Detail of the wooden walkway at the Alvarado Water Treatment Plant (see pp. 170–75). Photo:courtesy of Robert Millar.

BELOW Pedestrians walk across Gregg LeFevre's bronze map inlay.

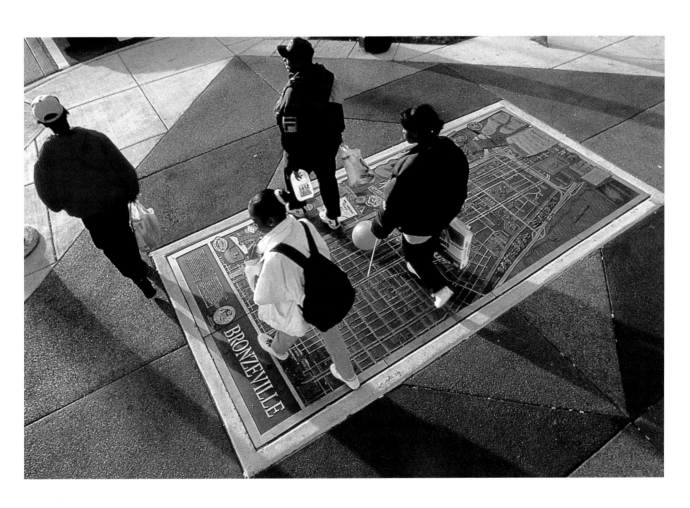

which, according to the artist, is bulging with hopes, dreams, and spirit. *Monument to the Great Northern Migration* is a new take on traditional monumental statues. It is informal; the texture resembles loosely molded clay and the figure stands in an easy, welcoming posture, his hand raised in greeting. Nonetheless, at 15 ft, standing at the northern entrance to Bronzeville, the statue is arresting; a visually striking piece that is coherent from the very first sight.

Gregg LeFevre's bronze map is a subtle contrast. The shallow relief is embedded into the sidewalk on the King Drive median, 7 ft by 14 ft. Often by accident, a viewer comes upon it while crossing the street, but it is best appreciated by lingering, perusing the map from directly above, and charting historic, cultural, and perhaps familial sites. The map depicts city streets, historic buildings, the location of famous houses, schools, hospitals, and other significant neighborhood sites. LeFevre, aided in his research by a Chicago city historian, included all Bronzeville's cultural eras, from a Native American trail to the present day:

For example, the area was at one point a prison camp for Confederate soldiers—thousands of whom died of starvation and neglect. I represented the boundaries of the prison on my map, and included text about the numbers of deaths. At another point it was a poor Jewish neighborhood. More recently it was an African American community, which started out as a very lively and culturally rich area, but then after the Depression fell on hard times. Images of a Baptist church with a Jewish star in the stained-glass windows were used to tell the story of this transition.[1]

LeFevre carved symbolic images of Bronzeville's cultural tradition across the left and top of the street map. He proposed these icons as "framing elements" emblematic of the neighborhood. These include a blues guitar, a bill announcing a Negro League baseball game, a poster for an NAACP protest rally, newspaper headlines, and logos for the Chicago Urban League and the Overton Cosmetics Company, both based in Bronzeville. Of particular note are the images that recall Bronzeville's musical and literary tradition. The map's borders are decorated with copies of original recordings by Junior Wells and Nat King Cole, a Muddy Waters album cover, and signs from many of the local venues where Waters, Cole, and Louis Armstrong played, including the Regency, the Savoy, and the Club DeLisa. There is also a cover from Richard Wright's *Native Son*, and extracts from the poetry of Langston Hughes and Gwendolyn Brooks.

Other newly commissioned artworks echo some of the images ringing the map. Artist Ted Garner designed a park bench shaped like a blues guitar, called *Tampa Red*, and many names of culturally important Bronzeville

BELOW Gregg LeFevre, detail of cultural elements in bronze streetmap.

BELOW, CENTER Allison Saar, *Monument to the Great Northern Migration*.

BELOW, RIGHT Ted Garner, bench representing Bronzeville buildings.

residents reappear in Geraldine McCullough's walk of fame.

The Bronzeville artworks vary in terms of media, tone, and scale. Park benches range from abstract pieces to traditional African patterns or iconic designs. Some benches are irreverent, while the walk of fame and the bronze map possess a sense of dignity. Despite their differences, the pieces reinforce each other by thematically focusing on Bronzeville history. In addition, they all invite the viewer to interact. The benches are simultaneously artistically intriguing and a comfortable place to sit. The map encourages the viewer to walk on top of it and to explore. Even the monumental sculpture is inviting, surrounded by a circle of bollards in the shape of suitcases, which are not as alienating as such enormous statues often are.

Design impact Bronzeville residents have played a large rôle throughout the improvement process. Neighborhood residents, organized through mailing lists and phone banks, first approached the Metro Piers Authority to invest in the area. Nine out of sixteen art selection members of the project panel—a board invested with choosing and overseeing the various art installations—live in the community. Gregg LeFevre worked closely with the people of the area, using a local historian to help select the cultural images to represent the neighborhood, and remaining highly responsive to other community input. He explains:

> Certain images that I chose to include surrounding the map became problematic for some. For example, one of the first successful black-owned businesses in the area was a cosmetics firm that manufactured, among other things, a "whitening" cream. I thought that the inclusion of an advertisement for this product said a good deal about the relationship between the two races at a certain point in history. Yet many found the ad offensive. My thought was, "Who am I, a white artist from New York, to insist on a particular representation of some aspect of this community, if the long-time residents,

some of whom have experienced a good deal of the history of the area, have objections?"[2]

The result is an art program that speaks to residents and tourists alike. Barbara Koenen, public-art coordinator for the Chicago Department of Cultural Affairs, says, "King Drive is anchoring community efforts to attract tourism, business, and redevelopment."[3] New townhouses, other infill housing projects, and a new bank have renewed investment in Bronzeville. The program has garnered positive pieces in the *New York Times*, the *Chicago Sun-Times*, the *Chicago Tribune*, and *American Legacy*, among other publications. These have all reflected on Bronzeville's rich cultural legacy, a notable achievement for an inner-city community that was until recently known for crime, gangs, and drugs. A few years ago, the only tourists were hard-core blues fans, who wanted to see the original venues where Junior Wells or Muddy Waters played. Now, the Chicago Department of Cultural Affairs sponsors Bronzeville tours, and receives numerous independent requests for their Bronzeville art brochure.

Residents have benefited in a more personal manner as well. Elementary school classes take rubbings of the map, and so learn about their community history. Other residents are encouraged to think about their own life or their family history. Says Koenen:

> Whenever I go to the Bronzeville installation and am looking at the clock or map, people just start talking to me without knowing who I am. When they were installing the Saar sculpture, a woman who was a nurse and who worked in the medical center across the way stopped and watched for a while, then said, "What's that?" I explained to her what the sculpture represented, and the nurse replied, "I don't like it." Then she thought about it, and started telling me the whole history of her family when they came up to Chicago. Then she said, "I don't know why I am telling you this." I responded, "Well, you're telling me this because of the sculpture." Even if you don't like it, it touches people and gets them to respond.[4]

1 Gregg LeFevre, artist, New York, correspondence, October 27, 1997.

2 *ibid.*

3 Barbara Koenen, public-art coordinator, Chicago Department of Cultural Affairs, correspondence, December 16, 1997.

4 Koenen interview, January 15, 1998.

Alvarado Water Treatment Plant

SAN DIEGO, CALIFORNIA

Project description

The fifty-year-old water treatment plant's redesign includes a native garden on top of a giant cylindrical reservoir; a wooden bridge inscribed with questions about San Diego's water history; and a steel-canopied viewing portal overlooking the water release area

Artist

Robert Millar

Agency

City of San Diego Water Utilities Department

Date

1992–98

Dimensions

Garden: ¾ acres
Bridge: 200 ft long

Materials

Concrete, soil, Douglas fir timber, stainless steel, native plants

Cost

$25.2 million for reservoir construction. public-art costs estimated at $250,000

Photography

Courtesy of the artist

THE RADICAL IDEA of Los Angeles artist Robert Millar for the renovation of San Diego's fifty-year-old Alvarado Water Treatment Plant was to leave much of it as it was. Many engineers and architects who design plants such as Alvarado attempt to camouflage the plants' industrial appearance to blend into the surrounding landscape. Millar's design, however, celebrates the plant's industrial purpose as a means of questioning San Diego's intimate and desperate relationship with its scarce water resources. A native xeriscape (landscaping that requires minimal water) covers the roof of one of the two 21-million-gallon cylindrical reservoirs. A wooden footbridge, designed to recall the Spanish-built water flumes that first brought water to San Diego, is engraved with questions about pertinent environmental, historical, and philosophical issues.

In the early 1980s, two proposed public artworks in San Diego generated considerable controversy. Ellsworth Kelly's steel and concrete arc prompted neighborhood furor because of its abstract aloofness. Vito Acconci's art park, which included airplane fragments near the site of a recent crash, unsettled residents. Neither was built. Since 1988, however, San Diego's restructured art program has installed eighty new artworks, and it is now considered one of the country's most successful art programs. The flexible art program allows City departments to choose case by case to what degree they think public art is appropriate to new public works construction projects or renovations.

In 1992, San Diego's Water Utilities Department (now the Water Department) began the renovation of the ageing Alvarado plant. Phase I, completed in 1998, included the construction of two 21-million-gallon reservoirs, supplying drinking water to half a million people. Phase II, still incomplete, involves the renovation of existing structures and construction of new buildings, without any art component planned so far. Near the beginning of the first phase, design team members selected Robert Millar from among three artists to join the team.

Southern California's water-based imperialism has been well documented. A semi-arid desert supports a population of

twenty million people, including nearly two million in San Diego County. A complex system of aqueducts, reservoirs, and water treatment plants allowed San Diego's growth into one of the nation's great manufacturing, shipping, and agricultural centers. Spanish settlers made the earliest attempts to draw water great distances in California, using wooden flumes to bring water to San Diego from the San Diego River's Mission Gorge, approximately 6 miles northeast of their settlement. In 1917, San Diegans dammed Chaparral Canyon, creating Lake Murray, which is now used recreationally.

The Alvarado Water Treatment Plant was built in 1951; its Spanish-style cement forms reflect those of contemporary public works projects in Southern California. The plant rests on Lake Murray in Chaparral Canyon, 10 miles from the city center. At the time, the surrounding hillsides retained a natural character, but since then upscale custom residences and middle-class tract homes have overtaken the landscape, providing one more reminder of the region's explosive growth and increasingly stressed water supply.

Southern California's water history is as closely associated with backroom meetings, secret wheelings and dealings, and widespread corruption as it is with scarcity, as revealed in Roman Polanski's *film noir* classic, *Chinatown*. Says Millar,

> The significant issue I identified during the process was public accessibility The public in California knows very little of water issues in the state because of the secrecy that pervades the entire industry. Both literally and figuratively, I wanted to allow the public through the barbed-wire fence.[1]

To this end, Millar's design plays up the water treatment plant's industrial character and purpose, revealing its technological aspects. The completed plant will include a tour directing visitors through the same course the water follows. Interpretive signage will comment on water issues. Glass windows will reveal the machinery. Architecture will reflect urban infrastructure.

Millar visited neighborhood residents to discuss community concerns. Nonetheless,

The steel-canopied viewing portal overlooks the outflow of the Alvarado Water Treatment Plant.

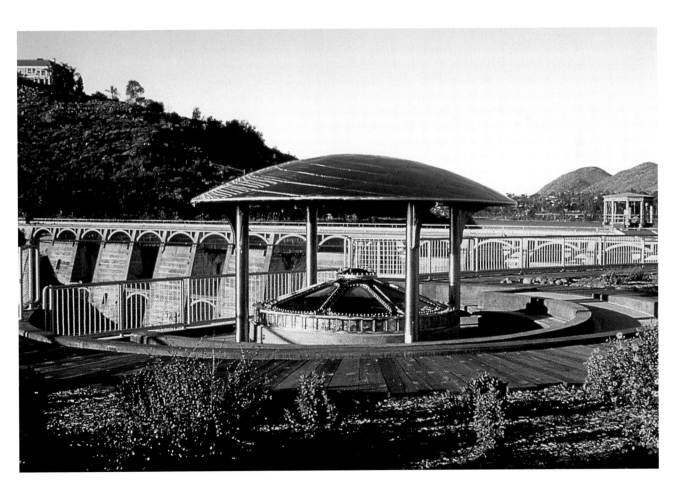

the plant's design upset many residents, who disliked its industrial appearance and desired a less evident color choice. The project's New York-based architects also took issue with the concept of exposing the plant. Their plans specified stucco painted pink or beige for the exterior walls, and drywall to transform a majestically vaulted and naturally lit interior room into 10-ft-square offices. At first, engineer and project manager Rick Brady was skeptical about working with an artist on the plant redesign. However, Millar impressed Brady with his inclusive design process, his interviews with nearby residents, and his spare, relatively inexpensive vision for the site. Brady remarks:

> As a result of this experience, as I have already said on a few occasions, I could not envision attempting another large municipal design without the services of a public artist.[2]

Consequently, Millar's influence is felt throughout the renovated plant, not only in the most obviously artistic elements, but also in

the industrial gray exterior and the intact open interior spaces.

Description Existing buildings at Alvarado contain expansive rooms, with pipes and machinery open to view. Because it is a water treatment plant, the renovated plant will contain incoming and outgoing pipes, various settling and cleaning basins, and two giant storage tanks. Much of this infrastructure is currently under construction.

When completed, Alvarado will include a tour of the facilities. Schoolchildren, public interest groups, and anyone interested in the water filtration process will parade past a series of interpretive signs explaining the plant's technical aspects. These signs will also contain portions of essays on California's history and ecology as it relates to water. Pipes will remain uncovered in interior spaces. In a typical water plant, viewers only see the pool's murky top, and the filtration process is hidden; here, glass walls will allow for views into settling tanks, where rotating filters sweep debris out of the water.

The wooden bridge and walkway (below) has topical inscriptions branded on to its surface (opposite).

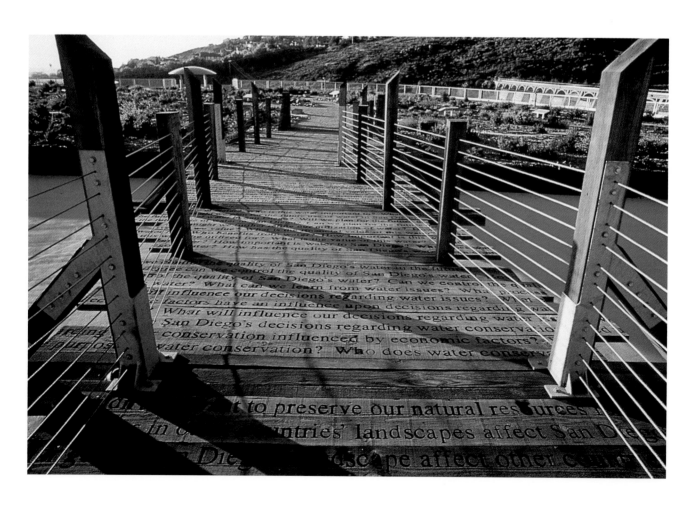

The educational tour continues on top of the two storage tanks, where Millar designed gardens composed of native drought-tolerant plants. In a region known for its water-guzzling exotics, such as palm and citrus trees, and manicured lawns, Millar's garden poses questions about Californians' planting choices. Looking across the storage tanks to the hills beyond, the viewer sees many of the same species used in the garden: sagebrush, chaparral, and cacti. A wooden bridge, built to resemble the early Spanish aqueducts that once supplied San Diego with water, leads to the garden. Using individual branding irons for each letter, a blast furnace, and a twenty-five-ton press, the artist and assistants pounded thirty thousand letters into the wood of the bridge to raise questions on such issues as water, San Diego's history, the rôle of art in education, and the process of questioning itself: What is the purpose of questioning? How has water affected cultural issues in California? How much water will be here in five thousand years? What is more important than our future?

At the garden's opposite end, a viewing portal overlooks Lake Murray and the plant's lower sections. A stainless-steel canopy mirroring the shape of Alvarado's other buildings shelters the overlook. Sited above the plant's outflow, the viewpoint completes the tour. Gushing water, 170 million gallons a day, will rush from beneath viewers' feet as they stand at the overlook.

Design impact Millar's design for Alvarado challenges conceptions of public art's limits, blurring the distinction between art and architecture. There is little for a viewer to recognize as traditional public art, as the plant's artistic elements are more conceptual than overtly aesthetic. A native garden, a wooden bridge, and a stainless-steel canopy provide Alvarado's visual components. More importantly, Millar's work incorporates a new conception of industrial projects. Alvarado transforms traditionally inaccessible, often secretive industrial plant design into an exploration of its processes

and their relationship to society. He says,

> Context is an important issue of my work, but in a broader sense than physical place. What is the work's place within history? What is the work's place within the cultural identity of the community? What is the work's place within the history of the programmatic system that commissioned it? What is the work's place within current artwork of this kind? What is the work's place within my body of work? What is the work's place within the daily life of the surrounding community?[3]

Millar achieves contextual relevance by drawing attention to examples of the plant's functionality and its historical rôle. Alvarado transcends traditional public art by incorporating programmatic issues, and goes beyond conventional industrial architecture by introducing concepts that question, educate, and deconstruct.

Situated in a canyon in suburban San Diego, Alvarado is not easy to visit. It presents no face to the neighborhood. It is no public destination. Although anyone can make an appointment to tour the plant, visitors generally don't walk in off the street. Typical tour groups include schoolchildren and public interest organizations. Otherwise, only Water Department employees and residents with views of the plant see it. Critic Robert Pincus of the *San Diego Union-Tribune* addresses this issue:

> Millar's garden raises intriguing questions about what constitutes public art and what doesn't. Do we define the genre as art that exists in completely public places, such as our parks, our streets, and our neighborhoods? Or, can it also be art—like Millar's or Richard Turner's recently completed project for the city's Metro Biosolids Center—that addresses public issues and conveys an awareness of itself as a vehicle for public dialogue?

Pincus continues:

> Millar's garden convincingly demonstrates that there should be room for both [a dialogue with city workers and with a nonart audience]. His solution: art, at an attractive site, with an agenda that blends education and unpretentious philosophizing Semi-public art is a valid enterprise for a public-art

The stainless-steel-canopied viewing portal overlooks Lake Murray.

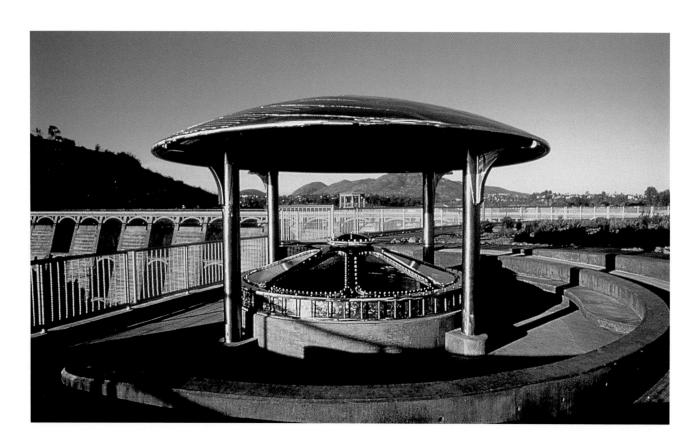

program. Millar's garden is likely to delight visitors and perhaps open eyes about how we use water. That is reason enough for it to exist.[4]

Other writers have commended Alvarado's design as a highly successful example of San Diego's lauded public arts program. Public-art consultant Mary Kilroy, responsible as former director of Philadelphia's Art Department for the country's first Percent for Art program, writes:

> [San Diego's public-arts policy is] heralded as one of the most responsive to community needs of those legislated in the 1990s, despite the fact that the city has no across-the-board mandated Percent for Art requirement for public construction. Art "objects" have been replaced by art integral to the creation of more interesting public spaces and have been designed through collaboration between artists and other design professionals. One of the most impressive new projects in San Diego is the Alvarado [Water Treatment] Plant.[5]

Positive press, in tandem with a visible design, combine to make Alvarado much more conspicuous than a typical utility plant. Former California governor Pete Wilson used the reservoir garden for the public unveiling of a statewide water plan. Millar has since been asked to lead a design team for another water-related plant in San Diego. The project, a conservation-oriented filtration plant that would convert sewer water into drinkable water, would be the first of its kind in the country. It has been shelved, however, as a result of controversy generated when the press labeled the project a "toilet-to-tap" system.

Nonetheless, *Architecture* magazine awarded the "Advanced Water Treatment Plant" a Progressive Architecture Citation for Visionary Design in 1998. Its design incorporates a membrane system into the architecture, taking viewers on a tour through several layers of material, metaphorically mirroring the process by which the water is cleansed.

Since Alvarado, the Water Department has used artists to enhance elements at the new reservoir, including an artist-designed front gate. The department has remained positive about using artists, but in 2006, the City of San Diego has tightened the purse strings and the Water Department faces a budgetary crunch. They are only proceeding with projects to fulfill federal and state mandates, and therefore spending on art (as well as other non-essential improvements) is out. Still, the open-mindedness of the department is alive, and the utility remains open to working on art collaborations supported with outside funding, such as projects through the arts commission.[6]

Although engineer Rick Brady declares that he wouldn't undertake another similar project without the services of an artist, Millar feels that many architects, engineers, and adminis-trators are still skeptical about including an artist in public works design, and working art into the architecture. Other examples in San Diego, however, illustrate that this type of design process is increasingly accepted. The Vermont Street Pedestrian Bridge, which includes steel railings with quotations cut into them, and a patterned footpath designed by artists Lynn Susholtz, Aida Mancillas, and Gwendolyn Gomez, is one example. Successes such as Alvarado influence the creation of further artist-led public works designs.

1 Robert Millar, artist, Manhattan Beach, California, correspondence, November 14, 1997.

2 Rick Brady, engineer, San Diego, correspondence, March 23, 1998.

3 Millar correspondence, April 23, 1998.

4 Pincus July 26, 1998.

5 Kilroy 1993.

6 Genevieve DePerio, community outreach specialist, City of San Diego Water Department, interview, February 2, 2006.

Cultural Landscape

SMITH CAMPUS CENTER, POMONA COLLEGE • CLAREMONT, CALIFORNIA

Project description

A bronze floor relief depicts Pomona College at the center of a cultural map of its surrounding landscape

Artist

Gregg LeFevre

Agency

Public Art in Campus Center committee, Pomona College

Date

1997–99

Dimensions

Nine bronze panels together measuring 11½ × 11½ ft

Material

Bronze

Cost

$95,000

G REGG LeFEVRE'S BRONZE FLOOR relief evokes part of the cultural landscape of Southern California, within a 50-mile radius of Pomona College. The piece is carefully integrated into the new architecturally acclaimed campus center that supports the context of earlier campus design.

Pomona College, one of the country's most distinguished academic institutions, attracts students from across the country and abroad. The oldest college in the consortium of Claremont Colleges, Pomona is also part of a historic landscape in the Pomona Valley, largely vanquished by suburban development. As Kevin Starr, University of Southern California (USC) professor and eminent cultural historian of the Southland, wrote,

How hauntingly beautiful, how replete with lost possibilities, seems that Southern California of two and three generations ago, now that a dramatically different society has emerged in its place. What possible connections, one can legitimately ask, can there be between that lost world, with its arroyo cabins and Spanish imagery, its

daydreams of Malibu sunsets and orange groves, and today's megasuburbia extending from Mexico to Kern County.[1]

Nationally known artist Gregg LeFevre incorporated images of the memorable buildings of the San Gabriel and Pomona Valleys, along with college memorabilia, into the relief for the Smith Campus Center. The resulting map depicts Pomona as a nexus in a region demarcated by the Arroyo Seco and San Gabriel Mission in Pasadena to the west, extending to the Romanesque Smiley Library in Redlands, and the Spanish Revival-style Riverside Inn to the east. The bronze relief enables its viewers to gaze beyond Pomona's ivied walls at a landscape studded with cultural sites but obscured by more recent development, *and* renders them visible to those who now know where to look.

Description In 1997, Pomona College commissioned Gregg LeFevre to design a "bronze ensemble"[2] for the west entrance lobby of the new campus center then in the planning stage. The artist was able to work

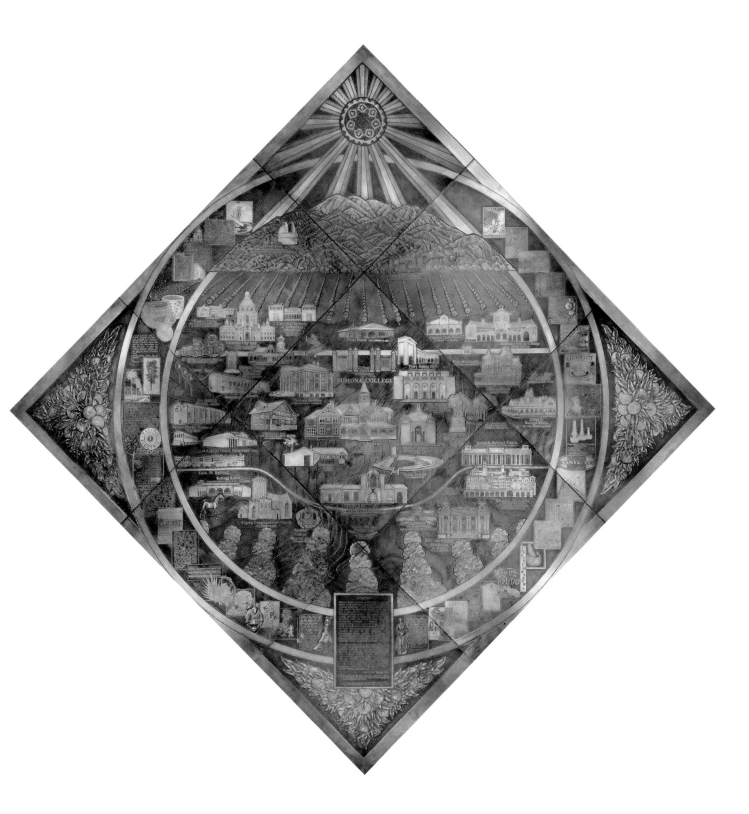

**Gregg LeFevre's bronze
relief collage shows Southern
Californian landmarks.
Photo: Greg Segal.**

directly with the architects of New York firm Robert A.M. Stern. The first piece in the ensemble was a bronze statue of Pomona, goddess of the orchard and college namesake, which stands in a niche above the west entrance doorway. LeFevre modeled the relief after a Roman marble statue in the Uffizi Gallery in Florence. The City of Pomona (just south of Claremont) had commissioned a copy in the 1880s, which still stands in the Pomona Public Library. Alluding to the college's original site in Pomona, the college public-art committee thought that the statue would serve an educational purpose. Professor George Gorse, chairman, notes, "Many of our students do not even know who Pomona is, and this will give her prominence on campus, equal to Jose Orozco's *Prometheus* in Frary Hall, enhancing our sense of historical roots."[3] The statue gazes down from her niche, holding a cornucopia filled with fruit.

The main body of work, a large bronze floor relief, is set in the pavement of the entry lobby below. The relief is made of nine panels that stretch $11^1/_2 \times 11^1/_2$ ft across the floor. LeFevre cunningly tied the statue above to the floor inlay by incorporating a piece of fruit that appears to have fallen from the goddess's cornucopia, adding sly wit to the work.

The relief is a stylized map of the landscape, both physical and cultural, that surrounds Pomona College. The center panel depicts several architecturally distinguished and historic buildings on campus, including the Hotel Claremont (now Sumner Hall), the first building on campus, which the Santa Fe Railroad originally constructed in 1887 to promote visitation and land sales; Carnegie Hall, the original library; and Big Bridges and Little Bridges (auditoria).

Around these landmark campus buildings, LeFevre carved other nearby sites, including the Kellogg Ranch, the former hilltop estate whose owners bred Arabian horses, now a focal point of California State at the Pomona campus; the Los Angeles County Fairground; and the Virginia Dare Winery, the oldest winery in the region. The churrigueresque (Spanish Baroque) Claremont railroad station, now restored and operating again after a long hiatus, welcomes a Santa Fe Railroad locomotive on train tracks that wind across the relief, while the depiction of Highway 66 frames the relief north of the campus.

Above and below the images of Claremont and the valley landmarks are rows of citrus trees, reminders of the industry that originally brought prosperity to the area when Sunkist was the nation's largest exporter of citrus fruit. The orchards stretch toward the San Gabriel Mountains and the Mt. Wilson Observatory, while the entire landscape basks in the rays of a stylized sun; the center is a basket pattern of the local San Gabrielino tribe of Native Americans.

BELOW The Victorian Morey House, built in 1890, shares space with historic Route 66. Photo: Severine von Tscharner Fleming.

BELOW, RIGHT Today the historic Hotel Claremont is part of Pomona's campus.

Surrounding the landscape in a ring are images reflecting college history. The artist, patron, and members of the Public Art in Campus Center committee collected reminiscences from long-time local residents, including former mayor Judy Wright, Charles Lummis, the early day promoter and historian, and novelist Ved Mehta. These quotations share space with old playbills, Native American baskets, trail guides, college humor magazines, and the college mascot (a sage hen). Here again LeFevre's sense of humor is apparent—he includes a scientific description of the mating habits of the sage hen. The distinctive orange-crate labels of the area and other nostalgic items provide a collage of the cultural history of the college and its environs. A dedication from the patron lies at the bottom edge of the relief:

> This terrain stretches from Arts and Crafts bungalows on the Arroyo Seco's rim to the invented mythos of revival styles at Riverside's Mission Inn. The bronze work also evokes the elusive memories of a lost Eden. Sprawling malls and ranchettes have vanquished shimmering eucalyptus on country roads and scented orange groves once plaiting the garden cities of the Pomona and San Gabriel Valleys. Yet an early and generous civic imagination still enriches the axis of this landscape. The Romanesque Smiley Library in Redlands, the greensward down Euclid Avenue in Upland, and the Baroque dome of

Pasadena's City Hall recall the idealistic vision of the City Beautiful Movement.

Design process Working against a deadline as the plans for Robert A.M. Stern's campus center neared completion, the Public Art in Campus Center committee evaluated art concepts that could be incorporated in the structure. The seven-member review board consisted of the president of the college, an artist member of the board of trustees, an art history professor, two deans, the college's director of development, and the director of the Montgomery Gallery (the college's art museum). It identified several locations for artwork in the building, but had no funds to spend. Patron and alumnus of 1963 Ronald Lee Fleming, long an advocate of more and better public art at his college, had earlier pledged to support such an effort. Fleming suggested a floor relief map, and the committee approved the concept, while adding the sculpture of the goddess that LeFevre had initially proposed.

Fleming knew of Gregg LeFevre's bronze map for Highland Park in Illinois. The scale and intricacy of that project, *Clinton Square Map*, and a less complicated map for Hamilton College that LeFevre was doing at the time, convinced Fleming that a landscape interpretation would be suitable for Pomona. Although Fleming thought that LeFevre would be an appropriate candidate for Pomona's relief, he notes that "the committee had to

BELOW Image and description of Roman goddess Pomona. Photo: Severine von Tscharner Fleming.

BELOW, RIGHT Local memorabilia depicted include an 1887 map of Southern California's railroads and a historic Orange Empire Trolley Trip timetable.

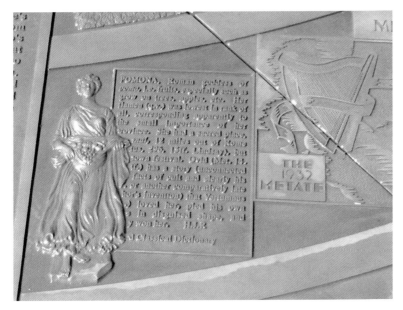

discover for itself that Gregg LeFevre was the right artist,"[4] and he therefore gave them the name of another artist as well. As a patron with long ties to the college and experience in administering other public-art projects, Fleming wanted to be involved in the development of this one; thus, an added incentive to commissioning LeFevre was his proximity in New York to Fleming's office in Cambridge, Massachusetts, allowing Fleming to examine the drawings easily throughout the duration of the project.

Fleming knew that he wanted the floor relief to be a representation of the cultural landscape surrounding Pomona, so patron and artist went on a driving trip around the environs of the college. LeFevre notes: "Working with history as rich and varied as that of Southern California and Pomona College was a pleasure. The architecture of the region and the colorful history of the college and its locale provided a wealth of images to choose from."[5] The public-art committee and Fleming kept adding suggestions for buildings to be depicted, ultimately resulting in a list of structures and objects that LeFevre incorporated in the final piece. George Gorse, chairman of Pomona's Art History Department and head of the campus art committee, did "the lion's share of the research,"[6] according to Fleming.

As the ideas for items to include in the relief accumulated, LeFevre began to fit the pieces of the puzzle together. "Work on the sculpture began with a huge pile of clippings,

old maps, yearbook covers, posters, photos, and the like. These fell into two categories: images of Southern California architecture and of Pomona College history."[7] The artist sorted through images and first created drawings of the final work to be cast in bronze.

Fleming and the campus public-art committee kept up a running commentary on the project, suggesting changes, finding more items to be included, and doing follow-up research. Fleming notes, "Late in the project I realized that after we had collected the photographs of the buildings we needed to include the dates and architects to make it more useful for students and townspeople, so my assistant started researching names and dates."[8] He also wanted to include an image of Claremont Inn, a building in the style of Greene and Greene, which had been demolished in 1965 as a fire hazard, probably only a couple of years before a growing community consciousness and a new historical commission would have saved it. Gorse supported the inclusion of the Riverside County Courthouse, "a beautiful Beaux-Arts building built in 1904 by Franklin Burnham of Chicago, who also built the Carnegie Building at Pomona in 1908. So there is a nice connection to Pomona."[9] Fleming also composed the lyrical dedication, and obtained quotations from Kevin Starr and other Southern California writers to be used in the memory ring around the landscape. The college art committee and Peter Stanley,

president of the college, made the final decision on which quotations to include.

In the past decade, Fleming had respectfully suggested that the college adopt a Percent for Art policy to cover the cost of art in the buildings. The college never did so, nor did it substantially fund other artworks for the campus center, though there are quotations from poet and Pomona graduate of 1973 Garrett Hong inscribed in bronze on the rim of the outdoor patio fountain, as well as bronze plaques with quotations relating to the environs of Claremont lining the main walkway through the building. Ultimately, gifts from Fleming and his mother's charitable trusts financed the entire $95,000 project for the map and relief, which, because of changes and corrections, was $10,000 over the initial budget.

Design impact Fleming noted, "There's been an extraordinarily positive feedback on the piece; I've heard from Peter Stanley [the president of the college] that he will be walking the campus late at night and find people just standing by it and talking about it." Committee chair and art history professor George Gorse added: "Community members comment about how much they appreciate the installation as a history of Claremont and the Pomona Valley and as a place to pause and reflect or to discuss campus and area history."[10]

The positive response on all sides was perhaps due to the level of communication and interchange of ideas between the college, patron, and artist. Although LeFevre found "collaborating with the patron and the committee upon the choice of images was not always easy; on a number of occasions I had to back off the micromanagers,"[11] he was pleased with the final result. George Gorse commented, "My rôle as advisor to the patron and artist was very fruitful and informative— an educational experience. Our relationship was often contentious, and I thought that was one of the most productive and interesting parts of the process."[12] Fleming observes, "We feel that the final result is richer than the concept as initially envisioned, but I am sorry they nixed Stinky's, an ancient student hangout on Route 66."[13]

Beyond the physical presence of the floor relief and statue, the project's impact on future public-art policy has yet to be reckoned.

Pomona College has not created a fund for public art, nor has it utilized the leverage of the development office to target gifts specifically for amenity projects, which Fleming has long advocated. There is a concern in the college administration that such a step would dilute the overall fund-raising efforts. Fleming argues passionately that such a step would elicit more funds because "art will open purse strings that otherwise would remain shut."[14] He also feels that "the question really is whether it will influence future decisions in terms of *integrating* art and craft in other buildings on the campus. This requires an ongoing oversight and a willingness to find architects who have some experience or interest in collaborating, rather than the *coordinative* method, which means hanging or placing works of art *in situ*. Trustee and developer Ranny Draper moved the college's policy to this point as the chairman of the Buildings and Grounds Committee, but they need to take the next step."[15]

This in fact is happening as a new president with a personal interest in art has encouraged the trustees to commission Jim Turrell (a 1965 graduate) to make a "sky frame" in the courtyard of the new psychology building. His art, grounded in the psychology of perception, which he studied while at Pomona, will examine perceptual boundaries in the form of a skyspace, a "floating" metal canopy that frames the sky. It will extend Pomona's vision from the floor terrain of the LeFevre relief to the sky with a complex interplay of light and atmosphere.

The LeFevre relief's dedication plaque closes with this admonition:

> The resonance linking people and places is recovered here while lost in the landscape beyond. The work functions as advocate, quietly exhorting the college to be "eager, thoughtful and reverent"[16] in the conservation and enhancement of its patrimony, while understanding and respecting the cultural context that shaped it.

Cultural Landscape provides that sense of orientation, complementing a building that understands the original campus plan and stylistically relates to the more significant earlier structures on the Pomona campus. Both building and sculpture will now set a precedent.

1 Kevin Starr, *Inventing the Dream: California Through the Progressive Era*, New York: Oxford University Press, 1985, p. viii.

2 Department of Art and Art History, correspondence, June 15, 1997.

3 *ibid.*

4 Ronald Lee Fleming, Chairman, The Townscape Institute, Cambridge, Massachusetts, interview, January 11, 2002.

5 Gregg LeFevre, artist, New York, correspondence, January 15, 2002.

6 Fleming interview, January 11, 2002.

7 LeFevre correspondence, January 15, 2002.

8 Fleming interview, January 11, 2002.

9 George Gorse and Public Art in Campus Center committee, correspondence, December 12, 1998.

10 George Gorse, chair, Public Art in Campus Center committee, correspondence, January 1, 2002.

11 LeFevre correspondence, January 15, 2002.

12 Gorse correspondence, January 1, 2002.

13 *ibid.*

14 *ibid.*

15 *ibid.*

16 Inscription on the college's gates.

Black Swamp

BOWLING GREEN STATE UNIVERSITY CAMPUS · BOWLING GREEN, OHIO

Project description

A pavement sculpture connects the geological history of northwest Ohio to the animation of a newly reclaimed pedestrian area at Bowling Green State University

Artist

William Nettleship

Agency and commission

Percent for Art funding, Bowling Green State University, Ohio Arts Council

Date

1996

Materials

Brick set on sand and concrete base

Cost

$88,000

Photography

Courtesy of the artist

Bowling Green, located 85 miles south of Detroit, in the state of Ohio, was among the last areas in the territory to be settled. Historically, a dense marshland known as the Great Black Swamp encompassed most of the region; early pioneers looked on it as a place of evil prospects and black magic. For years the marsh confined residents to the surrounding ridges and hilltops. Shortly before the Civil War, however, settlers drained the swamp to claim the land, and began farming it. This history commanded William Nettleship's attention and served as the conceptual basis of his *Black Swamp* pavement sculpture, which connects the geological history of northwest Ohio to the contemporary campus of Bowling Green State University (BGSU).

In 1995, BGSU initiated a reclamation project similar to that of the earlier settlers. Over the years, what had originally been an important footpath had become a transportation quagmire in which parking lots and busy roads constrained pedestrian use and eroded the dignity of the campus's quadrangle.

BGSU's master plan called for the removal of cars from the center of campus. To do so, they conceived of a pedestrian mall in the early 1990s. The Collaborative, Inc., an architecture, landscape architecture, and interior design firm based in Toledo, took on the $1-million task of re-forming a historic college green from the busy traffic center. As a first step, university officials acquired the city street that cut through this section of campus, and vacated it. Soon after, the university commissioned William Nettleship to create a pavement sculpture that would provide a dramatic centerpiece to the new pedestrian zone.

Description Nettleship researched the site and was intrigued by the historical importance of the Black Swamp. The artist located two patches of the original swamp forest still extant, and studied the leaves and branches of trees. He then selected the leaves of four species: two types of oak as well as maple and ash, and deployed them in sixteen patterns in a range of scales on one thousand paving bricks, which define the swamp section of the sculpture. These bricks, either black, white, or red, were set on a sand and concrete base within a concrete curb. Those at the western edge are

laid in a black and white pattern reminiscent of tree shadows and the ancient marsh.[1]

The *Black Swamp* pavement then spirals off into a grid pattern that suggests Bowling Green's current landscape of square fields, pastures, and country roads. The sculpture is flanked at the north and south ends by two sections of concrete flatwork, some in buff color: one carrying through the leaf theme, and the other that of the grid. The sculpture covers 87 sq. ft and tilts slightly toward an earth berm in order to increase the area's utility as an amphitheater.

Design process Ohio law does include a Percent for Art mandate for any state-funded project over $4 million, a criterion that *Black Swamp* met. The Ohio Arts Council selected a "core committee" of local representatives to choose the artwork. The committee included building representatives, senior administrative officials, students, campus security, and grounds officials. Robert Waddle, BGSU's master planner, notes that "the

committee generally designates the type of artwork we would like to see, as well as the general location of the artwork, and then we rely on the artists to develop the ideas for the projects."[2] In this, the university's first large-scale public-art project, the administration did not seek input from the community, a practice that has since changed.[3]

The university selection committee sent out a request for proposals, and then consulted with The Collaborative as it reviewed the twenty-two resulting responses, choosing a pedestrian mall combining landscaping and Nettleship's pavement sculpture. Waddle says: "The artist sold his project, without prodding from the committee, on the fact that [*Black Swamp*] would develop an interactive space that met all our needs in terms of maintenance, accessibility, etc., as well as being something recognizable and unique for the campus space."[4]

Once Nettleship was commissioned, he met with students and faculty, gaining a feel for the character of the university and the students

Black Swamp **marks areas of the campus that were formerly marshland.**

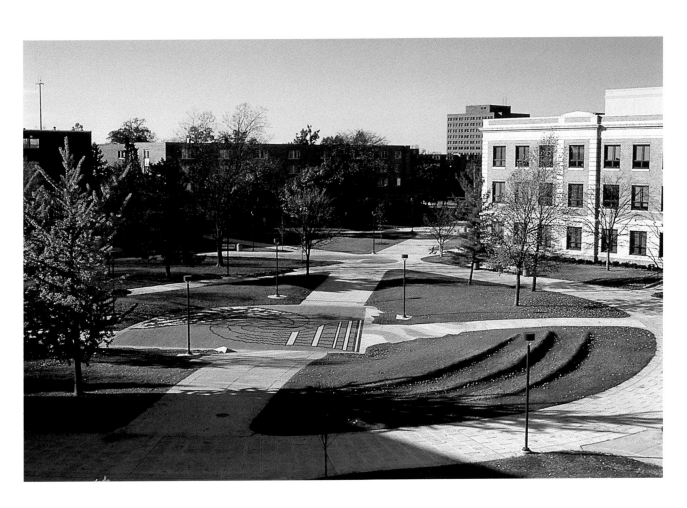

and professors it attracted. He also visited planner Philip Enderle of The Collaborative in Toledo. He commented: "From these conversations I concluded that the best opportunity on the site for a public sculpture would be a main crossroads of the walkways."[5] Foreseeing the importance of his sculpture to pedestrians, Nettleship decided to tilt it slightly toward an earth berm to increase its potential as an amphitheater.

After the university authorities had signed off on his idea, the artist worked with the construction teams to remove expanses of asphalt and replace them with wide criss-crossing concrete walkways—inviting

pedestrians as well as cyclists and rollerbladers. Crews constructed earthen berms to accentuate the flowing design of the walkways, and planted trees and shrubs to blend with existing mature trees and plants. New seating and stylized, simplistic bicycle racks—one-piece, bent-metal loops—were added, and are now the campus standard.

Although the landscape architects and artists developed their projects separately, the plans of each were designed to accommodate the other's needs and concepts. The sculpture's location is one by-product of the team effort. As Waddle comments, "the architects ... made a tremendous effort to

BELOW Nettleship used different colored bricks for dynamic tonal contrasts.

BELOW, RIGHT Students walk across *Black Swamp*.

BOTTOM View of *Black Swamp*'s swirling pattern (left), and a close-up of the black-and-white bricks and leaf imprints (right).

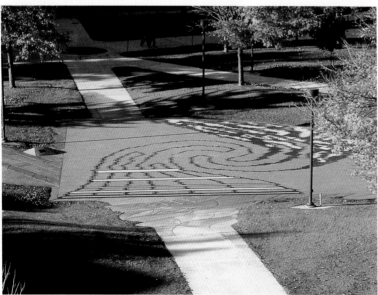

incorporate Will's artwork into the larger project. This was evident in their willingness to change the focus point or natural gathering point of the mall to center on Will's artwork. They also tried to extend elements from his work, like the brickwork, into the larger project in pleasant, understated ways."[6]

The collaboration between landscape designer and artist spread to other areas of the pedestrian mall's design. Nettleship understands the importance of coordinating artists and craftspeople, and was delighted when Brooks Contracting, Inc., the mall's general contractor, decided to integrate the leaf pattern into the concrete bases of campus lightposts. He also worked closely with concrete expert Leon Lickteig. Nettleship remembers, "I discussed putting a crown into the bricks so that the surface of the piece would look convex (and thus stronger) from a distance. Leon Lickteig developed a string line system so that the bricks would crown at the center with a smooth rise from every direction."[7] This collaboration was not only aesthetically advantageous, but also structurally so, as one would hardly guess that the area, which shows very little wear, is high-traffic.

Although the project was a success, it was not without its challenges. Waddle remembers that "because we essentially bid for two separate projects going on in the same place at the same time, both parties thought they should have been more involved with the other's work, and the university believed they should have collaborated with each other more closely to save everyone both time and money."[8] Nettleship was thankful for the cooperation he received during the process,

commenting: "Philip Enderle was helpful throughout the process of design and construction, taking an interest in the project and making numerous adjustments so that our work would fit together."[9]

Design impact The pedestrian mall helps to reconnect the Bowling Green campus. Campus planners estimate that more than ten thousand people traverse the area each day, and it serves as a popular meeting place for students. This is also a result of its careful planning, which included electrical outlets for audio, and food service to encourage the space's activation.

Robert Waddle has received only positive comments about the Pedestrian Mall and Black Swamp. "Most [commentators] have not separated the artwork from the larger project, which in many ways was the intention of the coordination efforts for this work."[10] As *Black Swamp* was one of the first public-art commissions with the newly allocated state funds, it set a precedent for the types of project that Bowling Green might attempt in the future. Robert Waddle noted: "It really has been a tremendous boost to the campus."[11]

The university continues to work on civic enhancements with money obtained through capital improvements on campus. In one such project, university planners enhanced a stretch of roadway at the campus entrance with brick curbing, bicycle racks and lighting. Meanwhile, Nettleship's *Black Swamp*, with its expressive approach, sets a precedent for an integrated approach to the design of campus amenities and is a contrast to the "plop art" seen on many campuses.

1 William Nettleship, artist, Placentia, California, interview, January 20, 2006.

2 Robert Waddle, master planner, Bowling Green State University, interview, January 12, 1998.

3 *ibid.*

4 *ibid.*

5 Nettleship interview, October 10, 1997.

6 Waddle interview, January 12, 1998.

7 Nettleship interview, October 10, 1997.

8 Waddle interview, January 12, 1998.

9 Nettleship interview, October 10, 1997.

10 Waddle interview, January 12, 1998.

11 *ibid.*

Sculpture as place setting

188 Empire State Carousel
 Cooperstown, New York

196 *The River: Time is a River
 Without Banks*
 Johnson County Administration Building, Iowa City, Iowa

200 Professor Longhair Square
 New Orleans, Louisiana

204 Vendome Firefighters Memorial
 Boston, Massachusetts

Empire State Carousel

COOPERSTOWN, NEW YORK

Project description

Handcarved wooden
carousel set on a
reconditioned 1935 Allan
Herschell wooden
platform

Artists

Principal carver:
Gerry Holzman
Over a thousand other
woodcarvers, painters,
and quilters donated
their talents

Agency

The Empire State
Carousel, Inc.

Date

1984–2006

Dimensions

23 ft high, 36 ft diameter

Materials

Carved, painted, and
stained basswood

Cost

$750,000 total
(estimated). $400,000
in cash; roughly 90
percent of the labor was
donated, approximating
$350,000 total in kind.

Photography

Gerry Holzman, Jim
Conlon, and Heather
Rubenstein

AFTER NUMEROUS SETBACKS and delays, New York State now boasts one of the first handcarved wooden merry-go-rounds to be produced in America since the 1930s.[1] The brainchild of woodcarver Gerry Holzman (who was also project director) and his fellow woodcarvers and native New Yorkers, Bruno Speiser and Jim Beatty, the carousel features hundreds of handproduced components, each of which commemorates New York history, the work of hundreds of New York-based carvers, painters, and quilters. The Empire State Carousel is an example of a unique and highly creative offshoot of a nationwide movement to preserve and restore vintage carousels dating from the late 1800s through to the 1930s. Increasingly, people around the country recognize the important rôle of carousels as an American cultural phenomenon, conjuring up images of county fairs, the Coney Island Boardwalk and other amusement parks of the early twentieth century.

Holzman sees the Empire State Carousel as a "cultural legacy" for New Yorkers. He remarks, "Every generation has the responsibility to pass on key elements of its culture to the next generation."[2] To fulfill this goal, Holzman designed a carousel that celebrates the history, tradition, and environment of New York State. Visitors can ride on any of twenty-eight different hand-carved animals. Scenery panels depict such scenes as Niagara Falls and a contemporary New York skyline. Wooden reliefs illustrate characters from New York's rich folklore including Leatherstocking and Uncle Sam. Portraits of diverse New Yorkers including Grandma Moses, Eleanor Roosevelt, Jackie Robinson, and Elizabeth Cady Stanton line the canopy. These portraits, like all other parts of the carousel, will be updated annually to reflect New York's changing history. Quilts designed to illustrate regional culture hang from the beams, and replicas of memorable buildings from the state's five largest cities outline the carousel's upper edge. A traditional wind-driven band organ decorated with carvings of prominent New York musicians plays such tunes as "Sidewalks of New York" and "Shuffle Off to Buffalo." Sixty-two pennants in blue and gold (New York

State's official colors), bearing the names of New York's counties, complete the carousel.

Modern-day carousels originated in medieval Europe. Young men learning to joust straddled wooden horses suspended from a wheel that turned on a center pole, striking at a fixed target each time they passed it.[3] By the nineteenth century the carousel had evolved into a device for amusement. In 1867, Gustav Dentzel built the first mule-powered American carousel.[4] Allan Herschell, a Scottish engineer living in upstate New York, unveiled his steam-powered carousel design at the World's Fair in New Orleans in 1885, generating considerable interest in the invention and bringing carousels into the mainstream.[5]

The carousel's golden age lasted from the mid-1880s to 1930. As demand increased, carousel factories were established all over the United States. Herschell's three factories in upstate New York competed with Brooklyn and Philadelphia factories for the carousel market. Between these years, United States factories produced over ten thousand wooden carousels. Of the thousands of carousels that existed, fewer than 155 are in operation today in the United States.[6] After 1930, carousel-makers cast figures in aluminum, replacing the time-consuming process of creating

handcarved wooden pieces. Today, only a few companies continue to make carousels, producing machine-made plastic or aluminum figures.[7]

Holzman grew interested in reviving the moribund art of carousel carving in 1983. Some Alaskan carousel aficionados needed a carver to help construct a carousel featuring Alaskan animals and Native American carvings. Funding failed to materialize, however, and the project foundered. Rather than be discouraged, Holzman adapted this idea to the benefit of his home state, deciding to create a handcarved carousel based on New York's culture. In 1984, with two woodcarving friends, Jim Beatty and Bruno Speiser, Holzman founded The Empire State Carousel Inc.—a nonprofit corporation—to bring his idea to fruition.[8]

Holzman, the principal designer of the carousel, decided to celebrate not just the history of New York, but also its rich craft heritage. As a result, Holzman showcased the state's wide range of talent by delegating a large portion of the woodcarving work. The Empire State Carousel Inc. contacted eleven regional New York carving clubs to carve different elements of the carousel. Holzman chose twenty-eight native New York animals from lists submitted by local schoolchildren

PAGE 184 Detail of Vendome Firefighters Memorial; see pp. 204–07. Photo: Ted Clausen.

BELOW Since 2006, the fully restored carousel has been in its new home in Cooperstown, New York.

and civic groups to grace the carousel's platform. He also designated 112 sections of the rounding board at the top of the carousel (each 16 in.) to be handcarved with the name and a representative symbol of various New York communities. In addition, carvers made portraits of prominent New Yorkers and native birds, which perch on the carousel's support beams, or sweeps.

To showcase other New York folk art traditions, Holzman borrowed an idea from medieval English carousels, in which wooden heraldic shields were attached to the sweeps. Here, twenty-four quilted banners created by New York quilting clubs, depicting regional scenes from New York, hang from the carousel's rafters. Holzman requested that all craftspeople donate their time and materials wherever possible. More than one thousand craftspeople have contributed to the project, the majority free of charge.

Almost immediately, the carousel found local support. The town of Islip, Long Island, granted the new organization rent-free use of a 1500-sq.-ft restored barn. The project organizers converted the barn into the carousel's workshop, storage area, and exhibition center.[9] In addition, an Islip-based commercial amusement company donated a 1935 Allan Herschell Art Deco wooden platform.[10] With a building to work in and a platform to build on, the making of the carousel itself could now go forward. The

carousel still needed many of its parts: the scenery and other carved panels necessary to conceal the machinery, the carvings for the rounding boards, and, crucially, the carousel animals themselves.

Description The Empire State Carousel is a highly complex construction, consisting of a dizzying array of handcarved, handpainted, and handsewn elements, each closely connected to some aspect of New York State history and culture. The most prominent features are the carousel animals, which are arranged in three rings with the largest, most intricately carved ones on the outside ring. Carvers created twenty-six traditional riding animals, most of which move up and down as the carousel turns. In addition, there is "Suzy Swan," who opens at the back and has space inside to accommodate a wheelchair. The figures are carved from traditional basswood, an inexpensive wood that has little grain and takes paint well.

While different carvers have different styles, each figure highlights expert talent that honors the carousel artists of earlier times. The level of the woodcarver's art is best demonstrated in the details. Saddles are trimmed with braids and tassels, every strand of which is discernible. Fish scales and bird feathers are equally delicate. All figures are painted with glossy, cheerful colors and ornamented with faceted "jewels" intended to

BELOW A handcarved portrait of Grandma Moses by Gerry Holzman.

BELOW, RIGHT Bucky Beaver.

reflect the carousel lights. Other carousel elements also display the talents of the volunteer carvers and painters. Eight stationary carved panels, each 30 × 40 ft, form a fence around the lower portion of the carousel's center, hiding its machinery and controls. Each panel is deeply carved and brightly painted or stained, and features a folklore scene chosen from a number of different regions and historical periods. The eight panels depict the narratives of well-known stories ranging from "The Sam Patch" to "Guys and Dolls."

Twelve 3-ft-long scenery panels with handcarved frames cover the top portion of the carousel's center mechanism. Angling slightly from the sweeps toward the riders below, these panels rotate with the carousel. Local carving clubs contributed frames depicting scenes and symbols from New York regions. The eleven scenery panels include mirrors. The twelfth panel, chip-carved in an elaborate geometric pattern by Bill Lockwood, encloses a bronze plaque commemorating the carousel's creators and dedicating the carousel to the people of New York.

The rounding boards, located at the edge of the carousel's canopy, provide additional opportunities to showcase New York talent. They feature handcarved letters 10 in. tall spelling out the name, Empire State Carousel, and carvings of the state seal and a state map. In addition, nineteen 3-ft-high portrait panels depict twenty-three prominent New York historical figures. Even interior surfaces have been used to tell the history of New York State. The insides of the twelve rounding boards are also painted with scenes of significant events in the evolution of the state, beginning with the formation of the Iroquois Confederacy around 1400 and continuing to the opening of the United Nations building in 1951. Some of the other historic events suggested by the paintings include the Battle of Saratoga, the Women's Rights Convention in Seneca Falls, the development of New York, and the building of Levittown. They are painted in the folk art style of the Works Progress Administration muralists of the 1930s.[11]

A repeating skyline decorates the carousel's top edge, showing prominent buildings from the state's five largest cities. For example, the Performing Arts Center represents Albany, and the Empire State Building and Statue of Liberty represent New York. The pennants are mounted on poles attached to the skyline. The sweeps are painted with continuous stencils of state symbols, including roses, bluebirds, sugar-maple leaves, and apples.

Two restored antique carousel figures reinforce the carousel's connection with the past. The Friends for Long Island's Heritage donated a Herschell Spillman carousel figure from around 1920, and the Empire State Carousel Company restored it. Alice and Avery Wheelock donated a half-metal, half-wood horse previously removed from the same Herschell carousel that provided the Empire State Carousel's mechanism and platform.[12]

In addition to the carousel itself, the Empire State Carousel Company commissioned several related components. In 1990, the Stinson Organ Company of Bellefontaine, Ohio, custom-made a new military band organ modeled after traditional carousel band organs that play paper rolls of music. Three-foot-tall figures of New York musicians George M. Cohan, Irving Berlin, and John Philip Sousa adorn the front of the organ. Surrounding the carousel are wood-carved sculptures of children and a ticket booth, ornately decorated in the Second Empire style.[13]

Design impact Holzman's goal is to use the Empire State Carousel as an educational tool. It reminds New Yorkers of all ages of the state's rich and diverse history. The carousel designers initiated a school outreach program and a series of course materials aimed primarily at children in the fourth to seventh grades. For one assignment, students will create a rotating photo display that will project student-taken photographs of New York on to a large television screen visible to carousel riders. Additional programs are planned for youth-oriented organizations, such as the Scouts, as well as for professional organizations such as woodcarving clubs and historical societies. Holzman will continue to visit the Cooperstown site to hold classes in history and woodcarving, and to conduct teacher's workshops.

Other communities have devoted efforts to preserving and restoring the few remaining historic carousels around the country. Watch

RIGHT Gloria Scheib, sketch of the Empire State Carousel, 1983.

BELOW Artist Gerry Holzman with some of his Empire State Carousel "friends".

BELOW, RIGHT The Seabreeze Carousel as it stands today, rebuilt after a fire destroyed it in 1994. Photo: Heather Rubenstein.

Hill, Rhode Island, has one of the nation's two oldest surviving carousels (dating from 1883), while Meridian, Mississippi, lays claim to a 1909 Gustav Dentzel Philadelphia carousel, a community-wide preservation project. These endeavors rely on a mix of public and private funding sources. Preservationists recognize the innate value of these limited models along with the time and artistry that went into creating each one. Municipalities see the carousel as an opportunity to set their city apart with a unique cultural resource.

Story City, Iowa, lays claim to a one-of-a-kind portable 1913 Herschell-Spillman carousel, bought by the city's Chamber of Commerce in 1938. Prior to that, the carousel had traveled to Story City for Independence Day celebrations since its construction. After years of neglect, however, the town had to close the carousel in 1977. Five years later, it reopened, after Story City citizens undertook a vast fund-raising effort. Like the Empire State Carousel, the fund-raising included thousands of hours of donated time from local craftspeople. Workers restored the original wooden structure, the menagerie of carousel figures, and a 1936 Wurlitzer band organ. The Story City Carousel is now permanently housed in a local park and has been placed on the National Register of Historic Places. It is at the center of the city's tourism efforts.[14]

In Holyoke, Massachusetts, a 1927 Philadelphia Toboggan Company carousel closed in 1987 after sixty years of continuous use. The Friends of the Holyoke Merry-Go-Round successfully raised $850,000 through several local fund-raising drives to buy the carousel and place it downtown in Heritage Park. Like the others, the Holyoke Merry-Go-Round relies primarily on volunteer labor. The Paragon Carousel at Nantasket Beach in Hull, Massachusetts, is another example of a refurbishing effort that demonstrates the dedication of local volunteers. Nathan Cobb reflects in his article "Horse Play:" "It's no small job bringing fifty-six scenic panels, ninety-eight beveled mirrors, and one very loud Artizan band organ back to life."[15]

The family-run Seabreeze Park, in Rochester, New York, is home to Philadelphia Toboggan Company #36, also known as the Seabreeze Carousel. Its platform dates from 1909. While the original carousel from 1915 burned in a fire at the park on March 31, 1994, a new handcarved wooden carousel now stands in its place. At the time of the fire, the Long family, who run the amusement park, declared that they would rebuild. The family had come to Seabreeze in 1904 as carousel builders and operators.[16]

These examples represent a fraction of the effort devoted to preserving the country's

Gerry Holzman on Funding

In general, obtaining consistent and reliable funding has been our single most serious problem. It has been very difficult to sell an idea as unusual as ours, particularly when we had no established tangible base like that of a municipality, an existing museum, or a cultural arts organization. And we had no track record. One prospective donor actually asked us, "How many other carousels have you built?" A proper question for a banker to ask, I guess, but a tough one for an artist to answer.

At first, we were patronized as romantic dreamers who had a fascinating idea, which was, unfortunately, unrealistic and impractical. It was not until we had over half of the carousel completed—about six years—that we began to hear the optimistic words "WHEN you finish …" instead of the more common "IF you finish …"

The grand sweep of our goal to use a carousel as a content base for preserving and perpetuating the culture of an entire state—has contributed to the funding problem. Despite an enormous amount of media coverage, we have not fully succeeded in explaining to the public that this is not "just another carousel."

In the twenty years since I started working on the carousel, I have experienced great joy and an appreciation for the talent and generosity of my fellow New Yorkers as well as continual frustration and even an occasional chest pain! But I have never regretted the time and effort I have committed to it. So, to anyone out there who has an "unrealistic" idea for a grand public project, I offer the words of my fellow New Yorker, Teddy Roosevelt: "Far better it is to dare mighty things … even though checkered by failure, than to rank with those poor spirits who neither enjoy much or suffer much, because they live in the gray twilight that knows not victory or defeat."[888]

remaining wooden carousels, of which there are approximately 155. Diverse fund-raising schemes, extensive volunteer efforts, and local civic pride characterize the movement. Restored carousels provide a period glimpse into American culture as well as a means for artisans to practice a traditional craft and to provide a source of amusement for today's riders. They animate place just as they help to individualize communities.

Design process Following several initial funding presentations, the project directors realized that prospective donors would only invest in the carousel if they could see a product. To this end, in 1985 Holzman completed the first carousel figure, a beaver, New York's official state animal. This figure was prominently featured in the carousel's first fund-raising brochure, along with a color drawing of the proposed finished carousel. To engage prospective donors better, the carvers gave every animal a special name and personality. The charismatic "Bucky Beaver," for example, with his toothy grin and a comical name, succeeds in creating a strong personal link to prospective donors and riders.

By November 1986, a number of other figures were complete, and three quilting societies pledged to produce quilts. In addition, at that time, half a dozen carvers

contributed birds for the rafters, and four woodcarving groups completed scenery panel frames. To encourage funding, carousel directors made each carousel element available for sponsorship. The directors, however, wished to balance sponsor visibility with the carousel's integrity. "We didn't want the carousel to be a rotating ad display," Holzman remarked. "So we decided that the dedicated plaques would have to be subtle and integrated into the design of the piece." Thus, they pursued sponsors connected to each individual carousel element. For example, hunting supply companies were sought to back the wildcat figure, an animal known for hunting and tracking. Appropriately, the wildcat carries a canteen and binoculars.[17]

People have developed unique ways of supporting the project. In 1991, woodcarver Bill Cooper offered to carve a bear for the carousel to commemorate his hometown of Waterloo, New York. Cooper completed the bear in time for Waterloo's bicentennial celebration in June 1993. He opened his woodcarving workshop to visitors, made dozens of presentations to organizations and schools, and organized a number of fund-raising events. By the time of the bicentennial celebration, the entire town had become involved in the project. The celebration opened with a parade led by Cooper riding the bear.[18]

A carving by Gerry Holzman illustrating the story of Sam Patch.

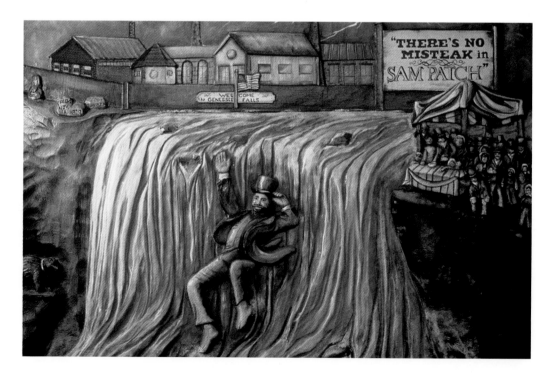

1 See Cathy Pickering, "Carousels Old and New," *Carousel Courier, The Empire State Carousel*, June 1993.

2 *New York Times*, February 29, 1988, p. B1.

3 See Pickering 1993.

4 See *The Empire State Carousel* 4, 1994.

5 William Kates, "Carousels Not Just Horsing Around," *Milwaukee Journal Sentinel*, September 5, 1999.

6 *ibid.*

7 See Pickering 1993.

8 See *The Empire State Carousel* 1, 1994.

9 Gerry Holzman, artist, Islip, New York, correspondence, September 24, 1997.

10 See *The Empire State Carousel* 3, 1986.

11 See "A Detailed View of Carousel Components," *The Empire State Carousel*, May 1997, p. 7.

12 See *The Empire State Carousel* 3, 1995.

13 See "A Detailed View of Carousel Components," *The Empire State Carousel*, May 1997, p. 8.

14 See "Story City, Iowa, 1913 Herschell-Spillman Antique Carousel," September 28, 1999.

15 Nathan Cobb, "Horse Play," *Boston Globe*, June 26, 1999.

16 Susan Hofsass, carousel design team, Rochester, New York, interview, October 16, 2000.

17 Holzman correspondence, September 24, 1997.

18 *ibid.*

19 *ibid.*

20 *ibid.*

21 Holzman Interview, July 11, 2000.

Despite innumerable individual contributions, sponsorship has consistently lagged behind expectations. To date, only thirteen of the twenty-eight figures have some form of sponsorship. According to Holzman, the problem is one of timing. "Today's corporations, like so many of today's Americans, want instant gratification. They don't want to give money in 1994 for a project that will not produce significant public recognition [for several years]."[19]

Although original plans for the carousel exhibition center called for it to be located on the same grounds as the carousel workshop in Islip, New York, a change in the political leadership of the town brought with it a change in attitude toward the idea of a carousel building on town property. Over the next few years, as the work on the carousel itself was being completed, repeated attempts by the carousel leadership to begin erecting a building were routinely thwarted by town bureaucrats. Because of those difficulties, the carousel board accepted the invitation of the mayor of Patchogue, a nearby village, to locate the carousel on village property. A local foundation pledged $100,000 toward the building and the Patchogue Business Improvement District pledged a similar amount; the balance of the building cost—$200,000—was to be provided by a village bond issue and was to be repaid by the carousel in the form of rent. During the following eighteen months plans were drawn and bids were submitted, and all was in readiness for the building when the mayor was defeated for re-election and the incoming administration put all projects on hold. Once more, the carousel leadership was confronted by a municipal government that was unwilling to make the financial commitments necessary to establish a carousel exhibition center. The agreement therefore collapsed.

One year later, the town of Broohaven, a very large political entity with a population of approximately five hundred thousand, invited the carousel to establish its home at its Wildlife Park and offered to modify one of the existing buildings on the site to accommodate it. Although it took the town government nearly a year and a half to make the structural changes required, the Empire State Carousel did have its grand opening on October 23, 2003. Three weeks later, in response to a complaint from an Albany official that the town's building was not in compliance with its own building and fire codes, the carousel operation, which had attracted nearly six thousand visitors, was ordered to close.

During the next twenty months the carousel board and its attorney attempted to work with the town to develop a viable solution to the building problem. As none was found, the board began to explore alternative options.

In August of 2005, the carousel board approved Holzman's request to donate the carousel, its band organ, and its exhibits to the Farmers Museum (and its affiliate, the New York State Historical Association) in Cooperstown, New York. A traditional carousel building compatible with the existing nineteenth-century style structures on the grounds was erected, and on Memorial Day weekend 2006 the Empire State Carousel opened. Holzman is thrilled that the carousel now lies in capable hands, after so many years of struggle to create the piece and find it a suitable home.

The carousel project has received a total of approximately $400,000 in contributions from corporations, individuals, foundations, associations, and grants on local, state, and federal levels. More importantly, the project's numerous artists have donated extensive amounts of labor, and several companies have given in-kind donations such as alarm systems, legal services, and office equipment. Holzman estimates the value of this donated time and material at $350,000, about half the carousel's total value.[20]

The River: Time is a River without Banks

JOHNSON COUNTY ADMINISTRATION BUILDING • IOWA CITY, IOWA

Project description

A cast-iron wall relief of the various watercourses in the county, installed in the Johnson County Administration Building

Artist

Shirley Wyrick

Agency

Johnson County Board of Supervisors

Dimensions

27 × 33 ft

Date

1986

Material

Cast iron

Cost

Casting: $13,000
Materials: $2000
Printing/video: $1300
Workshop: $6500
Assistant: (400 hrs) $3200
Installation: $4000
TOTAL: $30,000

Photography

Jon Van Allen

S HIRLEY WYRICK's *The River: Time is a River without Banks* reflects the community cooperation that helped to make this 27 × 33-ft cast-iron sculpture a reality. Johnson County is home to a population of one hundred thousand that is roughly divided between the major research and urban center of Iowa City, home to the University of Iowa and about sixty thousand people, and the farms and small rural towns outside the city. Wyrick's colossal sculpture, which depicts the rivers, streams, and channels of Johnson County interwoven with symbols of the county's primary activities, attempts to highlight what holds these dichotomous populations together—the waterways that flow between them.

From its location in the lobby of the new Johnson County Administration Building, *The River* provides the government center with a sense of authority and local identity. Although no specific location or obligatory local financial requirement had been earmarked for public art, Riley Grimes, then a county administrative assistant, and Deborah Burger, a local arts advocate at the time, convinced the Board of Supervisors to use this opportunity

voluntarily to create a prototype project modeled on Iowa's Art in State Buildings program. Federal revenue-sharing funds and a bond issue covered the building's construction costs, which would finance the artwork as well. The architects for the project, Roy Neumann and Dwight Dobberstein, endorsed the inclusion of public art and approached the Iowa Arts Council for advice. While prior commitments meant that they could not directly manage the project, members of the arts council recommended that a selection committee representing Johnson County's diversity (including an intellectual coterie from the University of Iowa, a rural component from the agrarian communities, and Deborah Burger) organize a competition to select a local artist for the commission. This jury, after reviewing proposals for their aesthetics, environmental integrity, durability, and artist background, chose Iowa City-based Wyrick from a handful of finalists.

In preparing her design, Wyrick was interested in the project's proposed location, a prominent wall opposite the main entrance of the lobby. A government-building lobby

represents an egalitarian space in which all residents should stand on equal ground for the basic reason that they are all citizens of the same jurisdiction. More practically, it is a place most county residents must pass through at one time or another. Wyrick's concept, a relief of the river-waters permeating the county and linking its urban, suburban, and rural communities, centered on this theme of "connectedness." For Wyrick, this focus on

shared experience is more than just a commentary on Johnson County; it is also her philosophy on the practice of public art:

> In the realm of art in public places, I feel that the artist owes the public more than just the creation and installation of a work of art. I believe that it is important to offer more access to the work and its meaning ... and I think I found several avenues for doing this.

Wyrick's final installation covers the wall in the front lobby of the Johnson County Administration Building.

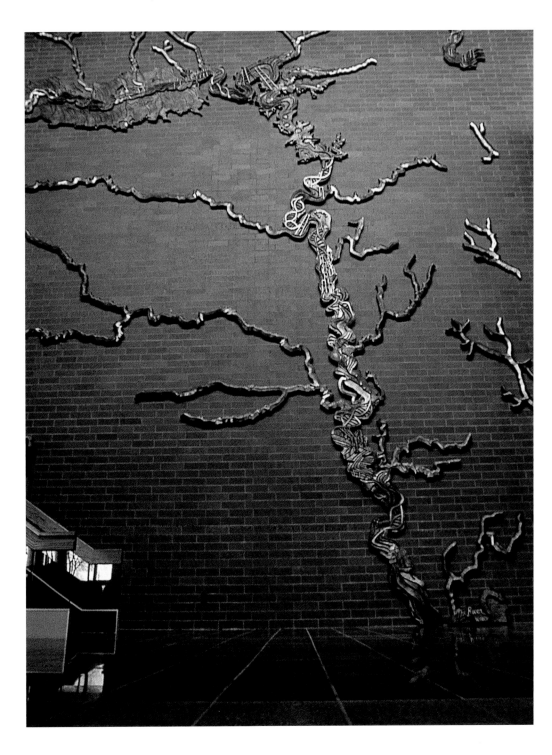

In addition to having one of our elementary schools tracking the work, spending time with me and creating their own related visual and literary artworks, which were shown at *The River*'s opening reception, videotapes of the work's development and related events and community concerns were made and are cablecast even today and shown to service groups. A brochure was printed, a public reception held, which included related exhibitions, and media interviews were given.[1]

The River provided a medium through which to demonstrate the universality of experience shared by the entire community of Johnson County.

Description The 33-ft-high cast-iron wall relief of local rivers and creeks captures the eyes and minds of visitors to the Johnson County Administration Building. Its dynamic shape contorts and sprawls in an expression of the river's flow. Although the shapes and lengths of the pattern of waterways are faithfully adapted from a topographical map of the area, Wyrick could not depict the watercourse's width to scale since the long, narrow rivers would have seemed nearly invisible on the expansive lobby wall. But the exaggerated span of the rivers and creeks gave Wyrick the space to complicate her design with a series of elements native to Johnson County. This undulating form, containing a succession of local symbols, draws viewers' eyes up and down the wall, creating a motion and flow similar to that of the river itself.

The River carries varied materials down its course, symbols of an abbreviated chronology of Johnson County's past, beginning with indigenous creation stories and continuing through the Voyager II space exploration. For example, an eagle's feather dissolving into the river in front of a group of teepees suggests the passing of Native American culture in the area. This historic moment is contrasted with the image of a tilting barn and outbuildings being pulled downstream, a reflection on the precarious nature of contemporary society and the farming industry, especially at the time *The River* was created. More literally, one might consider the destruction of the barn as evidence of river erosion. Through the interplay between the literal, the symbolic, the historic, and the present, Wyrick creates a relief of layered complexity that offers new interpretations and new questions to be answered with each viewing. All county residents can see something applicable to their own lives, and consider its connections to other cultures and other times.

Design process The size and scale of the piece testifies to the hours of labor invested in its construction. With Wyrick's commission so early in the construction process, she was able

BELOW Detail of *The River*.

BELOW, RIGHT Wyrick instals the artwork with the help of a paper template.

to work closely with the architects to custom-fit *The River* into the lobby of the administration building. The architects reinforced the brick wall to support the weight of the massive cast-iron relief, and Wyrick consulted structural engineers and metal preservation specialists to ensure that both the sculpture and the wall bracing would require minimal maintenance in the future. After this technical inspection, construction began. Wyrick first applied plastilene, a handmade oil clay, to the plywood river pattern she had designed from topographical maps of Johnson County. She then carved the relief symbols into this hardened base. Although not specifically equipped to fabricate works of art, the local Quality Iron Foundry experimented in collaboration with Wyrick, at a reduced rate because of its interest in this project, to overcome the challenges presented by the size and shape of the sculpture to cast Wyrick's forms. After eleven months of intensive work, the administration building was closed for the Thanksgiving holiday weekend so that contractor Iver Iverson, Wyrick, and two others could install the artwork. Despite the size and expanse of the heavy sculpture, the installation went smoothly until a slight difficulty was encountered when fitting the final pieces flush with those already *in situ* at the relief's highest point. Although the attachment of the individual segments into a cohesive whole was laborious and exacting, those installing the work were deeply moved to witness *The River* extend its flow as each piece was linked.

Design impact Wyrick's depiction of waterways connects the literal to the historic and the symbolic. Although the pattern is geographically specific, its meanings are more abstract and universal; they invite contemplation about the connections between watersheds and the histories of the communities they serve. With its integration of contrasts, *The River* is a landmark for Johnson County. The rural mentality

juxtaposed with the intellectual and artistic sophistication of the University of Iowa provides an interesting dynamic between members of the community as well as eclectic interpretations of the artwork.

Visitors to the administration building have ample opportunity to explore the varied details of *The River* time and time again: "*The River* goes hardly a minute without someone tilting their head up to ponder the symbolism and grace of the mammoth wall piece."[2] People constantly come and go to obtain licenses or permits, pay fees, attend meetings or conduct other business with the county. Each visit to the building is an opportunity to consider a detail never before noticed, and the shifting interpretations of the piece for a citizen of Johnson County or someone who lives along a particular stretch of the river.

The ultimate power of the work to reach people lies in the details, for the expanse of the sculpture makes it overwhelming as a whole. Wyrick wrote: "Because of the relatively shallow space in front of the work, people are usually viewing it by moving their eyes up the river rather than seeing it as one piece. That has interested me because one's physical movement while viewing the work makes it even more like an actual river."[3] In the same way that the artistic representation of a river can grow to embody characteristics of a real watercourse, *The River* actualizes its symbolic meaning by creating a common element for all community members to consider, discuss, and identify with. Just as the waters of the rivers connect the communities of Johnson County, Shirley Wyrick created a communal icon in *The River* that brought artists, politicians, local advocates, and community members together in necessary cooperation, and united the members of Johnson County in mutual contemplation of the past and present of their community. *The River* is a testament to the power of voluntary public art on community consciousness.

1 Shirley Wyrick, artist, Johnson County, Iowa, correspondence, January 17, 1998.

2 Mitch Martin, "*River* Runs Through Lives," *Cedar Rapids Gazette*, 15 November 1992, p. 18A.

3 Wyrick correspondence, October 15, 1999.

Professor Longhair Square

NEW ORLEANS, LOUISIANA

Project description

A plaza containing two figurative silhouette bronze sculptures of New Orleans blues musician Henry Roeland Byrd, known as "Professor Longhair" or "Fess"

Artist

David Tureau

Agencies

Arts Council of New Orleans and New Orleans's Percent for Art program

Dimensions

70 × 45 ft

Date

1996

Materials

¹/₂-in.-thick bronze plate for sculptures; colored and stained concrete in shades of pink and acqua-blue for plaza paving; and cast bronze letters set into the concrete

Cost

$50,000

Photography

William Drescher, courtesy of the artist

A STRONG AND LONG-STANDING relationship exists in New Orleans between music and place, and the work of artist and landscape architect David Tureau calls attention to this connection. He conceived of Professor Longhair Square as the center of a six-block linear park celebrating New Orleans's musical heritage. The wide median connecting Tchoupitoulas Street to Laurence Square along Napoleon Avenue is a local civic greenspace containing the Napoleon Avenue Branch Public Library and the 2nd District Police Station. Tureau's vision was to connect these civic buildings with a public-art corridor dedicated to New Orleans's piano players. In homage to native New Orleans rhythm-and-blues musician Henry Roeland Byrd, better known as "Professor Longhair" or "Fess," Professor Longhair Square was situated at the corner of Napoleon Avenue and Tchoupitoulas Street as the initial project and the focal point of Tureau's plan. The plaza's center contains silhouettes of Byrd in bronze, while colorful paving patterns inlaid with song lyrics radiate toward the streets.

Byrd defined the New Orleans piano style, and profoundly influenced a generation of New Orleans pianists, such as Dr. John and Allen Toussaint. His first popular stint lasted from the 1940s to the early 1960s, though he was only locally known because of his reluctance to leave New Orleans to tour. In 1964, he abruptly dropped out of the music scene, returning in 1971 to perform both locally and internationally until his death in 1980. He was best known for a distinctive style that combined Caribbean music with rhythm and blues, and for songs such as "She Walks Right In," "Mardi Gras in New Orleans," and "Tipitina," now the name of a popular New Orleans bar.[1]

Tureau says of Byrd, "He synthesized musical styles and rhythms and then tossed in the vocabulary of street culture."[2] As the Professor Longhair Square site is at the major intersection of Napoleon Avenue and Tchoupitoulas Street, Tureau approached the project as a collage expressing the "crossroads" quality of both the site and Byrd's musical style:

> The site of Professor Longhair Square is an intersection in a number of ways. [It is] not only a street intersection but also the

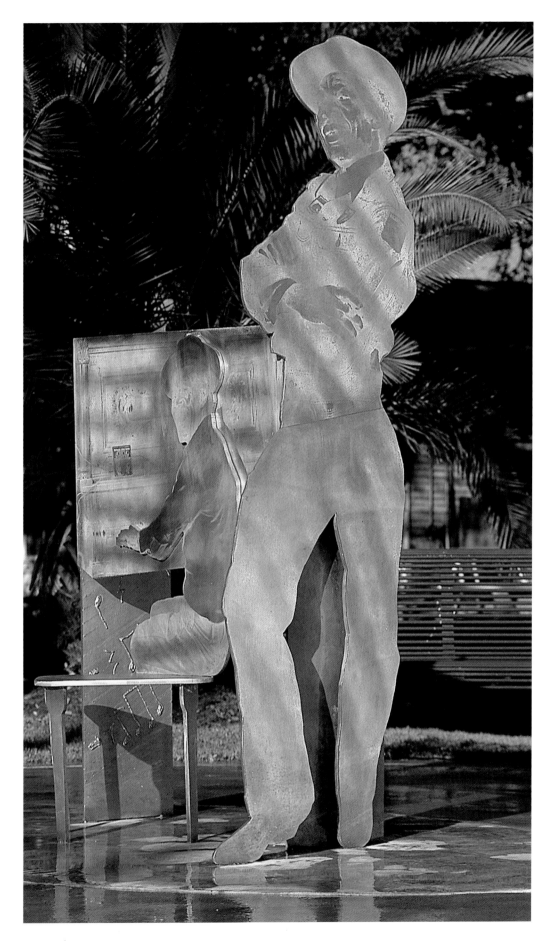

Bronze silhouettes of
Professor Longhair show
the musician standing up,
and seated at the piano.

intersection of water, rail and surface transportation, all integral in the cultural infusion that contributed to the diversity of New Orleans music.[3]

With funding contributed by New Orleans's Percent for Art program, the Professor Longhair Foundation and the Arts Council of New Orleans, a jury of community leaders and neighborhood residents selected Tureau's design from three finalists with an emphasis on site-specificity: "We want all our projects to be site-specific and to consider the unique qualities of a site."[4] After extensive site observation and interviews with local musicians, Tureau embraced this very interplay between subject and space:

> This is not a quiet, reflective space but one that is filled with the sounds of engines, clanging eighteen-wheelers, ship and train horns, all combining to make a rhythmic soundscape that at times is overlaid with the sounds of live and recorded music as well as loud conversation and laughter.[5]

The site of Professor Longhair Square is a confluence of elements, just as was his legendary music. As both a sculptor and a landscape architect, Tureau used place-appropriate metaphors to relate Professor Longhair Square to its particular location and to New Orleans's urban culture.

Description Professor Longhair Square's two-part design consists of a specially designed and inlaid pavement and a central sculpture of Byrd. Each element is incomplete by itself, but when taken together, they present an integrated, cohesive portrait of the musician.[6] Tureau designed the plaza's paving shape and pattern to suggest the global influence of New Orleans music. Inspired by cartography, grooves in the pavement emanate from the center to recall latitude and longitude lines. The pink- and aqua-stained concrete paving, and Canary Island date palms and Bermuda grass on the periphery, represent the strong Caribbean influence on New Orleans's culture and Byrd's music. Sandblasted lyrics from Byrd's songs and cast bronze letters embellish the colored concrete lines.

The cast bronze letters set in the concrete visually connect the plaza floor to the bronze figurative silhouettes of Byrd in the center. The figures were cut out of $^{1}/_{2}$-in.-thick bronze plates. One depicts a standing Byrd, while the other silhouette shows the musician at his piano. Tureau used a variety of surface textures for the sculptures' faces and edges to express Byrd's tumultuous life. Michael P. Smith's photographs of Professor Longhair were etched into the bronze plates, which were then heated, bent into postures and welded together. Multiple images overlap to form a collage effect that realistically chronicles Byrd's life and performances while stirring memories of his spirit. Finally, Tureau included the musical score from Byrd's "Go to the Mardi Gras" in bas-relief on the side of the piano.

Rather than being a mere testimonial, Tureau wanted the sculpture to be interactive. Not only is a bench included as part of the sculpture, so that a visitor can actually sit at the piano with Byrd, but also the sculpture itself requires the viewer to move around it in order to appreciate its meaning fully. Tureau explains:

> I felt that a cast statue alone could not possibly portray the magnitude of Byrd nor evoke in the viewer his life and work. The hero bronze on a pedestal in the park rarely conveys much more than the physical features and costume of the hero. The exceptions always require some combination of setting, abstraction in ideas and shared experience.[7]

The statue of Professor Longhair is at the center of the specially inlaid pavement.

Design impact Because of its integrated urban-design elements, Professor Longhair Square is counted as one of New Orleans's most successful public-art projects. According to Mary Len Costa, the current public-art director of the Arts Council of New Orleans,

> the passage of time has seen acceptance by the immediate community as the plaza is used by more and more pedestrians as a rest stop to and from the nearby food market and for [users] of public transit. Overflow Saturday night crowds from the adjacent Tiptina's Music Club are often found enjoying the plaza in continuing homage to the local music great.[8]

While the initial creation of Tureau's plaza was the evidence of successful coordination between the artistic community and civic institutions, the growing popularity of Professor Longhair Square is the result of strong communication between an artist and the local community.

Reinforcing the endurance of Professor Longhair Square is the fact that there has been little evidence of either deterioration or vandalism since its inauguration in 1996. The simple explanation is that poured concrete and bronze plates are "practically vandal-proof, an important factor at this popular intersection where not only late-night music-lovers congregate, but also where the uptown Mardi Gras parade crowds line up."[9] But Costa offers an alternate reason: "There is a certain respect for 'Fess' that has deterred this type of destruction."[10] Unfortunately, matters of respect and artistic sanctity are abandoned during the rainy season in New Orleans, when cars were often parked on Professor Longhair Square to protect them from flooded streets. It is hoped that street renovation has alleviated the flooding problems, but cracks from the weight of the cars combined with shallow tree roots remain. However, these blemishes are minor for a work of public art installed in 1996 at such a busy traffic intersection. The

combination of stable materials and community respect has preserved Professor Longhair Square amazingly intact. By luck, the square was also spared the persistent, damaging flooding that ravaged swaths of New Orleans during Hurricane Katrina in 2005.

Tureau intended Professor Longhair Square as the focal point of a larger public-art corridor—including a Piano Heritage walk of fame and informational kiosks on New Orleans's musical history—extending along Napoleon Avenue to Laurence Square. However, the other facets of Tureau's plan were not included in the initial Percent for Art program budget. Although the Arts Council of New Orleans has not proposed any further portions of Tureau's master plan since the completion of Professor Longhair Square in 1996, urban expansion by other agencies has continued to change the character of Napoleon Street. The Dock Board is designing a river outlook and planning beautification of the wharf entrance. The red streetcar line expanded its service along the riverfront, and the widening of Tchoupitoulas Street has opened the neighborhood to commercial expansion and residential renovation. No longer the capstone of a public-art corridor, Professor Longhair Square is now gaining popularity as the center of a new commercial district unforeseen during the design process.

Even with these changes in context, Tureau's design continues to interact with its location and to create a unique experience where the two meet. With Professor Longhair Square, Tureau seeks to design an interactive space: a testimonial to Byrd and New Orleans rhythm and blues that requires the participation of the viewer. The colored cement, sandblasted lyrics, and radial lines concretely evoke the relationship between Byrd's rhythmic gumbo music and the wide-ranging influence of New Orleans's distinctive sounds. As Ellis Marsalis once said, "In most places culture comes from on high, in New Orleans it bubbles up from the street."[11]

1 Rock and Roll Hall of Fame website: rockhall.com/hof/inductee.asp?id=173.

2 David Tureau's proposal to the Arts Council of New Orleans, November 1992.

3 *ibid*.

4 Lake Douglas, former assistant director, Arts Council of New Orleans, correspondence, December 24, 1997.

5 David Tureau's proposal to the Arts Council of New Orleans, November 1992.

6 Written description of the plaza, courtesy of the artist.

7 David Tureau, artist, New Orleans, correspondence, December 1, 1997.

8 Mary Len Costa, public-art director, Arts Council of New Orleans, correspondence, February 15, 2000.

9 Project description, courtesy of Mary Len Costa.

10 Costa correspondence, February 15, 2000.

11 David Tureau's proposal to the Arts Council of New Orleans, November 1992.

Vendome Firefighters Memorial

BOSTON, MASSACHUSETTS

Project description

A black granite arc with bronzed fireman's coat and hat commemorates nine firefighters who died in a fire at the Hotel Vendome, June 17, 1972

Artists

Ted Clausen
Peter White

Agencies

Vendome Memorial Committee and Edward Ingersoll Browne Trust

Dimensions

29 ft long and of variable height (waist-height at its highest point)

Date

1997

Materials

Black granite, cobblestone and bronze

Cost

$300,000

Photography

Courtesy of Ted Clausen

NUMEROUS STATUES line the Commonwealth Avenue Mall bisecting Boston's affluent Back Bay historic district. This pathway connects many of the city's landmarks and eventually leads pedestrians to the historic Public Garden located downtown. The mall is much visited by residents and tourists alike, yet few stop to reflect on the importance of the large and overwhelming monuments that honor many prominent individuals from Boston's past. However, it is not uncommon to find people gathered in front of an elegantly curved, black granite form at the corner of Commonwealth Avenue and Dartmouth Street. It is the Vendome Firefighters Memorial, inviting visitors and residents alike to share in a part of Boston's more recent history.

The memorial, dedicated on June 17, 1997, honors nine men who were victims of an unforeseeable accident that occurred at the historic Hotel Vendome twenty-five years earlier. While many of Boston's firefighters were executing routine inspection and clean-up after a four-alarm fire, the southwest wall of the building gave way. Twenty-five firefighters were trapped beneath the debris when four of the building's floors collapsed, leaving nine dead.[1] Most of the men involved had been off-duty, called in to relieve their fellow firefighters who had worked since afternoon. The cause of the collapse was later attributed to structural inadequacies of the century-old building.

Soon after the incident, members of the Boston Fire Department formed the Vendome Memorial Committee in order to devise a way to recognize the men who had lost their lives. In the late 1980s the committee presented a rough proposal, which was rejected, but a decade later, with the help of the Edward Ingersoll Browne Trust (EIBT) Fund, they were able to secure the necessary permission and support to bring the memorial to fruition.[2]

This second attempt proved successful as efforts shifted to the actual design and construction. The EIBT Fund was responsible for furnishing $150,000 of seed money for the project. An additional $150,000 was raised through private donations from retired and active firefighters both local and nationwide as well as from businesses, various other public

interest funds, and many Bostonians. From the groundbreaking ceremony to its dedication nearly three years later, the total project cost was $300,000. The Fund also provided a $15,000 artistic design development grant to begin the artist selection process.

To assist further with this challenge, the committee recruited Urban Arts of Boston. Together, they created an artist selection panel of twenty-two jury members from the De Cordova Museum, Fire Department, Parks and Recreation Department, and the Historic Landmarks and Arts Commission, as well as other artists. A regional call for entries in 1994 resulted in almost six hundred responses. The collaborative team of sculptor Ted Clausen and landscape architect Peter White was awarded the commission. Three members of the jury

who oversaw the mall asked that the artists accommodate concerns about the project's relationship to its surroundings—requesting specifically that the memorial be set on a stone base to link it visually with the other memorial sculptures on the mall. They also required that the names of those who had died in the fire appear somewhere on the monument.

Description The Vendome Firefighters Memorial is diagonally opposite the fire site itself. Gently curving into an arc, the monument stretches 29 ft in length, beginning low and rising to waist-height before again tapering off. This form rests on a cobblestone base, which rises a few inches in order to separate it from the walkway. The memorial sits on the mall, a landscaped pedestrian median dividing the northbound and

A life-sized bronze firefighter's coat and helmet rest on top of the monument.

southbound sides of Commonwealth Avenue, across from the Hotel Vendome site, now reconstructed as commercial offices.

The team began the design development process by interviewing Boston firefighters. Clausen's artistic style takes inspiration from the words, emotions, and stories of people's lives. He prides himself on his ability to extract hidden meaning from the way people express themselves during interviews. In the case of the Vendome Memorial, Clausen believed that the sculpture should extend beyond those who had lost their lives on that fateful day, to the dedication that all firefighters demonstrate in their work.[3]

Clausen accommodated the commissioners' requirement to name the fallen firefighters by etching their names, birthdays and death dates, fire companies, quotations, and information relating to the tragedy into the monument's smooth black granite surface. Clausen and White felt that using the dark rock draws the viewer into the story being told within the space. Both the

rock's engaging and powerful presence and its reflective nature bring the viewer's image into the memorial itself. As Clausen stated, "I wanted you to see yourself as you read about lives different from your own … . I want you to realize how different your life is from these firefighters."[4]

The curve of the wall coupled with a small bench carved out of the same black granite transforms an ordinary monument into an outdoor room. Pedestrians are attracted into this space but the words are only visible at close range. Once inside, they take on greater meaning. A chronological account of the events that took place on June 17, 1972 is woven together with the emotional accounts of the firefighters. The official account read: "5:28pm, without warning, four rear floors of the Vendome collapse, burying twenty-five firefighters." The fireman's words express pride, fear, and dedication: "Our families know that each day could be our last. It's just part of the work." Quotations were taken from the artists' interviews with Boston firefighters.[5]

The Vendome Firefighters Memorial is a focal point on Commonwealth Avenue.

At the memorial's highest point, the story climaxes, describing the collapse of the hotel and the death of the men. The artists chose to mark this point in the story with a life-size bronze firefighter's coat and helmet, a poignant, formal reminder of those who are honored.

Clausen and White's consideration of the detail of the relationship between the event's timeline and the ascending wall is similar in concept to Maya Lin's well-known black granite Vietnam Veterans' Memorial in Washington, D.C., which descends into the ground. Etching the names of the deceased into the surface has become common practice in recent monuments. These often focus on the mass of lost lives rather than the traditional celebration of singular exemplary heroes, such as the monumental sculptures of forefathers that line the Commonwealth Avenue Mall. This turn toward commemorating the common soldier rather than the famed general is popular because it helps to address the identity crisis of public art, which needs to serve the viewing public through accessibility of form and content. To incorporate the audience within the design is a direct solution. In the Vendome monument, the names open a personal window between the firefighters who lost their lives and the visitors to the memorial.

Design impact It is common to find a fire engine parked at the corner of Commonwealth Avenue and Dartmouth Street, or to see a few firefighters gathered around the memorial to reflect on the tragedy. Often they are taking care of the memorial: sweeping the cobblestones, plucking dried flowers from the wall, or collecting the mementos that have been left behind. The monument stands as a tribute to their entire profession and, through its upkeep, they honor both their work and the memory of the nine men who lost their lives.

For the families of the deceased, the memorial is a place of solace and a source of comfort, as they know that their loss has been formally recognized by the City. The memorial, however, is a success in the eyes not only of the families and the fire department but also of the

general public. Clausen's design manages to attract people to the site, and he has created a reason for them to stay and contemplate.[6]

However, few monuments are without their detractors, and this one is no different. Many Back Bay residents are displeased that it is not in compliance with the mall's master plan, which allows for only one monument per block, not two. Its placement, of course, was chosen based on the location of the event itself. However, project antagonists feel it would be more suitably sited in front of the old Hotel Vendome. Aside from its placement, its size exceeds the specified limits, leaving little room for landscaping.[7] Although much attention was given to the design of the wall, the location of the bench, and the inclusion of the uniform, they do not lead the casual observer's attention across the street, to the fire site. Without visible signs marking the old structure, the monument appears coincidentally located on the mall.

Despite the design's apparent shortcomings, the Vendome Firefighters Memorial does not detract from the theme of the mall, but engages the viewer in a piece of history, relatively recent in comparison to other Bostonian monuments. In contrast to the gallant historical figures composing much of Boston's public sculpture, the Vendome Memorial reflects in form the humble, faceless, and strong individuals that it commemorates. Using granite and bronze, traditional memorializing materials, the team brought that reverence and dignity to the working-class men who lost their lives in serving the city. Although the Vendome building has burned and been awkwardly reconstructed, the memorial marks the site's living history in a location rooted firmly in the past.

The memorial opened to an unveiling ceremony in 1997 with thousands of visitors.[8] It was again rededicated in 1999 in a Boston Fire Department ceremony, remaining as a testament to the continuing contribution of the fire department as well as a marker of the past. The Neighborhood Association of Back Bay now has a website for visitors, describing the memorials along the mall walk. In spite of their initial concerns, the association lists the memorial as a favorite among mall-walkers.

1 See Nick Capasso, "Vendome Memorial, Boston, Massachusetts," *Sculpture*, vol. 17, no. 6 (July/August 1998), p. 14.

2 Robert Fleming, conversation, July 27, 1998.

3 Ted Clausen, The Vendome Firefighters Memorial informational packet.

4 Cate McQuaid, "Forged from firefighters' words," *Boston Globe*, June 17, 1997, p. C11997.

5 Ted Clausen, The Vendome Firefighters Memorial informational packet.

6 *ibid.*

7 See Robert Campbell, "A modest monument amid the lofty," *Boston Globe*, June 11, 1997, p. E1.

8 "Vendome Hotel Memorial," firebuff.com/vendome, accessed January 19, 2006.

II

Interpreting place:
From marker to memory trail

210 Placemaking interpreted

238 Japanese American Internment
Memorial
Artist: Ruth Asawa

Placemaking interpreted:
Revisiting the past, revealing future choice

I.

Acts of
interpretation
in the
placemaking
drama

THE PRECEDING AND LARGEST SECTION OF THIS BOOK is the collection of case studies. These works of art and urban design are the big players in the drama of creating place meaning. They have larger roles and strut across the stage shouldering the big parts, shaping a space or providing a powerful backdrop. They can command the show as multidimensional phenomena—the *Cincinnati Gateway* or Pima Freeway murals, or the iterative drama of the Radnor enhancement strategy (coming at you over a 5-mile corridor of time and space.) They can also be subtle, elusive, and capable of sustaining return visits to discover more about them like *Mnemonics*, the glass vitrines of objects embedded silently and sporadically in the walls of Stuyvesant High School.

Of course, the larger placemakers do not just work as art or design, they also perform acts of interpretation. The vast concrete pattern of flora and fauna in the Pima Freeway is art as well as a dramatic interpretation of the natural world that is held at bay at the freeway's edge. We usually think of interpretation as a bit part in the drama; it is associated in our minds with historic markers and signs, with plaques on buildings and inserts in pavement with or without written information. However, the bit parts can sometimes have some power. We can experience a chorus of historic markers lyrically formed, carrying poetic messages, and crafted in handsome materials, but interpretation is usually the straight man: didactic, unassuming. Maybe it is just a little boring as a trailhead or a map bench.

As this chapter will reveal, interpretation can have an edge. It can talk back and show some lip. Wrapped in the raiment of innovative graphic design with photomontages and elegant juxtapositions of text and image, it can stir interest in, or even passion for, the proprietorship of a space. Interpretive markers in gay apparel can whisper off-stage and even demand that the audience respond to them. There is a language in the theater craft of interpretation that draws out the semiotics of the place. It can decode and explain; it can also provoke and annoy.

Recent interpretation of the language of American cities often focuses on the condition of the neighborhood, with a particular eye to the human values of those who have occupied it over time. Because of this attention to the human aspects of local life, recent interpretation often serves as an armature for placemaking art. By building up the presence of the informational base, we provide

the gist for inspiring artistic metaphors. Such interpretation enables artists to create works that comment on local conditions. The art can transcend the information while remaining accessible to those who do not know local history, or are not connected to the area. At the same time, local relevance can stimulate discomfort, reminding people of concealed wounds and hidden conflicts.

The political possibilities of more locally based interpretation can, however, be channeled in constructive directions. Interpretation of place can now become an interactive process, inviting the community to evaluate future civic planning and design options. Strengthened by new technologies and the experience of confronting controversy, both interpreters and artists are initiating dialogues with the public and occasionally collaborating. These dialogues can be catalysts for social change in a democratic and accountable process.

In an age of Post-modern reinterpretation, we take for granted that all of our actions, too, are historically contextual. Our markers and artistic works representing the past are etched indelibly in the style of our own hand. Through self-reflection and increased self-consciousness we may gain the sensitivity of perspective. The values that we hope to bring to reinterpretation are sympathy, respect, humanism, and empowerment—this is our own unselfconscious bias. With this apparatus comes the richness of a more open palette and the responsibility to use it.

Why interpret the past in the built environment today? One reason is to confront our own passivity in a complex society. Feelings of choice and proprietorship are often missing today as decision-making becomes more cumbersome, with multiple players and interests. The rift between the general public—the passive visual receivers—and the designers—the decision-makers—often severs the mental link between the history-making of the site and our current environmental condition. The simple fact that every building, standing or fallen, represents a choice made in the public sphere means that historical change is intimately linked with the world we see around us. To raise awareness of this timeline of choice puts the contemporary viewer in a key position to sort out the meaning of both past and present impacts.[1] We are the heirs to a resonant story that we can continue to evaluate through the mechanisms of design review. The fact that the public has choices and a right to maintain an institutional memory about past choices is sometimes obscured by the rhetoric of private property rights. But its consciousness can be activated with sensitive and effective interpretation that reveals both choices and motivations.

II.

History:
an ancient
tradition
becomes a
medium of
dialogue

Interpretation is as old as the built environment, or even as old as the cave drawings at Lascaux in France. The formalized notion of erecting commemorative plaques and monuments was well established by the time of the Egyptians. Constantine's Arch and Trajan's Column in Rome visually command spaces and transform our experience of them. However, interpretive elements are often simply part of the incremental encrustation of old places. On this less grand scale, battered plaques stud the walls of old cities and proclaim the deeds of men, usually the ruling élite, who defined their version of great events or marked their turf.

Interpretation of place based on such Classical models grew more common in more recent centuries. It is embedded in the entablatures of buildings and carved in relief on walls and foundations. The story of a city's evolution and development integrated itself in ornament. It could be etched in a foundation stone, formed in a bridge railing or cast on the back of a bench. Interpretation was everywhere, not just focused on a few powerful monuments. This narrative architectural tradition last appeared, in substantial quantities, in the Modern and Art Deco buildings of the 1930s, where decorative elements describe the function of the building or evoke the atmosphere of place through motifs incorporating the regional flora and fauna, such as in the Deco District in Miami Beach.

The narrative approach to interpretation largely disappeared in Western countries after World War II, as practitioners of the Modern Movement stripped away decoration on built form. Designers expressed the beauty of materials and form without explicit narrative: the tie between narration and traditional power was anathema to Modern architects. The universality of international design sought to transcend that power system, to avoid the claims of the nation state or the encoded triumphs of the local bourgeoisie. In a sense, Modern design projects were still a form of interpretation, though the central message, a protest against the older language of power, was usually neither locally specific nor universally understandable.

In the late twentieth century, following a cultural assessment of Modernism's impact on urban design, narrative returned, this time with a more rebellious demeanor than the often rigid formations of decorative elements of the past. Transformed by abstraction's critique, narrative now gives voice to perspectives hitherto ignored in the public arena. Governments and propertied interests are no longer the only commissioners, and the perspectives of the powerful are no longer the only acceptable stories in narrative interpretation. Rather than attempting to escape from the power system, as the Modern Movement did, narrative interpretation of place comments more fully on this framework, making its sometimes ironic commentary openly accessible. This approach functioned to democratize the interpretive function rather than reserving it for a small élite who understood the structure of the city and wielded the authority.

Interpretation now points out issues that shape the physical character of places, and comments on the patterns of architectural, economic, and social development that are translated into physical form. The simple event-oriented plaques, and dry chronological litanies of built history, often cast on metal plaques or carved in stone for a centennial celebration, have given way to a richer and more refined system of complex graphics and multiple messages. It is this sense of changing perspectives and a candid, even humorous acknowledgment of shifts in viewpoint that imbue the new interpretation with dynamism.

Ancient Roman inscriptions
These Roman examples of plaques, coats of arms and inscriptions are interpreted as showing the power of the ruling class.

Fruit-stand marker, Providence
This humble marker, installed by his family, commemorates the achievement of Francesco Garofalo's fruit stand.

Bargello Museum, Florence, Italy
The exterior wall of the Bargello Museum displays plaques of the former ruling families, demonstrating how public interpretation once served to reinforce the power of the élite.

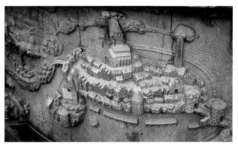

City Hall, Stockholm
This Romantic Nationalist-style city hall has early images of the city carved in relief around the entryway.

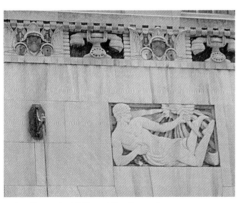

Telephone building, Cincinnati
An Art Deco frieze around the telephone building in Cincinnati imitates Greek and Roman styles of ornamentation.

Bridge, Berlin
A nineteenth-century bridge leading to the city palace depicts Berlin's growth during the seventeenth century.

III.

Interpretation as cultural criticism

In many cities there have been almost no recent attempts at interpretation, leaving their cityscapes opaque to the casual visitor, whether out of indifference or a desire to mask an unsavory past. For some cities, this is evidence of an aloof attitude, civic dysfunction, or even civic cowardice—a refusal to address issues of urban design or architectural preservation. Contemporary interpretation can threaten an existing power structure by making transparent the failure to develop effective policies. Interpretation can be subversive by asking tough questions about relationships and motives in the cityscape. Markers can discuss the policy effects of citizen action and civic design strategy. Why were certain buildings demolished?[2] Why were certain buildings not better designed to fit in? Why were certain voices not heard as part of a historic epoch?[3]

Although interpretation of such information can empower the imagination of artists, there are few alliances today between graphic artists and the developers of interpretation systems, such as historic commissions. While interpretation has the potential to fulfill this provocative rôle, it is often suppressed by existing powers afraid of offending some constituency. On the larger cultural horizon, historical interpretation should contend with the controversial issues affecting communities today. Through multiple-perspective history and the self-criticism arising from it, each story can attain dignity and a candor not always available in the often self-censoring and constricted realm of the public commission.[4]

One example of tackling a loaded and pivotal moment in history is the Sit-Down Strike Memorial in Flint, Michigan, which expresses layers of meaning in an eye-catching way that can be easily understood, even by a casual observer. It commemorates the great auto strike of 1936–37 in General Motors' Flint factories, where a worker sit-down paralyzed production, establishing the United Auto Workers union and eventually causing the company to recognize the union; it is considered a milestone in labor history. Memories of the great labor victory were all but obliterated in the 1950s and 1960s as the American auto industry boomed, and labor increasingly lost its leverage. It was not until the late 1980s that city hall and union leaders looking to revitalize a diminished downtown with new tourist attractions sought to recover this labor history by creating a memorial to the strikers. The memorial served an urban-design function as an entry marker for the historic Carriage Town neighborhood, where the auto industry had its first roots in carriage production. It is also the backdrop to an informal outdoor amphitheater sloping toward the Flint River, where hardwoods were floated down to supply the early carriage factories. The City commissioned this memorial with the help of The Townscape Institute, which recruited New York artist Johan Sellenraad to design the ceramic panels.

In a riverside park adjacent to the downtown park, Sellenraad re-created the story of the history of the strike with four large ceramic tile murals in a concrete mini-factory format, with viewing benches reconstructed by local union workers in the form of replica front seats from a 1936 Chevy. Drawing on the old Arts and Crafts traditions of the Pewabic Pottery in nearby Detroit, Sellenraad designed tiles commemorating the union's history with painted images from the strike based on photographic research. The multifaceted memorial design also incorporated bronze castings of the original car hinges that the workers fired at the sheriff's men with slingshots made from inner tubes when the local government tried to break the strike. Predella-like images bordering the larger panels place the strike in its historic perspective. They depict union leader Victor Reuther, and quote workers' statements about factory conditions in the 1930s, as well as citing popular union songs. The final panel in the sequence depicts electronically guided robots replacing humans in the production process. It is in one sense a resolution of the historical labor problems depicted in the earlier panels, but also an ironic reference to the challenges that labor currently faces. Unfortunately, water seepage has damaged the memorial, eroding the delicate ceramic tiles during harsh Michigan winters.

Like the statue of the man on horseback in the public square, the Sit-Down Strike Memorial is an artistic homage to a single event in history. By giving a voice to labor, however, it goes beyond traditional memorialization of heroic individuals. The integration of quotations and text, and the use of graphic techniques add richness and complexity, even irony, as the electronic robots in the last panel replace the union members.

One recent technique is to comment critically and directly on earlier efforts at interpretation. Older memorials that defined power relationships are now sometimes subject to "editing" as interpretation itself is reinterpreted.

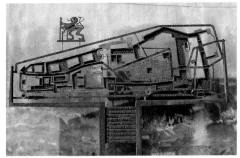

Royal Castle, Prague
Attributed to Jože Plečnik, who renovated the castle in 1930, this sign shows the layout of the castle with a transparency that casts a delicate shadow on an adjacent wall.

Stained glass, Cambridge, Massachusetts
This stained-glass window, part of a series, was installed in the 1990s during the renovation of a Victorian-era school in Cambridge. The designs relate the school's history as one of the first for African Americans in Massachusetts.

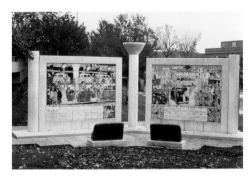

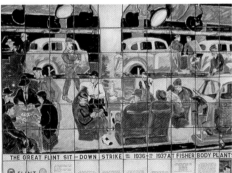

United Auto Workers Sit-Down Strike Memorial, Flint, Michigan
Artist Johan Sellenraad made this memorial from ceramic tile paintings based on photographs of the historic strike and hard-won victory of the United Auto Workers. Weathered bronze hinges (bottom) commemorate the battle between the autoworkers and the sheriff's deputies called in by factory owners.

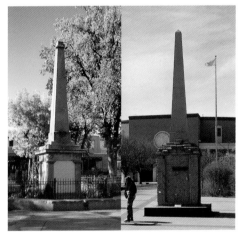

Two obelisks, Santa Fe, New Mexico
For Santa Fe's Third International Biennial (1999) entitled "Looking for a Place," Charlene Teters built *To the Heroes*, an adobe obelisk (right) in the same style as, and in response to, the old stone one in the central plaza. The title is derived from the first words of the old monument's inscription, which commemorated Anglo domination and referred to "savage Indians," words that were obliterated in recent politically correct times. Teters invited the community to contribute artifacts to embed in the adobe that would, in turn, wear away over time. It was displayed in front of the State House and administered by the Capital Art Association.

IV.

Interpretation
revealing
community
choices
for the built
environment

A particularly vivid and elaborate example of the interpretation of loss is the commemoration of the destruction of the main gate tower in Bern, Switzerland. The display (in English) in the basement of the city's very modern train station depicts its former main gateway tower. This was destroyed in the 1840s, following a close vote by the city council, to facilitate the construction of Bern's first train depot on this site. The marker itself was not installed until the 1970s, after the construction of the new station. As the 1840s vote revealed, there was a divisive gap between the older patricians who wanted to preserve the tower and more democratic forces who wanted to change the existing order. This kind of interpretive display reveals viewpoints that are still the cause of conflict more than a century later.

The Bern train depot is one "station" on the road to making people aware that there are alternatives to any particular design. The Bern display shows what was lost when the station was built, and thereby calls attention to a previously existing alternative. Interpretation can thus be seen as a means of sustaining institutional memory in a civic design process. The next step, however, is to display the many phases a design goes through as it evolves, showing to the public the potential disasters that have been averted, the original intentions of architects, and the incremental impact

Marker, Lexington, Massachusetts
This marker celebrates the 1920s public policy zoning victory in which land next to the town hall was acquired as civic open space instead of evolving into a strip commercial zone.

Train station, Bern, Switzerland
Top: One of a series of informative plaques commemorating the city tower that was destroyed to build the train station.
Above: Foundation fragments, a copy of the sculpture over the gateway, and the commemorative plaques *in situ*.

Parking lot, Portsmouth, New Hampshire
The eighteenth-century houses destroyed to build a parking lot in the 1950s are depicted on this 1971 photo metal panel.

of a design change. This sort of display might encourage people to think about buildings from the perspective of the designers, preparing them to play a greater rôle in civic design. Over time, this sort of communication can anchor a design review policy. To display a history of civic changes is to be honest with the public, which can be embarrassing for a developer. To present future possibilities is to welcome the participation of the public.

Unfortunately, the actual description of a policy change in a public format has rarely been produced. The marker program for the bicentennial in Lexington, Massachusetts, however, used the technique of photo metal aluminum to depict old photographs of lost buildings, exploring the impact that zoning policy has had on the character of the community today. The marker by the town hall noted that the green it marks might have evolved into a commercial strip if the town's leadership had not taken action in 1922 to change the zoning, protecting this green edge. Similarly, a marker in a parking lot in Portsmouth, New Hampshire, for example, shows a picture of the neighborhood that was destroyed in the 1950s to build the lot. It was the result of a National Endowment for the Arts grant to Strawbery Banke, a preservation organization that sought to increase awareness of the fragility of the neighborhood in the 1970s, before zoning protection.

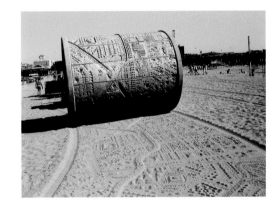

Art Tool

SANTA MONICA, CALIFORNIA

Carl Cheng's *Art Tool* brings the city of Los Angeles to the beach. Santa Monica, a seaside city of 89,000 inhabitants just west of Los Angeles, is known for its progressive politics and funky beachfront style, both of which encourage public-art experimentation. During a liberal regime in 1982, the City founded the Santa Monica Arts Commission, which has since sponsored murals and public sculptures. Encouraged by positive public feedback, Santa Monica passed a Percent for Art ordinance in 1986 and, two years later, employed the resulting funds to enhance the 3-mile-long beachfront through ambitious and comprehensive projects. The Natural Elements Sculpture (NES) Park along the shore is one outcome of this new initiative. *Art Tool*, the second of ten environmental works commissioned for this outdoor installation, sits north of the Santa Monica Pier. The *Tool* is a cast concrete cylindrical seal 9½ ft tall, which, when pulled along the beach, leaves a 12-ft-wide relief imprint of the city of Los Angeles as seen from above. The imprint image is thorough and complex, ranging from high-rises to highway overpasses complete with cars in traffic. This form of interpretive "mapping," although not precise or functional, brings the scope of the city to a ponderable scale. The image is as transient as the beach's shifting sands. Currently, owing to budget restrictions, it is rolled twice a year.

The commission contracted *Art Tool* from Cheng for $20,000. According to Hamp Simmons, coordinator of the Cultural Affairs Division, Santa Monica's largest provider of arts services, "it was so cheap in part because of when it was done, but also because the [art] program was new and the artists commissioned for projects at that time waived their fees."[5] In 1986, the Santa Monica Arts Foundation used its annual "Eat for Art" benefit dinner to help fund the project, raising $16,000. Funds from the Percent for Art plan provided the rest.

Photo: courtesy of the artist.

V.

Interpretation as armature for urban infrastructure

Integrating interpretive elements in the cityscape provides a conventional basis for enriching the meaning of sites without the formalized process of commissioning placemaking art. By working within the constraints of streetscape budgets and public works departments, small integrated projects are possible. Because funding comes from many sources, the protocol that might limit a town's public-art endeavors can be obviated, bringing in new proposals and perspectives. Funding can also be solicited from individuals and local businesses, again broadening the possibility of representing local and non-governmental outlooks. As Biddy Mason's *The Power of Place* project in Los Angeles revealed, multiple funding sources can allow for several interpretive projects (in print and inside the retail center, as well as outside in the public space) to come together in a placemaking scheme.[6]

Streetscape design connects interpretation to public works and planning departments, rather than to the more specialized responsibilities of public arts commissions and councils. Since every city and most towns carry out these functions, while only a comparative few have fully fledged arts commissions, this is a fruitful locus to initiate change. These common and rudimentary components of streetscape design (street furniture, shelter systems, trail and historic site markers, and street signage) are usually in the purview of public works departments, and are often simply purchased out of a catalogue. While most of these elements are simply embellished by adding interpretation, they are often crucial "players" in establishing an atmosphere. Signage and graphic design, as well as the introduction of craft, are ways of humanizing essential elements of cityscape, and of building public curiosity, which can accommodate more ambitious placemaking efforts. Since many public works projects are increasingly geared toward pedestrian amenities in streetscape design, we are on the cusp of a historical change that benefits the larger placemaking objective. Several examples of interpretation work integrated into infrastructure have been assembled here: they are types of projects where functional elements introduce site information while addressing other urban-design objectives.

Ned Kahn, *Encircled Stream*, Founder's Court, Seattle. Seattle Arts Commission, 1995 Kahn worked with Atelier Landscape Architects to design a courtyard interpreting the history of the state's geology. He created a sculpture using water that cycles into a basin, filling and draining rhythmically to suggest the history of flood cycles that have shaped the area's landscape. Photo: courtesy of Seattle Office of Arts and Cultural Affairs.

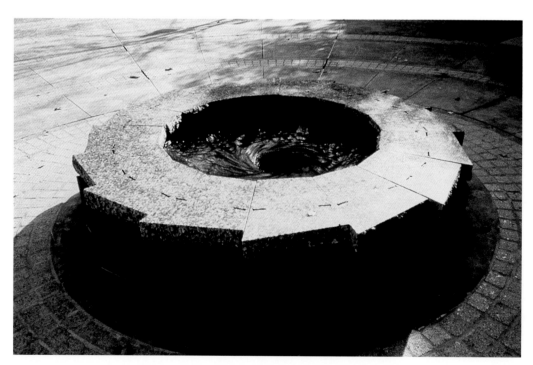

The new multipurpose thinking that links interpretation to pedestrian convenience has taken many forms in the late twentieth century. The use of interpretive street furniture becomes a pragmatic means of meeting pedestrian needs while conveying information about a specific locale and its history. This is particularly noticeable in transit facilities, where people are required to sit and wait. This idle time spent in public space can be focused on interpretive elements.

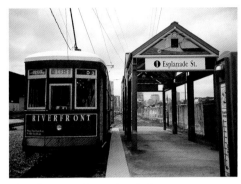

Riverfront stations, New Orleans
The Arts Council of New Orleans commissioned triangular pediments in the roof, referring to aspects of each particular stop along the city's Riverfront trolley line. These artistic pediments were designed by artist Thomas Mann and constructed in 1991 from anodized aluminum and steel. The boats, lines, and cables in this image refer to the nearby warehouses.

Vernon MTA station, Blue Line, Los Angeles
These brightly colored spools, a part of Horace Washington's *Tribute to Industry*, connect the garment district transit station to the surrounding neighborhood, and serve as distinctive seating.
Photo: courtesy of LA MTA.

Pencil Ramada at Machon School, Phoenix
Part of an entryway marker to the William T Machon School, this has appropriately bright colors and a school-related theme. Designed by artist Ginny Ruffner in 1993, the entire project, including this ramada, a drinking fountain, a colonnade, a system of patios, and surface detailing of a map of Arizona, cost $119,000.

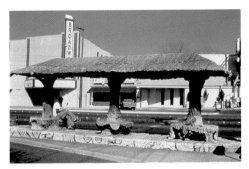

Trolley stop, Alamo Heights, Texas
This 1920s-era shelter originally serviced a trolley that no longer runs along this street. Artist Dionisio Rodriguez based the creation on Mexican architectural motifs and used sculpted concrete to make it.

Light rail station, Salt Lake City
Salt Lake City has used part of its Percent for Art program's funds to embellish this light rail station, one of the "TRAX" stops in the new transit system linking the downtown area with the suburbs. The station (top), completed in 1999, celebrates the neighborhood around it, and is the result of a collaboration between eight artists. The close-up picture (above) shows one section of a long display of poetry composed by Aden Ross, with photography by Ruth Gier.

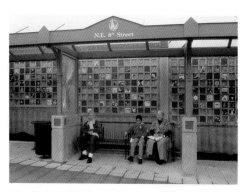

Northeast 8th Street, Bellevue, Washington
In 1987, the City of Seattle hired an artist to travel to schools along the bus route so that students could decorate approximately one thousand glazed tiles to be installed in the bus shelters in Bellevue at a cost of $6000. The tiled back wall of the bus shelter also served as a sound barrier for the road.

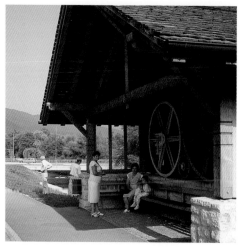

Bus kiosk, Delémont, Switzerland
This bus kiosk presents the history of the grist mill on the edge of this rural town.

Hollywood and Vine subway station art, Hollywood, California
This head house (above) by Gilbert "Magu" Lujan, on the 1999 extension of the Los Angeles transit link, is inspired by the architecture of theaters along Hollywood Boulevard, where the station is located. The design extends into the station, where film reels form a pattern on the ceiling above the tracks. It was paid for as part of the construction budget for the station. The artist also completed a head house recalling Grauman's Chinese Theater and bus shelters including this one (below), in the form of the Brown Derby, a famous early restaurant. Los

Angeles Metro Transit Art program sponsored the nine-year project along the Metro Red Line. Photos: Melissa Tapper Goldman.

Waiting For a Date, University Drive, Tempe, Arizona

This bus-stop bench includes life-size sculptures of date palms, a common local tree introduced in the nineteenth century. It was commissioned in 1995 by city agency Tempe Public Art from artist Joe Tyler, for $10,000. Photo: courtesy of Tempe Public Art

International District bus shelter, Seattle

To design this 1998 bus shelter, artist Laura Brodax extensively researched the International District community, a primarily Asian district next to the controversially sited Seattle sports stadium. The exterior of the shelter displays colorful screen-printed photographs from the community's history, and the interior contains neighborhood pictures with captions for every decade starting with the 1880s. The project cost $10,000, including donated time. Here we see the pictures from the 1970s, when the neighborhood protested against the stadium. Brodax says that in designing the interior, she was inspired by a scrapbook lent to her by Jerry Arrai, a local architect and long-time resident of the district. Photos: Laura Brodax.

La Sombra, Tempe, Arizona

Artist Joe Tyler and designer Scott Cisson created this sculptural bus shelter on University Drive in 1995 from welded metal and acrylic paint. The shelter was created within the limited space of University Avenue, which had been narrowed to create a pedestrian-friendly environment. Photo: courtesy of Tempe Public Art.

VI.

Interpretation through trail systems and trailheads

It is only a recent phenomenon in America to link interpretive elements together, orchestrating increased meaning from the resulting effect, and using this comprehensive approach to nurture dramatic encounters with information. As a result, we have only found a few examples to support the concept. Connecting such a system to a centralized information bank or "trailhead" is even rarer, and although we have found trailheads and marker systems, we have yet to discover a sophisticated link between the two in an American city.

The Seven Hills Park trailhead in Somerville, a densely populated city adjacent to Cambridge, Massachusetts, lacks an accompanying marker system. The trail is on the site of a former railroad line that begins adjacent to the Red Line subway station in Davis Square. This small park is segmented by tall pole signs topped by symbols representing landmarks characterizing the development of the seven hills of Somerville. Created as part of the expenditure for a trail linkage, using an old rail line that now provides a pathway to Lexington, Massachusetts, it is a powerfully graphic set of design elements that recall these varied hilltops. A dairy was once located on one hilltop, a Bulfinch-designed house on another (later forming part of the McLean Hospital), and Charles Tufts, the founder of Tufts University, once lived on Walnut Hill. The cluster of poles commemorating these sites could be linked to trails and markers connecting the different hills.

Similarly, in blue-collar Chelsea, Massachusetts, a waterfront community just north of Boston, a "memory wall" of ceramic panels alongside a pedestrian walkway running on to the main street could have served as a guide to interpretive sculptures along the street. These art elements were part of a "2 Percent for Pedestrian Orientation" program when the area was revitalized in the late 1970s with $3.1 million from the Economic Development Administration (EDA), which allocates grants to deprived communities.

These elements—a trail system, interpretive panels, and placemaking public art—have rarely been integrated, as they are often the province of different government agencies whose activities are usually not connected. But the introduction of trail systems is probably the best way to encourage interaction between different commissioning or sponsoring agencies, because it can physically and mentally link disparate sites together. The trail markers can introduce the area, its political and social history, the physical character of its architectural styles and building material, and the geography, flora, and fauna of the natural environment. Even the lexicon of the place can be introduced—the history of its place names, which can reveal the complexity of its mental landscape of associations. Combining this didactic approach with small elements of public art can even transcend the educational purpose and evolve into something delightful, perhaps even enchanting.

Paradoxically, even cities with an extraordinary sense of place can benefit from such integrated interpretive strategies. A self-contained, self-guided walking introduction to an area may reveal mysteries and complexities that a casual observer could spend years without comprehending. Trail systems have emerged in the last decade that link a series of spread-out interpretations. The idea is to have an introduction or central guide at the trailhead, expressing ideas to which each element along the trail is related. Somerville's Seven Hills Park is one such example; however, this project makes no link to the specific sites of its markers. It is a trail system, but not really a placemaking one. A good example of this concept is yet to be revealed. Chelsea experimented with a trail system by using revitalization funds for civic orientation, but no connections were made between a central panel of information and the little sculptures on the trail.

Trail systems are also very useful in tourist destinations as they provide a self-contained, self-guided walking introduction to an area. Imagine the difference it would make for Venice, an opaque city practically devoid of interpretive markers, to adopt a trail system? What if there were a series of trail markers radiating from an interpretation center in the train station to help disperse tourists away from tourist-infested St. Mark's Square, to discover other parts of the city? Interpretation at the gateway to the railroad station could comment on the history of the city's conservation strategy; on efforts to preserve and restore individual monuments and works of art; or on the impact of the *acqua alta* that increasingly floods the city. Despite the millions that have been spent on these projects in Venice, there is nothing there to inform visitors of such efforts. Restoration organizations from abroad, such as the American "Save Venice" and the British "Venice in Peril," acknowledge the difficulties in communicating with the Venetian bureaucracy. Besides leaving tourists without

Seven Hills Park, Somerville, Massachusetts
Steve Purcell carved the sculptures for these markers, designed by Clifford Selbert Design. The City commissioned the project, which was completed in 1990 at a cost of $10,000 for each sculpture, excluding the tower structures. The total cost of the park was $480,000. Each of the seven hills of Somerville has a different symbol mounted on a pole in Davis Square at the start of the path that follows the old rail line to Lexington. The marker in the foreground (top) commemorates Walnut Hill, where Tufts University was founded, and in the background, on an adjacent hill, can be seen a mansion designed by Charles Bulfinch. Photos: Selbert Perkins Design.

Street sign, San Jose, California
Thirty-eight markers line a historic trail. The entire trail is depicted on the lower part of this pole, by artist Michael Manwaring. The design includes a sunburst as well as stylized leaves of a plum tree, a reference to prunes, the first major agricultural product of the region, which is now home to many dotcom companies. The

ongoing project began in 1987 through San Jose's Redevelopment Agency.
Photo: Dana L. Grover.

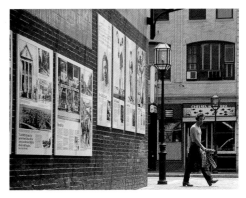

Memory Wall, Chelsea, Massachusetts
An interpretive wall, conceived in 1979 by Ronald Lee Fleming, Peter Johnson, and Susan Roberts. The close-ups show a portion of the wall with picture and text devoted to Laura Lee, an early bohemian whose memorable quotations are still arresting today. The author and his associates designed this wall in an alley connecting Chelsea's main street to a parking lot. The panel was later moved to the city hall because there was no long-term site-management strategy to address vandalism.

Hackensack River trail markers, New Jersey
One of sixteen digital prints on vinyl designed and installed by Richard K. Mills as markers on the Greenway, a walking path along the banks of the Hackensack River. Mills's goal was to promote conservation efforts by "getting people to fall in love with the river." On the right we see the flower of the cat-tail, a plant that naturally marked the sites where clay could be excavated, and on the left is the *John Schmults*, a nineteenth-century schooner that transported the excavated clay. Text from a 1916 poem by Owen Terry evokes the Hackensack region and mentions the beauty of schooners while, in the lower left corner, Mills explains that cat-tails have nearly disappeared from the Hackensack region because of increased salinity from a dam.
Photo: courtesy of the artist.

direction, the opportunity to deepen the understanding of the process of conservation, to connect the average visitor to these efforts, or even to show how he or she could be involved in protecting a world resource, is lost. By beginning the tour at the train station, many visitors could be introduced to Venice in an intelligent way without excessive logistical planning—and the same visitors would come to an appreciation of the preservation work currently underway. Perhaps they would even become inspired to enlist in the constituency working toward further conservation.

VII.

Interpretation in street signage

Some street markers have a graphic style or logo suggesting the very character of a place. The complexity of the place can sometimes be revealed by graphically complicated images that depict timelines or changing physical conditions. A marker on Erie Canal in Waterloo, New York, for example, uses text and photographs to illustrate changing time periods, while a marker on a wall on Philadelphia's Pine Street uses simpler information to describe the development of street architecture over three hundred years (see p. 237).

Aside from the built environment, which a community can mold through design review and urban-design policy, there is also the opportunity for a subtler form of communication through graphic design, which can give unity and cohesion to an area. As all governments already use (and pay for) such functional graphic elements as street signs, markers, transportation signs, and directional maps, there are extraordinary opportunities for rethinking these systems. As in San Jose's markers and Riverside's skateboard guard, coherent graphic gestures reveal community identity and pride, as well as being attractive and connecting to historic imagery. Indeed, Riverside's identifying graphic, the icon of its historic Mission Inn, links the infrastructural elements as well as giving a kind of "brand identity" throughout the city's neighborhoods. Even when the literal meaning of graphics is not immediately readable, it can still build new associations upon a historical and visual tradition. In fact, graphic identity is a way of fortifying a sense of place by drawing on a significant bank of visual associations that users already understand, before asking them to reach out in order to learn about their community history. It is a way of whetting the appetite for historical information, while recognizing the power of simple elements of the urban environment. Obviously, care must be taken to avoid triteness in graphic identity.

Street sign, New Castle, Delaware
The most compelling architectural element in this colonial city, the city hall's cupola, is visible on this street sign and on the building in the background.

Entry sign, Hammond, Louisiana
A handcarved wooden marker of a building on a cake celebrates the creation of the Main Street historic district. A bake sale, in which citizens participated by donating cakes depicting historic structures, raised the funds for the necessary historic survey leading to the establishment of the district. Photo: Laurie Moon Chauvin.

Olney, Buckinghamshire, England
This sign shows the ladies of the town competing in its annual Pancake Race. Women of the town race 415 yds in traditional housewife's dress, carrying a pancake in a pan, which they must successfully flip upon reaching the finish line.

Aventura, Florida
Richard Haas's 1990 mural at Home Savings of America displays a map of the town.

Toledo, Ohio
Artist George Greenameyer's sculpture marks a fire station next to a historic district of Toledo.

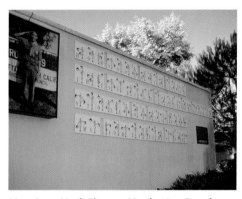

How Soon Hath Time ..., Manhattan Beach, California
In 1992, Gary Sweeney, a former Boy Scout, made this work at the Joselyn Center. Measuring 6 × 17 ft, it faced the building where his troop used to meet. The photograph on the left shows the artist as a Scout in 1964, and the semaphore cards spell out an excerpt from a poem by John Milton, decoded in the red plaque reading: "How soon hath time, the subtle thief of youth, stolen on his wing my fortieth year." Sweeney says he shares this sentiment when looking back on his Scout days.

Albuquerque, New Mexico

This ramada (a traditional shade structure and marker) was built as part of the city's Tricentennial in 2006. The map, text and relief orient the viewer physically and temporally within the area's history.

Interpretation as mapping and orientation

Catalina Airport, California
This tiled bench at Catalina's airport is in the shape of the island, off the state's southern coast.

City History Museum, Stockholm
Visitors to the museum are encouraged to walk on the interactive map.

Community participation

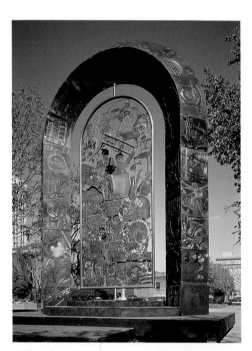

Millennium Gate, **Greensboro, North Carolina**
Jim Gallucci's functional *Millennium Gate* and its surrounding arch consist of one hundred icons, each representing an event of historical importance to the town. The artist invited citizens to submit ideas for the icons, and local artists came up with many of the designs, which include Nascar (National Association for Stock Car Auto Racing) and the 1918 influenza epidemic. The artwork is made of bronze, galvanized steel, silicon, and granite.
Photo: courtesy of the artist.

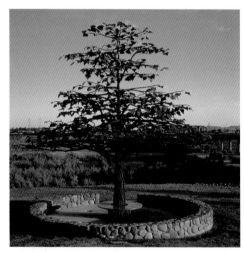

Adopt-A-Tree monument, Tempe, Arizona
Tempe is located on Rio Salado, which dried up when a local dam was built. In the 1970s, Tempe decided to restore the waterway as Tempe Town Lake. Parks were created along either side of the 3-mile stretch of water, and the City began to raise funds to plant trees in them. This sculpture by Joe Tyler and Scott Cisson commemorates those who donated enough money to purchase and plant a tree. Each donor's name was engraved on to a leaf that was then welded on to the sculptural tree. This is one of two Adopt-A-Tree program monuments, bearing about five hundred names. Marilyn Zwak created the other out of adobe.
Photo: courtesy of Tempe Public Art.

Interpretation as urban infrastructure: overpasses

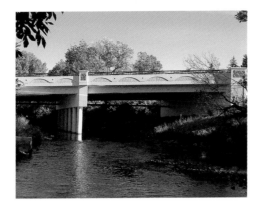

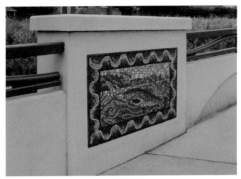

Thompson River bridge structures, Loveland, Colorado

This overpass (above) at Thompson River in the small town of Loveland displays a number of small mosaics by artist Mario Echevarria. Paid for through a Percent for Art ordinance, the overpass also includes a mural on the underside (below), which is visible to pedestrian traffic. The mosaics depict various wildlife species that have been seen in the area of the overpass, and the mural illustrates scenes from the artist's childhood, spent on the same river.
Photos: courtesy of the artist.

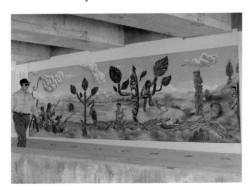

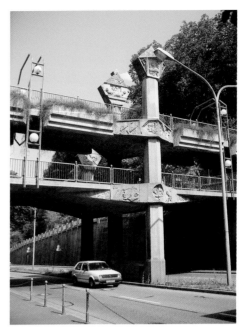

Freiburg, Germany; Glenrothes, Scotland

This pedestrian overpass (top) connects the old city of Freiburg to adjacent suburbs. The cast-concrete walls narrate the story of US and British bombings during World War II. Overpasses can provide a good infrastructure for interpretation, as demonstrated by this example. The underpass in Glenrothes (above) was designed by Richard Harding, an artist-in-residence in the city's public works department. High-school students assisted the artist with forms that symbolize the history of the town, from mills to computer chips.

VIII.

Interpretation as civic gateway or entry sign

The anticipation of entry, and the fulfillment of arrival, can be among the most dramatic aspects of place interpretation: the shimmer of lights across a darkling plain foretelling the approaching city; geographic features defined against a tight urban settlement pattern in the distance; or the historic procession into a metropolis through the portals of a great train station—these gateway experiences constitute powerful impressions of place. An iterative narration can build momentum over space and time, introducing us to the richness and complexity of a particular area. Historically, railroad stations were major entry points. At their best, they were built to induce a sense of awe and wonder. But today we see that sprawling land-use patterns, the demise of passenger rail traffic, and the arrival of the freeway have obscured the natural boundaries of many American cities, disorienting the traveler and robbing him or her of this sense of arrival. So the potential for reconnecting Americans to the drama of entry is a palpable, often transcendent, urban-design opportunity. It can be approached at a variety of levels and by a range of efforts, some as modest as defining entry through signage, and others as complex as the reconfiguration of freeway walls, or the erection of new entry gateways.

As the twentieth century ended, only a few American cities had realized this potential with new public-art and urban-design strategies. Many of the great train stations have been demolished, and the edges of most American cities and towns are blurred with the homogenized detritus of brand names, increasingly aggressive billboard lobbies, thickets of overhead wires, and miles of undistinguished suburban development. Yet potential exists for graphic systems and entry signs that relate to the special character of cities and towns; the development of "gateposts" and entry buildings; and, most ambitiously, whole linear corridors that build up the drama of entry using orchestrated points along the way.

Even the modest investment in special graphic effects for a city entry sign has the potential to suggest community character. Signs can evoke the roadside culture of a particular era. The welcome sign at Castro Valley, California, conceived by artist Sheila Klein, for example, and the more anonymous effort of a roadside artist who painted the small sign of a town in Louisiana's Cajun country both demonstrate a different approach to the task of graphic identification. We do not denigrate the carved wood or mosaic of the "tasteful" sign, which made an appearance in the cityscape in the 1970s, 1980s, and 1990s as part of a beautification phenomenon across America. But it is the unusual effort of trying to capture the particular spirit of place in signage that draws our admiration. Often, gateways and graphic signage are the only remaining media that allow communication between the community and those who would pass through and who might stop—if sufficiently intrigued.

There are cities with a particular policy of creating new monuments, either as gateways to the city as a whole, or to particular neighborhoods. Cincinnati used its bicentennial and neighborhood celebrations to construct entryway monuments that mark the riverfront, the downtown, and the principal nineteenth-century district of Over-the-Rhine (a moniker referring to a canal separating the downtown from an early German neighborhood that extended to the defining hills west of the downtown; see pp. 58–61). With its "faux deco" metallic monument in the roadway near the Proctor & Gamble headquarters, its new brick bell tower celebrating the oldest clock-manufacturing company in the country, and the steamboat columns and archways of Andrew Leicester's *Cincinnati Gateway* (see pp. 54–57), Cincinnati is a testament to a proud city's ability to redefine itself through the construction of gateways. Perhaps because the river and the arc of hillsides give Cincinnati such a pronounced flavor, it was easier to begin this process of redefinition at the end of the twentieth century than it has been for some other cities.

Welcome sign, Castro Valley, California
When this sign was commissioned in 1997,
residents refused to allow it to include a chicken
(the city was once a chicken farming town),
so artist Sheila Klein chose instead to use the
handwriting of the original settler to write
the word "Castro," and included an image of a
canoe. It was extremely controversial, and barely
escaped removal in 1998.
Photo: Sheila Klein.

Sign, Baldwin, Louisiana
An artisan folk sign graces the highway entry to
this small town in Cajun country.

Archway, Federal Hill, Providence
With its hanging pineapple, a symbol of hosp-
itality, this archway defines the entry to Federal
Hill in Providence. A plaque on one of the columns
supporting the arch announces that the arch is
dedicated to Buddy Cianci, the former mayor, who
was imprisoned on corruption-related charges.

The Radnor Cairn, Radnor, Pennsylvania
The cairn was designed by artist William P.
Reimann and constructed under PennDOT. This
ancient form marks the entrance to Radnor from
the Blue Route, and is 30 ft high (see pp. 48–53).

**Boylston Place Gateway (including Swan Boat
and Frog Pond Bridge in Boston Garden),
Boston**
Dimitri Gerakaris designed the gateway in 1991.
As it faces Boston Common, the artist chose to
include images depicting the park's important
features.
Photo: courtesy of the artist.

***Big Wave*, Santa Monica, California**
Tony Delap's neon arch, the winning entry to a
design competition, marks the entrance to the
City of Santa Monica.

Gateway marker, Laguna Beach, California
This gateway marker to the shopping district in Laguna Beach incorporates the original gate that stood here.

Highway sign, Haleiwa, O'ahu, Hawaii
This sign marks the entrance to Haleiwa, the surfing capital of the North Shore of O'ahu.

Washington Middle School Park, Albuquerque, New Mexico
At this school, 135 students created many of the tiles covering the pillars that Eddie Dominguez conceived, designed, and implemented in 2002. The center column tells stories of neighborhood residents, past and present. The left column depicts simple geometric shapes, while the right column shows existing neighborhood houses against the Albuquerque skyline.
Photo: Nancy Johns Fleming.

***Understory*, Seattle (now in Issaquah, Washington)**
Although this sculpture, entitled *Understory*, was photographed at its temporary location at Union Station, Seattle, the series of 12-ft-tall orange plants was placed along a pedestrian trail at the foot of Tiger Mountain in Issaquah, Washington, in 2003. The trail includes an 80-ft-long tunnel underneath the highway. Commissioned by Sound Transit, these sculptures, which appear at the tunnel entrances, try to make sense of the juxtaposition of forest with the huge concrete highway structure. Designed, forged, and fabricated by Jean Whitesavage and Nick Lyle, they all represent small plants that were photographed within a quarter of a mile of the site. The plant in this picture is a wild geranium. Photo: Jean Whitesavage.

Still another approach is to construct actual gateways, of which Federal Hill, the old Italian district of Providence, is probably the most grandiose example, with its arch and columns. But such an entryway can also configure a little district, such as Boston's Boylston Place, where Dimitri Gerakaris's iron gateway evokes the proscenium of neighboring theaters as well as the imagery of curtain drapery, and includes depictions of the swan boat, a police horse, and the famous row of ducklings, all of which can be found in the adjacent Boston Common and Public Garden.

Other places faced conflict over invasive highways, but were able to use the tension as a way to fund enhancement strategies that interpreted place. So far, Phoenix's Squaw Peak Parkway and nearby Scottsdale's Pima Freeway have used the work of two artists, Marilyn Zwak and Carolyn Braaksma, to evoke their sense of place dramatically in the concrete highway walls. Zwak's molded adobe forms recall designs of the valley's early Native American settlers, the Hohokam (see pp. 34–41). In Braaksma's *The Path Most Traveled*, imagery taken from local flora and fauna is visible from the highway, thus celebrating the art marketing strategy of this small resort city as well as embracing the area's environmental heritage. Scottsdale's project utilized walls that would have otherwise been budgeted for standard "beautification," diverting these funds toward a public placemaking endeavor, and thus reducing the total cost of the project (see pp. 42–47). This initiative on new freeways could be replicated with the retrofitting of the many concrete channels that slice through American cityscapes, and points to the potential for highly visible graphic solutions defining place. Many highways undergo systematic maintenance and expansion, and opportunities for such programs arise regularly within routine construction.

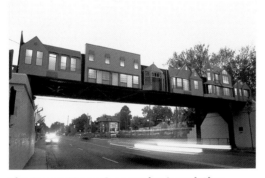

The Cooper Young Community Association, Memphis, Tennessee
In 2000, the association commissioned local artist Jill Turman to create a gateway for the neighborhood on the sides of a railroad tressle, based on nearby buildings.
Photo: Steve Davis.

Pedestrian bridge, Phoenix
The 1998 Mountain Pass pedestrian bridge, made from galvanized chain link, draws on the mountain vista to the south, approximating the distant peaks with the bridge's profile. Artist Laurie Lundquist utilized construction funds from the Arizona DOT and the City of Phoenix Street Department Capital Improvement Program, as well as Percent for Art.
Photo: Craig Smith.

As described on pp. 48–53, Radnor Township, in a Main Line suburb of Philadelphia, sought an iterative design strategy to reimagine the megalithic landscape from the memories of the original Welsh settlers who founded this town in the seventeenth century. Five miles of cairns, stone rings, and megalithic monuments culminate in a giant cairn and a 90 × 100-ft Welsh griffin at the intersection of the new Interstate 476 and the old Lancaster Pike, Route 30.

These images are discussed in case studies and shorter descriptive paragraphs in the "Gateways" and "Transit" sections of this book, and become a basis for introducing our broader proposal for urban-design plans that strengthen and affirm the sense of arrival. They demonstrate a major design opportunity for the twenty-first century, as Americans seek to consolidate their images of place, and to strengthen and interpret place meaning.

IX.

Interpretation as animation strategy

Clock, Radnor, Pennsylvania
This electrically animated American glockenspiel, conceived by the author, designed by artist William P. Reimann, and constructed by Dennis Sparling, is sited at the key intersection in Radnor where increased patronage in the adjacent bank building, now renovated as a second-story restaurant, can watch its movements. The Conestoga Wagon, electric trolley, Liberty Bell train, and steam locomotive, all of historical importance in Radnor, rotate past the milestones on each quarter hour, while the griffin and lion—township symbols—pop out of the tree under the clock face on the hour. Constructed from mixed metal, the clock stands 18 ft high.
Photo: Sergio Rojstaczer.

Mythology * Texas * Reality, Austin, Texas
Jill Bedgood's 1999 installation in the Austin-Bergstrom International Airport pays homage to the mystique of Texas life and history. Etched into the mirrors above the restroom sinks, "big hair" and "big hats" invite the viewer to "try on" Texas mythology. City of Austin, Art in Public Places Program, Permanent Artwork Collection
Photo: Melissa Tapper Goldman.

Name That Architecture, Cedar Rapids, Iowa
In 1991, the Cedar Rapids Downtown District's Art in Public Places Committee (formerly the Renaissance Group) commissioned six artists to produce groups of bronze blocks to be embedded in the sidewalk. The blocks of Iowa graphic artist Terry Rathje's *Name That Architecture* illustrate points of historic architectural interest around town, such as gargoyles on the 16th Street Bridge, Corinthian capitals at Guaranty Bank, and stained glass at St. Paul's Church. The blocks combine orientation with an active animation of the city, calling on viewers to explore surrounding sites and create a mental network of place associations.
Photo: Melissa Tapper Goldman.

Marker, Boston
Lilli Ann Killen Rosenberg and Marvin Rosenberg's animating marker of hopscotch reminds us that the old Boston Latin School, the first public school in America, once stood next to this site.
Photo: Lilli Ann Killen Rosenberg and Marvin Rosenberg.

X.

Beyond the bronze plaque: the presentation of interpretation

With new interest in interpretive markers, and new ways of transmitting information, it has become important for designers and planners of interpretive elements to exercise good judgment in order to avoid physically overwhelming a place. It is somewhat ironic if a historic marker further erodes the character of the place it describes.

The giant tomblike markers that loom in a small traffic island triangle in Cambridge, Massachusetts, between Harvard Square and the Cambridge Common, represent this type of interpretive overkill. The site where George Washington took command of the Continental Army has become a giant textbook, with huge pages interrupting the pedestrian's vision. At re-enactment events, it is impossible to feel a connection to a previous time period precisely because the concrete slabs that ostensibly exist to recall past times intrude upon our reveries. While they offer dense paragraphs of text that acknowledge the complex forces affecting a specific place, their 5-ft projections demean the character of this famous common. One yearns for a sense of subtlety in such a historic place, but not the earlier minimalism of markers that denote events with simple blue plates citing a few pithy facts, modeled on the London system that originated in the 1860s! On the other hand, some monuments use nothing but their form to express information clearly about their location. Sculpted milk bottles in Bern and corn cobs in Dublin, Ohio, evoke the activities that formerly characterized these places.

Cornfield, Dublin, Ohio
A "cornfield" in Dublin re-creates the real cornfield that once grew on the site, now surrounded by development. Without using textbook-like narrative, the artwork is immediately intelligible.

Milk bottles, Bern, Switzerland
These monuments use nothing but their form to express intelligible information about their locations, achieving more than either of the two graphically dull Cambridge markers pictured overleaf. Guerrilla artists installed them on Milchstrasse (Milk Street) without municipal permission, to commemorate the site's history as the point where milk canisters were transferred from the trains to milk wagons for distribution.

Traffic-island marker, Cambridge, Massachusetts
An example of the more recent historical markers in Cambridge, describing William Dawes's ride during the Revolutionary war. Their massive size represents marker overkill.

Blue marker, Cambridge, Massachusetts
Recent attempts to interpret the city's sites have abandoned these traditional blue markers, which cite pithy and uncontroversial facts and, in their discretion, add little to them.

Plaque, Loveland, Colorado
Colorful sculptured tiles surround this bronze plaque inside the Loveland Museum.
Photo: Suzanne Janssen, Loveland Museum.

Independence National Historic Park, Philadelphia
The National Parks Service visitor center at the Independence National Historic Park was built in 1976 in a Brutalist style.

The visitor center for the Independence National Historic Park in Philadelphia (designed by Cambridge Seven Associates) is an example of how a building conceived to interpret a site in fact intrudes upon it. To construct the center, and to clear the adjacent parkland that connects it to eighteenth-century buildings, the National Parks Service demolished historically important nineteenth-century architecture, including nearby structures designed by the city's most famous nineteenth-century architect, Frank Furness. These buildings were replaced with the current boxy brick structure, so clearly a product of the 1960s or 1970s, and sited directly opposite the Greek Revival Second National Bank building of 1859.

In each of these cases, the designers of the interpretive elements were single-purpose thinkers, concerned only with the content that they wished to publicize. To avoid this, it is important that interpretive elements be clearly presented, so that the physical character of the marker or interpretive center expresses as much about the place as the content of the picture or text. New interpretive markers tend to take a humanistic approach, not only in their politics but also in their presentation. Their appearance is inviting, and their meanings are accessible to all observers. This is possible in part thanks to new technological techniques, as can be seen in the examples opposite.

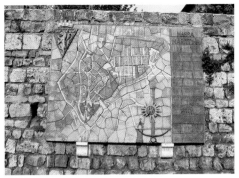

Entry sign, Porto Stefano, Italy
This map in Porto Stefano, a resort community on the Monte Argentario coast, north of Rome, demonstrates how an artisan tradition in ceramics has enriched the interpretation of a place.

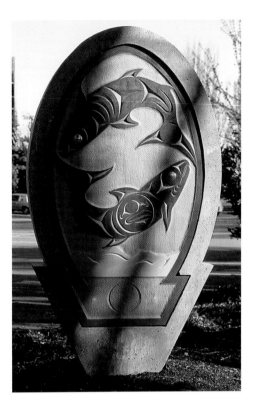

La Roche-Bernard, France
Lucite and metal give translucence and drama to markers in the fortified town of La Roche-Bernard on Brittany's coast. This is one of a series of markers that depicts the events that have shaped the history of the little town, and shows a sophistication of design sensibility that many larger communities could envy.

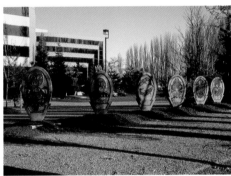

Native American mythology, Seattle
This concrete and red cedar plank is one of six storyboards designed by Susan Point that narrate the story of the Northwind Fishing Weir, a Native American regeneration myth set on the nearby Duwamish River. The plank shows the weir made of ice that Northwind erected after defeating Southwind, when he made the land extremely cold. The weir prevented the salmon from running upstream to spawn, and thereby starved the people living higher up. The plank shows one female and one male salmon.
Photos: Joe Manfredini.

Marker, Chapel Hill, North Carolina
A building marker marks the site of a former watchmaker's shop. It is part of a series encouraging respect for nineteenth-century buildings that could be replaced by modern structures, such as parking garages.

Industry panel, Ontario International Airport, California
Using the graphic designs of orange-crate labels, the new Ontario airport tells the story of the citrus industry in the Pomona Valley.

House marker, Santa Barbara, California
An artisan-style ceramic plaque commemorates an old adobe house that is now a busy shopping arcade in downtown Santa Barbara.
Photo: Douglas Campbell.

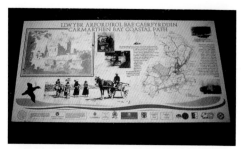

Town marker, Laugharne, Wales
A marker near the home of Dylan Thomas is written in both Welsh and English. It uses a complex juxtaposition of old photographs, maps, and symbols to depict the life of a small town in Wales.

Angels Flight, **Los Angeles**
This marker was installed when John H. Welborne restored the Angels Flight cog railway on Bunker Hill, the original high-rent district of Los Angeles, which was scraped clean in a 1950s urban renewal program and replaced much later with high-rise office towers. The signpost provides information about the railway using innovative graphic design methods.

aterloo, New York
ows the history of the Erie Canal.
exhibit, it can be more elaborate,
re information. Its elegant
akes it easy to understand.

raphically complicated images that
n exterior marker on a wall adjacent
n to describe the evolution of a street
ty architecture evolved as the street
arker on the Erie Canal in Waterloo
ges, as well as the drama of artifacts.

t build "institutional memory" of
art of an interpretation strategy. By
e the layperson a greater perspective
nse. Ideally, some cities will recognize
d be the best place for a civic design
gested that the City of Boston "require
tography of the structure or structures
well as the architect's drawing of the
rstand how the Design Commission
same concept, extending the sugges-
gned by artists not only to encourage
al memory. Over time, interpretation
rs alike, helping us all to recall and
l position, and challenging us to react

f Environmental Design, *Issue 1601,*
lissa Tapper Goldman.

The Power of
Landscapes as
y, Cambridge,
ress, 1996.

ons, coordinator,
airs Division, Danta
rview, August 25,

Hayden, "An
ense of Place,"
ues in Public
Art: Content Context and

Fleming, *Façade Stories:* between public art and public

Controversy, ed. Harriet F.
Senie and Sally Webster,
Washington, D.C.: Smithsonian
Institution Press, 1992, p. 268.

7 Ronald Lee Fleming, "Public
Also Has a Rôle to Play in
City Projects," *Boston Globe,*
October 4, 1993.

Japanese American Internment Memorial

Project description

Bronze plaques outside San Jose's Robert F. Peckham Federal Building and Courthouse commemorate the stories of Japanese Americans both nationwide and within the community, during their World War II internment.

Artist

Ruth Asawa

Agency

San Jose Public Art Program, initiated by the Commission on the Internment of Local Japanese Americans

Date

1994

Dimensions

5 × 14 ft

Materials

Bronze bas-relief set on granite stairs

Cost

$212,000 ($170,000 from the city transit mall art fund and $42,000 raised by the local Japanese American community)

FROM 1942 TO 1945, over 110,000 Japanese and Japanese Americans were forcibly detained in camps around the American West. For almost fifty years, there was no commemoration of this critical period in the Californian city of San Jose, home to an active Japanese American community, and one of only three Japantowns in the United States. The city was also home to the former War Relocation Authority for the region, which organized the internment of the large local Japanese community. In 1994, San Jose's public-art program unveiled its attempt to mark this tragic chapter in the region's history, installing Ruth Asawa's Japanese American Internment Memorial in the plaza of the downtown Federal building.

The internment of Japanese Americans in camps within the United States, a despicable and incomprehensible occurrence, had been fading fast in the memories of Americans. To combat this growing amnesia and to honor the experiences of local Japanese Americans, the San Jose Commission on the Internment of Local Japanese Americans proposed a memorial, which the city's public-art program would commission. To tackle such a profound and sensitive subject, the public-art program determined that the selected artist should have a deep understanding of the event through personal experience as an intern in the camps. Eventually, without sending out a call to artists, the commission found artist Ruth Asawa in nearby San Francisco.

Asawa had used her time during this potentially alienating and embittering experience to delve into her love of art. One of seven children raised by *Issei* (first-generation Japanese) farmers in Southern California, she developed a strong work ethic early in life while laboring long days on the farm alongside her brothers and sisters. After the bombing of Pearl Harbor, Asawa and her family were separated and forced into two different internment camps, where they remained apart until 1946. Asawa was sent to the camp at Santa Anita Racetrack. Among those interned at Santa Anita were three Walt Disney studio artists who kept the uprooted children occupied with art lessons. Asawa, who had always dreamed of being an artist, drew five hours a day, and sometimes into the night.

After her internment, she received a scholarship to North Carolina's Black Mountain College, where she studied with Buckminster Fuller and Josef Albers as a part of the school's avant-garde art program. Asawa began her long and accomplished career with exhibits of her works in the 1950s at the Whitney Sculpture Annual and the Museum of Modern Art, New York.

The City transit-mall art fund provided $170,000, and the local Japanese American community raised an additional $42,000 in support of this budget. The City of San Jose Public Art Program brought in Asawa and oversaw the design and installation process. The General Services Administration, which manages the Robert F. Peckham Federal Building and Courthouse, now owns this piece.

Description Asawa saw the commission as a chance not only to commemorate, but also to inform, commenting: "It is important that the narrative form be direct and simple so that any viewer, whether child or adult, Japanese American or other American, can understand why this is a memorial with a minimum of explanation."[1] To accomplish this, she chose a narrative depiction of the events in bronze bas-relief, starting with the immigration and pre-war lives of *Issei*, and ending with a summary of the 1988 redress. To prepare for the piece's execution, she did extensive research on the events so that it would not be based solely on her personal experience. To achieve more active visual integration of other internees, she culled personal stories and *mon* (Japanese family crests) from families in the Santa Clara Valley for use in this monument. Asawa led the creative process, assisted by members of her family and artist friends.[2]

The four narrative panels cover the surface of a free-standing rectangular slab measuring 5 × 14 ft, positioned in front of the Federal building and courthouse at 280 South 1st Street. To view the piece in its entirety, the viewer must walk around it, taking the time truly to visit the monument. The siting supports this approach. Although it does

Ruth Asawa's Japanese American Internment Memorial stands in the federal plaza in San Jose. Photo: Dana L. Grover.

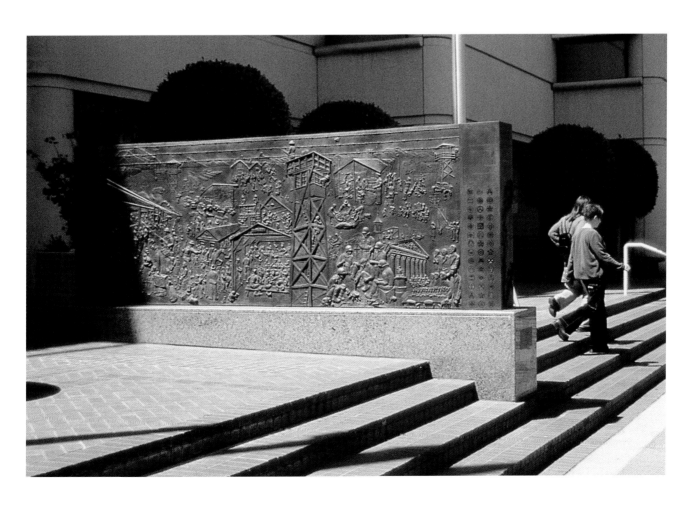

not impede pedestrian traffic on the plaza, the monument is conspicuous and appealing to the visitor looking for a visual diversion.

The first panel depicts images of the *Issei*'s arrival in the United States, including their first steps out of the immigration office, their struggles as laborers, and finally their success in building a Japanese American community complete with a Buddhist temple. The following panel shows the forced evacuation of all Japanese Americans following Franklin D. Roosevelt's Executive Order 9066 in February 1942. Asawa used memories of her father being taken away from his crops by the FBI as inspiration for the first image, which is followed by Japanese families burning any items that might have connected them with Japan. We see the once-vibrant and

RIGHT A man considers the Japanese American monument. Photo: courtesy of the San Jose Public Art Program.

BELOW, RIGHT Detail of the Japanese American monument and the *mon* (family crest). Photo: courtesy of the San Jose Public Art Program.

BELOW, FAR RIGHT Detail of a panel depicting life in the internment camps. Photo: courtesy of the San Jose Public Art Program.

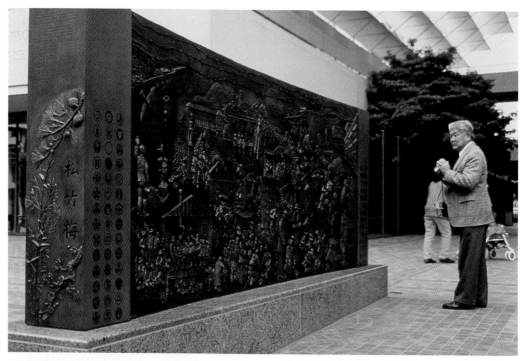

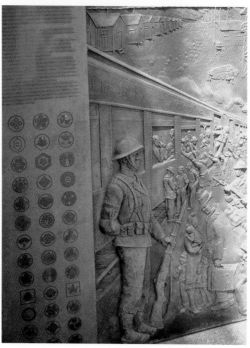

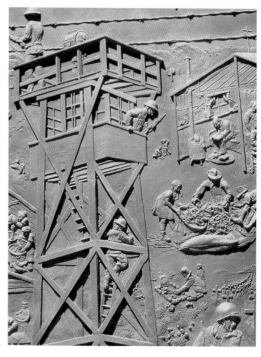

prosperous Japantown deserted, as its residents evacuate to internment camps. A copy of Executive Order 9066 completes the series. The third panel, smaller in size, is textual and informational, presenting a copy of the relocation instructions, a map of the locations of internment camps, and each camp's population.

Before continuing with images, Asawa included a summary entitled "Hysteria of War," which explains the rationale for, and methods of, this drastic alienation and persecution. This weighty statement is followed by images of Japanese Americans boarding the train to the temporary camp at the Santa Anita Racetrack, - where they were held in horse stalls until the permanent camps were completed. Asawa, who was interned at Santa Anita, portrays everyday scenes of camp life as well as those of Japanese Americans outside the camps. A pictorial representation of their struggle against the unjust internment by Japanese American leaders completes the images, and the panel itself finishes with a written summary entitled "Camp Life and Post War."

The final side panel includes a summary of the redress, in which President Reagan issued a formal apology and $20,000 to each surviving interned person in 1988, and depicts three plants that are symbolically significant in Japanese culture: *Matsu* (Japanese pine), meaning endurance, *Take* (bamboo), symbolizing strength, and *Sakura* (cherry blossoms), promising friendship.

Design impact Today San Jose has a thriving Japanese American community that celebrates its heritage and culture, and remains connected to Japan through a sister-city program with Okayama. When the City of San Jose Public Art Program decided to proceed with the commissioning of the internment memorial, it carefully considered the memorial's location, eventually choosing the east plaza of the Robert F. Peckham Federal Building, ironically only half a block away from the site of the original War Relocation Authority Building for Washington, California, and Arizona.

The memorial location supports the purpose of educating the public because of its centrality and accessibility. Since the memorial narrates an event in danger of being forgotten by the non-Japanese American population, it was important to place it outside the context of Japantown. Before the piece was executed, Jerry Hiura, chairman of the Fine Arts Commission, prophesied: "Asawa's piece is going to educate the general public and will be a nice, safe, non-political vehicle to understand an aspect of Japanese American history and provide meaning to those who experienced the camps."[3] In eleven years, it has done just that. The public continues to visit the memorial as part of the San Jose Museum of Art's guided tours of the city, and visitors from outside the area are always encouraged to visit it by the volunteers at the San Jose Museum of Japanese American History. It is also an important stop for students. Almost all the nearby educational centers have Asian study programs in which students research the Japanese American internment.

The public shows not only a great interest in this piece, but also a great respect for it. It has never been vandalized, and is not used disrespectfully. This is likely to be a reflection of how inviting it is. As Asawa's eldest daughter, Aiko Cuneo, puts it, "what's important to understand about my mother's work is that she's always tried to bring art to a human scale. She doesn't think art should be an intellectual exercise. It should be approachable. I think that's why people like it so much."[4] Indeed, and that is also why they accept it as a positive part of their environment.

With news of a possible relocation of federal facilities in San Jose, measures are being taken to preserve this piece's visibility. Although a site has yet to be specified, it is just another indicator that the work, even after over a decade of visibility, still remains significant to the San Jose community.

1 "Asawa to Design Internment Memorial in San Jose," *North American Daily*, artworks-foundry.com/clientshowcase/artists/asawa, October 6, 1992.

2 See Ruth Asawa, "Making the Japanese American Internment Memorial," ruthasawa.com/Pages/AsawaatWorkMatierePages/AsawaatWorkProcess Internment.htm, n.d.

3 "Asawa to Design Internment Memorial in San Jose," 1992.

4 Chiori Santiago, "Ruth Asawa: The Armature of Family," *The Museum of California Magazine*, chiorisan.com/other1.html, 2002.

The Character of Street Furniture

244 An armature for placemaking

252 Street furniture: a compendium
of projects

274 Pavilion at East Boston Piers Park
Artist: William P. Reimann

280 Mercer Island Streetscape
Artist: T. Ellen Sollod

An armature
for placemaking

WE LIVE IN AN AGE OF CATALOGUES. No wonder, then, that generic street furniture arrives in large numbers in our public spaces and along the street corridors of our communities. Artist- or artisan-designed street furniture may seem old-fashioned; certainly, some of the richest examples of furniture craft in cities date from the nineteenth rather than the twentieth century. But street furniture continues to be an important armature of placemaking today. Although recent place-specific street furniture sometimes replicates nineteenth-century styles, much of it uses radically new techniques. However, cutting-edge technology has long been linked with street furniture. Eleven years after the first electric streetlights were installed in Cleveland's Public Square, architect John Wellborn Root included a dramatic arboreal streetlight in his design of the Society National Bank in the square. His lamppost includes a leafy pattern that seems to take possession of its street corner, spreading like ivy over the adjacent building. Today, much street furniture incorporates new technology into the craftsmanship itself, with laser-cutting and photography. The montage of street furniture elements in this chapter gives a quick visual overview of the ways in which artist-designed furniture has recently succeeded in communicating information about locale. Good street furniture may not "make" a place, but it can certainly add meaning, as well as a richer image of continuity.

As public-art programs across the country mature, they often move away from large stand-alone works by big-name artists, and are increasingly funding more modest projects, including artist-designed street furniture. New large-scale projects often involve an artist in plans to redesign sections of cities comprehensively. Once again street furniture can be an important part of these streetscape redesign and enhancement projects. This new wave of artist-designed street furniture is in part a reaction to the mass-produced faux-Victorian street furniture purchased in the 1970s, 1980s, and 1990s as part of main-street revitalization projects. Some of these projects are recognized to be already out of style, as this main-street aesthetic is, rather ironically, already dated.

Some of the best examples of place-related street furniture tell specific stories about their sites, reiterating or reinforcing information that was already known about the place. This is true, for

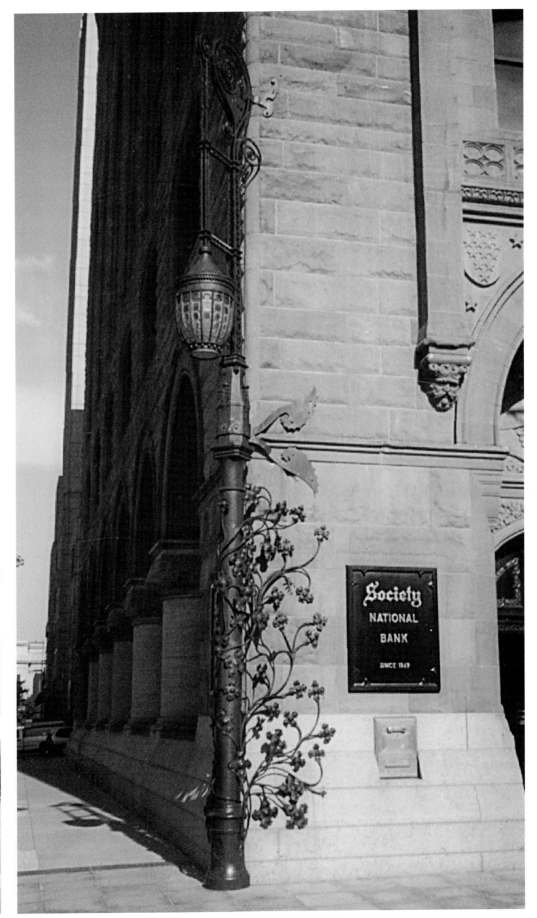

RIGHT John Wellborn Root designed this iron lamppost at the corner of the Society National Bank in Cleveland in 1890.

BELOW These two pictures show new street fixtures on Berlin's grand avenue, Unter den Linden, which hark back to the nine-teenth-century design that stood here before World War II. The cast-iron linden leaves on the pole refer to the lime trees lining the street. The original avenue was destroyed during the battle for Berlin in 1945, and new trees were planted in the 1950s.

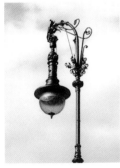

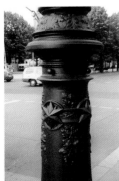

example, of the Boat Bench constructed by Carl Lind for Elizabeth Conner's *Waterway 15* project on Lake Union in Seattle. It recalls the boat-building traditions of this waterfront. Other street furniture merely supports the use or identity of the space that frames it. The bench at the Creston Nelson Substation in Seattle celebrates the function of an electric power station. The bicycle rack in Oxford, Ohio, is adjacent to a bicycle store. Although the design of these two examples is imaginative, they could be located at any power station, or any bicycle shop, without losing their meaning. They help to make the place memorable, but their meanings only connect to the function of the building they support. Bill Woodrow's bench entitled *Sitting on History* is another example of street furniture that responds to the generic characteristics of its locale. Woodrow created this bench independently of the several libraries where his limited edition of the bronze bench now resides.

Although we prefer the specificity of interpreting a particular locale, we also celebrate the wit of these examples, which simply makes sites more memorable. In the visual exploration of street furniture at the end of this chapter, the aim was to find street furniture that reveals or recovers the history of particular places. Also included, however, are some vivid examples of a more generic style, as well as artist-designed elements that add to the memorability of places because of the quality of their craft, even if they avoid a direct reference to time and place. Craft in street furniture can be seen as a final defense against the generic.

The production of nineteenth-century lighting witnessed several generations of street furniture embedded with symbols of place. The streetlights in Seattle, for example, bear a stamp of Chief Seattle; these bronze medallions are so treasured that many have been pried off by curiosity-seekers. The bases of lighting fixtures in the nineteenth and early twentieth centuries often had castings of flora and fauna from a particular locale. Cast-iron manhole covers revealed designs that were often site-specific; benches would frequently have the name of the city or town framed in a cartouche at the top, on a side support, or by the bench feet. So it is ironic that the street furniture of many main-street revitalization projects of the 1970s and 1980s has a sameness to it; it all comes from catalogues of so-called "Victorian" models.

Street furniture thus became part of a vocabulary of design elements that *extended* the concept of place. Sometimes a piece of street furniture was so strongly associated with a city that it turned into a symbol, like the dragons perching on the drinking fountains on Basle's street corners (see opposite). The dragons recall a sculpture of St. George slaying the dragon on the façade of the cathedral. The four distinctive spouted drinking fountains of Portland, Oregon, were the munificent gift of a late nineteenth-century Prohibitionist who sought to protect the citizens from the evils of strong drink. Although they lack the symbolic sculpture of Basle's fountains, they are still specific to Portland. Such features are generic in the sense that they are simply elegant designs that could have been made for another city, but their individualized design now memorably connects them in our minds to a particular locale. The intricate bishop's crook lights off 14th Street in New York are among the few survivors in this district of a light that was once a signature of the streetscape. Most were vanquished by cobra-head sodium vapor lights in the 1950s, but a stripped-down version of the bishop's crook, retaining the handsome profile but

BELOW *Boat Bench* displays the techniques used to make the wooden boats that once plied Lake Union. It was sponsored by the Municipality of Metropolitan Seattle, designed by Elizabeth Conner and Dick Wagner, and built by Carl Lind. Photo: Elizabeth Conner.

BELOW, CENTER A series of collaborative public artworks, including this bench by Ries Niemi, form a cordon around the Creston Nelson Substation in Seattle. The works refer only to the generic identity of the place as a power station. Photo: courtesy of Seattle Public Art.

BELOW, RIGHT This witty bicycle rack is located outside a bicycle shop in the main square of Oxford, Ohio.

RIGHT Bill Woodrow's self-commissioned bench, *Sitting on History*, 1998. This one, installed in the foyer of the British Library in London, is the fourth of twelve bronze castings. Photo: courtesy of the artist.

FAR RIGHT This skateboard guard in Riverside, California, serves a practical purpose, while the bell representing the city's historic Mission Inn employs the local graphic identity. Photo: Severine von Tscharner Fleming.

RIGHT A bronze medallion depicting Chief Seattle decorates the base of a streetlight in Seattle.

FAR RIGHT The side of this Milan fountain bears the city's seal.

BELOW, RIGHT Here we see one of the few surviving "bishop's crook" lights off 14th Street in New York.

BELOW, FAR RIGHT In this fountain in Basle, Switzerland, a dragon holds a small oval shield displaying a bishop's crook, another symbol for the city, which was once governed by a bishop.

not the ornamentation, now rises again on 14th Street near Union Square, as part of a street renovation project.

The advent of Modernism, with its design legacy of stripping off decorative motifs and focusing on the clean-limbed and functional, meant that tubular benches, and simple grids and grilles of pressed metal replaced much of this earlier and more elegant street furniture. Sometimes these new elements were sleek and startling in their simplicity, but more often they were merely brutal no-nonsense items that the eye will not linger on, nor the heart cherish. Their very simplicity supported the development of catalogues. The evidence of the past fifty years reveals that architects and planners have relied excessively on these catalogues! Also, even the most well-recognized designers often make no connection between their own work and these simple store-bought items that furnish the public spaces that their buildings shape.

Why is this condition the norm today? It is partly because artists and craftspeople do not work in the same studios as architects, as they did in the Beaux-Arts period, and so there is not the same level of interaction. This failure to collaborate results in a lack of mutual support between artists, craftspeople, and the architectural and landscape professions. Just as American cities and towns have been made less interesting by zoning that separates functions, so the different design disciplines have been divided from each other at the expense of the visual complexity of places. Architects may feel awkward about suggesting ideas for street furniture to a landscape designer working on his own "turf." This landscape designer may, in fact, never have been asked to shape a bench in design school (and probably not a bench that related to an adjacent building). Importantly, this disjuncture makes it difficult for the team of professionals to coordinate and assess or even understand the behavioral functions of the space, the singular sum of all their efforts.

Indeed, I have lectured at professional schools, and it seems to me that little or no attention is paid to contextual design in most architectural and planning programs. This is influenced in part by the nature of the award systems in national design magazines, which champion "originality," claiming dramatic front-page illustrations with radical new designs. There appear to be limited efforts to blend in or embellish an existing investment in design, such as a traditional streetscape or public plaza. The notion that community design is a collection of related parts that support and enrich each other is an idea that is more often associated disdainfully with the picturesque. We look at traditional building in European cities and towns as a repository for this approach, but do not often connect it to the American tradition. The concept of "townscape," where the effect of the buildings in a streetscape is more than the sum of the parts, has been neglected. With this neglect for the character of the whole comes a decline in the energy for crafting the particular.

The re-emergence of more elaborate, eccentric, and sometimes place-focused street-furniture design is often a result of the growth of public-art ordinances rather than the initiative of architects or landscape architects. As the public-art commissioning process becomes more sophisticated, artists and artisans are involved in collaborative designs that affect entire environments. The result is that there are now more examples of eccentric street furniture as well as occasionally more integration of street-furniture elements, despite the failure to nurture this behavior in design schools.

Public-art planning, especially the integrated design of some recent transportation facilities, now involves something more than the simple *coordination* of disparate elements that characterized much of the earlier public art of the 1970s and 1980s. However, the 1980s street furniture around the publicly owned power substations in Seattle is an innovative example that points the way with its careful integration of ideas about power transmission and the history of the power utility.[1] Alas,

RIGHT Built in Baltimore in the 1970s, this Modernist fountain's only relationship to its location is one of aggression.

FAR RIGHT AND BELOW, CENTER The two head houses across the street from each other at Boston's Copley Square subway stop illustrate the discrepancy between architecture and street furniture today. The old head house from 1915 (far right), adjacent to McKim, Mead & White's public library, boasts elaborate iron grillework that connects to the elegant wrought-iron lighting along the sides of the palazzo-style library. The 1970s head houses adjacent to the equally intricate New Old South Church (1874) across the street (right) are stripped to a minimal geometry of angular forms and super graphics that clearly date them and pay no respect to the church's exterior.

BELOW, RIGHT The bicycle rack at the entryway of Michael Graves's Post-modern Mission Revival library in historic San Juan Capistrano, California, does not serve as an adequate prelude to the carefully designed Graves furniture inside the building. Tables and lampstands echo the "Mission Moderne" of his architectural design and reinforce his comprehensive approach, but outside, the street furniture is an obvious afterthought pulled from a catalogue. Photo: courtesy of Lady Fiona Baker.

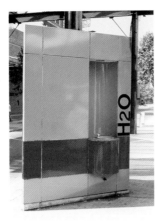

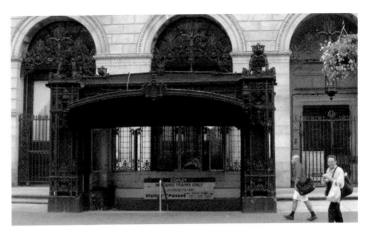

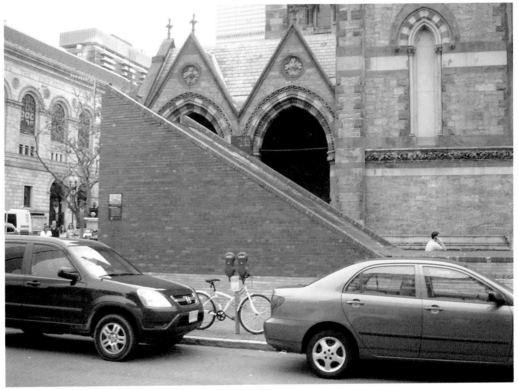

more often than not, some elements of the new street furniture are still treated in the same way as the isolated objects of public art that were typical of earlier projects, when public plazas received "plop art" commissions.

The metal palm bench in a park on the Miami Bay waterfront, and the ceramic bench in the Post Oak corridor in Houston, radiate eccentricity. Although they are both admirable as objects, the Miami bench does not support the character of the streetscape or the plaza as does *Post Oak Divan*. The Post Oak bench is itself a map of the area as it appeared a century ago. A schoolhouse and farming areas are depicted in their original locations, and there is a star that says "Here We Are" to indicate the bench's site.

Of course, the most classic demonstration of street furniture as an armature for place transcends the interpretation of a locale through the furniture. Instead, the furniture directly supports the presence of the architecture, and extends its meaning. The stone benches in Orvieto, Italy, across the piazza from the cathedral, reinforce the architecture by repeating the stripes of black and white marble that start on the cathedral façade and continue across the piazza pavement. Hugging the walls of the buildings surrounding the piazza, they provide a frame for the space.

The restoration of the tiled Mission-style benches in the newly renovated plaza of the old San Diego train station offers a contemporary solution. This furniture picks up the patterns in the station and the Native American cross of the Santa Fe Railroad's logo. The new space defers to the place, and is directly inspired in its contextualism by the 1930s rail station. As such, its creation is a rare act of architectural ego subjugation. To undertake such work today, when there is no restoration involved, often evokes the scorned word "pastiche" from many contemporary design practitioners. Indeed, some designers would probably feel awkward doing something that so deliberately responds to the character of the place. This is a sad commentary on their training, which places an emphasis on innovation that pays homage to the *architectural* world rather than to the feeling of the locale.

The approach to this modest arena of street furniture in the past several decades, when banality is the norm, demonstrates the need for a new ethic at the spot where the pavement meets the shoe. We need a civic ideal that respects existing investments in design and comprehends the band of memories embedded in place. Street furniture offers dynamic possibilities for realizing these investments. It can sustain narrative as it connects a number of elements that cumulatively build content. By enriching the number of coordinated elements that engage the eye with richness and complexity, it can also strengthen the design vitality of a place. Most contemporary designers have yet fully to understand this capacity and to seize the possibilities for transformation, utilizing a modest investment as a catalyst to encourage better comprehension of the power of place.

A shorter version of this text appeared in Landscape Architecture, *July 2004, with the collaboration of Jeannie Miller and editorial assistance from Melissa Tapper Goldman.*

1 An extensive discussion of one such Seattle substation (the Viewlands/Hoffman Substation) can be found in Ronald Lee Fleming and Renata von Tscharner, *Place Makers: Creating Public Art That Tells You Where You Are*, San Diego: Harcourt, Brace, Jovanovich, 1987.

BELOW Jeanne Liman's bench, entitled *Post Oak Divan*, is part of a corridor enhancement plan for Houston's Post Oak Boulevard. For the project, Liman embedded ceramic tiles into a cement base.

BOTTOM New benches at the Santa Fe railroad station in San Diego by Douglas Campbell of Campbell and Campbell Landscape Architects, Santa Monica, California. Photo: Douglas and Regula Campbell.

TOP RIGHT Old benches across the piazza from the cathedral in Orvieto, Italy

BOTTOM RIGHT Artist Kim Brandell's amusing and contextual bench stands as an isolated object in Miami's Coconut Grove. Photo: courtesy of the artist.

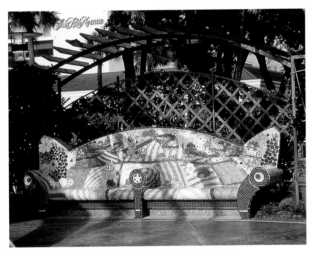

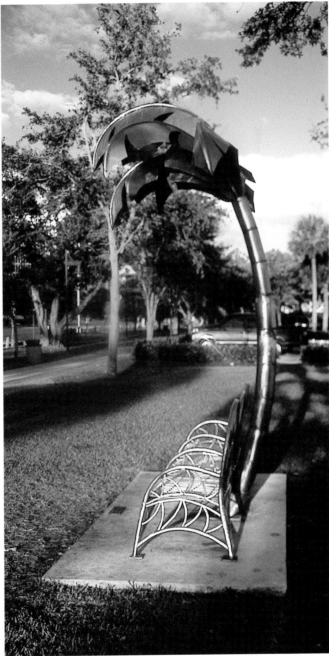

Street furniture:
a compendium of projects

Map Structure

Location: Never installed on site; currently, two benches are on display at the De Cordova Museum in Massachusetts, while the other two have been exhibited at Massachusetts College of Art since October 2002.

Artist: Leila Daw

Agency: Massachusetts Turnpike Authority (MTA)

Date: 1998

Dimensions: 4 ft high, 8 ft long, 6 ft wide

Materials: Urethane on powder-coated perforated steel

Cost: $28,000

Photography: Leila Daw

The MTA commissioned Leila Daw to create four different benches for four sites along the Massachusetts Turnpike. She made large, partially unfolded road maps like those that motorists often examine at rest stops, two of which depicted the areas where they were slated to be installed. The one shown on the left is a map of Massachusetts with the turnpike running along the ridge, and the one on the right is a map of the New England states, including the turnpike. The MTA refused to install them, so they are now located at the De Cordova Museum and the Massachusetts College of Art, far from the sites that inspired them.

History Bench

Location: First Ward, Charlotte, North Carolina

Artist: Jim Gallucci

Date: 2000

Dimensions: 10 ft long

Material: Steel

Cost: $5000

Photography: Jim Gallucci

The cutouts in this 10-ft bus-station bench depict four historic buildings in the area: the Afro-American Cultural Center, the First Presbyterian Church, a shotgun house of the kind that was once prevalent in this district, and a historic brick mansion that has since been converted into a business.

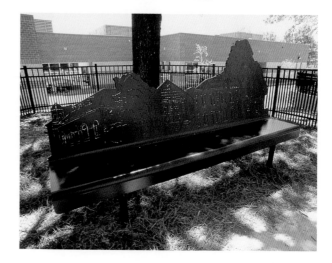

Waterworks Gardens

Location: East Division Water Treatment Plant, Renton, Washington

Artist: Lorna Jordan

Agency: The Municipality of Metropolitan Seattle

Date: 1996

Materials: Mosaic made from shards of recycled marble

Cost: The cost of the bench could not be separated from the cost of the entire 8-acre project, which was $1.63 million

Photography: Lorna Jordan

Lorna Jordan's *Waterworks Gardens*, a landscape that enhances a sewage treatment plant near Seattle, has many components. Its "spiritual core" is "The Grotto" (pictured), which includes a bench behind which water seeps out of the walls and trickles past seated visitors. The mosaics on the ground and bench show vines creeping up the bench. Jordan's goal for the larger project was to incorporate nature into a presentation of how the water treatment plant worked, thereby expressing the importance of such treatment plants for conservation.

The Basket Maker

Location: 2925 South 112th Street, at the Duwamish River, Tukwila, Washington

Artists: Caroline Orr and John Gierlich

Agency: King County Public Art Program

Date: 1997

Materials: Silicone bronze backs, red cedar seats, galvanized steel supports

Cost: $15,000 for three benches

Photography: Joe Manfredini

The design is inspired by the "Grandmother-on-the-Hill" part of the Northwind Fishing Weir story, a Native American regeneration myth. According to project coordinator Barbara Luecke, the story describes how "North Wind's grandmother was banished to a nearby hill, where she wove baskets that she filled with tears and poured on to the valley. The backs of these benches were cast from a basket woven by the grandmother of a Duwamish woman who was consulted on this project. The basket was then laser-cut into bronze."

Mesa

Location: North entrance to Woodland Park Zoo, at North 57th Street and Evanston Avenue North, Seattle

Artist: Ken Little

Agency: Seattle Office of Arts and Cultural Affairs

Date: 1991

Materials: Cast bronze

Cost: $50,000

Photography: Ken Little

The bench was created during Ken Little's one-month residency at the Woodland Park Zoo. Little chose the site and project himself, and it was approved by a jury. On the surface of the table are the names of extinct vertebrates overlaid by a map of the United States, and drawings of a grizzly bear and a white-tailed deer—two endangered species in the Northwest. Several "salt and pepper shakers" are cast in place in the center of the table, forming a miniature cityscape of downtown Seattle. Two attached bench seats chart the Earth's geological evolution.

Maple Leaf Bench

Location: Interstate 90 rest area, western Massachusetts

Artist: Ross Miller

Agency: Massachusetts Turnpike Authority (MTA)

Date: 1996

Dimensions: 32 in. high; seats 18 in. high

Materials: Douglas fir with powder-coated steel structural members

Cost: $12,000 for three maple-leaf benches. $8500 for five benches in the linden-leaf cluster

Photography: Ross Miller

Two of a series of eighteen benches built by Ross Miller at four different highway rest areas. The designs use the shapes of the leaves of native trees (linden, honey locust, and maple) that are planted next to the benches.

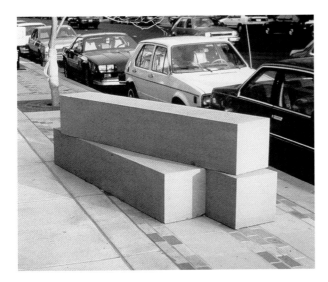

Inventory on Will-call

Location: West 6th Street, between Lakeside and St. Clair Avenues, in the "Warehouse District," downtown Cleveland

Artist: Buster Simpson

Agency: West 6th Streetscape Project with Cleveland Public Art

Date: 1988

Material: Sandstone

Cost: Funds came from savings on other projects by the same artist on West 6th Street

Photography: Cleveland Public Art

This is one of several benches that Buster Simpson designed to resemble the packing crates that could be found on West 6th Street in the late nineteenth and early twentieth centuries, when the neighborhood housed wholesale groceries, tool suppliers, and garment manufacturers. Simpson used sandstone, a traditional material in the area, for the benches.

Tree Chair

Location: 32 Clay Street, North Cambridge, Massachusetts

Artist: Mitch Ryerson

Date: 1999

Material: Tree stump

Cost: $2500

Photography: Mitch Ryerson

This is one of twelve chairs and benches that Mitch Ryerson, a local furniture craftsman, carved out of tree stumps over a six-year period. When a tree is damaged, the City has to cut it down, but it leaves 8 ft or so, which is enough for Ryerson. He makes it a habit to consult abutting property-owners, and has received much support from them over the years.

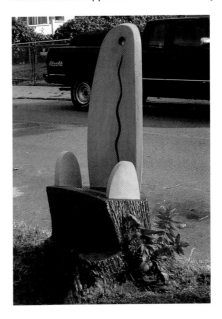

Fountainhead Rock

Location: Corner of Water and Don Gaspar Streets, Santa Fe, New Mexico

Artists: Tomas Lipps with George Gonzales and Michel Giannesini

Agency: City of Santa Fe, New Mexico

Date: 1988

Material: Stone

Cost: $54,000

This seating area, wall, and fountain structure mask the view of cars in an adjacent parking lot. Located in the historic center of Santa Fe, one block east of the Plaza, it was facilitated by Santa Fe's Percent for Art program.

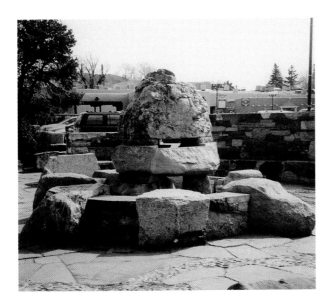

Market Place/Meeting Place: An Urban Memorial

Location: The Gateway, between Jacob's Field (baseball park) and Gund Arena, Cleveland

Artists: Angelica Pozo and Penny Rakoff

Agency: City of Cleveland

Date: 1990–94

Materials: Ceramic on a concrete base cast in sections

Cost: $80,000

Photography: Courtesy of Cleveland Public Art

This bench also forms the edge of a planter, and commemorates Central Market, which once stood on the site, now the gateway area for two large sports arenas. Large ceramic fruit and vegetables by Angelica Pozo line the bottom of the bench, while its 64-ft-long surface displays a mosaic by Penny Rakoff, including tiles and captioned photographs of the site's history and that of surrounding neighborhoods. At the four turning-point keystones, Rakoff placed such relics as fragments of glass and crockery that were uncovered during an archaeological excavation at the site.

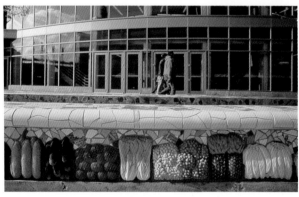

Another Place, Another Time

Location: Kent Historical Museum, Kent, Washington

Artist: Stuart Nakamura

Agency: City of Kent, Washington

Date: 1998

Materials: Concrete, granite, stone

Cost: $50,000, including $13,000 of polished and engraved granite, $3000 for metal engravings, $8000 of concrete contractual services, $2000 of stone paving, and ten months of work

Photography: Stuart Nakamura

The Kent Historical Museum is located in a late nineteenth- or early twentieth-century house once owned by a prominent Japanese American. The commissioner specified that the artwork should revolve around the experience of the *Nissei* (second-generation Japanese Americans), so Nakamura created a seating area with paving stones and markers displaying quotations gathered from *Nissei* in nearby areas. The picture on the left shows granite arcs with quotations and pictures of cabbages, lettuces, and peas—the vegetables that Japanese immigrants used to grow and sell at Pike Place Market in downtown Seattle. The quotation on the granite block comes from an interview with Koji Norikane, a *Nissei*: "They came as young immigrants before the turn of the century, helped clear the land and set their roots in the fertile soil. Through diligence and fortitude the *Nissei* were very successful in their endeavors in agriculture, and contributed much to the economy of the White River Valley."

Tiled Corner Bench

Location: Santa Barbara, California

Artist: Blair Looker

Agency: City of Santa Barbara

Date: 1992

Dimensions: 9 × 3½ ft

Materials: Handpainted porcelain tiles and commercially produced tiles

Cost: $10,000, including four additional walls of painted tiles

The benches depict the Coast Daylight and the Coast Starlight, the original steam-train routes that connected California from north to south.

The Forest is Waiting

Location: Delridge branch of Seattle Public Library, Seattle

Artist: Jean Whitesavage and Nick Lyle

Agency: Seattle Public Library

Date: 2002

Material: Forged steel

Cost: $3500

Photography: Jean Whitesavage and Nick Lyle

This architecturally integrated project at a branch of the Seattle Public Library also includes fur grilles and three sculptural buttons. The forged steel forms depict plants from a nearby creek.

Bellevue Light Base

Location: Central "pedestrian corridor" district of downtown Bellevue, Washington

Artist: Mark Hinshaw, city architect

Date: *c.* 1983

Cost: $20,000 for the original design concept; between $2000 and $3000 for each light fixture

Photography: Mark Hinshaw

This is one example of Seattle's practice of artistically designing street furniture and then making the molds available to developers. Besides its original use in downtown Bellevue, this light design has also been used in several public works projects, including a new transit center. Architect Mark Hinshaw says that the design reflects "the agricultural heritage of the community. This area used to be a group of farms where apples, strawberries, and hazel trees grew. (The city's plat map still reads "Cheritan Fruit Gardens," despite the fact that the grounds are now dominated by high-rise buildings.) A local newspaper initially made fun of the design, referring to 'fruits and nuts,' but the fixture is now recognized as a part of the downtown setting."

Lighting the Diamond District

Location: Diamond District, New York
(47th Street from 5th to 6th Avenues)

Artist: Howard Abel of Abel Bainnson Butz

Date: 1999

Materials: Acrylic and glass marbles

Cost: $250,000 for four lights

This is one of the four light fixtures that act as an entryway to New York's Diamond District. The diamond part of the light is made of two sheets of acrylic containing over five thousand glass marbles, which make the lights sparkle. At the same time as these gateway lights were installed, many other commercial lights appeared, making the area much more attractive at night.

Kent Gateways, Light Standards, and Memory Pins

Location: Regional Justice Center, 410 Fourth Avenue North, Kent, Washington

Artist: Sheila Klein

Agency: King County Public Art Program

Date: 1997

Cost: 4 gateway pieces: $25,000; 14 light standards: $35,000

Photography: Joe Manfredini

The top image is a gateway, and beneath that we see one of a series of light standards that line the driveway of the Regional Justice Center. Both baskets of the scales of justice contain a light that shines downward. The design on the lighting poles recalls heraldry used on official buildings, and it represents the water, mountains, and forests in Kent's river valley.

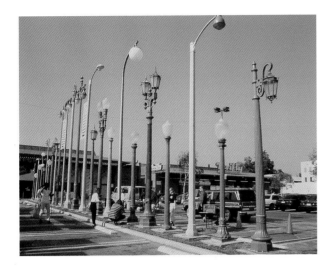

Corn Stock Streetlights

Location: Milpas Street Roundabout, Santa Barbara, California

Artist: David Shelton

Agency: City of Santa Barbara

Date: 2000

Cost: $186,000

Photography: Nell Campbell

When Santa Barbara built a new traffic roundabout on Milpas Street, David Shelton designed these corn-themed streetlights as the required public-art component of the project. Milpas is a Spanish word that means "place where maize grows," and it is appropriate to the site, as the Spanish-speaking community grew corn there in the 1850s and 1860s. Shelton included tassels in his designs, thereby basing them on a native, historic breed of corn rather than today's hybrid variety. He also designed purple decorations for the "stop" lights and a protective barrier for the walkway of a nearby overpass that showed corn in various stages of growth. The streetlights are tall enough to be seen from Route 101 as it traverses the

overpass, thereby identifying Milpas Street to the traffic. The Santa Barbara County Arts Commission sponsored the project, and when the lights were first installed, it organized a "corn festival" on site as publicity, at which it gave out corn-themed T-shirts.

Vermonica

Location: Vermont Avenue and Santa Monica Boulevard, Los Angeles

Artist: Sheila Klein

Date: 1993

Cost: Sheila Klein received $9000 to complete the project, although she says that it should have cost $20,000

Photography: Sheila Klein

Sheila Klein arranged twenty-two streetlights in the parking lot of an urban mall, creating an outdoor museum displaying the variety of street lighting used in Los Angeles over the past decades. The lights are arranged by height to create a candelabra effect. Klein chose a site where the storefronts had been burned in the city's riots the previous year, and installed the lights with the help of volunteers from the Bureau of Street Lighting. She hoped to raise awareness of the variety and beauty of streetlight designs already gracing the streets of Los Angeles.

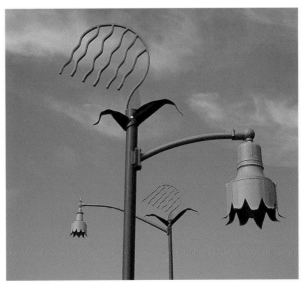

REI Lightmasts

Location: REI flagship store, Seattle

Artist: Peter Reiquam, with architects from Mithun Partners

Date: 1996

Dimensions: Each mast is 7 ft 7 in. high and sits on a constructed wall section. Overall height is 11 ft 7 in.; overall width 7¾ ft

Materials: 1 × 2-in. steel tubing, perforated steel panels, REI climbing ropes, climbing carabiners, Rock Exotica "Wall Hauler" cam-locking devices, and low-voltage halogen lights

Cost: $805 for each of six light masts

Photography: Peter Reiquam

Although this is a privately funded development, the architects used the King County Artist-Made Building Parts program to find seven artists for the project. These lights guide electrical, telephone, and computer lines from an overhead cable tray to the cashiers' stations. The design refers to the "Ice Axe," a T-shape that appears in various locations throughout the store, including the door handles. The lights also include REI climbing equipment.

Everett Waterways Map

Location: Everett Station's Great Hall, Everett, Washington

Artists: Judith and Daniel Caldwell

Agency: City of Everett

Date: 2002

Dimensions: 50 × 60 ft

Materials: Terrazzo floor with bronze ship inlays

Cost: $35,000

Photography: Judith and Daniel Caldwell

The floor of this entrance hall (bottom) is covered by an artwork of a large map of Everett and the nearby estuary where the Snohomish River flows into Port Gardner and Possession Sound. There are twenty-nine bronze inlays of such historic steamships as the *Black Prince* (below), which operated on the Snohomish River from 1901 to 1936. There is also a bronze inlay of Everett Station, as if to say, "You are here."

Waterway 15

Location: North shore of Lake Union at Northeast Northlake Way and 4th Avenue Northeast, Seattle

Artists: Elizabeth Conner, working with landscape architect Cliff Willwerth

Agency: The Municipality of Metropolitan Seattle

Date: 1993

Materials: Concrete pavers, bricks, cobblestones, wooden planks, crushed marble, river rock, tile, various artifacts

Cost: $50,000 landscaping; $50,000 artwork

Photography: Courtesy of the artist

A new water outfall was built on Lake Union as part of a project to separate sewage from storm water. Artist Elizabeth Conner designed a park on the site, called *Waterway 15*, and its layout creates a timeline of the history of Seattle. Here we focus on the artist's use of paving materials to trace the city's physical history. Starting at the shore, she used river rock, then crushed marble, followed by wooden planks, cobbles, recycled bricks taken from University Street downtown, and finally cement blocks. The wooden planks refer to the maritime uses of the historically well-trafficked Lake Union. Conner has also included a number of tiles with pictures and text narrating various stories and facts about the history of the place, and various artifacts embedded in the low walls, including the photographic images in the picture. (For another element of this project, see *Boat Bench*, p. 246.)

Mud Life of the Maumee and Ottawa Rivers

Location: Kleis Park, Point Place, Toledo, Ohio

Artists: Mags Harries and Lajos Héder

Agency: Arts Commission of Greater Toledo, in collaboration with the Department of Natural Resources

Fabrication: Scott Tiede, Kelly Kaczynski

Date: 1998

Dimensions: Five figures ranging from 10 to 77 ft

Materials: Brass inlaid in concrete with exposed aggregate patterning

Cost: $70,000 for construction of the brass. Total park $185,000

Photography: Mags Harries

Mags Harries and Lajos Héder depicted the living food chain that exists in the two rivers that surround the area and sustain the community by attracting resort fishing. The mayfly, sludge worm, larva, clam, and polichaete are re-created in brass and embedded into a choreographed pathway system. A technique of exposing the stone aggregate in the concrete paths, in free-flowing organic shapes, was used to create an extended, water-related world around the figures.

Full Circle

Location: Harborview Medical Center, main entrance lobby on Eighth Avenue, Seattle

Artist: Linda Beaumont

Agency: King County Public Art Program

Date: 1993–96

Dimensions: 1800 sq. ft

Materials: Etched stone and terrazzo

Cost: $6000 design; $75,000 fabrication

Photography: Joe Manfredini

This entryway floor spans many cultures, incorporating quotations from Jorge Luis Borges and Lao Tzu, as well as a picture of elephants circling dragonflies—a Hindu image about the creation of the world. The circular imagery is about time, and the different ways to imagine it, but it also calls to mind microscopic cells. Artist Linda Beaumont said: "My idea was to deal with the big picture, big science, and big time, but also the microscopic world. Then there's also the idea that your world feels very small and it's in one sphere when you are ill or when someone you love is ill."

City at the Falls

Location: Commonwealth Convention Center, downtown Louisville, Kentucky

Artist: Mags Harries and Lajos Héder

Assistants: Scot Tiede, Kelly Kaczynski, Tom Pfannerstill, Patrick Donley

Contractors: Rosa Mosaic & Tile Co., DeAngelis Iron Work

Date: 1999

Dimensions: 67,000 sq. ft (two city blocks)

Material: Terrazzo

Cost: $1.8 million for floor and a ceiling sculpture

Photography: Bob Hower

Harries and Héder use local geography in their terrazzo floor and sidewalks. Drawing from such diverse sources as the local river, fossil beds, and contemporary city context, the artists bring Louisville's history to the fabric of the building.

Flight Paths

Location: McCarran International Airport atrium, Las Vegas, Nevada

Artist: Gregg LeFevre

Agency: Las Vegas Airport Authority

Date: 1998

Material: Terrazzo

Cost: $1.2 million, including $40,000 design fee

Photography: Gregg LeFevre

Inspired by aeronautical charts of Las Vegas airport, *Flight Paths* uses hundreds of aeronautical symbols. According to the artist, Gregg LeFevre, such charts typically use a series of concentric circles to represent the airspace around an airport, but, as he explained, "the circular format of Las Vegas's airspace is interrupted in numerous places because of the airport's proximity to nuclear test sites, secret air-force bases, and other military facilities. The resulting abstraction has a fortuitous counterpoise that fits perfectly into the circular atrium floor space." Cast-aluminum replicas of Boeing 757 aircraft appear to fly down the space between the escalators, to land on the floor's flight map.

Cornerstones

Location: Sidewalk along Eastlake Avenue East between East Galer Street and Fuhrman Avenue East, Seattle

Artist: Stacy Levy

Agency: Seattle Office of Arts and Cultural Affairs

Date: 1997

Dimensions: 24 × 24 in.

Materials: Cast glass, sandblasted Wilkinson sandstone

Cost: $45,000 for thirty-two insets

Photography: Rob Wilkenson/Art on File

Each of thirty-two sidewalk insets depicts different micro-organisms, such as protozoa, rotifers, algae, diatom, and crustaceans found in nearby Lake Union or on its shores. The western, lake side of the avenue holds aquatic micro-organisms, while the terrestrial ones appear on the eastern side of the street. Glass insets display the names of the cross-streets.

Butterfly Gate

Location: Hershey Children's Garden at the Cleveland Botanical Garden, 1130 East Boulevard, University Circle, Cleveland

Artists: Brinsley Tyrrell, artist; Steve Jordan, blacksmith

Agency: Cleveland Botanical Garden

Date: 1998–99

Material: Iron

Cost: $17,000

Photography: Cleveland Public Art (top); Don Snyder (bottom)

These gates to a botanical garden feature three-dimensional flowers, leaves, and insects. Artist Brinsley Tyrrell has used the botanical theme cleverly and functionally: for example, the gate's handle is a praying mantis's arm.

Serpent Fence

Location: Fence surrounding Indian Pueblo Cultural Center, Albuquerque, New Mexico

Artist: David Owen Riley

Agency: Friends of the Pueblo Cultural Center

Logo design: Sheila Hill

Contractor: Joe Abeda of Sun Arrow Construction

Date: 1986

Cost: $3000

This fence around the Pueblo Cultural Center in Albuquerque displays the center's logo (originally designed by Sheila Hill) to passing motorists. The logo depicts the Plumed Serpent, a character in Pueblo mythology who listens from the center of the earth for the dancing and drumming of the Pueblo, indicating that they are fulfilling their religious duties. Artist David Riley placed two Plumed Serpents along the fence of the north and south sides of the center. At the same time, he installed two similar fence additions depicting spirals that refer to Pueblo priests' practice of placing semi-circular stones above the village to collect goodwill.

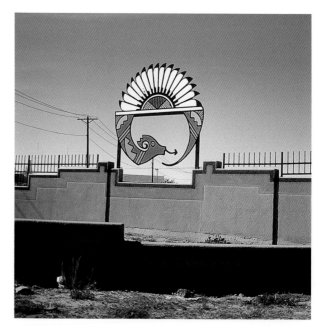

Orchard Fence

Location: Orchard Elementary School, Cleveland

Artist: Brinsley Tyrrell, design; Steve Jordan, fabrication

Agency: Cleveland Public Art

Date: 2002

Material: Iron fencing

Cost: $27,460

Photography: Don Snyder

This handforged fence shows figures running, playing music, and interacting. They converge at two large apple trees, chosen as a reference to the school's name.

Blackbirds and Gulls

Location: Regional Justice Center,
410 Fourth Avenue North, Kent, Washington

Artist: Jean Whitesavage and Nick Lyle

Agency: King County Public Art Program

Date: 1996

Dimensions: 35 ft diameter

Materials: Forged mild steel, powder-coated steel, and stainless steel

Cost: $128,000

Photography: Jean Whitesavage and Nick Lyle

This rotunda railing is in a complex that includes courtrooms and a detention facility. Artists Jean Whitesavage and Nick Lyle chose blackbirds and gulls as their subjects since both birds have "highly evolved social structures."

Mouth of Truth

Location: Loveland Police Station and Courts,
Loveland, Colorado

Artist: Mario Echevarria

Agency: City of Loveland Visual Arts Commission

Date: 2002

Dimensions: 27 ft tall

Material: Hot rolled steel

Cost: $33,000

These steel cherry trees at the entrance to the police station and courthouse recall Loveland's history as the most productive cherry-producing town in the area.

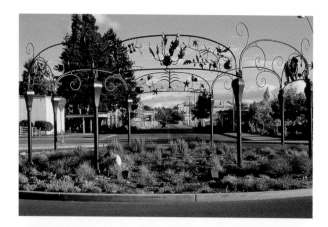

Rainforest Gates

Location: King Street Center, 201 South Jackson Street, Seattle

Artists: Jean Whitesavage and Nick Lyle

Agency: King County Public Art Program, National Development Council, and Wright Runstad and Company

Date: 1999

Material: Painted steel

Cost: $259,000; main entry gates and brackets $135,000

Photography: Peter DeLory

The King Street Center is located in the historic Pioneer Square district, where buildings display the results of historic cooperation between artisans, architects, and craftsmen. These gates, which display representations of plants and animals from the Pacific Northwest rainforests, were commissioned in an effort to extend that practice into the modern day. They serve as the entrance to the "art zone," and are flanked by side gates and panels by the same artists.

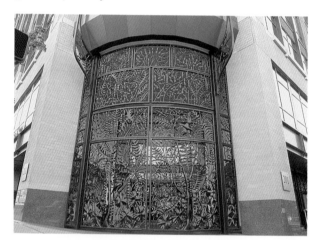

Triumph of the Vegetables

Location: Entrance to Olympia Farmers' Market, Olympia, Washington

Artists: Jean Whitesavage and Nick Lyle

Agency: City of Olympia Arts Commission

Date: 1998

Materials: Forged steel and landscaping

Cost: $65,000

Photography: Nick Lyle

This sculpture (top), installed on a traffic circle at the Olympia Farmers' Market entrance, portrays many locally grown plants available within, all of which are identified in a plaque across the street (above). One of the arches contains wild foods harvested and eaten by indigenous peoples of the Pacific Northwest as well as by early European settlers.

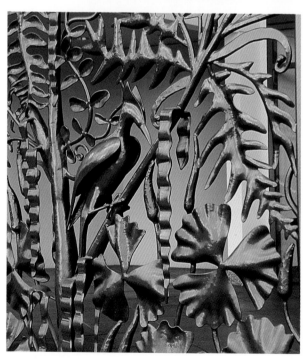

Harborview Quilt

Location: Cafeteria, Harborview Medical Center, Seattle

Artist: Deborah Mersky

Agency: King County Public Art Program

Date: 1997

Dimensions: 97 ft long

Materials: Steel panels cut with
lasers and painted with enamel

Cost: $6000 design; $75,000 fabrication

Photography: Joe Manfredini (top); Deborah Mersky (bottom)

When artist Deborah Mersky painted the walls of a hospital cafeteria, she chose to depict food and transportation, subjects of universal appeal and interest.

Security Screen

Location: Regional Justice Center,
410 Fourth Avenue North, Kent, Washington

Artist: Mark Eric Gulsrud

Agency: King County Public Art Program

Date: 1997

Materials: Glass, metal

Cost: $117,000

Photography: Roger Schreiber

Funded by a Percent for Art ordinance, this large security screen appears in the entrance lobby of a new courthouse and jail. Its weave-pattern design, according to the publicity pamphlet, "reflects the overall concepts of the building—straightforward, elegant, understated, and welcoming."

Brandon Court Reliefs

Location: Brandon Court, Southwest Brandon, and Delridge Way Southwest, Seattle

Artist: Noelle Congdon

Date: 2000

Materials: Concrete and bronze

Cost: $5000 for thirty tiles in three different designs

Photography: Noelle Congdon

Brandon Court is located about two blocks from Longfellow Creek, which runs through several miles of Seattle's Delridge area. Noelle Congdon is a naturalist and artist who has been involved in a project to clean up the creek. The goal is to make it clean enough for the wildlife to return to. Congdon placed tiles depicting the animals along the walls of Brandon Court as if they were swimming toward Longfellow Creek. Some of the same tiles, as well as a few additional designs, also appear in a park across the street, giving continuity to the location.

REI Elevator Surrounds

Location: REI flagship store, Seattle

Artists: Peter Goetzinger and Glenn Herlihy at New Volute

Date: 1996

Material: Cast concrete

Cost: $8000 for six elevator surrounds on three floors

Photography: Glenn Herlihy

These elevator surrounds, located in an outdoor-sports store in Seattle, appropriately use themes of nature and adventure sports.

Salmon Mural

Location: South Seattle Police Precinct, Seattle

Artist: Liza Halvorsen

Date: 1980

Cost: $12,500 for the mural, as well as interior elements like the one pictured here, and exterior details

Photography: Liza Halvorsen, Seattle Public Art

Using salmon as her theme, artist Lisa Halvorsen ran a fish ladder up to the entry, and continued the salmon migration through the interior of the building by means of a ceramic mural. The goal was to create a sense of calm within the police station, and to introduce representations of the local wildlife.

Walking Wall

Location: Orthopedic Clinic at Harborview Medical Center, Seattle

Artist: Harriet Sanderson

Agency: King County Public Art Program

Date: 1997

Material: Walking canes

Cost: $3000 design; $20,000 fabrication

Photography: Joe Manfredini

A clever installation in an orthopedic clinic. Made of walking canes, it has smooth undulations that echo the rhythm of walking.

Keep them Well

Location: Harborview Medical Center, Seattle

Artist: Tad Savinar

Agency: King County Public Art Program

Date: 1997

Material: Sandblasted glass

Cost: $6000 design; $65,000 fabrication, plus construction credits for glass and installation

Photography: Joe Manfredini

This wall of glass in a hospital walkway displays quotations in several languages from patients and nurses in the hospital: they express human experiences of sickness and healing.

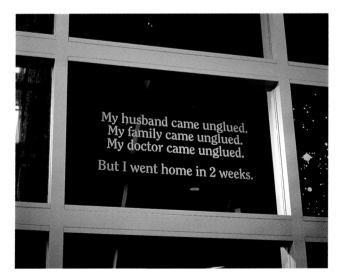

Main Street Louisville

Location: Three blocks of Main Street, Louisville, Kentucky

Landscape Architect: Idea conceived by Dennis Carmichael of EDAW in Alexandria, Virginia

Artists: Ronald Cooper, Ed Hamilton, Miller & Bryant, Tom Butsch, Alyson Ziegler, Miller & Bryant, Marvin Finn, Thomas May, Dawn Yates, Junior Lewis, Michael Farmer, Miller & Bryant, Raymond Graf, Glenn Ziegler, Darrell Brock, Miller & Bryant (**pictured below, left to right**); Jeanne Dueber (**pictured bottom**); Tim Lewis, Barney Bright, Jeanne Dueber, William Duffy, Wayne Ferguson, and Gary Lawton Hargis (**not pictured**)

Date: 1994

Materials: Carved wooden walking sticks, cast in iron

Cost: $2000 per tree

Photography: Courtesy of American Communities Partnership

These cast-iron tree guards (bottom), which now surround trees on Louisville's historic Main Street, celebrate such local elements as the town's cast-iron façades and the local craft of carving walking sticks. Some tree guards represent the history of nearby buildings. For example, the tree guard associated with what was once a bank has a bag of money with an eyed pyramid. The image on the right shows the original walking sticks before they were cast in iron.

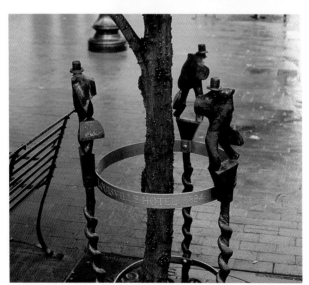

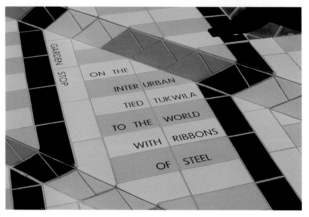

Water Carry

Location: 13980 Interurban Avenue South, Tukwila, Washington

Artist: Claudia Fitch

Poet: Judith Roche

Agency: The Municipality of Metropolitan Seattle

Date: 1996

Materials: Steel, epoxy paint, and sandblasted porcelain tile

Cost: $60,000

Photography: Claudia Fitch

Where a pump station serving the Duwamish River now stands was once an Interurban train station. This sculpted briefcase appears to have been left behind by a commuter. Other elements of the sculpture include a tile pattern that "flows" like the river; poetry about the Interurban line; a shelter that looks like the coat trees from the old train station; and benches designed to look like baskets from a Native American legend.

A Gathering

Location: Canal Street subway station, New York

Artist: Walter Martin and Paloma Muñoz

Agency: New York Metropolitan Transportation Authority
(MTA) Arts for Transit

Date: 2000

Material: Bronze

Cost: $147,000 for 189 birds

Photography: MTA, Rob Wilson

The Canal Street subway stop features railings and beams in the
mezzanine area decorated with bronze grackles, blackbirds, and
crows that have been sculpted interacting with one another, in
order to reflect the social disposition of New Yorkers. The New
York MTA Arts for Transit commissioned this project as one of
several throughout the city (others are discussed on pp. 80–89.)

Usher Bollards

Location: Hollywood Boulevard, Los Angeles, California

Artist: Kenny Schneider

Agency: Community Redevelopment Agency

Date: 1995

Dimensions: 48 × 28 in.

Materials: Cast concrete and stainless steel

Cost: $15,000

Photography: Kenny Schneider

This set of twelve bollards was commissioned by the
Community Redevelopment Agency. The bollards' design refers
to the ushers who stand along Hollywood Boulevard shining
their lights on to the curb.

Herald Square gates

Location: Herald Square, New York

Artist: Gregg LeFevre

Agency: New York City Department of Parks
and 34th Street Partnership

Date: 1993

Dimensions: Lifesize

Material: Bronze

Cost: $20,000 for two owls

Photography: Courtesy of the artist

Herald and Greeley Squares are two complementary triangular
parks located respectively near the old *Herald* and *Tribune*
buildings pre-dating the *Herald/Tribune* merger. On the
Herald's masthead was a pair of owls; on the *Tribune*'s a pair
of eagles, which explains why artist Gregg LeFevre uses the
animal symbolism on the park gateposts.

Sophron

Location: Turner Court, Hayward, California

Artist: William Nettleship

Agency: Alameda County Art Commission

Date: 1997

Dimensions: Focus sculpture: 5½ ft high, 16½ ft wide, 8 ft deep; the curb
units ranging from 11½ ft to 24½ ft long and from ½ ft to 3¼ ft high

Materials: Concrete, paint

Project description: Landscape enhancement surrounding Alameda
County Public Works Agency, including curb units, road paint, and a
sculpture decorating the entrance to the building, all of which refer
to the work of the agency

Cost: $28,500

Photography: William Nettleship

Alameda County Public Works Agency brought in sculptor Will
Nettleship to enhance a new headquarters building and repair
yard at Turner Court. To prepare for the job, Nettleship went
into the field as part of an approved study period through the
Alameda Arts Commission, to observe the workers' efforts at
flood control and road repair. Struck by their "quietly heroic"
work, he decided to focus the art on the elemental power of
the environment that the agency controls, entitling it *Sophron*,
an ancient Greek term that connotes the basic wisdom
necessary for survival. The project comprises several concrete
sculptures that mimic the rugged forms of the surrounding
hills. The entryway piece echoes the hilly backdrop of Alameda
County, and there are ten curb units around the parking lot.
These works are all connected by orange-and-blue stripes
painted from one to the next, tying the project together.

Brickworker and Ballplayer

Location: Rindge Field, North Cambridge, Massachusetts

Artist: David Judelson

Date: 1983

Material: Brick

Cost: $25,000

This drinking fountain in North Cambridge commemorates the brickyard workers who were a part of this community. We can tell that one seated figure is a brickmaker by his heavy boots and lunchbox. The fountain also celebrates ballplayers from the neighborhood who won scholarships to Boston College. Congressman Tip O'Neil, who won one of the scholarships, presided over the dedication ceremony.

Pavilion at East Boston Piers Park

BOSTON, MASSACHUSETTS

ARTIST WILLIAM P. REIMANN approached the East Boston Piers Park artist-selection committee with a clear description of his concept: he would create carvings depicting emblematic images from the visual traditions of East Boston's fifty most populous ethnic groups, as determined by the 1990 census. The art-selection committee was composed of neighborhood residents, government officials, and the park's landscape architects, Presley and Associates. It had contracted with UrbanArts, a Boston-based arts advocacy with a renowned public-art slide library, to help choose an artist for the Piers Park site. From an initial list of over fifty artists, the committee selected five, and gave each $1000 with which to conceive a design. Only the East Boston residents on the committee made the final selection, since the design most affected them. They chose Reimann's design to complement the newly created Piers Park. The budget was $100,000.

East Boston Piers Park is the result of a $17 million collaboration between the Massachusetts Port Authority (Massport) and East Boston residents, two factions that are often at each other's throats. Massport controls much of the East Boston waterfront with shipping docks and container ports; it also runs the adjacent Logan International Airport, which, in the community's opinion, generates excessive traffic and noise. In addition, Massport decided in the 1960s to construct a runway extension at Logan to keep up with the Boston area's air-traffic demand. The new runway was to be built on the site of East Boston's beloved 65-acre Wood Island Park, designed by Frederick Law Olmsted. East Boston residents protested, but the politically powerful Massport prevailed, and the park was converted to a runway.

More recently, however, Massport has worked with residents on a number of projects geared toward increasing the amount of green space in East Boston, and returning resident control to the waterfront. In 1986, legislation established a project advisory committee to give East Boston residents a voice in the waterfront planning process, with meetings open to all residents. Massport officials are quick to portray these efforts as more than just symbolic atonement for past actions. Many East Boston

Three of the fifty ethnic
symbols etched in Stony
Creek granite.

residents remain skeptical amidst Massport's recent proposals to add yet another runway, but they are nonetheless pleased with the early results. East Boston Piers Park, a well-maintained 6½-acre spread at the long-vacant site of a former industrial pier, is the first completed project. The new park includes a playground, a police substation, landscaped walkways, two pavilions, and Reimann's carvings. Other waterfront-access park projects are currently in the planning stages.

Reimann's granite carvings are not the primary attraction at Piers Park, as even the artist himself admits. The magnificent view across the harbor to Boston's towering skyline quickly captivates park-goers, who often walk past the carvings located halfway along the pier to reach the view at the end. Reimann notes that the scale of the L-shaped park and the power of the view dwarf his work. Indeed, he thinks the idea to include artwork at the park site was something of an afterthought. Massport, which was legislatively mandated to create and fund the park, did not receive an arts budget until late in the process, and the park was complete when Reimann was selected as the artist. Because of this timing, a number of restrictions burdened the artwork. Massport specified that Reimann could dig no more than 3 ft below the surface level because it had sealed the pier at this depth to contain contaminated soil from World War II, when the pier was used for loading and unloading oil and other cargo. This precluded the artist from using a large-scale element that would have to be structurally supported by footings. Because of these structural limitations, Reimann decided to arrange the relief panels on the stanchions of an existing pavilion. Massport also requested that Reimann use the same pink stone as the park's walkways and walls for his carvings, in order to integrate the art into the existing park.

What, then, is the rôle of Reimann's sculpture? The carvings are not intended as a confrontational centerpiece to the park, nor were they planned as an integrated part of it. While the gorgeous Boston skyline may draw the viewer's attention across the harbor, Reimann's creative solution to a site with numerous restrictions is to celebrate East Boston's other attributes—its cultural diversity and rich history. It is an attempt to focus attention on East Boston itself, not only on the views that lead away from it. This is a community that has been beset by various problems, notably crime, noise, industrial pollution, and a lack of open space. The median household income was under $30,000 in 1997 and, with household sizes the largest in Boston, it is one of the city's poorest neighborhoods.[1] East Boston has long been an industrial area, but also the first stop for waves of newly arrived immigrants—the "Ellis Island" of Boston. Italians and other southern Europeans arrived early in the twentieth century; more recently immigrants have arrived from Latin America, the Middle East, and West Africa, among other places. Even within the last ten years, the immigrant populations have changed; Reimann points out that the Albanian population has risen so quickly that its size was not reflected in the 1990 census. Thus there is no symbol among the reliefs for one of East Boston's most rapidly growing populations.

Issues of gentrification have also affected the area, upsetting longtime residents and new immigrants who find it harder to afford to live here. Prices have climbed, as wealthier Boston citizens discover that the positives of the view outweigh the negative aspects of being located so near to the airport. Some residents appreciate the money coming into the neighborhood, arguing that it will improve the community's run-down look. Others are concerned about the rising prices, fearing they will be forced out. Many worry that the community will lose some of the diversity

and memory that make East Boston an interesting place to live. Reimann's piece calls attention to this very diversity, and gives residents, new and old, a sense of what makes their community unique.

Design Piers Park includes a wide area at the base of the pier containing a playground, a police substation, and rolling lawns, with pastel-colored brick walkways. The pier juts out at one end of this base. Along the walk to the end of the pier are sheltered benches, lampposts, and two pavilions, one at the end of the pier, one halfway out. Reimann's carvings face the outside on twenty panels attached to the columns of the latter pavilion (four more explanatory panels face the inside). Outward-facing panels are arranged geographically, with East Boston at the center. Thus, Latin American images adorn the south panels, while East Asian ones comprise the east side. In some cases, logistical realities forced incongruities in this arrangement, since the number of representations for each world region does not always correspond to the amount of space on the panels. On one panel, for example, Middle Eastern cultural symbols share space

with those of northern European cultures. The inside of the pavilion provides explanatory panels for each symbol, and a quotation that reflects the artist's intentions, co-written by William P. Reimann, his daughter Katherine A. Gardner, and his friend the late Richard Marius, a Harvard writing professor. Some general wording reads:

> These images represent cultures that shaped East Boston and gave us the people who live here now. They show both the endurance and the fragility of cultural identity. Several artifacts that inspired these designs were destroyed by war. Our common heritage as a united people glows with the exuberant variety of cultures from other days celebrated here. We hope this homage to a vital past will help inspire a peaceful future.

As well as using imagery from the most common East Boston ethnicities, Reimann included symbols for some groups who left a historic imprint on the area. Three indigenous American cultures—the Micmacs, the Penobscots, and the Iroquois—are represented respectively by an interwoven circle, a bow-legged deer, and a circle of

The pier seen from the park. The carved panels are attached to the supporting pillars.

dancers. For all the carvings, Reimann tried to find indigenous images to represent cultures, using Harvard's libraries, the Cambridge Public Library, and other sources to conduct his research. Thus, Philippine symbols precede even the area's early occupation by the Chinese, and pre-Columbian designs inspired the Latin American representations. Puerto Rico, for example, is represented by an endemic frog, "Coqui," which figures prominently in Puerto Rican mythology.

Reimann sandblasted the reliefs into salmon-colored granite from Stony Creek, Connecticut—the same stone used for the walls and other decorative elements in the park. He says of the stone: "It is a handsome pink granite. It made the pavilion share the color scheme and textures of the pier, and helped it appear to be a more 'natural' outgrowth instead of an arbitrary addition." Sandblasting lightens the stone, creating a contrast in colors that allows the viewer to discern the image more easily. The resulting delicate lacy patterns cause the heavy stone to appear much lighter. The thin lines intertwine and create intricate geometries; where different ethnic symbols share the same panels, the lines often wind from one symbol to the next.

Reimann made clear to the project advisory committee that he held sovereignty over the heritage images. By contrast, the artwork's other element, a carving sandblasted directly into the cement walkway leading up to the pavilion, was very much a collaborative effort. This carving is in the shape of a "Flemish Eye," a knotwork that sailors create from rope laid on a boat's deck. Images and dates depicting East Boston's history encircle the carving. Reimann says of these images:

> The medallions around the edge of the knot were not my choice, but something the locals wanted. However, I listened with great care to what they said. The board members asked very insightful questions. For example, we debated whether to include the words "Piers Park" in the logo. We eventually decided this was unnecessary because it said this everywhere, but we did end up writing "East Boston" and the date of the city's inception.[2]

Reimann carved this piece on location (the others were carved in his studio) and says

people often approached him to ask questions or make comments.

Design impact The Piers Park carvings successfully tackle the thorny issue of representing ethnicity. Reimann says:

> Issues of misrepresenting cultures are inevitable. The best way to deal with them is to encounter them head-on. Though some people love a fight, if you deal with them by being considerate, and show that you have put time and care into representing their culture, they become less suspicious.[3]

Alice Gray, project manager for Massport, adds:

> He did what a public artist is supposed to do. He incorporated everything the community wanted to see. He made it known at the beginning that the diversity images were his, while the circular piece was the one that got community input. Even so, when a bunch of people went to see him in his studio, they were concerned about the image he had used to represent the Sicilian population. I was worried there would be a conflict between his wanting to do his own ideas and the community wanting control. But he listened instead to their criticism, and changed it to a design they liked.[4]

Some Jewish residents were upset there was no symbol representing Israeli culture, though Reimann points out that most East Boston Jews immigrated from Eastern Europe at a time when Israel didn't exist. One woman felt that the images should reflect only the heyday of the Sicilian dockworkers, and she left the committee. For the most part, however, Reimann's sincerity, meticulous research, and willingness to listen to resident input won over residents to his designs. While working on site on the Flemish Eye carving he asked many curious passersby about their heritage. In this way he met and conversed with representatives of many of the cultures, often converting originally suspicious viewers into interested parties. Gray attributes the positive response to the degree of control residents had over the project. She says: "There is a sense of ownership because residents know they chose him as the artist."[5]

On most days, steady trickles of people walk through the park, with larger numbers in the evenings when people stop by on their way home from work. Many park-goers are tourists, who might earlier have taken a Boston Harbor cruise and noticed the attractiveness of the park from the boat. Yet the park is never so full that it feels crowded; the Massport police officer stationed at the park calls it "an undiscovered jewel."[6] He helps explain the carvings to people who stop to admire their intricacy. He says people go hunting for the representation of their particular ethnicity, and adds that the panels would benefit from an explanatory pamphlet. Even without one, however, people are affected by the reliefs. Some take rubbings of the designs. Alice Gray calls the piece "art you can touch and take away with you."[7]

The Piers Park reliefs are a model of who we are in a multicultural society. They favor no one ethnicity while celebrating many. Those who take the time to scrutinize the carvings are rewarded with information about their own and other cultures. Reimann says of his mission as a public artist:

> If you lose your culture, you melt into bland suburbia. And if you preach too much fiery nationalism, you become racist. But these are human conflicts we can't get away from. I am concerned about immigrants' children, who are born here and have little exposure to their own culture. They are often raised on American television. They frequently appear to have little or no idea of the ebullient, joyous visual culture in their background. I tried to represent this joy with my adaptations of their designs.[8]

1 See Stephanie Ebbert, "Upscale Visions for East Boston," *Boston Globe*, June 3, 1999, p. A1.

2 *ibid.*

3 *ibid.*

4 Alice Gray, project manager, Massachusetts Port Authority, Boston, interview, August 3, 1999.

5 *ibid.*

6 Lieutenant William Judge, Massachusetts Port Authority police officer, Boston, interview, August 3, 1999.

7 Gray interview, August 3, 1999.

8 William P. Reimann, artist, Cambridge, Massachusetts, interview, July 28, 1999.

Mercer Island Streetscape

MERCER ISLAND, WASHINGTON

Project description

The 76-acre streetscape redesign includes artist-designed street grilles, lampposts, gates, and a widened sidewalk inlaid with items linked to the island's history

Artist

T. Ellen Sollod,
The Sollod Company

Landscape architect

Colie Hough-Beck,
Hough Beck and Baird
Inc., Seattle

Urban designer

Mark Hinshaw AICP

Agency

City of Mercer Island

Date

1994

Cost

$5.1 million street redesign, approximately 1.5 percent of which is for the public-art component. Tree grates: $5000 artist's fee, $6000–7000 for the concept and about $650 each

Photography

The Sollod Company

M ERCER ISLAND DEVELOPED after World War II in the fashion of most suburban towns, around the convenience of the automobile. Located 4 miles west of Seattle in the middle of Lake Washington, the island became a summer community in the 1870s, then a suburban bedroom for Seattle during the 1950s and 1960s. Vast parking lots, large-scale signage, and low-scale commercial strip development dominated the downtown, while narrow or no sidewalks and minimal landscaping discouraged pedestrians from walking around. Today, after a multimillion-dollar street redesign, Mercer Island's center is both transit- and pedestrian-friendly for the island's population of nearly twenty-two thousand people. Artisan-designed street furniture, fashioned with intricacy and connection to place, anticipates and supports pedestrian interest and movement.

Project landscape architect Colie Hough-Beck said of the island's previous 1950s streetscape: "You could get around, but that's all it was; getting from Point A to Point B, with no real place to stop in-between."[1] For years, uncertainty about the construction of

route I-90, which clips the northern edge of the island, discouraged tentative downtown developers. By the 1980s, the downtown saw utilities put underground, signs reduced in scale, and some landscaping introduced, yet there was little revitalization of the core. By the early 1990s, commercial vacancy was high, and a two-story height limit discouraged further reinvestment downtown. The central business district was poorly designed for merchants, property owners, citizens, pedestrians, and motorists alike.

To solve this problem, Mercer Island City Council adopted the Growth Management Act in 1993, which focused planning attention on the downtown. The council formed a design team to establish a vision that would transform Mercer Island's built environment. The design team consisted of "downtown stakeholders" (local businesses), an artist, a landscape architect, fifteen citizens, city staff, a consultant engineer, a transportation manager, and an urban designer. With recommendations from the design team, the city council approved a plan for the central business district permitting building

to five stories and defining a streetscape redesign plan.

It took some leveraging to fund this program. The project was large by island standards, as the city council seldom spent as much as $1 million a year on all its streets, including maintenance. However, during the years of the I-90 construction, the City set aside $2.6 million for street improvements and reconstruction. In the spring of 1993, it applied for federal funding by way of the Intermodal Surface Transportation Efficiency Act (ISTEA), and received a $2.3 million grant with the requirement that construction begin within the year. The Washington State Department of Transportation also made a $150,000

contribution. Combined sources totaled $5.1 million for upgrading the downtown streetscape. Within five months, the design team developed a plan for street and sidewalk improvements, new landscaping concepts, lighting, street furniture, and integrating public art into the streetscape.

Description An initial task force of citizens and professionals established the priorities for the streetscape program, then the design team developed an overall strategy for the entire downtown. Urban designer Mark Hinshaw convinced the City Manager's Office to hire Washington artist T. Ellen Sollod as a comprehensive designer rather than as an artist in order to avoid the Art Commission's lengthy selection process. Sollod developed a design strategy for integrating tree grates, sidewalk inlays, and light-fixture embellishments into a tangible streetscape design that drew upon island character and history as metaphors. She describes her initial phases of learning about Mercer Island's past and present cultural and sociological elements:

> I set out to understand what was unique about Mercer Island and what residents wanted to reflect to the "outside" world. I researched the history of the island, visited the local historical society, and conducted a series of interviews. The interviews included individuals from a broad perspective: long-time residents, newcomers, youth, business owners, etc. Over time what emerged was a shared pride in the fact that Mercer Island is an island ... and that people were concerned that the history of the community was not lost.[2]

Sollod discovered that the residents wanted to share their history, yet demonstrate their identity as an island to the outside world. The community also wanted to emphasize the large school-age and cyclist population on the island today.

The design team approached the redesign of the street layout from several angles. After analyzing traffic patterns and observing people navigating the streets, they derived aesthetic and functional solutions. Sollod describes her downtown design as "a scavenger hunt with clues to the history 'scattered' through the sidewalks in the form of bronze inlays."[3] The inlays include a bronze

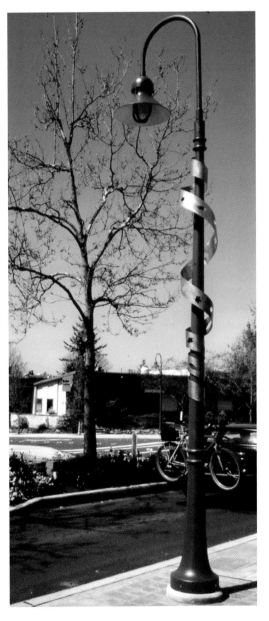

draft horseshoe that recalls the horses that helped pull logs along a local logging route, known as Skid Road. A map of *(In)visible Histories* reveals the locations of forgotten geological and historical sites. Two bronze milk bottles have an invented logo of a dairy that once occupied a section of downtown. A 36-in. cross section of a log entitled *Conveyance by Time: History of Transport* chronicles migrations to the island, beginning with the settlement of the Lushootseed Indians. At certain ramps Sollod also inlaid the former street names, names that were removed in 1930 when King County changed all street names to numbers. These inlays provide a "ghost image of the previous destination."[4]

Sollod also designed a number of street furniture elements. Tree grates provide metaphors for the island mentality. Around the borders of the grates are a stanza of poetry by W.H. Auden and a verse from Herman Melville's poem "The Enviable Isles":

Sweet fern and moss
 in many a glade are here
Where, strown in flocks,
 what cheek-flushed myriads lie
Dimpling in dream,
 unconscious slumberers mere,
While billows endless round the beaches die.

The grates themselves contain motifs of salmon and birds. Sollod worked with lighting manufacturer Bega to create unique streetlamps, manufacturing stainless-steel ribbons with leaf cutouts that wrap around the lampposts. Sollod and Hough-Beck combined efforts to align the freeway entrance and exits with magnolias and evergreens and to place over one hundred flowering pear and red maple trees in the retail core. These trees intentionally replace the many red maples cut down during construction of the I-90.

The final design also compressed auto space and expanded sidewalks, bicycle lanes, and medians. On two streets, a continuous turning lane accommodates automobiles. Through the middle of downtown, a pedestrian street enhances the existing landscape median. Extra transit lanes were converted into pocket parking, and sidewalks were widened to 14 ft. "If you combined the entire sidewalk area, it would be wider than the street," says Hough-Beck.[5] Additional breaks in the median encourage pedestrians to cross the mid-blocks of the street. Non-artist-designed street furnishings, including benches, trash receptacles, and bicycle racks, were also placed throughout the downtown to encourage pedestrian and bicycle traffic.

Design process Extensive community involvement encouraged the smooth planning and implementation of the project. According to Mark Hinshaw, several major strategies streamlined this process. The team erected a special field office at the project site, where city employees could address public relations concerns as they arose. A fifteen-minute video aired repeatedly on the government access channel, revealing existing conditions and proposing design solutions. It included inter-

BELOW The *Ghost Image* inlay shows the historic street names of this location.

BELOW, RIGHT Milk bottles capture the name of the dairy company that delivered on the site.

views with residents, city officials, and consultants. Representatives of various commissions, boards, and committees in the city met frequently and followed the process comprehensively, moving from initial schematic designs to the final contract documents. An open house designed like a street fair with booths showcased different aspects of the project, including mock-ups of the planned brick sidewalks that people could test-walk. Finally, a "talk show"-format city council meeting was arranged with council, staff, and the design team on stage, while a moderator moved among the audience, encouraging the public to ask questions.

Property owners' concern about the impact of the I-90 construction complicated the project's implementation. The City needed to be sensitive to the commercial property owners and businesses just recovering from the I-90 construction uncertainty. To ease tension, it adopted the campaign "Bear with Us," launched on the day prior to street construction. Local youths were invited to paint the soon-to-be-demolished sidewalks, and business owners passed out "Bear" stickers. As well as this singular event, the authorities focused on other ways to foster communication and interaction among all players. The street team, a group of local businesses, and Chamber of Commerce representatives met with the contractor weekly and maintained communication throughout the project, informing the contractor about issues affecting local businesses. Consequently, local

businesses were more understanding about the pressures of construction needs and scheduling. This collaboration among the contractor, employees, the City, and local businesses was key to the project's remaining on schedule while minimizing impact to local businesses.

Design impact Initially, the design team encountered resistance to the plan. At a Street Task Force meeting on January 6, 1994, members claimed that Ellen Sollod's images did not accurately portray Mercer Island's history; after discussion, however, they voted to approve her designs.[6] Some local architects and citizens opposed the plan as well, believing that city money would be wasted as people would not use the proposed sidewalks and benches.[7] Mark Hinshaw commented: "If there's anything we've learned from 1970s-style urban malls, it's that you can't force people to walk. There's a resistance to that ... but if you give people a choice, they'll take it."[8]

The team completed the redesign in two phases, in 1994 and in 1996, working with the idea that the design would align the streetscape with future buildings.[9] Since then, a substantial amount of reinvestment has occurred in the downtown area. As a result of the design, buildings are closer to the street edge. Outside dining enlivens street life. New privately supported street art, benches, trees, and fountains have been added. The new streetscape has animated activity in the downtown, thus strengthening commercial investment and changing pedestrian patterns and

Tree grilles were specially designed for the project. Some display lines of verse around their edges.

The project also featured artist-designed street-lamps. "Ribbons" of steel with leaf cutouts wrap around the lampposts.

S.E. 27ᵗʰ St

1 Colie Hough-Beck, *Landscape Architecture*, March 1995.

2 T. Ellen Sollod, artist, interview, January 25, 2006.

3 *ibid.*

4 *ibid.*

5 Quoted in Claire Enlow, "Calmer Traffic Makes Livelier Town," *Seattle Daily Journal of Commerce*, December 3, 1996.

6 See Chris Norred, "Rebuilding Downtown Streets," *Mercer Island Reporter*, January 1994.

7 See Chris Norred, "Downtown Street Plan Gets Approval," *Mercer Island Reporter*, January 26, 1994. See also Chris Norred, "Islanders View Plans for New CBD Streets," *Mercer Island Reporter*, January 19, 1994.

8 Quoted in Enlow 1996.

9 Sollod interview, January 25, 2006.

10 Rich Conrad, city manager, interview, November 15, 2002.

11 *ibid.*

interactions. Residents and visitors are now encouraged by the downtown environment to linger and converse, reflect, and relax. Six years after the redesign was completed, developers began to build homes in the downtown area, more than doubling the amount of housing there. According to plans, eight hundred new units of multifamily housing will be built between 2002 and 2005, adding to the seven hundred existing units. Rich Conrad, Mercer Island city manager, points out that the timing can perhaps be accounted for by Seattle's zoning laws and growing population, but also notes that the street redesign made Mercer much more attractive to Seattle's developers: "If you build it, they will come," he says.[10]

The downtown is still in transition, as recent city efforts include the construction of a new firehouse as well as surrounding public spaces. Yet the project has been successful in revitalizing the core of the island. Private companies have made improvements since the redevelopment: a grocery market has undergone extensive interior and exterior remodeling work, and a bank remodeled its exterior and improved pedestrian access. Retail and small business have seen improvements in profit caused by visitor and resident interest in an area that was once inhospitable and uninviting. Former mayor Judy Clibborn noted that before the overhaul started merchants complained that too few people shopped downtown. Now they complain that there are not enough parking spaces to accommodate all the people downtown.[11] The artwork draws its strength from the history and past events that have shaped Mercer Island, while engendering a sense of identity and pride in residents of the town. Furthermore, the public art fostered community involvement and integration that makes this streetscape an *extension* of residential proprietorship. The area has become a place to stroll and be seen in as one shops or simply enjoys the amenities of the space.

IV

Public-art planning: What we have learned from the past

Planning for placemaking[1]

The Rationale

ARTS AGENCIES HAVE TURNED THEIR ATTENTION to planning, something predicted and encouraged by the recommendations in the *Place Makers* book of 1987. Planning is a vital tool for any agency aiming to make best use of its resources and to coordinate effectively with its community and with other bureaucracies. But to create *placemaking art*, planning is almost a prerequisite. This means that commissions have to do their homework about place. Agencies that commission placemaking art serve their constituencies by linking people to places. Planning for placemaking has two functions: the first is to foster the community's investment in art as a fixture of the community. It is a process whereby people take ownership of their surroundings, staking a claim in the narrative that brought them to this point, and reclaiming both their visual environment and their community memory from the homogeneous corporate forces and banal local development besieging the contemporary landscape. The second purpose of public-art planning is to focus the art around stated urban-design objectives, which the planning process allows the community to define for itself. Both are still commonly neglected.

Often a community, a selection panel, or even an arts agency cannot know the spectacular range of work that artists produce. While it is the artist, and not the commission, that brings this inspiration to the process, the very nature of a place can also set the frame for inspiration. A community will not understand what it can gain from an arts program without investing energy to tap into the substance of the place itself, through cultural, physical, and behavioral analysis. What is inspirational about the history of a booming urban metropolis may be quite different from the requirements of sustaining life and dignity for a small industrial town in a rural setting. However, all communities share a need for comprehensible, well-executed public-art projects that can bear real fruit in expressing local ideals and reflecting the *genius loci*. Without planning and its attendant research, public-art commissions risk being just another government program stenciled on to the surface of a community's fabric or plopped next to tabletop architecture. Planning research should ensure that the resulting art has resonance, and serves an overarching vision responding effectively and equitably to the placemaking needs of the area. Placemaking does not mean dictating what an artist produces, but it requires research that extracts meaningful content from a site, thus establishing metaphors for the use of both artists and community, and hence setting expectations for all.

Creating one project, with one small grant, sometimes produces a well-loved local centerpiece. Such actions can inspire community activists and municipal leaders to invest in public art. This is a vintage strategy that the Cambridge Arts Council used with its first series of projects—low-budget murals

created in the program's first six months, with funds from the short-lived CETA (Comprehensive Education and Training Act) initiative that brought attention and recognition to the new agency in 1975. But such lone projects do not really address the holistic need of a city or town to create, enhance, and sustain a feeling of place. Unless public-art agencies work in concert with planning offices, historical commissions, local officials, and departments of public works, they fight an uphill battle. Great art means very little without an amenable venue for delivery. In the case of public art, the platform is the cityscape, including the physical constraints and opportunities, and the practical usability of the particular locations. There is a way to leverage the power of politics, physical planning, urban design, infrastructure, and ongoing maintenance that all cities and towns require in their day-to-day operations—to bring these forces together at the negotiating table. Arts agencies accomplish this through a planning process. This process requires the collection of information about potential sites, then puts that information into an urban-design framework, identifies the cultural and physical context of the sites (both constraints and opportunities), and often defines relationships to other partners, both private and public, who can support and implement the plan. Startlingly, there are still placemaking objectives that a plan could easily facilitate, which remain on the fringes of standard practices in commissioning public art. Here are some issues that a planning process can address:

A. Communication Programs that have nearby jurisdictions often fail to communicate altogether. For example, the City of Fort Lauderdale, the hub and seat of Broward County, has a small public-art program that has had no contact with the prominent Broward County Public Art and Design Program.[2] In Cambridge, the Women's History Office was adjacent to the Arts Council in its early years, and yet they never executed a joint project, an example of bureaucratic behavior that can nourish dysfunction. The very nature of the placemaking planning process requires communication, because one *has* to ask questions to learn about sites.

B. Integration Another basic but invaluable rôle that an arts commission can play is in designing a total artistic experience in structures and civic space. This massive task involves an integration of arts resources and an assessment of art's potential rôle in shaping the overall landscape. This approach was certainly prevalent from the Renaissance through Beaux-Arts and Art Deco traditions. Contrast the integrated enrichment of the Boston Public Library with its renowned murals, sculpture and floor inlay from 1895, and the city's sleek new Federal Courthouse. In the case of the

courthouse, federal judges led the effort to commission several pieces of public art, but as the architect Henry Cobb acknowledged at the opening ceremony, there was not the fluid integration of many pieces of art and craft that distinguished the work of his predecessors McKim, Mead & White at the Boston Public Library.[3]

"One of the things we're missing is material quality," says Cath Brunner, head of public art at 4Culture, King County's progressive arts division. "We need more handmade unique things. We're stripping the environment of tactile handmade materials because of code issues and risk management."[4] It is easy for the various departments of a City to pass the buck on this issue, and it is up to arts commissions to take it on aggressively. This is a particular sorrow for communities around the country with long and poignant craft traditions, largely ignored by public-art programs to this day. Craft is a modest way to explore this integration. Elevated to the gallery and isolated from the instruction of most architects in the academy, it is still difficult to bring it into a planning process dominated by larger-scale work.

C. Streetscape relevance Streetscape design is only just beginning to emerge as a priority in public-art planning, with such communities as Austin, Louisville, and Seattle exploring the way. Of course, streetscape design requires coordinated efforts, planning, and interdepartmental communication. It should broaden the constituency for public art because it affects the elemental experience in public spaces: the quality of kiosks, benches, lighting fixtures, tree guards, and grates, and their inventive capacity to sustain narrative about place.

Mixing planning agendas with public art thrusts the administrators and artists into complex territory. Planners can bring in art to serve as a superficial public-relations "band-aid" for such deeper problems as unchecked highway expansion or rezoning, hoping that art will cover up their shortcomings.[5] To serve the public, artists who take on the rôle of public artist must seek to have an impact from "within the establishment," rather than as marginal forces outside society (a major locus of contemporary art). But the challenge is pragmatic: artists run a risk to their own reputations when serving as mouthpieces for a governmental planning agenda that may simply be doing shoddy work. Now artists, no longer naïve, must face the question of whether they are receiving an opportunity to speak to a large audience, or rather are being used as a punch bag for a community's anger over some greater planning problem in the case of controversial quandaries in which they may not have the tools to maneuver, including highway expansion, urban "revitalization" (including the removal of poor residents), or simply a poorly designed public plaza.

Trends in public-art planning

Public-art planning has come a long way over the past twenty years, starting out as an improvised, generic statement of intent within a master plan, and becoming a maturing force of principles that defines community entryways, key nodes, and opportunities for the connection and interpretation of transit corridors and significant public spaces. There is now a cadre of seasoned professionals, and one can even obtain a university degree in public art.[6] Arts agencies are more often using public-art plans to secure their programs' places in the bureaucracy, to insure funding sources and to analyze the best ways of allocating and leveraging resources. While public-art planning now regularly includes the analytical implements in an urban planner's toolbox, it also increasingly utilizes the experience of artists as integral players on the planning team.

Old art plans looked much like a generic city plan, usually including goals and objectives, site

locations, and a methodology for site selection. Urban planning progressed from an arrogant wiping-away of organically grown cityscapes (an attitude supported by urban renewal policy and often resulting in the "sculpture on the plaza" approach) to a renewed respect for the character of different physical locales. This change is evident in public-art plans as well, which now more often embrace existing neighborhoods and celebrate local character. These new plans often include broader urban-design elements, and sometimes even engage the infrastructure. Increasingly, the plans collect essential community information, thus enabling in-depth analysis of particular spaces and the local community meaning attached to them. The specificity of this information then better enables plans to frame tailored objectives for streetscape enhancement, placemaking, and interpretation, with particular strategies for attaining these objectives. According to planner Todd Bressi, who teaches public art planning at the University of Pennsylvania, the first breakthrough in securing more comprehensive public-art planning was to ensure funding through links to capital improvement projects, such as Phoenix's influential 1988 plan that identified sites for art and focused the arts commission on urban-design goals.[7] Connecting capital improvements to public-art funding ensured that a reliable stream of income supported new projects and also, importantly, secured an administrative funding base for implementing ongoing work.

All these concepts—communication between units of government, integration of physical design, increased streetscape relevance, and artist as master planner—blur the lines between city planners and arts planners as they consider the broader urban-design implications and place needs of the community as a whole. These new planning concepts help leverage Percent for Art funding, but also encourage synergistic strategies that can separate monies from attachment to particular capital improvement programs. This may mean advocating new funding sources, or pooling capital improvement funds or, in some locales, private developer contributions for far-reaching projects.[8] In Seattle, pooling public-art funds within departments has allowed the public-art program to distribute money in a concerted way rather than being restricted to small projects whenever a meager sum becomes available. While some communities invest in a major art planning endeavor that brings them on to the national radar, others grow their programs out of community support, and still others struggle without the aid, guidance, and security that planning provides.[9]

The rise of the master plan

An essential element of a successful public-art program is a clear vision. Many commissions go through a long process of winning the public's cooperation by outreach and "feel-good" projects. But a few pieces in a few supportive neighborhoods do not necessarily produce a cityscape full of life and character, and are often not enough to garner the support of a whole city and its administration. To build a strong base of support, even fledgling public-art programs need a systematic approach to commissioning. Agencies can use planning as insurance against the omnipresent influences of political manipulation, the specter of public controversy over particular choices and sometimes stubborn, recalcitrant, or turf-conscious city administrators. A sound plan provides a methodology for identifying the best potential projects and selecting artists. Importantly, it should also outline a process and insure a timetable for reviewing the budgets of other agencies to secure resources at the beginning of the budget cycle. Planning cannot prevent failure, but it can provide a safety net of accountability when something goes awry. According to the Americans for the Arts Public Art Programs Fiscal Year 2001 survey, one third of responding public-art programs have a master plan. Seasoned art planner Jerry Allen, based in San Jose, has worked on thirty plans over the past twenty

years and estimates that about one quarter of US programs have some form of master plan.[10]

The number of arts organizations sharply increased up to the millennium, and has since leveled off. The first major guide to public-art procedures, *Going Public*, tallied 163 agencies in 1988, including both government commissions and nonprofit organizations. Americans for the Arts's *2005–2006 Public Art Program Directory* contains data on the 341 public-art programs in the US, including twenty-five transit programs. Although the number of programs is steady, the breadth of funding opportunities is increasing as commissions grow larger and gain more public support. In 2003, there were ten programs with more than two percent of capital improvement budgets provided for art funding; in 2005 there were seventeen!

Unfortunately, some new programs still view planning as far-off on the horizon, or an unnecessary expenditure.[11] Some administrators of young programs say that they don't have the resources to plan, when it is often the planning process that *garners* the funding and provides the procedural back-up to insure workable art ordinances. Jerry Allen has consulted on public-art plans for the whole gamut of community types, from Los Angeles with 3.7 million people inside its city limits, to Capitola, California, with its population of three thousand. He insists that any program, even in the smallest community, can pull together the resources for planning. Todd Bressi puts it simply: "A plan is a means to get from point A to point B."[12] A plan that creates a rationale for the public-art program and a relationship with the city or town government has the capacity to launch engaging and dimensional initiatives, drawing upon the community's self-reflection from the planning process.

The new volume *Public Art by the Book* (2005) is a comprehensive overview of existing practices in public-art agencies, edited by Barbara Goldstein, the former director for the City of Seattle's renowned public-art program.[13] It is no accident that in this compendium of procedures, the first chapter deals with planning. Planning sets the stage for all other work: without the strategy that it provides, commissions face controversy over the allocation of funding, and the sum of their piecemeal efforts is often totally ineffective in impacting on the larger cityscape. Still, with or without a master plan, these nascent programs will usually face more challenges to their vision and continued existence than an established program. The best-executed public-art projects are usually deeply intertwined with other City departments, utilizing shared resources and a common vision for the direction of the cityscape. But that relationship takes time and concerted effort, a presence in City meetings over a period of time, and trust and familiarity between project managers and arts administrators. Until city officials, city planners, and arts administrators have common, aligned goals, they will invariably step on each other's toes, even when they are friendly, well-meaning people. Sometimes other City departments are overtly hostile, even screening their departmental budgets from arts administrators. A strong plan is one way to ensure that the short- and long-term goals of the city and the public-art program unfold in concert, because it puts a mandate on interdepartmental coordination and production timing. As with many programs, even the much-vaunted Seattle program had to win over City departments one by one,[14] gradually building a relationship through successful projects and having the City departments understand the value the artwork could bring to their projects.

According to Kerry Kennedy, former manager of public art and design in Broward County's public-art program, "Design Broward"—the master plan that accompanied the county's ordinance in 1995—has been essential to the success of this medium-sized program.[15] The overarching vision in the plan set out goals as well as values that served to ensure proper support for the programs. Ten years later, public-art staff are still using it as an operations guide. It also laid the groundwork for a five-year plan launched in 2001, which Broward will replace in 2006. The stage was now set for

project-specific master plans, such as the recent Parks/Land Bond Master Plan, *A Theater of Regeneration*, created by a design team with the leadership of artist Lorna Jordan in 2004. Plans also infuse public art with the values of the commission. When a program's mission is to utilize art to develop a sense of place, it requires a public-art *process* that will draw meaning from the community and location *consistently*. It is not just an artist's job, but is built into the public-art protocol. Commissions can leverage artists' unique skills of research and reinterpretation for *planning* efforts as well, sometimes involving lead artists to help coordinate opportunities for other artists along the way.

Plans and their components

A strong art master plan is still the basic staple of good forethought.[16] Thorough plans, like Seattle's, identify opportunities for specific projects citywide. Others, such as San Jose's, go thematically through the aims of the art program, addressing such specific goals as enhancing neighborhood pride, while defining design objectives, guiding principles, approach, and artist selection procedures step by step, for a variety of civic spaces including downtown and branch libraries.[17] Well-researched resources, such as the physical and cultural maps created for *The Houston Framework* public-art plan, lend insight when addressing the needs of a specific site.

Increasingly, cities take a deeply pragmatic approach to the process, rather than hoping for an expert planner to wave a magic wand and create results. Jerry Allen:

> I see the rôle of the public-art planner as ... trying to take in information and reflect it back to the community in a fairly faithful way The fact is that any two or three people with some experience in public-art programs could sit down in a weekend with two or three good bottles of wine and write a perfectly good plan for the city. But it would lack the one thing that is crucial to the effort, and that is a consensus in the community about the course of action Identify the stakeholders, and get their buy-in to the process.[18]

The professional planner brings two key tools to a community planning process: authority and expertise. "Part of it is just confidence-building," explains Glenn Weiss, senior planner in Coral Springs, Florida, and former public-art administrator in King and Broward Counties. Especially with new programs, the planner often simply plants "seeds of possibility" in the community, and fosters the ideas and inspiration that locals already have.[19] According to Weiss, his job is also to give people a sense of scope, and of the costs of production.

Allen also believes that communities should create new plans serially, every five to seven years, in order to educate each round of newly elected politicians. Because of term limits, those who voted for the Percent for Art program disappear from city councils. A plan helps gain the support of each current administration. It also reinvigorates the relationship between an arts commission and the local government, and keeps arts visible on the public agenda.

Artist as planner, planner as diplomat

Still relatively new but of dramatic importance is the rôle of artist as master planner. Again 4Culture leads the way with the Brightwater Water Treatment Plant, a major utility construction with a $4.3 million art budget. Seasoned public artists Buster Simpson, T. Ellen Sollod and Jann Rosen-Queralt joined the design team and produced a public-art master plan, which started along with the project in 1999 and will not be realized until 2011. The artists first served in the rôle of art planners, creating

the master plan that set out a number of "zones of experience" within the plant. Each artist took control of a zone, and created public-art opportunities in each, including major works for themselves and subsidiary opportunities for other artists, whom they helped to hire. These artists will see the project through to the end. 4Culture will also pay these leaders to act as mentors for the artists working in their zones. In this way, the commission granted the lead artists the task of developing a broader vision of art's involvement in the site.

According to public artist Jack Mackie, who has an extensive background in arts planning and administration, team members in any discipline working in an urban-design project should represent their profession in the planning process. This includes artists, who know the broad scope of the impact that art can make. To this end, artists also serve as advocates for the potential of art as part of a larger urban-design scheme (and allocating limited budget funds for art), demonstrating through eloquence or example the possibilities of art entering into such seemingly impenetrable capital improvement efforts as manhole covers or sidewalks. The expanded rôle transforms the artist into the prime shaper of public space and related infrastructure. According to Mackie, all the members of a design or planning team approach the problem from the constraints of their disciplines. For his own contribution, "I try to shape the human interaction rather than the shape of the ground."[20] Orchestrating the experience of public spaces, it seems, has now entered the purview of the artist.

Rather ironically, it is the flexibility of an artist-planner (or any planner for that matter) that runs the risk of compromising the master artist's overall vision. These artists must walk the fine line between diplomat and visionary, without losing sight of their own ideals. But this is a profound shift in a power relationship that has the potential of bearing dramatic benefits. There is also the danger of losing the edge of clarity that comes from being an outsider within the bureaucratic mainstream. The pragmatic skills obtained by working within the system give increased leverage, and artists can potentially contribute more and more as professional boundaries blur.

The definition of plans as consensus-builders requires a key skill from an arts administrator: bureaucratic savvy. This means working well with city planners, parks directors, library directors, physical plant managers, transportation administrators, politicians, and community members. It requires administrators who will be invested in civic life, with a finger on the pulse of local politics. This is a more than full-time commitment, and it can be difficult for an artist to come in and fill this rôle.[21] According to Mackie, "an artist who's going to be in a planning process has to be seasoned in a number of different media, including that of city hall." The question then arises regarding what advantage there is to bringing in an "artist as planner." Some artists do an exemplary job in this rôle, though it is an altogether different skill set than that required of a fine artist doing commissioned work.

The idea of compromise, of gradual adjustment to meet the needs of different constituencies, was better learned by artists under the old Beaux-Arts system where they worked on creating larger environments with architects and artisans. Lorna Jordan's Broward County Parks/Land Bond Master Plan is an example of the work of someone who has brought her experience of conducting research as a public artist to the planning process, with award-winning results.[22] Prominent public artist Jack Mackie also works with Jerry Allen on planning teams, thus enabling the expertise of a public artist to be utilized in the planning context.

Many communities, including Seattle, Broward County, and San Jose, use master plans as well as sub-plans. A plan for a parks system, airport, or large-scale library ensures that arts commissions are able to divide funds in a deliberate way rather than lumping in small, unchoreographed projects as they come along. Cities often call in artists or art planners, or involve artists in teams to devise

these sub-plans, such as Broward's park plan or King County's extensive transit plan. Lorna Jordan's 2005 Broward County Parks/Land Bond Master Plan defined opportunities for artists in the short- and long-term development of the region, going well beyond the original scope of the plan to address the area's needs on a large scale.[33] The plan delved deeply into the natural history of Broward County, providing extensive research on the waterways, ecosystems, and even some demographics. It set out two- and ten-year goals for the program, including sixteen proposed projects. As an accomplished public artist, Jordan carried out the planning research with an understanding of what kind of knowledge must go into a public-art project. Other artists could then be found to work within the framework of that community-approved content.

Planning also ensures that programs have a strong system in place to guide artists and administrators as they proceed with the often delicate and laborious process of gaining consensus. Commissions learned from experience that controversy comes not only from internal tensions in a community, but from art that ignores community needs, or that has not been presented in an approachable way (see pp. 328–41). In Jerry Allen's words: "We realized that without some more meaningful and participatory engagement from the community that would eventually be the audience for a particular work, we were going to continue to see controversy." San Jose's solution has been to increase community involvement. It started with the first capital engagement, for which a community-based task force was assembled. Importantly, key people in the community were identified and encouraged to follow the project from beginning to completion. Utilizing the existing leadership in a community ensures that the project is firmly rooted in the local social network, and moves some of the advocacy work to trusted community members.

Broward County, Florida, produced the award-winning Parks/Land Bond Master Plan *A Theater of Regeneration* by artist Lorna Jordan in 2005. Images: courtesy of Lorna Jordan.

Questions to ask a public space[24]

Pondering some of the banal, bleak, and dreary public spaces we have created in the past several decades, we concluded that it might help lay commissioners, city planners, and members of boards who review design proposals to have a set of questions to ask when evaluating a space. Some of the following questions relate to particular conditions observed at Albuquerque's Civic Plaza, but most of them could be asked of spaces anywhere.

Designers who find good answers to these questions will be well on their way to creating better public spaces. However, we believe that most designs can also be improved through concentrated review by a discerning group of potential users, who should also find good answers to these questions. The space may then succeed in transcending its physicality, and becoming an environment of meanings and layered uses that can create and sustain a feeling of place. With that feeling, we hope, will come a sense of community proprietorship for the space.

1 Do the configuration and size of the space support the functions that were planned for it?

2 Does the space have a complexity that allows it to be enjoyed by a variety of users?

3 Conversely, is it simple enough to be memorable as an integral space?

4 Is there a clear sense of direction across the space to popular destinations?

5 If you were blindfolded, would you encounter obstacles in passing across the space?

6 Does the space support a defined palette of colors appropriate to the cityscape?

7 Can one comfortably eat outdoors, watch a concert, or do both at the same time?

8 Can a small child find sources of amusement in the space? Are there design clues that can help a lost child find its way out of the space?

9 Can an elderly person sit in a sunny spot in the space and feel safe?

10 Is one free to move about the space without feeling intimidated by others?

11 Does the space avoid complex level changes, sunken areas, and hidden alcoves that might encourage antisocial behavior?

12 Conversely, does it provide a variety of feelings of enclosure that sustain various levels of intimacy?

13 Does the space include a location where people want to be seen by others?

14 Are the materials in the space easily maintained or replaced, such as stone-dust or gravel?

15 Can a handicapped person easily traverse the space and find comfortable places to rest within it, use the drinking fountain, and find the restrooms?

16 Does the space provide a clear sense of destination for pedestrians?

17 On a sunny afternoon, can you buy a snack, a book, a balloon, or a city map?

18 Is the space designed to support social events? Are there electric outlets, inserts for kiosks, and places for removeable bollards to block off areas? If desirable, are there public electrical hookups and wireless internet for people looking to work on computers in the afternoon or during a lunch hour?

19 Can you play games in the space, for example bocci, shuffleboard, or chess?

20 Is the space accessible to fire trucks, utility equipment, farmers' trucks, and catering vans? Can these vehicles easily negotiate the space without damaging the paving, the landscaping, or its water features? Are such features resilient enough to stand up to this traffic?

21 Can you see across the space?

22 Is there information that tells you what was there before?

23 Are there narrative elements that connect different parts of the space?

24 Does the space encourage you to savor moments of contemplation?

25 Are there elements in the space that help you to measure time and the passage of the seasons, and to understand the movement of the planets or the evolution of the area's geology?

26 Is there flora and fauna, either artificial or real, that are native to the place?

27 Do the works of art in the space have meanings that are accessible to the general public?

28 Does the space reduce the impact of the visual cacophony of its surroundings?

29 Conversely, does its design vocabulary support the character of the surroundings, if they are pleasing?

30 Do the design elements in the space relate to the human figure?

31 Does the human figure create a sense of dimension in the space?

32 Do the intricacies of the space sustain interest? Are they worth considering five or six times?

33 Are the building materials, building finishes, and structures in the space of the type a child would wish to touch? Would this tactility add to the pleasure of the space?

34 Are there design features in the space that the community could add to over a period of time?

35 Are there design elements that encourage one to linger in the space? For example, are there moveable chairs so one can define one's own space? Are there comfortable benches in the shade on a hot day and in the sun on a cold one?

36 Are there elements of continuity that reinforce the overall design character of the space and establish a pattern that is discernible by pedestrians, not only from a bird's-eye view?

37 Does the space avoid arbitrary shapes or objects that are out of scale to their relative importance in the design?

38 Does the space allow the viewer to enjoy its intimate details?

39 Can you hear site-specific sounds in the space: the rustle of leaves, the thud of horseshoes, the trickle of water, or the sound of a band?

40 Do the design elements used in the space include arts and crafts particular to the region?

Designing the artist selection process

Another key element that an art plan must cover is the artist selection process. Formerly, curators made sweeping decisions, often at odds with community interests and identity, but the recent trend has been to include community members on panels. King County's cultural services organization, 4Culture, uses three design professionals and two local citizens on a selection panel. "People know place, peers know cutting edge," according to 4Culture's Cath Brunner. Agencies still widely use the usual methods: slide/digital registries; requests for qualifications (RFQ); requests for proposals (RFP); and invitation and direct purchase.

Some agencies have moved away from one method of artist selection to another. For instance, the cost and organization of maintaining a slide registry is prohibitive for some agencies, while others don't have the staff power to sort through the many applications for high-visibility RFQs. Direct purchase and invitation are less popular now for agencies moving away from "sculpture garden" approaches toward site- and place-specific works. But direct purchase and invitation are still methods of choice, when allowed, for private developers looking to install public art as part of a mandate. These methods allow developers maximum control over the art, and enable them to hire whomever they please to create it, which can bring about its own set of problems.

Some agencies have explored different methods for influencing artist selection and including community input, while some projects will always require specific requests for qualifications or proposals. According to Brunner, roster selection gives three important advantages in many cases. First, it is the most economical for a program that can afford to maintain it: rather than receiving and handling new materials for every RFQ, commissions have a pre-screened sample to choose from. Secondly, one can select quickly, which is sometimes key when a commission needs to bring an artist on to a design immediately. Lastly, the pre-selected roster allows community involvement with the selection process because all of the pre-juried artists are capable of working with the agency, and the agency can look to community members for selection.[25]

Jerry Allen uses a two-stage process in San Jose. First, artists apply for a pre-qualified pool, selected by arts professionals, which is available for city projects. During the second stage, the arts commission creates a community group for the project and presents a sampling of artists to the group. The group members then choose the artist with whom they want to work. According to Allen, "the quality control is there because all of these are artists that have been juried in by the panel of professional peers, but a level of community buy-in to the project is emerging on our projects that has surprised even us." While effective, these mechanisms for artist selection reflect a Machiavellian view of manipulating public participation, which planners learned before them.

Gail Goldman, former public-art coordinator for San Diego, has looked at a "call to *administrators*" method, to recommend trusted applicants for specific projects. On the one hand, this encourages communication between agencies to spread the word about new and existing talent, and saves them having to review artists who have worked effectively with public art in the past. On the downside, it greatly tilts the balance toward selecting established public artists available on the national level before focusing on the possibility of local talents.[26]

The traditional RFP, RFQ, and roster methods of artist selection sometimes break down when programs attempt to utilize traditional arts and crafts. Unfortunately, the established thinking "within the box" has left this crafts approach relatively unexplored. The local and vernacular arts are still ignored by almost all public-art agencies, in part because it is unclear how to use the artists' skills and assess their potential contributions. To dismiss local arts and crafts over and over, in favor

of big-name imports, is evidence of the remnants of curatorial snobbery in the procedures of arts agencies. Some reconsideration of the rôle of the artist is required to counter this. In some cases, the rôle has changed from individual visionary to facilitator. Todd Bressi:

> The really agile public-art agencies will be figuring out how to involve [artists *with* local vernacular artists]. The curatorial approach might be to say we want a pavement pattern here, let's get a big name. The grassroots approach would be to say we need a pavement pattern here, there are women in our community who weave kente cloth, let's get somebody who can help them translate their patterns into pavement Where the disconnect often happens is where you have local arts communities who are doing great grassroots things but they have no way of *articulating* what that means when the City is building a fire station.[27]

New approaches should encourage artist- and community-initiated projects, and actively research and engage local cultural resources. Before aping the procedures of other agencies, a commission needs to look within the community to leverage its cultural wealth. In this way, a planning research process can inform an understanding of the community, and refine methods of artist engagement. We outline an environmental profiling technique for achieving this in the appendix at the end of this chapter (pp. 317–20).

Teamwork: artists on design teams

Since the 1970s, Seattle has incorporated artists into integrated design teams as part of its planning process. There are important reasons to incorporate artists into a design team. First, the art should be part of the overall project budget from the very beginning. It is harder to excise it when there is an integrated approach that comprehensively addresses building parts and amenities. The artist's very presence on the team serves as advocacy for the art's survival in the budget, and influences the design process as a whole by bringing artistic, sometimes even thematic, elements into the equation. Because many artists and project managers lack experience in incorporating public art into large-scale projects, the cooperation needs to start immediately to mitigate the inevitable resistance that will form around the practical problem of integration, and the tension over the domains of the different design professionals who may already consider themselves the primary artists. It is not unusual for architects to say that there is no need for more art, since the very existence of the building is the art. More often these days, the architect wants to control the siting of the art, which can either minimize or amplify its impact. Full standing for an artist on a design team can help such projects move beyond coordination to real collaboration, a more important goal.

Importantly, the artist's creative assets have much to offer a design team, from carefully integrated details to commanding, large-scale art of the magnitude of the architecture itself. One key insight that experienced public artists bring to design teams is an understanding of how to enrich and infuse

Artist Kay Kirkpatrick served on the design team for the Southwest Police Precinct building in Seattle, using text from conversations with the police force amid a fingerprint design on glass, among other works integrated into the site's construction. City of Seattle, Fleets and Facilities Percent for Art, 2003. Photos: Peter De Lory.

the project with a holistic approach: to see the project in its entirety and to expand its potential impact. Sometimes, in projects where the hierarchy and responsibility of designers at all levels has been muddied, with bricklayers in the public works department working under contractors in the parks and recreation department, and with perhaps the interference of a mayor or the guidance of a dynamic planner, the artist can step in to provide an overarching vision. Perhaps the misgivings about "design by committee" are born of fundamental flaws in the organization of power. While the interactive processes of public collaboration and design committees themselves are obviously necessary for a respectful and responsible result, powerful leadership is still a key ingredient. It may not be politically correct, or even smart, for an urban planner to dominate the process and set out a rigid sequence of actions. The dangerous alternative is a conglomeration of narrowly focused interests lining up like lobbyists on Capitol Hill to assert their agendas. The burden of creating a coherent artistic landscape, then, falls on the umbrella professionals: artist-planners and arts administrators.

Ideally, artists should know "their place at the table"[28] and be confident about this rôle, according to artist-planner Lorna Jordan. But this is a skill set that comes with experience of working on teams. To explore the arts and crafts possibilities, and weave public art effectively into the fabric of a building project, the artist should be present from the beginning, rather than having to stake a claim in the process once it has been negotiated between design consultants, architects, and contractors. According to former Seattle public-art director Barbara Goldstein, Seattle's innovative program of hiring artists-in-residence for City departments allows these departments to incorporate art slowly into their day-to-day proceedings. Artists have worked in Seattle Public Utilities, in City Light (the electricity utility), in the Department of Transportation, and in the Planning Department. The artists have the responsibility of working creatively with the resources allocated to city infrastructure, and bringing employees "on board." Working with city corporations is not without its risks, however. In 2004, the City of Seattle faced a class action lawsuit regarding, among other things, public-art funding through City Light. Seattle's Percent For Art program is now in the process of changing its relationship to the utilities departments.[29] But Seattle's program has built an open relationship with city government and much citizen support through its creative programming, which included the striking collaboration of the Viewlands/Hoffman and Creston-Nelson Substations.

As Goldstein explains, the design team and stakeholders participate in the artist selection, so that the artist is chosen and integrated early on, and the team works to support the artist, whom they already know. As the first program to accept the challenge of coordinating collaborations between architects and artists,[30] Seattle has learned from its experiences. Seattle's "no shotgun marriages"[31] approach also encourages a strong and collaborative relationship over time between the artist and others on the team. The City selects teams composed of artists and architects who are comfortable working together, having learned whether the friction or synergy going into a collaboration will make a project dynamic or unworkable. Jerry Allen insists on a requirement within the ordinance to engage the artist early in the process. This is not a philosophical issue, but

Creston-Nelson Substation Gate, 1982, Clair Colquitt. This is the second Seattle utility substation to use a design-team approach including several artists. Photo: Seattle Arts Commission, now Office of Arts and Cultural Affairs.

one driven by results. When artists and architects communicate rather than butt heads over turf, Allen says, "the art is usually better The recurrence of 'plop art' often derives from a disconnect between the artist and architect," where the artist is assigned a space to do his or her thing without influencing the larger design.

But there is a more basic reason to bring artists in early: to use the general construction funding from the capital project to fabricate the art, when possible. Since money and construction efforts are already in place to carry out the capital improvements, artists can accomplish the most by far if they use these larger budgets that typically fund generic elements in the infrastructure, rather than sprinkle specific artworks over the top. In Scottsdale, Arizona, the construction of a $97.5 million stretch of freeway was set to be a visual disaster after the state's Department of Transportation eliminated funding for aesthetic enhancements. The City of Scottsdale elected to pitch in for the aesthetic components for the community's sake, eliciting $2.15 million in capital improvements funds in 1996, including the cost of constructing and painting highway retention walls. This generated a fee of $40,000 for public art. The team, led by artist Carolyn Braaksma, along with an engineer and landscape architect, used the already implicit materials costs to pour concrete and paint the textured designs along the 6 miles of highway (see pp. 42–47).[32]

A project of this scope is impossible without coordinating resources. But communicating with contractors, project managers, and engineers, and winning them over to the idea of sharing time and effort, is a skill all of its own. When Jerry Allen worked on the Dallas Convention Center, he found that they had just $250,000 allocated for public art because the construction was budgeted before the Percent for Art ordinance was defined, and he faced a resistant client. Allen explained: "So [we told the team of artists] the $250,000 is your design fee, now go find something in the project that will become the art. So they created a 140,000-sq.-ft terrazzo floor that tells all of the multiple histories of North Texas, by using the budget for terrazzo that was already scheduled into the construction project."[33] In the end, $4 million was spent on the art. Artists Garrison Roots, Norie Sato, Phillip Lamb, and William J. Maxwell designed terrazzo floors for the convention center, with the support of Margaret Robinette at the Dallas Office of Cultural Affairs, and project manager, artist Brad Goldberg. Allen adds that this is a good example of the public art feeding back into the value of the total project. Convention center brochures highlight the art contribution and use it as a selling point. Planners, he says, have to make the connection for city officials and developers between the value of the art and the *value added* to the project.

Seattle also sometimes hires "lead artists" to oversee the artistic opportunities in such large-scale projects as their Justice Center and City Hall. These artists work on the design team and also

Dallas Convention Center, 1994. Artist Garrison Roots used imagery from the local environment in his terrazzo floors. Photo: courtesy of the artist.

develop art plans. They create site-integrated works through a collaborative process, identify art opportunities for other artists to execute, and coordinate the team of artists. While not having a specific commission of their own, they are able to give a broader vision.

In San Jose's Capitol Expressway Light Rail expansion, the Valley Transportation Authority will hire an artist to oversee the system in its entirety, and, along with local and emerging artists, to create public art in individual stations. Having an experienced lead artist managing the planning or subsidiary art projects allows a program to take risks with new artists who may be approaching their first large-scale or public work. Rather than allowing fear to govern the selection process, programs are free to choose a new artist when assured that he or she can rely on the mentorship of a team leader who has learned lessons through trial and error. Artist Jack Mackie enjoys taking on this rôle on some projects, while working on design teams in other communities. Mackie worked on the team to write the "aesthetic guidelines," including a process of community research. He held meetings with community members, bringing examples of art and architecture that the project could include, and bouncing ideas off the public. He also asked the community questions about its character and identity.

For Mackie, the rôle of artist-planner allows him to share his experience as part of a support network for artists attempting to work within a complicated system. He speaks about his experiences before the artist's rôle was recognized in a design team: "The first design team I was on, I had no idea what I was doing. I spent the first month convincing the landscape architect that I wasn't trying to put up a piece of sculpture anywhere. That resulted in the *Dance Steps*." Since this famous 1982 example of art integrated into the streetscape, artists have gained more recognition on some design teams, although there is still a fair amount of advocacy required in every project, if only to convince a contractor of the piece's constructability. But behind every public artist is a support network. Mackie said: "I went to city engineering and told them I wanted the dance steps to have a quarter of an inch variation from grade. They said no, it has to be absolutely flat. The architect told me, 'Jack, we'll handle this.' They went outside with a camera and shot all of the city's sidewalks that aren't flat. They came in and negotiated with the engineers, saying, 'If Mackie has to make this stuff flat, the City has to as well.'" By assisting artists with everything from reading contracts to talking with fabricators, Mackie ensures that art programs are free to take the risks with new artists that the Seattle Arts Commission took with him.

Holistic approaches: infrastructure and public/private partnerships

Seattle's program is also particularly successful because it engages streetscape and infrastructure as basic parts of its public-art strategy. Collaborations and ongoing relationships with various City departments have resulted in a variety of creative projects. Seattle is lucky enough to be served by two outstanding public-art organizations, both through the City of Seattle and through 4Culture (formerly the King County Arts Commission), which administers the county's Percent for Art program, and works for-hire with communities throughout the region.

4Culture is known nationwide for its creative approaches to administering public art. Since it branched off from the county government, 4Culture administers arts, heritage, preservation and public-art programs. One of the projects that brought the most attention to the former King County Arts Commission is the Artist-Made Building Parts (AMBP) project, started in 1992. Looking to *The Guild Sourcebook*, a national inventory of craftspeople, King County Arts Commission compiled a resource guide of craftspeople and artists who wanted to get involved with construction projects. According to former administrator Glenn Weiss, he wanted to include the crafters and fabricators

who had been left out of public art because of curatorial bias, as well as simply bring cashflow to local artists. There was a need for crafted products but no communication between the construction industry and the arts community. In a few cases, artists were even able to outbid general fabricators on projects with unique requirements.[34]

In Weiss's view, the greatest accomplishment was the connection forged between the contractors and the crafters, which reaped benefits on small and informal opportunities that ordinarily do not go out to public bid. Construction managers began to look to artists as well as contractors to price out small-scale projects. According to Cath Brunner, the AMBP project was a "'Trojan Horse' approach. First you see what an artist can do on a handrail, then a plaza, then an environment."[35] With opportunities for greater material quality and workmanship, art seeps its way into community development; the relationship between artists and contractors is built from the ground up. Brunner also saw the roster as a way to "stimulate imagination," serving as a reminder of the creative engagement with the larger built environment that sometimes appeared relegated to the past. With an annual investment of $20,000, the program requires an RFQ every three years, and pricey maintenance of a website and color catalogue (distributed free of charge to area contractors and designers). But it has brought in more than $5 million in artist work above the required 1 percent that 4Culture manages.

One example of a public/private partnership using the AMBP roster is the King Street Center. This building, constructed in 1999, is used by the county as well as private developers. An arts advisory committee managed the design elements, and formed an artist selection sub-committee, which chose artist Maya Radoczy to do glass art, and Nick Lyle and Jean Whitesavage to craft the breathtaking and locally orienting *Rainforest Gates* (see below and p. 266). Also, artist Jack Mackie designed a user-friendly, art-infused plaza as part of the design-team effort. The general contractor installed Mackie's plaza, working ingeniously with a modest budget. The roster's success has flourished with work and dedication, as its impact has rippled through the community. Establishing the program in its infancy took much legwork. Brunner said, "We tried to do one good project at a time." While some arts administrators balk at the idea of pleading with developers to take a chance on art, Brunner says that finding the right partners was the key to their success. "We don't try to influence every project. I know how to convince project managers to use artists. You do it by seeking out people who

Detail of *Rainforest Gates*, Jean Whitesavage and Nick Lyle, 1999, part of the King Street Center public/ private partnership. Photo: courtesy of 4Culture.

want to do it, people who have pride in what they do. We appeal to their professionalism."

The work commitment is real on the part of both the administrators and the contractors. Sometimes this means that a contractor must come up with a material budget earlier than normal, or even break down the budget much further than would ordinarily be necessary in order to determine "construction credits," or the amount of money a project would have spent anyway to pay for a single element, such as stainless-steel railings. This funding, often married with some additional art money, can then be turned over to an artist to complete the same element but with custom-made detail. Brunner believes that "people who want to do a great job aren't scared off by the work of it." This positively affects the developer's bottom line and gives builders the chance to do exemplary work. Jack Mackie's plaza won a concrete award, which 4Culture assisted the contractor in applying for. According to Brunner, these professional results create a culture of competition and support for the arts among the building and developer groups that operate in the region.

Slowly, programs across the country are making strategic use of infrastructure opportunities, but this requires intense cooperation. Some types of project, such as transportation and wastewater treatment sites, require a team approach, says Cath Brunner. When engineers, architects, artists, and landscape architects come on board, early coordination is key, and is often only possible when mandated by a thoughtful plan. While not all designers like the idea of collaboration, they get used to it once a program has been established. Artists also create an impact on the master strategy even if there is no discernible art product, according to Brunner. The process of a team, including an artist, elicits a deeper understanding of design issues in the overall discussion.

In the greater Seattle area, 4Culture has come in to administer the Brightwater Water Treatment Plant arts component even though it falls just outside their home base, King County. With projects so deeply integrated into facilities that many citizens have never associated with art "enhancements," there have been some detractors along the way. But, according to Brunner, prior projects have set a strong precedent, and now even small communities approach her when word of developing new facilities first breaks, such as with a smaller water treatment plant in rural Carnation, Washington— a town with a population of 1843. They want to know, "What's *our* art component going to be?"

To this end, some programs, like the one in Arlington, Virginia, have moved toward integrating arts planning into the overall city planning process. But many programs still do not engage the infrastructure, even if they would like to. This is a daunting task for a small arts program used to working alone on isolated projects, removed from other departments. However, this misses the greatest source of growth available to public-art programs if they only know how to access it—the regular construction budget. In some areas, such as Seattle/King County, collaboration has become accepted as a requirement. In other regions, such as South Florida, where there is no political cooperation or a can-do attitude, collaboration is almost impossible, according to Glenn Weiss.

Planning can also ease the conflict between a community and the forward march of development, even in a rural environment where residents are accustomed to having little interference with their land. In Danville, Vermont, a mandated highway reconstruction to update the main road through the small town (population 2211) threatened to have the community up in arms. The townspeople were concerned about pedestrian safety; about compromising the village green; and about the destruction that comes as part of any construction development. The village was able to express its priorities and values in a time of change, using a collaborative process guided by the Vermont Arts Council with artists David Raphael and Andrea Wasserman, through a local review committee and with the Vermont Agency of Transportation. Using the Vermont tradition of public meetings, the artists and

RIGHT *Luminaries*, 2003, by Norman Courtney elaborates on the Art Deco style of the King County International Airport terminal. Courtney was selected through the Artist-Made Building Parts roster. Photo: Spike Mafford.

BELOW, RIGHT AND BOTTOM As part of a design team, renowned public artist and artist-planner Jack Mackie created the award-winning plaza for the King Street Center in 1999, working with the Artist-Made Building Parts roster through collaboration with a private developer. Photos: courtesy of the artist.

engineers came up with a process of meeting the technical standards with a context-sensitive and respectful dialogue, which they envisioned as a model for other communities facing the common challenge of upgrading their transportation infrastructure. The process specifically tapped into the potential contribution of artists to the creative design process, but, more significantly, benefited from their facilitation of an ongoing and productive community dialogue. In fact, the project sought to demonstrate that the use of artists early in the design process actually saves money over the life of a project.[36]

The local review committee selected an "acorn-style" lamp for the streetlights, from a number of historical options. They also chose stone benches as well as classic metal and wood benches, and helped determine a plan for renovating the village green's bandstand and landscaping. Drawing on the area's agrarian past, granite posts like the ones historically found here will be enhanced to tell the story of the town, throughout the reconstructed zone and on the village green. As part of the design process, community members selected weather as the salient theme for the art, since the dramatic climate of northern Vermont has been such a significant force in shaping the character of the community. Artist-designed markers contain weather-related metal ornamentation and bas reliefs or photographs reflecting aspects of the community. Additionally, a carved marble map of nearby mountains will orient locals and tourists alike. Gateways along the small highway will announce the motorists' entrance to the town. Construction is slated to begin in 2007.

The Cultural Arts Council of Houston and Harris County (CACHH) serves both the city and the county. CACHH, like 4Culture, is part of a new wave of arts agencies that have officially split from the government, and manage the Percent for Art programs as private organizations. This allows for a broad scope in considering the entire region's cultural needs, and how to manage them holistically. For example, 4Culture and Portland's public/private partnerships can address cultural resources for the region, while also taking on the management of some individual towns' public-art programs, drawing upon experience and resources that small communities cannot normally command on their own.

Maps as art planning tools, from *The Houston Framework*, produced by the Cultural Arts Council of Houston and Harris County, with Core Design Studio. Photo: courtesy of Core Design Studio.

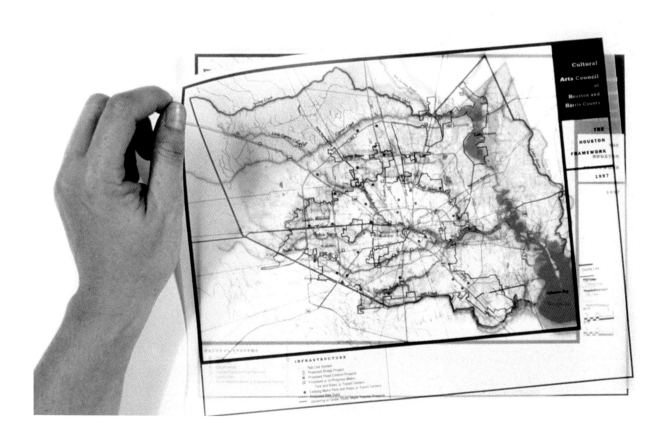

CACHH's master plan of 1997, *The Houston Framework*, cites infrastructure as a key element in public-art planning. The framework uses creative maps to assess the needs and possibilities of public-art projects analytically, arranged by themes. The authors of the plan drew on existing urban plans for areas within the region. They addressed these as maps of interwoven networks, with the region as an entire system.[37] The maps include citywide infrastructure projects, natural systems, and community gathering places. This diagrammatic approach to analyzing spaces is a powerful didactic tool, now used throughout the design professions and perhaps best exemplified by superstar architect Rem Koolhaas's influential books.[38]

The holistic view of arts planning is a revealing phenomenon. The arts agency and the arts planner have taken on hugely important rôles in the community that ought to be shared by all the interested stakeholders. Since nobody in city government is addressing the needs of the public realm as a whole, it comes back to the artists—the thinkers, the dreamers, the outsiders—to ask the pressing cultural questions. Each City department is so insular that there is often no one else to manage the experience of the city at large. Even city planners are diverted from this task, focusing on minimizing the impact of private development on civic life or, conversely, encouraging economic growth through private development. As Todd Bressi puts it,

> Everyone in departments thinks about one little segment of the world, which may be public space, but they don't think of it as public space. Urban designers are trained to think about large-scale architecture whereas the public-art planner is thinking about public realm, public space, public place, and is thinking about it not only as a physical thing but also as a cultural thing. ... In Arlington there are eight parks right next to each other along the creek. They are technically different parks because they were acquired and added to the parks system at different times and managed and planned for as independent units. Why? Go figure. The art plan said forget how many independent units there are. It's one watershed. Take the funding that you have to do art, and use it in the watershed.[39]

The fact that arts planners have this opportunity to reframe the public realm is unique and new. It reflects a crisis in the state of urban design, where all members of a community have ceded responsibility for the public realm. But it presents an opportunity for visionary bureaucrats—art planners—to bring public space back to a human scale, with local cultural values. This requires art to solve problems well beyond its scope, but in a sense it redefines art as *whatever makes up that solution*. This creates openings for new kinds of problem-solving and the reframing of questions. Now is a time when the public spaces that arts administrators and artists fashion must teach our society, anew, the function of places. After many years of portable collections, sculpture gardens, and superficial fixes, placemaking has now truly become the art planner's foremost goal and obligation.

Percent for Art in private development

As cities and towns begin to seek more creative funding sources, and partnerships with developers who are profiting from changes in their communities, more are engaging Percent for Art in private development partnerships. These initiatives require developers who are working over a certain budget to pay for public art, or contribute to a pooled fund administered by a local agency. In 2005, fifty-three programs incorporated a Percent for Art in private development programs, an increase from thirty-nine in 2003, many in California. Although developers typically throw up strong opposition to any measure increasing their cost of doing business, a growing number of communities have found ways around this obstacle. When Jerry Allen works with a community to develop a public-art plan, he often finds a desire for private development initiatives. One solution that he has found to obtain

City support for the ordinances is to work with developers on the plan, particularly ones who ordinarily support the arts and who voluntarily add public art to their developments, seeking to add value to the project and the community. Some programs, such as Seattle's, allow or encourage developers to contribute money to a public-art fund rather than incorporating art into their own developments, so that the program can better coordinate the city's developer-sponsored art.

Obviously the thrust of the planning, as well as the details of execution, varies from community to community. Some ordinances only assess the public-art requirement to private commercial buildings, some to residential developments over a certain value, before obtaining a building permit. For example in San Jose, 2 percent for public art is allocated from capital improvements, 2 percent for commercial developments and 1 percent for non-residential developments costing over $5 million. At the other end of the spectrum, the modest community of Capitola, California (population three thousand), obtains all of its public-art revenue from a giant mall and from tenant improvements. This provides $60,000–70,000 per year that is reinvested in community public art. Art from private development may be an effective tool with which to gain some recompense from the placeless mega-malls stamped on to the American landscape, for communities that don't have the political or design expertise to address this problem directly.

Even without a requirement, some developers learn that art has the potential to add value to a site, both culturally and fiscally. In King County, Seattle-based company REI, a retail outfitter, used the Artist-Made Building Parts roster to solicit artists who could enhance the flagship store. Seven artists created a narrative about the company and brought design awards and media recognition to the store (see pp. 260, 268). This collaboration brought attention to the AMBP program, the artists, and the company, as well as contributing to an attractive design feature.[40]

Maintenance

Many programs, including those in Seattle and Broward County, have begun to analyze the key issue of maintenance in their plans. "In an ideal world, planning for maintenance would begin at the same time as the inception of a public-art program," says Seattle public-art manager Ruri Yampolski.[41] The importance of long-term planning for routine repair costs and deaccessioning procedures is increasingly apparent as programs mature. They are faced with the costs and concerns of ageing public art. Because issues of conservation, artists' rights, and deaccessioning are potentially controversial and sensitive, it is even more important to follow a well-conceived methodology.

Some pieces, such as Isaac Witkin's *Everglades* in Springfield, Massachusetts (see p. 331), continue to suffer vandalism with no provision for maintenance. It must be part of a commission's projected budget from the start, as difficult as it is to squeeze in this funding when the results are not immediately apparent. Contemporary public artists look for creative ways to integrate their works into the landscape, often using non-traditional materials, which can sometimes become maintenance nightmares far into the future. Projector bulbs that may cost $3000 can blow unexpectedly, and must be replaced quickly. In Seattle, one projector for an artwork in the public library was installed in an inaccessible location above a nine-story atrium, which caused great difficulty when the bulb very quickly burnt out.[42] The Arts Council of New Orleans requires all artists to consult a conservator who will devise a maintenance plan, which becomes a permanent part of the project file.[42] Considering conservation before an artwork is even erected may seem like jumping the gun. In fact the *normal* wear and tear on public art can turn a local gem into an eyesore. Consequently, conservation should become a part of its conception from the start.

The Visual Artists Rights Act

The federal Visual Artists Rights Act of 1990 (VARA) changed the terms of contract between arts agencies and artists. The act protects artists' "moral rights," or claims of authorship. This requires that an artwork be attributed to its artist(s). More significantly for public art, it also states that if an artwork is altered, damaged, or pulled out of context, potentially damaging its integrity or an artist's reputation, the artist can dissociate from it. It also requires that the artist be notified when the work is being deaccessioned or moved (in the case of site-specific art). Rather than throw the art in the junk heap without any notification, building owners or agencies must give the artist the chance to reclaim ownership of the piece if he or she can move it from the original setting. There is also protection against negligence, although normal wear-and-tear is not covered by the law. This amounts to little more than common sense, but only applies to works of "renown" by artists of "recognized stature" created after 1990. It does not affect the copyright, and artists can be asked to waive their VARA rights. There is an additional exclusion for works incorporated into a building, or works for hire. With so many exceptions, it is difficult to know what will be the long-term impact of this legislation on public art.

According to Cath Brunner, one immediate and unfortunate outcome was needlessly to scare the building community away from commissioning art, out of fear of losing control over properties. Since then, some education in the field has helped allay concerns.[44] This has affected the practice of muralism, protecting some artists from building owners who are uninformed or dismissive of the rights of the muralist. It has also frightened some building owners away from even allowing artists to fund their own murals on their sites. Some programs, like Joliet's successful Friends of Community Public Art, now create some of their murals on signboard, which can be removed for maintenance or if a building is sold or torn down.

On Boston's shoreline, Fidelity Investments and its subsidiary Pembroke Real Estate, Inc. leased a large parcel of land from the local managing authority Massport. Pembroke agreed to develop the parcel and to design and construct two office buildings and a hotel. The company also agreed to design and maintain a 1½-acre park adjacent to one of the office towers. The park was to be open to the public twenty-four hours a day, seven days a week.

During the design process, landscape architects Halvorson Design Partnership fought detail by detail for their scheme for the public space. Three artists were chosen to contribute artwork to the park. Sculptor David Phillips contributed the bulk of the artwork: twelve pieces of representational work and fifteen pieces of abstract art. The park opened to public acclaim, and building employees and tourists frequented the space. About two years after the nearly $5 million park was finished, Pembroke decided to redesign it.

First, the company wanted to move the entire park to a Fidelity campus in Smithfield, Rhode Island, and when Phillips protested the proposed move, Pembroke offered to keep some of his work but rearrange some of his other work in the park. The second solution was even more abhorrent to Phillips than just moving the park away from its urban, public location by the shoreline.

Hesitantly, he sought the help of the Volunteer Lawyers for the Arts. Boston attorney Andrew D. Epstein agreed to help Phillips bring Pembroke Fidelity to court. Epstein brought suit in the United States District Court for the District of Massachusetts under the provisions of the Massachusetts Art Preservation Act (MAPA) and the federal VARA. The federal judge refused to issue an injunction under VARA but did issue an injunction under what she considered the broader protection of MAPA. She determined that most of Phillips's abstract work in the park, along the northwest–southeast

axis, was "one integrated work of visual art" entitled to protection under both MAPA and VARA. The federal judge further found that Phillips's work was site-specific, that is, the sculptures had a marine theme that integrated them with the large granite stones of the park, and with the granite seawalls of Boston Harbor. The court said that Phillips incorporated the harborside location of the park as one element of his art. However, it found that Phillips's work was exempt from protection under VARA because of a narrow exception that provides that the site of a work is not safeguarded under the federal statute. The court did find that Phillips's work was protected under the broader definitions of MAPA, and issued an injunction under the state statute.

Pembroke appealed against the federal court decision under the state statute to the Massachusetts Supreme Judicial Court. Pembroke claimed that the federal court misinterpreted the Massachusetts law, which had never before been fully litigated. The Massachusetts court agreed with Pembroke and stated that such site-specific art as that of Phillips was not protected under MAPA. Epstein disagreed with the Massachusetts court, but since the Supreme Judicial Court is the highest court in the state, Phillips is bound by its decision. Epstein has appealed against the ruling of the federal court to the First Circuit Court of Appeals, and the case remains pending.

The outcome of the Court of Appeals case may ultimately determine the future of site-specific work. When the dust clears, Pembroke may very well put Phillips's art in a storage facility far from public view. Both Pembroke and Fidelity benefited from an abundance of positive press for the public park and the privilege to lease and develop the state's shoreline property, on the condition that they maintain the park for public access. Yet the initial redesign is much less welcoming to the public, and it is bewildering why the company designed the park the way it did, only to change direction soon after construction and dedication. Phillips fears that his work will soon disappear, although he and Halvorson Design Associates still continue to receive frequent compliments from the public about the park.[45]

It is important not to instill fear in the hearts of businesses that want to support the arts, but they must come to understand that if they bring art into their premises, whether mandated or as an act of philanthropy, they must take on certain commonsense obligations. This means relinquishing some element of control—a prospect that businesses often find confounding. That arrogance is predicated on the fallacy that businesses operate in a vacuum, without having to attend to the needs of the communities around them.

VARA has encouraged cities and property owners to think about the buildings that they lease and acquire, and to consider their responsibilities to the artists and artworks. According to Ruri Yampolski, VARA forces agencies to review potential changes to a site in the future, and what impact this will have on the art.[46] This concern is rather elemental; other administrators, such as Glenn Weiss, are attempting to address it simply for the sake of the art's longevity, without recourse to legal action. While the law adds to the many conflicting factors juggled by an arts agency, Seattle attempts to keep artists' VARA rights intact rather than asking artists to waive them. 4Culture also maintains artists' rights, and works within contracts to prepare for inevitable shifts in the future. If a site needs to be changed, or an artwork altered, 4Culture agrees contractually to hire the artist to provide advice and help with the transition.[47]

Brunner sees this agreement, and the other outcomes of VARA, as opportunities to engage with site owners in a discussion about the presence and importance of art. The law does not require facilities to keep art, but merely to remain aware of its presence. Sometimes the requirement is nominal. According to Brunner, "nine times out of ten, you take a look and the consensus is that it is not a significant work," and there's no need for further trouble. But she feels that the dialogues that emerge from these encounters have been fruitful, even if the outcome is simply to put the brakes on a raze-and-rebuild reflex for one brief moment, and inject the *sensibility* of preservationism into

a forward-paced world. The legal protection for the right of attribution has simply proliferated little placards around the country. But Brunner sees the deeper significance of this credit-card-sized requirement. "We've come a long way toward identifying what our cultural resources are."

Learning from pitfalls: moving forward as a profession

After twenty years, public-art administrators are in a better position to anticipate problems before they develop. In times of controversy or failure, commissions do well to have a strong procedure to fall back on. Many of the hurdles that arise are symptoms of a systemic problem: a lack of communication and understanding within the community. To alleviate this, commissions have begun to build political allegiances and relationships with citizens *before* problems arise. Sometimes this involves attending community group meetings or city council meetings regularly, to make their presence known *even before* lobbying for funding or specific projects. This also requires proactive and sensitive public relations, with a focus on accessibility and outreach. Public relations is yet another hidden overhead cost associated with commissioning, added on to creating public art.

According to a sampling of public-art administrators around the country,[48] pitfalls cluster around the same core issues, and their solutions are consistent: ensuring early coordination of artists in the overall design, and involving the community in the public-art commissioning process. Another often-overlooked consideration is the cost of integrating art into public spaces, which transcends the art budget. Early coordination can mitigate this cost. This trend toward integrating art into architecture and infrastructure has demonstrated itself across the country as a way to invest in the cityscape, and to employ placemaking techniques effectively. From bus stops in Tempe to tree grates in Louisville, integration strengthens the environmental connection by utilizing the larger armature of public works that every community pays for.

Planner Glenn Weiss has been frustrated by commissioning public art that winds up at odds with the public space where it is sited, sometimes just because of small events like the failure to trim plantings. Simple landscaping of public spaces can dwarf, minimize, or totally compromise the impact of potentially prominent artworks. This conflict of efforts stems sometimes from the constraints of the site, and sometimes from different administrators holding opposing visions of the space. This lack of coordination between public works and public art is symptomatic of a failure to approach the design of public spaces holistically. In order to make sure that pieces are well sited, Weiss created a form for artists to fill out during their design process and final proposal, declaring the essential environmental factors that the project requires for success. Acceptance of a proposal, therefore, comes with an understanding of what other elements need to work in concert.

In 2003, artists Carol May and Tim Watkins installed *Dream Song*—painted steel kinetic sculptures—in Halpatiokee State Park in Martin County, Florida. A backdrop of green trees provides a contrast to the brightly colored sculptures that is necessary for the particular visual impact intended. Weiss required the artists to include an environmental context statement in their initial application, which was approved by the parks department, although unfortunately the upkeep is not required to appear in ensuing maintenance plans. Weiss was able to convince the parks director to state a

There is an ongoing battle between the client, Fidelity Investments, and prolific local sculptor David Phillips over his work at the company's Eastport Park plaza in 2000. Photo: courtesy of the artist.

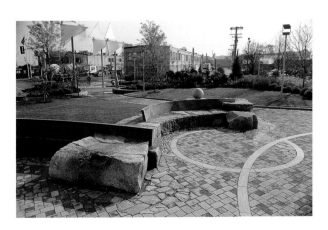

commitment to keeping the bank of trees as part of the relationship with the artwork. This problem is not unique. As artworks become integrated into public works in City departments and throughout civic infrastructure, artists and programs face new challenges. While artists cannot require City departments to maintain an artwork's surroundings, VARA laws protect an artist's rights to dissociate from the work if the change renders it a professional embarrassment. Apprehension from risk managers can hold a community back from engaging with integrated public art. According to 4Culture's Cath Brunner, artists and commissioners can become familiar with risk management to counter this concern and educate city officials about real and perceived problems.

Weiss recognizes that a promise from the parks department will not prevent changes in the long term, as a legal easement protecting a view corridor would, and he feels that it would be impossible to gain the necessary support for such a contract. However, Weiss says that it is important to register these considerations on the system, since they are often even more crucial to the success of the artwork than materials and maintenance. These considerations should be part of standard "environmental profiling," as detailed in the Appendix below, to avert avoidable problems arising from a site's given context.

Regarding approaches to planning, methods differ from community to community, based on politics, constraints, and values. When Jerry Allen first started writing public-art plans in the 1980s, he found that communities simply asked for a copy of Seattle's ordinance and adopted it wholesale. Besides the fact that this ignored the political groundwork and budgetary context of the city with the newly transplanted ordinance, it also neglected to gain the support and understanding of the parties involved, including the mayor, city council, planning department, and contractors.[49] Moving between areas of the country, art planners, such as Glenn Weiss, have found that what works easily in one political climate can prove difficult in another. So planning is an individual process, adapting the arts strategy to the community's priorities, capacities, and unique challenges.

When the Cambridge Arts Council (CAC) in Massachusetts was incorporated as a nonprofit organization in 1976, two years after a City ordinance guaranteed its funding, City departments made it purposefully difficult for CAC to inspect their budgets, in order to avoid the Percent for Art mandate. This type of resistance can emerge with any bureaucratic change, and its basic remedies are a strong ordinance and a planning process that brings City departments into the fold. Today, CAC manages a street performers' program, community art grants, two city festivals, a gallery, and a Percent for Art program (a rarity in the area). Commissions have found other ways to work with difficult City departments, most importantly the establishment of a public-art fund.[50] This allows departments to fulfill their Percent for Art obligation without going through a public-art process, by contributing the required amount into the fund, in the same way private developers often do to fulfill percent requirements. This money is then pooled to work on ongoing efforts elsewhere in the community. One hopes that as arts commissions establish a body of positive experiences around the city, departments will be more open to fulfilling their "percent" requirement the old-fashioned way, which ultimately reinvests their money in their department.

This has proved true in Seattle, where collaboration with City departments is a key part of CAC's groundbreaking work. According to Lorna Jordan, a former artist-in-residence, having an in-house desk and a departmental email address facilitated open communication and collaboration, from casual chats to frank and fruitful confrontations.[51] As with many groundbreaking programs, the public utilities percent funding has come under fire in Seattle, and has been included in a class action lawsuit questioning whether "ratepayer" funds can be spent on artwork that benefits the

general community. In late 2005, the Washington State Appeals Court upheld the Percent for Art ordinance as it relates to the City Light utility's participation, but also agreed with the lower court's stipulations requiring a "nexus" between the art and utility. While the public utilities programs are rescinded in their old form, the strong links that the public-art program has forged with this City department will, it is hoped, lead to new opportunities for collaboration. As a result of the bonds created with City departments, through the appeal of the lawsuit, Seattle's public-art program had an understanding with the water utility to fund art projects without any mandate.[52] In 2005, artist Daniel Mihalyo also completed a residency to produce an arts plan for the Seattle Department of Transportation.

Another major change over the past twenty years has been the growing base of artists with experience and training in *public* art. For planners and consultants, the breadth of strong examples can bring a skeptical community on board through meetings and slide shows. Where once it took a financial and attitudinal risk for a community to jump into public art, it is now easier to see enticing examples of art that reinforce confidence. Experienced public artists have a number of advantages. Many have worked within architectural and engineering constraints. Many have worked with community groups through dialogue, education, and outreach. Some specialize in projects that engage the community as part of the design process. This is particularly important for placemaking art, where often a community is the only bearer of its own (oral) history, or where the highest aspiration for the work is to draw out a connection between the community and the place. This cannot function with opaque metaphors and without an engagement of the people who encounter the art day-to-day. With more experienced artists, one also finds increasing numbers of artist-designer teams, where architects, engineers, and artists develop long-term working relationships and strong collaborative rapports.

The principal evidence of growth and maturation in this field, according to Jerry Allen, is that the many experienced artists and administrators provide a base of knowledge, and each community does not have to reinvent the public-art process on its own. Still, more experience globally does not translate into an effective public-art process locally. Even with a solid public-art plan, new agencies should be wary of biting off more than their inexperienced staff can chew. Todd Bressi points out that having a plan does not mean that an agency can accomplish a multimillion dollar project in its first few tries. This may not be a matter of incompetence, but the simple fact the agency has not had

Carol May and Tim Watkins,
***Dream Songs*, 2003. Photo:**
courtesy of Martin County
Public Art.

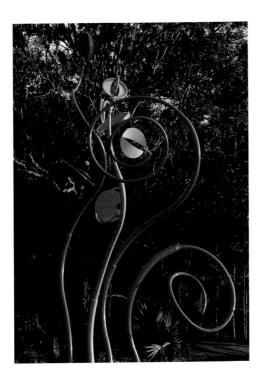

the chance to develop strong bonds with other important government agencies essential in facilitating major projects.

The overall asset of more experience nationwide makes projects run more smoothly, but Glenn Weiss believes that this can come with some potential drawbacks. The power of the early work done in the field of public art was in the creative problem-solving and can-do (or must-do) attitudes that the artists shared. Now he is disheartened by what he sees as an over-professionalism rather than the entrepreneurialism that jumpstarted the field. He sent out a survey around the country for names of artists who had done works for over $50,000, and was horrified that all of these major commissions were going to a small group of twenty artists, who were charging increasingly high fees and choking out opportunities for smaller-scale artists. This professionalism is a double-edged sword; on the one hand, it is difficult to conceive of hiring an inexperienced artist for a project with such a big price tag, but on the other, with 350 arts agencies in the US, there is a need for experienced artists dispersed around the country to explore local needs. Local artists have both firsthand knowledge of placemaking nuances, and an established rôle within a community. According to Jack Mackie, not all up-and-coming public artists need the skill set of a seasoned professional, but they have to know when to ask for help. While the national expert planner can leverage key authority and perspective in public-art strategy, the sometimes skeptical attitude of the public toward professional artists can be tempered by the credibility and familiarity that only locals possess.

Furthermore, the best advocates for the arts, especially in traditional or conservative communities, are the local artists themselves, who animate public spaces and foster personal connections between citizens and the arts. There must be opportunities for local artists to make a living from the local economy's support of public art. If all the great public artists must live in Seattle and New York, then this is not a useful measure of distinction for public art. The field requires excellent products, administered continually and fostered in cities and even villages scattered across the country. For people to view art as approachable, woven into the fabric of their communities, they need to see a living arts culture locally. According to Weiss, the public-art field now shows biases against artists who don't know how to "talk the talk," or who don't appear to do work in line with the contemporary standards of public art. While these standards may seem canonized today, they are in fact a recent phenomenon, since all public-art methodology was generated by creative improvisation less than twenty-five years ago by administrators who valued ingenuity. This bias can work productively toward encouraging excellence in execution, but when the insider's circle ignores the local character while seeking to impose a cadre of nationally recognized artists, this professionalism can prove self-defeating. Cath Brunner notes that there has been a tendency recently to ask artists to do the work of arts administrators, handling bureaucratic details and contractual issues because the client doesn't have the professional staff to administer the project. This is a poor use of an artist's time, according to Brunner, and often a trap for artists, because those who are adept at administration come to divert more of their time and energy toward it and away from the practice of making art.

The other sign of the field's professionalism and maturity is the emergence of educational programs focusing on public art. These days, departments of art or architecture are increasingly offering classes in public art, such as those at the University of Washington, University of California San Diego, and Wake Forest University,[53] where students can learn to work with a client group. Master's programs in public art have also gained momentum, and graduate certificates in public art, such as the one at Arizona State University, can supplement degrees in arts administration. It is

too early to tell what the contribution will be from artists and administrators trained in public-art schools. But the academicizing of public art has provided a medium for discourse on the problems in the field.

Some arts commissions now consider self-reflection and sharing their wisdom to be part of their responsibility, and their business method. Programs with seasoned administrators are releasing their guidelines and other pedagogical material. San Jose has published a resource guide, and Seattle put out *Public Art 101*, a curricular guide to the operations of a public-art program in 2001, based on conferences of the same title held in Seattle in 1998, 1999, and 2001. Recently, Barbara Goldstein has edited a compendium of practical information, *Public Art by the Book*, to provide uniform information to the many programs around the country that have solicited her help. In 2002, Hafthor Yngvason of Cambridge Arts Council edited a practical volume, *The Conservation and Maintenance of Contemporary Public Art*. Also, Phoenix's extensive, established, and renowned program published a sampling of twenty years of its public art in 2005 to serve as a guide to other communities.[54]

Another key medium for communication between public-art professionals is the Public Art Network (PAN), an initiative of Americans for the Arts, a national lobby in Washington. PAN releases a program guide every other year that details the public-art programs around the country and their vital statistics. It also organizes an annual pre-conference to the Americans for the Arts convention, a time when public artists and administrators gather to share lessons and accomplishments. A Year in Review slideshow also disseminates information about the strongest projects nationwide. This is particularly significant in a field where evolution occurs slowly, spread out over fifty states and hundreds of communities. Free downloadable PAN documents outline artist selection guidelines and a "call for artists" resource guide. But most notable is PAN's use of new media to connect arts professionals. The PAN email list has 350 member subscribers, mostly arts administrators who use the tool to put out calls to artists, ask questions about legal issues, discuss controversies, and perform research on timely subjects. Digital media have brought artists and commissioners closer, with downloadable images being ten seconds away by email, and free web venues for advertising RFQs opening up the lines of communication nationally and internationally.

Systematic research: the environmental profile

Many now-mainstream placemaking techniques (such as using urban-design objectives to guide public-art commissioning) appeared in the *Place Makers* books of 1981 and 1987, during the early history of public-art administration. One of the few techniques that has not yet been adopted in a direct and widespread manner is the process of "environmental profiling," or the systematic gathering of information to instruct an arts commission and artists about community needs. Some programs conduct a form of profiling, including Kansas City, New Orleans, and Broward County.[55] Others, like Seattle and 4Culture, have research and review processes built into their commissioning procedures. There appears to be a general aversion to the concept of setting forth themes for public art, which comes along with a fear of encroaching on artists' creativity. Ultimately, when the rôle of the public artist is clearly defined and not the subject of mythology and controversy, the artist's substantial contributions speak for themselves. Environmental profiling facilitates projects related to urban design, coordinated responses to community needs, and distribution of major funds, although it may not be possible to profile for a spontaneous or *ad hoc* project.

Broward's Parks/Land Bond Master Plan exemplifies an environmental profiling process, compiling copious data on the environment of the region as well as indigenous, demographic and

ecological history. It also sets out goals for specific projects and themes that will unfold with public-art commissions in the county, in this case rooted deeply in environmental issues. Still, this is a master plan rather than a profile created from a team of the region's constituencies. Environmental profiling can serve arts commissions, especially when addressing the needs of public spaces or aiming to satisfy particular urban-design objectives. Profiling is also handy when coordinating a scheme of projects or a sequence of related commissions, such as an airport master plan. Agencies can also use environmental profiling to assess the cultural needs and issues in a community, addressing them more systematically through public art, as planner Glenn Weiss has begun to do in towns in Florida. Such profiling ensures that place and placemaking information are a part of the commissioning process, and that artists, arts agencies, and community members are on the same page when determining what will be meaningful, resonant, and possible.

The goal of the environmental profile is first to produce a clear and concise statement about site information, contextual constraints and opportunities, local artistic resources and craft traditions and a behavioral analysis of the site usage. This material, called "the brief," then becomes the bedrock for mining themes and metaphors that can generate some community validation and become a catalyst for both stimulating artistic creation and providing a framework for evaluating the content of artists' proposals. The metaphors and themes may be first identified or later confirmed in community meetings or workshops. The content behind public art requires *some* consensus among community members. Like planning, profiling is an opportunity to garner consensus and understanding of what content a community wants or needs.

The environmental profiling process becomes a means of community empowerment because it puts the community in touch with the sources of its own identity. It also encourages artists to produce within a context that respects that identity or potential identity. This idea is already in place in many public artists' research processes, which can produce rich results, but foists the community relations and time burdens solely on to the shoulders of the individual artist. This is unfair to artists and to communities whose needs are not systematically accounted for. Ultimately the profiling should not inhibit artistic creativity, but rather challenge it, giving the artist informational grounding with which to build lasting and resonant work. An arts commission should have a procedural way of incorporating this process into the initial stages of a project. The agency should build consensus and vision among its constituency, which it can establish through the creation of a formal environmental profile document.

If the goal of the environmental profile is to produce a clear and concise statement for both the creator and the commissioning body, then the objective is to do this in a way that acknowledges economies of time and resources so that the process can meet the budget of the commissioning body with modest funds. The process outlined here depends chiefly on coordinating local resources and allowing time for public feedback, so that many diverse interests are at least considered, if not always accommodated, during the process of commissioning public art.

Appendix
Environmental profiling procedure

1.
The team

- A local historian
- The designer of the space (if the art is not commissioned concurrently with the space)
- One or more community chroniclers; people with long memories who can reflect the oral history of the community
- A community leader with long-term proprietary interest in the turf, often someone who could alternately oppose the project
- Several local artists and artisans who understand local craft traditions. These individuals will understand that they are not seeking a particular commission.
- A director of maintenance for the space
- At least one member of the sponsoring agency
- A behavioralist who can analyze the current and potential uses of the space

Where possible, members of the assembled group should be paid small honoraria. In the best of possible worlds, this group would develop the profile before a particular architect or landscape designer had been selected to design the space or building.

2.
**Setting the stage:
preliminary staff work and meeting**

Once panel members are assembled, and provided with clear guidance on their rôle as evaluators of information and generators of ideas, they meet on or near the site. If appropriate, they should plan to meet at different times of the day, in order better to evaluate the space's use patterns.

At the first meeting the sponsoring organization will usually communicate, both visually and in written form, whatever information has by then been assembled. This is not to enable the sponsoring organization to dominate the discussion and impose its agenda, but to round up the necessary materials. These will include early design proposals; other art projects, and the community's experience with them; examples of local crafts and building materials from the architecture of the area; and photographs that show how the area has evolved, documenting the kinds of people and uses that characterize it.

3.
**Preparing the agenda of inquiry
for the environmental profile**

3.1 Physical setting
3.1.1 What is the significance of the site in terms of larger urban-design issues or relationships? Can it provide a connection to other key nodes in the cityspace? Is there a possibility for including a long vista, or to organize series of relations with objects that are already part of the site configuration? For example, can a group of thematic ideas be translated into elements that move across the site?
3.1.2 What particular constraints and opportunities does the site afford?
3.1.3 How has the physical setting changed over time?
3.1.4 What are the larger dynamics of change in the entire cityscape or the quarter where the site is located?
3.1.5 What aspects of the location's natural history (geology, flora and fauna) can be mined for resonant elements of the local narrative?

3.1.6 What effects will climate have on the use of the site and on the deterioration of art objects?

3.1.7 What is the pattern of natural and artificial lighting in the area?

3.1.8 Could a design be planned for parts to be assembled incrementally over time, using the skills and contributions of local people? This can continue to engage a community in a project's success over time, although it brings in an element of uncertainty that many agencies are not comfortable with given today's commissioning strategies. But adding to this work over time through community involvement, allowing people to leave their mark, can create a significant act of community empowerment and a sense of proprietorship.

3.2 Historical, sociological, folkloric content

3.2.1 Can objects in this space serve some larger strategy of cultural interpretation by making connections with other similar efforts in nearby locations? Check out local ventures by arts agencies. Often, agencies working toward related goals have little or no communication, for example the National Trust for Historic Preservation and the Americans for the Arts (once housed in the same building during the latter's former incarnation as the American Council for the Arts). A local preservation commission can provide the historic background material to inspire an arts council commission.

3.2.2 What historical events (citywide or regional) took place in the vicinity?

3.2.3 Are there ethnic traditions in the surrounding area that might be focused on a particular site?

3.2.4 Is there evidence of an arts and crafts tradition in the built environment of the surrounding area that could be continued or embellished in this site?

3.2.5 Are there legends, characters, or myths particular to the site or surrounding area?

3.2.6 Are there unrecorded triumphs or traumas that might become the focus of public art?

3.2.7 What human resources in the area could be employed to create public art at the site? Are there people with special craft skills whose work is respected in the community and thus might have more meaning than that of an outside artist? Artisans' work can greatly increase the claim that the space makes to the general public because it slakes the thirst for intricacy and craftsmanship, for the evidence of care and love, that is missing from much of a prefabricated and industrialized building program.

3.2.8 Could local schoolchildren be involved in the art process? Is that desirable?

3.2.9 Can an event that the community finds significant be translated into a work of public art so that a sense of resonance over time is evoked?

3.3 Behavioral analysis

3.3.1 What program of activities is contemplated for the space? How do people use the site now, and how do they want to use it?

3.3.2 How do the patterns of sun, shade, and artificial light affect the use of the site and hence enjoyment of public art in it?

3.3.3 What animation objectives can the public art realize or strengthen?

3.3.4 What is the choreography of pedestrian movement and how does this affect the use of the site?

3.3.5 How can the art relate to the area of the space where people will predictably congregate?

3.3.6 Who are the proposed users (children, tourists, employees, families, etc.)? What features of the site are oriented toward them? Should the art take into consideration the physically impaired?

3.3.7 Can an artist play a rôle in the holistic design of the space?

4.

Interaction with the environmental information—"the brief"

This checklist of information and the assembled answers form the environmental brief. To assemble this material, it is important to have the advice and help of some staff from the sponsoring organization or from some other community agency, such as a historical

commission or planning office. If the space is part of an ongoing architectural project, some behavioral analysis may already have been carried out by the architect, and a required environmental impact statement may already have documented this information. Remember that if the discussion takes place at a table, passing around information or artifacts can lead to useful comments by slowing down the thinking process instead of simply using the rushed lecture format. Bringing a tape recorder is also useful for maintaining records of the project.

5.
Crafting the metaphor

The next step is to translate the assembled brief into metaphors, story lines, themes, symbols, and priorities. Through opening up resonances and patterns, opportunities for art and artists will present themselves. It is important to record these, and the relevant trail of information that inspired them, so that they can be summarized and distributed to others who were not present.

The statement of metaphors and themes *combined* with the environmental brief—a) the physical design constraints and opportunities, b) the historical and sociological context, and c) the behavioral analysis—constitute the environmental profile. *This is the basic document for both informing the artists and evaluating the art proposals.* This can be available before a Request for Qualifications, or distributed to artists or finalists in a Request for Proposals. In this information era, it is simple to have the document available for download to artists and community members alike, but it should also be highlighted in all project publicity, so that people find it accessible. The profile should also be accompanied by realistic information on the budget, and other available project details.

6.
Assembling the cast

The environmental profile is now ready to be used to identify and assemble artists and artisans for the proposed project. This is a delicate task, especially when several of the most qualified local artists have served on the team to assemble the

brief. There are advantages to keeping the panel that assembled the brief, which has developed a familiarity and identification with both the place and the proposal, whether or not they are qualified to evaluate the merit of artworks. Often there is a need for some art professionals on the jury that ultimately selects proposals, but their approach should be balanced with community interests and priorities documented in the environmental profile.

Involving community members in artist selection is now common practice. Environmental profiling, unfortunately, is not. An environmental profile works most effectively with the submission of specific proposals that respond to it, rather than an open call for qualifications. By doing the extra work of site analysis, the committee prepares itself to undertake a more demanding selection process that should elicit some site-specific proposals.

In spite of the cliché about the camel being a horse designed by a committee, a well-instructed group can in fact influence a design by creating moral authority for the context and encouraging the artist to respect that context. The process should continue to evaluate an artist's desire to respond to these concerns, through interviewing the artist and assessing his or her work with communities in the past.

7.
The artist's proposal

The environmental profile provides an avenue for background information that should be salutary, even if not sacrosanct. In fact, the profile may generate ideas completely different from those anticipated by the sponsoring agency. That is a function of imagination that may separate the artist from the planner. The profile can serve as a base from which to make the spirit manifest—a guide to inspiration. For the jury, however, it serves the added function of providing a fallback position. In an age in which much contemporary art deprives laymen of any capacity to evaluate it, the profile can reaffirm criteria of public value that can restore confidence. Besides establishing a frame to evaluate proposals and artists, the profile creates consensus, or at least discussion, about what the community seeks to accomplish. As

mentioned before, this also relieves the research burden, which has up to now been placed squarely on the artist, who is already spread thinly responding to RFPs and community outreach.

In conclusion, the process of compiling the environmental profile not only encourages interaction among the different constituencies, but also generates a body of useful information for the artist, sponsor, and users that none of these groups alone could easily acquire. The profile should not be viewed as a constraint on the artist's creativity, but rather as challenging that creativity to respond to the context of a given environment and to express more fully what that context connotes—*the mental landscape of associations as well as the physical realities*. The modest expense of such an effort may avoid the more exorbitant cost of stalemate, outright failure, or lingering community resentment. Almost worse is the ambivalence that comes with projects receiving lukewarm receptions from communities that had no say in their creation. These projects sink into the background, perpetuating community passivity about place, landscape, and the built environment. It is this attitude that allows public spaces to lie fallow, sometimes decaying into faceless postindustrial wastelands.

8.

Postlude: the evaluation

Finally, after the implementation of the art project, there needs to be some evaluation in order to keep projects in the public eye, and learn lessons from past endeavors. What has been the response to the work? Is it being adequately maintained? Even with good planning, some pieces will not meet universal acclaim. Still, the sponsoring agency should keep a clipping file on public response and a record of maintenance problems. The agency should reserve the right to remove (not destroy) the work if a public process reveals that it is no longer serving the public's larger purpose of enjoying a public space, while respecting the artist's rights (as defined by the federal Visual Artists Rights Act). This material must be reviewed at intervals, for example after one, five, and ten years, and an overall assessment of an agency's projects should occur at annual meetings. This information can become part of a project's record, and can accompany new information about changes in a site's usage or physical context. Rather than considering this a technical "grading" of past projects, a sponsoring agency should take seriously its responsibility to learn urban planning lessons from the public-art projects it supports. Institutional memory preserves cautionary tales and catalysts for refining future endeavors. It encourages responsibility and provides accountability. Creating and sustaining place requires the delivery of some finetuning and the occasional radical redirection of effort!

1 The author wrote this chapter in collaboration with Melissa Tapper Goldman.

2 Kerry Kennedy, former manager of public art and design in Broward County's public-art program, correspondence, autumn 2003.

3 The author witnessed this modest declamation at the ceremony, on April 18, 2001.

4 Cath Brunner, head of public-art division, 4Culture (formerly King County Arts Commission), interview, March 11, 2005.

5 See María Luisa de Herrera, Kathleen Garcia and Gail Goldman, "Public Art as a Planning Tool," Contrasts and Transitions Conference Proceedings, APA 1997, San Diego.

6 Many university programs are emerging that teach the varied skill sets required for careers in public art, including the University of Southern California's professional Master's in public-art studies degree.

7 See William Morrish, Catherine Brown, and Grover Mouton, *Phoenix Public Art Master Plan*, Phoenix Arts Commission, 1988 (the first citywide public-art plan).

8 Todd Bressi, planner, interview, June 1, 2005.

9 Only a small number of the 350 public-art agencies nationwide have such plans. Todd Bressi estimates thirty to forty (interview, June 3, 2005).

10 Jerry Allen, deputy director of the Office of Cultural Affairs, San Jose, California, and principal, Jerry Allen and Associates, interview, February 2, 2005.

11 Townscape Public Art Planning Survey, launched November 2004 on the Public Art Network email list, with thirteen respondents from the USA and Canada.

12 Bressi interview, June 1, 2005.

13 See Barbara Goldstein, *Public Art by the Book*, Seattle and London: University of Washington Press, 2005.

14 Jim McDonald, director of Seattle's public-art program, correspondence, February 7, 2006.

15 Kennedy correspondence, autumn 2003.

16 See plans including *The Houston Framework*, 1997; *2005 Municipal Art Plan*, City of Seattle; *City of San Diego Public Art Master Plan*, March 2004; *Public Art Master Plan*, City of San Jose Office of Cultural Affairs, December 2000; Edward Lebow and Betsy Stodola, "The Thomas Road Overpass at the Squaw Peak Parkway," *Public Art Works: The Arizona Models*, ed. Betsy Stodola, Denver: Western States Arts Foundation, 1992, pp. 42–48.

17 See *Public Art Master Plan*, City of San Jose Department of Cultural Affairs, December 2000.

18 Allen interview, February 2, 2005.

19 Glenn Weiss, senior planner in Coral Springs, Florida, and former public-art administrator in King and Broward Counties, interview, March 29, 2005.

20 Jack Mackie, artist, Seattle, interview, February 10, 2006.

21 Bressi interview, June 3, 2005.

22 EDRA (Environmental Design Research Association)/Places Award for Planning, 2004, Lorna Jordan Studios for *A Theater of Regeneration*. edra.org/awards/prfs/Places2004Winners.pdf, accessed June 12, 2006.

23 The Broward plan won a Places Design award, 2005. Lorna Jordan, *A Theater of Regeneration*, Parks/Land Bond Master Plan, Broward County, Florida, 2005.

24 An earlier form of this guide appeared in *Places: A Forum of Environmental Design*, Summer 1990.

25 Cath Brunner in Goldstein 2005, p. 155.

26 Gail Goldman, presentation, Americans for the Arts Public Art Preconference Austin, Texas, June 9, 2005.

27 Bressi interview, June 3, 2005.

28 Lorna Jordan, presentation, Americans for the Arts Public Art Preconference, June 9, 2005.

29 Seattle Office of Arts and Cultural Affairs, "News about the Public Art and Seattle City Light Lawsuit," ci.seattle.wa.us/arts/news/citylight5-2004.asp, accessed September 7, 2005.

30 See Jeffrey L. Cruikshank and Pam Korza, *Going Public: A Field Guide to Developments in Art in Public Places*, Amherst, Mass.: The Arts Extension Service, University of Massachusetts, 1988.

31 Barbara Goldstein, correspondence, July 30, 2004.

32 See above, pp. 42–47, and Scottsdale Public Art website: scottsdalepublicart.org/collection/pimafreeway.php, accessed May 19, 2005.

33 Allen interview, February 2, 2005.

34 Weiss interview, March 29, 2005.

35 Brunner interview, September 9, 2005.

36 See "Significance," Danville Project website: danvilleproject.com/files/significance.htm.

37 Jessica Cusick in Goldstein 2005, p. 9.

38 For a recent example, see *The Harvard Design School Guide to Shopping*, ed. Chuihua Judy Chung, Cologne, Germany: Taschen, 2002.

39 Bressi interview, June 1, 2005.

40 Cath Brunner in Goldstein 2005, p. 160.

41 Seattle Public Art Program, Public Art 101, p. 159.

42 Public Art Network communication, Americans for the Arts, May 19, 2005.

43 Mary Len Costa, director of public art for the Arts Council of New Orleans, Public Art Network list, correspondence, July 14, 2005.

44 Brunner interview, September 9, 2005.

45 See Geoff Edgers, "Sculptor sues Fidelity to keep his artistic vision intact," *Boston Globe*, October 7, 2003; and David Phillips, artist, Boston, and Andrew Epstein, attorney, correspondence, February 13, 2006.

46 See Seattle Public Art Program, Public Art 101, p. 91.

47 Brunner interview, September 9, 2005.

48 Townscape Public Art Planning Survey, launched November 2004 on the Public Art Network email list, with thirteen respondents from the USA and Canada.

49 Allen interview, February 2, 2005.

50 Brunner interview, September 9, 2005.

51 Lorna Jordan, public artist, Seattle, interview, May 2005.

52 Ruri Yampolski, project manager, Seattle Public Art Program, interview, September 9, 2005.

53 David Finn, associate professor of art, Wake Forest University, interview, June 9, 2005.

54 Recent examples include Goldstein 2005; Phoenix Public Art Program, *Architecture/Art/Regeneration*, Black Dog Publishing, 2005; and Hafthor Yngvason, ed., *Conservation and Maintenance of Contemporary Public Art*. Cambridge, Mass.: Archetype Publications, 2001.

55 Townscape Public Art Planning Survey, launched November 2004 on the Public Art Network email list, with thirteen respondents from the USA and Canada.

Annotated guide to public-art plans

THE FOLLOWING ARE GUIDES assembled by city and state arts organizations. For a step-by-step guide to best practices in public art see *Public Art by the Book*, ed. Barbara Goldstein (University of Washington Press, 2005). This thorough compendium uses much of the same material as *Public Art 101*, the guide by the Seattle Arts and Cultural Affairs public-art program that Goldstein headed. Further discussion of some of the plans that we have found most successful and noteworthy can be found earlier in this chapter.

I.

State guides for communities considering public art

Public Art Handbook for Louisiana Communities: A Guide for Administrative Success, by Lake Douglas, photographs by David G. Spielman (Louisiana Division of the Arts, 2001). 103 pages; heavily illustrated in black and white.
This is an encouraging guide both for communities with an existing public-art program, and for those wishing to initiate one. Although the plan argues that public art is an expression of community identity, many of the pictures show art that has no recognizable connection to the locality, and there is no mention of providing artists with information about community character. It suggests developing a relationship with the media, so that if a controversy arises, it will be only one of many projected messages, and need not be lethal for the program. The plan includes advice on encouraging more equal collaborations between artists, architects, and landscape designers, and recommends the use of public art to accomplish physical planning objectives, but does not mention integrating art into such functional urban-design elements as street furniture or interpretation.

New Works: A Public Art Project Planning Guide, Patricia Fuller (Durham Arts Council and North Carolina Arts Council, 1988). 36 pages; no illustrations.
An introductory guide for North Carolina communities, outlining implementation processes that have evolved since 1968. It stresses local uniqueness, community involvement, and the importance of identifying the goals of the community and the arts commissioner before engaging artists.

Creating Place: North Carolina's Artworks for State Buildings (North Carolina Arts Council, 2002). 48 pages; well illustrated in color and black and white.
This is a historical document describing the now-defunct Artworks for State Buildings (AWSB) program (1982–95) as part of an initiative to encourage and facilitate the commissioning of public art by local communities ("Creating Place: Public Art and Community Design Initiative," 2001). The bulk of the publication consists of public art and design program director Jeffrey York's illustrated inventory of all the artworks commissioned during AWSB's lifetime, organized by subject. There is also a brief history of the program, as well as an introduction to public art and how it can be commissioned on a county or community level.

Public Art Works: The Arizona Models, ed. Betsy Stodola (The Phoenix Arts Commission, 1992). Joint funders include the Design Arts Program of the National Endowment for the Arts; Arizona Commission on the Arts; Phoenix Arts Commission; Design Center for American Urban Landscape, University of Minnesota; and The Dayton Hudson Foundation on behalf of Dayton's and Target stores. 70 pages; well illustrated in color.
This is a collection of six separately authored essays interspersed with quotations and

pictures that convey a sense of Arizona's evolving identity. 1) Nancy Rutledge Connery's essay entitled "Urban Infrastructure" suggests that public art should bring attention and meaning to the physical infrastructure that sustains urban life, as in, for example, the municipal water supply. 2) Shelley Cohn's essay "Arizona: The Look of Communities" provides a history of public-art planning in Phoenix and Arizona, and notes that since 1988, there have been fewer proposals for individual artworks, and more for general streetscape master plans including key sites for artworks. 3) Deborah Whitehurst's "Phoenix: The Challenge" characterizes public art as "a change agent for the community," and describes how attitudes toward public art have evolved so that artists are asked to do more than disguise poor architecture and urban design. She argues that artists must be involved with construction projects and infrastructure from the beginning. 4) In "Making a Public Art Master Plan," Catherine R. Brown and William Morrish, two of the three co-authors of Phoenix's public-art master plan, describe the process of creating the Phoenix plan, and give a summary of it. Many of the projects had been completed in the four years since the plan was adopted in 1998. The final two chapters inventory completed projects and projects in progress in Phoenix as well as throughout the state.

II.
County and city master plans

ONE NEW TREND IN PUBLIC-ART PLANNING is the "site master plan," a plan that does not address an entire city, but instead deals with a specific subset of the city as a whole, such as an airport, a neighborhood, a mall area, a public transit network. In this section, we have for the most part chosen to exclude such small-scale plans in favor of master plans that relate to an entire city or county. Robert Irwin's 1986 plan for Miami Airport has had a historical impact, and Seattle's public utilities master plan is unprecedented.

Most of the master plans we reviewed are organized either by site opportunities or by the function of public artwork. Either they suggest several dozen sites to concentrate on in the next few years, or they give suggestions on how sites should be chosen (entryway points,

pedestrian focal points, transit stations, sites that are visible to automobile traffic, etc.) Many plans also include information about the city that could be used by artists, but only Phoenix's 1988 plan specifically recommends providing information to artists as soon as they are hired.

ATLANTA, GEORGIA

Fulton County Public Art Master Plan: 1995–2000, Traurig and Rome consulting team (Fulton County Arts Council, 1995). 70 pages; black and white "before" photographs and maps. This plan begins with a brief history of Fulton County, and then presents the suggestions of nine "idea teams," including potential sites for public artwork and suggested concepts for the work in those locations. Each suggested site is illustrated in its current condition, and each is then located on a map. Several locations are identified as "priority sites" and their history and use patterns more comprehensively developed. The plan also includes several suggestions to guide the commissioning of artwork: public pieces should be located in high-use areas, and they should be visually accessible both to automobiles and to pedestrians. The plan emphasizes artworks that can be comprehended from an automobile over more intimate art that demands pedestrian scrutiny. It cautions that artworks must be equally distributed through the north and south of the county, and also advocates that artworks be appropriate both for one-time 1996 Olympic visitors, and for local residents who will see them repeatedly. The plan also includes minimal administrative policies and procedures, which demand that the public-art coordinator maintain information for each site about "geographic, demographic, environmental, social and cultural conditions, as well as amenities within the area."

City of Atlanta Public Art Master Plan, Project for Public Spaces, ed. Atlanta Master Plan Task Force, directed by Eddie M. Granderson (City of Atlanta Department of Parks, Recreation and Cultural Affairs: Bureau of Cultural Affairs, 2001). 77 pages; no illustrations. This is a 2001 revision of a plan initially composed and implemented in 1994 as part of

the preparations for the 1996 Olympics. The document thus perpetuates a public-art program established for the sake of the Olympics, yet fails to evaluate what was in fact produced for the Olympics—perhaps for good reason. It is purely an administrative document, detailing procedures for finding funding, commissioning artworks, and managing existing collections. Gathering background information about the site is left to the discretion of the artist, but he or she is required to meet with a "stakeholders committee" to explore different concepts. The plan recommends that artists be selected during the preliminary concept stage when they are to collaborate with an architect, so that they can participate early in the design process. Project and site selection guidelines emphasize the relationship between artwork and site, and the potential for artwork to revitalize pedestrian spaces.

CARY, NORTH CAROLINA

Town of Cary, NC, Public Art Master Plan Draft, Jennifer Murphy/Citi Arts, August 23, 2001. 67 pages plus a six-page executive summary; no illustrations.

This plan includes a brief summary of Cary's history, geography, and current character. The bulk of the document identifies six "layers" of Cary that should be expressed through public art, and suggests a number of potential projects, sometimes identifying a site in detail, but more often merely giving a title, and a paragraph explaining the inspiration and goals of the suggested project. The layers incorporate several important sub-categories, including gateways, traffic corridors, parks, festivals and events, the town center, and Greenways. The final chapter is a seventeen-page set of definitions, procedures, and administrative policies for running a public art commission.

FT. LAUDERDALE, FLORIDA

Design Broward: Public Art and Design Master Plan for Broward County, FL, 1995–1999, Jerry Allen and Associates (Jennifer Murphy and John Graham), (Broward Cultural Affairs Division, September 1995). 142 pages; illustrated in color.

Revised Ordinance and Recommendations have shifted the emphasis from placing paintings and sculptures in public buildings toward integrating aesthetic amenities into buildings. The consultant advocates that artists be contacted at the same time as architects, in order to establish a more even playing field as a basis for effective collaboration, as opposed to the more frequent coordination. The plan encourages artists to reach out to community members so that their work can address the community's needs. However, there is no mention of requiring that the content of the art express the community's identity; placement and style could be enough. The plan includes a chapter on Broward County's history and identity, as well as several short essays on the importance of artwork in specific situations, including manhole covers, gateways and entryways, mass transit, integrating public art with architecture, sculpture, plazas and parks, and homeless shelters. The plan also offers thirty pages of public-art opportunities, with suggested sites, costs, and special considerations for artists; some projects are specially designated as favoring a historical or narrative approach. Half the plan is devoted to policies and administrative questions; there is no mention of providing site information to the artists. The appendix offers proposals for certain potential sites, including pictures and detailed designs developed by "design teams."

GRAND RAPIDS, MICHIGAN

Frey Foundation Public Art and City Enhancement (PACE) Initiative, submitted by Project for Public Spaces, with The Townscape Institute, Partners for Livable Communities, and Works of Art for Public Spaces, 1995. 31 pages; full-page illustrations.

The Frey Foundation is a large private foundation in Grand Rapids whose mission includes "nurturing community arts." This plan defines the process for the foundation's efforts in commissioning public art. One-third of the report is devoted to describing the history of Grand Rapids, and suggesting some possible themes for artworks, and it specifies that this part of the report must be shared with artists. A summary of the plan specifies that artwork must respond to the site's history. The plan describes what has been done so far, and outlines a timeline for future actions. It also makes recommendations for improvements

to a local downtown mall/plaza that was perceived as an unsafe obstruction to pedestrian traffic. It served as the basis for Maya Lin's commission to design an ice-skating rink on the site.

HOUSTON, TEXAS

The Houston Framework: Community Vision for Civic Art and Design in the Houston and Harris County Region, The Cultural Arts Council of Houston/Harris County, 1997. 52 pages; maps and black-and-white illustrations.

This is a guide for the Cultural Arts Council of Houston/Harris County as well as private commissioners of artworks. It identifies important sites and suggests appropriate rôles for public art on each site, using five maps: Nature, Infrastructure, Neighborhood, Treasures, and Gathering Places (both formal, like the Houston Livestock Show and Rodeo, and informal, as in jogging trails). It also suggests particular projects and identifies potential funding partners for each one. The appendix has an annotated bibliography of forty-five public-art plans for particular neighborhoods and transit networks in Houston. It also lists reference documents, giving background information about various aspects of Houston, and some areas within it.

MIAMI, FLORIDA

Miami International Airport Arts Enrichment Master Plan, Robert Irwin (1986). 58 pages.
This plan offers a systemic analysis of the airport, including such suggestions as color-coding the concourses and making portable gardens. The plan identifies fifteen areas in the airport that require public art, and assigns each to an artist, architect, or designer, with the concept of addressing a general task at each site, for example "Pique curiosity" or "Define order and direction." These individual directions are intended to work together to form an overall choreography of the artwork in the airport. This plan is both earlier and more eccentric than the other plans discussed here, but it reflects a particular vision. This is not an administrative document, and there is no implementation guide, only a sketch of personnel, budget, and timeline. There are no explicit requirements that the artworks relate to the locality or its history, but about half of

the plan is devoted to narrating the history and mythology of the area, as well as discussing metaphors of Miami, the airport's site, and the airport structure.

PHOENIX, ARIZONA

Public Art Plan for Phoenix: Ideas and Visions, William Morrish, Catherine Brown, and Grover Mouton (Phoenix Arts Commission, 1988). 147 pages; many drawings.

Phoenix's plan identifies sites and criteria for selecting artists or proposals. Much of the plan is devoted to defining "Working Zones"— areas in the city that should be considered for artwork. Each zone includes a map, description and use patterns, as well as several recommended projects with sketches. It makes a strong effort to link public art with the infrastructure and traffic patterns of the city. Most of the proposals are concerned with streets, bridges, airports, etc. The plan suggests several street furniture projects (including manhole covers, and unique lighting systems for pedestrian underpasses), as well as civic gateways, mass transit stops, and pedestrian focal points. It specifies that when an artist is to work with a designer or architect, he or she must be included in the project from its inception. Several projects involve incorporating an artist into streetscape design work. This is one of the only public-art plans to recommend specifically that an artist receive an adequate description of the site at the outset. The appendix includes five maps showing different "systems" in Phoenix (water, parks, vehicles, landmarks, pedestrians). Finally, there is a summary of the kinds of projects planned, with a hierarchy denoting their relative importance.

1997–1998 Project Art Plan (Phoenix Arts Commission, Public Art Program, 1997). 25 pages; no illustrations.

This is not a master plan, but a working document listing new, continuing, and future projects. It gives the following information for each project: district, title, location, funding source, cost, and description. There is no background information, and no sense of the purpose or content of artworks to be commissioned. Future projects use such vague words as "improve" and "enhance." The plan

is, however, explicit about the artist's responsibility to communicate with the community, as well as with the designer or architect, from the inception of a project.

Public Art Master Plan, Jerry Allen and Associates, approved October 15, 2002. Online (cityofreno.com/com_service/arts/artplan.html); 90 pages; several inset illustrations.

Reno's public-art master plan is the result of a recommendation in the 2001 Community Cultural Master Plan (also by Jerry Allen), and it comes in the wake of a 1996 controversy over an abstract art piece entitled *Perforated Object*. Artist Michael Heizer sculpted the large flat piece of metal, perforated many times over with circular holes, and installed it at the Bruce R. Thompson Federal Building in Reno, drawing his inspiration from a pendant that he and his anthropologist father unearthed in a Nevada cave in 1936. The plan provides for the establishment of a public-art program with permanent staff and an artist registry to be used both internally and by private commissioners. It includes a proposed ordinance (2 percent of public construction projects to be set aside for public art), program policies, and guidelines. For each administrative recommendation, the plan identifies a responsible agency that could implement it. It suggests establishing an "urban-design review board" to help choose art sites, plan the skyline, and review building projects. (Allen mentions the City of Seattle as a place where this is done successfully.) The plan suggests including existing community groups in the commissioning process, and it emphasizes functional and representational art, including street furniture, such as manhole covers. Gateway artworks are also an important part of the plan. More than most plans, this one discusses the political problems that can affect public acceptance of

public-art programs. Building support for such programs is a major focus of the plan. Much of the plan is devoted to narrating the rationale behind the various objectives, which includes quotations from planning participants, and details about the history of art in Reno.

SAN ANTONIO, TEXAS

Catalogue of On-Site Artist Services (COSAS), San Antonio, last updated 2003. Online (sanantonio.gov/cosas/); 41 artist pages; searchable by various criteria.

This online database is comparable in intent to the *Artist-Made Building Parts* publications (from 4Culture in Seattle). Both provide contact information for local artists whom private developers and architects might conveniently hire. About one-third of the artworks, including furniture, are designed for private residences. Whereas Seattle's program is geared toward large-scale construction projects, COSAS lists many *trompe l'œil* and faux-finish wall artists.

SANTA CRUZ, CALIFORNIA

Imagine Santa Cruz: Public Art Master Plan, Jerry Allen and Associates (Santa Cruz City Arts Commission, September 1998). 182 pages; a few black-and-white photographs and diagrams.

This is mainly a procedural document, and includes, for example, sample contracts and a proposed ordinance. The last eight pages list seven potential sites for public art, along with suggested proposals for these sites. Pictures of the proposals are interspersed throughout the text. Priorities in the plan itself include integrating artists with other design professionals including architects and landscape architects, as well as using artwork to achieve urban-design goals. The plan includes no information about Santa Cruz, and makes no provision for supplying such information to artists. There is no mention of artisans or teams of artists.

Artist-Made Building Parts Catalogue, vols II (1995), III (1998–2000), IV (2001–04), (4Culture, formerly King County Arts Commission).

This series of books devotes a page to the work of each artist. It includes several high-quality photographs of past artwork, a brief statement of philosophy, and contact information. The book is fashioned to help professional designers, architects, and contractors (residential and commercial) find local artists who can contribute to private projects. The third volume also includes two "project profiles" showing how artists from the AMBP programs have been incorporated into architectural projects. A panel reviews and selects from artists who respond to an open call. The entire catalogue is also available online. King County Public Art Program (now King County Cultural Development Authority) also maintains a register of artists who work particularly well as part of a design team.

Seattle Public Utilities Arts Master Plan, Lorna Jordan, artist in residence, Seattle Arts Commission (Seattle Arts Commission, 1998). 46 pages; illustrations on chapter title pages and in appendix.

As artist in residence, Jordan's main work here is to propose seven new projects for integrating art into Seattle's public utilities. Each utility project includes several opportunities. Jordan gives background on each site, and defines possible themes for artworks, as well as suggesting potential artworks in certain sites. She includes a list of current and past projects, and suggestions for the rôle of the artist in residence in the future. The appendix includes an overview of Seattle's public utilities, including their history as well as descriptions of utility services for water, drainage and wastewater, solid waste disposal, engineering, customer service, and conservation.

Poetic Utility: Seattle Public Utilities Arts Master Plan, Buster Simpson, artist in residence, Seattle Arts Commission (Seattle Arts Commission, 1999). 17 pages; black-and-white illustrations.

Simpson alludes to Jordan's master plan, but includes many new ideas for successfully integrating artists into public utilities. He suggests a "boot camp" for artists to discuss how to resolve problems in working with the public and with the city. He also suggests methods for publicizing the public-art program, and improving relations with citizens (including a detailed proposal for elements to add to the popular citywide Torchlight Parade). He also proposes several new sites and several new artworks.

STOCKTON, CALIFORNIA

City of Stockton Public Art Master Plan: Inspiring Creativity in all Aspects of City Planning and Construction, City of Stockton Public Art Task Force and Wright Consulting (July 2000). 85 pages; many color illustrations.

Design teams were formed to identify sites, and their illustrated proposals are interspersed throughout this plan. For the most part, it is an administrative document, listing procedures and guidelines. It recommends an "urban-design review board," and emphasizes the importance of having a community base for every project, to build political support. It also recommends encouraging art in privately funded construction projects. There are ten pages of research on Stockton's history and culture, the urban-design context, and potential collaborators including other government agencies, educational institutions, public utilities, and public transportation services.

Failure and the
potential for redemption

In *PLACE MAKERS* (1987), the authors identified several examples of what they viewed as unsuccessful public-art installations while the public acceptance of the projects still hung in the balance. In the 1970s and 1980s, artists often took on public projects without the skills or experience to understand site-specific needs, both in terms of user behavior and site content. The protocol of creating public art did not yet embrace public opinion and "environmental briefs," describing the history of the area, design constraints and opportunities, or behavioral patterns and craft traditions (see pp. 317–20). All these elements help to hold artists and commissioning agencies accountable, but are still too rare, which is one compelling reason to continue analyzing cases of failure. During this era, corporate "responsibility" in support of the arts often resulted in the naïve commissioning of Modernist or avant-garde art for such public or semi-public spaces as malls, building complexes, and privately owned courtyards and plazas. The most famous names in contemporary sculpture attracted the companies and their arts consultants. They may have had a sincere interest in supporting the best contemporary accomplishments in art, but without sensitivity to the context, they had little understanding of the reception that the public art would receive. These three examples of failure are archetypical tales of what happens when public art goes wrong.

Commerce Center, Cincinnati

In 1978, the Palace Theater in downtown Cincinnati, near Fountain Square, received a much-needed restoration by a group of independent businessmen. Although the theater was magnificent and historic, it did not maintain itself financially, and the investors sold it for the price of the land. The theater was demolished in 1982 and in its place rose Cincinnati's Commerce Center, a bland, strip-windowed high-rise. The owners privately commissioned a piece of public art in 1984 for the small public area in front of the building[1] at a cost of around $100,000.[2] Clement Meadmore's sheet steel sculpture called *Open End* was an elongated and twisting geometric band with sharp edges.

In this case, Meadmore's stated intention was to build "a bridge between the scale of the pedestrians and that of the building,"[3] but with no explanatory cues, this abstract aim remained

meaningless to most passersby. According to E. Pope Coleman, former interim director of the Cincinnati Contemporary Art Center,

> the phrase "site-specific" does not seem to be well understood by either artists or the clients who commission [such artworks]. Certainly, at the least, public art should contribute to the fabric of the public spaces it inhabits. At the best, public art can engender community pride and even affection. Sadly, this is not often the case, especially in the instance of some famous artists' signature works.[4]

Indeed, the sculpture is instantly recognizable as the kind of work that Meadmore does across the country. According to Coleman, soon after its installation, a small brick platform was inserted to protect pedestrians from impaling themselves on the sculpture's edges. In 1999, the owners decided to renovate the Commerce Plaza and donated the sculpture to St. Xavier High School on the outskirts of the city. Although the piece had been designed "with the downtown in mind," the artist himself was pleased with the new setting. A local rigging company, owned by a St. Xavier alumnus, donated its services to move the five-ton sculpture. It remains at St. Xavier today.

Pynchon Plaza, Springfield, Massachusetts

In Springfield, the consequences of this disappointment with public art are clearer, because the rejected piece remains downtown. Isaac Witkin's *Everglades*, a sculpture produced from giant curved "leaves" of Cor-ten steel, still sits in the middle of Pynchon Plaza, in the center of the city. This concrete-terraced park is situated on a hillside between the main business district and the Springfield Museum of Fine Arts. The sculpture rests at the bottom of a steep incline, with street level below and buildings above. The plaza was constructed during the city's bicentennial in 1976, at the center of the urban park movement, with the help of a commission of businessmen and citizen activists. In an effort to use "cutting-edge Modernist design," the sculpture brought Springfield forward into the future—right past the two hundred years of tradition being commemorated in the

bicentennial celebration. Many members of the bicentennial committee, in charge of steering the city's construction during this event, were young, enthusiastic, and inexperienced. The other members representing nearby businesses used their influence to persuade the committee that Springfield would benefit from being "on the map" among communities using state-of-the-art urban planning and design.[5]

Tall concrete walls screened off the nearby buildings. As part of young landscape architect Bill Burbank's vision, *Everglades* is the focal point of the space at the bottom of the steps traversing the steep hill. Corporate boosters pushed for Burbank's futuristic design, while younger members of the bicentennial committee posed concerns about the functional life of the space that remained unresolved at the time. According to Frances Gagnon, chair of the Springfield Historical Commission, and then one of the young interrogators on the bicentennial committee, they questioned the art's relevance from the start. "Everglades?" she commented. "Come on. We are sitting at the heart of the Connecticut River Valley." In terms of the sculpture, "people were expecting more history on the bicentennial."

Once built, the park continued to be a disaster. The steep steps inhibited even the robust visitor from comfortably moving between the park and neighboring buildings above. Unforeseen problems ranged from stagnant summer air baking in the depressed concrete-walled area, to a lack of seating or playing areas for children, to crime and vandalism in the elevator that was supposed to make the park accessible. The wall fountains provided opportunities for playful and destructive pranks—on one occasion saturating the downtown with bubbles, and on another with the stench of rotting fish. Soon after Pynchon Plaza's opening, the parks department shut down the elevator and fountain because of the ensuing social problems, which required the additional cost of maintaining security and repairing vandalized surfaces.

Funding dwindled and full-time security became imperative, and the parks department closed the plaza to the public within several years of its initial opening. Already economically troubled, the city could not support the unpopular park. For a brief period in 2000, the park was reopened during summer daylight hours with donated security from neighboring building owners. But now the park and statue are defunct, visible from the main thoroughfare only through a fence. With no money to make a change, the sculpture will not be relocated, restored, or replaced with something more effective.

The committee never had funds budgeted for maintenance, security or refurbishing. Says Gagnon, "Back in those days, we thought you just paid for a sculpture and put it out there, end of story."[6] The neglected park remains an eyesore. It is an unfortunate waste of space and money, having squandered the opportunity for an effective urban park in this central location. Small restoration efforts on other Springfield art pieces, such as the statue of President McKinley, have produced good results, but were only possible through private funding. With no positive precedent for publicly appreciated contemporary art, Springfield is not inclined to take risks on new projects.

Wills Eye Hospital, Philadelphia

In 1981, renowned sculptor George Sugarman conceived and installed his untitled gateway of dynamic aluminum layers framing the entry to Wills Eye Hospital in downtown Philadelphia. Unfortunately, Sugarman's vibrantly colored sculpture created an immediate hazard for the visually impaired clientele. These patients, guided around the building by a bright red guardrail designed by the local

RIGHT Clement Meadmore's *Open End*, originally situated in downtown Cincinnati, now sits in the grounds of a Catholic high school on the outskirts of town. This photograph from the 1980s shows it downtown, covered in protective plastic. Photo: Paul J. Zook.

CENTER, RIGHT Isaac Witkin's *Everglades* was installed as part of an urban park downtown revitalization project, and has sat forlornly in the fenced-off central downtown of Springfield, Massachusetts.

BELOW, RIGHT Sugarman's massive untitled sculpture in its original setting at the entrance to the Wills Eye Hospital in Philadelphia. The piece was removed because it posed a risk and an inconvenience to the visually impaired patients at the hospital, who needed to use the handrail seen at the right.

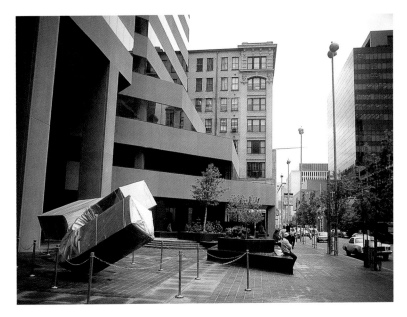

architectural firm Ballinger, were led directly into the sculpture's sharp edges, due to an unfortunate miscommunication between the two design professionals. The gateway nevertheless remained at the hospital for nearly ten years.

Because the Philadelphia Redevelopment Authority (PRA) owned the land, the hospital came under the authority's Percent for Art ordinance. A committee, including a representative from the hospital, and members of the PRA and the City's arts commission, approved the design. Nobody today is willing to accept accountability for the hazardous siting.[7]

When the piece was first installed, hospital personnel soon perceived it as a nuisance. It is, of course, a challenge to address a work of public sculpture to a visually impaired audience. While pedestrians and drivers on 9th Street may have enjoyed the flamboyant colors, the hospital's patients were adversely affected. In spite of the hazard, the hospital still did not have reason enough to petition for the work's removal through the City's bureaucracy. But it saw its opportunity to redress the situation in 1987, when the hospital needed to create a pedestrian drop-off on the increasingly busy 9th Street to protect the visually impaired clientele. The sculpture was in the way of the new construction.

The issue of moving site-specific art is always sensitive. As part of the PRA's standard procedure when approving the relocation of an artwork, the artist is notified and, if possible, involved in the process. Strictly speaking, the artist has no claim to refuse the move, although, since the federal Visual Artists Rights Act of 1990, the moving of a site-specific artwork can become legally tricky. Sugarman was not pleased with the prospect of removing his art, which he conceived as "site-specific." However, he cooperated with the proceedings, which gave him a say in the fate of the piece. The hospital administrators and the PRA sought a suitable new location for the sculpture and approval for the move from the same authorities who had commissioned it in the first place. The effort to appease the many involved players, the PRA and their fine arts committee, the artist, and the new owners, was costly in fees and in time for hospital administrators. The process dragged on from 1987 to 1991. The University of Pennsylvania's Morris Arboretum in Philadelphia finally agreed to accept the sculpture after the hospital promised to refurbish it. The artist accepted this offer to house the work "temporarily" in the arboretum until a suitable urban context was found. The sculpture remains in the arboretum today.

The hospital paid over $45,000 to move the sculpture, and agreed to pay expensive yearly maintenance fees. Without the immediate mandate to remove the sculpture, the hospital never could have justified the cost of removal. Additionally, the city commissioners are hesitant to interfere with works of art, both for reasons of public relations and because they do not like to admit that public funds were used to support an unsuccessful endeavor in an already unpopular domain. Even with cooperation from all involved parties, the process of moving Sugarman's sculpture was expensive, political, and difficult to maneuver. Clearly this was a compromise of the integrity of a site-specific artwork. But it was a compromise that respected the public perception that it was a hazardous and apparently irrelevant work that had become an annoyance.

There is now no art to enhance the exterior of the former hospital building. The hospital has since moved; no public art is required in the new building either. "The common sense factor, in my opinion, was lost," said James Mulvihill, the administrator who handled the move, and now the CEO of the hospital. "I certainly wouldn't go out of my way to put public art around the building knowing what I'd have to go through if I do ever have to change my mind It has left me with a negative taste."[8] In effect, a major institution has concluded that it will never electively work with

an art program. The prevailing sense of working against the arts administrators, rather than with them, remains.

For private companies able to circumvent the bureaucratic steps to move a piece (and also the legal obligation to commission it in the first place), the same sculptures can be attractive decorative elements, such as Sugarman's *Sun Rays I* and *Sun Rays II*. These sculptures are wrapped around a free-standing elevator in the Buckland Hills Mall in Manchester, Connecticut. The artist also designed twelve of his signature benches for the mall, but these were removed as an alleged safety hazard after some young patrons, attracted to the candy-colored furniture, bumped their heads. Because the mall did not need municipal permission to remove the benches, they disappeared quietly, without the knowledge of the artist's estate. Because the artist made the sculptures before the federal Visual Artists Rights Act, the mall was not obliged to contact the artist regarding the move, although courtesy and common practice might have suggested otherwise. These works of aesthetic pedestrian-level decoration could have been relocated with little effort or money. At the time of remodeling, the mall discarded the sculpture as scrap metal after an unsuccessful search for a patron to fund its relocation. Without a governmental mandate, this site-specific piece was junked in a corporate scenario that parallels the public misadventures in Springfield and Philadelphia.

Certainly nobody expects a corporation to keep a hazardous or unsightly work of art in place, but still art in public space is held to different rules. As more of the postmodern city becomes semi-public space, such as corporate-owned malls and plazas, a new set of circumstances arises. Public art has always been in the hands of the powerful, but its audience is now often the multitude of consumers. Abstract sculpture can be unappealing as public art because it is so often difficult to understand and contextualize. Thus it rarely engenders the public affection needed to sustain its continued presence. Ironically, these same qualities that are shortcomings in public art are merits in corporately funded art, where content and message are not marketable or desirable.

The artistic and moral implications of these corporate and public cases suggest the difficulty that most abstract work faces in the public and quasi-public realms. The didactic planning process of "environmental profiling" that we advocate is one method of encouraging the collecting and analyzing of information that can sometimes prevent such public-art disasters from occurring.

Design portrait of Eugene, Oregon[9]

In *Place Makers* (1987), the "Tank Trap" water feature at the intersection of a downtown mall in Eugene was identified as the very epitome of banal placelessness in 1970s city renewal. How heartening it is, then, to see in the same city an ugly monument replaced with a sensitive place-specific series of artistic signposts identifying local landmarks, near a juncture at the center of downtown. The dramatic change led to a more general interest in other aspects of this small and progressive city, home of the University of Oregon, 1 mile from the central business district. Why did this change happen here at all, and how did it relate to other innovations, such as the university plan, the nationally recognized work published as *The Oregon Experiment*?

User-oriented design in the university's buildings has encouraged the integration of art in architecture, particularly in the science complex of 1989, and the Knight Library, first built in Beaux-Arts style and expanded in 1994. In the downtown, there is also a performing-arts center, opened in 1982, which actually engaged a team of artists to enhance the building, all the way down to such small details as painted tiles in the restrooms that are a reflection of the play-making in the building.

The attention to detail and intimacy shown in these artistic elements is a phenomenon that requires a closer look. Despite the typical problems of many small American cities facing sprawl, Eugene may prove an inspiration to the many communities that find themselves in similar circumstances. The city deconstructed its history through urban "revitalization" in 1971 with a dead mall. But the encouraging, delightful, and challenging art of 1995 authenticates the city's efforts to reclaim a sense of place in its downtown.

The worst of 1970s sensibilities: watching the train wreck

With the widespread suburbanization of the late 1960s, Eugene experienced a similar phenomenon to that faced by cities around the country. Businesses, once focused on the city center, gravitated toward the edges, as highway development and low-cost mortgages subsidized sprawl. With this centrifugal force, the urban density of the downtown shrank. The city leaders sought a federal urban renewal grant from the Department of Housing and Urban Development (HUD) in the late 1960s to remedy the situation, by purchasing and revamping real estate in the center.[10] Unfortunately, this took momentum away from utilizing the City's zoning powers to curb the sprawl. Eugene had the mixed blessing of receiving the very last HUD urban renewal grant ever awarded. In 1971, the City used the funds to construct a downtown pedestrian mall according to the simplistic prevailing wisdom at the time—"cars bad, people good."[11] Local landowners continued to develop regional malls on the outskirts of Eugene. Some visionaries in this community saw pedestrian malls as a panacea. According to Fred Tepfer, planning associate at the University of Oregon, "Eugene had the misfortune of being very progressive at the wrong moment."[12]

The City hired a local architectural firm, Unthank Seder Poticha Architects, to design the mall. Otto Poticha refused the project, pointing out that the mall was a very expensive quick-fix to a much larger problem, which the City did not yet understand. Instead, he suggested that his firm conduct a study of the pedestrian needs in the downtown.

Poticha's team hired thirty local "consultants"—citizens with an interest in the downtown's future. Poticha commented:

> It was unusual to ask for public input other than at the official meetings. We decided that the best consultants you could have are people who really cared about the city … . We were not trying to plow new ground.[13]

After looking at the needs for downtown, the group concluded that creative and locally tailored solutions suited the City much better than the raze-and-rebuild option set out by the mall proponents. But Eugene's director of urban renewal and the desperate and influential local businesspeople were not pleased with the result, and Poticha and his firm were not included in the actual design.

Another citizen-based council selected a scheme for the new downtown from among submissions in a public Request for Proposals (RFP). Hugh Mitchell, of Mitchell and MacArthur Landscape Architects, designed the plaza in 1970, focusing on the city's central intersection, Broadway and Willamette Street. In order to build the mall, many functional, historic multistory buildings were torn down and replaced by a flat expanse of single levels.[14] With the downtown's built history wiped blank, and its sense of place diminished, there was a clean slate on which to construct the new mall. The main street in the downtown, already economically distressed, was effectively closed for a full year during the mall's construction. Otto Poticha muses on the downtown's unfortunate state: "Who was left when they cut the ribbon? Merchants couldn't sustain a year of barricades, it was already tenuous."

The aesthetic vision for this new mall was limited. In contrast to the methodical process often undertaken with the support of an arts commission or arts council, the design was left to the landscape architect. Although this was an opportunity to create a coherent public space at the core of downtown, Mitchell's design solution was extremely harsh. For the center, Mitchell designed a massive concrete "water feature" (as fountains were against the regulations of the HUD grant). With its clunky Modernist concrete form, it became derisively known as the "Tank Trap."

Within a few years, problems emerged with the water feature. Its spotlighting went out, and cracks developed in the concrete. It functioned on-and-off for ten years, but eventually, after heavy use, a very expensive pump broke and the City shut off the water.[15] In a major mistake of 1970s planning, the City neglected to retain any of its grant money for maintenance. Within a decade, the fountain had become a dusty trash-littered eyesore, rather than an amenity.

Meanwhile, the experiment in vehicle-free living was failing. The idealistic urban planning hoped to open up a vibrant car-free market center like the pedestrian-friendly city centers in Europe. But these centers accommodate multiple functions, including housing above the stores. Business continued to plummet in Eugene's downtown. However, it was the users and not the businesses who determined the viability of the space, much to the confusion and dismay of the City. Poticha said:

> The merchants, who were desperate, went to the city council and said, "Hey, there are a lot of people using the benches and the grassy knolls in downtown who don't have any shopping bags. So we need an ordinance so people can't loiter in downtown." And they actually passed an ordinance to keep people from loitering in the downtown.[16]

The civic enhancements did not soften the blow. According to Douglas Beauchamp, former executive director of Lane Arts Council in Eugene, "[the fountain] looked like something meant to impede progress … . It became a symbol."[17] The stark visual representation of the dysfunctional downtown, the dysfunctional fountain, remained a remnant of bygone planning ideas.

Undoing the legacy of the "Tank Trap"

However, Eugene's historic character, eroded by 1971, remained in the mental landscape of many residents. Downtown very slowly began rebuilding itself as a place. Local arts advocates in Lane County unsuccessfully brought a funding measure to elections on two occasions in the early 1970s to build a world-class performing-arts center. By 1978, they had garnered enough support to pass a bond levy for a hotel-room tax in the City of Eugene to support the project.[18] The City constructed a performing-arts center behind the site of the "Tank Trap," and only a few blocks away. It demonstrated both an understanding of and commitment to an integrated approach, involving artisans and artists. The Hult Center for Performing Arts, opened in 1982, used local craftsmanship and integrated art to enrich the space. Funding from the National Endowment for the Arts, Oregon Arts Council, private donors through the Eugene Arts Foundation, and 0.5 percent of the construction budget supported works by thirty artists, most from the region. The center also houses a gallery with temporary exhibits.

The details of the building are artistically embellished. One playful example is the decorative tiling in the restrooms, handpainted by Oregon artist Anne Storrs. The men's tiles illustrate the straightening of a tie, while the women's depict putting on make-up in front of a mirror, both references to life backstage in a theater.

While the percent of construction cost set the art budget, the integration of art and craft into the architecture demonstrated a strong commitment to the overall success of the space as a center of culture in the city. In 1981, the city council approved a Percent for Art ordinance for certain capital projects, but still the core of downtown remained depressed. By the 1990s, citizens had narrowly voted to open the mall to traffic, in an attempt to revitalize the center. This phenomenon transformed pedestrian malls across America. The hulking "water feature" between the two main streets had to go. Maintenance and restoration were not even considered, as the piece and the intersection's infrastructure were fully integrated. Mayoral candidate Ruth Bascom even ran her winning campaign with a promise to jackhammer the sculpture. And jackhammered it was, in 1995.

Unlike today, when deaccessioning rules and legal protections guard public art in Percent for Art programs, there was nothing to prevent the City from demolishing the piece. As with Denver's skyline mall, another concrete abstraction, and Fresno's geometric concrete slabs, the pieces were consequently demolished rather than retrofitted. But the cost to overhaul the mall did provide Percent for Art funding for the works now standing in the intersection. When the city council created a design committee to oversee the change, the members soon realized that there was a much greater opportunity than a simple aesthetic enhancement. The committee went to the council and asked for more money to accommodate what it saw as a great opportunity—"a placemaking project."[19]

The team looked at space and related issues, much as Poticha's original team had done long before. But by now the City was ready for this functional wisdom. The team brought their vision to the city council, which doubled the money originally set aside for redevelopment, including around $100,000 for public art. The Lane Arts Council used the design committee's completed study to focus its search for artists. Beauchamp explained: "We'd gone through the plaza design process. It established principles … . We were better informed and could tell artists what we were trying to accomplish with the plaza."

The arts council sent out a detailed RFP with goals, which included the requirement for "a sense of arrival and connection to the community beyond," as well as for "a place that expresses symbolic, historic and ceremonial community values."[20] This explicit request demonstrated that placemaking was a key factor in what the arts council sought, and encouraged place-related proposals.[21] The council received almost thirty submissions, from which it selected finalists; it then chose a proposal that anchored the location to community identity.

One of two winning proposals included a set of pillars made from concrete, stone, and metal. These markers sit on the corners of the intersection that was once filled by the "Tank Trap." According to

Handpainted tiles by Oregon artist Anne Storrs in the Hult Center for Performing Arts, Eugene, Oregon.

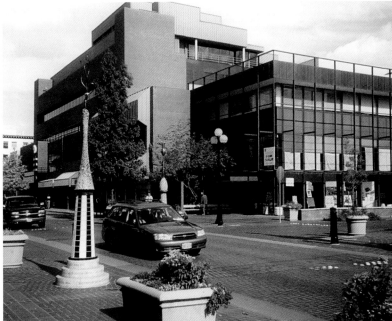

ABOVE AND ABOVE, RIGHT
The non-functioning concrete fountain known locally as the "Tank Trap" sat from 1971 to 1995 in the main intersection in Eugene (left), now open to auto traffic and enlivened by these placemaking columns, commissioned by the county's Lane Arts Council (right). Photos: Rebecca Evans.

RIGHT In 1996, local artists Betsy Wolfston and David Thompson created four sculptural markers relating to place history. Detail of column base, *Summer*. Photo: Rebecca Evans.

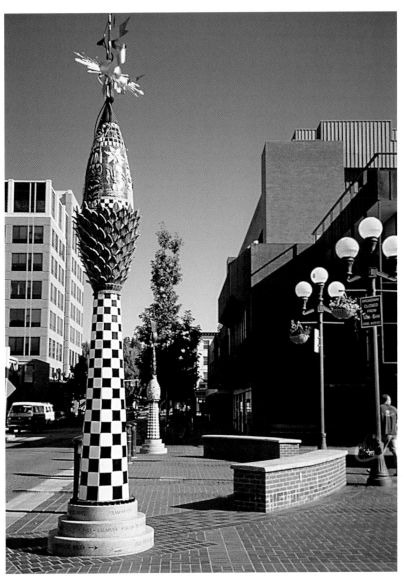

Beauchamp, the arts council selected local artists Betsy Wolfston and David Thompson in part because of their reputations as superior local crafters. One for each season, the pillars incorporate tiers of textual information about local places of historical and environmental significance, both well-known sites and those off the beaten track. The pillars also mark Eugene's varied (and sometimes controversial) history, and the name of the seasons carved in different languages. Betsy Wolfston's commitment to portray her hometown honestly compelled her to include some of the city's more difficult history. One caption on the base of a pillar marked the saga of the region's native tribe: "Kalapuyas forced to reservation." But her selections were not just based on controversial events— she wanted to show a broad range of the city's heritage, both cultural and natural.[22] According to Douglas Beauchamp, "part of the plaza strongly changes in the different seasons, based on shadows, so there was an attempt to make them markers, marking seasons, landscape, intersection, memory."

Six years after the installation, the authorities again intended to open up downtown to more traffic. The markers' placement came into question as the City sought to widen the street on which they stood. Often, this vulnerability to urban-design change can become a reason or excuse to get rid of controversial art, as it was with George Sugarman's untitled arch sculpture at Wills Eye Hospital in Philadelphia. But because the markers are admired, the city's architects and designers rallied around them. In contrast to the "Tank Trap," these markers have a constituency.

The university: a parallel universe

In 1971, several years after Poticha Architects' experiment in community planning, another street became a pedestrian walkway. This time, a group of student demonstrators spontaneously closed a main road through the university campus, about a mile from downtown, thus becoming planning advocates.[23]

In 1974, with the aid of architect and theorist Christopher Alexander, the university's planning department adopted *The Oregon Experiment*, a schematic approach to campus growth rather than a fixed master plan. The plan served to guide the university's development and continues to bear influence on campus. Alexander outlined six planning values: organic order, participation, piecemeal growth, patterns, diagnosis, and coordination. He defined these in his trilogy comprising *The Oregon Experiment*, *A Pattern Language*, and *The Timeless Way of Building*. The university planners still apply these principles today. At the center of the scheme is participation, so that users of the proposed buildings and spaces are deeply involved in the design and planning processes. This commitment to user participation has become some part of the university's identity, although to be realistic, most students are not even aware of the program's existence.[24]

The user groups that helped design the science complex took these issues to heart. In one case, because of budgetary constraints, the user group accepted a 12 percent decrease in assignable space in order to keep some important design features.[25] This sense of proprietorship forces users to make tough and realistic decisions, and to consider their values. How important is art? How important is a livable space? The university planners involve building user-groups in the art selection process as well. According to Fred Tepfer, it can be difficult to get people on board with more challenging or interesting art, but the committee is familiar with how people use the building. This is an essential insight in choosing and siting art effectively, so that it can be meaningful.

Through the Percent for Art program, moveable and art-in-architecture projects are incorporated around the campus. Integration was key in the designs of the Beaux-Arts Knight Library, renovated

RIGHT Northwest artist Wayne Chabre sculpted his copper bear, raven, and salmon in 1986 as part of a series of local wildlife gargoyles adorning the university's Museum of Natural and Cultural History. Photo: courtesy of the artist.

BELOW Mike Mandel's 2004 photo mosaic columns outside the University Stadium stand 22 ft tall, with content taken from archival photographs. Photo: courtesy of the Oregon Arts Commission.

BELOW, RIGHT *Physics Wall* by Kent Bloomer integrates physics-related ornamentation into the architecture of Willamette Hall, part of the collaborative design effort of the university's science complex in 1989. Photo: courtesy of the artist.

in 1994, and the science complex, which opened in 1989. A feat of collaborative design, the complex includes several art projects, some conceived more successfully than others.

The design of the science complex was, by all accounts, an impressive coordination of efforts and interests. The many science faculties of the university worked together to create departmental and interdepartmental spaces. The art was thoroughly considered as well. Lotte Streisinger coordinated the integrated art for the performing-arts center and also for the science complex. She was deeply concerned about avoiding "plop art". To sidestep needless controversies, the committee selected a broad range and a large number of works, with the strategy of appealing to many different building users. Also, users participated in the art selection process; plenty of public information was available throughout the installation.[26]

Thematically, the art in the science complex tied the building to the sciences housed within. *Cascade Charley*, a "water stair" by Alice Wingwall, flows next to the geology courtyard, and contains stones brought in by the geologists themselves. Gargoyles by Northwest artist Wayne Chabre depict prominent scientists, including a playful Einstein with his tongue sticking out (inspired by the famous snapshot). Chabre had also completed a series of animal gargoyles in 1986 for the university's Natural History Museum. Still, according to artist Marc Pally, full integration was impossible because artist proposals were invited only after the science complex had been designed. This lack of early collaboration left the gargoyles without niches, appearing dwarfed by the architecture and out of scale.[27]

Finally, *Physics Wall* by Kent Bloomer in Willamette Hall represents the branches of physics housed in the building through a system of art and ornamentation. Details throughout the huge atrium display motifs based on themes suggested by the physicists themselves. Bloomer also suspended a field of metal "stars" in the tall space. The university hired the artist under a separate agreement from that of the builders, causing multiple conflicts between the artist, his construction crew, and the contractors running the site.[28] In spite of these hurdles, the science complex provided the budget and the opportunity for a slew of public artworks, which were, according to Streisinger, well received by the university community.

The university, under the auspices of the state, and separate from the City, runs a Percent for Art program similar to Lane County's. Since there is only one staff member at the Oregon Arts Commission available to oversee public art, it is often impossible to coordinate artists and architects early in the design process, when it is most important. Although the planning department knows that early collaboration is a priority, administrative delays get in the way.[29]

However, public art is well loved on campus, and now some departments are taking the initiative to purchase their own art, without incentive from the arts commission. Although the City and university operate independently, the influence of the most successful projects can be seen reflected between the campus and downtown, as exemplified by the university's science complex and the city's Hult Center for Performing Arts.[30]

Slow change

The downtown is still in depression, despite the street-level changes.[31] Many buildings are still vacant. With growth boundaries for municipalities, Oregon's progressive land-use laws of 1973 are slowly bringing about some growth, while a cycle of shifting demographics unfolds. Developers and low-rent tenants now solicit the downtown buildings, once home to department stores. Disappointed

citizens, once again impatient and ever ready to oppose change, protest against this evolution, even though the alternative is dead space and boarded-up buildings. Planners in Eugene work from guidelines adopted in 1998 to promote sustainable development, and also from a zoning plan to protect local wetlands, approved in 1992.[32] But some changes, such as well-built low-income housing and new municipal buildings, are gradually reanimating parts of downtown. Plans for new buildings have emerged, including a library and downtown apartments.[33]

Low rents also serve as catalysts for creative solutions to the problem. Art galleries and other tenants of the area, and groups like the Downtown Initiative for the Visual Arts (DIVA) set out to revitalize downtown through artistic endeavors, exhibits, classes, and events. Also, the Eugene Community Trust has worked since 1995 on efforts to fill major vacancies. It established the Tango Center, a community center offering dance classes, to encourage activity in the downtown. The trust hopes to fill downtown Eugene with community-oriented spaces through this effort.[34] A Saturday market, featuring produce and crafts, has drawn an idiosyncratic crowd to downtown since 1970 when Lotte Streisinger conceived the idea.[35] Some shops and restaurants are lively during the weekends, and, according to one university student, "downtown contains some interesting public spaces that give the impression of being great places, even when nobody's there."[36]

Tepfer, a long-time Eugene resident, muses to himself while walking around downtown, with his resident- and planner-glasses on: "Sometimes when I walk through, I think I'm beginning to see signs of life. But sometimes when I walk through I think, oh my gosh, this used to be a real townscape and not a mallscape." The art planning hasn't changed the social fabric, but with a strong public-art process, durable and significant projects have a chance to enrich the city while the economy evolves. The placemaking guideposts, born out of the trauma of design failure, are the most significant elements so far to mark the recovery of place meaning.

1 See Outdoor sculpture sites, idiotech.com/oacdocs/oacbin/26openend.html, www.sculpturecenter.org/oosi/sculpture.asp?SID=554.

2 See Phillip Pina, "Sculpture Leaving Sixth and Vine," *Cincinnati Enquirer*, June 23, 1999.

3 *ibid.*

4 E. Pope Coleman, former interim director, Cincinnati Contemporary Art Center, founder of the Cincinnati Institute and the Cincinnati Hillside Trust and founding member, Partners for Livable Communities, correspondence, March 31, 2004.

5 Frances Gagnon, chairman of Springfield Historical Commission, interview, September 23, 2003.

6 *ibid.*

7 James Mulvihill, CEO, Wills Eye Hospital, interview, September 10, 2003.

8 Michael Sorkin, ed., *Variations on a Theme Park: The New American City and the End of Public Spaces*, New York: Hill and Wang, 1992. (There is much other material on suburban sprawl.)

9 An excerpt from this section appeared in *Public Art Review* 32, Spring/Summer 2005, with the collaboration of Melissa Tapper Goldman.

10 Fred Tepfer, planning associate, University Planning Office, interview, August 27, 2004.

11 Richie Weinman, City of Eugene Community Development Division, interview, December 12, 2003

12 Tepfer interview, August 27, 2004.

13 Otto Poticha, Poticha Architects, interview, September 2, 2004.

14 Tepfer interview, August 27, 2004.

15 Jerry Gill, former development analyst, City of Eugene, interview, December 16, 2003; Otto Poticha, Poticha Architects, interview, September 2, 2004.

16 Poticha interview, September 2, 2004.

17 Douglas Beauchamp, former executive director of Lane Arts Council, chair of design committee for Downtown Revitalization Project in 1990s in Eugene, interview, March 11, 2004.

18 See Hult Center website hultcenter.org/content/contentid/250, accessed December 15, 2004.

19 Beauchamp interview, March 11, 2004.

20 Lane Arts Council Call For Proposals, 1995.

21 Beauchamp correspondence, October 5, 2004.

22 Betsy Wolfston, artist, Eugene, Oregon, interview, September 24, 2004.

23 Tepfer interview, August 27, 2004.

24 Siena von Tscharner Fleming, student, University of Oregon, interview, September 9, 2004.

25 See John Moseley, "The University of Oregon Science Complex—From Participation to Ownership: How Users Shaped the Science Complex," *Places*, vol. 7, no. 4 (1992), p. 16.

26 See Lotte Streisinger, "The University of Oregon Science Complex—People, Place and Public Art," *Places*, vol. 7, no. 4 (1992), p. 56.

27 See Marc Pally, "The University of Oregon Science Complex—Finding a Place for Collaboration," *Places*, vol. 7, no. 4 (February 1992), p. 64.

28 See Kent Bloomer, "The University of Oregon Science Complex—The Confounding Issue of Collaboration between Architects and Artists," *Places*, vol. 7, no. 4 (February 1992), p. 58.

29 Shawn Peterson, University Planning Department, interview, April 1, 2002.

30 Tepfer interview, August 27, 2004; Weinman interview, December 12, 2003.

31 Weinman interview, December 12, 2003.

32 See Scott Maben, "Green Eugene," *Planning*, October 2004, p. 10.

33 *ibid.*

34 Eugene Community Trust website, eugenecommunitytrust.com, accessed September 27, 2004.

35 Eugene Saturday market website, eugenesaturdaymarket.org.

36 Von Tscharner Fleming interview, September 9, 2004.

Curatorial truth and contextual consequences:

The evolution of federally funded public art at the GSA and NEA[1]

THERE USED TO BE TWO FEDERAL PROGRAMS dedicated to funding public art. Now there is one. It is easy to imagine circumstances in which we would still have both, or in which both would have vanished. In fact, for a long time both programs were on the same road to self-destruction: funding projects that the general public found incomprehensible at best and offensive at worst. The story of how one program adapted while the other disappeared is instructive for anyone concerned with how government can and should support artists. The recent history of public art in America is marked by instructive controversies that have changed federal policy toward the funding of art. The most high-profile controversies have been, not surprisingly, on the national level. A firestorm surrounding exhibitions of Robert Mapplethorpe's sexually explicit photos and Andres Serrano's *Piss Christ* generated congressional criticism of the National Endowment for the Arts (NEA). This eventually led to the cessation of the individual artist grants program in the visual arts. The national spotlight on the hearing regarding the removal of Richard Serra's rusty iron arc in a public plaza in New York provoked the General Services Administration (GSA) to change its procedure for commissioning public art. At the GSA, the Art in Architecture (AiA) program continues to support public art today in federally funded building projects. The NEA supports some public artworks through its Visual Arts program, but its Art in Public Places program (APP) disappeared in the mid-1990s. One agency was able to learn from criticism and make the policy changes that insured results. The other clung to a notion of artistic integrity and was hoist by its own petard.

Public art, unlike gallery art, must be made *for* the public, since the public is its patron and audience. One can choose to avoid a gallery, but people amble through public places as a matter of course, and they have a right to opinions about the artwork that they have funded there. This does not necessarily amount to censorship of unappealing projects, but simply to a realistic assessment of a public-art program's accountability. This attitude challenges the politically correct notion of art as a sacrosanct endeavor. But one must recognize that public art is a special kind of art. The GSA and NEA learned this lesson, as did many programs nationwide, by trial and error. But the two programs responded to their hurdles in quite different ways. The GSA utilized the wisdom of the

evolving field of public art, influenced by local community input at the building sites as well as by the apparent evolution of art forms that encourage integration of art and architecture. However, the NEA's APP program, assaulted with the knife of congressional budget cuts and public scrutiny, did not exercise the same learning curve and was not robust enough to survive the institutional shifts that demonstrated the fragile nature of its core constituency of curators, artists, and museum directors.

Much of the publicity directed toward tax-funded art is reactionary, appearing as letters to the editors of local papers or evening news editorial exposés. People want to know: where does the tax money go, and to whom is it distributed? Who creates the policies, and to whom are they accountable? This discussion is difficult to approach, even for arts professionals, because it is considered out-of-station for non-curators to criticize artists' work. Laypeople who express negative judgments are disregarded as troglodytes. This silence can protect artists from ignorant attacks. But it does a disservice also, removing art from productive discussion and entrenching artists' places in the margins of society. All citizens, including artists, have a right to free speech, but nobody has a free ride to use taxpayers' money without any discussion. Ideological debates on artistic standards by partisan legislators may be biased and shortsighted, but even naïve slander can carry a measure of truth. If a senator misunderstands a sculpture in a plaza, how is the average passerby supposed to make sense of it? And why *should* there be a great disconnection between the viewing public and an artist working in a public space?

In its earlier history, federal patronage of art was managed by panels of curators. The curators' formal concerns and their training usually favored abstraction and often did not encourage the addition of identifiable meaning to the places receiving the art. The curators' tastes in art reflected the fashion of the time, with a predilection for the abstract and the avant garde. Because of this initial bias, which was effective in lending the movement credibility among some powerful élites, the history of the federal government's involvement with public art is fraught with struggle. Controversies

James Surls's *Sea Flower* of 1978, outside the Federal Building in New Bedford, Massachusetts. Photo: Melissa Tapper Goldman.

caused programs to change direction or cease operation. They increasingly pitted curatorial preference—often gallery art imposed on a pubic setting—against a public wanting discernible meaning and relevance, increasingly skeptical of banal spaces and incomprehensible abstraction. One significant difference between the GSA's AiA program and the NEA is that the endowment is not a commissioning agency. It grants money to organizations to create works of their own design, so it will not give specific guidelines for the art's creation. Set up as a support for the arts, the NEA never intended to create ostensibly official government art, like Nazi or Soviet propagandist art. But clearly the impact of individual artist fellowships is hugely different from sculptures created through the APP and displayed in a public plaza. For 2006, the NEA had an appropriation of $125 million, distributed to many discrete projects. In contrast, the GSA uses a percentage of construction budgets on new or substantially expanded federal buildings to pay for art on the premises, spending only $10–15 million over the past five years on commissions. The two programs operate separately and have evolved on their own. Each has faced conflicts that have shaped its policies on public art. Each program's response to these controversies, and each program's adaptability toward growth and evolution, have carved two separate paths for the two organizations.

The GSA's Art in Architecture program: a learning curve defined by controversy

The GSA keeps a collection of fine art, as well as commissioning public art through its AiA program. Although this expenditure is not mandated by law, since 1963 the GSA has allocated at least 0.5 percent for public art from the construction budgets of new federal buildings and major renovations.[2] In some cases, as in new construction, the art budget is cut-and-dried. In other situations, such as structural updates or partially redesigned spaces, the decision whether to commission art is made case by case, with input from the regional project managers.[3] The program initiates approximately ten to fifteen projects per year, each one completed over three to eight years.[4]

Since Alexander Calder designed the famous *Flamingo* for Chicago in 1972, the AiA program has commissioned works in federal buildings and plazas under its current title. According to Susan Harrison, manager of the AiA program, the frequency of commissions has not changed since the late 1980s, but the focus has shifted from monumental sculpture to multimedia work and art integrated into architecture.[5] The method of selecting artists has also evolved to look much more like other public-art agencies. This involves more respect for context and user satisfaction, attained by assembling more diversified review panels.

Although the program has a self-declared "commitment to showcasing the entire range of contemporary American art ... avoiding any uniform national federal style,"[6] it has not always been successful in this realm. In the earlier period of the program, the taste and pedigree of public-art administrators demonstrated particular biases, even according to an internal GSA history:

> During this time, the artworks commissioned were in keeping with the architectural vocabulary of the day—works of abstract painting and sculpture in modern buildings, which did much to illuminate the architects' and artists' ideals of abstract structural beauty.[7]

Unfortunately, the general public neither appreciated nor understood what the Modernists considered universal, and many artworks generated derision, such as George Sugarman's *Baltimore Federal*, and even outright rejection, as with Richard Serra's *Tilted Arc*.

A typical example of the GSA's pre-reform mis-step is a sculpture in front of the federal building

in New Bedford, Massachusetts. James Surls's *Sea Flower*, plopped outside the Hastings Keith Federal Building in 1978, was widely viewed as an eyesore. The citizens were already put off by the aggressive architectural statement that the building made: it was placed at a diagonal to the city grid, causing a rupture with the streetscape.[8] Then the large-scale sculpture reared its pointy head in the plaza. Its style and siting alienated the public, although the anemone was meant to riff on an ocean theme for this historically seafaring community.

New Bedford is a relatively art-tolerant community, according to Arthur Motta, city marketing director, describing this small city with its many cultural landmarks and a rich history of monumental sculpture and art. At the time of *Sea Flower*'s siting, a local newspaper survey found that 86 percent of respondents disliked the sculpture.[9] "The steel was rusted, and then bled across the sidewalk over the course of years. Every now and then you'd have a report in the paper of a little old lady who banged her head on one of the projectiles and hurt herself."[10] A berm was later installed to help the blind avoid injuring themselves on the piece.[11] The original cost was $9000, relatively low for a large-scale sculpture, and administrators were sure that people would come to appreciate it. Whether offended by the appearance, the placement, or the fact that it was "the federal government's autocratically chosen contribution to the civic landscape,"[12] the GSA left a mark with the people of New Bedford. One man from a nearby town commented, "It would be nice ... if the city came along and torched it."[13] Still, even great public art can receive a few bad reviews. In this case, however, it was not only the public that disliked the sculpture. In 1986, the mayor and city council were in agreement. The council endorsed a request to have the GSA get rid of it, although it never followed through with the removal.[14] Then, in 1999, the artist agreed that the piece could be moved to make room for a memorial for veterans of the Korean war, but nothing ever came of this effort.[15] The GSA restored the dilapidated sculpture in 2001.

This example is typical of GSA projects of the time: arts commissioners, without local input, bring in a well-recognized but non-local artist to plop an artwork somewhere very public, with no explanatory materials or educational programming. This work, in turn, cannot be removed without extreme controversy and hassle, no matter whether it turns out to be great or terrible, *even* according to the test of time. Ironically, it was the "wait and see" attitude that the administrators first took when approaching controversy. They made a promise that the cutting-edge art would be culturally uplifting and bring communities in line with cosmopolitan art trends. They told the public to wait until the initial outrage of public money being spent on something unappealing and unapproachable had died down, paving the way for lasting appreciation. We term this the Eiffel Tower principle. But unlike the case of the Eiffel Tower, public acceptance does not always come over time.

The lack of public education and consultation compounded a feeling of alienation by the viewing public and federal building users. This problem transcended the GSA process. The canonical contemporary art of the time did in fact, if unintentionally, embody an elitism, as the artworks' meanings were usually only accessible to the educated professionals involved in their production. In theory, the abstract pieces should have been universally approachable in their simple appearance, but in practice they were not. Sociologist Steven Tepper sampled GSA public artworks up to 1998. Of forty-one projects he surveyed, eleven were representational, of which only one produced some form of public conflict. Strikingly, he noted conflict surrounding thirteen out of thirty abstract pieces, or just over 43 percent.[16]

The epitome of the GSA's old approach was exemplified by the great tumult over Richard Serra's *Tilted Arc*. Commissioned by the GSA, the internationally famous sculptor designed a wall of Cor-ten

steel running through New York's Jacob Javits Federal Plaza in 1981. For reasons explained below, judges in the courthouse led a petition in 1985—signed by nine hundred of the thirteen hundred occupants of the Federal Building—to have the Serra piece removed. This generated a three-day hearing. Traditional artists, behavioral psychologists, and building users were pitted against parts of the art establishment in the city, which argued that to move such a site-specific work was to destroy it.[17] Finally, in 1989, in spite of a rearguard effort by the arts community, the sculpture was removed. The GSA currently houses it, in pieces, in a storage facility.

But in truth, Serra *intended* the dividing wall through the plaza to have disturbing implications, with the aim of underlining the ways in which our public life and our involvement with the government affect us. Serra's objective was to divide the plaza visually and reroute walking traffic around the wall. Ironically, this effect is more perceived than real, as a huge, defunct fountain in the plaza to one side of *Tilted Arc* was the main cause of the interrupted walking path. And this piece *did* ruffle feathers and make many people uncomfortable. But without any public education or interpretive signs, the annoyance was, as would be expected, taken out on the sculpture itself. So Serra's subtle protest was, purposefully, in direct conflict with the plaza's ease of use. To disable a public space to make such a modest point might also seem a colossal act of hubris, which would have been more acceptable if Serra had attached wheels to the piece so that it could be moved aside. But then, with the exception of such kinetic artists as Niki Saint-Phalle and Jean Tinguely, a sense of humor has not been noticeably present in works of civic sculpture. It can be a deadly serious game. Indeed, one workman was killed installing a Serra sculpture.

While the GSA's commitment to a range of contemporary American art compelled the commissioning of such work, this stands in direct opposition to the GSA's other (more central) commitment, to build and maintain functional federal public spaces. The case of a dysfunctional plaza with a broken fountain demonstrates a larger problem that plagued the GSA—unfriendly architecture and poor design of public spaces. In this case, the brutal art matched the barren space. But it must not be the art's job to make up for urban-design flaws, a lesson that the GSA would later come to address through its Good Neighbor program.

For Serra and other artists, the fundamental question that remains is whether the value of public art lies in bolstering structural power (as in the old-time statues of founding fathers, located in our historic public parks), or in remaining true to the artistic vanguard of the day, even when it is destructive or revolutionary in nature. Or, on the other hand, whether there is an obligation in *public* art, found outside galleries and private institutions, to serve the will of the users and funders (taxpayers). In the 1980s, supporters of the AiA program used vague, grandiose, and antiquated notions about the sanctity of art to defend it in the wake of criticism:

> Installations that may have been judged by the press, critics, and others to be difficult to comprehend (or less than completely successful) are to be expected in such a courageous program.[18]

This type of justification does not allow for valid criticism of the program or its structure, and so by the time of the *Tilted Arc* controversy, the GSA's AiA program had fallen behind the times, as public-art administrators across the country were beginning to seek more responsibility and accountability from publicly funded art. Today, accountability and public involvement in all phases of the commission are still not part of a strictly interpreted policy at the GSA. However, with attention to public education throughout the construction process, there is a better chance that the art will at least meet with a more favorable reception.

The *Tilted Arc* controversy also paved the way for the federal Visual Artists Rights Act (VARA) of 1990. VARA acknowledges artists' "moral rights" to their work, and sets up certain legal protections for artists. Today, it is even more difficult to deaccession works of public art because of this legislation. Still, the GSA has changed its contracts to reflect the law, rather than asking artists to waive their rights. (For more on VARA, see pp. 309–11.)

The composition of these influential artist selection panels has changed drastically over the past twenty years, thus shaping the direction of commissions. In 1989, the GSA moved from a three-person panel comprising high-level arts professionals selected jointly by the GSA and NEA, to a ten-member panel. According to Susan Harrison, "the regional offices of the GSA wanted more involvement in the commissioning process." The NEA's policy had been to appoint only "peer professionals," that is, artists, curators, and administrators in the field. The NEA and GSA mutually parted in 1989, while the NEA began its battle with the press and congress over controversial commissions. The new GSA panel included five arts professionals and five community representatives. Over fifteen years, the mix has continued to change.

In 1996, Robert Peck, a new "commissioner of the buildings" at the GSA, sought a comprehensive review of its art commissioning process.[19] The former aid to Senator Moynihan and former assistant director of the NEA's Federal Architecture Project[20] had a strong interest in public art and urban planning. He streamlined the approach to commissioning, making it similar to local and state public-art processes. He involved a panel of local administrators as well as artists and national experts when reviewing portfolios, which came from a nationally maintained registry (as well as nominees suggested by the panel). The current selection panels include two arts professionals, a community representative, the architect of the project, a representative of the building client, and two GSA associates. Of the two arts workers, one is a nationally recognized authority, and the other is selected locally. The updates were a mixture of trial and error, and evolution, made possible by changes in administration, and a creative attitude from the program staff themselves.[21] These procedures are more accountable to the local public being served. Without micromanaging the process, Peck has created a structure to encourage more sensitive decision-making.

Other changes in GSA policy have also broadened the possibilities for commissions, including hiring artists who do not fabricate their own work. In these cases, general contractors can build or manufacture the work, allowing for a much more integrated and collaborative effort, rather than building the site and expecting the art to be designed and to function in a separate sphere.

The GSA no longer commissions monumental sculpture. According to Robert Peck:

> [Previously], I didn't think that most of the artwork did squat for making the building, as they would sometimes say about the art program, "a more pleasant addition to its community." By the time I got there, GSA had decided that it was running a museum program or a sculpture garden program— what people refer to as "plop art."[22]

The problems with the program's monumental sculpture turned out to run deeper than the works of art themselves.

> The GSA had a thirty-year tradition of building [an unsuccessful building] and then putting a world-class piece of sculpture in it First, let's start doing good architecture that the people in the community

will love Second, let's see if we can really challenge artists to work *with* the building, use the art to create good *places*.[23]

Peck took a critical look at the commissioning process and made a few pointed changes. He felt that "the single most important thing we did was to say we are going to require that the artist be hired for a project almost simultaneously with the architect so that there can be some dialogue."[24] This early hiring ensured that the art wasn't cut at the last minute from overdrawn budgets. To put this into action, Peck required that the building proposals have artists on board at the design development review, thirty to 35 percent of the way into the project. Peck wanted to state the program's goals concretely and give a focus to the commissioning process.

We did also draw up some guidelines that said, what we're looking for is art that works with the architecture. We tried not to define that too much because you don't want to tell people exactly what that means. We also said that we were looking for things that made the building a better, friendlier, more welcoming place in its community.

His experience of working for the NEA in the 1970s, and hearing about the public-art commissions from the perspectives of artists, curators, historians, and design professionals, gave him a healthy pragmatic view of both the challenges and the great possibilities for public art.

[The NEA] influenced me to think that the dichotomy that the arts community often throws up— saying that as soon as you tell them that the art needs to serve a purpose you're somehow flouting the artist's creativity—is garbage.

The GSA commissioned Richard Serra's *Tilted Arc* for the federal plaza in New York in 1981. It removed it in 1989.

He pitted this stance against the constructive dialogue he has enjoyed with artists who said: "There's actually nothing that's more intriguing and challenging than being told that ... the person commissioning your art actually has a purpose in it, and you need to do it within a context."[25]

Peck's conviction that situating art with attention to its purpose and context enriched rather

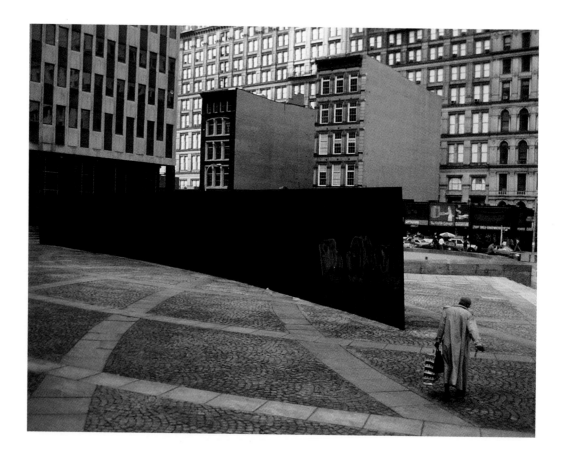

than inhibited the AiA program's horizons has driven his results-oriented approach to commissioning. The program's responsibility to the communities and employees that it serves can not be at odds with the apparent artistic goals that it upholds. Peck has sought to address this conflict by revamping departmental policy to reflect today's multidisciplinary approaches to art for the public. Finally, in order to ensure success with the commissions, the GSA also does local outreach and education, as well as having more diverse voices on the panel, including representatives from the community that receives the art.[26]

But the after-effects of the Serra debacle still haunt the program. In the plaza where *Tilted Arc* used to sit, a new landscape design commands the space. While the celebrated designer Martha Schwartz did carry out behavioral research into the needs of the plaza's users, the playful scheme has very limited content. The 1992 effort elaborates on the theme of New York's Olmstedian parks, with no reference to the multilayered history of the site. The design did not address the tumult that the location had seen with the Serra controversy, and in fact helped accomplish the task of erasing the unpleasant history. But Schwartz was also unaware of the square's other resonant history: it was the home of the largest source of fresh water in Manhattan until 1811, when it was filled in, having become polluted by industrial waste. This intriguing story had been explored in artist Jane Greengold's temporary public artwork *A Drop in the Bucket* in 1985. Surely this history and the recent art responding to it could have been made a part of the design opportunity?[27] The plaza's design did not include an art element, though Schwartz conceives of her design artistically. The reworked plaza was not considered a major refurbishment justifying public art and its more complicated processes, including an official commission by a selection panel. The federal plaza in our world-class city, New York, once warranted Serra's important $175,000 commission, but apparently now does not need artwork at all. Susan Harrison commented, "GSA has a lot of leaky plazas and they often have parking garages under them, which makes it very difficult to make them into humane spaces because of the structural loads and carrying capability of the plazas."

Apparently, the New York plaza is not alone in slipping under the radar of public-art protocol.

Today, the plaza of *Tilted Arc* fame is home to artistic design by landscape architect Martha Schwartz. Jacob Javits Federal Plaza New York, 1992. Photo: Melissa Tapper Goldman.

While the GSA maintains that it uses public art as much as it ever did, it is situations like New York's that put the program's commitment to the test. The subjective assessment of whether such a project is a minor fix or a major refurbishment warranting an art commission comes down to the perspective of the building administrators. Since it is incumbent upon the regional offices to push for (or against) public art, both good and bad precedents shape the opportunities arising today for better art and planning. As it is now, these plaza projects continue without public art, with the GSA and artists missing out on valuable opportunities to mold public space. Designs like Schwartz's, while artistic, attractive, and even inventive, do not benefit from the input and rigor that an art commissioning process offers. In this sense, although the GSA appears to continue its AiA program with full force, the effects of poor planning from the *Tilted Arc* era still reverberate.

In recent history, the GSA has managed to avoid public controversies. Some people attribute this to the eventual acceptance of great works. But a more accurate reason may be that the art currently commissioned better represents local needs, and is better integrated into the projects as a whole. Susan Harrison also feels that art has sometimes been targeted when other design or planning issues actually caused larger discontent among the communities.

> We have issues of projects where the judges are complaining that the buildings don't look like courthouses to them. The architects have told them they can rely on the art to solve that issue, to be the poster child to announce that it's a courthouse.[28]

Another of Robert Peck's visions was the Good Neighbor program, established in 1997 to coordinate GSA development with local urban-design efforts. The program orchestrates workshops for the various constituencies in a design project, from neighboring property owners to client agencies. According to director Frank Giblin, the program didn't start any new procedures, but created a framework for discussions on a national level with urban-design advocacy agencies, such as Project for Public Spaces.[29] This frames the task at hand in creating public places, and improves community relations for the agency. The simple yet essential thrust of the program is to coordinate GSA development with local urban planning initiatives, and to provide a single point of contact for community groups to ensure that their needs are heard. The Good Neighbor program, while tackling many of the same public place issues, does not work in conjunction with Art in Architecture. AiA commissions are still independent works rather than engaging a collaborative design process, but AiA and the urban-design efforts at Good Neighbor both seek to bring the artist on board early in any project.

The new guidelines and procedures are intended to avoid such problems, and are successful for the most part, though the design and engineering are still conceived separately from the art elements, as in the Jacob Javits plaza. Until these elements are more integrated, the full planning potential will not be realized. While the GSA has made significant strides to keep up with the public-art world after its wake-up call in 1987, its controversial history remains visible today in its earlier commissions and the legacy left by *Tilted Arc*.

One 1998 piece at the Ronald Reagan Federal Building and Courthouse in Santa Ana, California, shows the paradigm shift in the approach to GSA commissions. Along the winding "piano wall," the architecturally integrated mural by local artist John Valadez displays Orange County history over the twentieth century. From orange groves to the traditional summer festivals held throughout the region, the artist researched the area's roots by attending festivals and seeking out historical

photographs. The art is not just accessible to the building's employees and visitors, but it also ties the federal edifice to the land's history and the local community. A far cry from New Bedford's plop sculpture, this thoughtful integration displays a commitment to serving the public by bringing resonant, approachable art into the daily lives of the mural's real patrons.

NEA's Art in Public Places: relying on the old guard

The National Endowment for the Arts (NEA), established in 1965 by Congress, funded works of public art through its Art in Public Places (APP) program from 1967 to 1995. This program, a granting subsection of the NEA, disappeared after the endowment cut its funding for individual artists' projects. Pressure from Congress and publicized controversy had made certain speculative grants appear very risky.

Particular instances of projects funded in part by the NEA, such as Andres Serrano's famous 1988 *Piss Christ*, a photograph of a crucifix suspended in the artist's urine, incited heavy criticism. The endowment had maintained a hands-off policy with regard to the artworks that it supported. It relied on the high level of competition among artists to ensure the highest quality of grantees, and the grantees were then trusted to produce great works without censorship or guidance from the commissioners. This also meant accepting the current biases of contemporary art curatorship. The view of Bert Kubli, grants officer for the APP program from 1974–95, was, "If you believe in what an individual artist can do, stand back and let them do it." In retrospect, this policy appears sometimes naïve when it is meant to address the particular needs of public art.

The NEA's decision to cut individual artist grants may have been beside the point of the criticism, since the works that were ruffling so many feathers in Washington did not derive from funds for individual fellowships. The hope in cutting the program was simply to avoid the blame of controversy, in which the NEA became entangled every time a discussion of artistic standards came to the negotiating table of these so-called "culture wars." A traveling, judged exhibition, partially funded by an NEA grant, contained the Serrano photograph among the work of ten featured artists. The 1988 traveling retrospective of Robert Mapplethorpe's career, entitled *Robert Mapplethorpe: The Perfect Moment*, was backed by an institutional grant supporting the reputable Institute of

Local artist John Valadez painted this mural in the Ronald Reagan Federal Building and Courthouse in Santa Ana, California, in 1998, entitled *We the People: Summer Festivals of Orange County*. Photo: courtesy of the artist.

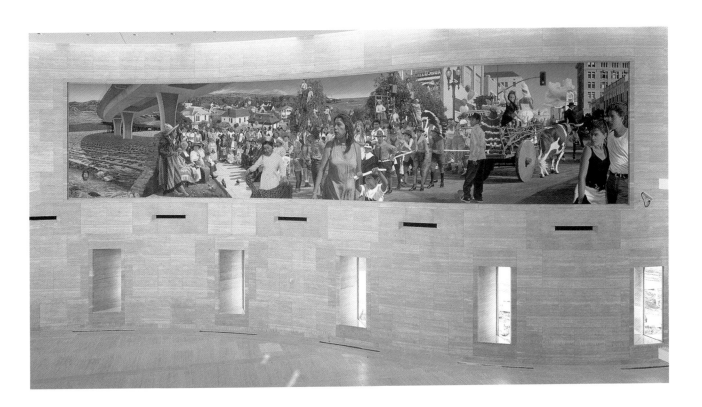

Contemporary Art in Philadelphia. A storm of controversy followed the exhibition to Cincinnati, where the arts center and its director were indicted on obscenity charges.[30] Although the NEA had given the exhibition an institutional grant and not a single artist's fellowship, the spotlight fell on the support of the individual artists featured in this show and others. According to historian Michael Brenson, the misplaced rebuke of the NEA's artists' fellowship program, and the ensuing criticism, caused the program to be eradicated as part of a zealous campaign by conservative forces.[31]

While the right of the artists to work was never in question, the reasonable issue was raised: what art is appropriate to be supported with tax dollars? In the context of an important public debate on the rôle of publicly funded art, politicians and lobbyists launched attacks on the immoral and offensive character of contemporary art. Even moderates adopted critical language, amid the pro-art rhetoric. Senator James Jeffords of Vermont promised, "There will still be grants available to individuals at the state level, and there will be a large number of challenge grants. All the good works that have not proven to be offensive to anyone will still be able to go forward." Unfortunately, there is no litmus test to determine what art will not prove offensive to any constituency, and it is not the task of the NEA to assess that. The endowment stands for the US government's commitment to leadership, both cultural and political, by supporting the arts. But in a population with many conflicting interests, it is impossible not to step on toes, and this leaves the program in a tricky position. It is at this vulnerable moment that a program's popularity is put to the test. Because the NEA's projects embodied the curatorial culture, they appeared foreign to much of the viewing public, and to the elected officials deciding the program's fate. The disconnection between the public and its art left the NEA without a solid base of public support to help it weather the storm of fiscal difficulties. At this time, the highly visible products of the APP program became liabilities rather than assets.

In 1996, the NEA faced debilitating budget cuts allotted by Congress—$99.5 million, down by 40 percent from 1995's $162.3 million.[32] After the heavy congressional debate and many threats to cut NEA funding entirely, the endowment ended its individual artists' fellowship program in 1996, except for literature. Organizations could apply for grants, sometimes for particular works, but lone artists could not seek funding to support their work. At the time, the NEA completely reorganized its granting structure, from seventeen discipline-based subdivisions to four major categories. By 1996, amidst this shuffle and without public support, the APP program had been quietly erased. The lack of support for this program was due in part, no doubt, to the same perceptions of elitism and esoteric irrelevance that plagued the GSA commissions of the period. According to a book published through the NEA itself in 1997, entitled *American Canvas: An Arts Legacy for Our Communities*:

> In the course of its justifiable concern with professionalism, institution-building and experimentation during the 1960s and '70s, the arts community neglected those aspects of participation, democratization and popularization that might have helped sustain the arts when the political climate turned sour.[33]

The trends in contemporary art and the needs and tastes of the general populace were at odds. This is no new or unique phenomenon. But the debate highlighted the underlying issue: the "rights" of individual artists to create work without direction or input, and the "rights" of the public to have effective and meaningful artwork that reflected their needs, since they were paying for it. Advocates and opponents of public art had rallied on both sides of this issue, as in the case of Richard Serra's *Tilted Arc*. No matter which side of the debate, rhetoric ran high, and the parties often deflected basic concerns.

From the perspective of artists' rights, historian Michael Brenson writes, "In its eagerness to root art into community and demonstrate art's potential for social good, the individual artist was thrown out."[34] But the inverse problem is equally insidious. Brenson says: "In its visual artists' fellowships program, in its Art in Public Places program, and in other visual arts programs, it put artists on pedestals, which reinforced the predisposition of many people to feel that artists, and the NEA, were arrogant and disdainful."[35] This conflict remained unresolved, especially in relation to the APP program. Artists garner their authority both by creating successful works and by being met in a respectful context where viewers consider their contribution seriously. In a museum or gallery setting, viewers take the importance of art for granted. The elevation of artists' power, in Brenson's words, "results in objects that depend upon galleries and museums to mobilize an aesthetic emotion whose specialness is defined in part by its separateness from everyday life." But in the public setting, the art is not bolstered in the same way. The public may grant critical renown to a sculpture in a gallery, but ridicule it when encountered in a public place. This is demonstrated by example after example of famous sculptors, such as Sugarman and Serra, meeting very different results in the street from those met within art institutions. So when art meets everyday life, as in works of public art, the romantic justifications put in place by the institutional art world fall short of meeting our understood requirements for the public realm.

The field of public art had been working to solve this conundrum long before the NEA caught up with the trend. The change did eventually come for the APP program. According to Bert Kubli:

> The public began to ask the question about the relationship of the object to the community, and to the site, and then the field [arts administrators and curators] began to ask that question. This is when the word "site-specific" appeared. And the public-art administrator rôle began to surface. In fact [the author] was part of that process.
>
> Education became more and more demanded in the guidelines, not as ... a reflexive or reactionary part of the process, but as a genuine belief that the public had something to contribute ...
>
> In the latter part of the history of the program, the involvement of the community in many phases of the creation of public artwork became ... possible without disturbing the rights of the artists. That was a difficult thing to manage, because everybody who called me said, "I want to apply for a public-art grant." They had a picture in their mind of what they wanted right then. Whether they were a mayor or an art administrator, they knew exactly what they wanted. They had to back away from that image Over time, many artists developed skills of dealing with the community, in fact incorporated the relationship with the community before they came up with even the idea of what they wanted to do.[36]

The program had begun to learn some of the important lessons in public art, but too late. By the time the endowment saw the need to revamp its programming quickly, the APP's rocky relationship with the public had taken its toll.

Like the GSA commissions, many of the earlier NEA public artworks were abstract sculpture, such as the APP's famous first project, Alexander Calder's *La Grande Vitesse* in Grand Rapids, installed in 1969. Received hesitantly at first, the huge and colorful sculpture has now become the city's brand icon, appearing on garbage trucks and the city letterhead. It serves as a backdrop to the annual festival of the arts, and its presence has helped to wake up this sleepy Midwestern city, but it remains on a windswept, barren, and inhospitable plaza, somewhat lost in the blank, Modernist space.[37] This production of culture has proved effective in some instances, but often such works are ignored

or seen to blend into the background, passively experienced like functionalist modern architecture, products of mere necessity rather than expressions of cultural values. And in truth, there is nobody to assess whether this condescending notion of cultural enlightenment has actually had any effect, because there was no analysis or oversight of NEA art.

With increased congressional scrutiny, the NEA had shifted its policy toward stricter guidelines. The endowment itself was disdainful of this change. Kubli thought it was unnecessary,

> because what we were trying to do was provide money that would be matched to communities to commission artists to create public artworks, and beyond that, it was none of our business what they did with the money.[38]

At that time there was no bureaucracy, manpower, or desire to retrieve and analyze such data as extensive final reports. But the apparently uncaring attitude characterized a full ideological stance: the art would be judged on the community level, from where much of the funding would derive. The local reception, better at self-censorship and self-assessment than a federal authority, would regulate the local artwork. This identity crisis ran deep: was the NEA a financial bolster for the independent work of artists, as selected by national curators? Or was it charged with using tax money to foster a strong relationship with the arts nationwide? The restructuring of the NEA in 1996 was a compromise. Individual projects were no longer under the purview of the national team; instead, the grants went predominantly to local arts organizations, which had the responsibility of distributing the funds as well as the accountability at community level. Sadly, even with this reform the available funds were still greatly diminished. The new structure was unquestionably better able to adapt to community needs, but the key question remained: how can a granting agency operate responsibly with no systematic way of assessing the effectiveness of its past grants?

The reason that the NEA could not hold its protocol up to such criticism was the continued lack of accountability for the works produced, with no distinction made between private projects and works for public places. Not only did the NEA trust its artists and believe in their rights to create their best works unhindered, but it also had no policy of tracking and assessing past projects to learn from their reception. Mistakes and successes were communicated "through the grapevine," according to Bert Kubli. But in truth, this lack of systematic hindsight haunted the organization's evolution. Without a methodology to put these public reactions on the books, new administrators coming into the NEA would have no idea about a project's history on the ground. This word-of-mouth approach rests entirely on the experience of a few long-standing employees. As in Kubli's case, some of these veteran administrators left or were squeezed out after the restructuring. While many of the projects were considered great successes by the art world, some, like Isaac Witkin's *Everglades* (see p. 331), fell by the wayside with no public education and no budget for routine maintenance, vandalized and sitting in a seedy concrete park, closed to the public for most of the past twenty-five years. Furthermore, locals (businessmen and criminals alike) saw the works as extrinsic, not warranting basic respect or even a second glance. In the mix of Witkins and Calders, sometimes notable sculptors in their own right, the accountability of the artist and grantor *to the public* slipped through the cracks.

In 2002, Save Outdoor Sculpture (SOS!), an effort by Heritage Preservation, catalogued the NEA's APP commissions through 1992, including five hundred works of outdoor sculpture. This was a difficult task, as the projects are located across the country, and not all of their histories have been thoroughly documented, even at the local level. Although some were temporary works, of

those that remained, almost half are in need of conservation. Approximately 10 percent have been removed or destroyed, and whereabouts of others are unknown. The records were dredged from the national archive, with no institutional memory of the program's history within the NEA. After Kubli's retirement, he offered his time archiving APP projects for the endowment as a service to the program that he was so proud of:

> I came back because I was trying to get the files in order so that future historians would find it useful. I had a lot of information, but I couldn't get any cooperation out of the staff so I stopped doing it after about four years.

The indifference toward learning from the past was a symptom of the NEA's attitude crisis, and explains why it is slow to improve on its mistakes. According to Wendy Clark, director of the Visual Arts Program at the NEA, the cutback was met with grave disappointment, and denial. The staff thought that the programs would be reinstated,[39] so they were hesitant to write or analyze their history. To this day, it is challenging to acquire historical information about the program's restructuring and shifts in commissioning panel make-up. In our own research, we encountered people who attempted to help us, but the basic information that we sought was unavailable. They ultimately sent us to file Freedom of Information Act requests in order to obtain basic facts on policy changes within the NEA's commissioning process. This lack of transparency may serve as a shield from divisive, overly critical media (and politicians), but it also prevents self-analysis and growth. Some of the criticism may well be unfair, but that is no reason to dismiss all criticism altogether. Furthermore, a solid program, responsible to the needs of its constituency, can often withstand controversy. In fact, controversy can provoke healthy dialogue.

Mirroring the shift in GSA commissioning inclinations, today the NEA supports many multimedia and educational programs, as well as community-oriented art projects (both those created by the community, and those implemented *for* community development). The projects follow the trends set by the applicants, unlike the GSA commissions, which seek out artists for a specific project. The main criterion for individual grants was the "excellence of the artist,"[40] whereas now the guidelines are much more structured, and new requirements, such as a detailed post-project report, are strictly followed, although there is no chance to revisit the history of a piece over the course of its lifetime.

Attitude adjustment

The GSA's procedural evolution from 1967 to the present, bringing building users and local arts professionals into the commissioning process, results in more approachable and likeable artworks that reflect the values and preferences of the communities. It is a good thing, since the communities have to contend with the art long after the administrators have gone away! But it was the flexible and practical attitude of the GSA that encouraged the program's transformation. What makes the GSA's story refreshing is that it reflects a bureaucracy's ability to respond to changing circumstances. The results are particularly interesting since the GSA *chooses* to furnish art, unlike the more common Percent for Art programs, which *require* public art in cities around the country. In order to protect AiA, which does not have the security blanket of a legal mandate, the GSA administrators understand that local support ensures the entire program's future. While they appreciate the importance and potential of public art to animate spaces and connect people to place, they know that with a serious price tag comes serious responsibility to provide something meaningful for their efforts.

The NEA remains purposefully hands-off in order to let the artistic milieu set its own tone, understandably wary of imposing a federal agenda on the art world. But the key to Peck's reform of the GSA's AiA program was his willingness to impose accountability on the arts bureaucracy. Such accountability requires good internal record-keeping to facilitate the development of valuable institutional memory. The NEA may be out of the glare of public scrutiny for the moment, but without any way of learning from its past mistakes, and even lacking any apparent desire to do so, one wonders if it is only a matter of time before the national funding of art is in the hot seat again. For the fiscal year 2007, budgetary cuts requested by the President threaten the existing Challenge America grants program, a series of grants with a simplified application process for organizations supporting public access to the arts. In a field where any press may be bad press, the issue requires a thoughtful dialogue rather than the usual degeneration into vitriolic name-calling on both sides of the debate, between the "populist philistines" and the "aesthete standard-setters."

According to the NEA's Wendy Clark, the endowment supports many works of public art among other projects in the broader funding categories, such as Local Arts Agencies or Visual Arts and Folk & Traditional Arts. Organizations may apply for funding to pay for public art, but no funds are specifically earmarked for this purpose, and it depends on the pool of applicants how much money or focus is put into these projects. Because of public perception and trends in art administration, the days of monumental sculpture are over. Instead, small-scale public projects fill local needs, like the Coney Island Sign Painting Project of 2004, which joined contemporary artists and traditional sign painters to reclaim Coney Island's sign heritage. But without any oversight, it is impossible to know to what extent the NEA is funding public art. Since there is no organized funding program for public art, even the program directors have no idea how much grant money goes toward public art.

Arts bureaucracies are still bureaucracies

Perhaps the most significant difference between the diverging paths of the NEA and GSA public-art programs lies in their views of themselves. GSA's AiA proved successful thanks to the leadership of administrators who recognized that even an arts bureaucracy is still a bureaucracy, where responsible procedures produce good results. This means that to be successful, it needs to be willing to organize itself under some principle of accountability to the taxpayers who fund it. In fact, its success depends on the commissioning of high-quality art that is accessible to the public. But the GSA program does prove that in order for public-arts patronage to be a success, artistic bureaucrats and bureaucratic artists need to recognize that none of them are operating in a vacuum.

At a time when America's cities and sprawling suburbs increasingly need the placemaking that public art can support, and with the vast experience of arts administrators, there is a potential for federal arts bureaucracies to do great things. Of course, it is neither possible nor desirable to create art that is foolproof or that nobody will object to. That is a fatuous goal and an impossible standard. But what we need is a realistic assessment of risk. Indeed strong programs that define procedures not only for recruiting local talent, but also for understanding local conditions, will help strong works of art to weather healthy criticism. The task for commissioners and grantors is this: how can you meet the needs of your constituency? Even El Greco had a client, a patron who gave him the theme of *Christ Driving the Money Changers from the Temple*. Working under the constraints of the theme did not thwart El Greco's distinctive contribution!

The first step is doing your community homework. What makes a meaningful place? It is usually a combination of factors involving scale, street furniture and amenities, and high-quality materials, as well as public art and craft. We term the process of asking questions about a specific space "environmental profiling," and it is really the basis for the commissioning process (see pp. 317–20). Since granting agencies like the NEA select from applications rather than setting assignments for projects, the task for such an agency is to assess whether the issues that would be raised in an "environmental profile" have been addressed in a grant proposal. Setting up such specific guidelines in the application process is one step to directing the results. Obviously locals are going to be more intuitively aware of the environmental factors of a place. Indeed the creative tension in having artists acknowledge the behavioral patters, local artistic traditions, and the physical design constraints (i.e. a historic district) are not a "buzz-kill" for the infinitely imaginative artist, but a focus to guide the productive process and define the purpose of the art.

The point is not to create art that caters to the lowest common denominator of populist consensus, but rather art that finds its inspiration in a certain contextual rigor—that challenges the public rather than approaching it with contempt. It is out of that brief that an effective set of metaphors can be crafted, and the talents of the artist as problem-solver as well as creative force can come most constructively into play. The community then has some basis of ownership in the work that comes out of this process. public-art policymakers at the GSA and NEA help to buttress this argument through their pragmatic success at adapting to context, and also in their naïve failure to address local needs.

This essay was produced in collaboration with Melissa Tapper Goldman. A shortened version appeared in The Public Interest, *no. 157, Autumn 2004.*

1 Additional sources:

Jeffrey L. Cruikshank and Pam Korza, *Going Public: A Field Guide to Developments in Art in Public Places*, Amherst, Mass.: The Arts Extension Service, University of Massachusetts, 1988.

GSA Art in Architecture website: gsa.gov/artinarchitecture.

NEA website: nea.gov, accessed January 13, 2004. Also nea.gov/about/Chronology/NEAChronWeb.pdf, accessed January 31, 2004.

Miwon Kwon, "Public Art and Urban Identities," 1997, eipcp.net/diskurs/d07/text/kwon_prepublic_en.html, accessed December 18, 2003.

2 See Steven J. Tepper, *Unfamiliar Objects in Familiar Spaces: The Public Response to Art-in-Architecture*, Princeton, NJ: Princeton University Center for Arts and Cultural Policy Studies, 1999, p. 5.

3 Susan Harrison, manager, Art in Architecture program, GSA, interview February 2, 2004.

4 *ibid.*

5 *ibid.*

6 *ibid.*

7 GSA Art in Architecture program, "A Contextual History of the Art in Architecture Program," pamphlet, p. 5.

8 Arthur Motta, New Bedford marketing director, interview, June 3, 2004.

9 See Dick White, "Criticism of City's *Sea Flower* Blooms," *New Bedford Standard Times*, May 19, 1998.

10 *ibid.*

11 Motta interview, June 3, 2004.

12 *New Bedford Standard Times*, editorial, "Sea Flower Sculptor Deserves a Big Bouquet of Real Flowers," accessed online, July 29, 1999.

13 White 1998.

14 *ibid.*

15 See *New Bedford Standard Times*, editorial, 1999.

16 See Tepper 1999, p. 19.

17 This is a powerful argument to this day, still waiting for settlement in major court cases.

Since 1991, the federal Visual Artists Rights Act protects certain artists from seeing their work destroyed without the possibility for intervention, but it is still a hairy situation when it comes to site-specific works (see David Phillips, p. 309 above).

18 "Celebrating Excellence," in *Presidential Design Awards*, Washington, D.C.: Design Arts Program, National Endowment for the Arts, 1984, p. 6.

19 See GSA Art in Architecture program, "A Contextual History of the Art in Architecture Program," pamphlet, p. 7. Also, Robert Peck, GSA commissioner of the buildings 1995–2001, interview, March 25, 2004.

20 The Federal Architecture Project was fully supported by an NEA contract from the Design Arts program. Robert Peck, GSA commissioner of the buildings 1995–2001, correspondence.

21 Harrison interview, February 2, 2004.

22 Robert Peck, GSA commissioner of the buildings 1995–2001, interview, March 25, 2004.

23 *ibid.*

24 *ibid.*

25 *ibid.*

26 Harrison interview, February 2, 2004.

27 For a case study of this public artwork, see Ronald Lee Fleming and Renata von Tscharner, *Place Makers: Creating Public Art That Tells You Where You Are*, San Diego: Harcourt, Brace, Jovanovich, 1987.

28 *ibid.*

29 Frank Giblin, director, Good Neighbor program, GSA, interview, April 2005.

30 See Jackie Demaline, "Mapplethorpe Battle Changed Art World," *Cincinnati Enquirer*, May 21, 2000, enquirer.com/editions/2000/05/21/loc_mapplethorpe_battle.html.

31 See Michael Brenson, *Visionaries and Outcasts:*

The NEA, Congress and the Place of Visual Arts in America, New York: The New Press, 2001, p. 95.

32 See Barbara Koostra, ed., *The National Endowment for the Arts, 1965–2000, A Brief Chronology of Federal Support for the Arts*, Office of Communications, NEA, 2000, p. 54.

33 *ibid.*

34 Brenson 2001, p. 91.

35 *ibid.*, p. 145.

36 Bert Kubli, former grants officer, Art in Public Places program, 1974–95, NEA, interview, January 12, 2004.

37 Paula Fogerty, Grand Rapids resident and president of local Kindel Furniture Company, interview, March 3, 2005.

38 *ibid.*

39 Wendy Clark, director, Visual Arts program, NEA, interview, October 22, 2003.

40 Kubli interview, January 12, 2004.

The artist's perspective:

Working in the field of public art

DIMITRI GERAKARIS
is an artist who for years
edited the artist-
metalsmiths' magazine,
The Anvil's Ring. He has
acted on both sides of
the placemaking
process, and has been
involved as an artist in
over a dozen public-art
commissions. He has
also served as a
commissioner of public
art for state-level
Percent for Art projects.
He is currently one of six
artists comprising the
New Hampshire State
Council on the arts
advisory committee.
Basing his designs on
historic, aesthetic, and
community
considerations, he has
completed commissions
for the New York MTA,
the City of Boston,
various states,
universities, and public
gardens, and created the
Boylston Gate that
appears on p. 229.

GREGG LEFEVRE
has completed over
sixty public-art
commissions in
different US cities. He
usually works in large-
scale bronze reliefs,
embedding in the
pavement images and
text about a place's
history, culture, and
physical geography. His
work appears in over a
dozen places in New
York, including Foley
Square, Union Square,
Park Avenue, and near
Grand Central Station.
In Chicago he has a
work in Bronzeville, the
city's historic African
American neighborhood
(pp. 166–69). He has a
bronze relief at Pomona
College (pp. 176–81),
and an adapted flight
map in an airport
terminal in Las Vegas
(p. 263).

ANDREW LEICESTER
has created over twenty
major permanent public
artworks in the US since
emigrating from
England in 1970, and
worked on the Central
Area Surface
Restoration Art Project
in Boston, as part of the
Big Dig project. His
Cincinnati Gateway
project, in which he
integrated many
artworks into a large
park, is discussed above
(pp. 54–57). He also
produced *Ghost Series*, a
project in Penn Station,
New York, that recalls
the architecture of the
previous station
building (pp. 74–79).

WILLIAM P. REIMANN
is a sculptor, draftsman,
and public artist who
taught at Harvard's
Department of Visual
and Environmental Arts
from 1964 to 2002. His
1999 project at East
Boston Piers Park and
his 1989 contributions
to the Radnor Township
project appear on
pp. 48–53. Other recent
projects include a
memorial for veterans
of the Korean war in
Holyoke, Massachusetts.

T. ELLEN SOLLOD
has been involved in
public art for over
twenty years, as an
artist, administrator,
and planner. She served
as executive director
of the Seattle Arts
Commission from 1989
to 1992, and has been
involved in creating a
public-art master plan
for Milwaukee, as well
as design guidelines for
SeaTac International
Airport. As an artist, she
designed a number of
integrated streetscape
elements on Mercer
Island (pp. 280–85) and
has recently completed
Bella Figura, a large
wind-activated
sculpture in Seattle.

project. So I don't know how you'd beat that, but it's certainly worth thinking about. Maybe you could have a mentor situation in some of your commissions where an older, more seasoned artist mentors a younger artist and helps him or her create the work. It's possible. Maybe you pay the mentors as part of the process.

SOLLOD: There is usually considerable communication between the staff project manager and the artist. The process is only as good as the staff support provided by the agency. I have had times when they have been wonderful and other times when they have been useless.

LEICESTER: It's very important for an artist to maintain constant communication with the commission. They're a resource; they know people. My commissioner in San Jose is excellent. Her job is to communicate flawlessly between my work and the planning process. She supervises all the progress. She sends me names of local contractors, landscape architects, civil engineers, and so on. It's especially helpful when you're doing work where you don't live. Most places don't have people who are as efficient as she is. My advice to arts commissions is to hire competent, motivated people with experience in allied fields like city planning, landscape design, and construction, and have them help artists in all phases of design and construction. Basically you need an ombudsperson.

3. Can you comment candidly on the impact the design review process has had on some examples of your own work?

GERAKARIS: I start every public-art project, as I do private commissions, by getting as much input as I can. But then, I totally resist anyone's attempts to micromanage where the design

goes from there. This happens fairly often and can really kill a design that has been very carefully put together. I come up with a design I think is appropriate thematically and artistically after having digested all this input. And I don't show Plan A, Plan B, Plan C. I will not go back and continuously change this and that, because the relationships in my designs are far more complex and interdependent than a committee can comprehend in the few minutes they have to view the design. I finally generate and present one design that I really think is the best, and then it's for the selectors to decide if it flies or not.

I have been involved with this process both as a submitting artist and as a commissioner. The greatest good can be achieved by providing input to the artist before the design process begins. After that, it should be basically thumbs up or thumbs down. Of course, every member of a review board will think of how they might design a particular commission, but if that is their overriding concern, they are sitting on the wrong side of the table.

I feel uncommonly fortunate that my projects have proceeded so smoothly once they were begun—but getting through the approval process while maintaining the integrity of the design has often been like running the gauntlet. Several times, I have traveled many miles to professionally present a design and the volunteer art commissioners failed to produce a quorum. (Interestingly, I have experienced this in two very major cities, but never in humbler locations.)

LeFevre: Design review is a mixed blessing. Certainly it is often helpful if there is someone to review a project with quality in mind. At the same time, a committee often performs such reviews, and we all know the limitations of committees. What is often difficult is when each member of the committee feels that he

has to impact the project in some way—and that is when the artist has to draw the line. It is also difficult when a committee wants to make very specific suggestions about design, where it becomes an issue not of quality, but of individual taste.

REIMANN: I've never minded people who were fussy about detail in my projects. They care enough to be engaged, and if you convince them that you are also engaging with the

project conscientiously they can be very useful. Such exercises have usually been helpful. As above, if one has professionals of integrity and competence, the design process is assisted. Sometimes this is conditioned by how I am seen by the reviewers: if I am specifically regarded as "an artist," our relationship is tinged a little differently from if I am considered "a designer." Reviews were most useful, if sometimes embarrassing: when someone brought up an idea in an area I hadn't adequately considered. This has usually not been because I ignored a stated concern, but because a (normally) unrelated voice was injected into the conversation.

GERAKARIS: I could cite many stories to reveal the behind-the-scenes human dynamic, but will share with you one of my favorites:

I was invited to submit a design for a commission in a major US city. Five artists of national standing were invited and paid to develop concepts for a competition. We were given virtually unlimited freedom of design and told that the budget would be X number of dollars, and it was a substantial amount.

After tremendous research into the history of the community and the theme I had selected, I painstakingly wove the elements together into a design with which I was very pleased. It seemed to flow artistically, structurally, and intellectually. Everything I wanted it to contain was there and yet it was honed to contain no superfluous element.

We artists made our presentations to an enormous body of constituent groups, seven of whom had a vote. "Congratulations!" I was later told by the head of this process, head of a public department. "Your design has won, but I have an issue with one element."

"Express your concern, and I will consider it as objectively as I can," said I.

"I find one element of your design particularly offensive," was the reply. It was a matter of "political correctness" and I thought it required a great stretch of the imagination to see the element as a problem. Plus it involved an aspect of the design that I considered essential. We could sign the contract if I dropped this element, but I simply could not do it. We were stalemated, and this went on for months.

An upset election eventually sent shockwaves through the commissioning agency. The person with whom I had been negotiating, who had been enjoying an appointed position, called and said the project would be killed if I did not consent to a very significant budget reduction. My response was affirmative. "Really!?" "Yes, indeed," I responded, "but the element I have been insisting on must stay."

We soon signed the contract with the lower budget and the element I insisted upon, and shortly thereafter the negotiating party was nevertheless replaced. When this city asked for an "official image" of the completed artwork, I happily sent a detail of the element for which I had battled, and relinquished $30,000. Years later, rather than feel embittered, I still feel a rosy glow.

My take on it is this: if you are doing art for the public with money collected from their pockets that could otherwise be spent on healthcare or education, you'd better make it right.

LEICESTER: Right now I'm involved with a project in San Jose, California. They offered the project to me because I had applied for other projects and they were familiar with my work. This project is for the new civic center being built by the architect Richard Meier. I was brought in as the artist to do the public-art component of the two-block pedestrian promenade connecting on the north and south sides. The north side leads into the residential area and the south side connects City Hall to the university, the academic core of the city. This is also the heart of Silicon Valley, so you've got all the big companies there—Intel, Hewlett-Packard, and so on.

A hundred years ago, it was called the Valley of Blossoms, because of all the fruit orchards for the canning industry—plums, peaches, and cherries. In the springtime all the orchards were in bloom, and people used to come from all over to see it. It was a paradise. Lord Kitchener came from England and said, "there were enough prunes to feed the English army." On May 13, 1901 they had a Festival of Roses to welcome President McKinley. They started having blossom festivals in the 1920s and 1930s with floats and various blossom queens. Wallace Stegner

referred to it as "this brief Eden." A local university football team, called the Spartans, inspired a float where people dressed as Spartan soldiers pulled a giant Trojan horse made of white roses. The San Jose airport was promoting a longer runway, so they built an airplane out of roses. There was a blimp float in the shape of a blimp entirely made out of flowers. It became part of the identity of the place to represent high-tech things with crafted flowers.

The project I came up with for City Hall comprised a parade of floats where each float was loaded with bounty and objects representing some aspect or product of the town's community and history. They were all heading to City Hall like people bringing taxes, or rather tithes. One of them was full of silicone chips. All the floats were pulled along by a gigantic Trojan horse. The floats were made of tile, and they had benches built in to sit on. The horse was a pavilion and you could walk under him. I did some beautiful drawings and presented them to the committee.

First there was silence from the committee, and then they said to me, "Haven't you heard of the Fallon horse? We don't want any more horses in our town!" The Fallon horse was a commission from a few years earlier. It was a bronze of a grand old white father of the city sitting on a horse. It had elicited an outcry from the Hispanic community, and so when I was talking to this committee, it was being stored in a basement somewhere.

Many of the committee members said afterward that they'd love a horse, but they were too intimidated to speak up in the group. They felt that the public-art program was very vulnerable to the whimsy of the mayor and the city council, and if something were to become controversial the public-art program might be stopped altogether. So they took out the horse.

Admittedly, the Trojan horse is a sort of doomsday symbol. City Hall is a symbol too. It's the repository of all that is valuable in the city, and what's valuable now is codified information. It is a vast network of computers. They are building steel and concrete walls around it for fear of bombing, but the real danger is not so much a physical threat, but the infiltration of computer systems. That's called a Trojan horse in computer slang. So the Trojan horse could have been a reminder of the town's vulnerability to theft and disfigurement of its civic memory. As such it would have had resonance and importance as a symbol.

Half the town likes it because it's a symbol of the local football team, and other people like it because it's made of beautiful ceramic tiles, and it calls to mind the blossom festivals.

So now I'm building the floats, but instead of a Trojan horse at the front of the parade, I'm putting a column with a figure on top. But I'll put in a little Trojan horse somewhere. Somehow I will preserve the integrity of this project.

4. Do Percent for Art programs or communities with art plans have any particular advantages or disadvantages as commissioners?

LeFevre: With most public-art agencies you end up spending a lot of time either educating or compromising. Percent for Art programs are usually advantageous for the artist because they have a staff dedicated to the arts, and commission procedures that have been worked out over time. Quite often the staff have a high level of sensitivity toward protecting the interests of the artists involved in their programs.

Reimann: I have rarely been involved with Percent for Art, which is too often completely politicized. Other difficulties show up—for example, landscaping or signage is substituted for an artwork. The advantages include

working at a fairly large scale, and working with professional engineering staff. Disadvantages are little or no institutional memory; contracts not honored; and work destroyed without notice.

GERAKARIS: I have been both artist and juror (never at the same time) for many Percent for Art projects. This is a fabulous way to mandate art that would otherwise not happen for the public. One percent of a large construction project can often buy a substantial amount of artwork for the public. This is a great way for an emerging artist to become known or for an established artist with more lucrative work still to have the satisfaction of serving the public.

LEICESTER: I did a project in Los Angeles called *Zanja Madre*, or "mother ditch." It's the largest project I have ever done. It was initiated by the Los Angeles Community Redevelopment Authority, which manages the art program for the city in all public buildings. They hooked me up with an architect, and I designed the plaza for the building.

I had to totally redesign it three times because there were three committees. And each time I had to fly to Los Angeles to present the new proposal to the three committees. The client committee was made up of Japanese businessmen and cowboy American developers. It was the strangest mix of people you can imagine—eminently cultured and tremendously subtle Japanese having to work with brash vulgar developers. When I presented the first proposal to them, they flew the director over from Japan. His interpreter said to me only this: "Yes, we like the work." That project went to review by the public-art committee who liked it also. Then I had to show it to the urban-design review board, which is responsible for city planning. They liked the idea, but rejected it, saying that it didn't fulfill objectives for Streetscape because it stepped back from the edge of sidewalk and didn't create the illusion of streetwall.

Here's what that means: In older cities, you usually have buildings with their four corners built out to define the street grid. In New York, people started building lozenge-shaped buildings because with a lozenge-shaped building you get many more corner offices. That eroded the grid, and created all these little triangular plazas at the street corners. Urban planners decided that it was destroying the look of the city. The building in Los Angeles that I was working on was lozenge-shaped, and so I had to create an arcade or colonnade at the edge to define the corners. That's why I failed the first time.

I went back a second time and showed the same imagery with a line of columns added in. This time, the art panel didn't like it. Finally, the third time, all the different committees approved it. The moral of the story is: get the different committees to communicate with each other and tell the artist the rules ahead of time. I'm sure that this rule was included somewhere in the documentation I was given, but it should have been emphasized much more strongly. Committees must figure out which are the unassailable objectives.

LEICESTER: Percent for Art is very important. These are the only arts programs that I apply to; I don't do private commissions. When I started my career, I came to America as a sculptor and I expected to make art for galleries. Public art as a separate field didn't exist then. Earthworks in the desert were commissioned by a few private foundations but nothing was happening in the urban domain except a few temporary projects, and a few pioneering projects in Ohio at Wright State University. I got work by doing temporary projects in cities. One project was a site where a house had been knocked down, and the art had to "interact with the site." All of us were teaching. We started to teach a generation of students about site and context in the 1960s and 1970s. "Public Art" as a name came out in the late 1980s and early 1990s along with the Percent for Art programs. So it's breeding a whole generation now who can say, "I want to be a public artist." The downside is that since programs are run by committees, you get a generation of young artists who, unless they are warned about the pitfalls, either will not be successful, or else will "succeed" by making really mediocre art. Then the whole thing falls into oblivion as a creative discipline.

SOLLOD: There are both advantages and disadvantages to public-art programs. Perhaps the greatest disadvantage is that the artist's involvement is often sought well after the rest of the design team has begun its work. This often puts the artist at a distinct disadvantage because where and how the artist works is defined by others rather than through a collaborative process. In addition, since artists are often added to a preexisting team, the working relationship needed for effective collaboration is sometimes difficult to achieve. The greatest advantage is that the artist has an "official" advocate throughout the process, as

well as someone to assist the artist in navigating the bureaucracy, when necessary. The existence of Percent for Art programs also means there will be a designated amount of money that may not be used or subverted for other purposes. Unfortunately, this amount is often insufficient for the task. Some savvy arts administrators have successfully used the public-art money to leverage other resources from other parts of the project budget to enhance the art allocation. For example, if the artist is going to create a specially designed terrazzo floor, the preexisting budget for a standard floor will be added to the artist's budget.

5. Do you seek community involvement in your placemaking work? If so, how do you get the community interested in your work? Do you welcome outside input or do you see it as an infringement of your artistic expression?

LeFevre: I welcome community involvement in most of my projects. I am happy to listen to what community members have to say. But getting the community involved is not an easy task. Simply advertising a presentation of the project usually leads to a very sparsely attended event. Getting an existing group or institution involved in presenting a project can usually lead to greater community participation. I flew all the way to a big city in the center of the country recently, to attend a public meeting with "the community." Three people showed up—one of whom was psychotic, one was a "crackpot" in the truest sense of the word, and one was a local artist who wanted to find out how to get a commission. Then there were the local officials who wanted to give everyone who showed up their due—not the best use of everyone's time.

LEICESTER: Yes, I seek community involvement. First of all, you have to familiarize people with your approach. In Boston, for the *Central Artery* project, and in San Jose, I did public presentations, and I handed out questionnaires to send back to the commissioning agency. I was trying to get everybody excited and into the discussion because most people have no idea what public art is. You have to let them know that their involvement is important and that it will affect the outcome of the project. Otherwise they just sit there passively and resent you imposing ideas on them, especially as an outsider. I look for wonderful serendipitous events—I can be sure that someone in that audience has some bit of information that will spark off an idea. It's like research. You find more when you open yourself up to more sources of information.

SOLLOD: Community involvement is definitely part of the creative process. It is also important for building support for the final idea that emerges. It varies depending on the project, the time frame available, the interest of the community, and the resources to engage it. Community involvement can range from facilitating a community design charette, to conducting individual interviews with community members, to participating in larger workshops organized by the design team. I usually try to find out who the "stakeholders" are in a project and at least engage them in a conversation, if there is not a more formal mechanism for involving them. I feel that all of this informs, rather than controls the work.

I do not view this as an infringement of my artistic expression; however, I am not personally interested in engaging the

community in actually making the art or in simply realizing their ideas. I am not wild about kids' tile projects and the like in general, because they often literally (as well as figuratively) fall apart over time. Work in the public realm must, in my opinion, be aesthetically and technically strong enough to last beyond the current neighbors or inhabitants or local interest groups.

6. In what ways have your works been integrated into architecture, rather than simply coordinating with it? To what extent have architects understood and supported your work?

SOLLOD: The majority of my placemaking work is made in conjunction with architects and landscape architects as a member of the design team. Because of Seattle's long-standing and successful public-art program, the design community is very sophisticated about working with artists. Rather than seeing artists as competition or art as a frill, the artist's work is viewed as an essential

ingredient of an overall project. I enjoy collaboration and have worked very well with architects, landscape architects, and engineers. Working in this realm enables me to create art on a much larger scale than I could on my own.

LEFEVRE: Architects have usually understood and supported my work. At the same time, it has been my experience that if the artist and the architect are both working for the client, instead of the artist working for the architect, there is a much greater propensity for true collaboration.

LEICESTER: I've had some nightmares trying to collaborate with architects. It's potentially very difficult, and potentially very rewarding. It's fortunate when it works because usually the architect and the artist don't know each other. Most times, the panel overrides the architect's suggested artist. At first, the architect will have some resentment if they aren't allowed to work with their pet artist. The new artist has to try to develop a relationship and an understanding with the architect nonetheless. And the architect has to be willing to allow the artist to inform the whole design process, and to have an impact. Most architects aren't used to that.

GERAKARIS: I have very much enjoyed working with architects and landscape architects while the whole project is still in the very early planning stages. That way, the artwork is developed as an integral part of the overall scheme and does not appear as a superfluous afterthought, as "plop art." In the best instances, the architecture and site planning have actually evolved this way to better embrace the artwork, the artwork has enhanced the architecture, and the whole has become more than the sum of its parts.

LEICESTER: I just finished a General Services Administration project in Youngstown, Ohio. GSA is in charge of federal buildings, and it was one of the first to have an "Art in Architecture" program. It deserves a lot of respect for having had the courage to do that in the 1960s and 1970s.

All over Ohio there are steel mill towns, like Youngstown, that run on the coal from Pittsburg. Steel went belly-up in the 1950s. Only one mill is still working. Now there's a steel museum, and Robert A.M. Stern Architects did a federal courthouse that used steel on the primary face of the building as a connection to the history of steel. I referred to the steel industry in my project as well. I designed two huge lanterns at the front of the building. They were 25 ft tall and you could walk between them. I built two big lamps that are based on blast furnaces. They are sinister-looking things, and at night they light up with intense sodium light, and white light shoots straight up, which looks great in the fog.

Unfortunately the two lanterns have started to rust, and I am, of course, responsible. GSA brought in their conservator to look at them, and the conservator told me I should have used a certain type of primer and finish paint. I said to GSA afterward, "This is like putting the cart before the horse. If you had brought in the conservator before I started building, his valuable expertise would have prevented this situation. Most artists would value this type of professional help."

I may have to go back at my own expense next spring and have the whole thing redone, and so I will lose all of my profit. This is where you need to have a very competent interface between the artist and the client.

REIMANN: My history of working with architects has been rewarding and positive. I am currently at work on a site-specific work for a private party. The architect contacted me early in the construction phase. The communication was good, and the way he understood what we both were about was a welcome support.

I feel the majority of the architects I've collaborated with were sensitive to differences in our approaches. Most valued was their comprehensive grasp, whether visual, intellectual or practical/economical, and their willingness, when timely, to exercise restraint.

7. How has the general public reacted to your placemaking art? Have they seen meanings you did not contemplate?

LeFevre: The vast majority of the public seems to be fairly oblivious to public art. I have done user surveys, and except in major tourist spots, less than 1 percent of those who walk past a piece of public art, mine or someone else's, takes any notice of the work.

REIMANN: The vast majority are indifferent about public art. However, anyone who has any poetic propensities at all in their nature will find meanings that I haven't contemplated. That's one of the hopes one has.

LEICESTER: My plan for the *Cincinnati Gateway* included a flying pig that reflected the city's history of pork-packing. It caused an uproar at first, since it was seen as undignified, but eventually it became the city's mascot. The first time I went to San Jose, I saw a restaurant bar called The Flying Pig with a sculpture outside, and T-shirts with pictures of flying pigs. I went inside to find out what was going on, and I met the owner. He said that he had moved there from Cincinnati, and chose the name of the restaurant because it was the symbol of his

home town. Now I'm a welcome visitor there, and he loves to introduce me as the creator of the Cincinnati flying pig!

8. What was your most rewarding placemaking project and why? How do you measure the success of placemaking projects?

LeFevre: I have two projects that I consider to be my most "successful." In downtown Boston, in Winthrop Lane, I have inset over one hundred small brick-sized bronze pavers, each of which highlights some aspect of the history or character of Boston. The work is very diverse—some of the pieces are humorous, some tragic, and some purely educational. Watching a busy pedestrian hurry down the lane, barely pausing to see one of the pieces, then pausing again to see another, and finally coming to a complete stop, is one mark of success. If you can stop someone in their tracks, you have accomplished something. It has also been gratifying to meet people in different contexts all over the country who not only know the pieces, but also can remember specific elements that they liked.

The same can be said for my series of bronze panels set in the paving of Park Avenue at 41st Street in New York. On this site once stood the "Architects' Building," home to many of the designers of the city's older skyscrapers that are featured in relief in the paving. Gauged by the number of people who stop to look, and by the number of people that I meet in my day-to-day life who know the pieces, the project is a success.

REIMANN: My two most rewarding projects were rewarding in very different ways, so don't allow comparison. The Radnor Township project was rewarding because of the scope it allowed; the community support; cooperation from other contractors; and the (relative) permanence of the installations, even if they

remain totally anonymous. The East Boston Piers Park project was perhaps the most integrated work, without at the same time becoming overweeningly obstructive.

The most unsuccessful was one of the most publicly popular (a granite basin filled with water, turtles, and frogs). It was installed on the Mass Turnpike at the Framingham service plaza. The piece was razed, the bronze cast was stolen, and the project never paid up, with no notice given.

SOLLOD: Creating *Of Science and Faith* for Swedish Medical Center, Seattle, is probably the most satisfying work I have completed to date. There are a number of reasons. I feel that artistically it is a strong work. The hospital was a great client with a great project manager. They were committed to the work and provided coordinated support. The architect was willing to allocate resources from the larger construction project to help realize my work. This included having the construction budget absorb the cost of the concrete

LEICESTER: I walked away from one project. I was hired to design art for a fire station in Kansas City. They wrote to me and said, "We want to try a new paradigm. We want you to select an architect. We've advertised. You are going to be part of the selection team." So the architect knew from the beginning that he had to work with an artist. We picked a young guy who said he was going to be the project architect, and who seemed to understand what was entailed in working with an artist.

At the appointed time, I walked into the office of the architect that I was going to work with. Instead of the man I had met, there was an old gray-haired senior architect waiting for me and beside him was his young protégé, completely different from the guy who came to the original presentation. And all around the wall were drawings of what the fire station would look like. As soon as the sketch exists and is put on the wall, it becomes the pre-eminent image. I said, "We have to start again!" but I was unsuccessful. I had to resign from the project altogether.

In Minneapolis I worked on a lightrail system and its plaza. I went to the architecture firm to meet with the architect for the first time. He was there with some other architects and all these drawings. I said the same thing: "We have to start over!" This time, the architect was amenable. His drawings showed futuristic deconstructed buildings. I had some drawings too, which I put up, and they looked quite different. We essentially agreed to start from scratch. We took a walk to the river, and then went to look at the site's neighborhood together. In the end, it worked out because the architect agreed to work with me, and I had learned from that prior experience to be more persistent and persuasive.

contractor to incorporate my engineering needs. The work was completed on time and on budget and I was not subject to delays outside my control (e.g. lengthy public process or approvals). The hospital administrators, doctors, and nurses all seem to love the work and I get great feedback on it from the art community as well.

9. What is your attitude toward placemaking art? Is it a "lesser" art because it is more literal? To what extent does representational art diminish the capacity for metaphor?

LEICESTER: Public art tends to be a lesser art. As an example, let's talk about *Cincinnati Gateway*. It's a collection of icons reflecting my reaction to historic events. Some are very literal and others are abstract. The flying pig was a literal iteration of an unreal creature. The different parts of the 2-acre project are dispersed, so that it cannot be seen all at once. As a result, there are elements that are not art, but merely informative, while other parts of the project are poetically expressed. Some parts are whimsical and magical, and other parts are simply "backup." We had to fight to keep the pig a pig, mostly since it did not seem dignified enough—perhaps since it didn't seem like real art. As an artifact in itself, it's just a curiosity, a pig looking skyward singing the "Hallelujah" chorus for its dead brethren.

Public art is really about monument-making these days. It's gone through the period of abstraction where the art had no site connection in the social-historical sense. I'm not against abstraction, as it can be an important manipulator of space and mood. Richard Serra's work is a brilliant example. Whether it's abstract or non-abstract, it makes itself a monument, so that people remember it as marking or making a place, or remaking or remarking on a place. To be an effective

landmark, a person has to be able to communicate to someone else, "I'll meet you at such and such a place," maybe at the "giant yellow cube" or the "man on a horse," provided there aren't a lot of yellow cubes and men on horses in the vicinity!

SOLLOD: While my work is narrative in nature, I do not think of it as representational. I am always striving to create a metaphor that relates to the place and that is evocative beyond the actual image depicted. The fact that the work is permanently placed within the public realm does influence its nature. The desire, however, is that the "art" is not diminished by the placement. My goal in creating art that "tells where you are" is that it tells you something beyond the obvious, something that goes far beyond the literal to the metaphoric. The challenge of working in this way is to bring the viewer along so that he or she experiences the place in a more intense, informed way.

LEFEVRE: Placemaking is not a lesser art because it's more literal. You can have good- and bad-quality artwork, whether it be abstract, realistic, or placemaking. I like the standards that Henry Geldzahler, the late Met curator, used. His definition of good art had three components. First, it has to move you—it can make you happy, sad, pissed off, puzzled, or anything else, as long as it does something to you on an emotional level. The second point is that it has to be memorable. You have to

remember it and what it was a week later, a month later. And last, it has to unfold a little more of itself each time you see it.

GERAKARIS: I think one of the tests of really great placemaking art is this: if you see the work in its new context, and then imagine it being removed, will that place be diminished? To me, one of the best things an artist can hear about work done in the public sector is, "I never would have thought of that, but I really like it, and I'd hate to see it taken away." I find art theory fascinating, but am also a believer in the phenomenon of "the emperor's new clothes," and feel great when I see artwork that attracts children. The saddest thing is when public art is reduced to the safest possible solution, the lowest common denominator. This insults the viewer and I think it produces the type of work most commonly vandalized. Happily, there are a tremendous number of artists across this country and other countries who are doing some fantastic public art.

There is certainly a long history of placemaking art, whether we look at the Acropolis in Athens or the Duomo and environs in Florence. Michelangelo's *David* standing for small but defiant Florence is a great metaphor and inspirational as public art. How could you say it is a "lesser" artwork because it is literal? To wonder whether an artwork is lesser art because it has a type of functional capacity is, I think, a question really not worth asking. It is as logical as comparing apples and oranges.

BELOW Panel from Ellen Sollod's *Of Science and Faith* at Swedish Medical Center, Seattle. Photo: courtesy of the artist.

BELOW RIGHT Dimitri Gerakaris's *Woodside Continuum*: art integrated into architecture. The sculpture serves as part of the railing system in the New York MTA's Woodside station in Queens, 1999. Photo: courtesy of the artist.

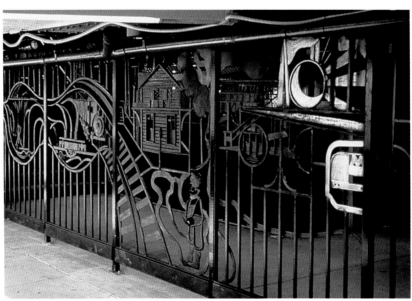

There is that which we refer to as "fine art," but some fine art isn't very fine. So, it's a distinction that can waste an awful lot of time. What excites me is placemaking art, public art that speaks to the community for which it was created and that develops its energy from the history of the community and from the future potential of the community as well.

I think one of the fun things about public art is getting it to work on many different levels. You shouldn't have to have a degree to appreciate art, or public art. You shouldn't have to have it explained to you, but at the same time it shouldn't feel pandered. Just spelling everything out as a storyline, as a didactic thing for the viewer, is counter-productive, because one of the things that makes art so special is the participation of the viewer. Viewers should get involved in the process and provide the missing links that connect the dots. When the viewer brings his own experiences and interpretation to the work, that is when the magic really starts to happen.

LeFevre: In one project, I was creating a series of bronze panels to be set in the paving that told the history of Union Square in New York. One of the images was to be a picture of the sculpture of Abraham Lincoln that was in the square. I had found a great newspaper photo of the Lincoln sculpture lying on its side, as it was about to be moved from one part of the square to another. The figure was lying in front of its base, which contained the Lincoln quotation about "malice toward none, and mercy for all." I thought that the photo, and the bronze relief work that I was going to create based on it, perfectly illustrated the fallen hero that Lincoln was, and his philosophy. One or two members of the design review board thought that the image was macabre, and I was told not to use it. I did the best that I could to convince the board to change their minds, but that didn't happen. The board also took issue with an image that I was going to use in another panel, this one of the Lafayette sculpture, which is also in the square. I planned to include an image of the raw casting of the figure, with all of its foundry "plumbing"—pour sprues, vents, and risers. It almost looked like there was a cage surrounding the figure, and in this way it was quite abstract. Some members of the board thought that the abstraction of the figure was out of character with my other works in the series, and in retrospect, I think that they were right. In the end, I reproduced the figure without the vents and risers.

10. How has your placemaking work been received in the arts community? How have art juries responded to it? Have your placemaking projects been more or less profitable than other projects? Do they take more time to complete?

Sollod: Among my colleagues in the public art and design world, I receive positive feedback. My personal work exhibited in galleries has been reviewed in art magazines though the public work has not. It has been featured in design-oriented publications like *Landscape Architecture*.

Certain things would be appropriate for people looking to commission public art and other things would be appropriate to submit to a jury of museum curators who are funding fellowships or artist residencies. This does not mean that public art or "placemaking art" could not be appropriate for the "fine-arts community," but it must be substantive, and artistically and conceptually solid. Work that is simply decorative or an architectural embellishment is not enough. It is not a debate between abstract and representational work but instead whether the placemaking work is substantial enough as a work of art to warrant support. In my own case, my work at Swedish Medical Center is a more substantive artwork than the streetscape at Mercer Island. Both are "placemaking" works.

The profitability (or the amount I pay myself) varies from project to project though I try to keep it somewhat consistent on an hourly basis. I try very hard to budget my projects realistically and to include a contingency, so that unforeseen circumstances do not jeopardize it. I also try to design with the budget in mind so that the work can be realized with the resources at hand. I expect to be compensated as a professional and at a level comparable with architects or landscape architects working on the same project.

Creating work in the public realm, whether architecture, landscape architecture, or public art, is subject to the vagaries of public process, weather, funding cycles, and the like. By nature, the rule seems to be that projects take several years to complete. I do not think that it necessarily affects the quality of the work, but it does affect your enthusiasm for creating it and challenges your ability to remain fresh with the idea. Perhaps a greater difficulty is the growing emphasis on including work in construction documents of larger projects and the lengthy approval process. The result of both of these is that the work becomes "frozen in time" and that better ideas that come later in the process cannot always be realized because it is too difficult or costly to make improvements.

GERAKARIS: The whole public-art process is a classic example of a "love–hate relationship." Nobody should enter it thinking it's going to be a stroll through a field of daisies—it's more like a minefield. But I give it my all and find that the feedback and satisfaction have been more than encouraging. To be sure, the other works I do tend to be far more lucrative, but the way I look at it is that the private commissions subsidize the public work. Since this is the case, however, I am very selective about what public art I am willing to take on. It's got to be worth it. But in the end, you keep coming back to it because there is something heady about creating artwork that tens of thousands of people experience daily, and feeling that your work ostensibly enriches their lives.

Select bibliography

A. Adams, "Whatever Floats is Welcome at Bayou Parade," *Houston Chronicle*, April 29, 1998

Stewart Ain, "High Marks for New Penn Station," *New York Times*, October 9, 1994, p. 13LI-1

Christopher Alexander, *The Oregon Experiment*, New York: Oxford University Press, 1978

— *A Pattern Language: Towns, Buildings, Construction*, New York: Oxford University Press, 1978

— *The Timeless Way of Building*, New York: Oxford University Press, 1978

Lawrence Alloway, "Public Sculpture for the Post-Heroic Age," *Art in America*, October 1979

— "The Public Sculpture Problem," *Studio International*, 1971

American School and University Facilities, Purchasing and Business Administration, "Louis I. Kahn Citation: Philadelphia College of Textiles and Science, Paul J. Gutman Library," AS&U, November 1993

Americans for the Arts, *Field Directory 2005–2006*, Washington, D.C.: Public Art Network, 2005

Veronica Anderson, "The Pride of Bronzeville," *American Legacy*, Spring 1997, pp. 22–26

Richard Andrews, *A Planning Study for Seattle: Art in the Civic Context*, Seattle: Seattle Arts Commission, 1984

Anon., "Is This Any Way to Build an Airport?" November 1994, p. 30

— "New Art Installation Graces Downtown Federal Building," *New York Voice of Harlem Inc./Harlem USA*, April 28, 1998

Claire Ansberry, "Perhaps New York Would Accept the Pigs in Trade for *Tilted Arc*," *Wall Street Journal*, January 19, 1998, p. 1

Ruth Asawa, "Making the Japanese American Internment Memorial," ruthasawa.com/Pages/AsawaatWorkMatiere Pages/AsawaatWorkProcess Internment.htm

"Asawa to Design Internment Memorial in San Jose," *North American Daily*, artworks-foundry.com/client showcase/artists/asawa, October 6, 1992Don Aucoin, "Eastie Loves Park But is

Suspicious of Massport's Gift," *Boston Globe*, September 16, 1995, p. 14

Penny Balkin Bach, ed., "New Land Marks: Philadelphia, Pennsylvania," *Places*, vol. 15, no. 1 (2002)

— ed., *New Land Marks: Public Art, Community, and the Meaning of Place*, Washington, D.C.: Editions Ariel, 2001

Debra Bricker Balken, *Aspects of New Narrative Art*, exhibiton catalogue, Pittsfield, Mass., The Berkshire Museum, 1984

Julian Barnard, *The Decorative Tradition*, Princeton, NJ: The Pyne Press, 1973

Roland Barthes, *The Eiffel Tower and Other Mythologies*, New York: Hill and Wang, 1979

John Beardsley, *Art in Public Places*, Washington, D.C.: Partners for Livable Places, 1981

— *Earthworks and Beyond: Contemporary Art in the Landscape*, New York: Abbeville Press, 1984

— "Personal Sensibilities in Public Places," *Artforum*, 19, 1981

Jack Becker, foreword, *Public Art Review*, Autumn/Winter 2005, p. 9

Joseph Berger, "*Tilted Arc* To Be Moved From Plaza at Foley Sq." *New York Times*, June 1, 1985, pp. 25, 28

Lee Bey, "Art Project Set for Bronzeville," *Chicago Sun-Times*, May 13, 1996

Baxter Black, "Farm Art," *Albuquerque Livestock Market Digest*, October 15, 1996

Peter Blake, *Form Follows Fiasco: Why Modern Architecture Hasn't Worked*, Boston: Little, Brown, 1978

Sandra Bloodworth and William Ayres, *Along The Way: MTA Arts For Transit*, Sandra Bloodworth and William Ayres, New York: Monacelli Press, 2006

— *Art en Route*, catalogue to the New York MTA stations, New York: Arts for Transit, 1994

Kent Bloomer, "The University of Oregon Science Complex— The Confounding Issue of Collaboration between Architects and Artists," *Places*, vol. 7, no. 4 (February 1992), p. 58

Roy Bongartz, "Where the Monumental Sculptors Go,"

ARTnews, February 1976

Juan Pablo Bonta, *Architecture and its Interpretation: A Study of Expressive Systems in Architecture*, New York: Rizzoli, 1979

Boston Globe, editorial, "Greenway in East Boston," December 12, 1998, p. A22

Michael Brenson, "The Case in Favor of a Controversial Sculpture," *New York Times* (Arts & Leisure section), May 19, 1985, pp. 1, 35

— *Visionaries and Outcasts: The NEA, Congress and the Place of Visual Arts in America*, New York: The New Press, 2001

Lester Bridaham, ed., *New Orleans and Bayou Country: Photographs (1889–1910)*, Barre, Mass.: Barre Publishers, 1972

British Columbia homepage, "Chemainus," britishcolumbia.com/regions/t owns/?townID=31

Brent C. Brolin, *The Failure of Modern Architecture*, New York: Van Nostrand Reinhold, 1982

Laura Brown, "Eastie Lot to Become $17 Million 'Active' Park," *Boston Herald*, June 18, 1999, p. 32

Lee Brozgold, "The Greenwich Village Murals," *SchoolArts*, December 1995, pp. 34–35

Margaret Bruning, "New Sites for Sore Eyes: Public Art Solutions to the Urban Freeway Syndrome," unpublished paper, 2000

Valerie Burgher, "Huntington Beach Plaza also a Crowd Pleaser at Surfing Event," *Los Angeles Times*, July 26, 1998, p. B-1

Cambridge Arts Council, *Administrative Structure, Policy, and Operating Guidelines for 1% for Art for the City of Cambridge*, 1980

— *Artplan 1982–1983*, 1982

— *Arts on the Line*, exhibition catalogue, Cambridge, Mass.: Hayden Gallery, Massachusetts Institute of Technology, 1980

Robert Campbell, "A modest monument amid the lofty," *Boston Globe*, June 11, 1997, p. E1

John Canaday, *What is Art?: An Introduction to Painting, Sculpture, and Architecture*, New York: Alfred A. Knopf, 1980

Debra Cano, "Mediterranean Plaza to Grace Pier Entry," *Los Angeles Times*, July 2, 1993, p. B-2

— "Pier Plaza Art to Show City History," *Los Angeles Times*, January 16, 1996, p. B-2

Nick Capasso, "Vendome Memorial, Boston, Massachusetts," *Sculpture*, vol. 17, no. 6 (July/August 1998), p. 14

Steve Carney, "Farewell, Maxwell," *Los Angeles Times*, July 10, 1997, p. B-1

— "Plaza Sweet," *Los Angeles Times*, June 6, 1997 p. B-1

Edward K. Carpenter, "Urban Art," *Design and Environment*, Summer 1974

Elizabeth Carter and Michelle Dennis, *Eugene Area Historic Context Statement*, Eugene, Ore.: Eugene Historic Review Board, 1996

Ted Castle, "Art in its Place." *Geo*, vol. 4 (September 1982)

Mary Voelz Chandler, "Access to the Arts Can be Tough at DIA," *Denver Rocky Mountain News*, May 16, 1999

— "Airport Art Projects Slow Taking Off," *Denver Rocky Mountain News*, February 8, 1998, p. 8D

— "Travelers will Sample some Tasty Art," *Denver Rocky Mountain News*, May 8, 1994, p. 48F

Chuihua Judy Chung, ed., *The Harvard Design School Guide to Shopping*, Cologne, Germany: Taschen, 2002

City Club of Eugene, *Eugene 1945–2000*, Eugene, Ore.: The City Club of Eugene, 2000

David Lewis, Laurie Olin, et al., *Duncan Plaza: Regional Urban Design Assistance Team*, American Institute of Architects and City of New Orleans, 1980

City of Phoenix, description of *Memory: Arizona*, phoenix.gov/ARTS/cp_19.html

Civic Art and Design Newsletter, Summer 1998, p. 5

Grady Clay, "Earthworks Move Upstage," *Landscape Architecture*, vol. 70 (January 1980), pp. 55–57

Gia Cobb, "By the People, For the People: Public Artworks

Program Aims to Enhance Sense of Community," *Arizona Republic*, September 14, 1997, pp. G1–G2

Nathan Cobb, "Horse Play," *Boston Globe*, June 26, 1999

Eva Cockcroft, et al., *Toward a People's Art: The Contemporary Mural Movement*, New York: E.P. Dutton, 1977

Houston Conwill, Joseph DePace, and Estella Conwill Majozo, *Statement of Approach to Public Art: "The New Ring Shout"*, March 9, 1998

Graham Cooper and Doug Sargent, *Painting the Town*, Oxford, England: Phaidon, 1979

Julie Courtney, *Points of Departure: Art on the Line 1998–2001*, Philadelphia: Main Line Art Center, 2001

Kimber Craine, ed., *Arts and Transportation: Connecting People and Culture*, Washington, D.C.: National Association of State Arts Agencies, 2002

Douglas Crimp, "Richard Serra's Urban Sculpture: An Interview," *Arts Magazine*, vol. 55 (November 1980)

Mike Crissey, "Walls Provide Blank Canvas for Desert Art; Freeway Display," *Arizona Republic* (Scottsdale/Foothills community section), July 17, 1999, p. 1

Jeffrey L. Cruikshank and Pam Korza, *Going Public: A Field Guide to Developments in Art in Public Places*, Amherst, Mass.: The Arts Extension Service, University of Massachusetts, 1988

Barbara A. Davis, et al., *The Effects of Environmental Amenities on Patterns of Economic Development*, Washington, D.C.: The Urban Institute, 1980

Douglas Davis, "Public Art: The Taming of the Vision," *Art in America*, vol. 62, no. 3 (May–June 1974)

Andrea Dean, ed., "Art in the Environment" special issue, *AIA Journal*, October 1976

Nancy Dean, "*Putt* Artist no Stranger to Houston," *Houston Chronicle*, May 27, 1998

Jackie Demaline, "Mapplethorpe Battle Changed Art World," *Cincinnati Enquirer*, May 21, 2000, enquirer.com/editions/

2000/05/21/loc_mapplethorpe_battle.html

Anne d'Harnoncourt, *Celebration, Buildings, Art and People*, Washington, D.C.: US General Services Administration, 1976

Barbaralee Diamonstein, ed., *Collaboration, Artists and Architects: The Centennial Project of the Architectural League*, New York: Watson-Guptil Publications, Whitney Library of Design, 1981

Sam Dillon, "Building Flaws Tarnish Stuyvesant's Showcase," *New York Times*, January 28, 1993, p. B-1

Jenny Dixon, "Resolving the Polarities in Public Art," *PLACE*, no. 3, January 1983

Marianne Doezema and June Hargrove, *The Public Monument and Its Audience*, Cleveland, Oh.: Cleveland Museum of Art, 1977

Erika Doss, *Spirit Poles and Flying Pigs: Public Art and Cultural Democracy in American Communities*, Washington, D.C.: Smithsonian Institution Press, 1995

Nina Dunbar and Deborah Whitehurst, "An Elephant in Your Living Room, or the Squaw Peak Pot Controversy," *Monographs*, vol. 1, no. 1 (October 1992), pp. 1–8

Robin J. Dunitz and James Prigoff, *Painting the Towns: Murals of California*, Los Angeles: RJD Enterprises, 1997

— and James Prigoff, *Walls of Heritage, Walls of Pride: African American Murals*, San Francisco: Pomegranate Communications, 2000

David W. Dunlap, "Next Stop, Murals; Change Here for Uptown Sculpture," *New York Times*, May 1, 1998, pp. E-37 ff.

Robert L. Dupont and Stuart Arnett, *The Public's Place in Art for Public Places—The Duncan Plaza Experience*, New Orleans: City of New Orleans, Office of the Mayor, 1981

Stephanie Ebbert, "Upscale Visions for East Boston," *Boston Globe*, June 3, 1999, p. A1

Tom Eccles, Anne Wehr, and Jeffrey Kastner, eds, *Plop: Recent Projects of the Public Art Fund*, London: Merrell, 2004

Geoff Edgers, "Sculptor Sues Fidelity to Keep his Artistic Vision Intact," *Boston Globe*, October 7, 2003

Encyclopedia Mythica, "Mercury," pantheon.org/mythica/articles/m/mercury.html

Claire Enlow, "Calmer Traffic Makes Livelier Town," *Seattle Daily Journal of Commerce*, December 3, 1996

Sabine Fachard, *L'art et la ville: interventions des artistes dans les villes nouvelles*, Paris: Secretariat général du Groupe central des Villes Nouvelles, 1976

Martin Filler, "Art without Museums," in Lisa Taylor, ed., *Urban Open Spaces*, New York: Cooper-Hewitt Museum, 1979

Tom Finkelpearl, *Dialogues in Public Art*, Cambridge, Mass.: MIT Press, 2001

Ronald Lee Fleming, "Aesthetic Policy and Community Identity" and "Cultural Tithing in Cambridge," in Luisa Kreisberg, *Local Government and the Arts*, New York: American Council for the Arts, 1979

— "Art and the Infrastructure," *Christian Science Monitor*, October 20, 1992

— "Art On a Neighborhood Scale," *Art New England*, no. 5, June 1984

— "Design Review Comes to My Garden," *Planning*, June 2004, p. 34

— "Dispatches—Castle and Context," *Places*, vol. 8, no. 1 (July 1992)

— *Façade Stories: Changing Faces of Main Street Storefronts and How to Care for Them*, New York: Hastings House, 1982

— "Finding Our Place," *GSD News*, Autumn 1993

— "Images of a Town," *Historic Preservation*, October 1978

— "Interpreting and Enhancing Townscape: Appealing to the Landscape of the Mind," in Anne S. Denman, ed., *Design Resource Book for Small Communities*, Ellensburg, Wash.: Small Towns Institute, 1981

— *Local Government and the Arts: The Cambridge Arts Council*, Washington, D.C., Management Information Service,

International City Management Association, December 1978

— "Lovable Objects Challenge the Modern Movement," *Landscape Architecture*, January 1981

— "The Meaning of Place," *Public Interest*, January 1982

— "Neighborhood Value—Reinvestment by Design," *Public Management*, August 1977

— "The New Senate Building," *Wall Street Journal*, February 4, 1983

— "Placemakers—The City as Public Art," *Design for Arts in Education 83*, 1983

— "The Preservation Movement Needs Some Snap Crackle and Pop," *Planning*, October 2005

— "Public also has a Rôle to Play in City Projects," *Boston Globe*, October 4, 1993

— "Public Art and Place Meaning: Some Comparative Impressions of Europe and the United States," *Livability*, Spring 1982

— "Public Art for the Public," *Public Interest*, Spring 2005

— "Recapturing History: A Plan for Gritty Cities," *Landscape*, January 1980

— "Reinventing An Old Idea: A Plea for Custom Street Furniture that Supports Specific Places," *Landscape Architecture*, July 2004

— "Save Our Historic Sites," *New York Times*, April 11, 1992

— *Saving Face: How Corporate Franchise Design Can Respect Community Character*, Chicago and Washington, D.C.: American Planning Association, 1994 (2nd ed. 2002)

— "Saving Shopping Centers: An Owlish View, or, Give a Hoot for Enhancement," *SAH Forum*, April 1993

— "Seeds for the Soul: Beyond Landscape: Strategies for Lovable Places," *The 1980 Longwood Program Seminars* (12), Newark, Del.: University of Delaware, 1980

— "Speaking of Places: Questions to Ask a Space," *Places*, vol. 6, no. 4 (July 1990)

— "Strategies for a Lovable Environment," *Environmental Comment*, Urban Land Institute, May 1979

— "Suburban Sprawl Blights Cities, Too," *Boston Globe*, October 26, 1994

— "A Tale of Four Cities: Eugene Oregon," *Public Art Review*, no. 32, 2005

— "A Tale of Two Villages," *Places*, vol. 7, no. 3 (July 1991)

— "Time is Now to Beautify City's Western Gateway," *Cambridge Chronicle*, April 8, 1993

— and Lauri A. Halderman, *On Common Ground: Caring for Shared Land from Town Common to Urban Park*, Boston: Harvard Common Press, 1982

— and Renata von Tscharner, *Place Makers: Public Art that Tells You Where You Are*, New York: Hastings House, 1981

— and Renata von Tscharner, *Place Makers: Creating Public Art That Tells You Where You Are*, San Diego: Harcourt, Brace, Jovanovich, 1987

Nancy Foote, "Monument—Sculpture—Earthwork," *Artforum*, October 1979

Benjamin Forgey, "A New Vision: Public Places with Sculpture," *Artnews*, September 1980

— "It Takes More than an Outdoor Site to Make Sculpture Public," *Artnews*, September 1980

— "The Perils of Street Sculpture," *Washington Post*, February 13, 1980

Gina Franz, "How Public is Public Sculpture?" *The New Art Examiner*, February 1980

Doris Freedman, "Public Sculpture," *Design and Environment*, Summer 1974

Frederick Fried and Edmond V. Gillon, *New York Civic Sculpture*, New York: Dover Publications, 1976

Mildred Friedman, ed., "Site: The Meaning of Place in Art and Architecture," *Design Quarterly* 122, 1983

Friends of Community Public Art, Sculptures: The Great Columns of Joliet, Champaign, Ill.: University of Illinois Press, 2007

Friends of the Santa Monica Pier Carousel, *Santa Monica Pier Carousel* pamphlet

Susan Froyd, "Travels with Sweeney," *Denver Westword*, June 4, 1998

Joan C. Fudala, "Highway to Heaven," *Scottsdale Airpark News*, March 2001

"Full Throttle for Penn Station," *New York Daily News*, November 20, 1999Emma Lilia Fundaburk and Thomas G. Davenport, *Art in Public Places in the United States*, Bowling Green OH: Bowling Green University, Popular Press, 1975

Dianne J. Gingold, *Business and the Arts: How They Meet the Challenge*, Washington, D.C.: National Endowment for the Arts, 1984

Paul Glasser, letter to the editor, "Stuyvesant Students Waited Decades for a New Building," *New York Times*, August 6, 1995, p. 13

Grace Glueck, "Art in Public Places Stirs Widening Debate," *New York Times*, May 23, 1982

— "New Sculpture under the Sun, from Staten Island to the Bronx," *New York Times*, August 3, 1979

— "Serving the Environment," *New York Times*, June 27, 1982

— "What Part Should the Public Play in Choosing Public Art?" *New York Times*, February 3, 1985, pp. 27, 28

Jane Golden, Robin Rice, and Monica Yant Kinney, *Philadelphia Murals and the Stories They Tell*, Philadelphia: Temple University Press, 2002

Amy Goldin, "The Esthetic Ghetto: Some Thoughts about Public Art," *Art in America*, May–June 1974

Barbara Goldstein, *Public Art by the Book*, Seattle and London: University of Washington Press, 2005

Robert Goldwater, *What is Modern Sculpture?*, New York: The Museum of Modern Art, 1969

James M. Goode, *The Outdoor Sculpture of Washington D.C.*, Washington, D.C.: Smithsonian Institution Press, 1980

Fernando Gonzalez Gortazar, "Sculptures as 'Vitalizing Elements' in Superficial Urban Settings," *Landscape Architecture*, November 1976

Al Gowan, *Nuts and Bolts: Case Studies in Public Design*, Cambridge, Mass.: Public Design Press, 1980

Dennis Green, *$ for Art, New Legislation Can Integrate Art and Architecture*, New York: ACA Publications, 1976

Kevin Green, ed., *The City as a Stage: Strategies for the Arts in Urban Economics*, Washington, D.C.: Partners for Livable Places, 1983

David Greenberg, Kathryn Smith, and Stuart Teacher, *Big Art: Megamurals and Supergraphics*, Philadelphia: Running Press, 1977

William Grimes, "Raising Artistic Sights of Riders in Nether and Upper Regions," *New York Times*, August 22, 1994, p. C-9

GSA Art in Architecture homepage, gsa.gov/artin architecture

Richard Haas, *An Architecture of Illusion*, New York: Rizzoli International Publications, 1981

Andy Leon Harney, "The Proliferating One Percent Programs for the Use of Art in Public Buildings," *AIA Journal*, October 1976

Neil Harris, *Building Lives: Constructing Rites and Passages*, New Haven, Conn.: Yale University Press, 1999

Stacy Paleologos Harris, ed., *Insights/On Sites—Perspectives on Art in Public Places*, Washington, D.C.: Partners for Livable Places, 1984

Helen Harrison, "ART; The MTA Efforts to Beautify its Transportation System," *New York Times*, December 25, 1994, pp. 13LI–10

Dolores Hayden, "An American Sense of Place," in *Critical Issues in Public Art: Content Context and Controversy*, ed. Harriet F. Senie and Sally Webster, Washington, D.C.: Smithsonian Institution Press, 1992, p. 268

— *The Power of Place: Urban Landscapes as Public History*, Cambridge, Mass.: MIT Press, 1996

Marvin Heiferman, ed., *City Art: New York's Percent for Art Program*, London and New York: Merrell, 2005

Diane Henry, "Some Residents of Hartford Are Throwing Stones at Sculptor's Extended 'Serenity of the Graveyard,'"

New York Times, September 5, 1977

María Luisa de Herrera, Kathleen Garcia, and Gail Goldman, "Public Art as a Planning Tool," Contrasts and Transitions Conference Proceedings, APA 1997, San Diego

Richard Higgins, "The Gospel According to Tom," *Boston Globe*, December 9, 1984

Mark Hinshaw, "Rush-Hour Art," *Seattle Times*, March 1, 1998

Manuela Hoelterhoff, "Tilting Over the Art: Art of Abomination?" *Wall Street Journal*, March 14, 1985

Charles H. Horr and John McClellan, *Floodwall Murals: 2000 Years of History, 2000 Feet of Art*, Portsmouth, Oh.: Portsmouth Mural Products Publishing, 2003

Colie Hough-Beck, *Landscape Architecture*, March 1995

Houston City Planning Department, *Public Art in Public Spaces*, Houston: City of Houston, 1976

Jeff Huebner, "Conservation Crusade," *Art News*, Summer 1999, p. 49

— *Murals: The Great Walls of Joliet*, Chicago: University of Illinois Press, 2001

Ada Louise Huxtable, "Public Sculpture—A City's Most Pervasive Art," *New York Times*, September 15, 1974

Institute for Urban Design, Report on Fellows Symposium, "Pennsylvania Station, New York & Boston Artery, Boston: Linking Infrastructure and Urban Design," December 3, 1997

Ann Jarmusch, "A Well-Deserved Accolade For City's Public Art Program," *San Diego Union-Tribune*, April 19, 1998

Ron Jensen, "Place Debate: Revisiting the Phoenix Public Art Plan—Artists and the New Infrastructure," *Places*, vol. 10, no. 3 (July 1996), pp. 58–59

John Johnston, 'This Little Piggie Flew Into History," *Cincinnati Enquirer*, May 7, 2004, p. E1

Phil Jones, "Place Debate: Revisiting the Phoenix Public Art Plan—An Evolving Mission," *Places*, vol. 10, no. 3 (July 1996), p. 62

Lorna Jordan, *A Theater of Regeneration*, Parks/Land Bond Master Plan, Broward County, Florida, 2005

Sherrill Jordan, Lisa Parr, Robert Porter, and Gwen Storey, *Public Art, Public Controversy: The Tilted Arc on Trial*, New York: ACA Books, 1987

Devorah Karasov, "Is Placemaking an Art?," *Public Art Review*, Autumn/Winter 1996

Janet Kardon, ed., *Urban Encounters—Art Architecture Audience*, exh. cat., Philadelphia: Institute of Contemporary Art, University of Pennsylvania, 1980

William Kates, 'Carousels Not Just Horsing Around', *Milwaukee Journal Sentinel*, September 5, 1999

Lawrence W. Kennedy, *Planning the City Upon a Hill: Boston since 1630*, Amherst, Mass.: University of Massachusetts Press, 1992

Alan F. Kiepper, "Art: Another Way to Move People," *Public Transport International*, February 1994, pp. 15–20

Mary Kilroy, "Public Art for the Nineties: Resharpening the Cutting Edge," *Public Art Review*, Autumn/Winter 1993, pp. 12–14

King County Public Art Program, *Artist-Made Building Parts Project, Vol. IV 2001–2004*. Seattle: KCPAP, 2002

Christopher Knight, "The 'Road' Daringly Traveled," *Los Angeles Times*, November 30, 2001

Barbara Koostra, ed., *The National Endowment for the Arts, 1965–2000, A Brief Chronology of Federal Support for the Arts*, Washington, D.C.: National Endowment for the Arts, 2000

Hilton Kramer, "Sculpture is Having a Coming-Out," *New York Times*, February 19, 1978

— "Sculpture on the Streets," *New York Times*, July 15, 1979

Louise Kreisberg, *Local Government and the Arts*, New York: American Council for the Arts, 1979

Derek Krewdel, "Christenson Sees Hope Through Bell Tower," *The Downtowner*, April 23, 2002. p. 13

Rob Krier, *Urban Space*, New York:

Rizzoli International Publications, 1979

Reed Kroloff, "Place Debate: Revisiting the Phoenix Public Art Plan—From Infrastructure to Identity," *Places*, vol. 10, no. 3 (July 1996), pp. 56–57

Miwon Kwon, *One Place After Another: Site-specific and Locational Identity*, Cambridge, Mass.: MIT Press, 2002

Suzanne Lacy, *Mapping the Terrrain: New Genre Public Art*, Seattle: Bay Press, 1995

Bruce Lambert, "A Deal to Open Stuyvesant's Doors (and Pool)," *New York Times*, September 19, 1993, pp. 13–16

— "At Penn Station, the Future Pulls in, Recalling the Past," *New York Times*, May 1, 1994, pp. 13–16

Philip Langdon, "Noisy Highways," *Atlantic Monthly*, August 1997, pp. 26–35

Gary O. Larson, *American Canvas: An Arts Legacy for Our Communities*, Washington, D.C.: National Endowment for the Arts, 1997

Kay Larson, "The Expulsion from the Garden: Environmental Sculpture at the Winter Olympics," *Artforum*, April 1980

Steve LaRue, "Wilson in LaMesa to Sign Water Bill," *San Diego Union-Tribune*, September 26, 1998, p. B1

Edward Lebow, "Place Debate: Revisiting the Phoenix Public Art Plan—Plans and Possibilities," *Places*, vol. 10, no. 3 (July 1996), pp. 54–55

— Plans and Possibilities," *Places*, vol. 10, no. 3 (Spring 1997), p. 54

— and Betsy Stodola, "The Thomas Road Overpass at the Squaw Peak Parkway," in *Public Art Works: The Arizona Models*, ed. Betsy Stodola, Denver: Western States Arts Foundation, 1992, pp. 42–48

Liz Leyden and Michael Grunwald, "New Penn Station has $484 Million Ticket," *Washington Post*, May 20, 1999, p. A16

Kate Linker, "Public Sculpture: The Pursuit of the Pleasurable and Profitable Paradise," *Artforum*, March 1981

Lucy R. Lippard, *The Lure of the Local: Senses of Place in a Multicentered Society*, New

York: The New Press, 1997

— *On The Beaten Track: Tourism Art and Place*, New York: The New Press, 1999

Charles Lockwood, "Going Green: Houston Lifts Up its Freeways," *Planning*, May 1999, pp. 16–18

Los Angeles Times, editorial, "Pier Plaza just what City Needs," June 14, 1998, p. B10

Thomas Lueck, "A $60 Million Step Forward in Rebuilding Penn Station," *New York Times*, November 19, 1999, p. B4

Rick Lyman, "Hollywood Boulevard Hopes for Second Act," *New York Times*, January 20, 2002

Kevin Lynch, *Image of the City*, Cambridge, Mass.: MIT Press, 1960

— *What Time is this Place?*, Cambridge, Mass.: MIT Press, 1972

Scott Maben, "Green Eugene," *Planning*, October 2004, p. 10

Robert McFadden and Eben Shapiro, "Finally, a Façade to Fit Stuyvesant," *New York Times*, September 8, 1992, p. B1

Douglas McGill, "*Tilted Arc* Removal Draws Mixed Reaction," *New York Times*, 6 June, 1985, p. C21

Stryker McGuire, "Phoenix on the Rise," *Newsweek*, July 12, 1993, pp. 58–60

Robert H. McNulty, Dorothy R. Jacobson, and R. Leo Penne, *From the Economics of Amenity: A Policy Guide to Urban Economic Development*, Washington, D.C.: Partners for Livable Places, 1985

Cate McQuaid, "For these resourceful artists, it's water, water everywhere," *Boston Globe*, December 31, 2004, p. C15

— "Forged from Firefighters' Words," *Boston Globe*, June 17, 1997, p. C1

Dian Magie, ed., *On The Road Again ... Creative Transportation Design*, Hendersonville, NC: The Center for Craft, Creativity, and Design, 1997

Mitch Martin, "*River Runs Through Lives*," *Cedar Rapids Gazette*, 15 November 1992, p. 18A

Anne Matthews, "End of an Error," *Preservation*, March/April 1999,

pp. 42–51

Mercer Island Reporter, editorial, "Decision Time on CBD Street Plan," January 9, 1994

Metro News Briefs, "Ex-Stuyvesant High Site is Designated a Landmark," New York Times, May 21, 1997, p. B2

Candice Miles, "The Aim of Public Art," Phoenix Home and Garden, May 1996, pp. 22–26

Don C. Miles, Robert Cook, and Cameron B. Roberts, Plazas For People, New York: New York City Department of City Planning, 1978

Malcolm Miles, Art, Space, and the City, London: Routledge, 1997

Judith Montminy, "Artist's Many Endeavors Feed the Muse," Boston Sunday Globe, February 14, 1993, pp. 12–13

"Monuments' Word Removed," The Santa Fe New Mexican, August 8, 1974, p. 1Anne Barclay Morgan, "Michele Doner, A Walk on the Beach," Sculpture, vol. 16, no. 9 (November 1997), p. 12

William Morrish, "Place Debate: Revisiting the Phoenix Public Art Plan—Raising Expectations," Places, vol. 10, no. 3 (July 1996), p. 63

William Morrish, Catherine Brown, and Grover Mouton, Phoenix Public Art Master Plan, Phoenix Arts Commission, 1988

John Moseley, "The University of Oregon Science Complex—From Participation to Ownership: How Users Shaped the Science Complex," Places, vol. 7, no. 4 (1992), p. 16

Clark Moulaison, "Views on East Boston," Boston Globe, June 14, 1999, letters page

Herbert Muschamp, "Claiming a Potent Piece of Urban Turf," New York Times, March 13, 1994

— "Enlightenment on the Harbor," New York Times, November 7, 1993, p. 4A18

— "On the Hudson, Launching Minds instead of Ships," New York Times, June 6, 1993, pp. 2–40

Museum of the City of New York, "Coming of Age in Greenwich Village: History at Your Doorstep," educational materials, 1992

National Endowment for the Arts,

A Brief Chronology of Federal Support for the Arts, 2000, nea.gov/about/Chronology/NEAChronWeb.pdf

New Bedford Standard Times, editorial, "Sea Flower Sculptor Deserves a Big Bouquet of Real Flowers," accessed online, July 29, 1999

New York Metropolitan Transportation Authority, Celebrating Public Places, video-cassette

— "Arts for Transit: Permanent Art Pamphlet," 1994, 1995, 1999

Linda Nochlin, "The Realist Criminal and the Abstract Law," Art in America, May–June 1974

Chris Norred, "Downtown Street Plan Gets Approval," Mercer Island Reporter, January 26, 1994

— "Islanders View Plans for New CBD Streets," Mercer Island Reporter, January 19, 1994

— "Rebuilding Downtown Streets," Mercer Island Reporter, January 1994

Len Novarro, "Art for Our Sake," San Diego Home/Garden Lifestyles, June 1997, pp. 14–16

Debra Nussbaum, "For Students of the Cloth," Philadelphia Inquirer Magazine, April 4, 1993

Brian O'Doherty, "Public Art and the Government: A Progress Report," Art in America, May–June 1974

Patrick O'Driscoll, "Artist Handles Joke with Authority," Denver Post, May 1, 1994, p. C8

Jim O'Grady, "Landmarks for Common Folk," New York Times, Nov 5, 2000

Claes Oldenburg and Coosje van Bruggen, Large Scale Projects 1977–1980, New York: Rizzoli, 1980

"Overlooked: Make Buffalo Bayou Access, Beautification a Top Priority," Houston Chronicle, January 18, 2000, p. 16AClint Page and Penelope Cuff, ed., Negotiating for Amenities; Zoning and Management Tools that Built Livable Cities, 2 vols, Washington, D.C.: Partners for Livable Places, 1982

Michael Paglia, "Lost and Found," Denver Westword, January 3, 1996, p. 45

— "A Site for Sore Eyes," Denver

Westword, March 8, 1995, p. 57

Marc Pally, "The University of Oregon Science Complex—Finding a Place for Collaboration," Places, vol. 7, no. 4 (February 1992), p. 64

Budd Palmer, "In Praise of Public Art," Sunday Advertiser, November 1, 1998

Dj Palmer, "Artistic Freeways," The Scottsdale Collection, Spring/Summer 2001, p. 36

Partners for Livable Places, "Cultural Planning Charrette, Hartford, Conn., June 3–6, 1984," unpublished, Washington, D.C., June 30, 1984

— Tools for Leadership: Building Cultural Partnerships, Washington, D.C., 1982

Cliff Peal, "Gateways Open Up Downtown," Cincinnati Post, May 27, 1999, p. 1A

Arthur Percival, Understanding Our Surroundings: A Manual of Urban Interpretation, London: Civic Trust, 1979

Mennard B. Perlman, 1% Art in Civic Architecture, Baltimore: Maryland Arts Council, 1979

Marlene Perrin, "Wynick: Everyone has Connection with River," Iowa City Press-Citizen, January 16, 1986, p. 1A

Phoenix Office of Arts and Culture, Infusion: Twenty Years of Public Art in Phoenix, 2005

"Phoenix Overpass Mixes Engineering, Art, Ancient History," American City and County, August 1992, p. 81Cathy Pickering, "Carousels Old and New," Carousel Courier, The Empire State Carousel, June 1993

Phillip Pina, "Sculpture Leaving Sixth and Vine," Cincinnati Enquirer, June 23, 1999

Robert L. Pincus, "Art Impaired Engineer Becomes Art Enthusiast," San Diego Union-Tribune, August 7, 1998, p. E6

— "Public Works: Is Limited Display at Reservoirs and Sewage Plants Fair Treatment for Art?" San Diego Union-Tribune, July 26, 1998, p. E1

Carol Pogash, "Bumper Crops For the Eye," New York Times, February 2, 2005

Blake Pontchartrain, "New Orleans Know-It-All," Gambit Weekly, October 5, 1999, p. 3

Robert Porter, ed., The Arts and City Planning, New York: American Council for the Arts, 1980

James Prigoff and Robin J. Dunitz, Walls of Heritage, Walls of Pride: African American Murals, Rohnert Park, Calif.: Pomegranate Communications, 2000

C. Pugh and P. Johnson, "Bayou Park Supporters Celebrate Downtown Destination," Houston Chronicle, May 3, 1998, pp. 8–9

Mike Pulfer, "Gateways Say Welcome: Donations Helped Build 10 Architectural Projects," Cincinnati Enquirer, July 2, 2001, pp. A1–6

Lynn Pyne, "City Stops for Roadside Art," Phoenix Gazette, June 14, 1990, p. D1

Arlene Raven, ed., Art in the Public Interest, Cambridge, Mass., Da Capo Press, 1993

Louis G. Redstone, Art in Architecture, New York: McGraw-Hill, 1968

E. Relph, Place and Placelessness, London: Pion Limited, 1976

— Public Art—New Dimensions, New York: McGraw-Hill, 1980

J.B. Reynolds, "Design Issues Arise for New Downtown Streets," Mercer Island Reporter, December 15, 1998

— "Task Force Draw New Streets for the Downtown," Mercer Island Reporter, accessed in Mercer Island Archives, n.d.

Peggy Reynolds, "Mercer Island OK's Big Street Project," Seattle Times, January 25, 1994

Melisa Rivière, "Graffiti and Aerosol Art," Public Art Review, Autumn/Winter 2005, pp. 25–27

Sara Roberts, Public:Art:Space, London: Merrell Holberton, 1998

Jacquelin Robertson, "The Current Crisis of Disorder," Education for Urban Design, New York: Institute for Urban Design, 1982

Margaret A. Robinette, Outdoor Sculpture: Object and Environment, New York: Whitney Library of Design, 1976

Garrison Roots, Designing the World's Best Public Art Images, Mulgrave, Victoria, Australia:

Images Publishing, 2002

Nancy Rosen, Ten Years of Public Art: 1972–1982, New York: New York Public Art Fund, 1982

Steve Rosen, "Art Alone May Be Worth the Trip," Denver Post, March 6, 1994, p. 36

— "A Critical Look at DIA Art: Mostly It's Hard to Find and Hard to See," Denver Post, March 19, 1995, p. E1

— "Objects d'Airport," Denver Post, January 30, 1994, p. A1

— "Sweeney's Offbeat America Should Tickle Throngs at DIA," Denver Post, October 2, 1994, p. E3

— "A Work (Still) In Progress," Denver Post, February 28, 1994, p. G8

Leland Roth, McKim, Mead & White, Architects, New York: Harper and Row Publishers, 1983

Chiori Santiago, "Ruth Asawa: The Armature of Family," Museum of California Magazine, chiorisan.com/other1.html, 2002

Peter Schjeldahl, "Artistic Control," Village Voice, October 14–20, 1981, p. 100

Eric Schmidt, "Capturing New York's History on Carousel', New York Times, February 28, 1988, p. B1

Donald A. Schon, "Problems, Frames and Perspectives on Designing," Design Studies 5, 1984

Stephanie Schorow, "Roadside Attractions: Urban Oasis—The Great Outdoors Meets East Boston at Piers Park," Boston Herald, July 9, 1998, p. 39

Nancy Scott, "Politics on a Pedestal, Art Journal, Spring 1979

Seattle Arts Commission, Public Art 101 Curricular Book: October 3–5, 2001, Seattle: Seattle Arts Commission, 2001

Seattle Office of Arts and Cultural Affairs, "News About the Public Art and Seattle City Light Lawsuit," ci.seattle.wa.us/arts/news/citylight5-2004.asp

Harriet F. Senie, Dangerous Precedent? The Tilted Arc Controversy, Minneapolis: University of Minnesota Press, 2002

— "Urban Sculpture: Cultural Tokens or Ornaments to Life?" *Artnews*, September 1979

— and Sally Webster, eds., *Critical Issues in Public Art: Content, Context, and Controversy*, New York: Icon Editions, 1992; Washington, D.C.: Smithsonian Press, 1998

"Richard Serra," (special section), *Arts Magazine*, 55, 1980

Mary Sherman, "Cambridge's *Water* Works as Accessible, Playful Piece," *Boston Herald*, November 4, 2001, p. 69

Kim Shetter, *Infusion: 20 Years of Public Art in Phoenix*, Phoenix: Phoenix Office of Arts and Culture, 2005

Stephen Sinclair, "When Art Meets the Community," *Cultural Post*, March–April, 1980

Peter Slatin, "High School Memories," *ARTNews*, vol. 92, no. 2 (February 1993), p. 26

Maeve Slavin, "Art and Architecture: Can They Ever Meet Again?" *Interiors*, March 1980

Louise Snider, ed., *Steubenville ... City of Murals*, Steubenville, Oh.: Tri-State Publishing Co., 1992

Robert Sommer, *Street Art*, New York: Links Books, 1975

Alan Sonfist, "Natural Phenomena as Public Monuments," *Tracks*, Spring 1977

Michael Sorkin, ed., *Variations on a Theme Park: The New American City and the End of Public Spaces*, New York: Hill and Wang, 1992

"Sound Off," editorial phone calls, *North Scottsdale Times*, October 2000, pp. 6–9

Jon Spayde, "Six Loaded Questions for Contemporary Muralists," *Public Art Review*, Autumn/Winter 2005, pp. 28–29

Brent Staples, "Manhattan's African Dead," *New York Times*, May 22, 1995

Kevin Starr, *Inventing the Dream: California Through the Progressive Era*, New York: Oxford University Press, 1985, p. viii

Daydre Stearn-Phillips, *Western's Outdoor Museum*, Bellingham, Wash.: Western Washington University, 1979

Karen Stein, "Snow-capped Symbol," *Architectural Record*, June 1993, p. 106

Frederick Steiner, "Connecting Infrastructure to Deep Structure," *Places*, vol. 10, no. 3 (July 1996), pp. 60–61

Anne Stephenson, "Design Team Spans Thomas Road, Two Professions," *Arizona Republic*, March 11, 1990

— "Freeway Bridge is Built of Mud, Steel, and Frogs; Overpass Design Honors Hohokam," *Arizona Republic*, March 11, 1990, p. F1

Mark Stevens, Mark Hager, and Maggie Malone, "Sculpture Out in the Open," *Newsweek*, August 18, 1980

Lotte Streisinger, "The University of Oregon Science Complex— People, Place, and Public Art," *Places*, vol. 7, no. 4 (1992), p. 56

Carol Strickland, "Architects Create Pizazz on Campus," *Christian Science Monitor*, July 21, 1997, pp. 4, 10

Joe A. Tarver, ed., "MAPEI Contributes to the Arts in Arizona," *TileLetter*, November 2000

Dolores Tarzan, "Art, the Public, and Public Art," *Seattle Times*, September 21, 1980

Christine Temin, "Making art for everyone from Phoenix to Wales to their own hometown, Cambridge-based public artists Mags Harries and Lajos Héder are changing the landscape one project at a time," *Boston Globe*, May 7, 2000, p. 16

— "Perspectives; TV Arts coverage unimpressive," *Boston Globe*, May 30, 2001, p. D1

Steven J. Tepper, *Unfamiliar Objects in Familiar Spaces: The Public Response to Art-in-Architecture*, Princeton, NJ: Princeton University Center for Arts and Cultural Policy Studies, 1999

Donald W. Thalacker, *The Place of Art in the World of Arcxhitecture*, New York: Chelsea House, 1980

Wendy Thermos, "Immigration Protest in Baldwin Park is Peaceful," *Los Angeles Times*, June 26, 2005

Geoffrey Tomb, "The Sea Floor: Airport's Terrazzo *A Walk on the Beach*," *Miami Herald*, April 22, 1995, p. 1B

Calvin Tomkins, "The Art World: Like Water in a Glass," *The New Yorker*, March 21, 1983

— "Perceptions at All Levels," *The New Yorker*, December 3, 1984

— "*Tilted Arc*," *The New Yorker*, May 20, 1985

— "The Urban Capacity," *The New Yorker*, April 5, 1982

Toppenish Mural Society, *Where the West Still Lives*, Toppenish, Wash.: Toppenish Mural Society, 1999

Bob Tutt, "Bayou Park to Offer a Feast for the Senses," *Houston Chronicle*, May 31, 1997, p. 33A

"Underground Gallery-Going," *New York Times*, January 28, 1996, pp. IV12

US Department of Transportation, *Aesthetics in Transportation*, Washington, D.C.: US Government Printing Office, 1980

— *Design, Art and Architecture in Transportation*, Washington, D.C.: US Government Printing Office, 1977–78

Gerry van Noord, *Off Limits: 40 Artangel Productions*, London: Merrell, 2002

Robert Venturi, *Complexity and Contradictions in Architecture*, New York: Museum of Modern Art Papers on Architecture, 1966

Doreen Vigue, "A Boom with a View," *Boston Globe*, April 22, 1998, p. A1

Wolfgang von Eckhardt, "Toward More Livable Cities," *Time Magazine*, November 1981

Juliet Vong, "Lighting Brings Focus to Elements of Integrated Design," *Seattle Daily Journal of Commerce*, April 20, 2000

Chris Waddington, "Frieze Frames," *Times-Picayune Lagniappe*, January 12, 1998, p. 14

Geoffrey Warren, *Vanishing Street Furniture*, North Pomfret, Vt.: David & Charles, 1978

Jane Weissman and Janet Braun-Reinitz, "Community, Consensus, and the Protest Mural," *Public Art Review*, Autumn/Winter 2005, pp. 20–23

Dick White, "Criticism of City's *Sea Flower* Blooms," *New Bedford Standard Times*, May 19, 1998

William H. Whyte, *The Social Life of Small Urban Spaces*, Washington, D.C.: The Conservation Foundation, 1980

Catherine Widgery, "With a Trace: Etchings and Handprints Add Meaning to Public Artworks in New Mexico," *Landscape Architecture*, September 2004, pp. 124–29

Wikipedia, "Millennium Park," en.wikipedia.org/wiki/ Millennium_Park

Isabel Wilkerson, "A Great Escape, A Dwindling Legacy," *New York Times*, February 15, 1998, pp. 8–10

James Q. Wilson and George L. Kelling, "Broken Windows," *Atlantic Monthly*, March 1982

Tom Wolfe, "The Worship of Art," *Harpers*, October 1984, pp. 61–68

Hafthor Yngvason, ed., *Conservation and Maintenance of Contemporary Public Art*, Cambridge, Mass.: Archetype Publications, 2001

Jim Zook, "Public Art Is Structuring the City's Landscape," *Metropolis*, October 1998, metropolis mag.com/html/content_1098/ oc98hous.htm

Websites

East Boston Master Plan: eastboston.com/MasterPlan/ MP_celebrate.htm

Eugene Community Trust, eugenecommunitytrust.com

Dimitri Gerakaris: art-metal.com

Heritage Sculpture: heritagesculpture.com

Hobby Center for the Performing Arts, thehobbycenter.org/ news/art_fence.html

Kristin Jones and Andrew Ginzel: jonesginzel.com

Mural Routes: muralroutes.com

National Endowment for the Arts: nea.gov

New York City Arts for Transit: mta.nyc.ny.us/mta/aft

Philadelphia University: building.philau.edu

Scottsdale Public Art: scottsdalepublicart.org

Stuyvesant High School: stuy.edu

General Services Administration: gsa.gov

The Verdin Company: verdin.com

Index

A

Abel, Howard *258*
Abel Bainnson Butz *258*
Acconci, Vito 170
Acoustic Weir, Cambridge, Massachusetts 155–57
Adopt-a-Tree monument, Tempe, Arizona *226*
Africa Rising, New York 161
Alameda County Public Works Agency *272*
Alamo Heights trolley stop, Texas *219*
Albers, Josef *239*
Albuquerque, New Mexico 19
 Ramada *225*
 Serpent Fence 264
 Washington Middle School Park *230*
Aldridge, Ira 83
Alexander, Christopher 23, *338*
Allen, Jerry 292–5, *298*, 300–01, 307–08, 312, 313
Allen's Landing, Houston 71
Alvarado Water Treatment Plant, San Diego *164*, 170–75, *171–74*
Alweis, Dick 62
America...Why I Love Her, Denver International Airport 65
American Legacy 169
American Song 161
Americans for the Arts 291–92, 315
Angels Flight, Los Angeles *236*
Another Place, Another Time, Kent, Washington *256*
Anti-Graffiti Network, Philadelphia 107
Antioch University 107
Arai, Tomei 161, *162*
Architecture Foundation of Orange County 127
Architecture magazine 175
Arizona Department of Transportation (ADOT) 35, 41, 42–47
Arizona Falls, Phoenix *159*
Arizona Society of Professional Engineers 38
Arizona State University 314–15
Arlington, Virginia 304
Armstrong, Louis 162, 166, 168
Army Corps of Engineers 104
Arrai, Jerry 221
Art in Architecture (AiA) program 342, 344–51, 356, 368
Art Deco 60, 89, 212, *213*, 289
"Art Fence" program, Houston 71
Art in Public Places (APP) program 342, 343, 351–53
Art Steering Committee, Denver 62
Art Tool, Santa Monica, California 217, *217*
Artist-Made Building Parts (AMBP) project 23, 302–03, *305*, 308

Arts Council of New Orleans 145, 202, 203, *219*, 308
Arts for Transit program, New York 76, 80–89, 271
Asawa, Ruth 238–41, *239*, *240*
Atelier Landscape Architects *218*
Athens, Acropolis 371
Atlanta, Georgia 323–24
Auden, W.H. 282
Aurora, Illinois 108
Austin, Texas 232, 290
Aventura, Florida *225*

B

Baca, Judith *97*, 102, 103, 104, *105*, 106
Baldwin, Louisiana 229
Baldwin Park, California 103
Ballinger 330–32
Baltimore, Maryland *249*
Baltimore Federal 344
Baratta, Steve 120
Bargello Museum, Florence *213*
Barlett, Harley 120
Barthelemy, Sidney 142–43, 145
Bascom, Ruth 336
The Basket Maker, Tukwila, Washington *253*
Basle, Switzerland 246, *247*
Battery Park City, New York 137
Bay Shore Icons, Long Island, New York 84–85, *85*
Bearden, Romare 80
Beatty, Jim 188, *189*
Beauchamp, Douglas 335, 336–38
Beaumont, Linda 262
Beaux-Arts period *248*, 289, 294
Bedgood, Jill 232
Bega 282
Bellevue, Washington 220, *257*
ben-Jochannan, Yosef 162
Berlin *213*, *245*
Berlin, Irving 191
Bern, Switzerland
 Milk bottles 233, *233*
 train station 216, *216*
Bethune, Mary McLeod 162
Bicentennial Park, Cincinnati 54
Big Bubble, Houston, Texas 67, 68, 69–70, *69*
Big Wave, Santa Monica, California 229
Black, Baxter 64
Black Swamp, Bowling Green, Ohio 182–85, *183*, *184*
Blackbirds and Gulls, Kent, Washington *265*
Bloomer, Kent *339*, 340
Bluff Street Architecture in 1840, Joliet, Illinois *111*
Bohemians, Christopher Street station, New York 83
Boat Bench 246
Borges, Jorge Luis 262
Boston 237
 Boston City Hall Plaza *18*, 19, 20
 Boston Public Library 289–90
 Boylston Place Gateway 229, 231

Central Artery 360
Copley Square subway *249*
Eastport Park plaza 309–10, *311*
 marker 232
Mattapan Square 24, *24*, 25
Pavilion at East Boston Piers Park 274–79, *275*, *277*, *278*, 370
Rise, Mattapan Square, Boston *24*, 25
Vendome Firefighters' Memorial *186*, 204–07, *205*, *206*
Winthrop Lane 369
Boston Society of Architects 53
Botello, Paul 104, *105*
Bowling Green State University Campus (BGSU), Ohio 182–85, *183*, *184*
Boylston Place Gateway, Boston 229, 231
Braaksma, Carolyn 42–47, *43–45*, 231, 301
Brace, Charles Loring 83
Brady, Rick 172, 175
Brandell, Kim *251*
Brandon Court Reliefs, Seattle *268*
Braun-Reinitz, Janet 103
Brenson, Michael 353
Bressi, Todd 291, 307, 313
Brickworker and Ballplayer, Cambridge, Massachusetts *273*
Bright, Barney 270
Brightwater Water Treatment Plant, Seattle 293–94, 304
British Library, London *247*
Brock, Darrell 270
Brodax, Laura 221
Bronzeville, Chicago 166–69, *167*, *168*
Broohaven, New York 195
Brookline, Massachusetts 21, 100
Brooks, Gwendolyn 168
Brooks Contracting, Inc. 185
Broward County, Florida 308
Broward County Parks/Land Bond Master Plan, Florida 292–93, 294–95, *295*, 315–16
Broward County Public Art and Design Program 289
Brown, Catherine 34
Brown, Roger 161
Brozgold, Lee 82–83, *83*
Bruning, Margaret 42, 43
Brunner, Cath 290, 298, 303–04, 309, 310–11, 312, 314
Buffalo Bayou Sesquicentennial Park, Houston 66–71, *67–71*
Bulfinch, Charles 222, 223
Bullock, Robert 108, *109*
Bunkley, Brit 84–85, *85*
Burger, Deborah 196
Burnham, Franklin 180
Bush, George 161
Bustling Bluff Street in the 1800s, Joliet, Illinois *111*
Butsch, Tom 270
Butterfly Gate, Cleveland *264*
Byrd, Henry Roeland 200–03

C

Cabrillo, Juan 127
Calder, Alexander 344, 353, 354
Caldwell, Judith and Daniel 260
Cambridge, Massachusetts 100, *215*
 blue markers *234*
 Brickworker and Ballplayer 273
 Harvard Square 21, *29*, 100, 155
 traffic-island marker 233, *234*
 Tree Chair 255
 Walter J. Sullivan Water Treatment Facility 154–59, *155–58*
Cambridge Arts Council (CAC) 154, 157, 159, 288–89, 312
Cambridge Seven Associates 234
Cambridge Women's History Office 289
Camp, Dresser & McKee (CDM) 154–55
Campana, Sam 42, 46
Campbell, Douglas *251*
Campbell and Campbell Landscape Architects *251*
Canada 96, 114, 118
Canal Street subway station, New York *271*
Cannon, Jerry 37–38
Canton, Ohio 118
Capitola, California 292, 308
CARECEN Mural, Los Angeles *105*
Carmichael, Dennis 270
Carnation, Washington 304
Carpenter, Ed 40–41
Carr, Carla *111*
Carter, Jimmy 108
Cary, North Carolina 324
Cascade Charley, University of Oregon 340
Castro Valley, California 228, 229
Catalina Airport, California 226
Cedar Rapids, Iowa 232
Centennial Arch, Steubenville, Ohio *117*, 118
Centerbrook Architects *24*, 25
Central American Resource and Education Center (CARECEN) *94*, 106
Central Artery, Boston 360
Cerney, John *99*, 100
Chabre, Wayne *339*, 340
Challenge America 356
Chandelier Fall, Hollywood, California 134
Chandler, Mary Voelz 64
Charles River 155, 158
Charlotte, North Carolina 252
Chase-Riboud, Barbara 161
Chavira, Javier 112
Chelsea, Massachusetts *8*, 222, 223
Chelsea, Vermont 14
Chemainus, British Columbia 99, 102, 115
Cheng, Carl 217, *217*
Chicago, Illinois 104, 344, 362
 Bronzeville 166–69, *167*, *168*
 Millennium Park 96, *98*

Chicago Department of Cultural Affairs 166, 169
Chicago Sun-Times 169
Chicago Tribune 169
Chin, Mel 67, 68–69, *68*, 70, *70*
Christenson, Fabienne 61
Christopher Street Neighborhood Association, New York 82
Christopher Street station, Greenwich Village, New York 82–83, *83*
Cianci, Buddy 229
Cincinnati, Ohio 352
 Cincinnati Gateway 54–57, *55*, *56*, 210, 228, 360, 369, *370*
 Cincinnati Public Library 61
 Commerce Center 328–29, *331*
 Open End 15, 328–29, *331*
 Over-the-Rhine Gateway 58–61, *59*, 228
 telephone building *213*
Cincinnati Enquirer 57
Cincinnati Historical Society 61
Cincinnati Post 58
City at the Falls, Louisville, Kentucky 262
"City Beautiful" movement *18*, *18*, 81
City Capital Improvement Funding 58
City Light 300, 313
Clarck, John Henrik 162
Clare, Ada 83
Clark, Wendy 355, 356
Clark, Captain William 120
Clausen, Ted 205–07, *205*, *206*
Cleveland, Ohio
 Butterfly Gate 264
 Inventory on Will-call 255
 lamppost 244, *245*
 Market Place/Meeting Place: An Urban Memorial 256
 Orchard Fence 265
Clibborn, Judy 285
Cliff Willwerth 261
Clifford Selbert Design 223
Clinton, Bill 79
Clinton Square Map, Highland Park, Illinois *179*
Cobb, Henry 290
Cobb, Nathan 193
Coe, Lee, Robinson & Roesch 49, 50, 52–53
Cohan, George M. 191
Cole, Nat King 166, 168
Coleman, E. Pope 65, 329
The Collaborative, Inc. 182, *183–84*
Collins Foundation of Portland 123
Colquitt, Clair 300
Combined Forces, Los Angeles 104, *105*
Comprehensive Employment and Training Act (CETA) 108, 289
Coney Island Sign Painting Project 356
Congdon, Noelle 268
Congress 351
Conner, Elizabeth 246, *246*, 261

Conrad, Rich 285
Conveyance by Time: History of Transport, Mercer Island Streetscape, Washington 282
Conwill, Houston 161–63, *161*
Cooper, Bill 194
Cooper, Ronald *270*
Cooper Young Community Association, Memphis, Tennessee *231*
Cooperstown, New York 188–95, *189, 190, 192, 194*
Corbett Foundation 58, 59–60
Corinthian Column, Penn Station, New York 75, *76, 77, 79*
Corn field, Dublin, Ohio 233, *233*
Cornerstones, Seattle *263*
Costa, Mary Len 145, 203
Courtney, Norman *305*
Creating Place: North Carolina's Artworks for State Buildings 322
Crescordia Award 40
Creston Nelson Substation, Seattle 246, *246*, 300, *300*
Crovatto, Constante 90, 93
Crown Fountain, Millennium Park, Chicago 96, *98*
Cultural Arts Council of Houston and Harris County (CACHH) 306–07
Cultural Landscape, Pomona College, Claremont, California 17, 176–81, *177–80*
Cuneo, Aiko 241
Cunningham-Terry, Fern 24

D
Dafford, Robert 100, *101*, 102, 118
Dallas Convention Center 301, *301*
Dance Steps, San Jose 302
Danowitz, Larissa *109*
Danville, Vermont 304–06
Danzas Indigenas, Baldwin Park, California 103
David, Florence 371
Davis, Michael 134
Daw, Leila *252*
Dawes, William 234
Day, David 58–61, *59, 60*
Day and Night, Penn Station, New York 72, 75, *77, 77*
Dean Martin, Steubenville, Ohio *115*, 116
Delap, Tony *229*
Delémont, Switzerland 220
Delgado, Robert 35
Dentzel, Gustav *189*, 193
Denver, Colorado 116, 336
Denver International Airport (DIA)
 America...Why I Love Her 65
 Fenceline Artifact 62–65, *63, 64*
Denver Post 64–65
Denver Rocky Mountain News 64
DePace, Joseph 161–63, *161*
Depression, The 63, 74, 166, 168
Deuber, Jeanne *270*
Dever, Robert *115*, 116, *117*
A Different Sense of Time (film) 62
Dixon, Linda 78
Dobberstein, Dwight 196
Dominguez, Eddie *230*
Donley, Patrick *262*
Doss, Erika 57
Douglas, Frederick 162
Draper, Ranny 181
Drawn Water, Cambridge, Massachusetts 154–59, *155–58*
The Dream, Houston 70, 71
Dream Song, Halpatiokee State Park,

Florida 311–12, *313*
A Drop in the Bucket, New York 349
Dual Meridian 62
Dublin, Ohio 233, *233*
Dueber, Jeanne *270*
Duffy, William *270*
Duncan, John 86
Dunlap, David 81

E
Eagle Scout Tribute Fountain, Kansas City 75
East Boston Piers Park, Boston 274–79, *275, 277, 278*, 370
Eastport Park plaza, Boston 309–10, *311*
Echevarria, Mario *227*, *265*
Eclipsed Time, Penn Station, New York 76, 78
Economic Development Administration (EDA) 222
Edward Ingersoll Browne Trust (EIBT) 204–05
Edwards, Melvin 161–62
Ehrenkrantz, Eckstut & Kuhn (EEK) 133
Einstein, Albert 340
Eller, Lennée 93
Empire State Carousel, Cooperstown, New York 188–95, *189, 190, 192, 194*
Encircled Stream, Seattle 218
Enderle, Philip 184, *185*
Engelmann, Jeff 42–47
England *225*
Environmental Design Research Associates 53
Environmental Protection Agency 158
Epstein, Andrew D. 309
Erie Canal 224, 237, *237*
Esser, Greg 34
Essex Works 84
Eugene, Oregon
 Hult Center for Performing Arts 335, *336*, 340
 Summer 337
 "Tank Trap" 15, 20, 333–38, *337*
Eugene Arts Foundation 335
Eugene Community Trust 341
Eutemey, Kate 24
Evans, Bill 44, 47
Everett Waterways Map, Everett, Washington 260
Everglades, Springfield, Massachusetts 15, 308, 329–30, *331*, 354
Eversley, Frederick 150
Exeter, California 114

F
Farley Post Office Building, New York 79
Farmer, Michael *270*
Farmers Museum, Cooperstown, New York 195
Farrell, Kathleen 99–100, 102, 103, 108–13, *111, 112*
Federal Hill Archway, Providence 229, 231
Federal Reserve Plaza, New York 19
Fenceline Artifact, Denver International Airport 62–65, *63, 64*
Ferguson, Wayne *270*
Fidelity Investments 309–10
Fine Arts Services, Inc. (FAS) 133
Finn, Marvin *270*
Fitch, Claudia *270*
Flamingo, Chicago, Illinois 344

Fleming, Ronald Lee 9, 49–53, 154, 179–81, *223*
Flight Paths, Las Vegas, Nevada *263*
Flint, Michigan 214, *215*
The Flood of 1937, Portsmouth, Ohio *101*
Flood Column, Cincinnati, Ohio 55–56
Florence 371
 Bargello Museum *213*
Florida 304, 316
Fokin, Igor 21
4Culture 290, 293–94, 298, 302–04, 306, 310, 315
The Forest is Waiting, Seattle *257*
Forman, Andrea 42, 43, 44, 46, 47
Fort Lauderdale, Florida 289, 324
Foster, Sir Norman 15
Founders, Christopher Street station, New York 83
Fountainhead Rock, Santa Fe, New Mexico *255*
France *235*
Franklin Street bench, Chapel Hill, North Carolina 18
Freiburg, Germany *227*
Fresno, California 336
Friends of Community Public Art, Joliet, Illinois 99–100, *111*, 112, 108–13, 309
The Friends for Long Island's Heritage 191
From Seashore to Tropical Garden, Miami International Airport 153
Full Circle, Seattle 262
Fuller, Buckminster 239
Furness, Frank 149, 234

G
Gagnon, Frances 330
Gallucci, Jim *226*, *252*
Gardner, Katherine A. 277
Garner, Ted 168, *168*
Garofalo, Francesco *213*
Garvey, Marcus 162
A Gathering, New York 271
Gehry, Frank 96
Geldzahler, Henry 371
General Motors 214
General Services Administration (GSA) 120, 160–61, 163, 342–51, 355–57, 368
Gerakaris, Dimitri 88–89, *88*, *229*, 231, 358–73, *358*, *371*
Germany *227*, 245
Ghost Image, Mercer Island Streetscape, Washington 282
Ghost Series, Penn Station, New York 74–79, *75–78*
Giannusini, Michel *255*
Giblin, Frank 350
Gier, Ruth 220
Gierlich, John *253*
Ginzel, Andrew 136, 138–41, *139, 140*
Giotto 100
Glenrothes, Scotland *227*
Goetzinger, Peter 268
Going Public 292
Goldberg, Brad 301
Golden, Jane 102, 107–08
Goldman, Gail 298
Goldstein, Barbara 292, 300, 315
Gomez, Gwendolyn 175
Gonzales, George *255*
Good Neighbor program 350
Gorse, George 178, 180, 181
Graf, Raymond *270*
Graham, Rev. Billy 102
Grand Army Plaza station, Brooklyn,

New York 86–87, *87*
Grand Central Terminal, New York 76, 81
Grand Rapids, Michigan 324–25, 353
Grand River 60
La Grande Vitesse, Grand Rapids 353
Grauman's Chinese Theater, Hollywood 130, 220
Graves, Michael *249*
Gray, Alice 279
Great Barrington, Massachusetts 18
Great Wall of Los Angeles, Los Angeles 104, *105*, 106
El Greco 356
Green Ribbon Project, Houston 38
Greenameyer, George *225*
Greengold, Jane 86–87, *87*, 349
Greensboro, North Carolina 226
Greenwich Village Murals, Christopher Street station, New York 82–83, *83*
Griffith, D.W. 132
Griggs, David 62
Grimes, Riley 196
Grohe, Eric *116*, *117*, 118
Grover, William 25, 26
Gulsrud, Mark Eric *267*
Gutman, Alvin 149
Gutman Library, Philadelphia University 146–49, *147, 148*

H
Haas, Richard 119–23, *119*, *121*, *122*, 225
Hackensack River trail markers, New Jersey 22, *223*
Hagstette, Guy 66
Hale, Mother Clare 162
Haleiwa, O'ahu, Hawaii 230
Haller, Jim 108
Halpatiokee State Park, Florida 311–12
Halvorsen, Lisa 269
Halvorson Design Partnership 309, 310
Hamilton, Ed *270*
Hammond, Louisiana 224
Hamrol, Lloyd 124
Harborview Quilt, Seattle *267*
Harding, Richard 227
Hargis, Gary Lawton *270*
Harries, Mags 38–39, 43, 154–59, *155–58*, 261, *262*
Harris, Beth 130
Harris County Commissioner's Court 67
Harris County Flood Control District 67
Harrison, Susan 344, 347, 349, 350
Hawaii 230
Hayward, California *272*
Heard in Plain Sight 61
Héder, Lajos 38–39, 43, 154–59, *155–58*, 261, *262*
Heins, George 81
Herald Square gates, New York *272*
Heritage Preservation 354
Herlihy, Glenn 268
Herschell, Alan *189*, *190*, 191, 193
Heyl, Karen 61
Highland Park, Illinois 179
Hill, Sheila 264
Hinshaw, Mark *257*, 281, *282*, *283*
Historical Society Murals, Portland, Oregon 114
History Bench, Charlotte, North Carolina 252
Hiura, Jerry 241
Hobby Center for the Performing Arts, Houston 71

New York 86–87, *87*
Grand Central Terminal, New York

Hollywood, California
 Hollywood and Vine subway station art 220
 The Road to Hollywood 130–35, *131–35*
 Usher Bollards 271
Hollywood & Highland 130–35
Holyoke, Massachusetts 193
Holzman, Gerry 188–95, *189, 190, 192, 194*
Hong, Garrett 181
Host Analog, Oregon State Convention Center 63
Hough-Beck, Colie 280, 282
Houston, Texas
 Buffalo Bayou Sesquecentennial Park 66–71, *67–71*
 Green Ribbon Project 38
 Houston Framework 293, 306–07, 306, 325
 Post Oak Divan 250, *251*
Houston Chronicle 71
How Soon Hath Time..., Manhattan Beach, California *225*
Huang, Albert 146
Hughes, Langston 166, 168
Hull, Massachusetts 193
Hult Center for Performing Arts, Eugene, Oregon 335, *336*, 340
Huntington Beach, California 124–27, *125, 126*
Hurston, Zora Neale 162

I
In our Victories Lies our Future, Los Angeles 97, 106
Independence National Historic Park, Philadelphia 234, *234*
Institute of Classical Architecture and Classical America 18
Institute of Contemporary Art, Philadelphia 351–52
International Committee for Monuments and Sites 14
Inventory on Will-call, Cleveland *255*
(In)visible Histories, Mercer Island Streetscape, Washington 282
Iowa Arts Council 196
Iowa City, Iowa 196–99, *197, 198*
Interborough Rapid Transit (IRT), New York 81, 86–87, 89
Irwin, Robert 323
Isaac, Jack 118
Isle of California, Los Angeles 125
Islip, Long Island, New York 190, 195
Issaquah, Washington 230
Italy 222–24, *235*, *247*, 250, *251*
Iverson, Iver 199

J
Jackson, Mahalia 166
Japanese American Internment Memorial, San Jose, California 238–41, *239, 240*
Jeffords, James 352
Jensen, Leo 24
John, Dr. 200
Johnson, Peter *223*
Johnson County Administration Building, Iowa City, Iowa 196–99, *197, 198*
Joliet, Illinois 98, 102, 103
 Bluff Street Architecture in 1840 *111*
 Bustling Bluff Street in the 1800s *111*
 Friends of Community Public Art 99–100, *111*, 112, 108–13, 309

Sauk Trail 112
United We Stand: Irish Heritage 112
Visions From a Dream 111
Visions of Joliet 111
Jones, Kristin 136, 138–41, *139, 140*
Jordan, Lorna 253, 293, 294, *295, 295,* 300, 312
Jordan, Steve *264, 265*
Judelson, David 273
Julius Erving – Dr. J, Philadelphia 107, *109*
Justice and the Prairie, Kansas City 120, *121*

K
Kaczynski, Kelly 262
Kahn, Ned 218
Kansas City, Missouri 315, 370
 Eagle Scout Tribute Fountain 75
 Justice and the Prairie 120, *121*
Karasov, Deborah 25, *26*
Keep them Well, Seattle 269
Kelly, Ellsworth 170
Kennedy, Kerry 292
Kent, Washington 256, 258, 265, 267
Kilroy, Mary 175
Kinetic Light Air Curtain, Denver International Airport 62
King, Martin Luther Jr. 162
King, Rufus 162
King County, Seattle, Washington 290, 295, 298, 308, 327
King County Arts Commission 302–03
King County International Airport terminal 305
King Street Center, Seattle 303–04, *303, 305*
Kirkpatrick, Kay 299
Klein, Sheila 228, 229, 258, *259*
Knight, Christopher 135
Koenen, Barbara 169
Koolhaas, Rem 307
Kubli, Bert 351, 353, 354, *355*
Kukla, Alison 91

L
La Guardia, Fiorello 83
La Roche-Bernard, France 235
LaFarge, Christopher 81, 83
LaFarge, John 83
Laguna Beach, California 230
Lamb, Phillip 301
Lancaster Turnpike, Radnor, Pennsylvania 48, 210
Landmarks Preservation Commission, New York 160
Landscape Architecture 372
Lane Arts Council 335, 336
Lansing Steam Clock Tower, Michigan 60, *60*
Lao Tzu 262
Las Vegas, Nevada 263
Lascaux caves, France 97, 212
Laugharne, Wales 236
LDDK Studios 78
Le Corbusier 97
Lebow, Ed 35, 39
Lee, Laura 223
LeFevre, Gregg 358–72, *358*
 Bronzeville, Chicago 166–69, *167, 168*
 Brookline plaques, Massachusetts 21
 Cultural Landscape, Pomona College, Claremont, California 17, 176–81, *177–80*

Flight Paths, Las Vegas, Nevada 263
 Herald Square gates, New York 272
Leicester, Andrew 358–71, *358*
 Cincinnati Gateway 54–57, *55, 56,* 228, 360, 369, 370
 Ghost Series, Penn Station, New York 74–79, *75–78*
Lemr, John 66
Leopold, Aldo 28, 29
Levine, Renée 141
Levy, Stacy 263
Lewis, Junior 270
Lewis, Captain Meriwether 120
Lewis, Tim 270
Lexington, Massachusetts 216, 217, 222
Liberty High School, Manhattan 82
Lickteig, Leon 185
Lighting the Diamond District, New York 258
Liman, Jeanne 251
Lin, Maya 76, 78, 207
Lincoln, Abraham 17, 372
Lind, Carl 246, *246*
Linde, Carl L. 119
Liner, Robert 66
Lipps, Tomas 255
Lipsett Wrecking Company 75
Little, Ken 254
Lockwood, Bill 191
Lombardi, Pallas 159
London
 British Library 247
 City Hall 15
Long Island, New York 84–85, *85*
Long Island Railroad 84, 88, 89
Long Island Railroad Terminal Concourse, Penn Station, New York 74–79, *75–78*
Looker, Blair 257
Los Angeles, California 102, 103, 124, 217, 292
 Angels Flight 236
 The Power of Place 218
 Social and Public Art Resource Center (SPARC) 97, 98, 103, 104–07, *105*
 Vermonica 259
 Vernon MTA station 219
 Zanja Madre 366
Los Angeles Community Redevelopment Authority 366
Los Angeles Cultural Affairs Department 106
Los Angeles Fine Arts Squad 125
Los Angeles Metro Transit Art program 220
Los Angeles Times 127, 135
Louis, Joe 166
Louisiana 228
Louisville, Kentucky 22–23, 290, 311
 City at the Falls 262
 Main Street 270
Loveland, Colorado
 Moment of Truth 265
 Plaque 234
 Thompson River bridge structures 227
Lower Hudson Valley 80
Luecke, Barbara 253
Luhan, Mabel Dodge 83
Lujan, Gilbert "Magu" 220
Luminaries, King County International Airport terminal 305
Lummis, Charles 179
Lundquist, Laurie 41, 231
Lyle, Nick 230, 257, 265, 266, 303, *303*
Lynds, Clyde 161

M
McCarran International Airport, Las Vegas, Nevada 263
McClaren, Alex 45
McCoy, William H. II 49–53
McCullough, Geraldine 169
Machon School, Phoenix, Arizona 219
Mackie, Jack 294, 302, 303–04, *305, 314*
McKim, Mead & White 74–76, 77, 79, 249, 290
Maguire Group 24
Majozo, Estella Conwill 161–63, *161*
Malcolm X 162, 166
Malmquist, Connecticut 333
Mancillas, Aida 175
Mandel, Mike 339
Manhattan Beach, California 225
Mann, Thomas 219
Manwaring, Michael 223
Map Structure 252
Maple Leaf Bench, Massachusetts 254
Mapplethorpe, Robert 342, 351–52
Marius, Richard 277
Market Place/Meeting Place: An Urban Memorial, Cleveland 256
Market Street, Steubenville, Ohio 116
Marsalis, Ellis 203
Martin, Cynthia 120
Martin, Walter 271
Mason, Biddy 218
Massachusetts Art Preservation Act (MAPA) 309–10
Massachusetts Port Authority (Massport) 274–76, 309
Massachusetts Turnpike Authority (MTA) 252, 254
Massillon, Ohio 118
Matteson, James 34
Maxwell, William J. 62, 301
May, Carol 311–12, *313*
May, Thomas 270
Mayor's Office of Art, Culture and Film, Denver 64
Meadmore, Clement 15, 328–29, *331*
Meadowlands, New Jersey 75, 79
Mehta, Ved 179
Meier, Richard 364
Melville, Herman 282
Memory: Arizona, Sky Harbor Airport, Phoenix 90–93, *91, 92*
Memory Wall, Chelsea, Massachusetts 222, *223*
Memphis, Tennessee 231
Menge, Evelyn 17, 142–45, *143–45*
Mercer Island Streetscape, Washington 280–85, *281–84,* 372
Mercury Man, Penn Station, New York 77–78, *78*
Mersky, Deborah 267
Mesa, Arizona 46
Mesa, Woodland Park Zoo, Seattle 254
Metro-North Railroad, New York 80, 84
Metropolitan Piers Exposition Authority (MPEA), Chicago 167, 169
Metropolitan Transportation Authority (MTA), New York 74, 76, 80–89, *83, 85, 87, 88,* 271
Mexico 96, 97, 98, 103
Miami, Florida 325
 Coconut Grove bench 251
Miami International Airport 150–53, *151, 152,* 323, 325

Miami Bay, Florida 250
Miami Beach, Florida 212
Miami-Dade Art in Public Places program 150, 151–53
Michelangelo 371
Mihalyo, Daniel 313
Milan, Italy 247
Millar, Robert *164,* 170–75, *171–74*
Millay, Edna St. Vincent 83
Millennium Gate, Greensboro, North Carolina 226
Millennium Park, Chicago 96, *98*
Miller, Ross 254
Miller & Bryant 270
Mills, Richard K. 223
Milton, John 225
Minneapolis 370
Mitchell, Hugh 334
Mitchell, Lucy Sprague 83
Mitchell and MacArthur Landscape Architects 334
Mithun Partners 260
Mnemonics, Stuyvesant High School, New York 136–41, *137, 139, 140,* 210
Modern Movement 17, 19, 212, 248
Monument to the Great Northern Migration, Chicago 167–68, *168*
Morris Arboretum, Philadelphia 332
Morrish, William 34, 39–40
Moses, Grandma 188, *190*
Motta, Arthur 345
Mountain Pass pedestrian bridge, Phoenix, Arizona 231
Mouth of Truth, Loveland, Colorado 265
Mouton, Grover 34
Moynihan, Daniel Patrick 75, 79, 347
MSR Architects 54
Mud Life of the Maumee and Ottawa Rivers, Toledo, Ohio 261
Mudd, Michael 127
Mullican, Matt 80
Mulvihill, James 332
Muñoz, Paloma 271
Mural Arts Program, Philadelphia 98, 107–08, *109*
Mural Routes group 114
Murray, Lake *171, 173*
Museum of the City of New York, New York 82
Music Under New York program 80
Mystic River 158
*Mythology * Texas * Reality*, Austin, Texas 232

N
Nakamura, Stuart 256
Name That Architecture, Cedar Rapids, Iowa 232
Nantasket Beach, Hull, Massachusetts 193
National Building Museum, Washington D.C. 53
National Endowment for the Arts (NEA) 217, 335, 342–44, 347–48, 351–57
National Parks Service 234
National Register of Historic Places 76
Natural Elements Sculpture Park, Santa Monica, California 217
Neighborhood Pride program, Los Angeles 104–06, *107*
Neo-classical style 74, 75, 78–79, 84, 87
Nettleship, William 182–85, *183, 184,* 272
Neumann, John 118
Neumann, Roy 196

Miami Bay, Florida 250
New Bedford, Massachusetts *343,* 344–45
New Castle, Delaware 224
New Orleans, Louisiana 22, 308, 315
 City Hall 17
 New Orleans Streets 17, 142–45, *143–45*
 Professor Longhair Square 200–03, *201, 202*
 Riverfront stations 219
The New Ring Shout, New York 160–63, *161, 162*
New Works: A Public Art Project Planning Guide 322
New York 104, 161
 14th Street streetlights 246–48, *247*
 Canal Street subway station 271
 Department of Cultural Affairs 80
 Farley Post Office Building 79
 Federal Plaza 27, 28, 163
 Grand Army Plaza station, Brooklyn 86–87, *87*
 Herald Square gates 272
 Jacob Javits Federal Plaza 345–46, *348,* 349, *349, 350*
 Landmarks Preservation Committee 76
 Lighting the Diamond District 258
 Long Island Railroad Terminal Concourse, Penn Station 74–79, *75–78*
 MTA Stations 80–89, *83, 85, 87, 88*
 The New Ring Shout 160–63, *161, 162*
 Park Avenue 369
 Stuyvesant High School 136–41, *137, 139, 140,* 210
 Ted Weiss Federal Building 160–63, *161, 162*
 Tilted Arc 344, 345–47, *348,* 349, *350, 352*
 Union Square 372
 Woodside Station, Queens 88–89, *88, 371*
New York City Department of Cultural Affairs 138, 139
New York City Landmarks Preservation Committee 76
New York Times 75, 81, 169
Newsweek 39
Niemi, Ries 246
Norikane, Koji 256
Northup, Ann 109

O
O'ahu, Hawaii 230
Of Science and Faith, Seattle 370, *371*
Office of Architecture and Urban Design (OAUD) 58
Ohio Arts Council 183
Ohio–Erie canal 55
Ohio River 54, 56–57, 102, 115, 118
Ohio River Walk, Cincinnati 54
Oka Doner, Michele 150–53, *151, 152*
Olmsted, Frederick Law 274, 349
Olney, England 225
Olympia, Washington 266
O'Mara, Kate 46
O'Neil, Tip 273
O'Neill, Eugene 83
Ontario International Airport, California 236
Open End, Cincinnati 15, 328–29, *331*
Orchard Fence, Cleveland 265
Oregon Arts Council 34, 335
The Oregon Experiment 338

Oregon Historical Society 119–23
Oregon State Convention Center, Portland 63
Orozco, José Clemente 97, 178
Orr, Caroline 253
Ortega, José 80
Orvieto, Italy 250, 251
Our Shared Environment, Phoenix, Arizona 34–41, 35, 37, 38
Over-the-Rhine Gateway, Cincinnati 58–61, 59, 228
Oxford, Ohio 246, 246

PQ

Padilla, Debra J.T. 107
Paducah, Kentucky 114
Paine, Thomas 83
Palatka, Florida 102
Pally, Marc 340
Parabolic Flight, Miami International Airport 150
Parks, Rosa 162
Patchogue Business Improvement District 195
The Path Most Traveled, Scottsdale, Arizona 42–47, 43–45, 231
Patrick Park Plaza, Phoenix, Arizona 41
Peck, Robert 347–49, 350, 356
Pelli, Cesar 137, 153
Pembroke Real Estate, Inc. 309–10
Pencil Ramada, Machon School, Phoenix, Arizona 219
Penn, William 53
Penn Station, New York 74–79, 75–78
Pennsylvania Department of Transportation (PennDOT) 52, 229
Pennsylvania Railroad 74
Percent for Art 98–99, 113, 291, 293, 301, 307–08, 355, 365–67
 Cambridge, Massachusetts 154, 157–58, 312
 Denver 62
 Eugene, Oregon 335, 336, 338
 Houston 306
 Los Angeles 132–33
 New Orleans 142, 145, 202, 203
 New York 76, 80, 138, 140
 Philadelphia 330
 Phoenix, Arizona 34, 39, 40–41, 42
 Salt Lake City 220
 San Diego 175
 Santa Monica 217
 Seattle 300, 302, 313
Pewabic Pottery 214
Pfannerstill, Tom 262
Philadelphia 48, 102, 113
 Independence National Historic Park 234, 234
 Market Street Bridge 75
 Mural Arts Program 98, 107–08, 109
 Philadelphia University 146–49, 147, 148
 Pine Street 224, 237, 237
 Wills Eye Hospital 330–32, 331, 338
Philadelphia Toboggan Company 193
Phillips, David 309–10, 311
Phoenix, Arizona 22, 291, 315, 325–26
 Arizona Falls 159
 Central Library 90
 Machon School 219
 Mountain Pass pedestrian bridge 231
 Patrick Park Plaza 41
 Pima Freeway Enhancement

42–47, 43–45, 210, 231
 Sky Harbor Airport 90–93, 91, 92
 South Mountain Community College 40, 40
 Sunnyslope Canal Demonstration Project 41
 Thomas Road Overpass 34–41, 35, 37, 38
 Wall Cycle to Ocotillo 38–40
Phoenix Arts Commission 34–35, 38–40, 90, 93
Phoenix Public Art Master Plan 34–35, 38, 39, 90
Phoenix Street Transportation Department 38, 40–41
Physics Wall, University of Oregon 339, 340
Pima Freeway Enhancement, Scottsdale, Arizona 42–47, 43–45, 210, 231, 301
Pincus, Robert 174–75
Pindell, Howardena 90–93, 91, 92
Pinto, Jody 41
Place Makers 315, 328, 333
Places magazine 53
Planning magazine 53
Plečnik, Jože 215
Plensa, Jaume 96, 98
Poet's Table, Huntington Beach, California 124–27, 125, 126
Point, Susan 235
Polanski, Roman 171
Pomona College, Claremont, California 176–81, 177–80
Portland, Oregon 246, 306
 Historical Society Murals 114
 Sovereign Hotel 119–23, 119, 122
Porto Stefano, Italy 235
Portsmouth, New Hampshire 216
Portsmouth Floodwall Murals, Portsmouth, Ohio 101, 102, 118
Post Oak Divan, Houston, Texas 250, 251
Poticha, Otto 334, 335, 336, 338
The Power of Place, Los Angeles 218
Pozo, Angelica 256
Prague, Royal Castle 215
Prairie Wedge, Denver International Airport 63
Presley and Associates 274
Pride and Progress 109
Professor Longhair Square, New Orleans 200–03, 201, 202
Progress Architecture awards 53
Project for Public Spaces 350
Proust, Marcel 17, 19
Providence, Rhode Island
 Federal Hill Archway 229, 231
 Fruit stand marker 213
Providers, Christopher Street station, New York 83
Public Art by the Book 292
Public Art Handbook for Louisiana Communities 322
Public Art Network (PAN) 315
Public Art Program Directory 292
Public Art Works: The Arizona Models 322–23
Purcell, Steve 223
Quality Iron Foundry 199

R

Radnor, Pennsylvania 231, 369–70
 clock 232
 Lancaster Turnpike 48, 210
 Radnor Gateway Enhancement 48–53, 49, 51, 52, 229, 369–70

Radnor Township Design Review Commission 49
Radoczy, Maya 303
Rainforest Gates, Seattle 266, 303, 303
Rakoff, Penny 256
Raphael, David 304
Rathje, Terry 232
Una Raza, Un Mundo, Universo, 149th Street station, New York 80
Reaching Water, Cambridge, Massachusetts 159
Reagan, Ronald 241
Reed, John 83
REI flagship store, Seattle 260, 268, 308
Reimann, William P. 358, 358, 362, 364–66
 East Boston Piers Park, Boston 274–79, 275, 277, 278, 370
 Radnor clock 232
 Radnor Gateway Enhancement 21, 48–53, 49, 51, 52, 229, 369–70
Reiquam, Peter 260
Religious Beginnings, Steubenville, Ohio 118
Renaissance 289
Renewal, New York 161, 162
Reno, Nevada 326
Renton, Washington 253
Reuther, Victor 214
Richards, Val 108
Richardson, Robert H. 58, 59, 61
Riley, David Owen 264
Rilke, Rainer Maria 14–15
Rise, Mattapan Square, Boston 24, 25
The River: Time is a River without Banks, Iowa City 196–99, 197, 198
Rivera, Diego 97
Riverfront stations, New Orleans 219
Riverside, California 247
Riverside Gateway, Cincinnati 228
The Road to Hollywood, Hollywood, California 130–35, 131–35
Roberts, Susan 223
Robeson, Paul 162
Robinette, Margaret 301
Robinson, Jackie 188
Roche, Judith 270
Rochester, New York 193
Rocky Mountains 62
Rodman, Henrietta 83
Rodriguez, Dionisio 219
Rodriguez, Vivian Donnell 150–51, 153
Romans 212, 213
Rome, Italy
 Constantine's Arch 212
 Trajan's Column 212
Romero, Alejandro 110, 111
Roosevelt, Eleanor 188
Roosevelt, Franklin D. 240
Roosevelt, Theodore 193
Root, John Wellborn 244, 245
Roots, Garrison 301, 301
Rosato, Antonette 62
Rosen, Steve 64–65
Rosen-Queralt, Jann 293–94
Rosenberg, Lilli Ann Killen 232
Ross, Aden 220
Rotary Club 60
Rotary Club, Steubenville, Ohio 116, 117
Rothenberg, Erika 130–35, 131–35
Ruck, Dean 67, 68, 69–70, 69
Ruffner, Ginny 219
Runnels, John 70, 71
Ryerson, Mitch 255

S

Saar, Allison 168, 169
St. James's Station, Long Island, New York 84–85
St. Petersburg, Florida 100
Saint-Phalle, Niki 346
Salinas, California 99, 100
Salmon Mural, Seattle 269
Salt Lake City, Utah 22
 light rail station 220
Sam's Friendly Produce Stand, Salinas, California 99, 100
San Antonio, Texas 326
San Diego, California 23
 Alvarado Water Treatment Plant 164, 170–75, 171–74
 Santa Fe railroad station 250, 251
 Vermont Street Pedestrian Bridge 175
San Diego Union-Tribune 174–75
San Fernando Valley 104
San Francisco, Balmy Alley murals 103
San Jose, California 293, 294, 295, 298, 308, 315, 364–65, 369
 Capitol Expressway Light Rail expansion 302
 Japanese American Internment Memorial 238–41, 239, 240
 street markers 223, 224
San Juan Capistrano, California 249
Sanderson, Harriet 269
Santa Ana, California 350–51, 351
Santa Barbara, California 236, 257, 259
Santa Cruz, California 326
Santa Fe, New Mexico 215
 Fountainhead Rock 255
 Trail of Dreams, Trail of Ghosts 27, 28, 29
Santa Fe Railroad 250, 251
Santa Monica, California
 Art Tool 217, 217
 Big Wave 229
 Natural Elements Sculpture Park 217
Santa Monica Arts Commission 217
Sato, Norie 301
Sauk Trail, Joliet, Illinois 112
Save Outdoor Sculpture (SOS!) 354–55
Savinar, Tad 269
Sawyer Point Park, Cincinnati 54–57
Scarboro, Kathleen 108, 111
Scarborough Arts Council, Toronto 114
Scheib, Gloria 192
Schneider, Kenny 271
Schoonhoven, Terry 124–27, 125, 126
Schutz, Karl 99, 102–03, 114, 115
Schwartz, Martha 28, 349, 349, 350
Scotland 227
Scottsdale, Arizona
 Pima Freeway Enhancement 21, 22, 42–47, 43–45, 210, 231, 301
 Scottsdale Public Art Program 42
Scrovegni family 100
Scully, Vincent 76
Sea Flower, New Bedford, Massachusetts 343, 345
Seabreeze Park, Rochester, New York 192, 193
Seattle, Washington 22, 23, 114, 248, 257, 290, 291, 293, 294, 299, 300–02, 308, 310, 312–13, 315, 327
 Brandon Court Reliefs 268

Brightwater Water Treatment Plant 293–94, 304
City Hall 301
Cornerstones 263
Creston Nelson Substation 246, 246, 300, 300
Department of Transportation 313
Founder's Court, *Encircled Stream* 218
Full Circle 262
Harborview Quilt 267
International District bus shelter 221
Justice Center 301
Keep them Well 269
King Street Center 303–04, 303, 305
Northwind Fishing Weir 235
Rainforest Gates 266
REI flagship store 260, 268, 308
Salmon Mural 269
Southwest Police Precinct building 299
streetlights 246, 247
Swedish Medical Center 370, 371, 372
Viewlands/Hoffman Substation 300
Walking Wall 269
Waterway 15 project 246, 246, 261
Woodland Park Zoo 254
Seattle Arts Commission 302
Second Perspective, Portland, Oregon 119
Security Screen, Kent, Washington 267
Sellenraad, Johan 214, 215
Seminary Ladies, Steubenville, Ohio 117, 118
Serpent Fence, Albuquerque, New Mexico 264
Serra, Richard 27, 28, 29, 163, 342, 344, 345–47, 348, 349, 352, 353, 370–71
Serrano, Andres 342, 351
Sesquecentennial Park, Houston 66–71, 67–70
Seven Hills Park trailhead, Somerville, Massachusetts 222, 223
Seven Wonders, Houston, Texas 67, 68–69, 68, 70, 70
Shawnee Village, Portsmouth, Ohio 101
Shelton, David 259
Shepley Bulfinch Richardson and Abbott 146, 149
Simmons, Hamp 217
Simmons, Leonard 145
Simpson, Buster 62–65, 63, 64, 255, 293–94
Simun, Konstantin 21
Sinatra, Frank 108
Singer, Michael 62
Siqueiros, David Alfaro 97
Sit-Down Strike Memorial, Flint, Michigan 214, 215
Site Seeing, Houston 67, 68, 69–70, 69
Sitting on History, British Library, London 246, 247
Skid Road, Mercer Island Streetscape, Washington 282
Skidmore, Owings & Merrill 79
Skoshe, Pattison 120
Sky Harbor Airport, Phoenix 90–93, 91, 92
Slavin, Arlene 18

Smith, Michael P. 202
Smith Campus Center, Pomona
 College, Claremont, California
 176–81, 177–80
Snider, Louise 115
Snyder, Jimmy "The Greek" 116
Social and Public Art Resource
 Center (SPARC), Los Angeles
 97, 98, 103, 104–07, 105
Soldiers and Sailors Memorial Arch,
 Brooklyn, New York 86
Sollod, T. Ellen 280–85, 281–84,
 293–94, 358–73, 358, 371
La Sombra, Tempe, Arizona 221
Somerville, Massachusetts 222, 223
Sophron, Hayward, California 272
Sound Transit 230
Sounds from the Past, Houston,
 Texas 67, 68, 69, 70
Sousa, John Philip 191
South Mountain Community
 College, Phoenix, Arizona 40,
 40
Sovereign Hotel, Portland, Oregon
 119–23, 119, 122
Spanos, Lisa 61
Sparling, Dennis 232
Speiser, Bruno 188, 189
Springfield, Massachusetts 308,
 329–30, 331
Squaw Peak Parkway, Phoenix,
 Arizona 35–37, 38–40, 231
Stanley, Peter 180–81
Stanton, Elizabeth Cady 188
Staples 100
Starr, Kevin 176, 180
Steel, Steubenville, Ohio 116, 118
Steel Workers Union Hall, Joliet,
 Illinois 113
Stendhal 17, 19
Stern, Robert A.M. 17, 178, 179, 368
Steubenville, Ohio 102, 114, 115–18,
 115–17
Stinson Organ Company 191
Stockholm, Sweden
 City Hall 213
 City History Museum 226
Stockton, California 327
Storrs, Anne 34, 335, 336
Story City, Iowa 193
Streisinger, Lotte 340
Stuart, Michelle 138, 141
Stuyvesant High School, New York
 136–41, 137, 139, 140, 210
Sugarman, George 330–33, 331, 338,
 344, 353
Summer, Eugene, Oregon 337
Sun Rays, Buckland Hills Mall,
 Manchester, Connecticut 332
Sunnyslope Canal Demonstration
 Project, Phoenix, Arizona 41
Surls, James 343, 345
Susholtz, Lynn 175
Swarthmore, Pennsylvania 49
Swedish Medical Center, Seattle
 370, 371, 372
Sweeney, Gary 65, 225
Switzerland 216, 216, 220, 233, 246, 247
Syma 146–49, 147, 148
Systems of Discovery, Stuyvesant
 High School, New York 138, 141

T

Taliesin West 91
Tampa Red, Chicago 168, 168
"Tank Trap," Eugene, Oregon 15, 20,
 333–38, 337
Taplin, Robert 80
Team HOU 66, 67, 68
Ted Weiss Federal Building, New

York 160–63, 161, 162
Tempe, Arizona 22, 311
 Adopt-a-Tree monument 226
 La Sombra 221
 Waiting for a Date 221
Tepfer, Fred 334, 338, 341
Tepper, Steven 345
Terry, Owen 223
Teters, Charlene 215
Thomas, Dylan 236
Thomas, Tamara 133
Thomas Road Overpass, Phoenix,
 Arizona 34–41, 35, 37, 38
Thompson, David 336, 337
Thompson River bridge structures,
 Loveland, Colorado 227
Thorne, Ann 124, 127
Thread City Crossing, Windham,
 Connecticut 24–26, 24
Tiede, Scot 262
Tiger Mountain, Issaquah,
 Washington 230
Tiled Corner Bench, Santa Barbara,
 California 257
Tilted Arc, New York 27, 28, 29, 57,
 163, 344, 345–47, 348, 349, 350,
 352
Tinguely, Jean 346
To the Heroes, Santa Fe, New Mexico
 215
Todi, Italy 14
Toledo, Ohio 225, 261
Toppenish, Washington 114
Toth, Donald 116
Toussaint, Allen 200
Townscape Institute, The 8–9,
 48–50, 53, 214
Trader Joe 100
Trail of Dreams, Trail of Ghosts, Santa
 Fe, New Mexico 27, 28–29
Tree Chair, Cambridge,
 Massachusetts 255
Tribute to Industry, Los Angeles 219
Triumph of the Vegetables, Olympia,
 Washington 266
TrizecHahn 130–32, 133–35
Truth, Sojourner 162
Tubman, Harriet 108, 162
Tufts, Charles 222
Tufts University, Aidekman Arts
 Center 157
Tukwila, Washington 253, 270
Tureau, David 200–03, 201, 202
Turman, Jill 231
Turner, Lana 132
Turner, Richard 174
Turrell, Jim 181
Twenty-nine Palms, California 114
Twitchell, Kent 107, 109
Tyler, Joe 221, 226
Tyrrell, Brinsley 264, 265

U

Understory, Tiger Mountain,
 Issaquah, Washington 230
Union, Lake 246
United Auto Workers union 214, 215
United Nations 162
United We Stand: Irish Heritage,
 Joliet, Illinois 112
University of California Los Angeles
 (UCLA) 104, 106, 107
University of California San Diego 314
University of Iowa 196, 199
University of Oregon 333, 338–40,
 339
University of Pennsylvania 332
University of Washington 314
Unthank Seder Poticha Architects
 334, 338

UrbanArts 205, 274
Usher Bollards, Hollywood,
 California 271

V

Valadez, John 350–51, 351
Vaughan, Thomas 119–20, 123
Vendome Firefighters' Memorial,
 Boston 186, 204–07, 205, 206
Venice, Italy 90, 222–24
Verdin, Jim 59
Verdin Bell Company 58, 59, 61
Vermonica, Los Angeles 259
Vermont Arts Council 304
Vernon MTA station, Los Angeles
 219
Vietnam Veterans' Memorial,
 Washington, DC 207
Viewlands/Hoffman Substation,
 Seattle 300
VIGOR 144–45
Visions From a Dream, Joliet, Illinois
 111
Visions of Joliet, Joliet, Illinois 111
Visual Artists Rights Act (VARA) 93,
 309–11, 312, 332, 333, 347
Volunteer Lawyers for the Arts 309

W

Waddle, Robert 183, 184–85
Wagner, Dick 246
Waiting for a Date, Tempe, Arizona
 221
Wake Forest University 314
Wales 236
A Walk on the Beach, Miami
 International Airport 150–53,
 151, 152
Walking Wall, Seattle 269
Wall Cycle to Ocotillo, Phoenix,
 Arizona 38–40
Wall Street Journal 57
Walter J. Sullivan Water Treatment
 Facility, Cambridge,
 Massachusetts 154–59,
 155–58
Washington, DC
 Vietnam Veterans' Memorial
 207
 Washington National Airport
 153
Washington, George 233
Washington, Horace 219
Washington, Lake 280
Washington Middle School Park,
 Albuquerque, New Mexico 230
Washington Post 53
Washington State Department of
 Transportation 281
Wasserman, Andrea 304
Water Carry, Tukwila, Washington
 270
Water Works, Arizona Falls, Phoenix
 159
Waterloo, New York 224, 237, 237
Waters, Muddy 166, 168, 169
Waterway 15 project, Lake Union,
 Seattle 246, 246, 261
Waterworks Gardens, Renton,
 Washington 253
Watkins, Tim 311–12, 313
Wayne Clock, Radnor, Pennsylvania
 50
We the People: Summer Festivals of
 Orange County, Santa Ana,
 California 351
Weiss, Glenn 293, 302–03, 304, 310,
 311–12, 314, 316
Weissman, Jane 103
Welborne, John H. 236

Welcome to Mummerland,
 Philadelphia 108, 109
Wells, Ida B. 162, 166
Wells, Junior 168, 169
Welsh, William and Juanita 118
Westchester Square station, New
 York 80
Wheelock, Alice and Avery 191
White, Peter 205–07, 205, 206
White Star Market, Steubenville,
 Ohio 116
Whitesavage, Jean 230, 257, 265, 266,
 303, 303
Whitmore, Kathy 66
Widgery, Catherine 27, 28–29
Wiggins, Sherry 62–65, 63, 64
Williams, Pat Ward 134
Willimantic River 24–26, 24
Wills Eye Hospital, Philadelphia
 330–32, 331, 338
Wilson, Pete 175
Windham, Connecticut 24–26, 24
Wineman, Adolph 77
Wings for the IRT: The Irresistible
 Romance of Travel, Brooklyn,
 New York 86–87, 87
Wingwall, Alice 340
Witkin, Isaac 15, 308, 329–30,
 331, 354
Wojczuk, Michael 115–16, 117, 118
Wolfston, Betsy 336–38, 337
Woodland Park Zoo, Seattle 254
Woodrow, Bill 246, 247
Woodside Continuum, Woodside
 Station, Queens, New York
 88–89, 88, 371
Works Progress Administration 107,
 108, 191
Wortham Theater Center, Houston
 68, 70
Wrice, Herman 108
Wright, Frank Lloyd 91
Wright, Judy 179
Wright, Richard 166, 168
Wyrick, Shirley 196–99, 197, 198

YZ

Yampolski, Ruri 308, 310
Yates, Dawn 270
Yngvason, Hafthor 315
York, Pennsylvania 114
Youngstown, Ohio 368
Zanja Madre, Los Angeles 366
Ziegler, Alyson 270
Ziegler, Glenn 270
Zink, Larry 120
Zwak, Marilyn 226, 231
 Our Shared Environment,
 Phoenix, Arizona 34–41,
 35, 37, 38

First published 2007 by Merrell Publishers Limited

Head office
81 Southwark Street
London SE1 0HX

New York office
49 West 24th Street, 8th Floor
New York, NY 10010

merrellpublishers.com

British Library Cataloging-in-Publication Data:
Fleming, Ronald Lee
The art of placemaking : interpreting community through
public art and urban design
1. Public art spaces 2. Public art 3. Urban beautification
I. Title
711.5'7

ISBN-13: 978-1-8589-4371-8
ISBN-10: 1-8589-4371-X

Produced by Merrell Publishers
Project-managed by Melissa Tapper Goldman
Designed by Evan Gaffney
Copy-edited by Louise Wilson
Indexed by Hilary Bird

Front cover
Top, left to right:
Cincinnati Gateway, Andrew Leicester. Photo: courtesy of the artist.
Trail of Dreams, Trail of Ghosts, Catherine Widgery. Photo: courtesy of the artist.
Mercer Island Streetscape, T. Ellen Sollod. Photo: courtesy of the artist.
Radnor Clock, William Reimann, Dennis Sparling, concept by Ronald Lee
 Fleming. Photo: Sergio Rojstaczer.
Bottom, left to right:
Ghost Series, Andrew Leicester. Photo: courtesy of the artist.
Cincinnati Gateway, Andrew Leicester. Photo: courtesy of the artist.
Mnemonics, Kristin Jones and Andrew Ginzel. Photo: courtesy of the artists.
The Path Most Traveled, Carolyn Braaksma. Photo: Dan Coogan.

Back cover
Top, left to right:
Linden Leaf Bench, Ross Miller. Photo: courtesy of the artist.
Thomas Road Underpass, Marilyn Zwak. Photo: courtesy of the artist
 and the Phoenix Office of Arts and Culture.
Drawn Water, Mags Harries and Lajos Héder Collaborative. Photo: courtesy
 of the artists.
CARECEN Mural, Judith Baca with Social and Public Art Resource Center.
 Photo: courtesy of SPARC.
Bottom, left to right.
Art Tool, Carl Cheng. Photo: courtesy of the artist.
Bronzeville Sculptural Bench. Photo: Todd Buchanan.
A Walk on the Beach, Michelle Oka Doner. Photo: courtesy of the artist.
Providers, Greenwich Village Murals, Lee Brozgold and students from P.S. 41.
 Photo: courtesy of the artist.